Picturing
a
Nation

Art and Social Change in Nineteenth-Century America

David M. Lubin

Yale University Press

New Haven and London

Published with the assistance of the Getty Grant Program

Yale Publications in the History of Art are
works of critical and historical scholarship by
authors formerly or now associated with the
Department of the History of Art of Yale
University. Begun in 1939, the series
embraces the field of art historical studies in
its widest and most inclusive definition.

Designed by Sylvia Steiner.
Set in Bodoni type by Tseng Information
Systems, Durham, North Carolina.
Printed in Hong Kong by Everbest Printing
Co., Ltd.

Library of Congress Cataloging-in-Publication
Data

Lubin, David M.
Picturing a nation : art and social change in
nineteeth-century America / David M. Lubin.
p. cm.
Includes bibliographical references and index.
ISBN 0-300-05732-6
1. Painting, American. 2. Painting, Modern
—19th century—United States. 3. United
States—Social life and customs—19th
century—Pictorial works. I. Title.
ND210.L83 1994
759.13′09′034—dc20 93-19392 CIP

A catalogue record for this book is available
from the British Library

The paper in this book meets the guidelines
for permanence and durability of the
Committee on Production Guidelines for Book
Longevity of the Council on Library
Resources.

10 9 8 7 6 5 4 3 2 1

Contents

Preface and Acknowledgments

I've always been charmed by that scene early on in *Citizen Kane* in which the impulsive young millionaire Charlie Kane, played by Orson Welles, announces to his bank-appointed guardian, Mr. Thatcher, that he wants to publish a newspaper. "I think it would be fun to run a newspaper," Kane explains. Thatcher repeats the phrase with a sputter of disgust at the offending word *fun:* "I think it would be fun to run a newspaper."

Acting not only as Kane's guardian and disciplinarian, but also, it seems, as a guardian of disciplinary boundaries, Thatcher asks his ward what he knows about running a newspaper. Kane resists the older man's disciplinary guardianship with what might be called antidisciplinary interdisciplinarity. "I don't know how to run a newspaper, Mr. Thatcher," he answers. "I just try everything I can think of."

Personally, I admire this spirit of try-what-works pragmatism. I am also aware of how such pragmatism, unanchored by long-term goals and principles, leads to a moral or political floundering (as it certainly does in the case of Charlie Kane). The book you have before you constitutes my version of try-what-works art history, cultural history, and social history all wrapped into one. But its thoroughgoing eclecticism is guided throughout by what I hope the reader will find to be consistent principles of socially critical inquiry and an aspiration toward multicultural equality. In the pages ahead I try everything I can think of—everything that might work—to elucidate, with these goals in mind, a handful of nineteenth-century American paintings and the varied society that produced them.

I finished my last book days after the birth of my daughter Molly and began this one days after the birth of my son Gus nearly two years later. Since then, good friends have had their own babies, loved ones have died, political systems have faced upheaval, and any calculation of misery and joy in the world seems more imponderable now than ever.

So many friends, colleagues, and family members have read and commented on various parts of this book at various stages along the way that I despair of remembering each and every name as I sit down to tally my acknowledgments. The following list is long, therefore, but surely not long enough. For critical readings of the entire book, whole chapters, parts of chapters, or public lectures that found their way into chapters, I would like to thank—a deep breath will be neces-

sary—Tony Anemone, Matthew Baigell, Karen-edis Barzman, Charles Bassett, Jon Bassewitz, Joel Bernard, Al Boime, Doreen Bolger, Sarah Burns, Jim Cuno, Linda Docherty, Johnny Faragher, John Fiske, Estelle Freedman, Jane Hunter, Carrie Jones, Joe Ketner, Michael Haney, Tony Judt, Richard Leppert, George Lipsitz, Karen Lucic, Michael Marlais, Walter Michaels, Angela Miller, David Miller, Fred Mosely, Alex Nemerov, Joel Pfister, Rick Powell, Vince Raphael, Bruce Robertson, Paul Rogers, Eric Rosenberg, Claudia Smeltzer, Gray Sweeney, Dick Terdiman, Katie Trumpener, Alan Wallach, Amy Warner, Sherry Wellman, and my copy-editor at Yale, Lawrence Kenney. Having said that, I would like Michelle Bogart, Ann Dietrich, Marianne Doezema, Ken Eisen of Railroad Square Cinema, Vivien Fryd, Alan Hess, Tom Jester, Margaretta Lovell, Amy and Jack Meyers, Thayer Tolles Mickelson, Dwight Miller, Pete Moss, Barry O'Connell, Hearne Pardee, John Peters-Campbell, Donald Preziosi, Carrie Rebora, Dan Reich, Jack Rushing, David Simon, Marc Simpson, Paul Staiti, Ted Stebbins, Roger Stein, David Steinberg, Gabe Weisberg, Gina Werfel, John Wilmerding, Steven Youra, and Rebecca Zurier to stand for an even larger network of friends and colleagues who shared with me their good advice, encouragement, and knowledge as well as in some instances difficult-to-find slides, elusive references, and lavish food and drink. My faithful friend, reader, and Roman restaurant guide was Dana Prescott. Two graduate students who were wonderfully forthcoming in sharing their ideas and research were Beth O'Leary (on Lilly Martin Spencer) and Lesley Wright (on Seymour Guy). My former Colby student Martin Berger, who is now writing a Yale American Studies Ph.D. dissertation on Thomas Eakins, read several chapters with extremely close and critical attention; there are certain sentences that we worked over so many times I can no longer tell if they are his or mine. But that, really, is the point of this necessarily unwieldy paragraph and, indeed, of the book as a whole: there is no such thing as an individual, isolated creator; all creation is collective. No sentence in this book is exclusively mine, none that was not formed in conscious or unconscious collaboration with all the authors cited in my bibliographic endnotes as well as my students, friends, colleagues, unknown audience members, and even critics who wrote adversarial reviews of my previous book or vigorously disputed ideas I presented in public forums at various locations over the years. As you will see in the chapters ahead, I believe that all art, however personal it may be, is similarly shaped and formed by the tug and pull of a variety of often competing social collectives—the artist's family, friends, professional associates, class affiliates, ideological opponents, and so forth.

Four individuals who have been mentors over the years not only intellectually but, more important, in terms of what they have taught me about largeness of

spirit are Wanda Corn, Beth Johns, Jules Prown, and Bryan Wolf. The late David Huntington was also a figure I much admired for his generosity toward new scholars coming along. In the course of writing this book I became friends with Bill Truettner, who is yet another inspiration for his receptivity to younger scholars and new ideas. I hope I am able to return to the field at large the goodwill and openness that these friends have shared with me.

While writing the book I was fortunate to receive fellowships and grants from the American Council of Learned Societies, the Getty Grant Program, the John Simon Guggenheim Memorial Foundation, the Smithsonian Institution, and the Stanford Humanities Center. The libraries, archives, and special collections across the country that assisted me in my research are too numerous to name, but as operating and acquisition budgets tighten everywhere, I have become aware that I cannot take these institutions for granted, and I thank them for their continuing efforts to keep their doors open to scholars. In 1986–87 the Department of Art at Stanford University and in 1989–90 the Program in Comparative Studies in Discourse and Society at the University of Minnesota kindly provided me with office facilities and secretarial assistance as well as warm collegiality. Colby College has been unfailingly supportive throughout, not only in terms of funds for travel, research, books, and permissions fees, but also for much-appreciated help of various kinds from custodians, deans, librarians, audiovisual personnel, my fellow faculty, and my department secretary, Pam Wilder. My students at Colby have been astute and energetic critics of ideas I have tried out in class and, as a result, they have helped to generate the various interpretations contained in this book. I am especially grateful for the research assistance provided to me in the summer of 1989 by Barb Shaw and in the summer of 1992 by Alex Peary.

My editor at Yale, Judy Metro, deserves special mention for her patient advice and delightful sense of humor. The writing of a book certainly has its moments of fun (whatever Mr. Thatcher might suppose), but for any author, seeing a manuscript through to publication is no barrel of laughs. Therefore, it is especially good to be able to work with one's editor as a friend.

I'd like to close with some affectionate words for the Lubins and Warners, my immediate family, especially for my parents-in-law, Ann and Dale Warner, and my father, Sam Lubin. Doris Lubin, my mother, died while I was writing this book but I must say that I feel her always with me, especially every time I successfully crack a joke. I dedicate this to her as well as to Molly and Gus and their mother, Libby, who is the best part of all my hours, Italian or otherwise. I may try everything that works, but she makes everything work.

The Politics of Method

Picturing a Nation examines how various groups of nineteenth-century Americans pictured themselves in their art. In so doing they pictured their nation—either as they thought it was or thought it should be. Artistic representation, as such, indirectly amounted to a form of political representation.

My way of addressing this rather broad topic is to focus on the work of six artists, three of whom, John Vanderlyn, George Caleb Bingham, and William Michael Harnett, are generally more appreciated by art historians than are the others, Robert S. Duncanson, Lilly Martin Spencer, and Seymour Joseph Guy. Regardless of his or her status, however, each of these painters constituted a unique intersection of American social groups. This is not to say that they were unique as artists or that only they were notable for such intersections. The claim of this book is that all artists, indeed, all individuals, similarly represent a mélange of social groups situated at varying distances from the fulcrums of power in their culture. I happened to write about these six painters rather than six others because for one reason or another I found their art or their careers especially fascinating, and either insufficiently treated in the literature or abundantly treated but not so in terms of the particular issues I would like to address.

Also, the wide social, artistic, and chronological range encompassed by this assortment suited one of the goals of the book, which is to dispel the admittedly convenient but misleading notion of a "nineteenth-century American painting." Indeed, despite the book's subtitle, there was no single

nineteenth-century America either, for as we shall see there were many Americas within the United States, all competing for dominance or at least parity.

My thinking on this subject has been influenced by the work of social historians and theorists who have disputed the melting-pot notion of America as a unified totality, a relatively harmonious blend of ethnic ingredients. The new social history calls attention to the way certain of those ingredients historically failed, or only temporarily succeeded, in masking out others. Each chapter in this book considers how Americans in the nineteenth century made use of visual art—as well as other forms of cultural discourse—to produce, for example, a socially agreed upon norm of whiteness by opposing it to a non-normative blackness, or, similarly, a norm of masculinity in opposition to femininity, middle-classness in opposition to upper- or lower-classness, and American identity in opposition to the un-American identity of foreigners from abroad and aboriginal Indians from closer to home. But *Picturing a Nation* is not itself a work of social history in the sense of focusing on the external environment rather than on the internal characteristics of the art that arose in that environment, for the art—particularly as a medium addressing the senses and the emotions as well as the mind—is the book's central concern.

In each chapter I have sought to understand how works of art that appear to have little or nothing to do with the underlying social conflicts of their era were nonetheless responsive to those conflicts, whether as direct commentaries, thinly disguised

allegories, or wishful attempts at escape. I have tried, in other words, to see how the very form of a painting was dictated by the artist's special circumstances: being a black man who painted for whites, a housewife who painted for other housewives, a portrayer of docile children who was himself artistically docile, and so forth. More broadly, I have tried to show how these personal circumstances and the art that emerged from them were symptomatic of larger social patterns: racial disharmony, evolving family structure, changing attitudes toward children and the art marketplace, and so on.

The reader should be forewarned, though, that this book is riddled with speculation about how these works of art were implicitly connected to the wider world. One of my operating premises is that we not only can but should endeavor to understand what paintings might have meant to artists and to viewers (and even to those in the society who had no access to the works under consideration) even when there is little or no *direct* evidence for subscribing to any such hypothetical interpretations. I am proceeding from a belief that texts bear or generate potential meanings that the producers and consumers of those texts may not be able to recognize because of mental paradigms that inevitably mask certain meanings while calling attention to others. We in a later era can be sensitive to meanings in the text that viewers of the time failed to heed, not because we in the present are smarter, wiser, or more self-aware, but because interpretive paradigms have shifted such that previously hidden meanings now emerge—even as, to be sure, other potential meanings drop from sight. In each chapter, I will examine paintings in terms of a wide variety of discursive productions of the period in order to show how such paintings partook of—and in some cases also resisted—the conceptual or

ideological languages and categories then current.

The structure of the book roughly follows a chronological succession of types or branches of painting in nineteenth-century America. During the first quarter of the century, history and myth painting commanded the highest regard of American artists despite the generally lukewarm attitude evidenced by the public for such erudite or grandiose undertakings. In the second quarter, landscape painting took precedence, genre painting flourished in the third quarter, and in the final quarter of the century still-life painting at last achieved widespread popularity and critical applause.

Still, each chapter is pinned to an individual artist, a single practitioner of the branch in question. But the chapters are not monographic. They are devoted instead to a three-way interplay among art (an aesthetic form of social practice with its own institutional codes, mechanisms, traditions, and so forth), artist (the individual practitioner), and society (the larger field of contest that shapes both the art and the artist and is in turn shaped by them).

Monographic art history has its roots in the nineteenth-century cult of genius, the romantic belief that certain privileged figures otherwise known as Great Men—women were by and large excluded—transcended local time and space and spoke to the ages. When the Great Man happens to be an artist, that is, a Great Artist, the role of the art critic or the art historian is to serve him with humility, even self-abnegation, all for the cause of making his genius better known and bet-

ter understood. Not that all monographs are about artists of the highest order, for they can be written about Americans as well. But even then the monographist treats the artist under consideration as a Great Artist manqué, perhaps of the second or third order, but still a figure of transcendent importance, if not genius. I have done my best to avoid such pantheonism.

But I have also tried to avoid the extremes of the postmodernist "death of the author" or "death of the subject" approach to art history. Some ten or twenty years ago, in the aftermath of the student revolts of 1968, this was the preferred mode of advanced journals in film, literature, and social science. The antihumanist theories of Louis Althusser, Roland Barthes, Paul de Man, Jacques Derrida, Michel Foucault, Jacques Lacan, and other structuralists and poststructuralists had taken hold with a new intelligentsia distrustful of the old humanist bromides, which now looked like ideological obfuscations by which the ruling class claimed and maintained its moral authority. Antihumanists charged that humanist values, the centerpiece of which was individualism (the basis of the cult of genius), were simply bourgeois values in disguise and led not only to the hegemony of that class but also to its justification for promoting world capitalism, which it then imperialistically defended throughout the Third World—most notably in Vietnam.

But if national and international events had a way of disillusioning younger scholars with humanism's penchant for justifying or covering over oppression of the masses, a couple of decades later it was antihumanism's turn to face up to history. Appalling details about the regimes of literal antihumanists in such places as Cambodia, the People's Republic of China, and Romania resonated, justifiably or not, with unsettling revelations about the personal lives of such prominent Western antihumanist theoreticians as Althusser, de Man, Lacan, and Martin Heidegger. Leftist intellectuals who had previously turned to theoretical antihumanism as a less mystified, indeed, more *humane* means of comprehending the world than that offered by humanism began increasingly to entertain doubts about the emancipatory potential of this so-called alternative.

Thus, however distrustful one may be of humanist art history with its fetishization of the individual, it nevertheless seems only right to reserve a special place for the artist as a real person rather than reducing him or her, in postmodernist terms, to a marker for the text's logocentric rhetoric of origins and presence. The effort to avoid such semiotic reductionism gives rise, however, to the countercharge of psychologism, the reduction of impersonal social processes (such as the class conflict) to individual psychological processes (such as the oedipal conflict). In each of the following chapters I have tried to account for the art in question not by privileging one reduction or another but by pitting several against one another, such that not only class conflict and oedipal conflict are pressed into explanatory service but so too are conflicts of race, region, and gender. In short, *Picturing a Nation* represents—that is, pictures as well as stands for—an effort to see the world in a manner that resists the excesses of both individualism and anti-individualism.

In recent years, what is known as *identity politics* has sought the middle ground between individualism and anti-individualism. The claim of identity

politics is that we are not single, isolate individuals but rather members of identifiable social groups: Irish-Americans, radical lesbians, midwestern tax accountants, and so forth. The world is seen as comprised neither of monadic individuals (humanism) nor of ideologically constituted social subjects (antihumanism) but of individualized social groups. At its worst, identity politics is simply individualism on a higher plane, where now the monad in question is not the person but the identity group. I hope to avoid this mere reconstitution of individualism by continually reminding the reader that the artist or viewer under discussion belonged at any given time to numerous identity groups, not all of which were necessarily in coalition with one another and some of which were actually in direct opposition. This too may be just another version of individualism, a mere multiplying of the identity-group modifiers and nouns attached to the subject in question, but it is an improvement, I think, in that it helps clarify the self-contradictory (nonidentical) nature of so-called personal identity in modern society. A painter, Lilly Martin Spencer, for example, might belong to one identity group that was in power (the white middle class), another that was out (housewives), and a third (the sentimentalists) that was in the process of acquiring cultural power in a manner that may have been at the expense of either or both of the other two groups (see chapter 4). Such attention to multiple and conflictual identifications on the part of artists is not by any means a full-scale rejection of individualism or a solution to the problems inherent in identity politics, but it is an effort to write about these artists and the various groups to which they belonged with sensitivity to the dialectical nature and political density of the history that produced them.

A common complaint about postmodernist writing on art is that it displaces the artist, indeed, that the postmodern critic seeks, however fatuously, with whatever delusions of grandeur, to take the place of the artist. The critic's attack on the concept of genius as an instrument of bourgeois mystification is itself taken as a sign of bad faith. The critic is accused of an illicit desire to substitute his or her own putative genius for that of the artist—a case of genius-envy if ever there was one. It would be disingenuous of me to pretend that I take no pleasure in trying to one-up the artists I write about. I do not see anything wrong with the critic competing, as it were, with the artist. The more interesting the art, the more competition it is bound to encourage. But the critic's business is not to belittle artists, any more than it should be to hold them or their work in reverence.

My attitude toward the contemporaries of the artist is the same. In the pages ahead they are neither disdained for their deficiencies and narrowness of vision nor treated, as in some social history, with a hands-off, value-free tolerance that absolves them of all shortcomings simply because everything is relative and therefore it is unfairly presentist of us to cast judgment on the inhabitants of a culture (such as the past) other than our own. It would be nice to be absolved of having to make judgments, but that is not possible. Jean Renoir, the film director, is often quoted for his anthem of pure tolerance in *The Rules of the Game*, "Everyone has his reasons," but what is typically overlooked is the agonized statement that precedes it, "*There is one thing that is terrible*, and that is that everyone has his reasons." What is so terrible

and yet necessary to understand is that when it comes to facing the ills that beset the world we must rely neither on abstention from judgment nor on the moral binarization that conveniently divides the world into bad and good, oppressors and victims, hegemonists and subversionists, or any other bipolar combination.

I have tried to empathize with the artists I write about, tried to understand what made them live and paint as they did. I have tried also to empathize with their contemporaries, even when their politics or aesthetics run counter to my own. And I have tried to empathize, if that is the right word, with my reader. I have done what I can to make this book readable, stimulating, provocative, friendly. Surely the Frankfurt School theorists Theodor Adorno and Max Horkheimer would judge such friendliness ersatz, an ideological ruse or deception aimed at establishing a false rapport with the reader, who is converted into a passive, gullible culture-industry consumer no less by the postmodern art historian playing talk show host than by the connoisseur posturing as an elite guide to civilization. That may indeed be the case; it is not inconceivable to me that authorial friendliness, chattiness, if you will, might ultimately have an insidious effect. My frequent use of *we*, for example, is dangerous to the extent that it elides difference and presumes a perhaps unwarranted identity of author and reader. All the same, I have tried throughout this book to pique and maintain your interest, put things as clearly as I can, challenge, anticipate questions or objections, and break up my otherwise one-way speech with plenty of asides (hence all the dashes and parentheses with which this text is larded). I have hoped to make it hard for you to read passively. I ask for an engaged response, often on a point-by-point basis. I invite you to laugh, scoff, be angry, scribble notes in the margin, write me a letter—and send it.

It goes without saying that *Picturing a Nation* is "interpretive" rather than "factual." The book is full of statements that cannot be proven in a manner either scientific (falsifiable) or juridical (beyond a reasonable doubt)—cannot, in fact, be proven at all. A fact-hound like Sergeant Friday would find what lies ahead of dubious value. But to admit that this book is not positivist in its orientation is not the same as to say that it is ahistorical. It attempts to be both historical and presentist: to be mindful of the past and its differences from the present, but also to recognize that it is not only impossible but undesirable to see the past completely on its own terms, detached from present-day needs and discourses. Why study the past if not better to understand, criticize, and reorganize the present?

The problem with presentism is its arrogance, its self-centered inability to see beyond itself, its habit of treating the past as little more than a mirror by which it can narcissistically gaze at itself. The problem with historicism is its tendency, whether naive or specious, to believe what it wants to believe, which is that the past can be recovered, known, held in view as an object for studious contemplation from an objective, disinterested, politically neutral position. On their own, unchecked by one another, presentism and historicism are equally guilty of obscuring rather than clarifying the world. In this book, they are dance partners. One may take the lead more often than the other, but it takes both to tango.

Picturing a Nation treats history as an infinite series of texts. Military engagements, works

of popular literature, party politics, letters home, household artifacts, newspaper editorials, Currier and Ives prints, treaties, treatises, and of course paintings all serve within these pages as historical evidence—as facts—but also as texts to be deciphered. Facts are interpretations in disguise. A fact is supposed to be anything that has actually happened or is really true. And yet only interpretation is capable of bestowing facticity upon a putative fact.

In this book, one type of fact is attended to more than any other, and that is the work of art itself. The paintings analyzed in the following chapters exist as material objects with both a present of their own and a past of their own. So to speak. Let us remember that these paintings are (in fact) inert, inanimate, sensationless pieces of matter onto which other pieces of matter—embodied artists, viewers, and historians—cast meanings that in one way or another serve diverse purposes and interests.

Here emerges yet another of this book's epistemological, if not ontological, dilemmas. On one hand it exhibits a strictly social-constructionist view of art, asserting that paintings cannot possess inherent, historically transcendent, acontextual meanings but are instead blank screens onto which various not necessarily compatible meanings have been and can be projected by viewers situated in specific viewing situations (whether that of the painter in the studio, the nineteenth-century spectator, or the present-day author or reader of an art-historical account such as this). On the other hand the book recognizes such social constructionism to be idealist or "mentalist" in philosophy and tries to compensate with a materialist regard for the active role of paintings in *producing* meaning.

The question might be phrased, Is a painting a receptacle for every conceivable meaning that history might throw at it or does its irreducible materiality constrain meaning in advance, sanctioning only certain interpretations while disallowing others? To put this another way, *is* the painting a screen or *does* it screen?

It comes down to a politics of interpretation. How licensed are we to interpret painting, how many legitimate interpretations can we provide, how many are useful, how many are merely interesting but not useful, and how many are too many? This book requires you to decide at what point you become a meaning cop, jumping into your hermeneutical squad car to flag down interpretations that go too fast or, worse, too far.

For some, textual presentism (interpreting a work from the past in terms of whatever the interpreter finds relevant to our present historical situation) can be exciting to behold, the more creative and audacious it is, the better. For others, the presentist's adventure in hyperinterpretation is irritating, an insult to past and present alike. Throughout this book I have tried to keep my own impulse toward flyaway presentism in check with heavy ballasts of historicism and textual materialism. I have tried, that is, to advance only interpretations that I can show to be congruent with issues that were alive, actually talked about, in the period under discussion (historicism) and that I can connect to the visual evidence of the painting itself (textual materialism). Even if no single viewer of the time consciously interpreted the works as I have interpreted them, these works nonetheless had the potential to resonate in the various ways suggested.

Still, from time to time I find myself looking wistfully at horizons of interpretive possibility that my hefty methodological sandbags have compelled me to leave unexplored. Such restraint may be for the best, but, frankly, I'm not sure. I remember well a time when the Dionysian energy of deconstruction seemed more an augur of socialist liberation than a mirror of capitalist consumption, an intellectual Molotov cocktail instead of cocktail party intellectuality. That early game-playing, convention-snubbing deconstruction, in which interpretive fecundity was irreverently privileged over strained profundity, when it was better to be virtuosic than virtuous, and when the very concept of epistemological grounding was anathema—all of that now seems irresponsible child's play. And yet, as discussed in chapter 5, free play (whether of children or of signifiers) is not necessarily a bad or socially unproductive thing, although in certain historical periods it has been so considered.

Presentist or historicist, I have been political in all my interpretations. Indeed, the thesis of this book is that everything is political, including theories of artistic value that scorn political art and revere art for art's sake. I realize that a problem with saying that everything is political is that it waters down the meaning of the word, giving rise to the phenomenon of present-day academics, presentists and historicists alike, flattering themselves that what they (we) do professionally is a viable political alternative to direct, interventionist political action. But the problem with reserving the term strictly for affairs of government, parties, and factions is that this perpetuates the notion

that the activities of personal and aesthetic life are (or should be) separate from public life and have no bearing on them. Coming of age with the generation of 1968, I cannot believe this to be so. Instead I think it is important to remember that *political* means *of the polis*, and in that sense all painting is political, and so too is all description, analysis, history, and interpretation of painting. Clarifying the historically specific interrelation of the political and the aesthetic without sacrificing one to the other is a primary goal of the chapters ahead.

Mahler believed that his symphonies should contain the world. Each of the following chapters attempts to be symphonic in that regard, grasping for everything that might be pertinent to the art or artist or historical period under consideration. This is not chamber music but overstuffed, asymmetrical, often arhythmic pastiches of art history, social history, intellectual history, popular culture, literary theory, feminist theory, and critical theory. The book proceeds through a continual juxtaposition of high and low art, verbal and visual text, nineteenth-century document and twentieth-century scholarship, biographical anecdote and theoretical generality, impressionistic description and analytic discourse, a fascination with yesterday and a preoccupation with today.

You have before you, then, a book that strives for cornucopian plenitude, that tries to say everything not by actually saying everything but rather by suggesting that whatever has been said, there is always a good deal more to say. Although each of the chapters attempts to be full, if not bursting, none pretends to be total or all-seeing—panoptic—in its vision. I have hoped to present material neither as a high priest in a pulpit nor a babbling barbarian on the street. I have sought, that is, to write art history that addresses the reader neither from church nor carnival but from an open and popu-

lated space in between. This trope is ideological, to be sure, an allusion to the liberal Enlightenment ideal of free speech, rational public discourse, and universal equality that we should admit has never been achieved in America. Nonetheless, this is the hypothetical democratic space from which I have attempted to speak and, in so doing, have tried to help make actual rather than merely potential.

I say I do not believe in ideological neutrality, and yet my attempt to balance competing theories or approaches implies that such an effort can lead, though certainly not to the one true history, to some sort of truer history—clearer, less mystifying, more humane, more worthwhile than a history that is uniformly humanist or antihumanist, historicist or presentist. I caution throughout that objectivity is a chimera, and yet my cobbling together of contradictory methods and theories bespeaks a pursuit of that chimera. Forswearing the notion of a value-free examination of the past, I repeatedly attempt to clarify what specific values I have brought to bear as an examiner. Paradoxically, however, the very admission that reality can never be seen free of distortion contains a presupposition that such distortion *can be* reduced. The assertion that reality is unknowable purports to say something knowable about reality, and thus the assertion deconstructs itself. Still, however deconstructable the assertion may be, its humbling spirit should always be with us in our efforts to know that which it claims cannot be known.

I believe we can never understand the past—or ourselves—completely, but what do all my contortionist efforts demonstrate if not an underlying conviction that at any given time we can understand more completely, more clearly, more illuminatingly than before. I say at any given time because I also believe that what qualifies as completeness, clarity, and illumination continues to change so long as history itself continues to change.

Picturing a Nation

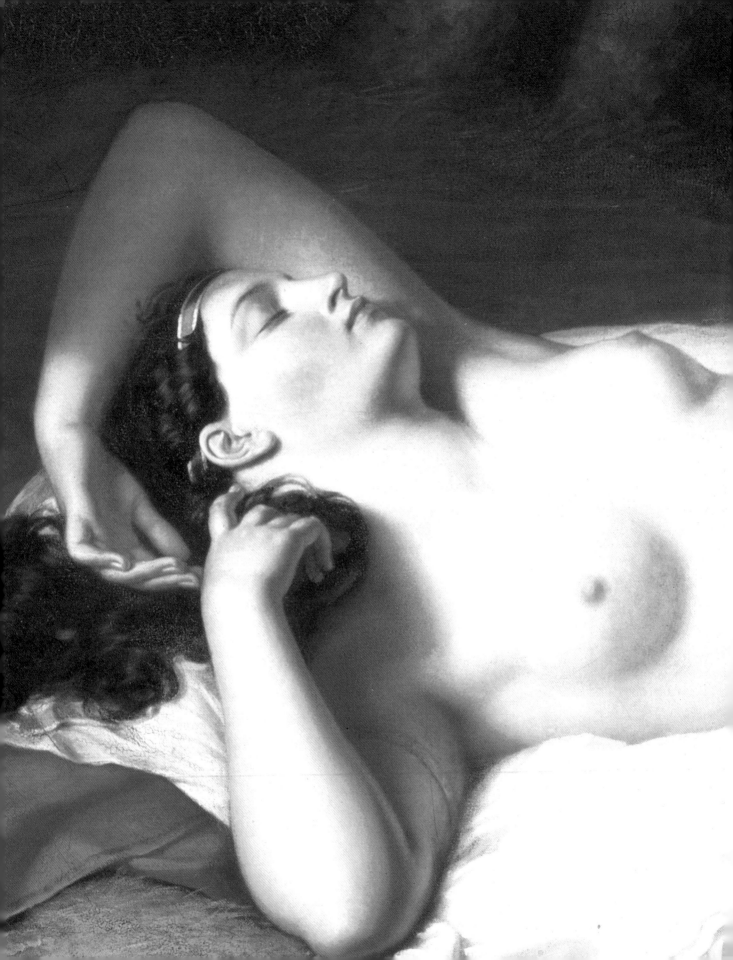

Labyrinths of Meaning in
Vanderlyn's *Ariadne*

John Vanderlyn had the world ahead of him. It was the beginning of the nineteenth century, and the young American who was living in Paris had already won acclaim for two powerful history paintings that had proven him to be not only up-to-date in his pictorial aesthetics but also strikingly political.

The Death of Jane McCrea (1804, fig. 1), representing an episode from the American Revolution in which a young colonial woman was hatcheted to death by Indian mercenaries in the pay of the British, was roundly applauded in Paris at a time when hostilities between France and England were at high pitch. The painting was commissioned by Joel Barlow, President Jefferson's envoy to France, who had described the incident in *The Columbiad*, his epic poem celebrating America's rejection of British authority and rule.[1] *Marius Amidst the Ruins of Carthage* (1807, fig. 2), no less timely than *Jane McCrea*, depicts an exiled Roman general who scowlingly contemplates revenge upon his enemies. Bonaparte himself is said to have awarded the painting a gold medal when it was exhibited at the Louvre. Obsessed with bending an unappreciative world to his will, the young emperor against whom all the counterrevolutionary armies of Europe were arrayed might have been pleased to identify with this rippling fantasy of hard-bodied, hard-minded masculinity defiant against the corrupt and corrupting opposition.[2]

In 1809, fresh from these two triumphs, Vanderlyn began his next major undertaking, *Ariadne Asleep on the Isle of Naxos* (fig. 3), and devoted to it the following three years of his life. Although certainly his best-known work, *Ariadne* is usually regarded as wholly apolitical, as though, in his zeal to scale the heights of academic neoclassicism, the ambitious artist unwisely, if not crassly, jettisoned his political sensibilities and moral passion. A recent commentator on Vanderlyn, pointing out that *Ariadne* "makes no overt reference to the American or French political climate," is thereby compelled to interpret the work exclusively in terms of formal sources, artistic styles, ancient myths, and timeless symbols, describing it "not only as a neoclassical idealization, but also as an essentially romantic investigation that is at once universal and intensely individual."[3]

I do not claim that Vanderlyn deliberately— that is, consciously—sought to make *Ariadne* as topically political as *Jane McCrea* and *Marius*, yet I do wish to show that the painting's subject (nude female figure in pastoral setting), style (neoclassical, French, romantic), and theme (seduction and betrayal) coincide in such a way as to be keenly relevant to some of the most pressing issues of the artist's time. It is almost as though the various aesthetic choices the painting embodies were themselves responses to a whole network of social choices confronting the new nation and its citizens

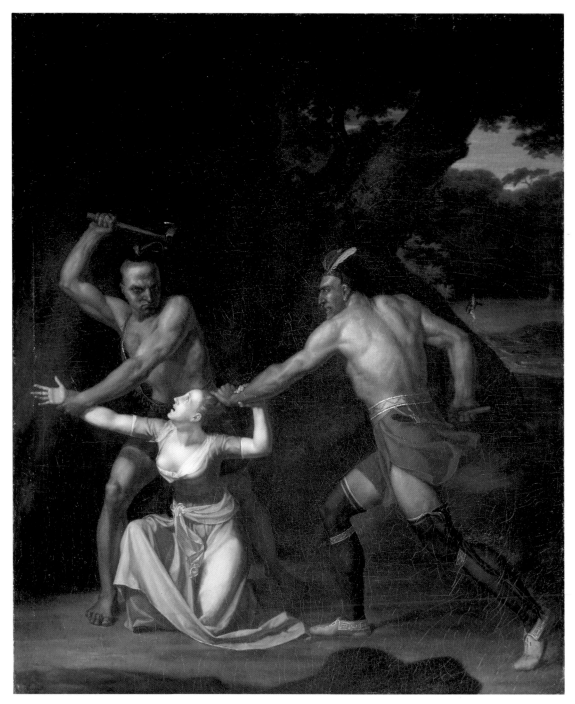

1. John Vanderlyn, *Death of Jane McCrea*, 1804. Oil on canvas, 32 × 26½ in.
Wadsworth Atheneum, Hartford, Connecticut.

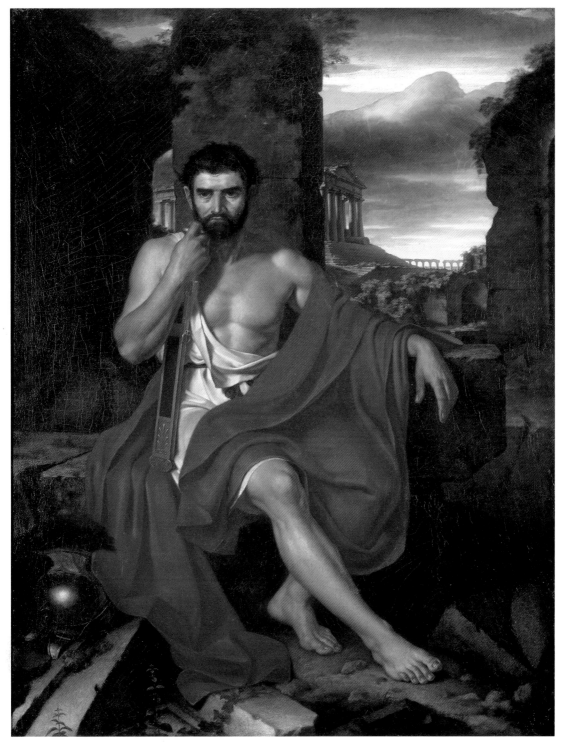

2. John Vanderlyn, *Marius Amidst the Ruins of Carthage*, 1807. Oil on canvas, 87 × 68½ in.
Fine Arts Museums of San Francisco. Gift of M. H. de Young.

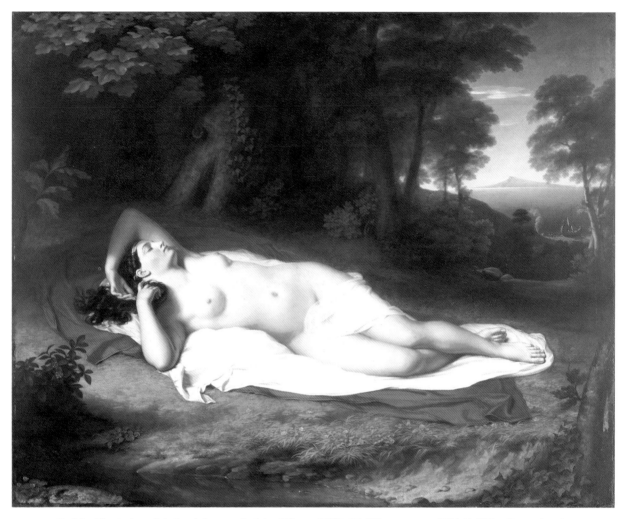

3. John Vanderlyn, *Ariadne Asleep on the Isle of Naxos*, 1809–12. Oil on canvas, 68½ × 87 in. Pennsylvania Academy of the Fine Arts, Philadelphia. Gift of Mrs. Sarah Harrison to the Joseph Harrison, Jr., Collection.

at home and abroad, John Vanderlyn among them.

In fact, when submitted to contextual analysis, *Ariadne* brings to the fore a variety of social conflicts faced by Americans and Europeans during the years in which it was produced. Accordingly, this chapter examines the painting in terms of the early nineteenth-century social melodrama of sexual seduction, regards the work as a cultural residuum of westward expansion and racial warfare, and relates it to the struggle for hegemony in the early republic between anglophiles and francophiles: between, that is, those who sought to navigate the ship of state toward British waters and those who wished instead to sail in the direction of France.

Certainly one of the most troubling issues for the young nation was how to position itself diplomatically, philosophically, and even aesthetically in terms of its European predecessors across the sea so that it might derive full economic and cultural benefit without returning to a subordinate or satellite status. Equally troubling were considerations of how the new republic was to maintain its high moral ground and yet situate itself, with fullest advantage, in terms of the indigenous peoples who possessed prior claim to the land. Yet a third area of concern focused upon the affectional relations of men and women and the need to define their roles toward one another and society at large. *Ariadne* provides an opportunity for examining these topics, and they in turn enable us to recognize the painting's cultural pertinence, which has long been obscure.

❧

We see a life-sized naked woman, pink and opalescent amidst dusky green, brown, and gray, and covered across her thighs by the thinnest, most translucent of veils. Parabolically shaped, this veil starts from behind the upper leg, rolls damply over

the rounded contour of the thigh, and extends over the figure's genital delta, a ridge in the fabric falling in line with the crease between leg and hip while a crescent curve in the cloth counterbalances by reversal the rounded underside of the abdomen. The woman wears a thin silver-and-blue band on her head and a tawny one bound tautly across her upper right arm.

Protected from the earth but also connected to it by abundant white and red drapery, Ariadne slumbers upon a gentle upward sweep of land. In keeping with the general openness of her form, the lustrous black hair falling away from her headband spills down and outward in myriad loose curls, lockets, and S-shaped tendrils. Abundantly repeated and frequently interlocked, the visual forms of the hair are echoed elsewhere in the figure by the interior folds of the ear and the drapery over the leg, and elsewhere in the painting by the ivy attached to the base of the tree above her.

Hair, ear, and ivy are all segments of a diagonal axis initiated in the lower left by a sprig of foliage that points directly toward the hair, almost reaches out to it. This is merely one of several instances in which Ariadne's body forms a continuum with the land that surrounds her, suggesting a visual congruence between nature and woman.[4] The shady promontory rising over the sea echoes the rounded contour of her hip, the two slender trees at her feet are entwined like her legs, and the distant mountain, tinged red at the peak, repeats the shape of her breast. The strangely cleft tree trunk that lines up directly with her profiled face forms a diagonal pair of lips with a dark hollow in between, as

though it were nature's extension of her mouth, if not an allusion to other bodily orifices such as those of sight, sound, or sexuality.

But if in this regard Ariadne forms *a part* of nature, in other ways she seems distinctly *apart* from it: her body is light, nature dark; her figure opens outward, while nature closes in. The white and red draperies that swirl cloudlike beneath Ariadne, though casting a reddish tint upon her flesh, separate her from the natural environment, protectively sealing her off. Moreover, inasmuch as her nude figure calls to mind a tradition of pastoral nudes originating in early sixteenth-century Italy (c. 1510, fig. 4), Ariadne invokes culture, civilization, the study and transmission of artistic techniques, and, precisely because of these high-cultural allusions, she could be regarded as the

antithesis of nature and that which is natural. To the extent that she alludes not only to Renaissance Italy but also to classical Greece, Vanderlyn's nude might further connote culture and light, a bulwark against the darkness and anarchy of uncivilized nature.[5]

Poised at the edge of the narrow beach in the upper right corner of the painting is a crescent-shaped vessel tethered in the water, its sail half-raised, a red pennant atop the mast, and he who will command it preparing to board. Viewers in early republican America familiar with standard works such as Thomas North's translation of Plutarch, Andrew Tooke's *Pantheon of Heroes and Gods*, or various renditions of Ovid's *Metamorphoses* would most likely have realized that this must be Theseus, the Athenian adventurer who, as captive of Ariadne's father, was sent into the Cretan labyrinth to confront the monstrous Minotaur.[6]

Opposing the authority of her father the king, the beautiful princess saved Theseus, the legend

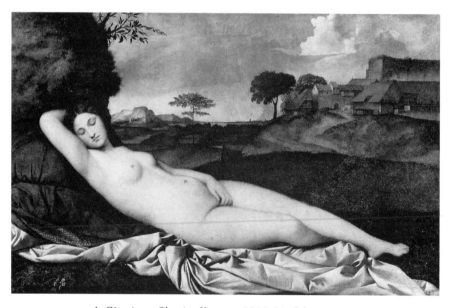

4. Giorgione, *Sleeping Venus*, c. 1509–10. Oil on canvas,
42½ × 68⅞ in. Gemäldegalerie, Dresden.

goes, by supplying him with a ball of thread to unravel on his way into the maze only later to rewind in order to retrace his steps and safely return. The Athenian then eloped with the lovestruck maiden, who fell tranquilly asleep upon the grass of Naxos after their lovemaking, not suspecting that her lover was setting sail for home without her. Forsaking Ariadne and further sensual indulgences with her, Theseus proceeded to Athens, became its king, and transformed it into a glorious new Athens, cradle of Western civilization. According to Plutarch's *Rise and Fall of Athens*, Theseus's father, King Aegeus, leapt to his death upon spotting his son's black-sailed ship in the distance, for black had been the prearranged signal that Theseus had perished on his journey. It is unclear why Theseus hoisted the wrong color, but the mis-

take, if that is what it was, cost the life of his father and made him the king. Ariadne, meanwhile, was rescued from heartbreak by the nature god Bacchus, who married her and gave her a crown of seven stars, as shown by Tintoretto (1578, fig. 5) in an allegory about the birth of the city-state of Venice, blessed by divine grace and crowned with liberty.

In seventeenth- and eighteenth-century Augustan fantasies of recreating the legendary golden era associated with such city-states as ancient Athens, the story of Ariadne—who initially saved

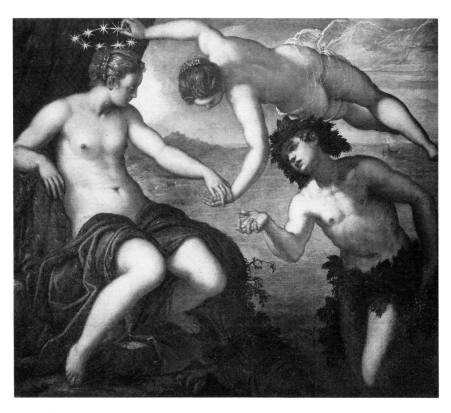

5. Tintoretto, *Ariadne, Bacchus, and Venus*, 1578. Oil on canvas, 57½ × 65⅝ in. Palazzo Ducale, Venice (Photo: Alinari/Art Resource, New York).

Theseus's life but then presented a womanly obstacle to his manly fulfillment of civic responsibility—was considered morally instructive. Jacques-Louis David's *Oath of the Horatii* (1784, fig. 6), also drawn from Plutarch, covers similar ground, pointedly contrasting manly civic virtue with womanly sentimental weakness.

In a preparatory sketch (c. 1810, fig. 7) Vanderlyn shows Ariadne's lower hand turned away from her ear, but now, in the finished work, her forefinger calls explicit attention to the ear, pointing toward it as the sprig of leaves points toward her cascading hair. This ear infolds a series of curves similar to those reappearing throughout the painting: bent fingers, lockets of hair, rounded breasts, belly, thighs, the ridged gossamer over her loins, the drapery swirling beneath her, the edges of leaves. The ear also resembles the Athenian ship, with its ridged and curving hull, and thus associates Ariadne with culture as well as nature, mind as well as body, insofar as the vessel is in turn associated with Athena, goddess of reason and wisdom. This intricate orifice toward which Ariadne's finger points is itself a miniature labyrinth; indeed, *labyrinth* is the anatomical term for the inner ear. Perhaps Ariadne is a victim of the Athenian's seduction and abandonment, but this emphasis on the ear suggests that she herself could be seen as a seducer, a waylayer, a trap from which he who enters may never return.

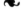

6. Jacques-Louis David, *Oath of the Horatii*, 1784. Oil on canvas, 130 × 168 in. Musée du Louvre, Paris (Photo: Alinari/Art Resource, New York).

Born of Dutch lineage in Kingston, New York, less than a year before the beginning of the American Revolution, Vanderlyn, the son of a farmer, left home at seventeen for the metropolis, where he found work in 1792 with Thomas Barrow, a former coach painter from England who was now a "seller of colors, glazing, paintings, and groceries." The boy practiced his promising skills as an artist by copying works that came into the shop for framing. Among these was a portrait of Aaron Burr, to whom Vanderlyn was introduced.[7]

A thirty-nine-year-old lawyer of abundant credentials and ambitions but not abundant wealth, Burr was so impressed with Vanderlyn's potential that he elected to become his patron and provide a stipend so that he might study full time as an artist. He sent the boy, who was now about twenty, to work with Gilbert Stuart in Philadelphia and then on to Paris to train with the neoclassicists. "I shall never imagine that I have conferred on him the smallest obligation," said Burr of Vanderlyn, "but shall be infinitely flattered by an opportunity of rescuing Genius from obscurity."[8]

Burr's generosity toward Vanderlyn was not without political ramifications. By sending his protégé to the Paris of the Directoire instead of to royalist London, where the expatriate Benjamin West held court to promising artists from the new republic, Burr not only made a statement about American cultural independence from England but indicated allegiance to the ideals of revolutionary France. From the start of his career, Vanderlyn thus occupied a symbolically anti-British position.

When the painter visited his homeland in 1801, Burr, now Thomas Jefferson's vice president, suggested he travel to Niagara Falls, paint topographical views of them, have the paintings engraved in Paris, and profit from the prodigious sales that would surely result from representations of the

American sublime.[9] Vanderlyn followed this advice. When he was back in Paris working on his representations of the natural wonder, Jefferson's diplomatic envoys to the French capital were working on an equally spectacular if more far-flung piece of nature, the territory of Louisiana then currently in French possession.

Sorely pressed for the means to finance what turned out to be an abortive invasion of Britain, Napoleon agreed to a price of $15 million for this vast parcel of land that stretched from Canada to the gulf, from the Mississippi River to the Rocky Mountains. Napoleonic imperialism dovetailed here with republican expansionism, profiting both. Not so, however, with Vanderlyn's designs on the land, his land "speculations" in both the optical and financial sense of the word, for the engravings he commissioned cost more than he had expected, while the sales that resulted were far fewer.[10] In disappointment the artist turned from landscape to history painting, a more prestigious and more profitable enterprise. This was the period during which *The Death of Jane McCrea* and *Marius* established Vanderlyn as a daring, politically committed, aesthetically up-to-date American in Paris.

While the painter's career was thus on the rise, his patron's was in decline. In 1804 the vice president killed his political rival Alexander Hamilton in an infamous duel that ended his own political career. Several years later he was federally indicted for conspiring to establish an empire in the Southwest. He won acquittal only after a lengthy trial that cost all his money and what little remained

of his reputation. Ignominiously exiled from the United States, Burr wandered through Europe, arriving in Paris in 1810, nearly broke. Immediately he searched out his former protégé: "Found Vanderlyn [he recorded in his diary]. He is the same as formerly. Took breakfast with him. An hour looking at his pictures. Marius on the ruins of Carthage obtained the gold medal in 1808. I see nothing in that line to exceed it. Other admirable things, both original and copied. Then walked to his shoemaker's."[11]

Among the "other admirable things, both original and copied" that Burr viewed in Vanderlyn's studio was *Ariadne*.[12] But also on hand and clearly relevant to Vanderlyn's conception of *Ariadne* were the carefully wrought copies he had made of Cor-

reggio's *Antiope* and Titian's *Danäe*.[13] In both of these mythological figure studies, beautiful young women, sensual and naked, are offered up for male delectation. Antiope, like Ariadne, lies asleep in a forest glade, one arm provocatively cast behind her head, while Danäe, awake and enthralled by Jupiter's shower of gold, smoulders with sexual heat (which is to say encourages it in the viewer).[14] These works, together with others Vanderlyn may have seen firsthand or known by engraving—for example, Giorgione's *Sleeping Venus* (see fig. 4), Titian's *Venus of Urbino*, Jan van Neck's *Diana Asleep at the Foot of a Tree*, van Dyck's *Jupiter and Antiope* and *Cupid and Psyche*, and maybe even Ingres's sleeping nude of 1808 (destroyed during the Napoleonic wars)—most likely played a role in his conception of *Ariadne*. Hoping to return permanently to the new nation and establish himself as its preeminent artist, Vanderlyn may have conceived of naked Ariadne not merely as an allegorical embodiment of European artistic tradition but also as

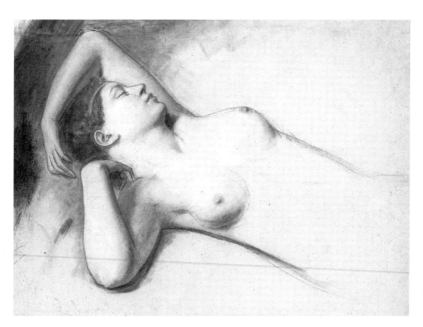

7. John Vanderlyn, *Ariadne: Study for Head and Torso*, c. 1809–12. Charcoal heightened with white on toned paper, 17⅝ × 23 in. Pennsylvania Academy of the Fine Arts, Philadelphia. Gift of International Business Machines.

8. Adolf Wertmüller, *Danäe and the Shower of Gold*, 1787. Oil on canvas,
59⅛ × 74⅞ in. National Swedish Art Museums, Stockholm.

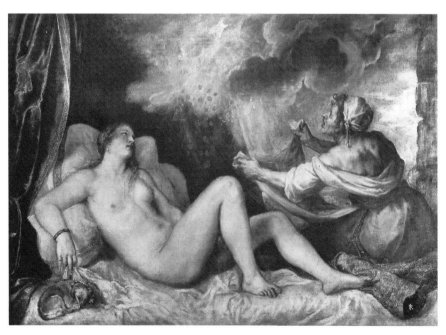

9. Titian, *Danäe*, 1554. Oil on canvas, 50⅞ × 70⅞ in. Museo del Prado, Madrid
(Photo: Alinari/Art Resource, New York).

the means of symbolically injecting that tradition into an artistically impoverished New World, her body a museum in the wilderness.[15]

Regardless of what he did or did not borrow iconographically or stylistically from the figural nude of the Western tradition, Vanderlyn invoked that tradition as a pillar against which to steady himself when, after his return to America, rumblings of middle-class outrage against *Ariadne* threatened to bring him down. As he protested in self-defense, "It is well known that in the principal galleries of Europe, pictures and sculpture representing the naked figure are to be found, being the work of artists of the first celebrity, who are never censured by the enlightened visitors of those galleries for having displayed in their choice of subjects an impure and immoral taste."[16]

Scandalized that *Ariadne* should be considered scandalous, Vanderlyn scrambled for the high ground. He could not, he contended, "believe that any person of refined and cultivated taste, whether male or female, artist or not, ever looks upon a beautiful statue of Michael Angelo, or Canova, or a naked Venus of Titian or Correggio, or any other of the great masters, with other feelings than those of admiration at the wonderful skill of the artist, and the grace and beauty which he has transmitted to the marble or canvas."

Perhaps. But in a letter written in the summer of 1809 Vanderlyn confided about *Ariadne*, "The subject may not be chaste enough for the more chaste and modest Americans, at least to be displayed in the house of any private individual, to either the company of the parlor or drawing room, *but on*

that account it may attract a greater crowd if exhibited publickly" (emphasis added). In the same letter he referred to Adolf Wertmüller's *Danäe and the Shower of Gold* (1787, fig. 8), a neoclassical sort of pinup painted in Paris and exhibited in 1806 in Philadelphia, where it achieved succès de scandale: "From the success a foreign artist—Mr. Wertmüller, met with in exhibiting a picture of Danäe in Philadelphia—a few years ago, I have reason to form similar expectations."[17]

Despite his pronouncements, Vanderlyn apparently had something besides artistic "grace and beauty" in mind, namely, sex and money. I say "besides" because we need not presume that he was knowingly, calculatingly specious; he probably would have found it a happy coincidence that his aesthetic beliefs (that is, those sanctioned by the elite class to whom he was beholden and sought admittance) were compatible with a promise of financial return for a properly marketed and popularized sense-spectacle. Immediately upon remarking that his copy of *Antiope* should "attract a greater crowd if exhibited publickly," Vanderlyn adds, "The subject may thus invite some who are incapable of being entertained by the merits the picture may possess as a work of art."[18]

Once the paired themes of sex and money are considered, Titian's *Danäe* (1554, fig. 9) becomes an appropriate and important source for *Ariadne* in more than merely the art-historical sense of the term. Jupiter, the quintessential male sexual predator, has transformed himself into a shower of gold in order to preoccupy the coarse, procuress-like woman who guards Danäe's chamber. Prostitution, if not explicit in the painting, is dramatically implied. Although Vanderlyn in 1809 may not have imagined himself either a prostitute (offering wealthy clients his charm and beauty for pay) or a pimp (planning to profit from the commercial exhi-

bition of Ariadne's sensual body), *Ariadne* itself, like *Danäe*, is a work of explicitly carnal sexuality, whatever its mythological pretext.

In Paris two generations later, such artists as Alexandre Cabanel and William-Adolphe Bouguereau gathered gold (medals and money alike) for painting allegedly chaste, artistic nudes of this sort. Cabanel's *Birth of Venus* (1863, fig. 10), snapped up by Emperor Napoleon III, looks like *Ariadne*'s sister: a curvaceous, rosy-cheeked, coral-nippled nude, she stretches languorously and licentiously the width of the canvas devoted to her but is so thickly wrapped in mythological balderdash that it practically cuts off her circulation (Zola described Cabanel's Venus as a "goddess of pink and white almond paste in a river of milk").[19] Surely a cause of the long-standing neglect *Ariadne* has received is that, with so many nudes of its sort preceding and following it over the course of centuries, it did nothing to disturb time-tested, well-worn formulae, unlike such efforts as Courbet's depiction of dirty-footed bathers (1853)

or Manet's defiantly modern-day *Olympia* (1863) and *Déjeuner sur l'herbe* (1863), works that resolutely sought, in Flaubert's phrase, to *épater les bourgeois*.[20]

Gazing at *Ariadne*, one cannot be surprised at rumors that Vanderlyn, sometimes in the company of Burr, a notorious philanderer and collector of sexual favors, sought out Parisian prostitutes or other women of easy virtue, perhaps having been aroused, despite his later protestations, by the erotic fantasy-work that governed his day.[21] It is not surprising either that this representation of a voluptuous human fruit ripe for the plucking baited guardians of taste and morality when it came to America. "War was made upon such pictures on account of their nudity," writes Vanderlyn's biographer.[22]

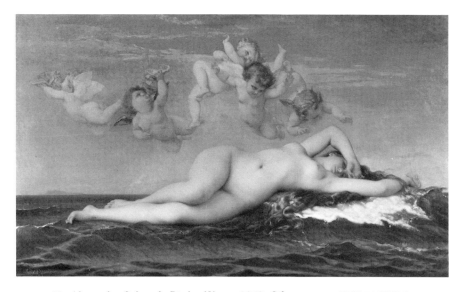

10. Alexandre Cabanel, *Birth of Venus*, 1863. Oil on canvas, 51⅛ × 88⅝ in.
Musée d'Orsay, Paris (Photo: Giraudon/Art Resource, New York).

Habituated to Old World attitudes toward art, Vanderlyn was (or claimed to be) perplexed. When a customs agent prevented him from exhibiting *Ariadne* in Havana in 1828, the artist responded, "Who would ever have dream't of such a thing in a place where the negroes go stark naked?" He missed the point. Ariadne was not a debased African slave toiling in a hot clime, and that is why she was not permitted to go stark naked. The larger point is that "war was made upon" paintings such as Vanderlyn's for deeper reasons than simply "on account of their nudity"—reasons having to do with America's various social classes jockeying for positions of dominance, embracing or rejecting one another's racial, sexual, and moral ideologies along the way.

Judging from Asher B. Durand's failure to find an audience for his accomplished engraving of Vanderlyn's nude in 1835 (fig. 11), it would seem that *Ariadne* was still not fit for public consumption some twenty years after arriving in America.[23] And yet when the painting itself was exhibited in Philadelphia in 1864 and donated in 1878 "amid much fanfare" to the Pennsylvania Academy of the Fine Arts by a respectable society matron, its once troublingly erotic quality had apparently transformed into something else, something culturally or morally valid. Not that the war upon such images did not continue. As late as 1891, a handbill representing "over five hundred (500) of the Christian women of Philadelphia" was directed to

11. Asher B. Durand, *Ariadne Asleep on the Isle of Naxos*, 1835. Engraving, 17½ × 20¾ in.
Metropolitan Museum of Art, New York. Harris Brisbane Dick Fund.

the academy's management in "protest against the flagrant indelicacy of many of the pictures now on exhibition." The protesters contended that "the claims of 'Art,' often so loftily insisted on, should never take precedence of the higher claims of public propriety and morality, the interests of which would be greatly subserved by excluding from public view such pictures as . . . 'Ariadne' of the Permanent Exhibition."[24]

Depending, then, on who the viewing (or defiantly nonviewing) audience was, the nudity of the figure elicited widely diverging responses. Those who desired American cultural parity with the Old World were likely to approve of *Ariadne* for its proficient variation and recapitulation of European high-art subject and technique and to consider their personal appreciation of such work evidence of their own "refined and cultivated taste." In the

period after the Civil War, cognoscenti might have admired *Ariadne* as a harbinger of the fashionable and in Europe substantially accredited salon nudes of Cabanel, Bouguereau, and others, which began entering American collections at this time.[25]

One wonders what Thomas Eakins, who in 1878 was a teacher at the academy, would have thought of *Ariadne*. Although many Philadelphians had disapproved of his *Anatomy Clinic of Samuel Gross* (1875), with its alarming display of blood and flesh, and his subsequent *William Rush Carving His Allegorical Figure of the Schuylkill River* (1877, fig. 12), an attempt to legitimate the "hon-

12. Thomas Eakins, *William Rush Carving His Allegorical Figure of the Schuylkill River*, 1877. Oil on canvas, 20⅛ × 26½ in. Philadelphia Museum of Art. Gift of Mrs. Thomas Eakins and Miss Mary Adeline Williams.

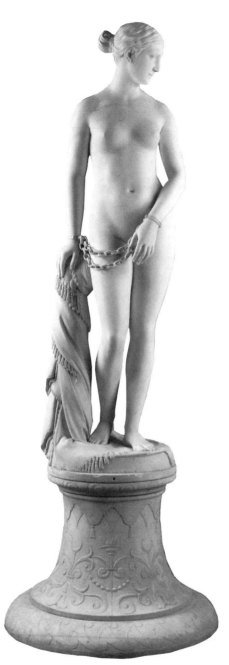

13. Hiram Powers, *Greek Slave*, 1843–50.
Marble, 65½ × 21 in.
Yale University Art Gallery, New Haven,
Connecticut. Olive Louise Dann Fund.

est" representation of nudity by linking it with the fulfillment of civic virtue, Eakins neverthe-less had his influential supporters, among them the wealthy and well-regarded board members who accessioned *Ariadne* into the academy's permanent collection.[26] With its slick surface, smooth tran-sitions, and academic idealization of the female body, *Ariadne* would seem to have nothing to do with the antiacademic nudes of Courbet, Manet, and Eakins besides symbolizing the visual rhetoric against which they rebelled, but even that puts it in the same universe as their work and makes it a part of the language they spoke.

I think the accession of *Ariadne* into the perma-nent collection was more than simply a matter of the academy in Philadelphia falling into line with the reigning tastes of the academy in Paris. By the 1870s, mainstream American viewers had become better equipped than their pre-Victorian forebears to appreciate what one recent historian has called the "moralistic pathos" of *Ariadne*. In the years that had intervened between the execution of the painting and its accession, the path toward a more sympathetic reception of *Ariadne* had been cleared by such works as Hiram Powers's *Greek Slave* (1843–50, fig. 13). Prior to the Civil War, Powers's pristine white marble nude was exhibited in a variety of eastern and western cities to resounding popular acclaim, laudatory poetry, and ministerial sermons that extolled the beautiful young slave's snowy white nakedness as a symbol of Christian purity and identified in her blank facial expression a testament to freedom enslaved but not eradicated (1850, fig. 14). If privately Powers's nude invited voyeuristic gazing and sexual titillation, publicly she was regarded as anything but naked, covered as she was in a pious narrative that identified her as a pitiable but devout virgin who relies upon her heavenly fortitude to endure the earthly trial of

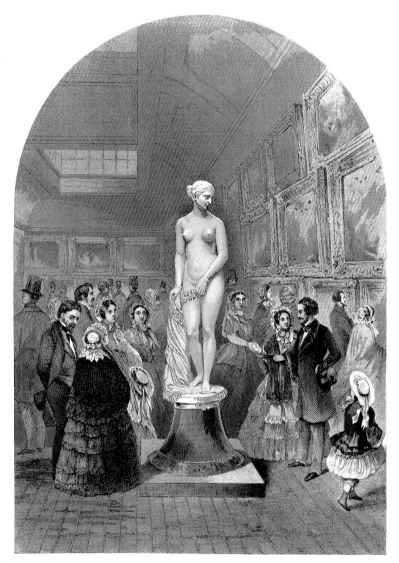

14. *The Greek Slave on View in the Dusseldorf Gallery.* Engraving from *Cosmopolitan Art Journal,*
December 1857. Henry E. Huntington Library and Art Gallery, San Marino, California.

having fallen captive to Turks who will sell her into a harem.[27]

In the years surrounding the Civil War, *Ariadne* must have benefited from the public's sympathy for Powers's naked maiden, for if she was the victim of pagan slavers, Vanderlyn's maiden could now more clearly be seen as the victim of a callous seducer. And yet as the protest handbill reveals, by the end of the century a new generation of viewers came once again to find *Ariadne* offen-sive. Like many of their antebellum predecessors, these viewers were seduced neither by the paint-ing's mythological credentials nor its moralistic pretensions.

❧

I have addressed both early and late nineteenth-century receptions of this work in order to make clear that the body of Ariadne was anything but singular in its meaning. At the very least it was capable of standing for—or invoking—venerable

old master traditions, fashionable salon sophistication, licentious male desire, and female victimization of an ultimately edifying nature.

The last of these significations is perhaps the least obvious or credible to a viewer today. But try to imagine how the painting could have been regarded as a sentimental parable in which a male fantasy of using and abusing women is morally condemned (even while, at a different level, that fantasy is entertained) inasmuch as the young woman depicted has been left helpless and bereft by a seducer who tires of her as soon as he has had his way. In contrast, Ingres's *Jupiter and Thetis* (1811, fig. 15), something of a *Marius* meets *Ariadne*, is unadulterated sex fantasy with no pathos or sentiment to disturb its exaltation of supermasculinity.[28] Although Ingres has depicted an allegedly nonsexual incident—the Nereid Thetis imploring Jupiter's intercession in the Trojan War on behalf of her son Achilles—what we have here is not exactly a sentimental depiction of maternal love. Thetis's pliant submission to one hypermale figure for the sake of another reinforces at the level of theme the work's emphatic depiction of femininity submitting to virility. While I would hardly claim that Vanderlyn's painting is less erotically charged than Ingres's or that Ariadne is any less a sex object than Thetis, a significant difference between the works is that Vanderlyn literally foregrounds the woman's subjectivity while treating that of the male as peripheral. True, the *narrative* of abandonment is merely a pretext for presenting viewers with a highly sexualized *rhetoric* of abandonment, but still that narrative of a

woman's emotional pain (or pain-to-be) occupies center stage and cannot or should not be so easily dismissed.

Vanderlyn may even have been signaling an ambivalence about his personal treatment of women as objects of desire. Ambivalence of this sort characterizes Benjamin Constant's *Adolphe* (1816), a French novel that, like *Ariadne*, balances neoclassical restraint with romantic sensibility. Adolphe is a young man who achingly longs for a seemingly unattainable older woman only to be faced with the problem of knowing what to do with her once he has had her: "It is a dreadful misfortune not to be loved when we are in love, but it is a very great one to be loved passionately when we have ceased to love. I had risked my life for Ellénore, but I would have given it a thousand times over to make her happy without me."[29] *Ariadne*, like *Adolphe*, might even be taken as a treatise—romantic in its concerns, classical in its analytic form—on erotic relations, a male artist's self-criticism of sexual philandering while also, intentionally or otherwise, validly or not, an advertisement of his sexual prowess.

In this regard Vanderlyn's painting resembles another contemporary European novel, this one the work of a woman. Like *Ariadne* and *Adolphe*, Mary Shelley's *Frankenstein* (written 1816–17) concerns itself with desertion. Almost amorously, Victor Frankenstein brings forth his Other only to be disgusted with himself after consummating the act. "I had worked hard for nearly two years, for the sole purpose of infusing life into an inanimate body. . . . I had desired it with an ardour that far exceeded moderation; but now that I had finished, the beauty of the dream vanished, and breathless horror and disgust filled my heart." Thereupon the fickle creator abandons his "wretch" to suffer, wither, and die. True, the victim of Franken-

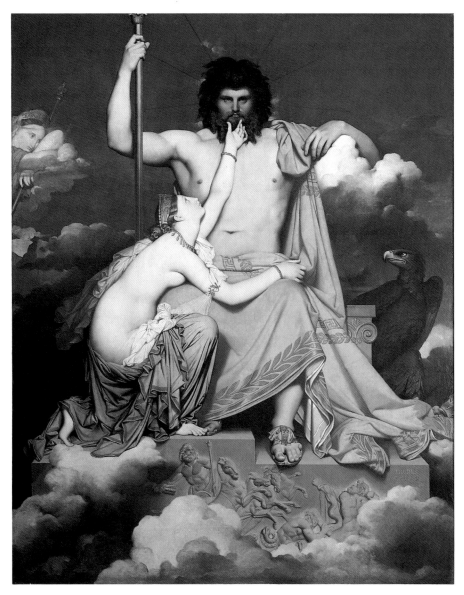

15. Jean-Auguste-Dominique Ingres, *Jupiter and Thetis*, 1811. Oil on canvas, 130⅝ × 101¼ in. Musée Granet, Aix-en-Provence.

stein's instrumentalist philandering is hideously ugly whereas Ariadne is sensually beautiful, but in both instances, as also in *Adolphe*, criticism of male rationalist and sexist instrumentality is latent if not pronounced.[30]

Adolphe's author was the companion-lover of the French protofeminist, Madame de Staël, while *Frankenstein*'s author was the daughter of the English feminist Mary Wollstonecraft. *Ariadne*,

however, possesses no such matrilineage. Nevertheless, the fact that Vanderlyn painted at a time and place marked by the stirrings of modern feminism is justification enough for considering how that nascent feminism lines up with the image that he produced and gives inflection to its meanings.

In 1796, the year Vanderlyn first went to Paris, Mary Wollstonecraft was abruptly deserted in that city by her lover, Gilbert Imlay, a dashing Ameri-

can adventurer and careerist—a Theseus, so to speak—shortly after the birth of their daughter, Fanny. Wollstonecraft attempted suicide, and Imlay, exiled from the American expatriate community for his notorious behavior, pushed on to the Isle of Jersey.[31] There is no reason to think of *Ariadne* as a *peinture à clef* concerned with these events, and yet not to look at the painting in terms of the gender inequalities that Wollstonecraft thematized in her life as well as in such books as *A Vindication of the Rights of Woman* (1792) is to be perversely unfaithful to the historical context from which the painting emerged.

The Wollstonecraft-Imlay scandal preceded *Ariadne* by more than a dozen years, but the radical disparity of genders it bespoke was by no means a dead letter. Vanderlyn's generation was similarly inequitable in its distribution of sexual truth and consequences. In 1814 Wollstonecraft's sixteen-year-old daughter Mary Godwin was pregnant by the poet Shelley, who abandoned his pregnant wife, Harriet, for her. Mary's premature child died, but in 1816 she gave birth to a son. Meanwhile her stepsister Claire Clairmont, infatuated with Shelley's friend Byron, pursued him and became pregnant by him in short order. That summer Mary began work on *Frankenstein*, and as Ellen Moers narrates with chilling succinctness,

> During the year of its writing, the following events ran their swift and sinister course: in October Fanny Imlay, Mary's half-sister, committed suicide after discovering that she was not [William] Godwin's daughter but Mary

Wollstonecraft's daughter by her American lover. (The suicide was not only a tragedy but an embarrassment to all. Godwin refused even to claim Fanny's body, which was thrown nameless into a pauper's grave.) . . . In mid-December Harriet Shelley drowned herself in the Serpentine; she was pregnant by someone other than Shelley. . . . In January 1817 Mary wrote Byron that Claire had borne him a daughter.[32]

Shelley's abandonment of Harriet, Byron's of Claire, and Godwin's of his stepdaughter Fanny all seem to be part of a widespread sexual pattern that Vanderlyn's painting of Ariadne's abandonment took up as mythology—and, to be sure, reinforced through its own eroticizing gaze.

The Enlightenment ideology that proffered "free-thinking" women as objects of free play for men of equal or higher social rank was hardly confined to Europe. According to Christine Stansell, "Male license for sexual aggressiveness increased in the two decades after the [American] Revolution" because, in addition to "very old beliefs about men's rights to women's bodies," there was general agreement that women who chose to stray outside the protective confines of the patriarchal family were asking for trouble, having decided to forfeit virtue and propriety for a fast life of the passions.[33]

"Feminist agitation during the French Revolution and the publication of Wollstonecraft's *Vindication of the Rights of Woman* combined to create a specter of female heterodoxy on both sides of the Atlantic between 1793 and the War of 1812," writes Stansell. "In England, anti-Jacobinism and anti-feminism . . . fueled the fire of the evangelical reaction. In the United States, Wollstonecraft was 'held in general abhorrence,' one woman reported in 1803; female advocates of a widened

women's sphere were ridiculed . . . ; the association of women's rights with social anarchy and sexual license grew stronger."

Aaron Burr was one American who did not hold Wollstonecraft in general abhorrence. He called the *Vindication* "a work of genius" and wrote to his wife, "I had heard it spoken of with a coldness little calculated to excite attention; but as I read with avidity and prepossession every thing written by a lady, I made haste to procure it, and spent the last night, almost the whole of it, in reading it." He then wondered why "I have not yet met a single person who had discovered or would allow the merit" of Wollstonecraft's book.[34]

Burr's feminist sympathies in no way dissuaded him from an avid commitment to amorous intrigue and libertinage. Those who villified Wollstonecraft for her unorthodox opinions about female sexuality would not have been surprised by the licentiousness of her disciple Burr. And had they looked at the *Ariadne* painted by his protégé, they probably would have regarded it as the unfortunate but predictable saga of an innocent turned voluptuary, a maiden who, upon abandoning the patriarchal homestead, is herself abandoned—and deservedly so.

Reformers of the early nineteenth century, refusing to recognize that young women abandoned the patriarchal homestead primarily out of economic necessity, assumed that it was the failure of public morality, particularly among the poor, that was causing the sharp increase in seductions, abandonments, and illegitimacies that appeared to threaten the republic's very foundation, the family. Middle-class common sense blamed the profligacy of poor women on what was taken to be working-class laziness, ignorance, and lack of self-control. When the victims of sexual seduction were of the middle class the blame was placed not on any in-

trinsic failings of that class but on excesses of sentimental fiction and French atheism. It was much easier, that is, to decry factors such as these than to attribute the problem to the onset of industrial capitalism in the case of the one class and, in that of the other, to the yearning of bourgeois females for social freedom and sexual parity with men.[35]

Not that it was only women who were held to account for the loosening of morals evidenced by the conspicuous rise in illegitimacies. Nancy Cott argues that the rhetoric of such women's groups as the Boston Female Moral Reform Society provided women a church-sanctioned language with which to criticize men and thus, in this one restricted channel, to wield some degree of power over them. "In moral reform activities," writes Cott, "women took up (literally with a vengeance) the power that ministers had for decades told them they possessed."[36] For these women a painting such as *Ariadne* might have been objectionable not so much because of its sensuous nudity but because the "victim" of the seduction appears neither contrite nor pitiable, and Theseus, the seducer who is little more than a remote speck of color, is not admonished for his reprobate behavior.

Prior to *Uncle Tom's Cabin*, the most frequently reprinted popular novel in the United States was *Charlotte Temple*, a seduction tale by Susanna Rowson, an actor, playwright, drama critic, poet, feminist, and later the founder and head of a Boston school for girls. A regular performer at the New Theater in Philadelphia during the period when Vanderlyn was there assisting Stuart, Rowson had originally published *Charlotte, A Tale of*

Truth in London in 1791. Its sales in England were middling, but in America after publication in 1794 they were astonishing, more than twenty-five thousand copies being sold in months—an extraordinary figure for a nation of four million citizens.[37]

The story concerns a middle-class English country girl, Charlotte, who is enticed to leave her loving parental home by a young British officer. After bringing her to America on his tour of duty, this handsome but heartless knave abandons her, helpless and pregnant. As Patricia L. Parker has noted, "Rowson's was one of the earliest American novels to use what became the conventional seduction theme, the father-daughter relationship disturbed by the daughter's lover." Parker notes that the focus of such narratives is usually on the daughter who has been seduced rather than on her wronged family or wronging seducer.[38]

The parallels between *Charlotte* and *Ariadne* are obvious. The latter may not necessarily be a classicizing version of the newly popular tales about virtuous daughters seduced and betrayed, yet the painting bears significant similarities to the novel. In both, the focus is upon the seduced, not the seducer. But also in both, the seducer is a military man identified with the color red: the British lieutenant is a redcoat, Theseus, so to speak, a redcloak. Could *Charlotte Temple* have had such extraordinary appeal for American readers precisely because they sensed in it an unarticulated *political* subtext, Charlotte's "cruel spoiler" being so explicitly a representative of Britannia? In a republic that had recently—to use a term both mar-

tial and marital—engaged in one war with England and was nervously looking toward another, the novel may have provided for American readers strong political emotions embodied as sentimental domestic ones.

A similar argument can be made about the most popular work of literature in the colonies prior to the Revolution, Samuel Richardson's epistolary melodrama *Clarissa* (1747–48). "The archetypal story of a young woman's tortured escape from parental tyranny, [*Clarissa*] offers more than a conveniently invoked literary parallel to America's flight from its parental tyrant, England," Jay Fliegelman observes. "The novel is the quintessential presentation of the inner drama that would inform the rhetoric and ideology of the American revolution against patriarchal authority."[39]

By the 1790s the success of the Revolution had made the metaphor of England as a tyrannical parent outdated, so that now the more appropriate epithet was that of evil seducer (the same metaphor applied to France and its radical philosophes by the guardians of morality described above). When Vanderlyn painted *Ariadne* on the eve of the War of 1812, the metaphor still held. Certainly the artist himself personally loathed the British, for they had "despoiled" his birthplace in upstate New York by burning it to the ground during the Revolution, they were now at war with his second homeland, Napoleonic France, and, with their outrageously arrogant naval impressment of sailors, they were literally stealing away young Americans. Might Vanderlyn have been alluding, through Theseus, to this despised enemy?

Clearly *Ariadne* is no *Charlotte Temple*. A novelistic narrative, *Charlotte* is filled with action over time as *Ariadne*, a painted narrative, is not. Printed in many editions up and down the east coast, *Charlotte* was readily available to the American

public as *Ariadne*, even when publicly exhibited, was not. The sensationalism of *Charlotte*'s plot was counterbalanced by the narrator's frequent moralizing, while the sensationalism of *Ariadne*'s nudity, so palpably visual, effectively blocked from sight whatever moralisms were allegedly meant to go with it.[40]

Although we can never say with certainty whether Vanderlyn intended his painting to convey anti-British sentiments or, more interesting, whether his compatriots responded to the painting in these terms, what is indisputable is that many Americans during the *Ariadne* period forcefully and emotionally disapproved of British imperial attitudes, behavior, and policy. Surely the art produced by these Americans encoded such powerful sentiments, regardless of whether audiences then actually decoded them. Although Susanna Rowson, unlike Vanderlyn, seems not to have been anti-British (she was, after all, an Englishwoman), her text fit into an anti-British matrix of reception as Vanderlyn's text, regardless of his personal politics, did not. At least one reason for this might be that the potential interpretation of Theseus as a redcoat would have been constrained by a recognition of Ariadne as an embodiment of Old World culture. That is, to the extent that she is regarded as representing the Old World, he, her antagonist and symbolic opposite, ceases to figure as an Old World representative as well. As we will see, identifications and associations in this painting are fluid and relational.

In late eighteenth- and early nineteenth-century Britain a standard metaphor for class exploitation was the image of a poor maiden seduced by a libertine aristocrat. According to Anna Clark, "This melodramatic image was explicitly political, becoming a crucial symbol in radical writing from the Jacobins of the 1790s to the anti–Poor Law

activists of the 1830s and 1840s." The viability of the image was that it "enabled fathers to blame familial crises on a predatory aristocracy while upholding chastity as an ideal. It portrayed class exploitation in vivid terms by presenting the theft of poor men's daughters by profligate aristocrats as a symbol for political exploitation and betrayal. As such, this image of seduction imbued [popular] fiction with a political content linking the reader to larger struggles, and inspired the public rhetoric of class struggle with personal, emotional images of oppression."[41]

Although the conventional seduction narrative originated in the sentimental and Gothic novels of the middle class, as in the works of Richardson and "Monk" Lewis, radicals such as Wollstonecraft and William Godwin employed it for their political fiction. Soon it found its way into the popular press and theater and thence into the rhetorical figures of working-class speechmaking. In the early years of the nineteenth century, the aristocratic seducer within such fictions and speeches was increasingly replaced by the seducer as capitalist, a switch commensurate with the shift from an agrarian to a predominantly industrial exploitation of the laboring classes.

What stayed the same was that the young woman betrayed was always the innocent daughter of a poor father. Thus one might wonder if there is any point in speaking of Vanderlyn's painting in these terms. After all, as the royal princess of Crete, Ariadne hardly qualifies as the unfortunate daughter of a poor father. Moreover, as a myth derived from classical literature, the Ariadne story prob-

ably would not have appealed to working-class audiences (whether English, French, or American) whose education did not encompass the classics and whose day-to-day concerns caused them to prefer narratives not so radically displaced in time. Finally, one might object that Vanderlyn himself, despite his artisanal past, was not a member of the working class, and thus, while we may legitimately insert him into the other two social categories mentioned in this section (the middle class and the anti-British), he did not share class interest with laborers, so his artistic production cannot be viewed from their perspective.

And yet throughout this chapter I am trying to imagine how *Ariadne* might have looked to a variety of social groups of the period in which it was painted. I am never claiming that each of these groups (that is, individual members from among them) actually looked at and pondered Vanderlyn's painting. To the contrary, the painting would literally have been invisible to members of certain social categories—slaves or American Indians or urban laborers—who would not have had the time, the admission fee, the aesthetic (dis)interest, or the social freedom or validation to come inside and see the painting on exhibition. Still, to say that a painting would have been invisible to members of a particular group is to begin interpreting it from that group's perspective.

Inasmuch as sexual seduction served working-class audiences as a trope for what they perceived to be their own exploitation by social superiors, *Ariadne* was relevant regardless of how unaware of it or disinclined toward it they might have been. By

neoclassicizing seduction Vanderlyn would seem to have depoliticized it, framing it as timeless myth rather than timely allegory. But even in doing so he was borrowing from and adding to the varied and often antithetical discourses of the day that treated the seduction and abandonment of women as a particularly pregnant metaphor for social conflict.[42]

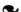

Given the prevalence of these various discourses regarding the consequences of seduction, it is hardly surprising that in Vanderlyn's time the focus of the Ariadne legend was on tragic loss rather than comedic, happy-ending union, as celebrated in such vivacious sixteenth-century paintings of salvation and marriage as Titian's *Bacchus and Ariadne* (1522–23, fig. 16) and Tintoretto's *Ariadne, Bacchus, and Venus* (see fig. 5) or the more flagrantly provocative versions by baroque artists such as Louis Le Nain (c. 1635) and Guido Reni (c. 1619–20, fig. 17). The reasons for this are historical. The late eighteenth to early nineteenth century was a period in which melodramatic sentimentalism prevailed in the art, literature, and drama of the European and American middle classes (1777–78, fig. 18; c. 1814, fig. 19). In 1766 Jean-Jacques Rousseau coined the hybrid term *mélo-drame* to describe his play *Pygmalion*, a drama with music. The word acquired common usage with the Parisian production in 1781 of a play by Georg Benda appropriately entitled *Ariadne of Naxos*.[43]

As a form of artistic expression that concentrates with high, almost hysterical intensity upon family relations, melodrama was perfectly suited to this period in which bourgeois and proletarian families alike were confronted as never before with extraordinary social change.[44] During the late eighteenth and early nineteenth centuries, the American and

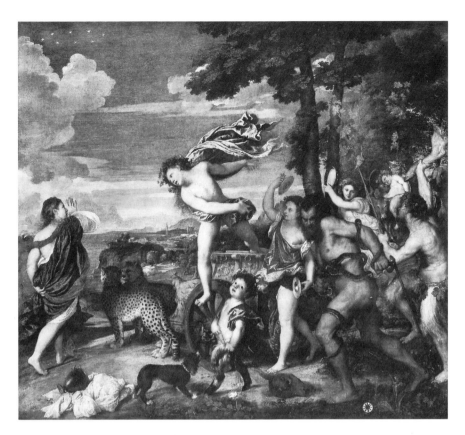

16. Titian, *Bacchus and Ariadne*, 1522–23. Oil on canvas, 69 × 75 in. National Gallery, London (Photo: Alinari/Art Resource, New York).

French political revolutions as well as the British industrial revolution severely tested family unity at both the microcosmic level of the individual (that is, the level of brothers and sisters, parents and children) and at the macrocosmic level of classes and nations (where one class, for example, could no longer successfully portray itself as the father of another or where one nation was now to be castigated as the ungrateful child of the other).[45]

A typical family melodrama of this sort was published in America in 1805 by a young English sailor named John Davis. Called *The First Settlers of Virginia*, the book contains a sensationalized narrative of a young woman who defies the wishes of her father, the king, in order to protect the life of his condemned captive, a foreign adventurer with whom the daughter has fallen in love. Though she wishes to elope with the prisoner she has rescued, he abandons her. Eventually she dies of a broken heart while married, by default, to another of his foreign race. The one twist in Davis's melodrama is this: the beautiful young maiden happens to be an Indian princess, and the man she plucks from death is a white settler, symbolically America's first white settler, Capt. John Smith. The princess, of course, is Pocahontas.

With the popular success of Davis's novel, Pocahontas began her career as one of nineteenth- and twentieth-century America's most revered legendary figures. This story of a Native American woman who sacrifices her safety out of love for a white man only to be abandoned by him is, as Philip Young has observed, "one of our few, truly native myths," for Pocahontas has "attained the status

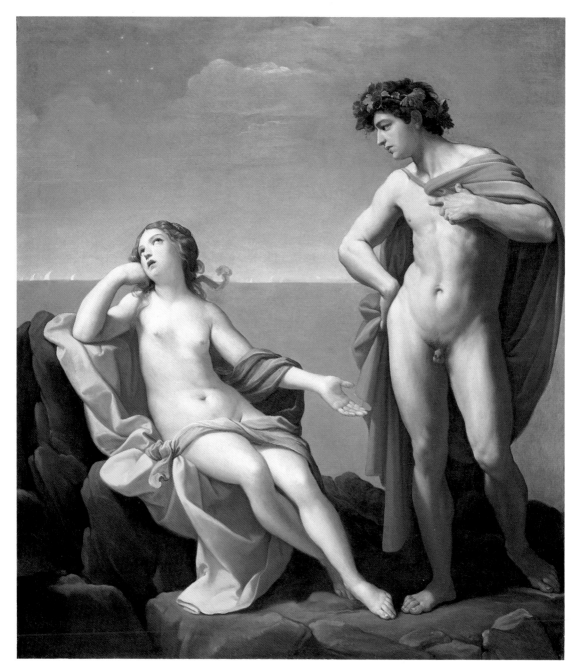

17. Guido Reni, *Bacchus and Ariadne*, c. 1619–20. Oil on canvas, 38 × 24 in. Los Angeles
County Museum of Art. Gift of the Ahmanson Foundation.

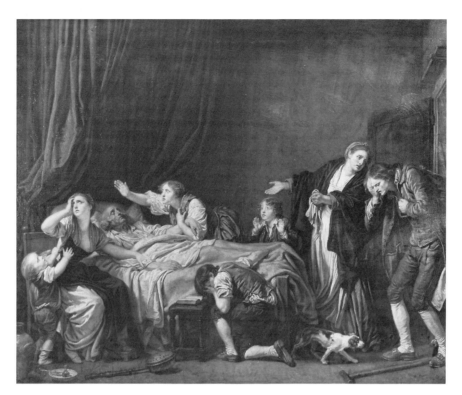

18. Jean-Baptiste Greuze, *The Son Punished*, 1777–78. Oil on canvas,
51 × 65 in. Musée du Louvre, Paris.

19. John Krimmel, *Country Wedding, Bishop White Officiating*, c. 1814. Oil on canvas,
16³⁄₁₆ × 22⅛ in. Pennsylvania Academy of the Fine Arts, Philadelphia. Gift of Paul Beck, Jr.

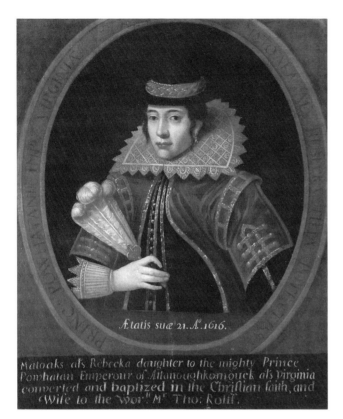

Ætatis suæ 21. Aͦ. 1616.

Matoaks als Rebecka daughter to the mighty Prince
Powhatan Emperour of Attanoughkomouck als Virginia
converted and baptized in the Christian faith, and
Wife to the wor.ͣ Mͬ Tho: Rolff.

20. *Pocahontas*, c. 1616–17. Oil on canvas,
30¼ × 25¼ in. After the 1616 engraving by
Simon van de Passe. National Portrait Gallery,
Smithsonian Institution, Washington, D.C.

of goddess . . . offered as a magical and moving explanation of our national origins."[46] But if the Pocahontas story is indigenous myth, variations can be found throughout previous ages and cultures. According to Young, the oldest version is in the ancient legend of Theseus and Ariadne.

John Rolfe, the English planter who wed Pocahontas several years after her famous encounter with Captain Smith, actually invoked the Ariadne legend to explain his reasons for marrying the heathen, whom he converted to Christianity and later introduced at the English court (c. 1616–17, fig. 20). He claimed that it was love of God and country rather than "unbridled desire of carnall affection" that was motivating him to take her to wife. But he also admitted fear for his "owne salvation" because his "mans weakenesse" for her had caused him to become "intangled, and inthralled in so intricate a laborinth, that I was even awearied to unwinde my selfe thereout."[47]

In Greek legend Ariadne is rescued from heartbreak by the god of wine and ecstasy, but obviously John Rolfe was no Bacchus. Neither, despite finding himself "inthralled in so intricate a laborinth," was he a Theseus. And yet, as in Plutarch's retelling of the story Ariadne represents the sensual temptation from which Theseus must free himself in order to found the new Athens, in Rolfe's Christian account of his marital motives there is also an equation of woman with danger: "Pokahuntas" does not deliver him from the "laborinth" so much as "intangle" him within it. When we recall that Vanderlyn's sleeping Ariadne points into the labyrinth of her ear (and by displacement into that area of her body covered by thinly ridged gossamer), she seems more the seducer than the seduced.

From the earliest days of New World exploration, Native Americans were constructed by Europeans as intemperate sensualists. Amerigo Vespucci, the

European who gave his name to the new continent (and was not exactly a reliable character witness), describes the natives as "libidinous beyond measure, and the women far more than the men; for I refrain out of decency from telling you the trick which they play to satisfy their immoderate lust." These "are women of pleasing person, very well proportioned, so that one does not see on their bodies any ill-formed feature or limb." Although they "go about utterly naked . . . they are no more ashamed than we are in displaying the nose and mouth." What is more, "They showed themselves very desirous of copulating with us Christians." The natives are such that "the greatest token of

friendship which they show you is they give you their wives and daughters; and when a father or a mother brings you the daughter, although she be a virgin, and you sleep with her, they esteem themselves highly honored; and in this way they practise the full extreme of hospitality."[48]

An engraving published in 1617 (fig. 21) shows Vespucci being offered his choice from a chorus line of young Indian women, all of them curvaceous

21. Engraving from Theodor de Bry's *America*, published in Frankfurt, 1617.
Rare Books Division, Library of Congress.

and naked, with long, flowing hair, and none of them any more Indian in skin tone or features than Vanderlyn's Ariadne. Another work, *Vespucci Discovering America* (1589, fig. 22), depicts a naked Indian queen rising from a hammock under the trees while a voyager from afar stands before her, his ship, like that of Vanderlyn's Theseus, moored in the upper right corner. In 1624 Captain Smith boasted that Pocahontas and "her women" came one day "naked out of the woods, onely covered behind and before with a few green leaves" and, later, "all these Nymphes more tormented him than ever, with crowding, pressing, and hanging about him, most tediously crying, Love you not me?" They begged him to do "what he listed"

with them.[49] These and similar illustrations and accounts of New World discovery were available during Vanderlyn's era, and although they may have had nothing specifically to do with the design of *Ariadne*, they, like the Pocahontas story, are among its conceptual and imagistic antecedents.

Considerably closer in time, of course, was *First Settlers*. Measure Davis's description of his Indian princess at rest beside a stream against Vanderlyn's rendition of *his* princess beside a stream: "There was a delicious redness in her cherub lips, a red, a little riper than that which burnt on her cheek, and the nether one somewhat fuller than the other, looked as if some bee had newly stung it. Her long black hair . . . flowed in luxuriant tresses down her comely back and neck, half concealing the polish and symmetry, the rise and fall, of a bosom just beginning to fill."[50]

The comparison between a classical princess and an Indian princess should come as no surprise.

22. Strandanus, *Discovery of America: Vespucci Landing in America*, 1589. Pen and brown ink heightened with white, 7½ × 10⅝ in. Metropolitan Museum of Art, New York. Gift of the estate of James Hazen Hyde.

Ariadne's skin, as noted earlier, has a decidedly reddish cast to it. Though this is to be explained as a tint reflected from the red groundcloth, if not also as a residual glow from lovemaking, the ruddiness of her flesh might have racial connotations as well. With the band that is tautly wrapped around her upper arm now falling into place as yet a further indicator of "Indianness," new byways of interpretation emerge.

To Europeans and Europeanized Americans of the late eighteenth and early nineteenth centuries, no one embodied or symbolized nature more than the noble savage, the so-called red man (or woman). As a dialectical reversal of the wild man —that "libidinous beyond measure" sensualist described by Vespucci and others—the American Indian as a paragon of self-restraint figured prominently in such highly influential works as Chateaubriand's romantic novel *Atala* (1801) and Benjamin West's *Death of Wolfe* (1770, fig. 23), in which

an Indian warrior muses sadly but philosophically at the feet of his fallen white leader.[51] Girodet-Trioson's *Entombment of Atala* (fig. 24), exhibited to critical acclaim at the Salon of 1808, which Vanderlyn surely attended, depicts Chateaubriand's half-Indian virgin in her semitransparent shroud as not an iota less neoclassically Greek in appearance than the Ariadne that Vanderlyn proceeded to paint, which only serves to indicate how widespread and loosely made was the mental association at the time of Indians with antique Greeks and antique Greeks with Indians.

West's celebrated comparison, when he came to Rome in 1760, of the Apollo Belvedere to an American Indian ("My God, how like it is to

23. Benjamin West, *Death of General Wolfe*, 1770. Oil on canvas, 59½ × 84 in. National Gallery of Canada, Ottawa. Gift of the Duke of Westminster.

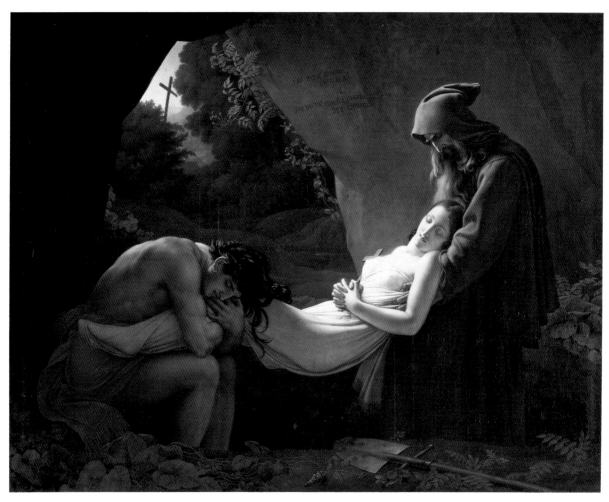

24. Anne-Louis Girodet-Trioson, *Entombment of Atala*, 1808. Oil on canvas,
81½ × 105 in. Musée du Louvre, Paris.

a young Mohawk warrior") established the neo-
classical and, subsequently, the romantic con-
strual of the Indian on one hand as nature's true
child and on the other as the reincarnation of
antique civilization, with its hypostatized beauty,
nobility, and simplicity. But even prior to the age
of neoclassicism the comparison was common-
place. The late sixteenth-century engravings of
statuesque Indians (1590, fig. 25) that were pro-
duced for the numerous editions of Theodor de
Bry's *America*, a multivolumed compilation of ex-
ploration narratives, were so widely admired and
imitated that the comparison of American natives
to heroic Greeks seemed self-evident to the En-
lightenment, although books such as J.-L. Lafi-
tau's *Moeurs des sauvages américains comparées
aux moeurs des premiers temps* (1724) still found
occasion to expatiate on the analogy at length.
Joseph Wright of Derby's *The Indian Widow* (1785,
fig. 26), based on a description of mourning rituals
in James Adair's *History of the American Indians*
(1775), shows a seminude Native American female
sitting pensively at her husband's mountaintop
grave, displaying the stoicism of a Roman phi-
losopher. As late as 1815 the editor of the presti-
gious *North-American Review* recapitulated for his
readers, who apparently never tired of hearing it,
this notion that America's "Aborigines" of bygone
years "possessed so many traits in common with
some of the nations of antiquity, that they perhaps
exhibit the counterpart of what the Greeks were in
the heroick ages." [52]

From the earliest periods of colonization until the
eve of the Revolution, artists, explorers, writers,
and political thinkers conventionally personified
America by means of a seminude Indian woman,
a so-called Caribbean Queen (c. 1595, fig. 27).
After that, allegorical representations shifted away
from the Caribbean Queen to a more youthful and

25. Engraving from Theodor de Bry's edition of
Thomas Hariot, *A Briefe and True Report of the New Found
Land of Virginia*, published in Frankfurt, 1590. Rare
Books Division, Library of Congress.

26. Joseph Wright, *Indian Widow*, 1785. Oil on canvas, 40 × 50 in.
Derby Art Gallery, Derby, England.

27. *Personification of America*, c. 1595. Engraving on laid paper, 8⅜ × 10⅜ in. After Marten de Vos's pen
and wash drawing of 1594. Henry Francis du Pont Winterthur Museum, Winterthur, Delaware.

anglicized or classicized Indian Princess (1790, fig. 28). According to E. Mclung Fleming, the new symbol for America was "a handsome, vigorous, Indian woman in her twenties or thirties . . . of noble visage [and] long, dark hair." Her skin was "sometimes dark, sometimes only moderately 'tawney' and often indistinguishable from that of Britannia." Such words could almost be used to describe Ariadne.[53]

Eventually the conventional symbol for America metamorphosed, to use Fleming's term, from an Indian princess to a Greek goddess (1804, fig. 29), the transition occurring, in fact, at the beginning of the nineteenth century, the period during which Vanderlyn was painting his Greek goddess asleep in the forest. I am not suggesting that Vanderlyn meant his seminude classical princess to be taken by the viewer as a seminude Native American princess *or* as symbol for America, but, again, the comparison of American Indians to ancient Greeks was so routine that the parallel may have been intuited by viewers without being consciously acknowledged.

Certainly in other instances Vanderlyn was deliberately involved in the representation of the American Indian, most notably so in *The Death of Jane McCrea*, in which the Iroquois warriors, along with the white woman they attack, seem to have materialized from a classical frieze. (They have a modern quality as well, resembling movable parts in one of those mechanical contraptions that Jefferson and his contemporaries were so fond of devising, their arms rhythmically synchronized like plunging pistons and rods.) The warriors in *Jane McCrea* are clearly evil, but the evil they allude to is that of Britain, in whose hire they perform their cruel deed. Other works by Vanderlyn, for example, his early landscape views of Niagara Falls or *The Landing of Columbus*

28. Augustin Dupré, *Diplomatic Medal*, 1793. Bronze restrike made at the U.S. Mint in 1876 after Dupré's original, 2⅝ in. Division of Numismatics, Smithsonian Institution, Washington, D.C.

29. *America* (from *The Four Continents* series), 1804.
Engraving, 13⅝ × 9¾ in. Henry Francis du Pont
Winterthur Museum, Winterthur, Delaware.

(c. 1840, fig. 30), painted at the end of his career, show Native Americans as quaint curiosities, gentle spirits, or awestruck children of nature. In all instances, though, his Indians carry symbolic connotations conveying political, racial, and ideological meanings that vary according to the circumstances at hand.[54]

Before his departure for Paris in 1796, Vanderlyn belonged to a New York democratic workingman's club, the Tammany Society, which was named for the legendary Indian sachem Tammany, or Tamenund. Club members dressed in Indian costume, concocted secret rites that purported to emulate Indian traditions, called themselves by Indian names, and employed Indian phrases as codewords, all as a means of setting themselves apart from the aristocratic and English pretensions of the gentlemanly Federalist clubs.[55] In 1773 rebellious colonists with symbolic intentions costumed themselves as Indians when, in defiance of the mother country, they dispatched British tea into Boston Harbor. By Vanderlyn's time, therefore, there was a well-established tradition for political democrats identifying themselves, however superficially, with the American Indian.

Let us return now to the Indian princess Pocahontas and the revival of her legend in the years leading up to *Ariadne*. Although accounts of Pocahontas began to circulate immediately upon Captain Smith's return to England in 1609, it was not until two centuries later that the princess's strange story took hold in popular imagination. Surely the reason for this has to do with the historical aptness of family melodrama as mentioned above, but I think there is more to it than that. Pocahontas caught the American imagination precisely at the moment that Americans for the first time gave serious consideration to a policy of national expansion. Her story made such a policy morally justifiable,

30. John Vanderlyn, *Landing of Columbus*, c. 1840. Oil sketch, 26½ × 39¾ in.
National Museum of American Art, Smithsonian Institution, Washington, D.C.

or at least palatable. As Philip Young explains,

> An informal survey of the children's sections of two small Midwestern libraries disclosed twenty-six different books on Pocahontas—and no wonder. Quite apart from the opportunity she presents to give children some notion of self-sacrifice, she is, in addition to all her other appeals, perfectly ideal propaganda for [the] state. . . . The story . . . inform[s] us . . . that we are chosen, or preferred. Our own ways, race, religion must be better—so much better that even an Indian . . . albeit an unusually fine one (witness her recognition of our superiority), perceived our rectitude.[56]

From the point of view of those who eventually obliterated the Powhattans, Pocahontas possessed courage, insight, and virtue. By her very actions she acknowledged and legitimated the *right* of the colonists to the American land. In America's original Pocahontas play, *The Indian Princess; or, La Belle Sauvage* of 1808, Pocahontas declaims to her Anglo husband:

> O! 'tis from thee that I have drawn my being:
> Thou'st ta'en me from the path of savage error,
> Blood-stain'd and rude, where rove my
> countrymen,
> And taught me heavenly truths, and fill'd my
> heart
> With sentiments sublime, and sweet, and
> social.[57]

Small wonder that President Jefferson took notice of *First Settlers*, Davis's novel, and allowed himself to be quoted on its behalf ("I have subscribed with much pleasure") for the second edition.[58] One of the primary concerns of Jefferson during his administration was the westward expansion of the country and with it an agrarian cultivation of the land thus acquired. This land had to be yielded up to white husbandmen at all costs, for in Jefferson's view a republic could be

great, its democracy true, only if the majority of citizens—that is, white males—were cultivators of the land, imbibing the wisdom and moral integrity traditionally believed to accrue from such labor.

Jefferson himself was well-intentioned toward the Indian peoples, believing they would fare better as yeoman farmers than as nomadic hunters. According to one historian, "The self-esteem and confidence of the Revolutionary and early national generations made it difficult for them to believe that the Indians would not also see the desirability of an end to savagery and their acceptance of civilization." Another historian, less generous toward the Jeffersonians, charges that to them "the Indian . . . was . . . the face of unreason. If he chose to remain an Indian, in the face of all paternalistic efforts to the contrary, then he confessed himself a madman or a fool who refused to enter the encompassing world of reason and order. The red child then had to be expelled from the landscape of pastoral tranquility—or buried under it."[59]

Thus it was during the Jefferson and Madison administrations that the United States unofficially began war on all Indian nations that resisted agrarian development. Given what amounted to a genocidal impulse against the Native American, there was no longer any place in the national iconography for the Indian princess of the revolutionary period, but there was a place, in folklore and melodrama, for the Indian princess who had shown the good sense to forsake her own civilization for that of the whites.

In 1811, while Vanderlyn was in Paris painting his seduced Grecian princess who bears, if

you will, resemblance to the romantics' notion of an Indian maiden peacefully—passively—asleep, the Shawnee leader Tecumseh was rousing his people to resist the white man's ceaseless encroachments, many of which had been achieved not by direct violence but by the blandishments of cheap whiskey and the flimsy vows of seductive treaties. "The white people are like poisonous serpents," cried Tecumseh, rankled at these betrayals; "when chilled, they are feeble, and harmless, but invigorate them with warmth, and they sting their benefactors to death."[60]

Unlike sleeping Ariadne, Tecumseh and the tribes he invited into a military confederation made every effort to prevent betrayal. "Brothers—My people are brave and numerous; but the white people are too strong for them alone. I wish you to take up the tomahawk with them. If we unite, we will cause the rivers to stain the great waters with their blood." While Tecumseh was away recruiting more forces, his army was devastated in an early morning raid in present-day Indiana by militia under the command of the territorial governor William Henry Harrison, who later campaigned successfully for the presidency by glorifying his role in the massacre at Tippecanoe.

An even greater national hero for the decisive way in which he demolished Indian resistance was Gen. Andrew Jackson, who at the Battle of Horseshoe Bend in March 1814 broke the back of the southern resistance led by the Creek Indians. The following year Jackson defeated the British at the Battle of New Orleans, thus proving himself no less effective against the overcivilized Old World than he was against the undercivilized New. Vanderlyn later produced a military portrait of Jackson with drawn sabre (c. 1821, fig. 31), and if no Indians figure directly in the painting, they (like the British) figure indirectly as the off-canvas an-

31. John Vanderlyn, *Andrew Jackson*, 1823. Oil on canvas, 94 × 64 in.
Art Commission, City Hall, New York.

tagonists whom the leonine general so masculinely confronts.

The issue of masculinity here is important. Michael Rogin contends in *Fathers and Children*, a psychohistory of Jackson and the Indian wars, that the anxiousness of American whites to crush out the Indians was deeply sexual in nature, but not in the way we might at first expect. Although Indians murdered white women and sometimes took them into captivity, they did this, according to Rogin, for political, military, or economic reasons, never because of sexual desire (Indians did not rape their victims). Still, claims Rogin, whites were *sexually* terrified of Indians because Indians embodied precisely that which whites were required to repress in the name of civilization: "The Indian was a fragment of the self, that primitive, oral part which was dangerously indolent and aggressive and therefore, in the name of self-defense, had to be destroyed. Indians evoked images of dismemberment, insane ferocity, and loss of individual identity. They called forth the pre-ego state of undifferentiated bliss and rage. . . . By killing Indians, whites grounded their growing up in a securely achieved manhood, and securely possessed their land."

Since the "pre-ego state," in this psychoanalytic reading derived from the work of Freud's student Melanie Klein, is that which is the domain of the Mother (or, in the case of the Indians, of Mother Nature), a child cannot become an adult until having successfully combated feminine and maternal forces that would psychically entrap him or her and prevent growth. "Jacksonians' personifications

of their enemies," Rogin contends, "expressed fear of domination by women. The culture resolved its ambivalence over women by splitting femaleness into powerful, uncontrolled menaces, which had to be destroyed, and feminine enforcers of civilized values, who had to be served and protected."[61]

Even if one finds Rogin's Kleinian viewpoint excessive, it is worth pondering *Ariadne* in these terms, regarding the naked figure as the fertile mother, at once loved and feared, hated and desired, good object and bad object, from whom the child (diminutively scaled Theseus) seeks escape. Note that Rogin's language for describing Jackson and the Jacksonians' psychic perception of Indians and of women—"dismemberment, insane ferocity, and loss of individual identity"; "powerful, uncontrolled menaces"—returns us to Mary Shelley's *Frankenstein*. The cost of a new world order, whether that sought by Theseus, Frankenstein, or the Jacksonians, is desertion of woman, monster, or Indian. This desertion is easier to live with when reconstituted as a flight from her (or its or their) smothering, engulfing, "intangling" and "inthralling" embrace.

Ariadne is neither a criticism of white seduction and betrayal of Indians nor the opposite, a justification in which the sensual nude symbolizes Indians (or women) "libidinous beyond measure" and therefore needing to be feared, detested, and deserted. Obviously the painting is neither direct criticism nor overt justification of anything. It is, however, a record of its time in the sense conveyed by Walter Benjamin's sobering observation that "there is no document of civilization which is not at the same time a document of barbarism"— the barbarism, of course, being that which was required to produce the civilization.[62]

In 1820 Vanderlyn's friend Washington Irving lamented the plight of the American Indians:

They will vanish like a vapor from the face of the earth; their very history will be lost in forgetfulness. . . . Or if, perchance, some dubious memorial of them should survive, it may be in the romantic dreams of the poet [or painter], to people in imagination his glades and groves, like the fauns and satyrs and sylvan deities of antiquity. But should he venture upon the dark story of their wrongs and wretchedness; should he tell how they were invaded, corrupted, despoiled, driven from their native abodes and the sepulchers of their fathers . . . posterity will either turn with horror and incredulity from the tale, or blush with indignation at the inhumanity of their forefathers.[63]

The novelist and reformer Catharine Maria Sedgwick did indeed dare to tell how the Indians, to use Irving's words, "were invaded, corrupted, despoiled, [and] driven from their native abodes," but contrary to what he might have predicted, the book in which she did this, *Hope Leslie* (1827), was a best-seller. Sedgwick's Pequod heroine, Magawisca, literally gives her right arm to save the life of the young white captive whom she loves, but the resulting deformity of the maiden—and, symbolically, of her people—is minimized in the text, with the noble self-sacrifice emphasized instead. Later in the story Magawisca is betrayed by other whites but not abandoned by the young man she rescued. Now it becomes his turn to save her, and although after doing so he marries someone of his own race, the book concludes with all lingering racial guilts happily erased.[64]

In other words, it was not only future generations that would turn away from painful reminders of the white people's despoilment of the Indians, but also the generation of this time itself. The editor of the *North-American Review*, William Tudor,

took an appalled glance at his Native American contemporaries:

The degenerate, miserable remains of the Indian nations, which have dwindled into insignificance and lingered among us, as the tide of civilization has flowed, mere floating deformities on its surface, poor, squalid and enervated with intoxicating liquors, should no more be taken for the representatives of their ancestors, who first met the Europeans on the edge of their boundless forests, severe and untamed as the regions they tenanted, than the Greek slaves, who now tremble at the frown of a petty Turkish tyrant, can be considered the likeness of their immortal progenitors.[65]

It is better, so Tudor implies, to think of such sorry people as they once supposedly were rather than as they have since sadly become. As Sydney J. Krause has recently noted, "Eighteenth-century views of the Indian were fairly dichotomized between the Rousseauists, with their ideal of a natural morality in the innocence of the Forest, and those in the opposing camp, who suggested that life among the natives led to degeneracy."[66] Early nineteenth-century public figures such as *Review* editor Tudor seem deftly to have avoided this philosophic dichotomy by positing good Indians in the prewhite past but bad ones in the present.

Insofar as she alluded to prevalent narrative, iconographic, and ideological constructions of the Indian, noble or otherwise, Ariadne would have been a reminder of precisely that which Vanderlyn's viewers cared not to be reminded. Focusing

not on an Indian woman's laudable, Pocahontas-like betrayal of her people but on a (white) man's churlish betrayal of her, the story simply does not have the makings of good national mythology, the purpose of which is to instruct, inspire, and elicit public pride. And this, I think, may have something to do with why Vanderlyn's painting, despite its salient similarities to popular plays, fiction, and visual images that *explicitly* alluded to the American Indian, was so soon relegated to the margins of art history, marooned on a desert island, abandoned by historiography that, with nationalistic purposes of its own, was not likely to be interested in the sad tale of racial betrayal and woe that *Ariadne*, however remotely, calls to mind.

❧

If Ariadne's body as a signifier of nature and nativeness gives rise to a Native American reading, the same body may also be viewed as signifying culture, in particular European culture. Little imagination is needed to see it as such. The flowing hair, the unfurled drapery, the polished profile, the coolly rendered pinkish-white flesh, and the elegant disposition of figure all join together, as we have seen, to speak of classicism and its various reincarnations. Whatever its compositional and coloristic alliances with the surrounding arcadian environment, Ariadne's body is in this regard a signifier of unnatural (because artfully, humanly constructed) Western cultural tradition. Accordingly, the man who abandons Ariadne in pursuit of distant land across the sea is a man who leaves that powerful and long-established tradition behind.

The abandonment of culture can be interpreted

as good or bad, depending upon one's point of view. Two antithetical interpretations result from the consideration of Ariadne as a trope for Western culture. These interpretations line up ideologically with the two political parties of Vanderlyn's era, the Federalists and the Republicans, who were also known as the Democratic-Republicans.

America's party system was by no means rigidly fixed in the early years of the 1800s, and within each party there were many factions and crossover alliances. For our purposes, though, it will suffice to speak of general principles. Federalists, whose economic policy was most clearly articulated by President Washington's secretary of the treasury, Alexander Hamilton, advocated a strong central government authorized to impose tariffs, issue currency, and regulate business. Republicans, led by Washington's secretary of state, Thomas Jefferson (who became president in 1800), tended to favor local over federal government, farmers over shopkeepers, and workers over aristocrats. Federalists looked to Great Britain as their guide, whereas the Republicans preferred revolutionary France, which eschewed aristocratic conservativism for a newfound openness to social and economic class mobility. If the Jeffersonians were intrigued by the French postrevolutionary experiment, the Federalists were appalled by Jacobin regicide and, when they had the power to do so, they went so far as to legislate alien and sedition laws in the hopes of preventing French radicalism from spreading to America.

Although Federalists and Republicans alike considered themselves republican (as opposed to monarchist), it was the Federalists who insisted that the country replicate the centuries-old pre-revolutionary political tradition of entrusting government to the best-educated, the best-trained, and, as this implied, the best families. J. G. A.

Pocock has traced the derivation of this republican ideal to the early sixteenth-century teachings of Niccolò Machiavelli and his contemporaries in the last years of the Florentine republic.[67] Inasmuch as Vanderlyn's painting directly descends from the nudes of early sixteenth-century northern Italy, Ariadne might even be thought of as an allegorical embodiment of the republican ideals that originated at that time.

Although the renewed classicism of late eighteenth-century France, as characterized by David's *Oath of the Horatii*, had seemed to French political progressives to stand for a civic republicanism set against degenerate aristocratic softness and corruption, to Federalists in America a generation later classicism was an ideal to be pitted not so much against privileged aristocrats as against presumptuous democrats. "With the growing democratization of American society in the early years of the nineteenth century," writes Gordon Wood, "the classical virtues became less a means by which enlightened men could improve mankind and more a means by which moralizing men could control the masses."[68]

Wood observes that to partisans looking back, "the Federalist era of the 1790s seemed to be a monument of classical elegance beset by the brawling and boorish tendencies of Revolutionary mobs. The Jeffersonian Republicans, the Federalists feared, were trying to usher in not simply a new political order, but an entirely new way of life, and to create a coarse and visionary society, like Jonathan Swift's land of Laputa, run by men with their heads in the clouds." Thus the sin of Theseus, in a hypothetical Federalist interpretation of *Ariadne*, is not that he seduced and abandoned a hapless young woman but that he, like the upwardly mobile working and trading classes in pursuit of their own selfish interests, turned his

back on the venerable culture that the princess represents. Along these lines it should be recalled that, however inadvertently, Theseus committed regicide, which to a political conservative such as a Federalist would signify the ultimate crime against both the state (culture) and the hereditary order (nature) that the state was charged to protect.

Inasmuch as painted images, like biblical text or constitutional law, *do* get interpreted in opposing ways by opposing groups of interpreters, Vanderlyn's painting may in fact have been equally adaptable to a Republican, anti-Federalist reading. Given a reverse set of presuppositions, we might now regard Ariadne's body not as the emblem of classical purity but, to the contrary, as a signifier of the Old World's aristocratic corruption of classical purity ever since the Machiavellian moment of the Renaissance. Soft, sensual, and somnolent, her body-as-Europe would, to an American democrat, signify decadence and temptation—as in the psychoanalytic reading prompted by Michael Rogin, it represented the threat of maternal sensuality that seductively prevented an individual from becoming an adult.

From this perspective, Theseus is wise to abandon what that naked female body symbolizes, now, before it is too late. Pocock has spoken of "a flight from history into nature, conceived by many Americans of the revolutionary and early national periods . . . in terms of a flight from the Old World, from the burden of a priestly and feudal past."[69] By leaving behind the "intangling" and "inthralling" "laborinth" of Ariadne, Theseus will travel forth to what shall become, under his guidance,

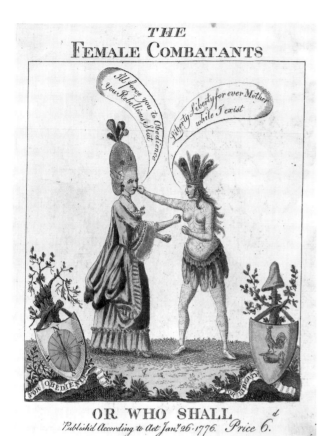

THE
FEMALE COMBATANTS

I'll force you to
Obedience
You Rebellious Slut

Liberty Liberty for ever Mother
while I exist

FOR OBEDIENCE

FOR LIBERTY

OR WHO SHALL
Publish'd according to Act Jan.? 26. 1776. Price 6.ᵈ

32. *The Female Combatants*, 1776. Engraving.
Print Collection, Lewis Walpole Library of Yale University,
Farmington, Connecticut.

"the new Athens," the very name that Americans of the republican period were flattered to bestow upon their country.

To mix mythologies, the Ariadne of this interpretation is the whore of Babylon, an epithet American republicans commonly bestowed upon England from prerevolutionary days to well beyond the War of 1812. Federalists, of course, also invoked the Babylonian whore to describe *their* European antagonist, which was not England but France. From their post-1789 point of view, Ariadne might have seemed an emblem of a formerly chaste body politic turned voluptuary by those seducers, the Jacobins, who now, having ruined one polity, threatened to import their corrupting virus to the yet-innocent United States across the sea. The point is, because both Federalists and Republicans alike embraced and relentlessly employed the rhetoric of republican civic virtue, the allegorical meaning of mythic figures such as Theseus and Ariadne was up for grabs, and they, like any political symbol, would have been relatively easy to manipulate. (Whether or not they were actually so manipulated is another matter, requiring empirical evidence about *Ariadne*'s reception that does not exist—hence the hypothetical nature of this discussion).

We have seen how colonial Americans may have experienced Richardson's widely read *Clarissa* in terms of their traumatic relation with England, which they vilified sometimes as a heartless parent and at other times as a cruel despoiler. Imagery of this sort found its way into such political illustrations of the revolutionary era as the anonymous *Female Combatants* (1776, fig. 32) and Paul Revere's *The Able Doctor, or America Swallowing the Bitter Draught* (1774, fig. 33), in which America is symbolically represented as a half-naked young female whom British merchants sexually molest while plying with tea from a dis-

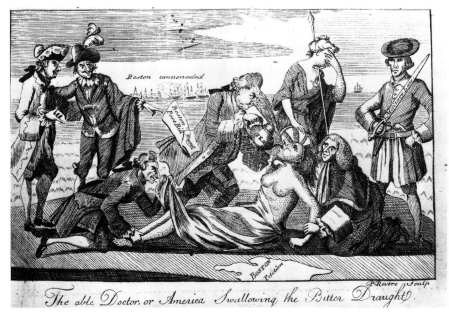

33. Paul Revere, *The Able Doctor, or America Swallowing the Bitter Draught.*
Engraving from *Royal American Magazine*, June 1774. American Antiquarian
Society, Worcester, Massachusetts.

tinctly phallic teapot. In *The Female Combatants*, Daughter America, symbolized by a seminude Indian maiden, cries out, "Liberty, Liberty for ever Mother!" while Mother Britain, about to slug her, snarls back, "I'll force you to Obedience you Rebellious Slut."

Ariadne can be viewed as an updating of *The Able Doctor*, America once again being represented by a supine and seminude young female. This time, however, the British are not cramming themselves down her throat, as in the days of the tea tax, but have instead violated her trust with broken treaties and other unkept vows, a situation that did in fact lead to military conflict.

If such political allegory seems oblique, especially in comparison to the unequivocal rhetoric of the Revere print, that may have something to do with the generic or formal differences between academic oil painting and political cartooning, but no less might it also have to do with Vanderlyn's personal situation of subscribing to certain beliefs

and affiliations that were in opposition to those of his chief financial supporters. I mean to suggest neither that Vanderlyn was trying to smuggle a subversive content beneath the noses of his patrons nor that he did his best to suppress such content. But I suspect that, like most of us, he thought and acted in antithetical ways because of harboring antithetical goals and aspirations, which in turn were the result of living in a society laden with contradiction. The instability of *Ariadne*'s political allegory is indicative of the political instability of the artist and his times.

If Vanderlyn aligned himself with either an elite or egalitarian point of view, which was it? Later in his life there was some controversy over the gentility of his origins. His biographer takes pains to indicate that Vanderlyn as a youth was not a man of the rabble, "a rough country boy," whatever others may have said of him: "Van Der Lyn was then a young man of about *twenty* years of age, blessed with an academical education, had passed three

years of his life in one of the most celebrated stores in the City of New York and thus was *accustomed to city life*. Could a young man, having enjoyed such advantages, become such a *boor?*" Another biographer was less determined to cleanse the artist of his workingman's roots: "Now we profess to be one of those who are far from thinking that there is any discredit in the circumstance of being a mechanic, or the son of a mechanic, but are rather disposed to consider the occupation more useful, and certainly less noxious to society than many vocations, although they may hold a higher rank."[70]

The Sons of Tammany to which Vanderlyn belonged during his years as an apprentice was a predominantly artisanal and working-class, anti-British, anti-Federalist, "militantly Republican" club.[71] Joel Barlow, who commissioned *Jane McCrea*, and Robert Fulton, who suggested the commission, were both dedicated Republicans. It has long been a matter of debate how dedicated a Republican was Vanderlyn's patron and friend Vice President Burr, but even if the duel he fought with Alexander Hamilton, the leading Federalist, had more to do with personal rancor than ideological conflict, Burr's killing of Hamilton seemed even at the time a symbolically anti-Federalist act.

Yet Burr, who plotted to establish a nation in the southwestern territories and appoint himself sole ruler, was not exactly a democrat. The bungled paramilitary expedition he organized, which resulted in his trial for conspiracy and temporary exile from America, was surely inspired by the imperial schemes of France's emperor, whom he admired. Vanderlyn, meanwhile, won a Napoleonic

gold medal that he boasted about for the rest of his life (even though he pawned it from time to time when impecunious). The one man's fascination with imperial rule and the other's honored acceptance of its rewards hardly seem consistent with a deep ardor for republicanism. Furthermore Burr's initial patronage of young Vanderlyn, lifting him out of penury so that he might study the art of the masters, was more in keeping with the aristocratic ethos of the Federalists than with the all-men-are-equal and every-man-for-himself spirit of republican free enterprise. Although normally low in funds, Vanderlyn enjoyed the patronage of such wealthy and aristocratic New Yorkers as John R. Murray and, later, the Whig politician and sage Philip Hone. "The state of the fine arts in America is . . . miserable," Vanderlyn grumbled to friends, and "the spirit of republicanism is directed solely against [the fine arts] whilst luxuries of mere ostentation . . . are alone sought for & cherished."[72] Here "republicanism" connotes crass commercialism rather than civic humanism. The word itself was as unstable in meaning as I have claimed *Ariadne* to be. As John Adams complained in frustration, "There is not a more unintelligible word in the English language than republicanism."[73]

What quickly becomes apparent is that we cannot slot Vanderlyn into this or that category without damaging our comprehension of the art in question, for such categorizations would force us to repress contradictions and explain away unruly, hard-to-systematize, counterintuitive meanings. There can be little doubt that republicanism and federalism, though philosophic and economic rivals, each in its own way appealed to Vanderlyn's needs and emotions and shaped his view of the world. As President Jefferson himself pronounced at his first inauguration, "We are all Republicans, we are all Federalists."[74] It is easy to deconstruct

the remark as a liberal pluralist mystification, a disguise of partisan interest. Even so, it might remind us that no one person—or no one work of art—is all one thing or another but is instead a dialectically complex and uneven blend of federalism and republicanism, sexism and feminism, passivity and activity, culture and anticulture insofar as these and other antagonistic social positions square off against one another in ways that are historically specific rather than timeless and general.

Even when inserted into a specific historical matrix, oppositional couplings such as federalism and republicanism (or any of the other pairings given above) should be regarded as having heuristic value only. The editors of a recent anthology devoted to particularist histories of the early republic emphasize this point. "Historians," they write, "used to make life easy for students by depicting the competition of our political parties, especially the early ones, in an essentially uncomplicated way. Conflict was and remains, of course, the basic theme of party struggles, but the conflict conveniently raged between opposites or antithetical forces." Thus, for example, "states rightists joined together against nationalists; the upper classes were pitted against the common man; frontier and farm clashed with seaboard and city; capital combined against labor; the pro-English encountered the pro-French," and so forth. But actually "our parties have never divided so neatly and simplistically, and sweeping generalizations based on their alleged ideological, class, or sectional differences inaccurately characterized them."[75]

Paintings, too, I have been arguing, are pluralistic combinations of meaning; they are texts (and in this sense political parties or philosophies are also texts) by means of which various competing or temporarily allied social groups attempt to write themselves—that is, represent themselves and their communal interests. Like parties and philosophies, paintings are cultural constructs that are not intrinsically meaningful but rather are invested with meaning (or the lack of it—which is itself meaningful) by historically situated subjects, whether they be producers, consumers, or nonconsumers of those paintings. These subjects belong to groups that have social, political, educational, economic interests. In developing strategies for achieving these interests, whatever they may be, social groups always manage to highlight certain meanings while rendering others invisible.

In the late colonial and early national period, for example, mutually exclusive literary representations of Native Americans existed side by side, each representation a response to or product of the political needs at hand. The "meaning" manufactured for the Indian varied, as we have seen, according to the demands of whatever group was doing the manufacturing (calling forth, that is, certain significations while constraining others). If Ariadne's sensual presence in a primeval forest prompts a reading of her as an American Indian, the positive or negative value of her Indianhood is no less fluid or variable than her potential status as an icon of federalism or republicanism. Any question about whether she would have been regarded as a good Indian or a bad Indian depends upon a consideration of what group would have had cause to look at her as such, and to what purpose.[76]

American history is not a matter of fixed camps of individuals holding to fixed conceptions concerning race, gender, and so forth, but one of ever-

shifting social aggregations motivated by an array of interests. When their group affiliations are multiple, as they usually are, individuals necessarily experience internal conflict (however quickly repressed that experiencing of it may be), inasmuch as the various social groups into which they are dispersed are themselves typically in conflict (affiliations based on gender, for example, run up against those based on class or race). Individuals can be no less crisscrossed and scarred with contradictory meanings than is the society at large that shapes and sustains them.

Thus if every document of civilization is simultaneously a document of barbarism, it is also a document of how civilization and barbarism coexist within her or him who is most responsible for producing that document. *Ariadne*, as a signifying system, is a constellation of meanings all emanating from Vanderlyn's life and the lives of the often-antagonistic societal groups and institutions to which, tenuously or not, he belonged.

Ariadne, the princess, rescued Theseus by providing him with a way out of the deadly labyrinth. He made love to her and then left her behind as he unfurled his sail for Athens, disposing of the old king and becoming the new king in his stead. In the early years of the nineteenth century, John Vanderlyn could very well have fantasized, consciously or otherwise, that *Ariadne*, the painting, would rescue him from the labyrinth of a promising but frustratingly unfulfilled art career. For three years or more he lavished his love—his attentions as an artist—upon *Ariadne*, but then he finished with her and moved on, heading across the sea

to the New Athens where, with his great canvas unfurled, he would outshine his artistic father, Gilbert Stuart, and assume the throne as America's reigning artist. Things, alas, did not work out that way, as no oedipal fantasy ever does.

Why did Vanderlyn reverse such an important detail of the legend by painting the ship's canvas white rather than black? A formalist explanation might revolve around the question of color and value appropriate for the composition as a whole. A psychoanalytic account, however, might regard the refusal to paint the sail a death-conveying, death-causing black an instance of disavowal, a defense against the guilt engendered by the artist's desire to depose his artistic father. In a deconstructionist account, the white sail could stand as a trope for the primed white canvas that this painting blankly was prior to being painted upon—a reminder, that is, of the text's pre-text, which both literally and figuratively lies beneath it.

Whatever the reasons for Vanderlyn's decision to paint the sail white, *Ariadne* proved not to be the vessel to New World success that he had hoped. But what matters now, nearly two centuries later, is that in its optical materiality, its colors, textures, and shapes, the painting provides, if not an escape from the labyrinth of social contradictions that produced it, then at least a stage upon which these contradictions, given visible form, can be reenacted.

❧

To the modern-day viewer probably the most obvious way to read *Ariadne* is to see it as a sexist reification of the female body. And this should not be considered an exclusively feminist, late twentieth-century response. Given the censure raised in Vanderlyn's lifetime as well as at the end of the nineteenth century, when those five hundred women of Philadelphia protested the work's public exhi-

bition, there has been an underlying consistency in complaints about its patently sexual objectification. Viewers from the Right as well as the Left, radicals as well as conservatives, feminists and antifeminists, lechers and prudes, and practically everyone but the most zealous, head-in-the-sand formalists (those to whom Vanderlyn pitched his defense) would be able to agree that *Ariadne* is very much about sex or, more particularly, female sexuality.

Certainly I too agree that the painting is about female sexuality in addition to, perhaps even in priority to, every other facet of potential meaning we have covered. But before bringing this chapter to a close, I want to consider this sexuality in a positive rather than negative light. In so doing I borrow from current feminist debates as to whether images of female sexuality are invariably oppressive toward women or if they can also in some sense, in some instances, be empowering. The crystalizing moment of these debates was the Barnard College conference in 1982 on the politics of sexuality, in which women-against-pornography activists confronted advocates of "alternative sexualities," the one side arguing that eroticized images of individual women debilitate all women and reinforce patriarchal domination, the other side contending that women need to claim for themselves the power to experience their own and other women's bodies sexually rather than continue to concede this power to men.[77]

Recent feminist scholarship describes ways in which female consumers of sexual images liberate them from the meanings prescribed by patriarchy and imbue them with meanings appropriate to their own social condition. Perhaps the best-known study of such consumer intervention is Janice Radway's *Reading the Romance* (1984), which ethnographically examines a group of midwestern

readers who absorb a steady diet of patriarchal romance fiction but process it in such a way as to augment their female solidarity and undermine their dependence on men.[78]

Although no ethnography of *Ariadne*'s early nineteenth-century female viewers is possible, one wonders if this text, like the late twentieth-century ones Radway has studied, could have served its contemporary female viewers as a means for imaginatively enacting and enforcing their own subjectivity. True, most contemporary romance fiction is written by women for female consumption, whereas *Ariadne* was painted by a man for the enjoyment of other men (chapter 4 below examines popular art painted by a woman primarily for female consumption). Surely, though, to some greater or lesser degree Vanderlyn's painting must have been conceptually or emotionally reappropriated by its female viewers, feminist or otherwise, inasmuch as all works of culture are reappropriated (to a greater or lesser degree) by all consumers as they internalize what they consume.

Thus we might imagine a romantic-era female who would conceive of Ariadne neither as a wanton sensualist nor a pitiful victim of seduction but rather as a free woman basking alone in nature, unfettered by restrictive clothing or social conventions, and undisturbed by the departure of a deceitful lover. And this hypothetical viewer need not have been a sexual or political radical such as Mary Wollstonecraft. She might have been like the New England schoolgirl Eliza Southgate, who at the start of the nineteenth century disdained old-fashioned arranged marriages and yearned for an

unconventional romance, one ruled not by sense but sensibility (that is, the emotions): "How I abhor the heart which is regulated by mechanical rules, which can say 'thus far will I go and no farther,' whose feelings can keep pace with their convenience, and be awakened at stated periods,—a mere piece of clockwork which always moves right!"[79]

Had young Southgate occasion to view *Ariadne*, she might inwardly have cheered the princess's disobedience to paternal decree and seen in the ripeness and relaxed physicality of the sexualized body an emblem of female strength and self-sufficiency. The Greek legend upon which Vanderlyn based his painting says that Theseus abandoned Ariadne, but female viewers so predisposed could easily have recast the scene in such a way as to see the puny little man on the margins as having been cast off by the beautiful giant in the center who no longer requires his services: *Goodbye, Theseus, and good riddance!* A daughter of wealth and advantage, Eliza Southgate was hardly a social radical, but her openness to a reading of *Ariadne* as an image of female self-sufficiency would have been in keeping with her bold romantic assertions that "I do not esteem marriage absolutely essential to happiness" and "I congratulate myself that I am at liberty to refuse those I don't like, and that I have firmness enough to brave the sneers of the world and live an old maid."[80]

Of course once we look at Ariadne this way, our previous interpretations become retroactively altered; figure and ground continue to shift. If we read Ariadne as a signifier of genuine satisfac-

tion and Theseus as having been dispensed with by her, this necessitates revision of the Federalist interpretation, the Republican interpretation, and the various other interpretations that emerged when we saw Ariadne in terms of someone else's pleasure or convenience, not her own. The corridors and byways of the maze proliferate rather than diminish, and we travel further from rather than closer to a limit, or even an equilibrium, of meaning.

Perhaps there is some connection, some congruence, between this unregulated flow of signification—the text's lubricious slippage of meanings—and the painting's manifest eroticism. In a certain sense, that which is erotic is that which instigates and maintains seemingly endless play, energy, possibility. Sexuality returns us, if only in imagination, to a more primal self's state of innocence and grace in which polymorphous perversity is another name for infinite horizons, boundless opportunities, bodily immortality.[81]

Thus for Vanderlyn's older French contemporary, the Marquis de Sade, sexual pleasure in a work such as *The 120 Days of Sodom* was the result not of discrete bodily acts that were confined within time and space but was instead the result of how such acts, *when imagined*, multiplied into an overflowing and unstoppable stream. As Simone de Beauvoir has remarked about Sade, "It was by means of his imagination that he escaped from space, time, prison, the police, the void of absence, opaque presences, the conflicts of existence, death, life and all contradictions. It was not murder [or sex] that fulfilled de Sade's erotic nature; it was literature." Or as Ronald Hayman has commented in his biography of the marquis, "Masturbation is a strategy for coping with a situation in which contact is being made with no other bodies; literature resembles it in so far as the act

of writing yields a pleasure in which no one else can participate, however much pleasure the results yield later."[82] The lambency of Ariadne's body as Vanderlyn has painted it, its iridescence, its powerful radiance of light from within, might cause us to think of that body as a symbol of self-generation and, in terms of erotics, as the symbol for meaning, pure meaning, continually and pleasurably reproducing itself. Thus intersect a feminist reading of Ariadne as female sexuality and subjectivity by and for itself and a semiotic reading of her as sheer, self-propagating signification. In both readings the male term, Theseus, is an element on her horizon, a factor in pleasure or meaning but not a boundary to it or limit upon it.

At this point, given how the battle lines are arrayed in today's academic discourse, the reader inclined toward historicism may have the urge to snap shut this book in exasperation, feeling that the obsessive interpreting of *Ariadne* has finally gone too far. But to do so would only give the reader inclined toward textual presentism an occasion to needle the historicist for repressively denying the insatiable hunger for interpretation that this painting has engendered and to accuse the historicist of betraying a dread of promiscuously proliferating meaning that echoes both a nineteenth-century dread of female insatiability and that century's alarm at uncontrolled propagation.[83] The historicist would then reply that the textualist prefers politically ineffective semiotic masturbation to the politically productive labor of rigorous historical analysis. And on they would go.

Fear of unstaunchable female sexuality was, of course, by no means unique to the nineteenth century, as suggested in the quotations above from Rolfe and Vespucci. Rousseau regarded uncapped female passion as a premier threat to the security of the liberal state: if men could not perform adequately in their own homes, which is to say in their own beds, how could they adequately perform their role as free citizens? It is clear, Rousseau writes, "that the father ought to command. In the first place the authority ought not to be equally divided between father and mother; the government must be single, and in every division of opinion there must be one preponderant voice to decide."[84]

The sexually conservative underside of political liberalism, as evidenced in the Rousseau quote, proved to be fatal to organized feminism in revolutionary and postrevolutionary France. "In 1793, the republican Left, inspired by Rousseauist ideas, blamed the public role of women for the current internal disorders and recommended the closing of all political clubs that had female members," observes one recent historian of the period. Neither under Napoleon nor under the restored Bourbons did French women, regardless of class, fare any better in applying pressure against legal, philosophic, and social codes that relegated them to the separate sphere Rousseau and others had extolled for them. Thus whatever feminist themes our viewing of *Ariadne* may call to mind, the painting itself was produced in a Napoleonic Paris in which feminism, as a political movement, was relatively unknown. But this is not to say that increased freedom was unwanted or uncalled for by women of that time and place—or across the sea in America, either, where, in the words of Eliza Southgate, "The inequality of privilege between the sexes is very sensibly felt by us females."[85]

But however much we may attempt to recover for *Ariadne* a culturally repressed discourse of femi-

nine subjectivity and autonomy of pleasure, we cannot avoid for long its more dominant discourse, which bespeaks woman as the object of male desire or dread or both, inasmuch as that dominant discourse prevailed in the society at large—and, to be sure, had also prevailed in the classical Greek civilization that the makers of the new social order idealized and wished to resurrect.[86] Thus, even if certain female viewers of Vanderlyn's era might conceivably have read Ariadne's body in terms of their own subjectivity and will to power, for most viewers the painting would have served to reinscribe patriarchal notions about men's supposedly timeless and natural right of access to women and their bodies. For such viewers, male or female, the painting would most likely have taught that in a state of nature (Rousseau's ideal state) woman was inherently sensuous and sexual, "naturally" removed from Theseus's world of politics and history.

Sexualizing certain groups or classes of people (such as women) provides justification for their social exclusion and exploitation. John D'Emilio and Estelle Freedman have pointed out that "in the nineteenth century, sexuality continued to serve as a powerful means by which white Americans maintained dominance over people of other races. . . . At a time when middle-class morality rested heavily upon a belief in the purity of women in the home, stereotypes of immoral women of other races contributed to the belief in white superiority" and, they add, "justified social control of [those] other races."[87] Rayna Green has observed that American popular culture of the nineteenth century split the female American Indian into two antithetical mythic personae, the chaste Princess whose sexuality "can be hinted at but never realized" and "the Princess' darker twin, the Squaw," whose sexuality was shockingly (and excitingly) unlicensed.[88]

Much as the Native American male, according to the political needs of the mythmonger in question, could conveniently symbolize either the nobility of the uncorrupted, non-European world or the ferocious, cannibalistic destructiveness of those who had to be expunged from it, so the Native American female could be converted from a patriotic icon to a sexual fetish object whose connection with immoderate lust justified Christian territorial expansion. The ideological distances were not great, this is to say, between the Indian Princess of official art and her sister the Squaw who, according to nineteenth-century popular song, "lays on her back in a cowboy shack, and lets cowboys poke her in the crack," or between the revered Pocahontas who selflessly rescued a white man named Smith and the same Pocahontas who, according to Smith, encouraged him to do "what he listed" with her.

At the most literal narrative level, Ariadne was a Greek princess, not a Native American, but given the grounds we have seen for the ideological slippage that would permit an equation of a naked white woman with naked and exotic savages, and both these classes with nature, we now can understand that nineteenth-century objections to *Ariadne* had more properly to do with power than prudery. The painting meant different things to different viewers and therefore cannot be ascribed any single meaning. But whatever these various meanings may have been, clearly their point of intersection was Ariadne's body and the sense of female sexuality it propagates.

I began by arguing that *Ariadne* and its long-forgotten contexts of production and reception needed, as it were, to be heard. In the preceding pages I have tried to help us hear not one but many voices. But whose voices have these been—mine, Vanderlyn's, *Ariadne*'s, the twentieth century's, the nineteenth century's, some combination? Is the historian who attempts to draw out the speech of the neglected or misunderstood or otherwise silent artifact inevitably playing the role of the male chauvinist who cannot resist answering for a supposedly helpless female every time she is asked a question, or, likewise, of the intellectual who presumes to speak for social classes to which he or she does not belong? Is to say of *Ariadne* that it is a labyrinth of meanings the same as saying, in effect, that it is beyond meaning or, another version of this, that it means anything you want it to mean? That is, that *you* want it to mean: that its meanings are yours, ours, mine, but not its own property or the property of its time; instead, the property, the intellectual consumer commodity, of this present time?

These are hard questions, admitting of no easy answers. If the painting gives rise to a labyrinth of possible and often-contradictory meanings, and if trying to think clearly about the relations of these various meanings to one another calls forth a second, methodological labyrinth (an echo labyrinth?), then that is because the painting itself, the artist who painted it, and we right now are all—with considerable differences, to be sure—wanderers within much larger social and historical labyrinths. Here I differ from J. Hillis Miller, whose deconstructive classic "Ariadne's Thread" considers the line of any literary narrative to be simultaneously the labyrinth in which the reader travels blind, searching for an exit while not knowing what twistings of plot lie ahead, and the thread by which he or she maneuvers through the text's corridors, its turns and alleys, one step at a time. For Miller, texts produce labyrinths, whereas here the claim has been that history produces the texts that produce the labyrinths.[89]

In an earlier draft of this chapter I planned to conclude with both closure and open-endedness. The closure would result from bringing back one last time the image of the labyrinth that had been threaded throughout these pages. The open-endedness would come from lauding the painting for refusing a bottom line, a totalization, a closure of meaning. But now, though my own desire remains for equal measures of closure and openness, I see that I had better avoid mystifying *Ariadne* by labeling *it* as a labyrinth, no matter how poetically apt that might be.

For this would be contrary to all that I have been seeking to accomplish. First, what I have been insisting upon throughout is that the painting is "undecidable" not for any magical properties or because it is so special and unique or because, if you prefer, it is so secondary and derivative, but rather because the society that produced it (and thus constrained in advance our latter-day interpretations of it) was in so many significant ways undecided, unfinished, and unequal. Second, the term *labyrinth* suggests stasis insofar as it implies continual movement that never actually goes anywhere. While as a material object the painting remains basically the same from generation to generation, as an object of critical interpretation it is no less changeable than the continuingly contested and constraining culture to which it belongs.

Bingham's *Boone*

Before we, too, abandon Ariadne on her desert isle, let us pause to consider her as the foundation of nineteenth-century American landscape painting. The future wife of Bacchus, nature god of wine and revelry, Ariadne, in all her sumptuous availability, is the trope of bountiful America ready for the taking. Such availability, in brief, seems to be the essential theme, intended or otherwise, of every major U.S. landscape painter of the middle two quarters of the nineteenth century from Thomas Cole and Asher B. Durand to Frederic Church and Albert Bierstadt. Even when, like Cole, these painters were anxious to assert the inviolability—as opposed to availability—of the land, the effect was to tantalize viewers, to seduce them with desire for the virgin lands that lay to the west.

No American painting of the period more memorably addresses Manifest Destiny—divinely sanctioned westward expansion—than George Caleb Bingham's *Emigration of Boone*, also known as *Daniel Boone Escorting Settlers through the Cumberland Gap* (1851–52, fig. 34). Technically *Boone* is not a landscape painting, given the predominance of its human protagonists over the land, which serves as a backdrop rather than primary focus of attention. More accurately *Boone* is a hybrid of history, genre, and landscape painting, and, as such, it is especially useful for discerning connections between representing the land visually (through art) and politically (through settlement). *Boone* makes explicit that which is implicit in the so-called pure (mostly or wholly unsettled) landscape paintings of the period: that land is to be colonized, if not literally by explorers, settlers, and real estate developers, then by poets, painters, and nature-lovers who, merely by looking, can range over it freely in their imaginations.

About three feet high and a little over four feet wide, *Boone* depicts the crossing of a gloomy and threatening wilderness pass by a beneficently lit party of pioneers. In the forefront is Daniel Boone, square-jawed, middle-aged, and garbed in a fringed, three-quarter-length buckskin coat, leggings, moccasins, a bright red shirt, and a Quaker-style beaver hat set perfectly in line with the angle of his brow. Marching toward the picture plane, Boone smartly shoulders his rifle while grasping the bridle of a gathered white steed that also steps forward, in synchronization, toward the viewer's space.

In the summer of 1775 Boone, a hunter and land explorer from Virginia and North Carolina, led his family and a contingent of other settlers across a gap in the Allegheny Mountains into Kentucky, a rich wilderness territory unsettled by whites. It is this historically significant crossing that Bingham depicts. Boone's militant posture and grim, alert demeanor can be attributed to his vigilance against Indians, who had thwarted him in an at-

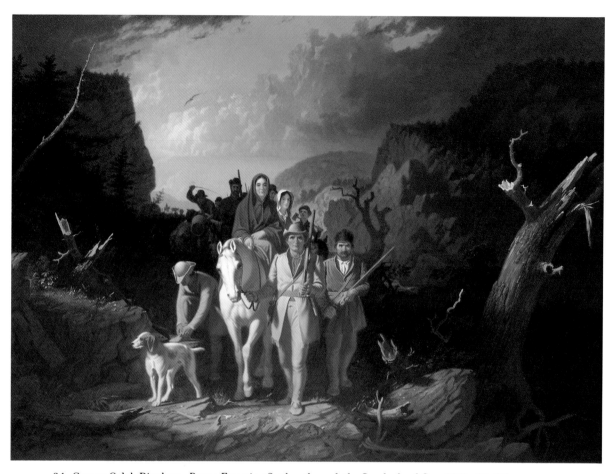

34. George Caleb Bingham, *Boone Escorting Settlers through the Cumberland Gap*, 1851–52. Oil on canvas,
36½ × 50¼ in. Washington University Gallery of Art, St. Louis. Gift of Nathaniel Phillips.

tempt two years earlier to bring his family through the Cumberland Gap and in so doing had killed his eldest son.[1]

Rebecca Bryan Boone, the pioneer's wife, garbed in a robelike shawl and riding side-saddle, looks as though she were Mary in a traditional Flight into Egypt. One hand rests upon her lap while the other holds the reins passively, relinquishing control of the horse to her husband. But this hardly makes Rebecca a figure of powerlessness. Her head higher than anyone else's, she is depicted as a heavenly mother but also as a strong physical presence. With dour expression, straight-ahead gaze, and steadiness upon her mount, she is the essential pioneer woman, rugged, unafraid, a key player in the shaping of her own destiny and that of her small migrant community.

The figure at Boone's left, traditionally identified as Flanders Callaway, is a wilderness man much like him, but older, stouter, a bit shorter, darker in tone. This sidekick (one thinks of Gabby Hayes, Buddy Ebsen, Walter Brennan, or some other ubiquitous character actor of Hollywood's golden age) is shaggy and grizzled, unlike the smooth-shaven Boone, but the belt at his waist lines up perfectly with his leader's, the leather strap across his shoulder parallels Boone's, and both men's jackets reveal shirts buttoned to the collar. If Boone's firearm constitutes a vertical element in the composition, Callaway's Kentucky long rifle is even more of a parallel to Boone's cross-strap than is his own cross-strap, which is slightly curved, fluidly giving way, as it were, to the curve of the blasted tree that intervenes between him and the distant, forbidding wall of granite. The diagonal of Callaway's rifle repeats not only Boone's taut cross-strap but also the stripped branch in the upper left of the painting, the sharp, jagged trunk beneath it, the wingspan of the bird soaring

through the sky, and the large blasted tree that veers dramatically off canvas.

The grasp of Callaway's hand upon his rifle reenacts Boone's determined grip on the reins, while the scout at the other side of Mrs. Boone is in certain ways a reenactment of her. His arms, like hers, swing around to join at the hands. The leather reins run lightly between her fingers while he also lightly touches leather, having stopped to tie the laces of his moccasin. Indeed, with his knee drawn up from the ground, he has more in common with her, who is seated, than with Boone, who strides forth with a palpable sense of purpose. As she rises above her horse, the scout leans over his dog; both animals appear to be patient, useful, domesticated. Presumably this is one of Boone's sons and, as such, is more of a boy, in the realm of his mother, than a man, like Callaway on the opposite side.

Boone's daughter Susannah, the white-bonnetted young woman, is linked by the color red to the other members of her family (Boone also wears red, while Rebecca and the scout are connected by a red saddle blanket). In back of this young woman is a young man situated directly over Boone. Wearing a cap shaped like Boone's, he seems a younger version of the pioneer, as Susannah is a younger version of Rebecca, thus implying that a new generation of leaders is coming through the ranks, patiently awaiting its turn at the head of the column.[2]

Other heads and silhouettes of heads and bodies fill out the contours of the pyramidal composition, creating the impression that the convoy trails back

to infinity. A bearded man in the distance carries his rifle over his shoulder on a line almost parallel to the vertical of Boone's rife—but not quite: no one in this painting is as straight as Daniel Boone. The viewer's eye skims the column of heads back into the deep space of the painting, where the most distant travelers cross the horizon in friezelike relief.

Such a solemn and stately march would appear almost static, despite the various bent knees (indicative of motion), were it not for the figure in the middle distance who imparts energy by cracking a drover's switch. Appropriately, it is a piece of wood that is responsible for adding dynamism to the procession, for the surrounding landscape itself is agitated with diagonally sprung branches, boughs, roots, trunks, and stems. Additional drama is wrought by chiaroscuro lighting that syncopates across the visual field and by jagged rocks, swooping hillsides, sharply angled cloud banks, and the lone bird, a hawk perhaps, that glides unfettered through the sky.

Numerous commentators have described Bingham's painting as a Flight into Egypt. Others have seen in it an allusion to Moses guiding the children of Israel out of Egypt. Still others have been reminded of the valley of the shadow of death invoked in the Twenty-third Psalm. All of these references pertain, given that Bingham and his contemporaries were steeped in biblical narrative and habitually thought of the nation's past (and present) as an errand into the wilderness, a mission of providential behest.[3]

But if the form of the painting derives from Renaissance traditions for visually depicting biblical events, one might imagine that a nonbiblical source was the Missouri River, beside which Bingham spent so much of his life and to which he devoted so much of his art, especially in the half-decade prior to taking up the brush for *Boone*. In those earlier works the peaceful river flowed down or across the center of the canvas in a seemingly endless stream. Now, in *Boone*, a river flows into the wilderness, no less peacefully and just as endlessly, but this time it is a river of humanity. (This river-of-humanity theme carried into Bingham's next major work, *The County Election* [1851–52, fig. 35], with the human river flowing through the streets of a western settlement and eddying up the steps of a rural courthouse.)

Bingham gained national prominence for his depictions of leisurely voyages down the Missouri and Mississippi waterways. Paintings such as *Fur Traders Descending the Missouri* (1845, fig. 36) and *Raftsmen Playing Cards* (1847, fig. 37) show pyramidally composed groups of figures floating slowly, harmoniously, through nature. In *Fur Traders* the implied movement is lateral to the picture plane while in *Raftsman* it is perpendicular, suggesting a movement toward the horizon indicated by converging banks of trees. In both instances the movement appears effortless, unlabored, coaxed along by nature rather than resisted. In *Raftsmen* the thrust into deep space is made inexorable by the raft's converging diagonals and their symmetry to the shoreline, so much so that the labor of the one raftsman who is at work seems obviated, as though his poling has less to do with propulsion than with a desire to accommodate the river's flow.

Seductively, such paintings purvey a dream of leisure, communal togetherness, and amiable accord with nature. Perhaps there's a sandbar here

on the left and a snag on the right, but these are visible, not concealed. Besides, such threats occur at the margins; they do not obstruct the mainstream. For Jacksonian Americans caught up in the hectic rhythms of contemporary life, Bingham's paintings of boatmen on the river constituted a pleasingly nostalgic, even therapeutic, recourse from the daily grind.[4]

In this regard, Bingham's river paintings, taken collectively, amount to a secularizing rejection of Thomas Cole's four-part allegorical series *The Voyage of Life* (c. 1840), which put forth a generic river—the river of life—as the symbolic site for spiritual abnegation and redemption. The paintings in the Cole cycle represent stages of human growth: childhood, youth, maturity, old age.[5] The third painting in the series, *Manhood* (fig. 38), portrays a bleak natural environment similar to that through which Bingham marches his Boone.

Yet whereas Boone travels in the company of his family and community, Cole's wanderer is fearfully alone, save for the nearly invisible angel that peers down from the upper reaches of the blackened sky. For Cole, salvation is deemed possible only when sought through proper religious channels and with due submission to higher authority.

A comparison of *Manhood* with *Fur Traders* clarifies Bingham's theological difference from Cole, a difference that *Boone* further addresses. The Cole voyage transpires in the stormy gloom of late afternoon or evening, the Bingham in the pink-tinged freshness of early morning as mists rise from the water. Cole's voyager is oarless and

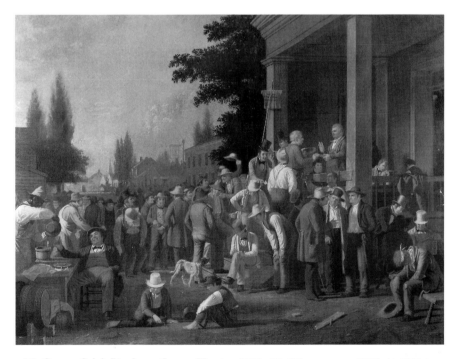

35. George Caleb Bingham, *County Election*, 1851–52. Oil on canvas, 35⁷⁄₁₆ × 48¾ in. Saint Louis Art Museum. Museum purchase.

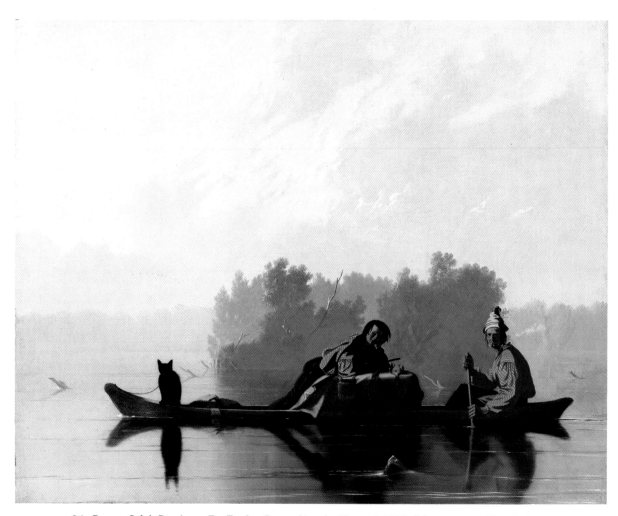

36. George Caleb Bingham, *Fur Traders Descending the Missouri*, 1845. Oil on canvas, 29 × 36½ in.
Metropolitan Museum of Art, New York. Morris K. Jesup Fund.

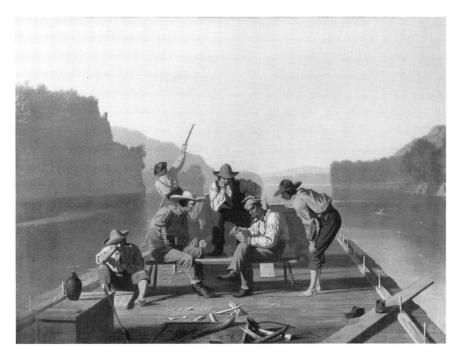

37. George Caleb Bingham, *Raftsmen Playing Cards*, 1847. Oil on canvas, 28 × 38 in.
Saint Louis Art Museum. Ezra H. Linley Fund.

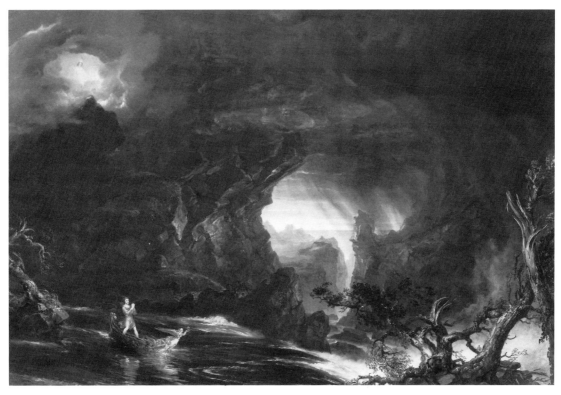

38. Thomas Cole, *Voyage of Life: Manhood*, 1840. Oil on canvas, 52 × 78 in.
Munson-Williams-Proctor Institute, Utica, New York.

rudderless, without choice as to where his vessel takes him. Bingham's voyagers know where they are going and how to get there. They let the river carry them but are not carried away by it. Cole's individual is existentially alone, alienated from the rest of humankind. Bingham's man and boy have each other, their cub, and us—for in establishing eye contact, they include us in their world.

Manhood cries out that individuals are too small to control their destiny. They must entrust themselves to Higher Authority. *Fur Traders*, by contrast, seems communitarian, democratic, mercantile. It depicts the harmonizing of social, commercial, and natural elements. The painting's utopian ideal presents grizzled white man, "half-breed" boy (as Bingham described him), and enchained black pet poised in splendid balance with one another and with the river upon which they glide.

Boone similarly refutes the stark alienation of *Manhood*. As in Cole's painting, a voyage transpires through the midst of a threatening wilderness, but the differences are crucial. If Cole's unfortunate pilgrim is alienated from the rest of humankind, Bingham's "pilgrim" is not an individual but a collection of many, a community. Cole's traveler, unable to master his fate, must await divine intervention. Bingham's travelers stride forth purposefully, their feet on the ground, their eyes fixed straight ahead, bodies in proximity, minds aligned. A void fills the center of Cole's composition. In *Boone* the gap is filled, literally plugged, by the pyramidal group. Whereas Cole's benighted individual cannot hope to navigate the abyss, Bingham's community, led but not dominated by a figure of authority, emerges from (or enters) the Cole-derived wilderness bold, unbowed, and ready for business.

To get an idea of just how much the landscape in *Boone* alludes to the wilderness landscapes of Thomas Cole, examine Cole's extraordinarily tumultuous *Landscape with Dead Tree* (c. 1827–28, fig. 39), which provides a powerful compositional prototype for the *Boone* wilderness. Bingham's original version of the work, as known from a lithograph (1852, fig. 40), was considerably more tranquil in aspect, but in repainting the background (after the original version failed to attract a buyer), Bingham seems to have hearkened explicitly to the model formulated a generation earlier by Cole. Another Cole painting, *Expulsion from the Garden of Eden* (1827–28, fig. 41), thematically prefigures *Boone* by depicting yet another biblical flight, this time of Adam and Eve out of the bright paradise of their homeland into a savage, threatening wilderness. Here again Bingham revises Cole, replacing his eastern predecessor's wretched and tormented sinners with a bright, steady column of pioneers who stride forth into the unknown holding their chins high.

Long before he embraced the Episcopalianism of his later life, Cole painted *Daniel Boone at His Cabin on the Great Osage Lake* (c. 1826, fig. 42). Cole's Boone is a Byronic loner, a somber, scowling frontier Marius seated not on the ruins of Carthage but amidst tractless autumnal wilds, with no one for company but the hound that attends alertly at his feet.[6] There is not even an angelic presence overhead as there was to be in *Manhood*. Cole's Boone has shirked all society, unlike Bingham's wilderness stoic who compositionally, and therefore also symbolically, bears society upon his shoulders.[7]

39. Thomas Cole, *Landscape with Dead Tree*, c. 1827–28. Oil on canvas, 26½ × 32½ in.
Museum of Art, Rhode Island School of Design, Providence. Walter H. Kimball Fund.

40. George Caleb Bingham, *Emigration of Daniel Boone and His Family*, 1852. Lithograph by
Claude Regnier after first version of the painting, 18⁵⁄₁₆ × 23¾ in. Missouri Historical Society, St. Louis.

41. Thomas Cole, *Expulsion from the Garden of Eden*, 1827–28. Oil on canvas, 39 × 54 in.
Museum of Fine Arts, Boston. Gift of Mrs. Maxim Karolik for the Karolik Collection of American Paintings.

42. Thomas Cole, *Daniel Boone and His Cabin on the Great Osage Lake*,
c. 1826. Oil on canvas, 38 × 42½ in. Mead Art Museum,
Amherst College, Massachusetts.

After Cole's premature death in 1848, his friend Durand succeeded him as the most influential of the Hudson River School painters. Durand's celebrated memorial *Kindred Spirits* (1849, fig. 43) shows two men, one of them Cole and the other the poet and editor William Cullen Bryant, commanding a pulpitlike outcropping in the midst of a sumptuous Catskills landscape. The names Bryant and Cole are carved into one of the three intertwined trees that swoop upward to canopy the two sages and enframe the upper edge of the painting. Three intertwined trees, rather than the two we might expect: a Holy Trinity in keeping with the work's quasi-religious sensibility. But three rather than two suggests also that Durand himself was a kindred spirit, no less a loving and reverent describer of nature than these two friends and colleagues with whom he associates himself by means of a signature tellingly carved into the rock upon which they stand and from which those three kindred trees arise.[8]

If *The Voyage of Life* advised that only God and his representatives, his angels, can tame the wildness of nature (including human nature), *Kindred Spirits* suggests that it is *nature artists* who serve that role in the modern world. It is they who function now as angels, mediators, cultural high priests. This is a self-serving thesis that *Boone* reworks even as *Kindred Spirits* reworks *The Voyage of Life*. For in Bingham it is the white immigrant family, the community of westerners, of settlers, of hunters and farmers—not a group of eastern intellectuals, artists, high priests—that bears responsibility for transporting civilization to the wilderness and mediating it for future generations. Durand's Cole stands to the side and points instructively *at* nature, while Bingham's Boone marches *into* it. Bingham mediates the wilderness

neither with guardian angels nor priestly artists but rather with a congregation of republican pathfinders.

Yet if *Boone* is a revision of *Kindred Spirits* or, even more specifically, a metaphoric rebuttal of that painting, it is so for reasons not merely philosophical or theological. In 1851 Bingham had more than one bone to pick with the New York art establishment controlled by liberal easterners such as Durand and Bryant. The Missourian's opposition was both professional and political.

Not only one of antebellum America's leading poets and most vigorously outspoken newspaper editors, Bryant was also unusually involved in the New York art world. Besides enjoying a long and close friendship with Cole, Durand, and other prominent artists, he served at one time or another as the chief administrator of various art organizations. The founder of the movement to create Central Park and one of the organizers of what was eventually to become the Metropolitan Museum of Art, Bryant was also the first president of the American Art-Union.

This short-lived but tremendously influential organization was in fact the source of Bingham's renown as a genre painter. It not only purchased *Fur Traders* and several rafting pictures but exhibited them prominently in large-scale exhibitions and raffled them in national lotteries. Intent on esteeming and publicizing *American* (as opposed to European and European-style) painting, the Art-Union had enthusiastically championed Bingham and his halcyon view of life on the frontier. The illustrated Art-Union catalogues, circulated

43. Asher B. Durand, *Kindred Spirits*, 1849. Oil on canvas, 46 × 36 in. New York Public Library. Astor, Lenox and Tilden Foundations.

throughout the country, even throughout the hemisphere, made Bingham's work familiar to thousands of midcentury viewers.

And yet toward the end of the 1840s Bingham grew disgruntled with the Art-Union, claiming he was underpaid and undervalued. Other artists, producers of academically styled history painting, were commanding five times the price he was paid for his western genre scenes. He vehemently blamed the directors of the organization for this inequity and took offense at their demotion of his work.[9]

When Bingham began *The Emigration of Boone* early in 1851, he was hoping to catch the trend away from genre to history painting. If genre painting depicts common, everyday occurrences, history painting aims to recreate important public events, ones that are or should be engraved in the collective memory because of their elevated and exemplary nature.[10] Unfortunately the art-

ist choked on the seriousness he brought to the project. Even in his depiction of the grizzled pioneer at Boone's side he was able to muster none of the precise character and spirit that he had vividly conveyed only a year earlier in his figures from *The Wood Boat* (see fig. 56)—one of whom, a seated man with a pipe, is the sort of crotchety old coot he normally took pleasure in painting.

Notwithstanding his efforts to fall in line with the type of paintings now preferred by the Art-Union, Bingham looked upon its management with contempt. From his rented New York studio, he wrote his closest friend back home, Maj. James R. Rollins, that the "managers of the Art Union display in some cases gross favoritism in the purchase of their pictures." Vowed the artist, "In my transactions with them hereafter, I shall act as if I were dealing with a Jew." [11]

William Cullen Bryant, who had earlier stepped down as president of the Art-Union, was not Jewish, and neither, one supposes, was his successor, a certain Prosper Montgomery Wetmore. Still, the artist's epithet is telling. At the very moment Bingham was painting an American Exodus he was denigrating his perceived enemies as Jews. His pioneer hero is a non-Semitic Moses, racially pure of the grasping qualities Bingham attributed to those he distrusted, Hebraic or otherwise. Although I am not arguing that Bingham painted *Boone* as an implicit rebuke of the Art-Union managers for swerving out of the path of their support for him, I wish to suggest that the painting's relation to *Kindred Spirits*, the work that apotheosized Bryant alongside of Cole, is more than purely aesthetic or philosophic.

A year later, Bingham was prepared to sue for what he considered a slanderously negative review of his work in the Art-Union monthly publication. Before the suit was able to develop, however, the

organization was dissolved by court order, thanks to a prior lawsuit contending that the Art-Union's annual lottery was illegal. This suit was supported by the newspaper publisher James Gordon Bennett, whose New York *Herald* accused the managers of the union of diverting lottery proceeds to finance antislavery propaganda. The Art-Union had indeed turned over its mailing list to the new abolition paper in town, the New York *Times*, which Bennett referred to as "a nigger penny organ." Like the *Times*, Bryant's New York *Post* was radically opposed to slavery and dedicated to the cause of abolition. [12]

In this way too, then, might Bryant, abolitionist liberal eastern Democrat, have been a nemesis of Bingham, slaveholding conservative western Whig. [13] To the extent that *Boone* is a reworking of both *Manhood*'s evangelical extremism and *Kindred Spirits*' complacent liberalism, it amounts to a position statement by Bingham, an embodiment of his secular, political, republican ideal.

The Whig party was formed in 1834 as a coalition of political groups opposed to Andrew Jackson and his Democratic party. Under the leadership of such figures as Henry Clay, John Quincy Adams, and Daniel Webster, Whigs shared a respect for the traditional forms and representatives of authority, a disrespect for plebeian upstarts such as Jackson, and an embrace of mercantilism, the doctrine that the economic interests of the nation as a whole are of primary importance and should therefore be enhanced as necessary by government intervention. Clay's American System, the core of Whig policy, was a plan for uniting the three geographic sec-

tions of the country—North, South, and West—by means of an economic policy that provided high tariffs to protect manufacturers from European imports, a national bank to standardize currency and capitalize ventures, and federal taxation used for subsidizing the construction of roads and canals in order to facilitate interstate trade. Whigs, Bingham among them, called for systematic government oversight of internal economic matters, whereas Democrats, including Bryant, tended to be adamantly opposed to federal intervention, preferring instead states' rights and laissez-faire approaches to economic affairs.[14]

In 1846 Bingham, running for state legislature on the Whig ticket, had beat his Democratic opponent in an exceptionally tight race. The race was so close that the legislature, dominated by Democrats, overturned the vote and assigned the office to their own man. The artist complained bitterly to Rollins, "An Angel could scarcely pass through what I have experienced without being contaminated. . . . As soon as I get through with this affair, and its consequences, I intend to strip off my clothes and bury them, scour my body all over with sand and water, put on a clean suit, and keep out of the mire of politics *forever*." [15]

In spite of his vow to keep out of politics forever, Bingham rejoined the fray two years later, this time successfully. Serving in the state legislature from 1848 to 1850, he championed various Whig causes concerning matters of economic assistance for internal improvements. Even his river paintings from this period may have constituted a sort of argument on behalf of the Whig program for developing local waterways as avenues of commerce.[16]

Saline County, which Bingham represented, was one of the heavy slave counties of central Missouri. Bingham's grandfather had held slaves in Virginia, and when Bingham's father migrated over the Alleghenies in 1819 he brought slaves with him (as Daniel Boone had done half a century earlier).[17] Bingham's closest ally, Major Rollins, held twenty-four slaves. Even Missouri's leading politician, Sen. Thomas Hart Benton, his vigorous antislavery speechmaking on the stump and in Congress notwithstanding, owned slaves. Though Benton and Bingham were of different parties, both were anxious to prevent the expansion of slavery into the territories, believing that such expansion would seal the doom of the republic by forcing a sectional rift that could not be mended. Significantly, no slaves accompany the Boone party in Bingham's painting, although in historical actuality they were present. Through this notable omission Bingham signals his disapproval of the territorial expansion of slavery (a matter that was at issue in his own time, not Boone's).[18]

During his single term in the legislature Bingham proposed the so-called Bingham Resolutions. Articulating a position against states' rights while calling for a referendum on slavery, these resolves defined the artist as a pro-Benton Whig. As a result he abruptly lost the support of his party, which was more interested in driving Benton out of Washington than in adhering to its save-the-Union platform. Bingham was outraged by his colleagues' dereliction of party principles and, embittered, did not run for a second term in the election of 1850.

It was precisely at this point of personal and party crisis that he began work on *Boone*. In the same letter to Rollins in which he announced the new painting and decried the Art-Union management, he proclaimed, "With a frank avowal of our

principles and a straight forward policy, we can consistently act with all who act with us, and to Benton and his friends I would extend the right hand of fellowship as far as they place themselves on our ground." The very terms he employs— "frank," "straight forward," "consistently," "extend the right hand," "on our ground"—serve to describe the heroic Boone taking shape on canvas. When Bingham promises he will countenance no further "bending" of principle, "even should war be the result," straight-backed Boone, rifle in hand, seems to be the symbolic embodiment of such a declaration.[19]

Although explaining to Rollins that the Boone emigration was a subject he thought likely to be popular and thus earn money, the artist possessed even more compelling reasons, as we have seen, for wishing to celebrate the undeviating staunchness of that quintessential westerner Daniel Boone, who had in fact lived the last years of his life in Missouri. John Cawelti has pointed out that "Boone, a pivotal figure in many versions of the western myth, here appears as a highly civilized man, dressed in a costume that has buckskin fringes but otherwise is the height of gentlemanly fashion."[20] If Bingham's Boone looks more like a Whig gentleman than a rough and tumble wilderness explorer, perhaps Bingham, at some level or another of consciousness, was addressing himself to those Whig colleagues back home who had not embodied the probity he exalts here. "*This* Missourian possessed integrity!" the painting seems almost to shout.

The fact that Bingham opposed extending slavery by federal fiat and had grown sympathetic to Benton, a vociferous antislaver, does not mean that the artist himself rejected slavery. Rather, it means that during a period of American political history byzantine in its complexity, with alliances shifting backward and forward at a dizzying

rate, Bingham was a seeker of the political middle ground. His model in this was the Great Compromiser himself, Henry Clay.

Clay, a slaveholding Whig from Kentucky, had masterminded sectional compromise in one political crisis after another for the previous three decades. The architect of the Compromise of 1820, which saw Missouri admitted to the Union as a slave state in exchange for Maine's entrance as a free state, the seventy-three-year-old Clay devised the Compromise of 1850 as a final attempt to prevent secession. An enormously controversial package of measures that required concessions from both the North and the South, the bill entailed admitting California as a free state, ending slave trade within the District of Columbia, lifting restrictions on slavery in the territories, and enforcing laws that required the return of runaway slaves. It was this last provision, the so-called Fugitive Slave Act, that made northerners as angry about the compromise bill as were southerners for other reasons.

After considerable debate and backroom negotiations, Congress passed the measures into law in September 1850. The conciliatory nature of Bingham's Missouri resolutions had probably been inspired by Clay's omnibus bill, but what had succeeded, however tenuously, on Capitol Hill failed, as we have seen, in Missouri. Still—or perhaps all the more so—the Great Compromiser must have seemed to Bingham a genuine hero, a figure to emulate. The painter-politician's depiction of Boone may therefore have had something of Clay in it. Like Daniel Boone, Henry Clay had emigrated

from the Old South to the new land of Kentucky, settling there in 1797, two decades after Boone had opened the way. If Boone was the exemplary pioneer of the West, Clay was known to his contemporaries as the great statesman of the West: the Star of the West, he was often called.

In 1844 Bingham had been commissioned to paint political banners on behalf of Clay, who was then running for president. "On one," Bingham wrote to Rollins, "I shall give a full length portrait of Clay as the Statesman with his American System operating in the distance, on the other I shall represent him as the plain farmer of Ashland [Clay's Kentucky estate]—each of them will also have appropriate designs on the reverse side, and will be so suspended, as to be eisily [sic] borne by four men walking in the order of the procession." Responding to Rollins's request that he produce a similar two-sided banner of Clay for the delegation from Boone County, Bingham suggested depicting "old Daniel Boone himself engaged in one of his death struggles with an Indian, painted as large as life." He added, "It would make a picture that would take with the multitude, and also be in accordance with historical truth. It might be emblimatical [sic] also of the early state of the west, while on the other side I might paint a landscape with 'peaceful fields and lowing herds' indicative of [the] present advancement in civilization."[21]

Considering the readiness with which Bingham was prepared to substitute a banner of "old Daniel Boone" for one of "Old Hal" [Clay], it appears that long before painting *The Emigration of Boone* he had associated the one legendary westerner with

the other. Perhaps he even thought of Boone and Clay as bookends to the history of the civilizing of the West: Boone in the early days leading whites into the area and Clay at present bestowing on them the order of law. Bingham thought in similar terms when he painted *The Concealed Enemy* (1845, fig. 44) and *Fur Traders Descending the Missouri* as a pair, the first work showing the savage state of the West while its pendant depicts the initiation of commercial trade and hence, as Bingham would see it, civilization. Similarly the river paintings, starting with *Fur Traders*, constitute a sequential series representing the steady advancement of civilization in the West commensurate with the development and improvement of inland waterways, a major political theme, as we have seen, not only for the Missouri Whigs but for Clay, their national champion, shown here in John Neagle's romantic state portrait of 1843 (fig. 45).[22]

Prior to the apotheosis of Abraham Lincoln, Henry Clay was the American statesman most commonly referred to as "the great lawgiver." To the extent that the Daniel Boone of Bingham's painting is some sort of Moses leading the children of Israel through the Wilderness and into the Promised Land (a standard trope in speeches, sermons, and literature of the era), to that extent the painting suggests an equivalence not only between Boone and the Hebrew leader, but also between the biblical lawgiver and the celebrated American lawgiver whom Bingham so ardently admired. Bingham once described a political figure from the other party as being "as welcome to the citizens of the district [of Columbia] as was Moses to the Israelites of old."[23] How much more so, in his mind, must Clay have seemed one part Moses, another part Boone.

If the story of Exodus is the Old Testament's paradigm of righteous emigration, certainly the New

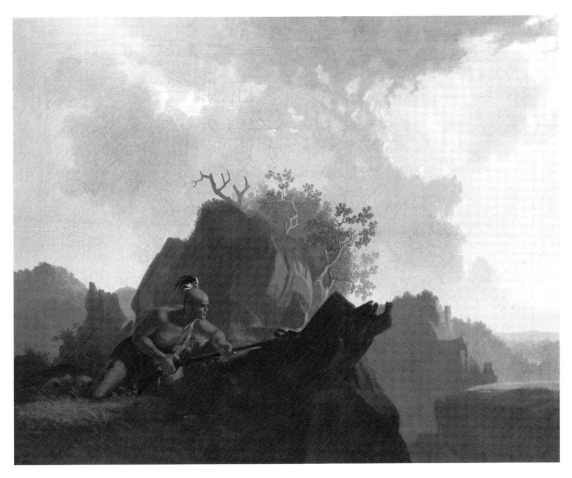

44. George Caleb Bingham, *Concealed Enemy*, 1845. Oil on canvas, 29¼ × 36½ in.
Stark Museum of Art, Orange, Texas.

Testament equivalent is the Flight into Egypt. The directions are reversed, of course, for Joseph and Mary seek refuge in the very land that their ancestors gladly departed. Nevertheless, in both instances travelers carrying all that they own have forsaken their homeland in hopes of finding refuge in a strange and faraway place (1423, fig. 46).

John Cawelti has written of *The Emigration of Boone*, "These are family groups. One of the central figures is a Madonna-like woman on a white horse led by a highly romanticized figure of Daniel Boone. Their composition evokes the traditional artistic symbolism of the Holy Family on the Flight into Egypt." As Dawn Glanz observes,

"Rebecca . . . appears as a Marianic figure. Seated on a white horse led by her husband, wearing a shawl draped over her head (an unusual headpiece for a frontier woman, and one which contrasts strikingly with the more typical bonnet worn by her daughter), Rebecca is so startlingly reminiscent of Mary in depictions of the Flight of the Holy Family into Egypt that the resemblance cannot be merely coincidental."[24]

Rebecca Boone figures into Bingham's painting as Mother Mary for several overlapping reasons. For the sake of clarity, we might analyze these separately under the categories of ideology, topicality, and personal biography. By ideology, I have

45. John Neagle, *Henry Clay*, 1843. Oil on canvas,
111¼ × 72½ in. Union League of Philadelphia.
Presented by Henry Pratt McKean.

in mind that aggregation of commonly held ideas of the period that scholars have recently taken to calling "republican motherhood" and "the cult of true womanhood." By topicality, I am referring to those migrations of families and communities to, within, and from the United States at the time Bingham was painting a historically earlier migration. And by personal biography, I am thinking of his feelings about his own mother—actually named Mary—who died the same month he began work on the painting.

The cult of motherhood is a familiar story. In recent years so many scholars have written about this phenomenon that it has become a commonplace of our assumptions about the era. As economically productive labor moved increasingly out of the home into the marketplace during the first half of the nineteenth century, middle-class American women ceased to be producers of household necessities and luxuries and became consumers instead. Their social function was thus redefined in the nation's accelerating transition from an agrarian economy to an urban theater of commodity relations. As women's materially nurturant function in the household diminished, their emotionally nurturant position increased. Devalued in their role as producers of saleable commodities, such women were vaunted all the more as producers of children: that is, as reproducers.[25]

Allied with this emotional investment of women into the psychic economies of their families (an investment that was there already, to be sure, but in a less venerated way) was the political rhetoric recently described in the phrase "republican motherhood." As identified by Linda Kerber, republican motherhood maintained that a woman's most important role within American democracy was not casting a ballot, a civic duty left to her husband, but rather bringing up male children to be

46. Gentile da Fabriano, *Flight into Egypt* (predella from *Adoration of the Magi*), 1423. Tempera on wood, 9⅞ × 34⅝ in. Uffizi Gallery, Florence (Photo: Marburg/Art Resource, New York).

virtuous citizens and female children to be virtuous wives, themselves future republican mothers. America could hardly be expected to maintain its historical destiny and produce selfless leaders unless upcoming generations were taken in hand by mothers who daily endowed their offspring with the love of liberty and virtue upon which, so it was agreed, the nation had been founded.[26]

Rebecca Boone, in this regard, appears the personification of republican motherhood. Her straight-ahead gaze, her erect form, her position at the head of the column of emigrants, and, above all, her weathered, middle-aged appearance make her seem considerably less a young virgin mother in flight with holy child than an embodiment of a national ideal of frontier motherhood. By no means the frail, simpering, delicate flower that many a viewer of today assumes constituted the middle-class Victorian notion of motherhood, Rebecca, as Bingham depicts her, is a pillar of strength. And yet, given her privileged (and sidesaddle) seat on the white horse, the way her husband takes the reins, and the heavenly blue cloak with which she is garbed, she is nevertheless marked with signifiers of femininity that set her off from the men around her.

Rebecca's prominence must be attributed to more than simply the embodiment of a prevailing ideology. At the time that Bingham conceived and produced the painting, the westward migration of families was a phenomenon of enormous topical concern. By featuring Rebecca and her daughter, Bingham directly addressed one of the great social facts of the era—and not merely a fact, but a problem, for in that terrific mass dispersal known as migration, women, who were considered the very embodiment of communal rooting and stability, were themselves becoming uprooted. Significantly in Bingham's rendering, neither Rebecca nor her daughter is shown with feet on the ground: in the context of True Womanhood, that would be a sign of ethereality, but in *this* context, it bespeaks social disconnection or dislocation.

Between 1841 and 1867, the year the transcontinental railroad was completed, some 350,000 North Americans emigrated along the Overland Trail to the Pacific coast, approximately 55,000 of these venturing forth in the peak year of 1850. Indeed, Bingham's Missouri River was the jumping-off place for most of the wagon trains, which usually departed from the new river settlements that were springing up between St. Joseph's, Mis-

souri, and Council Bluffs, Iowa. Although there were many instances of men traveling without families, especially during the Gold Rush years of 1849 and 1850, families normally constituted the basic social unit of the emigrant parties (fig. 47). "This migration was essentially a family phenomenon," historians of the West have observed. "The white family largely mediated the incorporation of the western territories into the American nation."[27]

Yet this act of mediation did not come easily, for the brutal rigors and deprivations of the six- to eight-month journey through the wilderness always threatened to destroy the family even as the family sought in turn to subdue the forces and environments arrayed against it. The men in the wagon parties were responsible for the actual physical transportation and protection of the emigrants and their goods, but the women were no less responsible for what might be called spiritual transportation and protection. That is, they were commonly entrusted with making sure that the emigrant families arrived at their final destination emotionally and morally intact. Such responsibilities weighed heavily. One mother, for example, worried in the pages of her trail diary about becoming inured to human suffering: "Not until . . . morning did we see that the camp-fire was on a grave—but it was not moved, I have mentioned our growing indifference, and can but think that [what] we are obliged to endure each day is robbing us of all sentiment—it is to be hoped we will not be *permanently changed*."[28]

Expected by others—and, perhaps more important, by themselves—to keep the psychological inner fires of their families burning just as steadily as the thrice-daily campfires (which in itself was no easy task, given shortages of fuel and excesses

47. Alma Walter Compton, "Joseph Henry Byington Family Near Calls Fort, Utah,"
c. 1870. Photograph. Western History Department, Denver Public Library.

of wind and rain), many wives and mothers continually faced despair. Livestock starved to death or dropped from exhaustion, children fell beneath wagon wheels, husbands succumbed to fever, and, less dramatically but no less grievously, perpetual hardship and tension eroded a woman's sense of worth and well-being.

Bingham's contemporaries were exceptionally well attuned to the saga of emigration to the Pacific because countless local communities throughout the States had been deserted, largely out of economic necessity, by sons or daughters or entire families moving west. Almost without exception, it was the men who made the decision to emigrate, the mothers and children who had little choice but to follow.[29] For many women, the thought of saying farewell, probably forever, to a familiar way of life, a network of friends, and the graves of parents and children was often devastating. The boldly confident, no-looking-back pioneer spirit that has long been celebrated in mythologies of the American past seems not to have characterized a great many of the pioneer women who doubted that the economic imperatives grabbing the attention of their husbands outweighed the emotional intangibles that these men were more ready than they to forsake.

As one emigrant recalled, "I would make a brave effort to be cheerful and patient until the camp work was done. Then starting out ahead of the team and my men folks, when I thought I had gone beyond hearing distance, I would throw myself down on the unfriendly desert and give way like a child to sobs and tears, wishing myself back home with my friends and chiding myself for consenting to take this wild goose chase."[30]

To look again at Rebecca in Bingham's painting, this time with such personal (but ubiquitously experienced) anguish of emigration in mind, is

to reconfigure the expression on her face not as the mark of iron-willed republican motherhood but rather as an acknowledgment of the almost inherent melancholy of migration, especially when viewed from a woman's point of view. Insofar as he wanted to promote the West, why would Bingham have wished to acknowledge rather than hide the harshness of emigration? Sometimes acknowledgment amounts to an especially effective form of concealment; what might be taken as the melancholy look in Rebecca's eyes makes her endeavor seem all the more inspiring. As one antebellum diarist remarked about her party crossing the Rockies, "When we are fairly on our way we have much the appearance of a large funeral procession." Although surely the trans-Allegheny migration of the Boone generation was not as entirely dislocating as the transcontinental migration of Bingham's contemporaries, still, migration was migration, and thus the appropriateness of Rebecca Boone's guise of mourning. In the literary passage that most likely served Bingham as the prototype for the work, Mrs. Boone is described as "a matronly woman, in weeds [mourning dress], and with a countenance of deep dejection." Her group as a whole "might almost have been mistaken for a funeral procession."[31]

And this is where Rebecca takes on an especially personal significance, considering that Bingham picked up his brush to paint *The Emigration of Boone* shortly after learning of the death of his mother. The painting is, so to speak, a funeral procession, an elegy for the departed. But the artist has transformed his deceased mother

from someone to be mourned into someone who mourns. Rebecca Boone, with the cloak over her head and the dolorous expression on her face, recalls a Renaissance pietà or perhaps the stoical mourner in America's first acclaimed history painting, Benjamin West's *Agrippina with the Ashes of Germanicus* (1768, fig. 48).

West's Agrippina, derived from veiled figures on classical friezes found on the Ara Pacis of Augustan Rome and various funeral steles, was meant as an embodiment of civic virtue and self-restraint.

Shown by West at the moment of her return to Italy with the remains of her husband, an assassinated hero of the Republic, Agrippina takes her place at the head of a processional line of mourners. This renowned neoclassical image was a standard eighteenth- and early nineteenth-century model of noble grief. During the Victorian period, however, sentimental conventions of mourning, in real life as well as in art, called for more expressive renderings of grief—more forthcomingly pious, less self-effacing—than was to be found in the model established by West.[32] Backward looking and respectful of the republican past, in keeping with the general Whig frame of mind, *Boone* is elegiac, like *Agrippina*, in its solemn treatment of its veiled "widow." But whereas West's painting is classical

48. Benjamin West, *Agrippina Landing at Brundisium with the Ashes of Germanicus*, 1768. Oil on canvas, 64½ × 94½ in. Yale University Art Gallery, New Haven, Connecticut. Gift of Louis M. Rabinowitz.

in imagery, Bingham's, as we have noted, draws heavily upon Christian art, and not only that which depicts the youthful Virgin on her flight into Egypt but also that which represents her in maturity mourning for her crucified son.

There is something historically odd about Bingham portraying Rebecca Boone in terms of a Madonna. The painting has the look not simply of Christian but of *Catholic* (or, more specifically, Italian Renaissance) art. Art-historically, there is nothing strange about this. After all, Bingham, mostly self-taught as an artist, always strove to make use of what he learned about form and composition from the Renaissance works he studied in reproduction. The pyramidal structure of the various "jolly flatboatmen" paintings are strictly derived from Raphael, as is the pyramidal unit in the forefront of *Boone*. But in the flatboat paintings the association with the Italian Renaissance is limited to form, whereas in *Boone* it is more direct, with veiled Rebecca Boone calling to mind any number of similarly veiled Madonnas.

The reason the Madonna imagery seems historically odd is not only because Bingham himself was a devout Baptist, and therefore theologically indisposed toward the worship of Mary, but because his social class, political party, and geographical location were all vehemently anti-Catholic during this period.

Anti-Catholicism had been a mainstay of American life from the era of the Pilgrim landings but at particular times it flared to unusual intensity, for example, in the aftermath of the French Revolution, when Roman Catholicism became associated in Protestant American minds with the bloody revolutionary purges (this despite the fact that the revolutionaries, espousing atheism, had assailed the church for its complicity with the ancien régime). During the Mexican War, typical propaganda portrayed the Latin enemy as an ignorant, cruel, and antidemocratic population subject to the bidding of the pope and his minions.

In 1827 there were more than thirty explicitly anti-Catholic magazines published in the United States. In 1834 a mob in Boston, incited by the antipapist preaching of Harriet and Catharine Beecher's brother Edward, attacked the Ursuline Convent on Mount Benedict and burned it to the ground. Ten years later a similar mob rampaging through the Irish districts of Philadelphia tore down churches and homes, and a slaughter resulted. The notorious *Awful Disclosures of the Hotel Dieu Nunnery of Montreal* (1835) by the pseudonymous Maria Monk purported to tell the true story of a beautiful Protestant woman abducted by Jesuit priests who raped nuns, murdered babies, and practiced ritual torture. Said to have sold twenty thousand copies within a few weeks and three hundred thousand in subsequent years, it may have been the best-selling book in American history prior to *Uncle Tom's Cabin*. *Six Months in a Convent* (1835) by "Rebecca Reed" was less replete with sex and sadism but nonetheless painted a picture of dire conspiracy behind convent walls. Not that all of the anti-Catholic literature was of such sensationalistic and dubious credentials; Lyman Beecher's *A Plea for the West* (1835) set forth a Whig agenda for restricting Catholic settlement of the West, and Samuel F. B. Morse, painter, professor at New York University, and inventor of the telegraph, strove with some urgency to prevent Catholic immigrants from becoming naturalized citizens lest they stuff ballot boxes with proxy votes from Rome.

Much anti-Catholicism was a symptom of anti-immigration sentiments directed most particularly at the Irish, who were pouring into the country at what seemed to nativists an alarming rate. Between 1820 and 1860, more than five million Irish-Catholics immigrated to the United States, initially because of land clearances and then devastating famine. Protestant America received this invasion of immigrants warily at best—offended, in the middle classes, by the allegedly flimsy morality of the Irish, and, in the working classes, by the newcomers' readiness to sell their labor well below the going rate.

Irish-Catholics generally affiliated with the Democratic party, causing Whig politicians and their supporters to become all the more incensed with what they considered to be the papalization of America. At the end of the 1840s, one particularly fanatic group of nativists, calling themselves The Sons of the Star Spangled Banner, vowed that their members, should they be interrogated under torture by papists, would simply respond, "I know nothing." By the early 1850s, the so-called Know-Nothings—also commonly referred to as Native Americans (!)—organized the American party, which fielded its own candidate in the presidential race of 1856 before amalgamating with the much stronger Republican party, which had been formed out of Whig coalitions only a couple of years earlier.

Irish immigration to Missouri was minimal at this time, but St. Louis was a magnet for German Catholic immigrants who flocked to America as a result of the uprisings of 1848. The city,

as its name indicates, had long been a haven for Catholics, having been founded by Jesuit missionaries and settled by French traders. But even here anti-Catholicism ran strong. The newspaper editor Elijah Parish Lovejoy, who moved to St. Louis from Maine to spread the word of his Protestant faith, enraged the local population as much with his hatred for the Catholic church as for chattel slavery, both of which institutions were deeply rooted in the area. Lovejoy's lynching at the hands of a mob has always been regarded as a martyrdom in the cause of abolition, but the viciousness of his anti-Catholicism may also have been to blame. "Think not that it is because I am an abolitionist that I am so persecuted," Lovejoy informed his St. Louis readers shortly before his death. "The true cause is the open and decided stand which [this] paper has taken against the encroachments of Popery." More explicitly, he confided in a letter to his brother, "There is a burning hatred on the part of the Popish priests and their minions, which would delight to quench itself in my blood."[33]

Although Bingham, based halfway across the state, never gave vent to such anti-Catholicism, his own county of Saline—predominantly Baptist in religious sentiment and agricultural in economy—was regularly arrayed in the legislature against the Catholic, immigrant, fledgling industrial metropolis of St. Louis located at the mouth of the Missouri. Hence the Marian imagery of the Boone painting seems altogether inappropriate, however appropriate its art-historical derivation. Perhaps the key to understanding what Bingham was doing by depicting Rebecca Boone as a Catholic Madonna is to alter the pronunciation of *appropriate*, transforming it into a verb instead of a modifier: "to annex or convert to one's own use" instead of "that which is suitable." In other words, Bingham was *appropriating* Catholic imagery for Protestant

purposes, invoking the Madonna as a way of de-Catholicizing and Protestantizing her, just as, at the same time, he Protestantized that most Jewish of Jews, Moses.[34]

Though *The Emigration of Boone* depicts internal immigration in the foundation days of the republic (c. 1775), it symbolically addresses immigration from abroad in its then-current phase, and in 1851 such immigration carried with it inescapably Catholic overtones. That Rebecca Boone wears raiment associated with the Catholic Madonna is, therefore, historically appropriate after all, for the painting draws its language, however transmogrified, from the world around it, and that world, notably the port of New York, where Bingham produced the work, was flooded with immigrant worshippers of the Catholic Madonna.

One can only wonder if the Madonna imagery was simply too much for Bingham's admirers and if this had something to do with the painting's failure to attract a buyer. The artist's dedication of the subsequent lithograph "To the Mothers and Daughters of the West" may have been a deliberate attempt to assure an ecumenical response to an image whose Catholicity (a term the nativist Morse used to describe the culture of the immigrants) was perhaps much greater than Bingham had intended.[35]

European Catholics migrating *to* the United States; California-bound homesteaders migrating *from* the United States: such was the migratory context of *Boone*. But both the historical period during which Bingham painted and the geographic region in which he was based were deeply marked by other internal and external migrations, namely, those of Mormons, African-Americans, and Native Americans.

In the 1830s, Bingham's frontier Missouri was briefly a haven for the persecuted Joseph Smith and his fellow adherents to the Church of Jesus

Christ of Latter-Day Saints. In short order, the large tracts of public land that these emigrants purchased as well as the homes and farms they built were confiscated by Gov. L. W. Boggs, who declared that Mormons should "be exterminated, or driven from the state." And by the end of the decade they were driven from the state, but not before the massacre of Haun's Mill left eighteen unarmed Mormons dead. Taking refuge in neighboring Illinois only later to be expelled from there as well, the Mormons, now under the leadership of Brigham Young, undertook their epic migration away from the United States to the desert wilderness of Utah, arriving in that distant promised land in 1847. Brigham Young may not have been a latter-day Daniel Boone, but Bingham's painting of the earlier pioneer leader, while certainly not intended as a timely allusion to the much-publicized Mormon expedition, belongs nonetheless to the same conceptual universe.

While Bingham worked on *Boone* in the first half of 1851, *Uncle Tom's Cabin* began appearing in magazine serialization. Harriet Beecher Stowe's popular novel, written in outraged response to the Fugitive Slave Act (the most controversial rider to Henry Clay's Compromise of 1850), singled out the forced disruption of black family life as the single greatest crime of the slave system. The book is filled with instances of involuntary migration, as family after family is pried apart by economic necessities or even the whims of the slaveholders. In actuality, no migration has ever been entirely voluntary—populations are driven from their homelands by war, famine, or destitution—but even in

these instances there may be an element of choice that was wholly denied to the American slaves.

Something of the difference between voluntary and involuntary migration can be conveyed by contrasting *The Emigration of Boone* with *Slave Market in Richmond, Virginia* (1852–53, fig. 49) by Eyre Crowe, a young English artist who accompanied the novelist William Thackeray on his lecture tour through the South. Crowe, avowedly sympathetic to abolition, based his painting upon a pencil study he made while observing a group of slaves at auction. Sweetly idealizing in its treatment, even to the point of supplying the women with perfectly pressed white smocks, the painting nevertheless shows a people legally deprived of the self-determination and geographical mobility

of the Boone contingent. Bingham's Americans have somewhere to go; these people do not—except perhaps "down river," through no choice of their own. On the other hand, escaped slaves, those who instead went "cross the river," did exhibit self-determination. Like the white emigrants Bingham idealizes, these black refugees were voyagers beset by terrible hardship, pilgrims who might never again look upon the loved ones they left behind. But unlike Bingham's emigrants, they were often compelled by circumstances to travel at night, alone, and in violation of the law—a situation described some years later by Theodor Kaufmann's *On to Liberty* (1867, fig. 50), which shows contraband slaves of the South hurrying to the safety of a Yankee military encampment.

Certainly *Boone* is no more about the forced migration of slaves than it is about the migration of Mormons or of European Catholics. Yet here again the social context is such that this hybrid history and landscape painting depicting a pilgrimage

49. Eyre Crowe, *Slave Market in Richmond, Virginia*, 1852–53. Oil on canvas,
20¾ × 31½ in. Mrs. H. John Heinz III, Washington, D.C.

through the wilderness was more timely in its references than the artist or his audience was likely to realize.

Finally, there is one other concurrent migration to mention, that of the American Indians. As a nomadic people, the Indians, in all their diversity of nations, had been migrating over the surface of the continent for centuries before and after the sixteenth-century invasion of North America by European explorers, settlers, and profiteers. In the nineteenth-century, however, the various tribal migrations resulted less from the rhythms of nature than from the pressures created by an ever-mounting territorial usurpation, sanctioned at times by peaceful trade of goods for land but always backed by military firepower. Thomas Jefferson had once predicted of the American Indians, "We shall be obliged to drive them, with the beasts of the forest into the Stony mountains."[36] Now, at the outset of the 1830s, President Jackson proposed to give the tribes residing within the United

States a fair choice: either assimilate fully ("become merged in the mass of our population") or leave the United States proper for territorial lands west of the Mississippi.[37]

"This emigration should be voluntary," Jackson loftily insisted, "for it would be as cruel as unjust to compel the aborigines to abandon the graves of their fathers and seek a home in a distant land." And yet such a migration would not be a uniquely terrible ordeal, for Americans, according to the president, possessed a long and valued tradition of being uprooted from their ancestral homelands. The picture Jackson paints is akin to Bingham's *Boone:* "To better their condition in an unknown land our forefathers left all that was dear in earthly objects. Our children by thousands yearly leave

50. Theodor Kaufmann, *On to Liberty*, 1867. Oil on canvas, 36 × 56 in. Metropolitan Museum of Art, New York. Gift of Erving and Joyce Wolf.

the land of their birth to seek new homes in distant regions." Despite the emotional pain that goes along with migration, Americans are happy, the president claims, to venture forth because of the dazzling opportunities that lie before them.

He concludes, therefore, that most Americans would be delighted to migrate west on the generous terms provided for the Indians of the eastern United States: "How many thousands of our own people would gladly embrace the opportunity of removing to the West on such conditions! If the offers made to the Indians were extended to them, they would be hailed with gratitude and joy." When the Cherokee nation of Georgia, refusing to hail Jackson's offers with gratitude and joy, won a ruling from Supreme Court Justice John Marshall declaring the federal removal order unconstitutional, the president, not known as Old Hickory for nothing, was said to have replied, "John Marshall has made his decision: *now let him enforce it!*"

Lasting through much of the 1830s, the resulting exodus was known as the Trail of Tears (or Trails of Tears, for actually there were a number of forced tribal migrations, not just one). Cherokees, Choctaws, Chickasaws, Creeks, and Seminoles succumbed in large numbers to untreated disease, starvation, deprivation of clothes and shelter, and continual harassment, physical as well as verbal, from whites through whose territory—including Bingham's Missouri—they passed. Four thousand of the Georgia Cherokees, nearly a quarter of their entire number, died before reaching their new "homeland" in Oklahoma. And the situation did not improve once all the eastern tribes had been

removed to the West, for before long an increasing mass of white homesteaders, driven westward by economic need, began laying claim to this land as well. As a result, the Indians were again forced even further west.

Their plight was exacerbated with the gold rush of 1849, for the floodtide of white emigration had the effect of driving Pacific coast Indians *eastward*, thus heightening hostilities not only between Indians and whites but also between one tribe and another. The supply of available food on the plains was already scarce and now could not sustain the suddenly increased demands placed upon it. Massacre and countermassacre became a new way of life. One pioneer woman, sickened by the carnage of an Indian raid, confessed to her diary, "I wish all of the Indians in Christendom were exterminated."[38]

In an earlier section I noted the significant omission of slaves from Bingham's depiction of the Boone party. Another significant omission is of Indians, for not only was the historical Boone frequently beset by hostile war parties during his migration to Kentucky, but the Boone of nineteenth-century lore and legend was virtually unthinkable without Indian combatants by his side. Andrew Jackson was regarded as a great Indian-fighter, but no one was considered a more lethal Indian-killer than Daniel Boone.

Whether or not Boone was also America's greatest Indian hater is another matter. The term *Indian hater* was introduced by the western writer James Hall in a short story, "Indian Hating," published in 1833, but it was Herman Melville who elaborated on the theme in a chapter of *The Confidence Man* (1857) chillingly entitled "The Metaphysics of Indian-Hating."

As explained by a riverboat traveler in Melville's novel, an Indian-hater is a backwoodsman trained

from childhood not merely to distrust but to despise his natural adversary, the Indian, with whom he is inevitably engaged in territorial (that is, economic) as well as moral contest. "The instinct of antipathy against an Indian grows in the backwoodsman with the sense of good and bad, right and wrong. In one breath he learns that a brother is to be loved, and an Indian to be hated." Yet the perfection of Indian hating takes more than mere nurture; it requires the massacre of the backwoodsman's dearest loved ones to turn him into a true Indian-hater. Then all hell will break loose, for he will devote his life to vengeance, not merely once but repeatedly, with the extinction of an entire race his goal. It will not matter to him whether the Indians he pursues are good or bad, benevolent or benign. According to Melville's traveler, the archetypal Indian-hater was none other than Boone himself: " 'Beware the Indian, kind or unkind,' said Daniel Boone, who lost his sons by them."[39]

Most nineteenth-century versions of Boone or of his fictional avatars (such as Cooper's Leatherstocking) stressed that his prolific killing was required for the protection of women and children and the advancement of civilization. Bingham said as much in his offer to paint the campaign banner that was to show on one side "old Daniel Boone himself engaged in one of his death struggles with an Indian" and, on the reverse, a pastoral landscape "indicative of [the] present advancement in civilization." In the words of Timothy Flint's best-selling *Biographical Memoir of Daniel Boone* (1833), "The nature of [Boone] was as gentle and affectionate as it was firm and persevering" and yet "in the order of things . . . it was necessary, that men like [him] should precede in the wilderness, to prepare the way for the multitudes who would soon follow."[40]

Nowhere is the justification for Boone's violence

against Indians more graphically depicted than in *Rescue* (1837–53, fig. 51), Horatio Greenough's monumental statuary group commissioned by Congress and prominently installed on the east steps of the Capitol for a century, until it was removed in 1958 as an embarrassment to some, an affront to others. Here a superhuman pioneer, commonly thought of as Boone himself, wrests the tomahawk from an all-but-naked savage who is about to brain the Caucasian mother and child at his feet. The Indian warrior is as helpless in the grip of the backwoodsman as that baby is in its mother's arms, but whereas she is literally bent in protection, the Boone figure is bent on destruction: the Indian brave stands no chance and does not, Greenough seems to imply, deserve one, either.[41]

Nearing the end of his account of the Indian wars in frontier Kentucky—a place commonly referred to by the settlers as "the dark and bloody ground"—Flint takes a moment to justify to his genteel readers the misdeeds of the backwoodsmen: "While their barbarity and horror chill the blood, they show us what sort of men the first settlers of the country were, and what scenes they had to witness, and what events to meet, before they prepared for us our present peace and abundance."[42] The Boone of Flint and Greenough kills Indians not out of hate but responsibility, and the Boone of Bingham does not kill at all, merely guides, his buckskins unstained by blood, his rifle at rest on his shoulder. This is the Daniel Boone of liberal consensus, the Disney Boone, we might say, a man driven to do what he has to do not by ugly, primitive hate, but by a shining impulse toward liberty for all (of his own race).

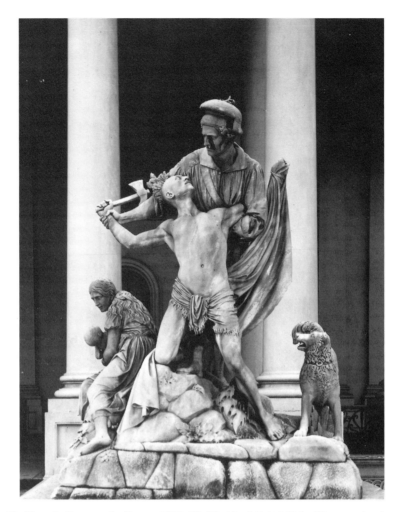

51. Horatio Greenough, *Rescue*, 1837–53. Marble, 141 × 122 in. Photograph taken before 1920, showing the work in situ at the east facade of the U.S. Capitol. In storage since 1958 (Photo: Library of Congress).

Melville—naturally, it would be Melville—points to the dark and dirty underside of this story: "Indian-hating still exists; and, no doubt, will continue to exist, so long as Indians do." Moreover, the Indian-hater's "feeling against Indians, to be taken aright, must be considered as being not so much on his own account as on others', or jointly on both accounts."[43] If Boone is the advancing civilization's guardian angel, the Indian-hater is its avenging angel. White civilization can no more do without the one than the other, although it prefers to venerate the one while disavowing the other.

A demonic figure himself, the Indian-hater, by his very existence, so cruelly, unbearably twisted, proves that the Indians must be demons after all, beyond redemption. The Indian-hater's value to white society has less to do with his prowess at destroying Indians than with his own monstrosity, which, so far as it was created by the natives, demonstrates that they need to be destroyed. In a manner of speaking, Indian Hating was the theory, Indian Removal the practice.

All of this, of course, is repressed in Bingham's *Boone*, certainly as well concealed as Indians

themselves were allegedly concealed whenever they chose to be. Bingham's *The Concealed Enemy* (see fig. 44) shows an Indian brave, probably an Osage, crouched with his rifle upon a rocky ledge while far below stand two unsuspecting figures who are thereby completely vulnerable to his gaze. He is concealed from *them*, that is, but not from us. The best concealed-Indian painting of all is Cole's *Schroon Mountain* (1838, fig. 52), in which three braves in the foreground are so well camouflaged by the autumn foliage that not only the distant party in the canoe on the lake is unaware of their presence but so too are most art historians who have written about the work.[44] With *Boone*, the concealment works the other way: what is concealed is not the Indian but the Indian hating. This is not to say that Bingham himself was an Indian-hater but rather that his painting effaces the one as-

pect of Boone that nineteenth-century Americans most commonly associated with him, his prowess at killing Indians.

Richard Drinnon points out that it was common to conceive of the American wilderness as empty or unpeopled until the arrival of whites, as though the many Indians who inhabited the forests were not people or humans. Drinnon views this as an ideological sleight of hand permitting genocidal behavior that would otherwise have appeared troublingly inhuman. One might argue that Bingham's omission of Indians from his depiction of a wilderness landscape that they actually occupied

52. Thomas Cole, *Schroon Mountain, Adirondacks*, 1838. Oil on canvas, 39⅜ × 63 in. Cleveland Museum of Art. Hinman B. Hurlbut Collection.

in great density at the time Boone passed through was a liberal gesture, an avoidance of having to depict, or even suggest, racial violence. Following Drinnon, however, one might wonder if the omission constitutes on a more subtle, epistemological level its own racial violence: racial erasure. Indian hating, that is, can take the passive form of ignoring Indians, pretending they are not or were not there. It is certainly a different, but not unrelated, manner of willing them out of existence.[45]

From this point of view, both *Schroon Mountain* and *The Emigration of Boone* put forth implicit denials of Indian humanity, for in the one painting their virtual concealment serves to characterize them as sneaky and treacherous, snakes in the grass, while in the other their absence implies either that they were never there or that they are lurking in the shadows, just off-canvas, ready to attack (and as such are even more treacherous than Jews and Art-Union managers).[46]

In Bingham's era the most provocative depiction of Indian hating was Robert M. Bird's *Nick of the Woods*, published in 1837 but thereafter frequently reprinted and theatrically performed as well as translated into numerous European languages. A contemporary English critic of the book was the first of many to claim that the author's unrelentingly vicious portrayal of Indians was "coloured by national antipathy, and by a desire to justify the encroachments of his countrymen upon the persecuted natives."[47]

Set in the dark and bloody ground of Boone's Kentucky, the novel concerns a mysterious, perhaps supernatural avenger who mutilates so-called savages while they sleep. The backwoodsmen refer to this diabolical figure as Nick of the Woods, while the terrified Shawnee call him the Jibbenainosay. The Indians may be masters of concealment, but Nick of the Woods consistently beats them at their own game. As it turns out, the secret to his success is that the hideous killer is none other than an apparently harmless, somewhat looney Quaker pacifist by the name of Nathan Slaughter (Boone too was the son of Quakers). Well known even among the Indians for his opposition to violence, Nathan generally comes and goes without arousing suspicion. But the virile Kentucky backwoodsmen scorn him for what they consider his sissified manner. That his actual last name happens to be Slaughter strikes them as a good joke. Tauntingly they call him Bloody Nathan, having no idea of their accuracy.

Hence, while the frontiersmen are the Indian-fighters, it is the supposed man of peace and thus the representative of Christian civilization who is the true Indian-hater: the Jibbenainosay always "autographs" his victims by carving a cross into their flesh.[48] Nathan's foil in the novel is an amusingly loudmouthed horse thief named Ralph Stackpole. Roaring Ralph, based on Mike Fink, the comic (or, if you will, viciously racist) folk character then very much in vogue, fights the Indians when he must but prefers to swindle them instead. An early instance of antiauthoritarian Southwestern regionalist humor ("My name's Ralph Stackpole, and I'm a ring-tailed squealer!"), crude in behavior and even cruder in speech, Ralph is in a variety of ways the antithesis of Quaker Nathan and the book's other representatives of social order. Yet, in the last analysis, *he* is ineffectual at systematically destroying Indians, *they* are not.[49]

The epilogue to the novel relates that Ralph eventually abandons oversettled Kentucky for fron-

tier further west, becoming, like Mike Fink, a boatman on the Mississippi—only a step or two removed, as it were, from Bingham's jolly flatboatmen. Nathan, on the other hand, disappears into the woods and is never seen or heard from again, his blood lust against the Indians finally satiated or at least embarrassingly inconvenient in a now-civilized territory. Indian-haters outlive their usefulness. John Ford made this point strikingly in the celebrated final shot of his film *The Searchers* (1956) when Ethan, the Indian-hater played by John Wayne, is seen hesitating on the threshold of a pioneer homestead, only to turn away at last to wander off into the desert. The film ends as the door swings shut, definitively closing us, the civilized viewers, within and the Indian-hater forever without.

From Bingham and Melville's time to Ford's and our own, the appeal of the backwoodsman has been his aloofness from society, his nonconformity, his (to borrow a phrase) rugged individualism. He may be in the world of settlers but never truly of it: "The tide of emigration, let it roll as it will, never overwhelms the backwoodsman into itself," remarks Melville's riverboat traveler; "he rides upon advance, as the Polynesian upon the comb of the surf." How buoyant, how self-confident this aquatic image; how unlike that of Cole's *Manhood*, where self-reliance portends the wreck of the self, salvageable only through intercession from above. The backwoodsman "is self-willed; being one who less hearkens to what others may say about things, than looks for himself. . . . He must depend upon himself; he must continually look to himself. Hence [his] self-reliance, to the degree of standing by his own judgment, though it stand alone."[50]

The passage invokes Emerson, hardly a backwoodsman but, like Thoreau, a theoretician of self-reliance ("self-reliance is the theory," one is

tempted to say, and despite what Emerson might otherwise have wished, "laissez-faire individualism the practice"). The Sage of Concord sneers at those who are not self-reliant: "Society is a joint-stock company, in which the members agree, for the better securing of his bread to each shareholder, to surrender the liberty and culture of the eater. The virtue in most request is conformity. Self-reliance is its aversion." He utters his edicts like thunderclaps: "Whoso would be a man must be a nonconformist"; "Nothing is at last sacred but the integrity of your own mind"; "Trust thyself: every heart vibrates to that iron string." What entrepreneurial capitalist could not bask in words such as these?[51]

Melville, of course, is not so sanguine about the values of self-reliance, entrepreneurial or otherwise. Consider Ahab. Consider the Indian-haters. Self-reliance might seem a lot more honorable—more manly—than conformist reliance upon the joint-stock company of society, but once you have set yourself free of social incorporation, how do you keep from drifting further and further into your own monomania?

In effect, Bingham's *Boone* asks the same question. Or, if not asks the question, at least poses an alternative to self-reliance. Bingham anchors his somewhat stodgy, middle-aged, middle-class backwoodsman within the pyramidal solidity of the figure group. This Boone goes nowhere without his community; compositionally, it rests upon his shoulders like a backpack. In this regard the painting is both anti-Emersonian and anti-Jacksonian: the advance of civilization depends not upon

53. Horatio Greenough, *George Washington*, 1832–41.
Marble, 136 × 102 in. National Museum of American Art,
Smithsonian Institution. Transfer from the U.S. Capitol.

self-reliance but group-reliance, not laissez-faire individualism but strict, hierarchically ordered "collective individualism." Pictorially it is an embodiment of the conservative Whig philosophy Bingham so lovingly championed.

The difference between Bingham's socially responsible pioneer and the Jacksonian-era's self-reliant superman can be seen by comparing Boone to Horatio Greenough's *George Washington* (1832–41, fig. 53), a massive statue installed in the Capitol Rotunda in 1841. What Greenough sculpted was not Washington as statesman or general but Washington as megahero, supersized, naked to the waist, pectorals bulging, abdominals rippling, a scowling countenance indicating an unwillingness to brook disobedience or dissent. Greenough's Father of the Country is a stern Olympian whereas Bingham's Father of the West is a grim gentleman of the people, a leader but not a ruler.

Contemporary viewers ridiculed Greenough's Washington for the nakedness of his body, but his body was not half as naked as his aggression. This was a Washington inspired by Greek colossi, Roman imperial sculpture, and French neoclassical deifications of Napoleon (Vanderlyn's *Marius* was probably also a source). It hero-worships the man of might, making him into a demigod—which was precisely the charge frequently leveled by Whigs against Democrats for turning the populist Andrew Jackson into tyrannical King Andrew, as his opponents called him. Attacking the "imperial presidency" some years after Jackson had retired, they described his administration in terms reminiscent of Greenough's *Washington:* "General Jackson's will was the *law* of his party . . . a party formed around him *personally* as a nucleus, centre, and source of influence. . . . The head was *monarch* of the party, *sole and absolute.*[52]

In the political lore of the time, the great anti-type to Jackson was Clay. Both were westerners (Clay, like Boone, hailed from Kentucky, Jackson from Tennessee) and both epitomized the self-reliant, self-made man.[53] But there the similarities ended. When Clay's maneuverings cost Jackson the election of 1824, the two thereafter became marked as both personal and ideological enemies, and the rival factions that centered around them became formalized as the two great adversarial parties of the era, the Whigs and the Democrats. As described above, the cornerstone of the Whig philosophy was the American system, Clay's program of hands-on government support of business enterprise: a protective tariff on behalf of domestic manufacturing; a national bank to finance economic expansion; and the federally funded construction of roads and waterways to ensure the transport of commerce from one section of the country to another. This system of government intervention represented everything Jackson distrusted and loathed. He viewed it as a conspiracy of the elite economic classes to deprive the popular classes of their autonomy, to compel their subservience, their dependence: in short, to undermine their self-reliance.

It was not only in political philosophy that Jackson and Clay were opposites, but also in political style. Jackson was the Great Individualist of the White House: rather than turn to official advisors for his administrative policy, he relied upon a small, private coterie (the Kitchen Cabinet), and his contempt for the checks and balances offered by the other branches of the government was legendary ("John Marshall has made his decision: *now let him enforce it!*"). Clay, on the other hand, was the Great Compromiser, time and again demonstrating his adaptability and capacity for

deal making. Jackson loathed the middle ground, but to Clay it was the place from which social well-being derived. In all things, Jackson symbolized self-sufficiency and Clay mutual dependency.

Whatever else Bingham's *Boone* may be, it surely is nothing less, as we have already noted, than a metaphoric tribute to the Star of the West, the aged, soon-to-die Clay, who had just put into place the capstone of his long career, the Compromise of 1850. The painting is a testament to mutual dependency (Boone not on his own but in the thick of his community) and to the heroicism of sticking to the middle of the road (Boone occupies the precise center of the composition). The painting embodies Clay's creed of compromise in the interest of orderly progress. It bespeaks a notion of peaceful expansion by means of an American *system* rather than pell-mell, slapdash laissez-faire individualism.

In this regard, *Boone* might be contrasted with a much more thrilling work, Charles Deas's *The Death Struggle* (1845, fig. 54). Deas was a St. Louis genre painter who made a career of selling bloodcurdling depictions of the West to eager audiences back east. In *The Death Struggle*, a bearded, red-shirted mountain man on a white pony is twisted in combat with a naked Indian who has thrown his arms around his adversary's waist. Both men, along with their mounts, are captured at the moment of careening off a mountain precipice into the great abyss. No compromise here.

With no ground, middle or otherwise, beneath their feet, the horses snort in wild-eyed terror. The

54. Charles Deas, *Death Struggle*, 1845. Oil on canvas, 30 × 25 in.
Shelburne Museum, Shelburne, Vermont.

brave, a dagger clenched in his fist, grimaces as he peers upward at the trapper with whom he death-dances toward oblivion. From the distance, a second brave looks on, half-concealed by the shadowy foliage. The mountain man, his eyes frozen in disbelief or the shock of comprehension, clutches unavailingly at the limb of a tree that itself appears to be exploding out of the ground, as though the entire earth is coming unhinged. With his other hand, this paradigmatically self-reliant representative of Jacksonian free enterprise clutches on his lap a weasel or mink that tries frantically to escape its leg-trap. The Indian hangs onto the white man, who hangs onto his source of income, which in turn is being hung onto by the leg clamp; arm crosses arm, limb clutches limb, eyes flare, hooves flash, man and nature, good, evil, and indifference, all go down together into the apocalyptic void.

Sensationalistic in its every dimension, pure melodramatic excess, *The Death Struggle* is the opposite of *Boone* not only in tone but also in its metaphorical conception of modern-day America. A few years after painting this work, Deas suffered a nervous collapse and was institutionalized for insanity until his death in 1867. *The Death Struggle* presents Indian fighting as an allegory of the struggle-for-survival in general and depicts economic self-reliance as never more than one precarious step removed from self-destruction.[54]

"Be sure you're right—then go ahead" was the famous self-reliance motto of David Crockett, bear-killer, politician, raconteur, and the fourth of the era's great western heroes (along with Boone, Jackson, and Clay). Born in Tennessee in 1786, two years before the twenty-one-year-old Jackson migrated there, Crockett served under Old Hickory in the Creek Wars of 1813–14. Elected to Con-

gress as a Democrat, Crockett was closely allied with Jackson until he abruptly switched sides, joining the anti-Jackson Whigs. In a ghostwritten autobiography, the new darling of the Whig propagandizers boasted of his independence from his former leader:

I let the people know . . . I wouldn't take a collar around my neck with the letters engraved on it,

MY DOG
ANDREW JACKSON. [55]

In this new guise as an anti-Jacksonian, Crockett served the Whigs well, but he himself suffered from political counterattack. Defeated in his bid for reelection, he abandoned his family for Texas, where in 1836 he met his fate at the Alamo and instantly secured the legendary status he holds to this day.

From 1835 (the year before his death) to 1850, Crockett was the protagonist of a series of independently published, anonymously written comic almanacs that originated both in the West (Nashville) and in the East (Boston, New York, Philadelphia, and Baltimore). Rabelaisian in excess (and, like Mike Fink, clearly a model for *Nick of the Woods*' "ring-tailed squealer," Ralph Stackpole), this Crockett—Davy rather than David—was an outrageous satirical figure who was superhumanly endowed or at least so claimed of himself: "I can outlook a panther and outstare a flash of lightning; tote a steamboat on my back and play at rough and

55. *An Unexpected Ride.*
Cover of *The Crockett Almanac 1839.*
Saint Louis Mercantile Library Association.

tumble with a lion. . . . I can walk like an ox, run like a fox, swim like an eel, yell like an Indian, fight like a devil, and spout like an earthquake, make love like a mad bull, and swallow a nigger whole without chocking if you butter his head and pin his ears back." Shown, for example, on the cover of an almanac from 1839 (fig. 55) riding backward on the horns of an elk as it rampages through the woods, Davy appears a mite concerned, but unlike the feckless trapper of Deas's *Death Struggle* he has nothing to worry about in the end because no force, natural or otherwise, can overtake him for long.[56]

As Carroll Smith-Rosenberg has argued, the widely read Crockett almanacs served a specific ideological function in Jacksonian America. They provided a seductively antiauthoritarian discourse through which young working-class men, cut off from their traditional rural communities as they sought jobs in the burgeoning metropolises, experienced in fantasy a fearlessness, nonconformity, and empowerment that was denied them in every other aspect of their lives. The mythical Crockett reveled in violence, obscenity, sexuality, and dirt—everything that, in embracing middle-class norms, the self-made man of the era was expected to renounce.

According to Smith-Rosenberg, "The Crockett myth flourished during the very years when the bourgeoisie was struggling to legitimize itself as the country's dominant class and to establish itself as socially, as well as economically, distinct from and superior to the new working class." The Crockett of the almanacs, "dirty, drunken, and sexual," offered an imaginary alternative to the self-renunciation tirelessly advocated in the religious tracts and conduct literature of the time: "Outside class boundaries and the proprieties of dressing and dining, elaborately violating the

grammatical proprieties so dear to the bourgeois heart, Crockett denied the naturalness, the desirability, and the inevitability of bourgeois values and class distinctions."[57]

Like Boone, as he was mythologized during this period, Crockett was a white-skinned version of Rousseau's natural man, an embodiment of instinct and nature. But whereas the Boone of Timothy Flint and, later, George Bingham served as a mediator between culture and nature, civilization and wilderness, the Crockett of the almanacs scoffed at culture and treated civilization as a joke. Bingham's Boone is immaculate, whereas the Crockett described first by the campaign tracts and then by the almanacs is almost invariably spattered with blood, covered with mud, smelly, unshaven, and preternaturally loud. And he likes it that way, too: "I'm the same David Crockett, fresh from the backwoods, half horse, half alligator, a little touched with the snapping turtle—can wade the Mississippi, leap the Ohio, ride upon a streak of lightning, and slip without a scratch down a honey locust."[58]

The anthropologist Mary Douglas has argued that every society reveals itself in its pollution taboos and purification rituals; the line between clean and dirty or pure and impure defines in any given case social priorities, acceptabilities, and distributions of power.[59] Bingham's squeaky clean Boone privileges a bourgeois view of society, of class order, that dirty Davy gleefully drags through the mud. Yet, paradoxically, the Crockett tales sustain rather than subvert hierarchical distinctions. By throwing the borderline between purity and impurity into greater relief, Crockett's myth functioned, perhaps even more effectively than Boone's, to underscore the nation's binary class system (upper/under; washed/unwashed; literate/illiterate). In so doing, according

to Smith-Rosenberg, it actually promoted adherence to dominant values by making alternatives to them seem either superhumanly unattainable or comically ridiculous, which is to say, vulnerable to ridicule.

For Bingham, purity and dirt had their distinctly political connotations. Let us look again at what he wrote to Rollins after he had been swindled out of office by the Democrats ("Locofocos") in the state legislature. The complete passage reads,

> If when you see me again you should not find me that pattern of purity which you have hitherto taken me to be, let the fact that I have been for the last four months full waist deep in Locofocoism plead something in my behalf. An Angel could scarcely pass through what I have experienced without being contaminated. *God help poor human nature.* As soon as I get through with this affair, and its consequences, I intend to strip off my clothes and bury them, scour my body all over with sand and water, put on a clean suit, and keep out of the mire of politics *forever.*

Despite this vow to stay clear of "the mire of politics *forever,*" Bingham soon after returned to politics, proclaiming in another letter, "I think we will either conquer in the next campaign *or split our breeches*" (emphasis his). Bingham's Boone, well tailored in his buckskins, is in no danger of splitting his breeches. Recall that in the same letter in which the artist describes his new painting he denounces both the "gross," Jew-like Art-

Union managers and the dirty deal-making, side-switching politicians back home. Scrambling up to a Boone-like moral plane, he declares: "With a frank avowal of our principles and a straight forward policy, we can consistently act with all who act with us, and to Benton and his friends I would extend the right hand of fellowship as far às they place themselves upon our ground." Crockett, the real-life politico who shifted parties at his own convenience, would doubtlessly have scoffed at such a declaration and tossed out instead his all-purpose "Be sure you're right—then go ahead." And certainly the Crockett of the almanacs would hardly have offered his right hand in fellowship to a former adversary when he could have "snapped at his nose and seized it between my teeth."[60]

The physicality of the language in Bingham's letter or, more specifically, its continual invocation of the physical body, its positions, conditions, and accouterments ("full waist deep," "contaminated," "strip off my clothes," "keep out of the mire," "split our breeches," "straight forward," "extend the right hand," "place themselves upon our ground") shows that he was by no means the body-denying prude that an initial contrast with the burping, belching, nose-biting Crockett might indicate. The artist's carefully observed rendering of bodies is his trademark: one thinks of the boy leaning lightly over the cargo in *Fur Traders* or the panoply of physical positions in *The County Election*. Surely a mark against *The Emigration of Boone* in terms of audience appeal was that, save for the switch-cracker in back and the boyish scout in front, all the figures within it, particularly Boone

himself, were ramrod stiff, "straight forward" to a fault.

Of course the meaning of body language depends very much, if not entirely, upon social context. Thus, to compare two Bingham paintings of 1850, *The Wood Boat* (fig. 56) and *The Squatters* (fig. 57), almost identical figural postures produce different connotations because of the settings in which they appear. In *The Wood Boat*, because the figures are shown at rest on the banks of the river as they relax from their labor, they seem friendly, and the viewer is not made to feel unwelcome, whereas *The Squatters*, by its very title and subject, suggests that in this situation these postures do not bespeak welcome. Depending upon their own class and party affiliations, viewers of the time would have come to Bingham's picture of poor, unentitled land-occupiers with an already formed image of the attractiveness or unattractiveness of the so-called squatter class.[61]

Even the word itself, *squatter*, has bodily connotations: squatters squat, which means not only "settling on unoccupied land without right or title" but also "crouch or cower close to the ground, as an animal." We do know, in fact, from Bingham's correspondence that he disapproved of squatters, considering them unwashed backwoods louts who in effect steal public property by setting up their dismal shacks on the land and then calling it their own. With this in mind, as well as all else we have learned about the artist's devotion to Whig principles of property and his disdain for Locofoco radicalism (which insisted vigorously on the land reform Homestead Bill that Bingham adamantly opposed), we are bound to look at the figures in *The Squatters* differently from those in *The Wood Boat*, despite their postural similarity. The old man with the big stick glowers from beneath the brim of his hat, staring in a mean, indignant manner as

sees shining in the sudden light of the thicket belongs to young Rebecca Bryan, who had been wandering through the woods alone and is spared certain death thanks only to the marksman's internal "palpitation" warning him to lower his rifle: "Both were young, beautiful, and at the period when the affections exercise their most energetic influence. . . . The young hunter felt that the eyes of the *deer* had *shined* his bosom. . . . He was incurably wounded by her, whose eyes he had *shined*."[66]

But the Daniel and Rebecca that Bingham portrays are no longer young, and his painting about them could not be more aseptic and asexual, even with all its phallicly bristling rifles, axes, and whips. The middle-aged Boones may glow with purpose but they do not *shine*. Neither does their daughter nor any of the other figures in the tableau. Aside from the lightning-split trees and gloomy skies, there is little evidence here of libidinal energy frantic to be released, as with Crockett and his stallion, or of tremors of impending sexual danger, as in Bingham's *Captured by Indians* (1848), John Mix Stanley's *Osage War Dance* (1845), Carl Wimar's *Abduction of Daniel Boone's Daughter by the Indians* (1853, fig. 59), Vanderlyn's much earlier *Death of Jane McCrae* (1804), or the various abduction and rescue scenes in *Last of the Mohicans*, *Nick of the Woods*, and other sexualized literary thrillers of the period.

To dispense with sexuality appears to be a part of *Boone*'s project. Not because this was ideologically necessary, for, as the examples above indicate, the theme of civilization's advance was not necessarily incompatible with eroticism, covert or otherwise. Rather, the painting's erasure of sexuality must have to do with its need to eradicate dirt of whatever kind: to allow, that is, the artist to

strip off his contaminated clothes and bury them, scour his body, put on a clean suit, and keep out of the mire of politics, and perhaps every other mire, "*forever*."[67]

Is *Daniel Boone* really about Manifest Destiny? Yes—and, as we have seen, about plenty of other things as well. But to be *about* is not the same as *to endorse*. In fact, Bingham's *Boone* rejects the more rabid instances of Manifest Destiny as it had been formulated in the previous half-dozen years and replaces it with a more stately, Whiggish conception of national expansion.

The term *Manifest Destiny* came into widespread use with an editorial by the flag-waving expansionist John L. O'Sullivan in 1845, but the concept had been politically mainstream since the 1820s. The Democratic party, under southern leadership, contended that it was the nation's God-given mission to expand its borders across the whole of North America, at least that part of it that lay beneath the border with Canada. Southern Democrats were desperate for an immense increase of arable land that could be made available for cotton production, the industry upon which the entire South was rapidly becoming dependent. Northeastern Democrats, representing a constituency of immigrant laborers who clamored for farmland and job opportunities to the west, also scored political points by calling for rapid territorial expansion. But no one was a more vigorous proponent of Manifest Destiny than Thomas Hart Benton, leader of the Western Democrats and, as a Missourian, the head of Bingham's political opposition.[68]

59. Carl Wimar, *Abduction of Daniel Boone's Daughter by the Indians*, 1853. Oil on canvas, 40 × 50 in.
Washington University Gallery of Art, St. Louis. Gift of Mr. John T. Davis, Jr.

In his concerted efforts to secure a larger portion of Oregon in the "Fifty-four Forty or Fight" boundary dispute with Great Britain, Benton declared, "Since the dispersion of man upon the earth, I know of no human event, past or to come, which promises a greater and more beneficent change upon earth than the arrival of the van[guard] of the Caucasian race (the Celtic-Anglo-Saxon division) upon the border of the sea which washes the shore of the eastern Asia." According to Benton, "The Mongolian, or yellow race" is "far above the Ethiopian, or black . . . and above the American Indian, or red; it is a race far above all these, but still far below the white; and, like all the rest, must receive an impression from the superior race whenever they come in contact." Thus, "the white race will take the ascendant, elevating what is susceptible of improvement—wearing out what is not," for "civilization, or extinction, has been the fate of all people who have found themselves in the track of the advancing whites."[69]

Although certainly Bingham's *Boone* depicts a scene similar to what Benton calls "the arrival of the van of the Caucasian race," Bingham himself, as a Whig uneasy with hurried expansion, may have intended his painting to bespeak not warlike ambition for new land but rather the peaceful settlement and "internal improvement" of land previously and legally bequeathed.[70] One would think that in 1851 the point would have been moot, with the United States having already acquired disputed territory from Canada and then grabbed hold of some 524,000 square miles belonging to Mexico. But, to the contrary, the Mexican Cession of 1848 only led to a new round of sectional antagonisms within the United States, resulting eventually in the Civil War. Previously, before all this new Mexican land had been annexed, debates as to whether it should be slave or free were

strictly hypothetical. Now that it was available for settlement and incorporation into the Union, the rivalry between sectional ideologies and economic systems achieved an intensity the nation had not hitherto known.

Adhering to Clay's compromise policy, Bingham may have been issuing, by way of *Boone*, not a paean to land-devouring Manifest Destiny but an exemplum of virtuous republican decorum. Maurice Bloch has pointed out that the figure of the young guide who stoops to tie his shoe derives from classical depictions of Cincinnatus. Lucius Quinctius Cincinnatus was a farmer the Romans elected leader at a time of national crisis. After guiding the armies of the republic to victory, he promptly resigned his office and went back to his farm. As Garry Wills has shown, Cincinnatus was a powerful symbol for the Whigs of republican modesty, duty, and circumspection.[71]

And yet surely whatever caution *Boone* may council, it partakes of Benton's imagery. Although hardly an instance of eagle-screaming, plunge-the-flag, white-race-forever rhetoric, *Boone* does, after all, treat the "arrival of the van of the Caucasian race" as a matter of high solemnity. Bingham, we should recall, had recently offered to "extend the right hand of fellowship" to Benton and his friends, thus indicating a willingness if not to fall in line with the expansionist Democrats, at least to forge a compromise with them. *The Emigration of Boone* may be the artist's gesture in that direction. In this regard, the painting might be more than a veiled allusion to Henry Clay, the Great Compromiser, it might be an attempt to exemplify his conciliatory

spirit, drawing upon the expansionist imagery of the era but sobering it up, tempering its spirit of zealous excess.

Having suggested that Bingham metaphorically represented Henry Clay, the Star of the West, by means of Daniel Boone, the Father of the West, and that Bingham's depiction of Rebecca Boone may have been an allusion to his recently deceased mother, I want now to pursue these and various other connections between the painting and key figures in the artist's biography. To turn to personal biography at this point is not to revoke my previous interpretations of the work in terms of the social and political issues concurrent with its production. It is instead an effort to glimpse how the private and public dimensions of this work are intertwined.

The event that the painting commemorates occurred in the summer of 1775, when Boone, a forty-year-old farmer and hunter from Virginia and North Carolina, led his family and several others through the Cumberland Gap into the then-wilderness lands of Kentucky. In 1818, Henry Vest Bingham, the artist's father, led his own family from Virginia to the thinly occupied lands of central Missouri, settling in 1819 in the newly formed river town of Franklin.[72] Along the way they must have passed through the eastern part of the territory, where Daniel Boone, at that point a widower in his eighties, lived alone in his cabin, having migrated to Missouri some years earlier after his land claims in Kentucky had been invalidated.[73]

In 1820 an itinerant artist named Chester Harding obtained permission from the world-famous recluse to paint what was to be the only portrait of him from life.[74] Boone died before it was finished. Harding's oil sketch, now in the collection of the Massachusetts Historical Society, shows a gaunt eighty-four year old with watery eyes and drooping lids, but the portrait completed some months later (1820, fig. 60) idealizes Boone: flesh hued the color of roses and cream stretches tautly over high cheekbones, flint-colored eyes peer out wistfully from either side of an aquiline nose, and thick, white hair billows upward like storybook clouds on a sunny day. Harding's Boone wears a fur-collared coat, probably a reference to Rembrandt Peale's portrait of a fur-collared Thomas Jefferson (1805), a westerner in imagination if not in fact and the architect of the Louisiana Purchase, which opened the way for all subsequent western exploration and expansion. To Americans of Bingham's era, Boone, though never a statesman or even a politician, had come to have a sort of Jeffersonian stature: if Jefferson was a Founding Father of the nation, Boone, as already noted, was the Founding Father of the West.

In the early 1820s, during the period that these two symbolic fathers, Boone and Jefferson, succumbed to mortality (Jefferson in 1826), Bingham's real father died at age thirty-eight, leaving his widow sorely in debt. As a result, eleven-year-old George was apprenticed to a cabinetmaker in another town, necessitating that the boy live miles away from home. Perhaps Bingham's midlife painting of Daniel Boone and his family entering the West therapeutically served the artist, during a troubled time, as a personal symbol for happy boyhood days when his own father was alive, his family intact, and great national heroes such as Boone and Jefferson trod the earth. In other words, Bingham's depiction in 1851 of a publicly mythologized event from 1775 may have functioned in his

private mythology as a reference to a third period, that of 1818 and a few years thereafter.

During his apprenticeship young Bingham showed talent as an artist and received rudimentary instruction from none other than Chester Harding. Might Harding have served, however temporarily, as a substitute father for the fatherless boy? It is impossible to say, but Bingham did promptly give up cabinetmaking to become an itinerant portraitist. Perhaps *The Emigration of Boone* treats Daniel Boone not only as an imaginary stand-in for Bingham himself ("frank," "straight forward," "a clean suit") and for Bingham's father (leader of the family exodus to the West), but also, at some deeply submerged level, for Harding, who was, after all, decisively linked with Boone, having created the life-portrait that was the basis for all subsequent nineteenth-century portraits of the pioneer, including Bingham's. Since Harding, moreover, was the man who fathered the young Missourian's art career, Bingham as a mature artist might consciously or unconsciously have been idealizing here not only Daniel Boone and his real father but also his erstwhile mentor. (Curiously, the younger artist appears to have borrowed Boone's eyes and nose from the Harding portrait and then thrown in a cleft chin, maybe simply for good measure—or perhaps for personal reasons that remain unclear).[75]

When Bingham embarked upon his Boone painting so many years later, he was rapidly, perhaps head-spinningly, turning corners in his life personally, professionally, and politically. In this regard he might have been choosing to identify himself with all pioneers who abandoned the familiar for the unknown—or more specifically those who, in the words of his contemporary Matthew Arnold, were "Wandering between two worlds, one dead, / The other powerless to be born."[76] The artist had

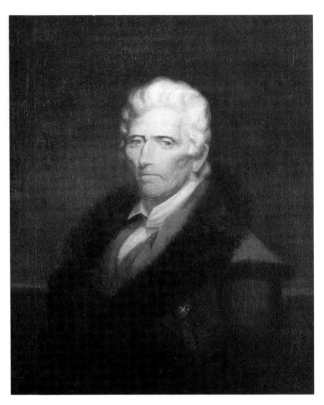

60. Chester Harding, *Daniel Boone*, 1820. Oil on canvas, 29 × 24 in. Private Collection.

recently suffered the death not only of his mother, but also of other close family members, including his first wife, Elizabeth. Professionally, he was in the process of losing the support of the Art-Union and was drifting away from the life-on-the-river genre theme that had made him famous. With his career at its own bend in the river, he was becoming increasingly involved, despite this portage through history painting, with a radically different genre theme, political electioneering. In terms of his political life, Bingham was disillusioned and embittered. Given these trying events and transitions, he may indeed have considered the Boone migration an apt metaphor for his current situation. While working on the painting he turned forty, the same age as Boone when he made *his* epic journey into the unknown.

Thus *The Emigration of Boone* might have elicited from Bingham a series of overlapping personal identifications: not only his mother with Rebecca Boone but also himself, his father, and his artistic mentor with Daniel Boone. We have already considered connections between Boone and Bingham's political model, Henry Clay. How overdetermined a painting this is, its "Daniel Boone" referring to the historical Boone as well as to his latter-day incarnation, Henry Clay, but also, in more personal terms, to Bingham himself as he passed through a dark valley *and* to the idealized father of his youth, whose name, it so happens, was Henry.

The significant duplication of names was nothing new to the artist. Not long after his young wife Elizabeth had died of tuberculosis in 1848 he met another young woman named Elizabeth, whom he married one year later. It would be crude to argue that Bingham made a father-surrogate of Clay *sheerly* on the basis of a first name—or that he painted a Mary-like image of Mrs. Boone because his own recently deceased mother happened to be named Mary. I do want to suggest, however, that when Bingham began painting *The Emigration of Boone* any number of important signifiers were attached or potentially attached to the project upon which he embarked. And as long as we are playing the name game: *Boon* means a welcomed benefit, a blessing; *Clay* signifies soil, earth, the body; and *Caleb*, meaning loyal or faithful one, was a leader of the wandering Israelites who, unlike Moses, was permitted by God to enter Canaan (see Numbers 26:65 and Deuteronomy 1:36).

Just as identifications can overlap, so can time frames. Thus *Boone* should be understood as referring not only to one date or period but to several: specifically, to 1851, when the artist painted it; 1775, when it nominally takes place; and 1819, when the eight-year-old Bingham and his family moved to Missouri. In the artist's private, perhaps unconscious, symbol system, it must have invoked both his own spiritually migrant present (Bingham having turned forty, not only Boone's age but also the number of years the children of Israel wandered through the desert) and a distant, heavily idealized past, where heroic grown-ups such as his mother and father led the way. Nostalgia for some remote point in one's childhood before the rigors and disasters of life set in can have a distorting effect on a person but can also be therapeutic, helping him or her to cope with a much-troubled present.

Bingham's painting of *Fur Traders Descending the Missouri* (fig. 36) may also have been an instance of Bingham's nostalgia for his childhood.

In this graceful image of a grizzly old trapper, his part-Indian boy, and their pet cub gliding down-river, it is early morning. Mists are rising; the sky is tinged with pink; one can almost hear the quiet splash of water parting before the bow of the dug-out or cutting against the snags emerging from the glassy-smooth surface. The trapper, stem pipe in mouth, a puff of white smoke trailing behind, glowers at the viewer. The boy, by contrast, is all innocence and dewy freshness. The image embodies the father-son, master-apprentice, mentor-pupil relationship that seems to have been crucial at every phase of Bingham's life.

His respect for his elders, his emotional allegiances to the past, were in keeping with his basically conservative, Whiggish point of view. Though he himself was of the West and thus associated with the new, he was continually drawn to the old, seeing in it a means of stabilizing the unsettling motions of the present. In this he was out of step with Herman Melville, who rejoiced at the demise of old times and old ways. "The Past is dead, and has no resurrection," Melville exclaims in *White Jacket* (1850). "The Past is, in many things, the foe of mankind; the Future is, in all things, our friend. . . . The Past is the text-book of tyrants; the Future the Bible of the Free. Those who are solely governed by the Past stand like Lot's wife, crystallized in the act of looking backward, and forever incapable of looking before." Or, as Hawthorne's Holgrave cries out in *The House of the Seven Gables* (1851), "Shall we never, never get rid of the Past? . . . It lies upon the Present like a giant's dead body!" Karl Marx observed that "the tradition of all the dead generations weighs like a nightmare on the brain of the living," but it was Thomas Jefferson who more than a generation earlier most simply and coldly expressed the modern view of the past: "The dead have no rights.

They are nothing." Words such as these would have left Bingham aghast.[77]

Bingham's *Boone* is a backward look at forward-looking pioneers, with the present very much on the artist's mind—or, to rephrase that, *in* the artist's mind. Whether he consciously thought about this or not, his painting of the Boone party is more than only marginally related to the wagon trains rolling west from Missouri, the Catholic immigrations, the Mormon exodus, the Compromise of 1850 and the Fugitive Slave Act, Stowe's *Uncle Tom*, the Hudson River School heritage of Thomas Cole, state politics and professional politics, businessmen who behaved like Jews, the debates over Manifest Destiny, and America's long history of Indian hating. It is at once a Flight into Egypt, a Flight out of Egypt, and a stoical journey through the Valley of the Shadow of Death.

Stagy and static, seemingly nothing more than a petrification of an official ideology, *Boone* is actually much more a palimpsest of discourses, some more outdated than others, but all, tragically or not, fluid and viable in our world today. Seen in terms of its many overlapping contexts, the painting is not simply a piece of propaganda, however much that is how it first appears. Think of it instead as a mosaic of meanings or, more organically, as a tissue of inextricably connected, often rivaling, attitudes, convictions, points of view, yearnings, desires, hatreds, fears. By no means a pure landscape, *Boone*, as examined here, constitutes a sober, if unintentional, reminder that America itself has never been pure, unpeopled, or free of the blessing—the boon—of civilization.

Chapter 3

Reconstructing Duncanson

All art must be for the end of liberating the masses.
A landscape is only good when it shows the oppressor hanging from a tree.
Right on! Right on, Bo, the henchmen chorused.
—Ishmael Reed

We are inevitably the result of earlier generations and thus the result of their mistakes,
their passions and aberrations, even of their crimes; it is not possible to loosen oneself entirely
from this chain. . . . We try to give ourselves a new past from which we should have liked
to descend instead of the past from which we actually descended.
But this is also dangerous, because it is so difficult to trace the limit of one's denial of the past,
and because the newly invented nature is likely to be weaker than the previous one.
—Friedrich Nietzsche

How difficult it sometimes is to know
where the black begins and the white ends.
—Booker T. Washington

The African-American artist Robert S. Duncanson painted landscapes in the style of the Hudson River School. Whether representing the Catskills, the Andes, or the Ohio River Valley, the so-called Hudson River School artists depicted locations in which forests, lakes, mountains, and streams stretched off into infinity and in which humans, if present at all, were mere bystanders at nature's mighty parade. The twin principles of Hudson River School painting were close observation of nature and religious reverence for it.

Until recently Duncanson has rarely been mentioned in surveys of American art. Despite the determined scholarship of such African-American art historians as David Driskell, Guy McElroy, James Parks, and James Porter as well as the non-African-American Joseph D. Ketner, Duncanson's oeuvre is still relatively unknown, his reputation, such as it is, resting upon a single painting, his *Blue Hole, Little Miami River* (1851, fig. 61). This, indeed, was the only item by an African-American included in the Metropolitan Museum's block-

61. Robert S. Duncanson, *Blue Hole, Little Miami River*, 1851. Oil on canvas, 29¼ × 42¼ in.
Cincinnati Art Museum. Gift of Norbert Heerman and Arthur Helbig.

61. Robert S. Duncanson, *Blue Hole*, *Little Miami River*, 1851. Oil on canvas, 29¼ × 42¼ in.
Cincinnati Art Museum. Gift of Norbert Heerman and Arthur Helbig.

Chapter 3

Reconstructing Duncanson

All art must be for the end of liberating the masses.
A landscape is only good when it shows the oppressor hanging from a tree.
Right on! Right on, Bo, the henchmen chorused.
—Ishmael Reed

We are inevitably the result of earlier generations and thus the result of their mistakes,
their passions and aberrations, even of their crimes; it is not possible to loosen oneself entirely
from this chain. . . . We try to give ourselves a new past from which we should have liked
to descend instead of the past from which we actually descended.
But this is also dangerous, because it is so difficult to trace the limit of one's denial of the past,
and because the newly invented nature is likely to be weaker than the previous one.
—Friedrich Nietzsche

How difficult it sometimes is to know
where the black begins and the white ends.
—Booker T. Washington

The African-American artist Robert S. Duncanson painted landscapes in the style of the Hudson River School. Whether representing the Catskills, the Andes, or the Ohio River Valley, the so-called Hudson River School artists depicted locations in which forests, lakes, mountains, and streams stretched off into infinity and in which humans, if present at all, were mere bystanders at nature's mighty parade. The twin principles of Hudson River School painting were close observation of nature and religious reverence for it.

Until recently Duncanson has rarely been mentioned in surveys of American art. Despite the determined scholarship of such African-American art historians as David Driskell, Guy McElroy, James Parks, and James Porter as well as the non-African-American Joseph D. Ketner, Duncanson's oeuvre is still relatively unknown, his reputation, such as it is, resting upon a single painting, his *Blue Hole, Little Miami River* (1851, fig. 61). This, indeed, was the only item by an African-American included in the Metropolitan Museum's block-

buster "American Paradise" exhibition of 1987, which, with eighty-eight works on the walls, defined for our age the canon of Hudson River School painters and paintings.[1]

I want to examine Duncanson's work in terms of American landscape painting of the mid nineteenth century but also in terms of American race relations during that same period. The procedure here will be as much biographical as artifactual, maybe even more so. But let me point out two of the pitfalls ahead. The first is that when a white art historian writes at length about a black artist, not only is that artist being reduced to an object of knowledge for the art historian, who reflexively assumes the superior position of knowing subject—which is a problem endemic to all art history—but further objectification arises inasmuch as a black person is being reduced to an object of knowledge for the white knowing subject. As the African-American feminist bell hooks has observed, "Even if perceived 'authorities' writing about a group to which they do not belong and/or over which they wield power, are progressive, caring, and right-on in every way, as long as their authority is constituted by either the absence of the voices of the individuals whose experiences they seek to address, or the dismissal of those voices as unimportant, the subject-object dichotomy is maintained and domination is reinforced."[2]

The alternative might seem to be silence: white art historians could simply agree not to write about black artists and thus steer clear of the racial subject-object dichotomy. But surely silence is not the only alternative. One might aspire instead for *dialogue* in which the white art historian neither enthrones himself (or herself) as an all-knowing, all-seeing authority nor plays it safe by abdicating inquiry and speech altogether. In bell hooks's estimation, "Problems arise not when white [scholars]

choose to write about the experiences of non-white people, but when such material is presented as 'authoritative.'" With this proviso in mind, I have tried to write about Duncanson, as about all the other artists in this book, not as someone who can be known fully and whose art can be fully understood, but as a site of inquiry at which various relevant questions (including those involving the social production of race) come together and play off one another.[3]

This leads to another pitfall, that of transforming Duncanson's paintings of the land into a discourse on race. One might well question my persistent application of racial themes to a body of work that clearly has a great deal to do with lakes and streams, clouds and forests but virtually nothing that can be directly pointed to that has anything to do with race. Why, one might insist, should not Duncanson be treated on equal terms with the other artists of the Hudson River School, whose art is never talked about in terms of race? Why are black artists always made to bear the burden of racial discussion even when those artists chose, as Duncanson did, to leave matters of race behind?

My response is that in America race cannot be left behind. The way to treat Duncanson with equality in regard to the other Hudson River School artists is not to shield him from a discussion of race but rather to begin looking into the racial operations of *their* art as well as his. This chapter, however, is not about Cole, Durand, or Church, whose work is, in fact, beginning to be studied in terms of race as it pertains to nationalism, Manifest Destiny, the war with Mexico, Indian Removal, and

so forth.[4] It is instead about an all-but-forgotten painter, an African-American at that, whose art and career, it seems to me, can and should bear a similar degree of critical scrutiny and ideological analysis. Moreover, Duncanson is a particularly intriguing subject for analysis because as a black artist with a predominantly white clientele, subject matter, and stylistic derivation, he was inevitably compelled to traverse the perilous and sometimes indefinable border between two hostile nations in nineteenth-century America, one white, one black.

But what is the nature of my own desire here? Why take the risk of writing about Duncanson when I am sure that doing so will only get me into trouble with any number of readers—those who will claim that, given my racial (which I would redefine as cultural or socially invented) whiteness, I do not have the right to speak, those who will say that Duncanson's paintings are not of sufficient artistic or historical merit to warrant such an extended discussion, and those who will find my speculative methods too remote either from documentary sources about the artist or from that which meets the eye in the paintings themselves. Whatever validity these claims may or may not have, I am willing to take the hits that I know will result because, for one thing, I find the art-historical anomaly of Duncanson to be irresistibly fascinating and, for another, because the theme of *passing* that will emerge is one with which I, like perhaps millions of other present-day Americans, can readily identify. Many of us, I suspect, try to pass ourselves off as something different from what

we normally take ourselves to be—more masculine or more feminine, more upper class or more working class, more of an assimilated insider or more a defiant outsider, and so forth. Passing, this is to say, is not restricted to the crossing of racial boundaries, and my consideration of the issues involved with regard to Duncanson should, if it accomplishes anything, prompt each of us to begin thinking about how, regardless of the race or ethnicity with which we are identified, we regularly go about our lives consciously or even unconsciously passing, contriving for ourselves a public if not also private identity, the coordinates of which are race-, class-, gender-, and sexuality-specific.

White or black, artists internalize the values and ideals of the various communities from which they originate, to which they belong, and to which they would like to belong. In the words of William Stafford, "A person's way of seeing, thinking, even feeling is never purely personal and unique, but is always moulded by the culture of the groups to which he or she belongs." In examining works of art, we gain an opportunity to discern how various communities, racial or otherwise, speak to themselves and to the rest of the world through their members. They do so *even when* those members do not think of their art as instances of communal speech or, indeed, would prefer it not to be so understood, for, as Stafford points out, "human beings never exist as self-contained individuals, not even when they live alone and lonely. The very fibre of their being is constituted by relationships they have, or have had, with others; self-consciousness regularly shades off into group consciousnesses of various kinds—sexual, racial, national, class, professional, generational. . . . The individual is a myth." As Nietzsche observes in the epigraph to this chapter, "We are inevitably the result of earlier generations" and "it is not pos-

sible to loosen oneself entirely from this chain."
What is inevitable is that we speak our past no
matter how we try to avoid it. Indeed, no matter
how we try to avoid it, our past speaks us.[5]

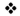

Before proceeding with details about Duncanson's
life and milieu, let us look closely at *Blue Hole*. The
painting is a tight, compact, beautifully designed
picture in which a narrow strand of foreground
gives way to a clear blue body of water that re-
produces on its surface the forest around and the
clouds above. At the edge of the water, three small
figures are gathered. One, a boy in a straw hat,
perches on a large, chunky rock with a fishing
rod that arches upward and curves down again in
the direction of the water. Another boy, in a white
shirt, spread-legs himself on the ground and cants
forward, working out a snag in his line or baiting
a hook. Barefoot in front of him, hiking up his
trousers at the knees so that he can squat down to
lend his friend a hand is an older boy, maybe even
a young man—he seems older because larger.
This gesture of interest or assistance from older
to younger adds a warmth, even intimacy, to a
work that is otherwise cool in its surfaces, tones,
and pristine geometry. Though the boys are distant
from the viewer and none of their faces visible, we
read them as concentrated, focused, intent upon
what they are doing. The untroubled water that lies
before them mirrors—that is, suggests—their col-
lective calm. They seem content with where they
are and what they are doing. There is no reason to
sense that, like *Boone*'s emigrants painted in the
same year, they are passing through this landscape
on their way to someplace else.

In keeping with the conventions of landscape
painting, these figures serve as staffage, providing
the viewer with a sense of scale and distance. They
also, again in keeping with tradition, humanize the

landscape by populating it with a small, represen-
tative sampling of those who work in, inhabit, or,
in this case, take leisure in nature. And yet, small
as they are in relation to the surrounding land-
scape, they come close to turning *Blue Hole* into a
genre painting, for the halcyon imagery of country
boys fishing is of a piece with such popular genre
works of the era as those of William Sidney Mount
and George Caleb Bingham.

In Mount's *Eel Spearing at Setauket* (1845,
fig. 62), a young white boy and a mature black
woman glide serenely upon a glassy smooth, hyper-
reflective stretch of water. In *Fur Traders Descend-
ing the Missouri* (1845, see chap. 2, fig. 36),
a French-Canadian trapper and his "half-breed
son" (as Bingham's original title described him)
similarly glide over smoothly reflective—although
occasionally snagged—waters, the boy wielding a
rifle, with which he presumably brought down the
duck over which he leans. In both of these works
the human actors predominate, while the land-
scape occupies a secondary status, whereas in *Blue
Hole, Little Miami River*, the reverse occurs. Still,
in all three instances, the harmonies of nature hold
a mirror, literally as well as figuratively, to harmo-
nious interactions of humans with one another and
with the land about them. Also, in the Duncan-
son as in the Mount and Bingham, a relation of
tutelage and instruction is suggested: the older,
barefoot boy shows the younger boys how to fish,
as the black mammy teaches her "young Mas-
ter" (Mount's words) how to spear eels and as the
grizzled trapper oversees his son's education in life
on the river.

62. William Sidney Mount, *Eel Spearing at Setauket*, 1845. Oil on canvas, 29 × 36 in. New York State Historical Association, Cooperstown.

In its precision and profusion of landscape detail, carefully delineating striations on rocks, leaves on plants, and bark on trees, and in its deft arrangement of the scene into interlocking pyramids of sky, forest, and water, *Blue Hole* lives up to Hudson River School dictates as they were quintessentially formulated by the academician Durand: "It is by reverent attention to the realized forms of Nature alone, that Art is enabled by its delegated power to reproduce some measure of the profound and elevated emotions which the contemplation of the visible works of God awaken."[6] Yet at the same time that the painting embodies the reverential devotion to nature requisite for the Hudson River School, it exploits narrative strategies employed to popular acclaim in such boy-in-nature works as *Eel Spearing* and *Fur Traders*.

To be sure, many other Hudson River School landscapes, for example, those of Thomas Daughty, Henry Inman, and Duncanson's colleague William Louis Sonntag, featured boys fishing on the banks of rivers or lakes, but few such works were as suggestive as *Blue Hole* in evoking a sense of a lived relationship between the figures who otherwise functioned as staffage.[7] And typically the other artists did not centralize or otherwise emphasize these grace-note figures as Duncanson has done but instead tended to sublimate them into the overarching landscape that was clearly the greater concern. Thus *Blue Hole*'s achievement resides in its supple integration of two seemingly disparate styles of antebellum painting, one that generally bespoke lofty ideals and leisurely refinement, the other associated with vernacular anecdote and popular egalitarianism. Duncanson mixes not only differing aesthetic styles but also diverse, if not in fact competing, signifiers of social class. Here we have an initial clue as to the ease with which he could appropriate styles

and genres associated with social classes different from his own.

Born in New York State in 1821 of a free black woman and a man purportedly of Scots-Canadian origin, Duncanson is generally thought to have spent his early years in Canada with his father. When he was about twenty he moved to a village outside Cincinnati to be with his mother and find work as a handyman and housepainter. During the 1840s young Duncanson, largely self-taught, worked as an itinerant portraitist and genre painter, dividing his time between Cincinnati, a river town that marked the boundary of North and South as well as East and West, and Detroit, another border town, in this instance on the line between the United States and Canada.[8]

When Duncanson arrived in Cincinnati in 1841 it was a burgeoning metropolis of 50,000 citizens. By the end of the decade its population was more than 115,000. In these years no city in America, apart maybe from New York, was more of a crossroads. Easterners traveling down the Ohio River to the West passed through Cincinnati, as did southerners who wished to trade with the North and westerners who sought access to the markets of the East. Close to half the adult population of the city was born abroad, most of these immigrants coming from Germany and the British Isles.

As a hub for trade and travel, the city was a magnet for artists, providing them with manifold opportunities for study, exhibition, and patronage. "Cincinnati!" exclaimed the editor of the New York *Star* in 1840. "What is there in the atmosphere of Cincinnati, that has so thoroughly awakened the arts of sculpture and painting: It cannot surely be mere accident which gives birth to so many artists." The following year another commentator proclaimed, "The *field of art* in Cincinnati is per-

fectly unbounded" thanks to a variety of factors, among them "the multifarious nations and characters here congregated . . . the grand and beautiful features of western scenery . . . and the deep moral and physical interest of the great social movements of the times."[9]

If Cincinnati was a haven for artists, it was a troubled city as well, and in no way more so than in terms of what was the greatest of the "great social movements of the times," the struggle over emancipation. Headquarters of various abolitionist presses and antislavery organizations, crossover point for runaway slaves, home to several thousand free blacks, the city was, nevertheless, also a southern town, with much of its population socially and economically committed to the South and its institution of slavery. Black Laws in Cincinnati strictly discriminated against Negroes, even stipulating that every black newcomer to town, whether fugitive or free, had to post a five-hundred-dollar bond with county authorities to guarantee his or her proper conduct. Floodtide immigration from abroad and periodic downturns in the economy provoked volatile job competition between white and black underclasses. Trade unions sought to protect their membership by prohibiting the integration of workshops. Only the most menial nonskilled jobs were reserved for blacks. As "A Colored Man" complained in an abolitionist newspaper, "We have among us, carpenters, plaisterers, masons, etc., whose skill as workmen, is confessed—and yet they find no encouragement—not even among friends [i.e., white abolitionists]." Although skilled black laborers "are sometimes

favored with a call to take an old door off its hinges, or some other petty job," the work allotted to them is always that which "no white carpenter will do unless well paid for." This is the situation in which the young craftsman found himself when he moved to Cincinnati.[10]

"In virtually every phase of existence," writes Leon Litwack about the antebellum North, "Negroes found themselves systematically separated from whites. They were either excluded from railway cars, omnibuses, stagecoaches, and steamboats or assigned to special 'Jim Crow' sections; they sat, when permitted, in secluded and remote corners of theaters and lecture halls; they could not enter most hotels, restaurants, and resorts, except as servants; they prayed in 'Negro pews' in the white churches, and . . . they were often educated in segregated schools, punished in segregated prisons, nursed in segregated hospitals, and buried in segregated cemeteries."[11]

Several racial incidents occurred in Cincinnati in the 1820s and 1830s, but none compared in magnitude to the conflagration that broke out in 1841, the year of Duncanson's arrival. This proved to be the most grievous race riot in America prior to the Civil War. Incited by interracial scuffles, a white mob 1,500 strong stormed a black neighborhood known as Bucktown. Two blacks and two whites were killed before local militia temporarily halted the violence. After a new outbreak of rioting on the part of the whites, city authorities took some 250 to 300 adult black males into "protective custody" with the pledge that their families and property would be safeguarded by police, firemen,

and militia. Overwhelmed, however, by renewed rioting, these keepers of the peace proved ineffectual. Much of Bucktown was destroyed by angry white assailants.[12]

Duncanson was a light-skinned African-American, a mulatto. The term is unavoidable because it was unavoidable for him and his contemporaries. The federal census of 1850, in fact, was the first of several in the nineteenth century to take into account whether African-Americans were black or mulatto. During the Civil War, regimental record-keepers for the Union armies went so far as to classify Negro soldiers along a color continuum divided into black, very dark, dark, copper, brown, mulatto, yellow, light, very light, and white. Duncanson's State Department passport (issued in 1853) does not classify him by race but does describe him as having "Eyes brown, Nose medium, Mouth large, Chin sharp, Hair brown, Complexion sallow."[13] Judging from a photograph of him taken in Canada in 1864 (fig. 63), he might easily have been viewed as a Caucasian, but nonetheless in the United States he was usually identified as a Negro or, what in effect was to say the same thing, a mulatto. In the antebellum North, as in the South, a racially mixed individual, regardless of skin tone, was legally and politically classified as black rather than white, a policy that later came to be known as the one-drop [of black blood] rule.[14] But even if mulattoes were legally black, socially and in terms of economic and educational opportunity they were marginally more privileged than their darker-skinned counterparts.

Social distinction according to skin tone was especially practiced in the South and in southern-oriented cities such as Cincinnati. Whereas in the North whites were inclined to lump all blacks together as equally inferior, in the South there was a long-standing tradition of regarding lighter-

skinned blacks as intellectually and temperamentally superior to the darker ones. This attitude resulted at least in part from the frequent possibility that the mulatto in question had been fathered by a white master. In general, though, the higher status of mulattoes derived from the racist assumption that individuals possessing even the slightest degree of European blood were automatically superior to individuals of solely African descent.

The ideology of intraracial superiority had credence with blacks as well as whites. In antebellum Cincinnati, black neighborhoods divided along skin tone, the poorer and less literate dark-skinned Negroes occupying shanties with names such as Bucktown or Little Africa, and the more prosperous, light-skinned Negroes living in self-selected segregation at the other end of town. According to one recent demographic study of Cincinnati in 1860, "There was as much residential separation between darker blacks and mulattoes as there was between blacks and whites in Brooklyn or San Francisco." In his study of the black bourgeoisie, the black sociologist E. Franklin Frazier says bitingly of the mulattoes, "Although they were not white, they could thank God that they were not black."[15]

And yet while mulattoes were the aristocrats of the black population, their mixed status position was often a source of personal anxiety. In the words of one historian of the American mulatto, "The very fact that the mulatto is often closer to the white man in cultural attainments and physical traits renders it all the more difficult for him to accept the extreme color division of the American racial system and the discrimination which accompanies it. The mulatto finds himself unable to enter the white group yet at the same time out of touch with much of the black."[16]

When Duncanson moved to Cincinnati, he was

63. William Notman Studio, "Robert S. Duncanson," 1864. Albumen print. Notman Photographic Archives, McCord Museum of Canadian History, Montreal.

opening himself up to a sort of double jeopardy, inasmuch as the city was dramatically polarized not only between white and black but also between black and brown. And yet, even though this was a time of "no encouragement" for Cincinnati's African-American workingmen, Duncanson quickly rose from the ranks of the working class, setting himself up as a genre, still-life, and portrait painter who garnered prominent white clients and prestigious commissions. Cincinnati's best-known abolitionists sat for him, and he counted the city's leading artists among his friends. In 1848 Nicholas Longworth, a prominent lawyer, philanthropist, and patron of the arts, commissioned Duncanson to provide murals for his home, Belmont (now the Taft Museum). The eight large landscapes that resulted two years later were regarded as a great success, and from then on Duncanson earned his living primarily as a painter of landscapes, which in some instances included painting from landscape daguerreotypes taken by him or an African-American colleague, James P. Ball, who owned a large and flourishing daguerrian gallery.

Looking at the images Duncanson produced during this first decade, the portraits, still lifes, genre scenes, and landscapes, we detect nothing to indicate that the painter was an African-American, partial or whole. There seems to be in his art a curious sort of denial, a striking absence of blackness or, should we say, brownness. One way of accounting for this is simply to observe that whites had practically all the financial resources in antebellum Cincinnati and for that reason it was they, as patrons, who determined what or whom

artists were to paint. But a more satisfactory—as well as more troubling—answer as to why, with a couple of exceptions, Duncanson steered clear of black subject matter is that at some level and in some manner he wished to pass for white.

This may sound like an insult, an accusation, and I do not mean it as such. Duncanson himself, as we shall see, was outraged to learn of talk among his relatives that, in the terminology of the time, he was attempting to pass. Granted, the issue is a sensitive one, but it is so pertinent to any candid discussion of race or ethnicity in America that I believe it would be a greater injustice to leave it aside out of a misplaced sense of delicacy.

Of course to say that Duncanson's painting constituted an attempt at passing on the level of culture is only to say what is true of a great many artists, white as well as black: their art is a vehicle toward social legitimation and acceptance into dominant society. It can be claimed that many Hudson River School artists, including Cole and Durand, saw a refined style of landscape painting as a means of transcending their own lower-middle-class origins and passing into gentility. But whereas for most of them the concern would have been with shifting class registers, for Duncanson the concern may have been to shift color registers as well.

I want to argue here that while stylistically Duncanson's art is practically identical to that of his contemporaries and in that regard is unexceptional, striking thematic consistencies within the work as a whole suggest meanings of a highly personal—and, indeed, social—significance. In landscapes of the Hudson River School, bodies of water are a frequent but by no means inevitable occurrence. For every view of a river or lake, there are just as many paintings of rocks, mountains, and forests in which there are watery cascades aplenty, vertical streaks upon the canvas, but no

expanses of water, no pools, lakes, or streams. This does not hold true for Duncanson's land-scapes, virtually every one of which is organized around a substantial body of water. *Blue Hole* is the most notable example, but from early in his career through to the end three decades later, the central element and most indispensable feature of his compositions was water, standing or rushing, turbulent or serene.

Rivers, lakes, ponds, Scottish lochs, the Bay of Naples: what characterizes the Duncanson land-scape above all else is the water transecting the composition, usually cleaving foreground from background but also, or instead, left from right. In every one of these instances, the body of water con-stitutes an obstacle, a space to be crossed, some-thing, as it were, needing to be passed. Or actually, to the contrary, *not* needing to be passed—in *Blue Hole* and most of the other works, there is water to be crossed over, but the figures display no discern-ible interest in doing so. In that regard, maybe the paintings are fantasies of having already crossed to where one would prefer to be.

This is not to say that Duncanson habitually structured passable bodies of water into his com-positions in order to speak in private code of his personal plight of being a light-skinned—and thus potentially passable—black man in an overwhelm-ingly racist society. But if purely personal matters are insufficient to account for his unusual concen-tration on this subject, so are the strictly formal (i.e., an argument that this was the only Hudson River School formula at which he was fully adept). We must in addition examine the cultural, that is, extrapersonal, significations of crossable water during this period.

Geographically, water-to-be-crossed made con-siderable sense as a subject for Duncanson be-cause of where he lived. Popularly called the

Queen City in honor of a famous riverboat, Cin-cinnati was virtually defined by its position on a bend in the Ohio. No aspect of life in the city was untouched by this great watery thoroughfare that every day bore transient traders and im-migrants, inhabitants come to stay, strange new ideas, and equally strange new vices. Only once did Duncanson actually paint the Ohio River—in his *View of Cincinnati, Ohio, from Covington, Ken-tucky* (c. 1851, fig. 64), where the steepled and smokestacked Queen City sparkles like a wonder-ful world of Oz—but it is easy to see how such a pulsing artery, so intrinsic to the character and tex-ture of his adopted hometown, helped him to arrive at the subject matter that remained predominant in his work. His canvases need not have the Ohio in them in order to bear its mark.

Detroit, Duncanson's other venue as an artist, was also a river city and border town. Across the Detroit River lay Canada. In the 1840s and then even more so in the fifties, with the passage of the Fugitive Slave Act, which threatened punishment to Americans who harbored runaways, crossing into Canada was for blacks an act laden with mean-ing. (Malcolm X articulated some of this mean-ing more than a century later in his remark that "Mississippi is anywhere south of the Canadian border.")[17] This is not to claim that Duncanson's landscape paintings are explicit allegories of pas-sage—in this case, of geographic rather than class or race passage—but rather to suggest that any landscape painter working out of Cincinnati and Detroit in the 1840s and 1850s, and all the more so an African-American artist painting during the

64. Robert S. Duncanson, *View of Cincinnati, Ohio, from Covington, Kentucky*, c. 1851.
Oil on canvas, 25 × 36 in. Cincinnati Historical Society, Cincinnati.

height of slavery, might reasonably have developed a zeal for representing water that was to be traveled upon or crossed.

Frederick Douglass recalls that in the darkest days of his life as a slave he used to envy the boats that flew freely across the Chesapeake Bay: "I have often, in the deep stillness of a summer's Sabbath, stood all alone upon the lofty banks of that noble bay, and traced, with saddened heart and tearful eye, the countless number of sails moving off to the mighty ocean." Douglass would cry out to himself, "It cannot be that I shall live and die a slave. I will take to the water. This very bay shall bear me into freedom." Another former slave, William Wells Brown, tells how the waters of Lake Erie represented a passageway for blacks out of America, with its "democratic whips" and "republican chains," into "the promised land" of Canada. The most famous passing scene of all occurs in *Uncle Tom's Cabin*, when the Kentucky slave mother Eliza, confronted with the Ohio River in midwinter, "vaulted sheer over the turbid current by the shore, on to the raft of ice beyond" and from there "saw nothing, felt nothing, till dimly, as in a dream, she saw the Ohio side, and a man helping her up the bank."[18]

Thus in Duncanson's era bodies of water separating one shore from another had an inescapably social, we might even say political, meaning. And, of course, religious meaning as well: "Deep River, my home is over Jordan," sang the African slaves; "Deep River, my home is over Jordan, / O don't you want to go to that Gospel Feast / That Promised Land where all is Peace? / Deep River, I want to cross over into camp ground."[19] In their depiction of sun-drenched valleys, serene forest coves, and magnificent arcadian vales, many of Duncanson's landscapes are pristine utopian worlds unblemished by human suffering. In terms of the slave

spirituals of the era, they are painterly depictions of the shores of Canaan, the land of milk and honey. Duncanson's work portrays the home that lies over Jordan, the campground where all is Peace. His figures do not yearn to be there because they already are. In the case of *Blue Hole*, that serene body of water is not an obstacle to be crossed in order to achieve freedom but rather the trope of freedom itself, a place where one can go fishing all day long, unhurried and unafraid.

Surely, then, it would be a mistake to believe that Duncanson's choice of subject matter was determined solely by the reigning conventions of landscape painting. Although water in the middle distance was a device routinely employed by all Hudson River School painters, its connotations in Duncanson's work are unique, given how bodies of water figured into the social discourses of racial passing and crossing to freedom that were so much more pertinent, and so much more problematic, to him than to the others. If this claim seems farfetched, could it be any more so than the presumption that depictions of the land carried the same meaning for this one artist as they did for those others who, according to the highest law of that land, were two-fifths more of a person than he?

I end this section, then, asking you to accept what may seem to be contrary interpretations. On one hand I invite you to believe that landscape painting was a way for Duncanson to eschew his black roots and gain some measure of acceptance by genteel white society and the material and psychological rewards associated with it. On the other hand I insist that his work alluded, how-

ever covertly or even unintentionally on his part, to black social concerns, idioms, outlooks. According to Frazier's polemical formulation, "There have been only two really vital cultural traditions in the social history of the Negro in the United States: one being the genteel tradition of the small group of mulattoes who assimilated the morals and manners of [white] aristocracy; and the other, the culture of the black folk who gave the world the Spirituals." In Frazier's estimation the twentieth-century black bourgeoisie "has been uprooted from its 'racial' tradition and . . . has rejected the folk culture of the Negro masses."[20] But I am arguing that however deep Duncanson's bourgeois aspirations may have been, his association with black folk culture was inescapable and simply could not, at his precise time and place in American history, have been uprooted, no matter how far from Bucktown he wandered.

What I am asking you to consider is the possibility that an artist, in this instance Duncanson, could attempt through his art both to erase his past and inscribe it: erase and inscribe, inscribe and erase, or, to switch metaphors, that he could launch his boat from an inconvenient and problematic communal shoreline and yet never be willing or able to let it disappear from sight. I think of what I myself have wished to renounce or disown of my heritage and yet have also frequently, if secretly, turned to as a comfort, strength, and inner guide, and I wonder why Duncanson too could not have accepted and rejected and reaccepted continually his first and primary community, in this case his working-class African-Americanness, forever

casting it away from him and reeling it back in like one of those boys he liked to show eternally perched on a rock angling for fish.

Nowhere in Duncanson's art is there an equivalent either to Douglass's yearning after the ships on the bay or to Stowe's melodrama of turbulent crossing. Indeed, most of his landscapes, as I have just indicated, are devoid of drama and could more aptly be described as representations of fulfillment than of its absence. All the same, Douglass and Stowe as well as many of their lesser-known contemporaries redefined for antebellum Americans the possibilities of what water might mean to those stranded on one side of it or another, those who traveled upon it, those who passed across it. For that very reason, even if the landscape paintings of this free mulatto eschew or evade the powerfully political associations that antislavery writers attached to lakes, bays, and rivers, those associations were too forcefully articulated in the writing and song of the period for us not to examine his work in their light. Duncanson, it is true, was not a slave, but we should not overlook the fact that his patrons were abolitionists, he was championed by the local antislavery leagues, and he was based in Cincinnati, the first stop on the Underground Railroad (and, as it so happens, the home town of Harriet Beecher Stowe in the 1840s, the years during which she gathered her materials for *Uncle Tom*, including a news item about a slave mother crossing the icy Ohio with babe in arms).

The most dramatic Duncanson ever allows a body of water to become is the river shooting down the center of *On the St. Anne's* (1863–65, fig. 65), a work he painted in Canada during the Civil War. At either side of the rushing stream, fallen branches, boulders, and wind-whipped trees aflame with autumn color enact some sort of anthropomor-

65. Robert S. Duncanson, *On the St. Anne's, East Canada*, 1863–65. Oil on canvas, 9⅛ × 15 in.
National Museum of American Art, Smithsonian Institution, Washington, D.C.
Gift of Herbert Drown.

phized passion play. Under tortured skies, the two halfs of the picture confront each other like armies on the march. To describe the painting this way, of course, is to construe it programatically in terms of the war. This would be in keeping with how other landscape paintings of the time, for example, Church's *Twilight in the Wilderness* (1860) and George Inness's *Peace and Plenty* (1865), were understood by Victorian Americans habituated to typological interpretation of contemporary events and works of art. Such interpretation was the bread and butter of the era's clergymen, editorialists, poets, and art reviewers.

And yet, amidst all the commotion in the painting, almost hidden midway up the far bank of the river, two tiny observers show that here too Duncanson's concern with passing, with getting across—or being across—finds expression. There is a discrepancy in the size of the figures. One, dressed in a dark suit, appears to be an adult, the other, clad in red, seems but a boy. Both are white. As in *Blue Hole* and many other works by Duncanson, a white youth and his father, older brother, or mentor occupy a modest but central place in the great theater of nature. In this painting, as in the others, the figures appear content with where they are, indicating no interest in crossing to the other side.

At this point I want only to hint at but not pursue a psychoanalytic account of Duncanson's work as a wish fulfillment of being reunited with his father (or paternal heritage and privilege) across the border in Canada. An interpretation along these lines will emerge, bit by bit, but for our

purposes Duncanson's personal motives, whatever they may have been, are ancillary to the collective motives of the various social groups (blacks, mulattoes, professional artists, aspiring bourgeoisie) of which, consciously or not, willingly or not, he was representative. To say that his personal or, more specifically, his psychological, motivation was ancillary is not to say that it was irrelevant to the broader social dynamic we are trying to examine, but rather to say that it was symptomatic: if Duncanson preferred to envision himself as a white boy enjoying landscapes serene or spectacular by the side of a white father, real or imagined, that preference arose out of concretely social, not merely idiosyncratic, circumstances.

Rather than concentrating on Duncanson's paintings as expressions of one particular African-American's sense of lack, his desire to pass to the other side, we have regarded them in terms of what we know of the hunger of antebellum African-Americans in general, dark-skinned or light, slave or free, to cross over from racial oppression to genuine, meaningful liberation. Yet these are paintings not about hunger but fulfillment; their subject is not getting to the promised land but being there. The young black pilgrim of Frederick Douglass's narrative aches at the sight of unobtainable freedom, whereas the young white surrogates in Duncanson's paintings do not yearn for such freedom, they bask in it.

The reader might argue that Duncanson painted happy scenes because he himself was happy: a prospering artist who enjoyed prominent patronage and favorable criticism. But to return to the analogy of the slave spirituals, a joyful song sung in the midst of oppression is hardly a sign of well-being. Given his connection to the antislavery societies that helped fugitive slaves reach freedom and that put former slaves on the lecture circuit,

Duncanson must have been intimately familiar with the songs and idiom, not to mention the longings, of the southern blacks. Indeed, if, as some have suggested, he spent his boyhood in Wilberforce, Ontario, much of his upbringing would have been spent with those who had once been slaves. In any case, despite his steadily increasing personal success, he himself remained a member of an immiserated racial class that was, if not *legally* enslaved, systematically deprived of social equality and respect.

"I have often been utterly astonished, since I came to the north, to find persons who could speak of the singing, among slaves, as evidence of their contentment and happiness," Frederick Douglass remarks. "It is impossible to conceive of a greater mistake. Slaves sing most when they are most unhappy. . . . The singing of a man cast away upon a desolate island might be as appropriately considered as evidence of contentment and happiness, as the singing of a slave; the songs of the one and of the other are prompted by the same emotion."[21]

Granted, it begs certain questions to compare Duncanson's landscapes, which were painted in the style of the white, urban-based, bourgeois Hudson River School, to the "sorrow songs" of rural black slaves. The spirituals were produced collectively rather than individually. They were freely exchanged, not privately commissioned or traded at market. Their audience was the slave community, not the middle class. And as W. E. B. Du Bois, John Lovell, Jr., and other ethnomusicologists have demonstrated, the function of the spirituals was militant, whatever their appearance to the contrary. Certainly these are noteworthy differences. But my claim is not that Duncanson's landscapes, almost all of them halcyon depictions of smiling, fructuous, benign nature, were *equivalent to* the slaves' double-coded songs about

the Promised Land. It is instead that such songs formed an unavoidable *context for* an African-American artist working in Cincinnati and Detroit, two hotbeds of abolition and stations of the Underground Railroad, during the crisis years of the American slave system and in the subsequent crisis years of Reconstruction.[22]

Thus, even though the typical components of Duncanson's style derived from his Hudson River School predecessors and look almost exactly the same as theirs, his use of them is in the end different because of the ways in which *he* was different from them, his root culture different from theirs. Du Bois speaks of "the Veil" that masks "the souls of black folk" from the prying or indifferent eyes of whites.[23] Having started off as an itinerant mulatto handyman who lived in unavoidable proximity to the black folk, Duncanson was in a position to lift the Veil and look inside; moreover, as a black man in the eyes of white society and its civil codes, he was actually in the lifelong position of already being inside the Veil and looking out at a white world that could never fully be his. This is not to say that he painted, therefore, "black" landscapes, which in some essentially immanent and concretely discernible manner are distinct from the landscapes painted by whites. But it is to say that when an artist socially construed as being black paints in the style developed by whites, it no longer means the same thing.

My argument here is analogous to the argument that, although the slave spirituals derived from Anglo-Saxon Protestant hymns transported to America by white settlers and sung at frontier re-

vival meetings, they acquired new meanings in a new context of usage. The slaves often sang the same words and tunes as the white pioneers, but under the conditions of the cotton field the inflections and coding were radically altered.[24] In similar fashion, Duncanson may have appropriated "white" landscape language and recoded it accordingly. He may even have done this with a parodic intent, one that was altogether undiscernible to his white patrons. This would be similar to what is known in African-American folklore as *signifyin'*, a term that refers to slyly double-coded speech or behavior. An individual is signifyin' when the words or actions mean one thing to outsiders and something different, often humorously antithetical, to those on the inside.[25]

The fact that Duncanson's paintings were seen and bought almost exclusively by members of the white middle class surely does not preclude the possibility that at some level the artist envisioned his most understanding viewers as black and used his art as a way of communicating or, more accurately, *communing* with them in their literal or figurative absence. That is, the lack of an external African-American audience for Duncanson does not mean that such an audience was not profoundly internalized at every stage of his art production.

If Canaan meant Canada to the slaves, did Canada mean Canaan to Duncanson? Maybe. At least, in Malcolm X's terms, it was not Mississippi. What is likely is that all the landscape sites the artist painted, whether in Canada, Michigan, Minnesota, Ohio, Scotland, or Italy, conveyed freedom to him of one kind or another: freedom from the

disdain or indifference of the white community to which he could not belong and from the ignorance and jealousy of the black community to which, as an upwardly mobile mulatto, he may not have wanted to belong.

Probably no painting of Duncanson's is more a depiction of Canaan than his *Landscape with Rainbow* (1859, fig. 66). While cattle loll in the middle distance beside a tranquil river or lake that mirrors an arbored hillside in its depths, a spectral rainbow arches up one side of the composition and falls in soft diffusion at the other. The sky is a pale, aqueous green above the horizon and then deepens in blue at the higher reaches. One plump white cloud hovers overhead like a sheep grazing in the sky, while another cloud, a whispy filament, streaks diagonally from left to right. Far below, a bar of light angled in the same direction races across the foreground, spotlighting shallow waters of a stream and richly painted passages of groundcover and top soil. Amidst all this pastoral splendor, two small figures arm in arm, a boy and girl, bound forward as though astonished that the world could actually be this beautiful.

This is the American Adam, to be sure, with an American Eve by his side. The painting fits neatly within the nineteenth-century cultural paradigm described by R. W. B. Lewis of new men striking out into a new land in a spiritually regenerative fashion.[26] The biblical tale of Adam admiring creation must have been ideologically appealing to blacks in search of equality as much as it was to whites in search of opportunity. But there is something more to this painting than Eden before the Fall. This is not a picture of paradise-to-be-lost, but rather of paradise regained. Rainbows appear after a storm, not before. In the book of Genesis, God makes a covenant with Noah for his faithful endurance throughout the travails of the flood. The

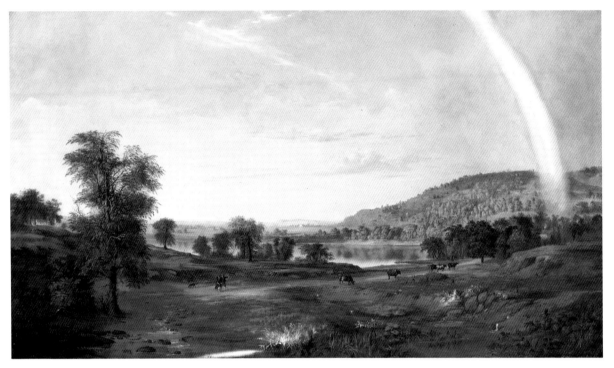

66. Robert S. Duncanson, *Landscape with Rainbow*, 1859. Oil on canvas, 30⅛ × 52¼ in. National Museum of American Art, Smithsonian Institution, Washington, D.C. Gift of Leonard Granoff.

sign of this covenant is a rainbow: "And it shall come to pass, when I bring a cloud over the earth, that the bow shall be seen in the cloud: and I will remember my covenant, which is between me and you and every living creature of all flesh; and the waters shall no more become a flood to destroy all flesh."[27]

Joyously transporting themselves through a valley at the edge of peaceful waters, the two figures are opposite in mood to those slaves of long ago, the Children of Israel, who had mourned, "By the rivers of Babylon, there we sat down, yea, we wept, when we remembered Zion."[28] But then this is a depiction of arrival in Zion, not exile from it. The Israelites were sustained throughout their long years of bondage by recalling freedom and its contours, keeping it firmly in mind. To recall something is to picture it. *Landscape with Rainbow* is similarly a picturing of freedom, making it visible in order to sustain strength in the face of its absence.

Again, one might object that Duncanson, a northern black, had his freedom all along, as did his white patrons and middle-class audience: to describe the work as depicting redemption from slavery would thus be to falsify whatever it is that it might have meant to the artist and his contemporaries. But there is no denying that in 1859, two years short of the Civil War, freedom and slavery were very much on the minds of Americans regardless of their class or color. The real falsification would be to overlook such a fact.

Also, as noted already, to be black in the antebellum North—prohibited by law from voting or testifying in court, barred from workshops and unions, residentially restricted, socially shunned —was hardly what most people today or then would think of as being free. Light-skinned mulattoes such as Duncanson may have fared better in the North than dark-skinned blacks, but as Harriet Wilson bitterly charges in *Our Nig* (1859), her autobiographical novel about a free mulatto woman in the North, "slavery's shadows fall even there."[29]

Duncanson, remember, is said to have spent his boyhood in Canada, where presumably he was not subject to the racial prejudice he surely encountered after moving to Cincinnati at the onset of adulthood. At this particularly personal level, then, *Landscape with Rainbow* might also be a nostalgic work, as much about a past as a future paradise. Looking both backward and forward, it is like the two-legged rainbow itself, seeming to travel in opposite directions at once. A rainbow is a bridge: it spans a great distance, linking remote areas, opposing shores, far-off places—or times. At least this is how Wordsworth treats it in "My Heart Leaps Up," a celebrated poem that Duncanson, a devoted reader of English romantic poetry, surely knew:

My heart leaps up when I behold
 A rainbow in the sky:
So was it when my life began,
So is it now I am a man,
So be it when I shall grow old,
 Or let me die!
The child is father of the man;
And I could wish my days to be
Bound each to each by natural piety.[30]

"My heart leaps up" describes the mood of the painting, so different from that of preromantic works such as Rubens's *Landscape with Rainbow*

67. Pieter Brueghel the Elder, *Landscape with the Fall of Icarus*, c. 1558. Oil on canvas,
28⅞ × 44⅛ in. Musées Royaux des Beaux-Arts, Brussels
(Photo: Giraudon/Art Resource, New York).

68. Pieter Brueghel the Elder, *Land of Cockaigne (The Fools' Paradise)*, 1567.
Oil on wood, 20½ × 30¾ in. Alte Pinakothek, Munich.

(c. 1636), in which peasant haymakers and drovers labor and flirt oblivious to the natural splendor arching overhead. The poet recalls the rapture in nature he experienced as a child, asserts that he is still capable of such wonder, and at first declares, but then more tentatively wishes, that this sense of wonder will never cease. As the rainbow connects earth to sky and earth to earth, a continuing love of nature would connect childhood, adulthood, and old age: "The child is father of the man."

Wordsworth's adage with the familiar Freudian ring gives us license—if not prompting—to read Duncanson's *Landscape with Rainbow*, and by extension his other works, as attempts to recover long-lost childhood bliss and unification with an absent or outgrown parent. Regardless of whether the small-scale figures in any given Duncanson landscape are young lovers, brother and sister, companions out fishing, or tourists on the stroll, there is always enough of a size difference between them to suggest an age difference as well. And even when there is a third figure close at hand, two of them in particular form a pair. Happy and at ease in an outdoor setting virtually mythological in its splendor, these Duncanson couples, no matter what the putative gender arrangement, carry on a tryst of primal proportions. Whatever the combination, one is tempted to see here an artist's attempt at recreating himself by recreating a childhood, real or imagined (in Nietzsche's terms, *invented*), in which he and a trusted, beloved adult, perhaps his father, strode together confidently through a harmonious world or simply stood back to gather it in.

What characterizes all of Duncanson's figures in the landscape is their leisure. They never work. From the time of Pieter Brueghel in the mid-sixteenth century, a standard device of landscape painting has been to show ploughmen in the fields, reapers at the harvest, shipmen unloading cargo, solemn hunters, stolid herdsmen (c. 1558, fig. 67). Brueghel's famous satire *The Land of Cockaigne* (1567, fig. 68) in fact makes fun of idlers on the land, who are shown sleeping off their gluttony and sloth in a Canaan of milk and honey where a meaty egg runs about with a spoon inside, a cooked chicken obligingly lays itself down on a dinner plate, and a pork waddles along with a carving knife hacked into its flank.

Duncanson will have no part of the ethos of feudal labor: his natural paradises are exclusively for looking or fishing, never for toil. One of his early paintings, a genre scene known as *The Drunkard's Plight* (1845, fig. 69), seems not so much to satirize the lazy indulger, à la Brueghel, as to show sympathy for his situation: the wife of a ragtag drunk howls at him from a distance, an attractive young lady smirks at him, and a jug of wine, his only source of peaceful oblivion, lies shattered at his feet. This painting can certainly be viewed as a moralistic admonition against drunkenness or as a crude piece of satire mocking a village drunk, and I would not argue against any such reading, but I do find myself wanting to see it also from the hapless drunk's point of view, the point of view, that is, of the town pariah, misfit, outsider. He may not be looking at that white-sailed ship gliding across the bay, but its very presence makes me think that he would probably just as soon be on it.

Whereas other Hudson River School painters might fill in the odd corner of their landscapes with a shepherd tending his flock, a woodsman felling a tree, or even an artist industriously sketching the

scene before him, Duncanson methodically rejects every sign of work. His landscapes portray a world in which work is not necessary, a world in which nature itself makes one drunk, but without harm, penalty, or disapproval. Duncanson's landscapes may be no less imbued with morality than those of the other Hudson River School painters, but the morality of his paintings, I contend, privileges carefree leisure in a way that the high-toned works of such eminent Victorians as Cole, Durand, and Church never could. In Durand's *Kindred Spirits* nature is treated as the inspiration for a Sunday school sermon. In Church's *Twilight in the Wilder-*

ness it serves as an emblazoned sign of God's blessing upon America. In Duncanson, nature is much less the occasion for rectitude and national pride than for sheer, unadulterated sensuous pleasure.

❖

The theme of leisure is most explicitly addressed in the work that Duncanson's contemporaries considered his greatest accomplishment, *Land of the Lotos Eaters* (1861, fig. 70).[31] At the same time,

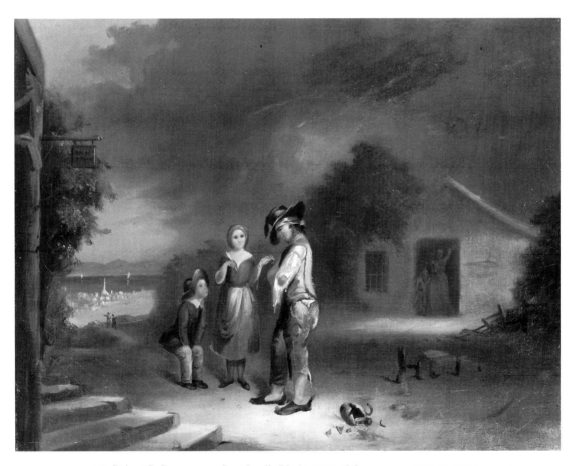

69. Robert S. Duncanson, *Drunkard's Plight*, 1845. Oil on canvas, 15¼ × 19¾ in.
Detroit Institute of Arts. Gift of Miss Sarah M. Sheridan.

70. Robert S. Duncanson, *Land of the Lotos Eaters*, 1861. Oil on canvas, 52¾ × 88⅝ in.
Swedish Royal Collections, Stockholm.

71. Frederic Edwin Church, *Andes of Ecuador*, 1855. Oil on canvas, 48 × 75 in.
Reynolda House, Museum of American Art, Winston-Salem, North Carolina.

72. Frederic Edwin Church, *Heart of the Andes*, 1859. Oil on canvas, 66⅛ × 119¼ in.
Metropolitan Museum of Art, New York. Bequest of Mrs. David Dows.

the painting draws upon other thematic and formal elements we have discussed: bodies of water intervening between one place and another, the land of milk and honey, the encounter of races. Virtually unknown today (it belongs to the Swedish royal collection), *Land of the Lotos Eaters* is perhaps Duncanson's fullest reflection on passing, paradise, and racial origins.

The painting's subject derives from Lord Tennyson's popular poem "The Lotos-Eaters" (1832; rev. 1842) and its style from the Latin American landscapes of Church. Painted on the horizontal like *The Andes of Ecuador* (1855, fig. 71) or *Heart of the Andes* (1859, fig. 72), the latter an especially acclaimed work seen by admiring crowds in several antebellum cities, including Cincinnati, *Land of the Lotos Eaters* similarly offers a panoramic view of a lush, tropical land overgrown with exotic foliage, beribboned with rivers and streams, and enclosed by stunning mountain peaks. Church's painting was so dazzling in its range of detail, every element near and far nailed down with hypernatural precision, that spectators took to viewing it at a distance through opera glasses in order to experience the work optically, as though they themselves had been magically transported to the foot of the Andes.

Duncanson strives for similar effects in *Lotos Eaters* and, considering its popularity, he successfully adapted Church's pictorial manner to his own. Yet, as Joseph Ketner has pointed out, "*Lotos Eaters* does not convey the formidable and primeval qualities that make Church's painting so overwhelming. The greatest distinction between the paintings is the sharp detail and veracity of the landscape forms that Church derived from observation. Duncanson's trees, ferns, and cliffs, on the other hand, have a blatantly fanciful quality of motifs taken from other art, not nature."[32]

In landscapes such as *Blue Hole*, painted a decade earlier, Duncanson had amply demonstrated his ability to represent nature naturalistically, so if the setting of *Lotos Eaters* is "blatantly fanciful," perhaps this is because the very subject of the painting is a land of fancy, a world to be found only in the imagination. To have employed the representational devices associated with Hudson River School realism would have been to give over to exactly the sort of prosaic fact-gathering that the painting, following Tennyson, eschews. What so captivated Victorians when confronted with an undertaking such as *Heart of the Andes* was the awesome diligence and meticulousness of the artist. Though the scene was set far from urban industrial civilization, Church's work—how apt the term—demonstrated an ethos of hard labor on the part of the artist. Moreover, in its thousands upon thousands of intricate, cleverly intermeshed brushstrokes, it embodied the spirit of modern engineering and industrial production. By contrast, *Land of the Lotos Eaters*, with its dearth of close observation, comparatively loose construction, and broadly rendered passages, might seem even the product of an idle hand, a hand more dilettante than diligent.

From nearly halfway up the composition, a tropical river winds around groves of palms, tumbles down a rocky shelf, and broadens into a shallow pool that flows forward to the bottom of the canvas. This river divides the picture in two. The lefthand side, containing a narrow margin of shore compressed beside tall cliffs and an overgrowth of fronds and flowers, is dark and inhospitable

in relation to the spacious lawns, groves, and inlets on the right. There, near the foreground, a handful of epicenely slender, long-haired, nearly naked light-brown figures proceed in single file toward the water, which several of their compatriots have already crossed as still others are in the process of swimming or wading. They greet a band of Europeans who have disembarked from a serpent-headed craft. The leader of the Europeans reaches for a garland of lotos leaves offered to him by the foremost native. Apart from this encounter of humans, all the action in the painting is to be found in the various-paced movements of atmosphere, water, and light described by Tennyson: "The languid air did swoon, / Breathing like one that hath a weary dream. / . . . And, like a downward smoke, the slender stream / Along the cliff to fall and pause and fall did seem."[33]

Tennyson's poem, based on book 9 of *The Odyssey*, tells of the encounter between Ulysses' sailors, whom he urges onward to Ithaca, and the peaceful, idle Lotos-eaters. Tasting the nectar of the lotos plant, the sailors lose their desire to return to civilization and the unremitting toil it entails. "Should life all labor be?" they demand. "Is there any peace / In ever climbing up the climbing wave?" "Let us alone," they beg of their captain: "Surely, surely, slumber is more sweet than toil." The poem thus amounts to a protest against what one Tennyson scholar has called "the restless accumulation of the European system and its purposeful and compelled labor."[34] Instead of putting forth the sense of purpose, of utilitarian self-will, embodied for Victorians by Homer's Ulysses (who drags his men back to the boat despite their pleas to remain), "The Lotos Eaters" tallies up the miseries induced by the bourgeois ethos of continual work, responsibility, and deferred gratification.

Given what we have seen of Duncanson's landscapes and what we have construed to be his personal concerns as well as the collective concerns of the disparate social groups to which he belonged (or wished to belong), no wonder he was drawn to Tennyson's attack on the Western work ethic. And although Tennyson was surely not alluding to African-American slaves when he spoke of "an ill-used race of men that cleave the soil, / Sow the seed, and reap the harvest with enduring toil," in the context of 1861, the year a free mulatto from an abolitionist border town on the cusp of slave territory chose to paint from the poem, these very lines would have been applicable indeed to the American system of compelled labor still very much in force.

Inspired by a trip through the Pyrenees, Tennyson describes a landscape of snow-capped mountains and shadowy pines. In Duncanson the setting is drastically changed to the equatorial tropics. This can be explained by reference to Church, who had so recently made swampy, tropical settings the vogue.[35] But it can also be regarded as a politically significant transposition from Tennyson's Europe to an imaginary third-world locale: Latin America, the West Indies, or, of special relevance to Duncanson's community and kin, Africa. By setting the scene in the tropics, Duncanson converts a poem that contrasts two economic systems into a contrast of races as well, with Europeans on one side and equatorial natives on the other. Duncanson's maternal ancestors had been kidnapped and brought to America in a context precisely such as this, in which white men from far away descended upon native people in their

homeland and—in the step not shown—abducted them across the sea.

Generally, slave traders preferred to take their prisoners from the agrarian tribes of West Africa because these villagers were considered peaceful and sedentary and thus easier to capture than were nomadic warriors of the hunter-and-gatherer type. Also they were thought more adept at the ways of land cultivation for which they were being exported.[36] To the extent that *Land of the Lotos Eaters* can be reconceived as a perversely idyllic image of the primal moment before the African's fall into slavery (or, conversely, the European's fall into slave-taking), the artist's Lotos-eaters would seem to stand in for the peaceful, agrarian, but nonaccumulative West African forebears of Duncanson and his fellow African-Americans.

In depicting the moment of encounter between European civilization and third world or aboriginal culture, *Land of the Lotos Eaters* is reminiscent of various "landing of Columbus" scenes popular in the mid-nineteenth century, in which effeminate and docile West Indian islanders greet the European newcomers either with open arms or dumbstruck wonder. Today the best-known of such works is probably John Vanderlyn's *Landing of Columbus* (c. 1840, see fig. 30), commissioned for the Capitol rotunda in Washington, although in the nineteenth century a number of widely diffused prints made hay with the subject (fig. 73). A variation of the theme circulated in representations of Captain Cook and his men touching land in the South Seas. Such images treated the advent of colonization from the point of view of the colo-

nizers. Even Tennyson's poem, though valorizing what it takes to be the natives' point of view, is seen through the eyes and uttered through the lips of Europeans, however discontent.

Duncanson, on the other hand, privileges the Lotos-eaters, devoting considerably more space to them and their land than to the visitors from abroad, whom he literally relegates to a margin. His too is an image of incipient colonization, but in the case of Ulysses, unlike those of Columbus and Cook, the colonization never takes place. The two races meet but do not battle, and, particularly relevant to a child born of mixed races, they do not mingle. That the term *miscegenation* was coined in America in the early 1860s reminds us that the mingling of races was more than a matter of this one artist's strictly personal concern (fig. 74).[37] But neither should his personal concern be ignored. In Duncanson's case, the encounter of races represented in the painting could be seen as the meeting *within him* of Eurocentrism (symbolized not only by his white ancestry but by his devotion to English literature, European scenery, and the Hudson River School style of painting) and Afrocentrism (symbolized by his black ancestry and the visions of Zion, or crossing the river Jordan, that his landscape paintings share with the slave spirituals of the time). In *Land of the Lotos Eaters*, the encounter between opposing cultures is perfectly peaceful—a fantasy projection indeed in terms of world history, but also in terms of Duncanson's own difficulty in reconciling such disparate influences.

Among African-Americans of Duncanson's era, it was common to wonder if leaving America to move "back" to Africa could restore the plenitude that was thought to have been lost in the slave diaspora. Given that talk of this virtually buzzed through the air of free black communities, *Land*

73. Nicolas Maurin, *Columbus Builds a Fortress*, c. 1845. Lithograph.
Cabinet des Estampes, Bibliothèque Nationale, Paris.

of the Lotos Eaters could be seen as depicting the primal moment before the Africans' fall into slavery, the moment when, like the Lotos-eaters in the painting, they innocently passed out of paradise into the clutches of their future oppressors. But such debates also entailed claims that black Americans immigrating to Africa would be bearing to their African sisters and brothers the torch of Western enlightenment. As former President Jefferson had speculated, "The establishment of a colony on the coast of Africa . . . may introduce among the aborigines the arts of cultivated life, and the blessings of civilization and science."[38] Duncanson's painting might be said to envision this version of cultural encounter as well (the west-

erners that arrive from the left serving as a trope for the colonizing African-Americans). Even if none of the artist's contemporaries viewed the painting in such specifically allegorical terms, its depiction of cultural and racial encounter partakes of the language and symbols of the back to Africa discourse that permeated various levels of African-American society during this time.

Not only did many blacks call for a return to Africa, but so too did those whites, Jefferson among them, who believed that America's racial problems could be solved by such so-called repatriation. Many of these whites worried that the emancipation of southern slaves would inundate the North with "a horde of Africans," to use the

74. *Miscegenation Ball*, 1864. Lithograph by Kimmel & Forster. Library of Congress.

words of an Ohio congressman who feared that his home state would become "Africanized" by "this lazy, ignorant . . . class."[39] Certain wage-paying manufacturers in the North, resenting the non-waged system of the South because they thought it unfairly disadvantaged them, sought to deprive southern competitors of their labor force by expatriating it to another continent. Meanwhile white laborers, many of them much more recent arrivals to the United States than the blacks they insisted be shipped to Africa, feared that newly freed slaves would take their jobs. They thus tended to favor the conventional view of African-Americans as inherently lazy lotos-eaters.[40] As one commentator had written about Mount's popular genre painting *Farmers Nooning* (1836, fig. 75), "How lazily lolls the sleeping negro on the hay [while] the white

laborers are naturally disposed about with their farming implements."[41]

The supposed humor of this imagined incident, which was widely circulated through inexpensive engravings, was repeated in such works as James G. Clonney's *Waking Up* (1851, fig. 76), in which prankish white boys tickle the face of a caricatured black man who slumbers while fishing from a rock at the edge of a lake, and Clonney's *Fishing Party on Long Island Sound* (1847, fig. 77), wherein a white lad industriously tugs at the line he has dropped while his young black counterpart snoozes away the day. (By painting *his* idle fishermen white rather than black, Duncanson may have been hoping to circumvent such invidious stereotyping and still speak to African-American dreams and desires.) After the Civil

75. William Sidney Mount, *Farmers Nooning*, 1836. Oil on canvas, 20¼ × 24½ in.
Museums at Stony Brook, New York. Gift of Frederick Sturges, Jr.

76. James G. Clonney, *Waking Up*, 1851. Oil on canvas, 27 × 22 in.
Museum of Fine Arts, Boston. Karolik Collection of American Paintings.

77. James G. Clonney, *Fishing Party on Long Island Sound, Off New Rochelle*, 1847.
Oil on canvas, 26 × 36½ in. Thyssen-Bornemisza Collection.

War, popular art perpetuated the stereotype with countless mass-marketed lithographs (fig. 78), sheet music covers, and political broadsides, such as one from 1866 (fig. 79) condemning the newly established Freedman's Bureau: on the left, white yeoman farmers labor beside a caption that reads, "The white man must work to keep his children and pay his taxes," while on the right, a grossly caricatured black man lolls about under the dialect caption, "Whar is de use for me to work as long as dey make dese appropriations?" By invoking Tennyson's poem, with its authoritative criticism of bourgeois toil and accumulation, Duncanson's painting may have been not so much a denial of the charge that native peoples were lotos-eaters as an implicit questioning of the dominant ethos of ceaseless labor.

In 1863, in an effort to distinguish themselves from the masses of black freedmen flooding the city in search of jobs, Washington's leading Negroes formed an exclusive social organization they named the Lotus Club. The allusion—to Duncanson perhaps but to Tennyson certainly—seems to celebrate indolence as a virtue rather than as a demeaning racial trait. It is not clear today whether the club members, in referring to themselves as lotos-eaters, were self-consciously mocking white notions of black laziness or if they were simply trying to signal status superiority to their lower-class racial brothers and sisters who could not afford the genteel "laziness" associated with membership in an exclusive club.[42]

In either case, we must realize that Duncanson's *Land of the Lotos Eaters* was anything but cut-rate Church and "slavish" imitation of the latest Hudson River School style. Regardless of the work's undeniably white lineage, it is black in origins as well. Intimately, if covertly, it responds to such vital metaphors of the black communities of the time as the crossing over to freedom (or, in this instance, to slavery); the encounter of races or, within the race, of classes; and the dichotomy between idleness and work.

❖

In the northern states, the stereotyping of blacks as lazy and uncivilized lotos-eaters worked to the advantage of various social groups that stood to gain from keeping these potential labor and business competitors in their place—that is, out of competition. Similarly in the South, the equivalent stereotype, that of Sambo, fulfilled political and ideological functions. David Davis explains that ever since antiquity societies have characterized slaves as lazy and irresponsible in order to justify the compelled subservience of these workers to their masters, who may thereby claim to provide their charges with well-being they would be incapable of achieving for themselves. According to John Blassingame, the Sambo figure of the southern plantation grew out of white Americans' entrenched belief "that Africans were ignoble savages who were innately barbaric, imitative, passive, cheerful, childish, lazy, cowardly, superstitious, polygamous, submissive, immoral, and stupid." Blassingame quotes a Louisiana physician who describes Africans as "endowed with a will so weak, passions so easily subdued, and dispositions so gentle and affectionate"—as good a description as one could want of the Tennyson/Duncanson Lotos-eaters—that they have "an instinctive feeling of obedience to the stronger will of the white man."[43]

As heinous as the Sambo convention may have

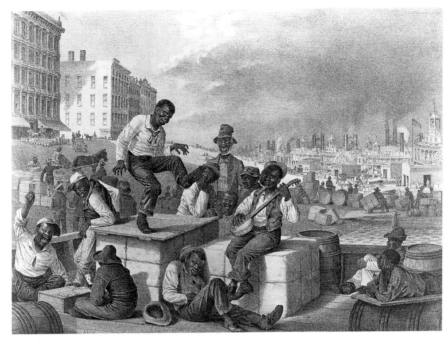

78. *Scene on the Mississippi*, 1878. Lithograph published by
W. J. Morgan & Co. Library of Congress.

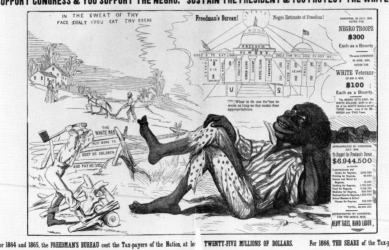

79. *The Freedman's Bureau! An Agency to Keep the Negro in Idleness at the Expense of the
White Man*, 1866. Broadside from a Pennsylvania congressional campaign. Library of Congress.

been, at times it worked to the advantage of slaves, who may have "shuffled" and enacted stereotypical ignorance as a means of fooling their masters, thus forcing work slowdowns that served their interests while forestalling the repercussions such resistance might otherwise have incurred. Assuming the indolent persona that was condescendingly attributed to them by the master class, such Sambos made use of one of the few weapons available to them, waging with it a psychological warfare against their owners. To use a twentieth-century term, these slaves were signifyin'.

We saw examples above of spirituals in which phrases like "freedom," "crossing Jordan," and "going to Canaan" sounded to white listeners like passive resignation whereas to the singers themselves such phrases encouraged and sustained mental resistance. Putting on the characteristics of Sambo was for some slaves another type of signifyin'. As noted, signifyin' is often a parodic activity, a repetition of the master's trope, but with a slyly humorous—if also serious—intent. In a nonslavery context, the name Lotus Club might have been chosen by members as a way of signifyin' upon white stereotypes of black idleness. Similarly, Duncanson's paintings may have been instances of signifyin' even if they were never seen by another African-American; it does not matter, so long as Duncanson himself, *as an African-American*, was capable of understanding them in this light.

His paintings showing the indolent enjoyment of nature may have constituted, that is, a sort of Hudson River School Samboism. The product of a black man, they celebrated an agreeable, nonthreatening idleness: boys fishing at the Blue Hole, a young couple frolicking before a rainbow, lotos-eaters fording a lazy river. Yet, especially to viewers who did not know the artist was an

African-American, these works sidestepped the stereotypical association of blacks and laziness by featuring figures that were clearly white or, in the case of *Lotos Eaters*, quasi Indian. In fact, in the only landscape painting by Duncanson that features a black figure, his *View of Cincinnati from Covington*, white children picnic and promenade, while the industrious black farmer they encounter on the road sets down his scythe only long enough to reply to their inquiries (the farmer's wife, in the distance, hangs out the wash behind their cabin). Noteworthy is the color of this farmer, probably the only actual laborer Duncanson ever depicted. The daguerreotype that Duncanson used as the basis for this painting reveals that the artist deliberately substituted a black man with a farm implement for a white man with a walking stick, as if to make a point, however subtle (which is to say, cautious), that African-Americans were industrious folk, all conventions of laziness aside.[44]

If one were to consider Duncanson's pale figures in the land as blacks in disguise, camouflaged by him for whatever political necessity, then what such works would seem to signify is not so much an acceptance or rejection of the laziness stereotype as a revision of it, construing idleness as a blessed state. As Tennyson's poem implies a criticism of, or at least a weary dissatisfaction with, the Victorian will to power, Duncanson's paintings envision in utopian fashion an alternative to the Jacksonian obsession with material success: both derive from a larger and older romantic discourse against worldliness. This is not to say that these paintings did not appeal to hardworking, self-made businessmen

such as Duncanson's patron, Nicholas Longworth, but rather that even the most fully certified members of the bourgeoisie found that there was some great, immeasurable entity or state of mind that the mere accumulation of capital failed to secure, a connectedness to nature and abeyance of time that an art of laziness appeared able to provide.[45] Such a romantic notion was embodied, for instance, in Coleridge's "Kubla Khan" (1816, begun 1797), with its "stately pleasure dome" and its hypnotic intonations about him who "hath . . . drunk the milk of Paradise."

Surely no Marxist or any other type of systematic social critic, Duncanson nevertheless offers, by way of the sheer physical attractiveness of what he presents, an implicit criticism of the nature-defying, time-constricting, money- and real-estate-focused world of capitalism. In this regard his work resonates not only with the largely apolitical romantic critique advanced by such artists as Wordsworth, Coleridge, and Tennyson, but also with the specifically political critique of bourgeois society contained in the early writings of Karl Marx, who envisioned a future in which laborers would no longer be alienated from the products of their labor and could afford to work at a humane pace that allowed time for the enjoyment of art, nature, and human society. These landscape paintings, to borrow the title of a book by Marx's son-in-law Paul Lafargue, proclaim "the right to be lazy."[46]

Duncanson may not have been a systematic social critic, philosopher, or utopianist, but insofar as his work addresses the concerns of his own social class in relation to those of competing classes, he was an intellectual in the Gramscian sense. "Each man," writes Antonio Gramsci, "carries on some form of intellectual activity, that is, he is a 'philosopher,' an artist, a man of taste, he participates in a particular conception of the world, has a conscious line of moral conduct, and therefore contributes to sustain a conception of the world or modify it, that is, to bring into being new modes of thought." Gramsci distinguishes between "traditional" and "organic" intellectuals. The former constitute a professional or priestly class of their own and have become alien to their class of origin, whereas the latter remain well within the orbit of their original class and seek, in one form or another, to articulate its interests. The organic intellectuals are similar to what Du Bois called "the Talented Tenth": "the Best of this race that . . . guide the Mass away from the contamination and death of the Worst, in their own and other races."[47]

The case I have been making for Duncanson amounts to conceiving of him as one of the Talented Tenth, as an organic intellectual who draws together in his work various, often rival, African-American points of view: black and mulatto, slave and free, southern and northern, Afrocentric and Eurocentric. Even if his art was motivated by an effort to resolve issues that were entirely personal and painterly rather than social, these personal and painterly problems, as we have begun to see, were inescapably linked to larger social concerns.

To view Duncanson's work exclusively in terms of Hudson River School painting is perforce to regard it as derivative, secondary, imitative (a term commonly used to describe Sambo, the black monkey). But this is not the case if we trace the African-American coordinates of the work. The purpose is not to elevate Duncanson's art from the debased category *imitative* to the esteemed

one *original*—which is a chimera in any case—but rather to understand how a body of work that was produced in the interstices of black and white society in antebellum America could give plastic form to immaterial hopes, dreams, and fears. More specifically, in the context of a ruthless ideological assault on black Americans—slave or free, dark or light—as an innately shiftless group of people whose proclivity toward indolence represented a drag on Anglo-Saxon initiative, Duncanson's celebration of carefree idleness in the heart of nature amounts to an ideological counterpunch.

As James Horton has argued in regard to black participation in the Jacksonian-era ethos of self-reliance and competitiveness, "Individualism may have been an unaffordable luxury for blacks. Competitiveness may have been seen as counterproductive. There were certainly individualistic black men and women, but the value of such traits may have been tempered by the pressing need for a cooperative communal spirit." Horton cautions against assuming that antebellum black Americans had a stake in the so-called American dream of material success for oneself and one's immediate circle: "To view Afro-Americans as simply one more group of Americans competing for part of a dream created by those whose social vantage point was substantially different, is to oversimply and, I believe, to misread the thrust of two centuries of black struggle." Whatever Duncanson's personal and professional ambitions may have been, his landscape art reminds us that in his era there were other dreams at hand besides the so-called American one of laboring obsessively on behalf of material accumulation.[48]

In claiming that Duncanson's painting was congruent with a certain anticompetitive, anticapitalistic point of view rooted in African-American communalism, I must emphasize that this is not

the same as to claim that Duncanson himself was a champion of the black cause and a warrior against capitalism. To the contrary, the case could easily be made that he was a Jacksonian individualist par excellence, a humble mulatto handyman and housepainter who became an international celebrity by dint of hard work and native talent: Emerson's self-reliance carried to perfection. In fact the artist took great pride in what he had accomplished: in a letter written at the end of his life he stated, "I have toiled hard, and have earned and gained a name and fame in my profession second to none in the United States."[49]

And yet in actuality Duncanson no more succeeded on his own than anyone ever does. He relied for his success on patrons such as Longworth and a variety of other leading abolitionists as well as on fellow artists such as William Sonntag, with whom he traveled, worked, and shared ideas. Being white and well known in their time, these supporters are fairly well documented. But surely there were other supporters, too, who were equally crucial to Duncanson's success, the members of his immediate community. Because they were black, however, their lives went relatively undocumented, and their identities have thus remained historically invisible. Duncanson himself was not quick to acknowledge them. "What have the colored people done for me?" he inquired testily of a relative who made noises about the artist passing himself off as white. Yet in the same letter he avers, "My heart has always been with the down-trodden race." From this letter, one of the only surviving documents from Duncanson, it

is not clear—perhaps because it was not clear even to himself—to what extent he identified with African-Americans and conceived of them as composing his core community. If his art, with its small groups of youthful figures lazily enjoying the beauties of nature, embodies an alternative to romantic individualism and its economic counterpart in Jacksonian competitiveness, it does so not because Duncanson was immune to the individualist ideology but, to the contrary, precisely because he was torn between it and the rival communitarian ideology that thrived among a people to whom, like it or not, he was juridically as well as emotionally bound.

In the eyes of the law, this is to say, Duncanson was black no matter how white he may have looked or how white his various patrons, sponsors, and colleagues may have been. Until the ratification of the Fourteenth Amendment in 1868, he was not even a citizen of the United States. During the Civil War he stayed well clear of Cincinnati, a town menaced by Confederate attack and embroiled in renewed racial strife, including clashes by free blacks and immigrant Irish over employment. Detroit was no more congenial. In 1863 a race riot erupted among draftable whites, who cried, "If we are got to be killed up for Negroes then we will kill every one in this town." A black witness to the event recalled that "to human appearance it seemed as if Satan was loose, and his children were free to do whatever he might direct without fear of the city authority." Thus it was to Canada to which Duncanson, in the words of a contemporary account, "repaired," for that was a

place where "his color did not prevent his association with other artists and his entrance into good society."[50]

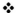

In 1865 Duncanson departed from North America altogether for an extended visit to England and Scotland. Feted by antislave aristocrats, he exhibited *Land of the Lotos Eaters* with notable success and even received what was rare, an invitation to visit Lord Tennyson on the Isle of Wight. Although he returned to the United States in 1867, he visited Scotland once again, perhaps twice, before his death in 1872, the rugged Highlands providing the setting for several poignant late landscapes.

One of these, *Ellen's Isle* (c. 1870, fig. 80), resembles John Kensett's *Lake George* (1869, fig. 81) of a year earlier.[51] Again, to view Duncanson strictly in art-historical context, he is derivative, a facile imitator. And yet so many of the personal and Afro-cultural themes recurrent in Duncanson's efforts take their place here: a body of water, a crossing to shore, figures at rest, nature ravishing and unadulterated. Sunlight flung from the sky skims through a mountain hollow to a tree-covered island that is reflected in the serene surface of a golden and blue Highland lake. Two skiffs traverse the water. One, bearing a party of voyagers, approaches a foreground thick with the shadows of lingering morning or perhaps of declining day. The figures aboard are too small to be distinguished as to age, gender, or race. Melancholy pervades the work, so much of its golden warmth being subsumed by cool dark blues and greens.

Ellen's Isle in Loch Katrine was the setting of Sir Walter Scott's enormously popular Highland saga *The Lady of the Lake* (1810), but Duncanson was not illustrating Scott's text so much as using it as a launching point, so to speak, for a voyage connected to his personal—but also inevitably

80. Robert S. Duncanson, *Ellen's Isle*, c. 1870. Oil on canvas, 28½ × 49 in. Detroit Institute of Arts.
Gift of the Estate of Razelmond D. Parker.

81. John Frederick Kensett, *Lake George*, 1869. Oil on canvas, 44⅛ × 66⅜ in. Metropolitan Museum of Art, New York. Bequest of Maria DeWitt Jesup.

social—concerns. Although nothing would seem more irrelevant to the problems of Reconstruction-era African-Americans than a sixty-year-old Scottish romance in iambic tetrameter, *The Lady of the Lake* might nevertheless have been more meaningful in this regard than one would assume. To put this another way, the epic, though written for, by, and about whites, may have functioned as a signifyin' text for blacks. Frederick Douglass, after all, took his last name from the rebel hero of Scott's poem. Du Bois, who was born in 1868, tells of memorizing the poem in high school and being so deeply affected by it that it induced him as a young man to travel to the Highlands to see Lake Katrine for himself. Addressing a convention of the National Association for the Advancement of Colored People in 1926, he invoked the natural

beauty and simplicity of Lake Katrine to symbolize the "sort of a world we want to create for ourselves and for all America"—a world devoid of crass commercialism and loud vulgarity. Hence Duncanson's representation of the land of Scott was by no means as gratuitous, out-of-touch, or evasive of African-American communal discourse and social concerns as might at first appear.[52]

The poem begins with a description of the thrilling pursuit of a great stag by bloodhounds, horses, and hunters: "A hundred dogs bay'd deep and strong, / Clatter'd a hundred steeds along, / . . . A hundred voices join'd the shout; / With hark and whoop and wild halloo."[53] Could African-Americans of the slavery and Reconstruction years have entertained such a description of the hunt without being reminded of an escaped slave chased

through the woods on a race to freedom? The sensational flight from Simon Legree dramatized in countless stagings of *Uncle Tom's Cabin* or similar blood pursuits depicted in such paintings as Thomas Moran's *Slaves Escaping through the Swamp* (1865) merely provided postbellum white audiences with a sense of the terrifying melodrama that blacks or their families and friends had experienced firsthand during the years before emancipation. But whereas the white version of black escape always presented the object of the chase as a pathetic victim, black accounts, as found in various slave narratives, conveyed instead a sense of the runaway's dignity. The white version sought to inculcate pity, the black version pride. Hence the pleasure black readers or listeners might have taken in the dazzling escape of Scott's "noble stag," perceiving in its triumph an analogue to ones of their own.

Such an interpretation, of course, is purely conjectural. There is no evidence that Duncanson, Douglass, Du Bois, or any other African-Americans read *The Lady of the Lake* in the manner suggested. It may be worth noting, however, that Duncanson made a gift of *Ellen's Isle* to Charles Sumner, the Massachusetts senator and antisegregationist who before the war had been the most outspoken congressional opponent to slavery and afterwards was equally belligerent on behalf of civil rights. That Duncanson chose to present him with this particular painting does not indicate that either the senator or the artist viewed it with African-American oppression in mind. And yet can the linkage be purely coincidental?[54]

Another, more personal way in which *The Lady of the Lake* might have been meaningful to Duncanson is that its central character, who calls himself James Fitz-James, is really a king in disguise, James V of Scotland. Duncanson could very well

have fantasized similarities between himself and the historical James V, who reigned from 1512 to 1542. As a child James lost his royal father, who died gallantly in battle. His mother, as regent, fought for control with a rival faction, the Douglas clan, sundering the boy's loyalties. As an adult James enjoyed masquerading among his subjects, passing as one of them—the man was not really a commoner (or, perhaps in Duncanson's case, a Negro) but was only pretending to be one. The epic hero Scott makes of James is not only a valiant hunter and dashing swordsman, but also a great admirer of mountain scenery: "From the steep promontory gaz'd / The stranger, raptur'd and amaz'd." As someone who made a career of seeking out magnificent mountain vistas, Duncanson must certainly have identified with this aspect of Scott's royal hero and his regal, all-encompassing optical experiences: "And thus an airy point he won, / Where, gleaming with the setting sun, / One burnish'd sheet of living gold, / Loch Katrine lay beneath him roll'd."

At another level of family romance, *The Lady of the Lake* tells of a father, the exiled warrior Douglas, and his child, Ellen, who live on an island in the middle of a beautiful lake in peaceful and idyllic communion with nature and with one another. The folkish simplicity of their lives is the antithesis of Douglas's former existence at court amid treachery and deceit. "In this idyll the rules of ordinary life are suspended, and real identities disguised or shed," notes a recent commentary on Scott's epic. "Ellen's Isle has several parallels with the enchanted island of Shakespeare's *Tempest*,

not least in being a place where ancient enemies are brought harmlessly together and through which their quarrel is eventually healed."[55] The applicability of such a narrative to Duncanson's own inner conflicts—as well as to the more public ones facing his nation in the aftermath of the Civil War and exacerbated by the divisiveness of Reconstruction—should be clear.

James, of course, is the hunter who leads the chase for the stag at the start of the poem. To suggest that Duncanson identified with both the pursuer and the pursued is not as paradoxical as it might seem, since the poem itself enacts this shift in focus. But more to the point, what lies behind the interpretation of Duncanson woven throughout this chapter is a view of him as a conflicted figure, doubly identified and thus doubly identifying. Romantic art, whether Scott's or his own, offered the painter an opportunity rarely available to anyone in actual life: the opportunity to be two people, or on two sides, at once.

Duncanson's art, it might then be said, is constructed upon denial. Denial of his separateness from blacks and separateness from whites, from his mother and from his father. Denial also that the ideal, labor-free landscape he depicts was an anomaly in the modern world, where enclosure laws, agricultural capitalism, real estate investment, and urban-industrial encroachment prevailed and promised to do so for generations to come. Works such as *Loch Long* (1867, fig. 82) and *Ellen's Isle* mask with unalloyed beauty the sweeping changes that had been ravaging the Scottish landscape as the so-called Highland Clearances wrested land from independent farmers ("crofters") and turned them into a landless proletariat. Rapid urbanization in response to farm foreclosure and the ruthless demand for cheap factory labor drove Scots off the land into cities that were notoriously unsanitary and overcrowded or sent them abroad to North America, New Zealand, and Australia. The Scotland that Duncanson portrayed as an earthly paradise was in fact a nation undergoing perilous transformation and repeated economic depression. Ironically, the Highland countryside that so attracted him during the 1860s was at the very time staggering from the collapse of the Glasgow textile industry brought on by the blockade of southern cotton during the American Civil War. None of this distress is visible in the idylls Duncanson depicts, paintings that are in their own way Highland masquerades. We might compare them to Thomas Annan's contemporaneous photographs of crowded and constrictive Glasgow tenements (1868, fig. 83), not to counterpose some putative documentary "real" against Duncanson's neoromantic "unreal," but rather to help calibrate the degree to which the rhetoric of these paintings diverged from concurrent rhetorics of social reform.[56]

And yet every denial is also an affirmation, in this case an affirmation through visual art of what the land should be in contrast to what it has become. In the terms favored by the Marxist cultural critic Ernst Bloch, paintings such as Duncanson's could be called "wish-landscapes" or "anticipatory illuminations" of a future worth fighting for. Bertolt Brecht, challenging Georg Lukács's prescriptive claims for social realism, argued that "anyone who is not a victim of formalistic prejudices knows that the truth can be suppressed in many ways and must be expressed in many ways. One can

82. Robert S. Duncanson, *Loch Long*, 1867. Oil on canvas, 7 × 12 in. National Museum of
American Art, Smithsonian Institution, Washington, D.C. Gift of Donald Shein.

83. Thomas Annan, "Close # 118, High Street, Glasgow," 1868. Photograph.
Gernsheim Collection, Harry Ransom Humanities
Research Center, University of Texas at Austin.

arouse a sense of outrage at inhuman conditions by many methods—by direct description (emotional or objective), by narrative and parable, by jokes, by over- and under-emphasis." Conceivably, even Duncanson's Highland fantasies, by means of their shimmering depiction of that which the world denied the vast majority of its citizens, black or white, aroused—or at least had the potential to arouse— that very sense of outrage at inhuman conditions that Brecht refused to credit solely to works of social realism.[57]

Horace Greeley, the New York newspaper editor, abolitionist, and labor supporter who unsuccessfully opposed Ulysses Grant for the presidency in 1872, argued throughout his career against "a system of Land Monopoly, which robs the producer of one-half to seven-eighths of the fruits of his toil; and often dooms him to absolute starvation on the soil which he has faithfully and effectively tilled! The right of owning land is one thing: the right to own thousands and even millions of acres of land is another."[58] If Greeley's editorials mounted a

frontal attack on the monopolization of public land, Duncanson's paintings, produced over the course of the same decades, could be seen as making a similar attack through the back door. Yes, they can also be seen, as I have suggested, as mystifications of land monopoly, hiding from sight its depredations. But a fuller view of the matter would recall that although Duncanson's patronage derived from the landowning middle class (Nicholas Longworth, for example, possessed extensive agricultural holdings), the artist's class of origin and family kinship was with a black underclass that took as its postwar motto the hopeful cry, "Forty acres and a mule!" (1888, fig. 84).

Duncanson seemed to be at the peak of his powers when he publicly exhibited *Ellen's Isle* in Detroit in September of 1871. But he was also profoundly troubled. Only several months earlier he had written the letter, quoted above, in which he protested against a relative's accusation that he was forsaking his race. "I heard today, not for the first time, of your abusive language toward me. . . . You have stated that I have all my life tried to pass

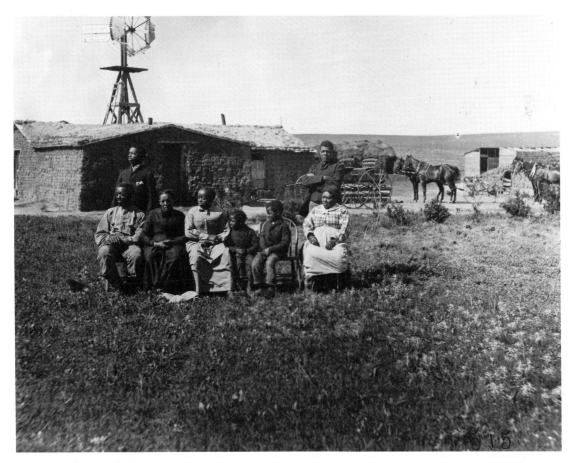

84. Solomon D. Butcher, "Moses Speese Family near Westerville, Custer County, Nebraska," 1888. Photograph. Solomon D. Butcher Collection, Nebraska State Historical Society, Lincoln.

for white. Shame on you! Shame!! Shame!! . . . There are colored persons in this city that I love and respect, true and dear to me. It does not follow that because I am colored that I am bound to kiss every colored or white man I meet. Hogs pick their company, and I have the same right." [59]

The artist's defense of his assimilationist philosophy has, in retrospect, a hollow sound about it. "Embedded in the logic of assimilation," bell hooks has noted, is the "assumption that blackness must be eradicated so that a new self, in this case a 'white' self, can come into being. Of course, since we who are black can never be white, this very effort promotes and fosters serious psychological stress and even severe mental illness." [60]

The following summer, while hanging another exhibition in Detroit, Duncanson suddenly broke into "weeping and wild laughter at his imagined mediocrity." Committed to the Michigan State Retreat, he died insane before the end of the year. According to an obituary, "He had acquired the idea that in all his artistic efforts he was aided by one of the spirits of the great masters, and this so worked on his mind as to affect him not only physically but mentally." [61]

On one hand Duncanson conceived of himself as an artistic mediocrity, on the other as the heir to a great master—although we do not know which one. The self-contradiction, the fluctuation between poles, is perhaps characteristic of many artists but certainly of Duncanson in particular. Neither all black nor all white, directed simultaneously toward Africanism and Eurocentrism, his

life was predicated upon an irreconcilable division. This was the greatest gulf of all, too deep and too wide for him to pass. [62]

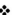

In the 1830s, Duncanson's childhood, Tocqueville had written of free blacks *in the North*, "When the Negro dies, his bones are cast aside, and the distinction of conditions prevail even in the equality of death. Thus the Negro is free, but he can share neither the rights, nor the pleasures, nor the labor, nor the afflictions, nor the tomb of him whose equal he has been declared to be; and he cannot meet him upon fair terms in life or in death." Throughout the 1860s, Duncanson's maturity, the situation had not improved: in Detroit, schools, churches, and cemeteries were still segregated; in New York, the nation's premier art institution, the National Academy of Design, prohibited blacks not only from holding membership but even from attending exhibitions. Four years after Duncanson's death, a blind judging of art at the Philadelphia Centennial Exposition awarded first prize to an artist, Edward Bannister, who was almost prevented from accepting the medal when it was discovered that he was black. And by the end of the century, in the case of *Plessy* v. *Ferguson*, the Supreme Court officially recognized the Jim Crow customs and legislations that had been in place in the South since the Civil War and in the North since several decades earlier. Plessy, a man who was one-eighth Negro and seven-eighths Caucasian, sued a railway company for forcing him to ride in a colored car and won; the high court, however, overturned the lower court ruling, saying that it was constitutionally legal to keep the races "separate but equal." If Duncanson had a difficult time negotiating the gulf in America between black and white, the problem was hardly his alone. [63]

And yet in a certain way he was ahead of his

time, suffering early what many more African-Americans were to suffer later. Although the great majority of the blacks of Duncanson's era had virtually no occasion to know what it was like to pass to the other side of the color gulf, Duncanson made the trip many times, thanks to the lightness of his skin and the prodigiousness of his talent. For most blacks, the situation was exactly what the Scottish bookseller William Chambers observed during a trip to the United States in 1853: "We see, in effect, two nations—one white and another black—growing up together within the same political circle, but never mingling on a principle of equality."[64] Yet Duncanson *did* mingle with whites, if not on a principle of equality, at least on the appearance of such. As a result, he was tormented by a double-consciousness not typical for blacks of his period.

A generation or so later, black double-consciousness did become typical, according to *The Souls of Black Folk.* In Du Bois's view, African-Americans had become heir to "a peculiar sensation, this double-consciousness, this sense of always looking at one's self through the eyes of others, of measuring one's soul by the tape of a world that looks on in amused contempt and pity." As a result, the African-American "ever feels his twoness,—an American, a Negro; two souls, two thoughts, two unreconciled strivings; two warring ideals in one dark body, whose dogged strength alone keeps it from being torn asunder."[65] In the end Duncanson was torn asunder, despite his dogged strength.

The Sermon on the Mount declares, "No man can serve two masters: for either he will hate the one, and love the other; or else he will hold to the one, and despise the other."[66] Duncanson, who "had acquired the idea that in all his artistic efforts he was aided by one of the spirits of

the great masters," seems not to have been sure exactly which "great master"—which "massa," which "father"—was his. Little wonder that he was so attracted to settings like the one depicted in *Blue Hole, Little Miami:* a protected cove, a haven, a refuge.

Duncanson's contemporary William Wells Brown remembered that as a slave he had been allowed only a first name, William, which was given to him at birth. When his master's nephew, also William, came to live on the plantation, the young slave was required to change his name. "This," recalls Brown, "I thought to be one of the most cruel acts that could be committed upon my rights; and I received several very severe whippings for telling people that my name was William." Years later, escaping (like Scott's noble stag) through remote forests, he resolved to take back the name that had been stolen. "I always detested the idea of being called by the name of either of my masters," he recounts, "so I was not only hunting for my liberty, but also hunting for a name."[67]

When William later added the name of Wells Brown, it was an act of tribute to the elderly Quaker who had rescued him in his flight but was also an exercise of his newfound freedom. Running through the woods of Ohio, William would say aloud his chosen name over and over to make sure that it was his. Duncanson, never having been a slave, never possessed a similarly clear-cut opportunity to redefine himself according to his own rather than his master's dictates. His "imagined mediocrity" must have resulted from the burden

of feeling his art so derivative—although this is ironic, for what makes Duncanson's art innovative is precisely its ability to derive from romantic landscape conventions in a signifyin' way.

Indeed, his entire career was an act of redefinition, of reconstruction. He did not run through the woods, he painted them. And in so doing, he asserted his name again and again. That this name, Duncanson, passed into obscurity upon his death is a tragedy that was his, but not his alone. With the demise of Reconstruction by 1878, black Americans lost for the remainder of the century, and perhaps a great deal longer, their best opportunity to cast aside the name of the master and take hold of their own.

The question, again, is who or what was Duncanson's master? The father he left behind? Some Scottish clan leader from whom in truth or imagination he was directly descended? Thomas Cole, the originator of the Hudson River School style that he slavishly followed? Sir Walter Scott, whose poetry and fiction inspired painters such as Cole and novelists such as Cooper to romanticize the American landscape as he had romanticized the Scottish? Or maybe Wordsworth, whose nature poetry, whose *view* of nature, underlies the work of all the figures named above and certainly that of Duncanson himself? All of these white men, to reverse the Wordsworthian trope, were fathers to the child that was Robert S. Duncanson. To what extent might Nicholas Longworth and other white abolitionists, attentive, dedicated supporters of his career, also have been the great masters who haunted him at the end—if not from the start? What of his black

fathers, that is, his black forefathers, the Africans and African-Americans to whom, willingly or not, he owed allegiance? As a member of the Talented Tenth (prior to Du Bois's coinage of the term) Duncanson may have felt burdened with a sense of obligation that caused him to bridle. "What have the colored people done for me?" he demanded rhetorically. Or was it self-defensively? Guiltily?[68]

Throughout her long career as a lecturer and writer, Duncanson's contemporary Frances Harper called often for her fellow middle-class African-Americans to "uplift the race." The summation of Harper's views is contained in her novel of ideas *Iola Leroy*, which hinges upon the choice made by young mulatto intellectuals to "cast their lot" with the black community even though, because of higher education, relative affluence, and very light skin, they possessed opportunities to ally with the white community instead. "When others are trying to slip out from the race and pass into the white basis," says Iola, the mulatta heroine of the book, "I cannot help admiring one who acts as if he felt that the weaker the race is the closer he would cling to it." As she explains elsewhere, "I must serve the race which needs me most." Less didactically, Charles Chesnutt makes a similar point in his "stories of the color line," in which well-to-do mulatto characters find themselves morally unable to forsake the lumpen folk community from which they have spent much of their lives trying to escape.[69] Certainly these were issues that Duncanson was aware of and needed in one way or another to resolve. I have suggested that a work such as *Ellen's Isle*, which not only alludes to a tale of reconciliation between warring factions but also depicts a natural world of harmonized colors and untroubled waters, was an attempt to reconcile artistically what appears to have been an unreconcilable situation psychologically.

Let me conclude these undecidable ruminations on Duncanson by examining a work of his that is more of a literary illustration than a pure landscape. Painted in 1853 on commission from the abolitionist editor of the Detroit *Tribune*, the Reverend James Francis Conover, *Uncle Tom and Little Eva* (fig. 85) depicts a scene in Stowe's chapter 22, "The Grass Withereth—The Flowers Fadeth." Little Eva, the saintly white child whose purity is too great to allow her long life upon this earth, reads biblical prophecy to her faithful retainer, Uncle Tom, on the mossy banks of Lake Pontchartrain in Louisiana. As Stowe describes the moment, "The lake lay in rosy or golden streaks, save where white-winged vessels glided hither and thither, like so many spirits."[70]

Any contemporary antislave reader might easily have been reminded by these "white-winged vessels" of Frederick Douglass's "beautiful vessels, robed in purest white." Douglass, in the passage cited earlier, relates that as a bondsman he "apostrophized" the ships on the Chesapeake: "You are loosed from your moorings and are free; I am fast in my chains, and am a slave! . . . O that I were free! O, that I were on one of your gallant decks, and under your protecting wing!" In choosing to paint the Lake Pontchartrain scene from *Uncle Tom's Cabin*, Duncanson advertently or inadvertently alluded to the most celebrated passage from Douglass's *Narrative*, a passage that he and his patrons are sure to have known.[71]

The scene from Stowe is a perfect embodiment of the Duncanson themes traced in this chapter. "Pointing to the glassy water, which, as it rose and fell, reflected the golden glow of the sky," Eva reveals to Tom her vision of heaven. Tom replies by singing, "O, had I the wings of the morning, / I'd fly away to Canaan's shore; / Bright angels should convey me home, / To the new Jerusalem." In this instance it is the child who instructs the adult rather than, as in most Duncanson, the other way around. Nonetheless the relationship is close and tutelary (and in fact, according to Stowe, it is not altogether clear who is the child and who the adult in this configuration, since she refers to the pair as "the old child and the young one"). Clutching hands in spiritual bonding rather than master-slave bondage, Tom and Eva exult at their vision of a heavenly paradise given earthly form by the wondrous landscape around them.[72]

Duncanson's painting is a complex interplay of light and dark. The sky is a limpid blue saturated in places with pink, gray, and yellow; Eva, white as a ball of cotton, is "flushed . . . with a kind of unearthly radiance"; and silhouetted Tom, no mulatto, is blacker than the shadows lying heavily across the foreground, so black that the expression on his face is virtually unfathomable.[73] A contemporary reviewer of the painting, in a piece disdainfully entitled "An Uncle Tomitude," blames Duncanson for depicting Tom as "a very stupid looking creature," and yet what the reviewer takes to be a stupid expression might instead be regarded as *no* expression or, rather, any expression one might care to project: stupidity, perhaps, or the humble awe described by Stowe, or the dejection experienced by Douglass in the face of freedom embodied by mere sailing boats but denied to him.[74]

The Uncle Tomitude review is unrelenting in its abuse of the painting. Eva, it smirks, "is complacently pointing toward a portion of the canvass [*sic*]

85. Robert S. Duncanson, *Uncle Tom and Little Eva*, 1853. Oil on canvas, 27¼ × 38¼ in. Detroit Institute of Arts. Gift of Mrs. Jefferson Butler and Miss Grace R. Conover.

which is deeply yellow, with a dusky-red fringe—probably intended to be a sunset." As for Tom, he takes "nearly all of her arm in his hand, as if intending to check the projected flight, and appears about to inquire—'what goin' dar for?'" Withered by this criticism, Duncanson henceforth turned exclusively to landscape painting, never again including figures of this size in his scenes and certainly never again depicting an African-American.

Stephen Foster, Duncanson's white contemporary who wrote such popular songs as "Camptown Races" ("Doo-dah! Doo-dah!") and "Old Folks at Home" ("Way down upon de Swanee ribber"), let it be known that he aspired to become "the best Ethiopian song-writer." Musically, that is, Foster tried to pass for black. In the popular minstrel, or "Ethiopian," shows of the time, white performers bootblacked their faces to mimic the "darkies" whom they "aped" on stage.[75] There was a lot of passing going on. A lot of signifyin'. In Duncanson's day, a pass referred to a gap in the mountains; it also meant a safe-conduct paper, as in *passport* or *passe-partout*. Duncanson's paintings, parodic or otherwise, were passes for him in both senses of the word. They made it possible for him to travel through difficult, even treacherous, social terrain. They allowed him to pass.

Yes, his landscapes were escapist. Instead of directly addressing the troubled world in which they were painted, they seemed to exchange it for a rainbow land, a lotos land, a land of Cockaigne in which hardship was nonexistent, labor unnecessary, skin color of no importance, and children knew no separation from their parents. Landscape as a form of escapism: land + escape = land'scape. I mean this, of course, not etymologically but psychologically. *Escapism* is a pejorative term; the behavior it describes is disdained. Escapists are to be denigrated.[76] Duncan-

son's African-American contemporaries, slave or otherwise, might have felt differently about escapism. After all, in their conceptual universe, an escapist was one who possessed the endurance, cunning, and courage to slip free of the bonds of the master. Duncanson's art is perhaps escapist in this way too.

During the period of his conversion to social activism, John Ruskin, the leading art critic of Duncanson's era, came to realize that the irresistible attraction of artists and viewers to beautiful landscapes derived from a "love of beauty, forced to seek in . . . external nature, the satisfaction it cannot find in ordinary life." Ruskin recognized that the very escapism embodied in landscape painting inevitably leveled a nonescapist critique at that abusive social order that produced the need for escape in the first place. In this regard, Robert Duncanson's landscapes are political statements even though, to return to the words of Ishmael Reed in the epigraph to this chapter, they do not show "the oppressor hanging from a tree." Uncle Tomitudes they may be, but they are also, at the same time, Gramscian instances of resistance.[77]

Duncanson, that is to say, can be viewed as both a good and a bad painter, a signifyin' resister of the dominant white society while also its willing collaborator. He was, in short, a mulatto in more than merely the color of his skin. His landscapes, in their deeply embedded mix of sources and allegiances, can truly be said to embody America's cultural chiaroscuro. Duncanson died in the service of his great masters. But also in the struggle to be free of them.

Lilly Martin Spencer's Domestic Genre Painting
in Antebellum America

Among art historians, a new connoisseurship has replaced the old. *Connoisseur:* an expert; one who knows, who speaks with authority; who understands the techniques and principles of an art and is competent to act as a critical judge. The old connoisseurship was the practice of passing judgment on art or artist according to aesthetic criteria: a work was good or bad, original or derivative, refined or vulgar, graceful or awkward, and so forth depending upon how it measured up to a supposedly timeless and universal set of standards. Since the 1960s connoisseurship of this stripe has been discredited by Marxism, feminism, postmodernism, and even liberalism engaged in the legitimation of cultural pluralism: all of these parties, despite their varied, sometimes antithetical agendas, have agreed that a single standard of aesthetic value is insupportable.

What I am calling the new connoisseurship is a replacement of aesthetic judgment by moral or political judgment. Nowadays when a work is said to be good or bad, its social utility or ethical (rather than aesthetic) value is often what is being judged, not its fidelity to universal standards of beauty. Instead of discriminating between the refined and the vulgar, the new connoisseur must decide whether a work, or an artist, is to be condemned as hegemonic or praised as subversive, censured as surveillant and disciplinary or credited for being resistant and counterideological. The symbolic

apparatus of the old-style connoisseur was the monocle and white gloves; the new connoisseur, symbolically speaking, wears X-ray glasses and writes with a raised fist.

The art of Lilly Martin Spencer, the most popular and widely reproduced female genre painter of mid nineteenth-century America, creates little problem for the old-style connoisseur but a great deal of it for the new. That is, from a modernist or formalist point of view, Spencer's work is simply and self-evidently bad, and that's all there is to it. For that reason, during the days when the old connoisseurship held sway, virtually no one took her art seriously enough to bother writing about it. On those rare occasions when Spencer was mentioned, as in this comment from a social historian of American art in 1950, the need to make aesthetic judgment remained irresistible: *This Little Pig Went to Market* [1857, fig. 86] shows a mother and baby being ostentatiously happy in the midst of an amount of detail which would quickly produce boredom except for the fact that the painter herself was fascinated with it and with her own knack of making it stand out with an extra degree of sharpness. The shiny brilliance of all textures, and in particular the sugary glossiness of what is supposed to be flesh, are amazing."[1]

Ever since the rediscovery of Spencer in the 1970s (initiated by her inclusion in the *Notable American Women* encyclopedia and by a retrospec-

86. Lilly Martin Spencer, *This Little Pig Went to Market*, 1857. Oil on composition board
with arched top, 16 × 12 in. Ohio Historical Society, Columbus.
Transfer from the Campus Martius Museum, Marietta, Ohio.

tive of sixty-eight of her works at the National Collection of Fine Arts), the aesthetic deficiency of her art has generally, if only implicitly, been conceded, and discussion has focused instead upon her difficulties in earning a living as a professional female artist in a male-dominated art world.[2] Minimizing issues of quality concerning Spencer's oeuvre, such discussions emphasize that as a woman who gave birth to thirteen children, seven of whom survived to maturity, she heroically maintained a bustling household while also supporting it financially, her husband, Benjamin, taking the subordinate role of assisting his wife in daily chores around hearth and studio alike.[3]

But such discussions have tended to finesse the apparently conservative nature of Spencer's oeuvre. To contemporary eyes, her art appears reactionary, both in terms of its family values content, with idealized children, Madonna-like mothers, happy housewives, and lovably inept husbands, and its sentimental rhetoric deifying motherly nurture, the beauty of domesticity, and the homey humor of family life. Regarded in this manner, Spencer's sentimental approach to the depiction of mothers, fathers, kitchen-workers, and children seems to have been complicit with furthering or "reproducing" systems of domination of mid nineteenth-century American women, those who were the main subjects of her work if not also its chief consumers.

My purpose here is to bring Spencer's artistic production back under scrutiny, but neither for purposes of proclaiming it admirable in light of the special struggles facing a female artist nor to castigate it for its alleged promulgation of bourgeois ideology. Instead of acting as a political connoisseur, passing judgment on the rightness or wrongness, social progressiveness or conservativeness of Spencer's work ("was she or wasn't she a pro-

gressive? only her revisionist knows for sure"), I want to examine the formal and iconographic devices of this work and consider the diverse and sometimes contradictory ways in which it took part in the class and gender conflicts of its era.[4] This is not an attempt to achieve a value-free analysis. But the effort to stave off blunt political or ideological categorizations of an artist's work is not the same as pretending to be value-free. It is, instead, an attempt to see with complexity and specificity, to understand modern culture's multitiered, multidirectional operations. It is an attempt to think dialectically about the intersection of elite and mass culture in mid nineteenth-century America as exemplified in the work of this particular artist, and about the clash, during the same period, of religiously orthodox, bourgeois liberal, and socialist-feminist views of women and their place in the nuclear family.

The starting point, then, is the presupposition, as Michael Denning puts it, that "mass cultural artifacts are at one and the same time ideological and utopian, and that popular culture is neither simply a form of social control [by a dominant group] nor a form of class expression [by a subordinate group], but a contested terrain." In what follows I seek to demonstrate that Spencer's work was *both* ideological (encouraging accommodation to norms associated with a rising middle class) and utopian (resistant to class or gender domination), at once an instrument of social control *and* an instrument of social subversion. If in the end the reader is left confused, uncertain as to which side of Spencer's art prevailed—the accommodational or

the resistant; social control or social subversion—take this not as a dereliction of responsibility, a refusal to pass judgment (although it is a refusal to judge as a new-style connoisseur), but rather as an implicit acknowledgment that art and the social configurations that produce it are inevitably multivalent, heterogeneous, and self-contradictory. Our job is not to conclude whether Spencer's art was good or bad but to understand the diverse and self-opposing ways that it functioned in a diverse and self-opposing national culture.[5]

Although Spencer's career stretched from the early 1840s to the end of the nineteenth century, she produced most of her best-known work during the decade between 1848, when she moved to New York from Cincinnati, and 1858, when she took up residence in New Jersey. This was a decade bounded at one end by the woman's rights convention in Seneca Falls, New York, and at the other by the financial collapse in the Northeast known as the Panic of 1857. However different in kind these two events may have been, they were alike in that both symbolically challenged patriarchal male authority: Seneca Falls proclaimed equal rights for women; the panic, like earlier ones, demonstrated the fallibility of men and their vulnerability to social and economic forces beyond their control. An examination of a few representative works produced by Spencer during this decade—nursery scenes, kitchen scenes, and anecdotal depictions of her husband—reveals an art that is neither an out-and-out affirmation of middle-class and patriarchal values nor an explicit rejection of such values, but rather an uncertain response: an em-

brace of them while also, increasingly (yet perhaps unconsciously), a teasing or mocking subversion of them.

In 1849, the year Spencer moved her family to New York in order to improve her opportunities as an artist, she painted *Domestic Happiness* (fig. 87), a work that achieved immediate acclaim. One reviewer reported that the attention it gathered at its initial exhibition "has exceeded that given to any other single production that has appeared on the walls of the Gallery since it was first opened." Another commentator later recalled that the painting's "vigor and freshness were as remarkable as its rich and harmonious coloring."[6]

Glowing with joy, a young husband and wife peer tenderly at two sleeping babes wrapped in each other's arms. Lightly bearded and full of face, the father wears a patterned silk dressing gown that blends harmoniously in hue with his wife's flowing robes of rose and green. The mother, with a face from Raphael and golden softness from Titian, raises a hand as though to stay her husband's enthusiasm for his children, whom he might inadvertently disturb—the work's original title was *Hush! Don't Wake Them*.

In terms of present debates over the nuclear family, *Domestic Happiness* may seem resoundingly conservative, but in the context of widespread debates during the 1840s over the function and structure of family, the position put forth by the painting was left of center—not radical, but not blandly middle-of-the-road either. Although the ideology of the home as a haven in a heartless world gained its ascendancy during the antebellum period, its route to acceptance was anything but uncontested. A wide range of sources provided what many Americans took to be compelling criticisms of or alternatives to the sentimental vision of

87. Lilly Martin Spencer, *Domestic Happiness*, 1849. Oil on canvas, 55½ × 45¼ in.
Detroit Institute of Arts. Bequest of Dr. and Mrs. James Cleland, Jr.

the nuclear family. Orthodox Protestants clinging to Calvinist tradition decried the new liberalization of the family, in which the status of mother and children was elevated at the expense of the patriarch. Feminists argued that the sentimental family was unduly binding of women. Socialists urged that household labor, including childcare and kitchen work, be reapportioned through public cooperatives. The followers of the communitarian John Humphrey Noyes advocated free love, Mormons practiced polygamy, and many who believed that the millennial day of judgment was at hand forswore sexuality altogether. At the time Spencer painted *Domestic Happiness*, the recent war with Mexico and the hurried migration of thousands of American men to California must have heightened the immediacy of the public debate, considering how many families were temporarily or permanently ruptured by these major events.

In this context, *Domestic Happiness* appears to be a vigorous assertion of the therapeutic value of the affectional nuclear family. Again, this may seem like a conservative position today but it was not in the 1840s. At that time, conservatives were those who *lamented* the advent of the sentimental family, with its exaltation of harmony, mutuality, and equality. Conservatives maintained that the family should be structured according to a strictly observed hierarchy, with father reigning unopposed over mother and children.

This orthodox position, though losing ideological ground by the time Spencer painted, continued to hold sway for most of the antebellum years. Such nationally known authority figures as Heman Humphrey, the president of Amherst College, exhorted parents to safeguard the future of the republic by instilling in their children patriarchal values at the earliest possible age. "Every father is the constituted head and ruler of his household. God has made him the supreme earthly legislator over his children," intoned Humphrey in 1840. "Children are brought into existence and placed in families, not to follow their own wayward inclinations, but to look up to their parents for guidance; not to teach, but to be taught; not to govern but to be governed."[7]

Domestic Happiness implicitly opposes this way of thinking. Whereas Humphrey claims that "children must be accustomed to cheerful subordination in the family," *Domestic Happiness* argues the opposite: that parents should cheerfully subordinate themselves to their children: "Hush, Don't Wake Them." Whereas Humphrey doubts "whether anything like a free constitutional government can ever be maintained over a people, who have not been taught the fifth commandment in their childhood," *Domestic Happiness* presents the sentimental family as a microcosm of social unity, with arms encircling arms as a metaphor for interconnectedness and cohesion.[8]

The painting, in other words, conveys the sensibility expressed by such liberal reformers as the popular novelist and essayist Lydia Maria Child, who insisted in her often-reprinted *Mother's Book* that "all our thoughts and actions come from our affections; if we love what is good, we shall think and do what is good. Children are not so much influenced by what we say and do in particular reference to them, as by the general effect of our characters."[9] Heman Humphrey might have agreed with this last statement about how children are influenced by the character of their parents, but for him the proper goal of such parental in-

fluence was to instill absolute obedience to patriarchal authority. For sentimentalists the character to be instilled was not submissiveness but love—which, to be sure, was seen as involving humility and submission, but also democratic self-respect. Moreover, the influence of character was seen as traveling both ways: just as children would learn affection from their parents, so the parents would learn affection or be reawakened to it by their children. The compositional circularity of *Domestic Happiness* attests to the circularity, the reciprocity, of familial love.

Richard Brodhead has astutely argued that the sentimental ethos of love, which he terms "disciplinary intimacy," disguised and reinscribed rather than replaced authoritarian domination. According to Brodhead, "The primary assumptions of discipline through love—its assumptions of extreme physical and emotional closeness between parent and child, and of the parent's availability to make the child the center of his attention—codify, as if in the realm of objective moral truth, the new middle-class social fact of a parent disoccupied from other labors." Thus "child nurture, the devoted labor of the leisured mother, confirms her moral right and duty to *be* unemployed—and to put someone else to work as a domestic in the service of her domestic idyl."[10] One could certainly contend that, even though Spencer herself never achieved the financial wherewithal to become a "leisured mother" enjoying a "domestic idyl," works such as *Domestic Happiness* participated in this more insidious form of middle-class control, seducing viewers into a new mode of affectional intersubjectivity (love) that, in helping to bring about the internalization of bourgeois norms, restricted behavior and political alternatives (for example, feminism and socialism) even more forcefully than the old authoritarianism had.

The point at present, however, is not to judge the extent to which the liberal ideology embodied by *Domestic Happiness* was actually a form of capitalist middle-class monitoring and control but to distinguish how this ideology positioned itself against the previously dominant form of control represented by patriarchal authority as sanctioned in conservative theology (1845, fig. 88).

In glorifying the sentimental family the painting amounts to a defense of sentimental thinking against political and religious conservatives who fumed over the breakdown of patriarchal authority, but at the same time it also defends the nuclear family from attack on the left. The socialist-communitarians of the era, for example, the Owenites, Oneidaists, and particularly the Fourierists (the followers of the French philosopher Charles Fourier), argued that individuals faltered and failed morally or economically not because they came from inadequate families but instead from overly adequate ones. "The isolated household is a source of innumerable evils," wrote one Fourierist. It "is wasteful in economy, is untrue to the human heart, and is not the design of God, and therefore it must disappear." *Domestic Happiness* opposes such a position. If on one level the painting served, as I believe it did, as a denial of Spencer's own anxieties about coping with a growing family during a period of financial scarcity, it was also, in the context of rising communitarianism and the woman's rights convention at Seneca Falls, an attempt to withstand an ever-mounting onslaught of feminist and socialist criticisms of the sentimental family.[11]

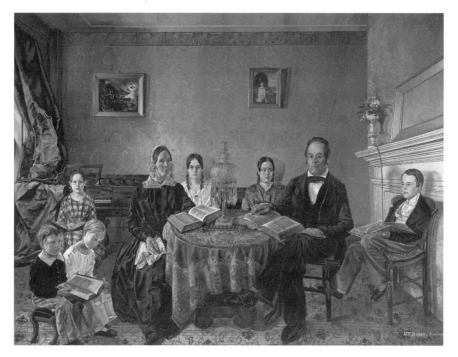

88. Henry F. Darby, *Rev. John Atwood and His Family*, 1845. Oil on canvas, 72 × 96¼ in.
Museum of Fine Arts, Boston. Gift of Maxim Karolik to the Karolik Collection of American Paintings.

In Spencer's case such criticisms originated from within her own family and were voiced by her mother, Angelique Martin. Martin, a schoolteacher who had immigrated to America from France, was an outspoken feminist and Fourierist. In the mid 1840s she and her husband helped form near Braceville, Ohio, a Fourierist "phalanx" (commune) that was dedicated to socialist principles, among them equality for women. Fourierists argued that isolated, single-family households and the wasteful duplication of domestic labor hampered the development of women and thus of society as a whole. They contended that the development of labor-saving devices and the removal of a variety of housekeeping responsibilities, including cooking and childcare, from the private into the public sphere would free women from the deadening drudgery that dulled their minds and political sensibilities. "No fuming, no fretting over

the cooking stove, as of old! No 'roasted lady' at the head of the dinner table!" predicted the Fourierist Jane Sophia Appleton in a utopian fantasy she conceived regarding a future in which women were the equal of men in all respects.[12]

Domestic Happiness as well as Spencer's numerous kitchen and nursery scenes of the 1850s eschews such a vision of collectivization, almost as though the artist were engaging in a private—perhaps unconscious—dialogue with her mother's radical ideology and was attempting to counter it with a centrist one of her own. When Angelique Martin urged her daughter to attend a woman's rights meeting, Spencer begged off, claiming that she was too busy. "My time . . . to enable me to succeed in my painting is so entirely engrossed by it, that I am not at all able to give my attention to any thing else." Throughout the 1850s, feminism must have seemed to the daughter, who perpetu-

ally struggled to make ends meet, a luxury she simply could not afford, even though her mother might have argued that feminism was in fact not a luxury but a necessity, a way of clarifying the housewife's self-interest, which was obscured by the cult of domesticity. How could the artist hope to compete with what she described as the "perfect swarm of painters" in New York when, as she bemoaned in a letter of nearly a decade later, "the mending and patching of the babeys" remained her never-ending responsibility? Despite Spencer's acute recognition that childcare and housekeeping severely impeded her professional responsibilities, she turned away from the feminism and socialism held out to her by Angelique Martin and embraced instead the sentimental ideal embodied in *Domestic Happiness.* [13]

Posing her husband and infant sons as models for *Domestic Happiness,* Spencer produced it at a time when she was filled with anxiety about her ability to earn a living in the highly competitive art world of New York. "We have not yet been very successful in our efforts—I have not been well encouraged for a long time in my painting," she confides in a letter to her mother. But then, bucking herself up: "Still we hope on and struggle on and help each other harmoniously [and] though poor, we are very happy with each other." [14] This sudden reversal, this immediate denial of the anxiety that had just escaped her pen, is typical of Spencer's letters home and, moreover, of her work in general, which seems, in this regard, an art of denial.

And yet to characterize her habitual reversals as mere denial is to back into an oversimplifying binary opposition (expression/repression). It is to say that Spencer's work and sentimental culture in general were nothing more than a denial of social inadequacy, a repression of women's understanding of their political powerlessness. Another view

of the matter suggests that denial is an implicit rejection of the current state of affairs rather than simply a refusal to acknowledge them. From this perspective, sentimental art such as Spencer's was an act of female instrumentality and agency, of antebellum women, in the absence of suffrage and property rights, taking hold of the most effective weapon at their disposal, public culture, and using it on their own behalf. Even if we could ascertain, which we cannot, that the result of sentimental discourse was increased ideological domination of the very women who were its chief producers and consumers—that is, a dulling of their powers of resistance—we would be historically remiss to regard such discourse as pathetically weak, passive, and insignificant, for at the very least, by imagining that modern women could be powerful, useful, and satisfied, it pictured for them a more equitable world, which is a necessary precondition for achieving such a world. Relevant here are the words of the first-person narrator of Margaret Atwood's *Lady Oracle* (1976), a closet romance writer who asks herself, "Why refuse them [her female readers] their castles, their persecutors and their princes, and come to think of it, who the hell was Arthur [her leftist husband who "took up Women's Liberation"] to talk about social relevance? Sometimes his goddamned theories and ideologies made me puke. The truth was that I dealt in hope, I offered a vision of a better world, however preposterous. Was that so terrible? I couldn't see that it was much different from the visions Arthur and his friends offered, and it was just as realistic." [15]

At a time when women possessed no legal protection for themselves or their children if abandoned by a husband, an image so lushly rendered as *Domestic Happiness* may even have served as a rhetorical device to persuade (in sentimental terms, inspire) male viewers to renew their commitment to their families. To look at it this way, the painting was a politically active endeavor designed to improve a grievous, real-world situation by means of a seductive representation of an ideal world (as sentimentally conceived). The cult of domesticity, Stephanie Coontz has argued against the conventional wisdom, "was a strategy for *resisting* too complete a separation of home and work." In this regard *Domestic Happiness* takes a stand against the "domestic misery" encapsulated in the following cautionary tale:

A young man meets a pretty face in the ballroom, falls in love with it, courts it, "marries it," goes to housekeeping with it—and boasts of having a home to go to and a wife. . . . [But then] his pretty face soon gets to be an old story . . . [and he] gives up staying at home evenings; consoles himself with cigars, oysters, whiskey punch and politics; and looks upon his "home" as a very indifferent boarding house. A family of children grow up about him; but neither him nor his "face" knows anything about training them; so they come up helter-skelter . . . and not one quiet, happy, hearty, homely hour is known throughout the whole household.[16]

By means of its sinuous design, fluidly integrated hues, and sumptuous handling of paint (note for instance the father's white sleeve, tinted blue-green by the robe), the painting amounts to an effort to undo what by midcentury were becoming increasingly prevailing indications of household disharmony not only among the lower classes but also within the middle class.[17] The inauguration at this time of a variety of reform campaigns directed against the evils of drink, divorce, gambling, prostitution, and abortion, all of which vices were supposedly gaining currency among the genteel, suggests that, whether or not there actually was a rise in family disharmony, there was a rising perception that such was the case. Thus *Domestic Happiness* battles on three fronts at once: against the reactionary hierarchism of religious conservatives, against the antisentimental values of socialist communitarians, and against the dissolution of the family.

One way of trying to grasp the enthusiasm of middle-class audiences for *Domestic Happiness* is to consider their enthusiasm for analogous texts such as Susan Warner's enormously successful evangelical novel of 1850, *The Wide, Wide World*. The tear-stained tale of young Ellen Montgomery, who passes unwanted from one guardian to another until she finally accepts God's love, begins when Ellen's father, preoccupied with business, sends his ailing wife to France for a cure and dispatches Ellen to live with unkindly relatives she does not know. In the most often reprinted novel of the early republic, Susanna Rowson's *Charlotte Temple* (1793), tragic circumstances were set in motion by a child's desertion of her parents, but now, in the sentimental culture that produced and so extravagantly admired *The Wide, Wide World*, the greater source of pathos was the parents', not the child's, abandonment of the home.[18]

Domestic Happiness is the daydream to *Wide,*

Wide World's nightmare. Surely the popularity of both were forms of public response to the alarmingly accelerated unraveling of families in Jacksonian America: sons deserting farms to find work in the cities, daughters forsaking home to reside at the mills, fathers crossing the continent in search of California gold. Only mothers could be counted upon to stay in place, unless, like Ellen's mother, they fell victim to sickness or death.[19] *The Wide, Wide World* addresses this unraveling by reconstituting it as a conversion narrative, a Victorian-American *Pilgrim's Progress*. Spencer's painting likewise responds to social disintegration. It does so, however, as a sentimental icon of family solidarity rather than as a pious saga of alienation followed by redemption through self-immolation.

Painted nearly a decade after *Domestic Happiness*, *This Little Pig Went to Market* (1857, see fig. 86) treats the parent-child bond with more of a sense of humor, less total reverence, than the earlier work. As noted in Virgil Barker's description of the painting quoted above, the surface texture of *This Little Pig* is hard and brilliant, the details everywhere sharply in focus: by contrast to the color-harmonized romanticism of *Domestic Happiness*, *This Little Pig* is brash and vulgar. Even their respective titles bespeak a contrast, the earlier one reverential and quasi-religious, the latter insistently secular and perhaps satiric. Its reference to the rollicking street rhythms of the Mother Goose nursery rhyme undercuts the religiosity of the composition, suggesting that this depiction of a latter-day Madonna enthroned beneath an imperial canopy is to be taken more as a joke than as a pledge of allegiance to the middle-class sentimental creed—and maybe even as a criticism of such a creed, given the rhyme's attention to the disparity between rich and poor, haves and have-

nots ("This little pig had roast beef, That little pig had none"). Perhaps what Barker calls "the sugary glossiness" of the flesh is an indication not of Spencer's inability to paint lifelike skin tones, for she did that ably well in *Domestic Happiness*, but rather of her inability to continue painting nursery scenes without her tongue finding its way into her cheek.

Once she moved to New York, Spencer consistently injected her domestic pictures with a touch of vulgar humor: a punning title, a grinning face, splashy, unmodulated colors, a comedic situation. Though the domestic and financial stresses of her life went unabated—indeed, they increased—she made a point of treating domesticity humorously, a point that won her many admirers. All the same, even with this newfound humor, her nursery paintings retained a flavor of syrup. It was not there but in her kitchen scenes that Spencer allowed herself more freedom to paint with vinegar.

She delighted her contemporaries with her anecdotal and in some regards implicitly utopian kitchen tableaux. Indeed, her career as an artist is said to have begun when, as a teenager in rural Ohio, she replied to her mother's request for help baking bread by sketching onto the kitchen wall a depiction of herself kneading dough.[20] The story is hagiographic but nonetheless appropriate. The precocious Ohio farmgirl eventually became the nation's foremost portrayer of homey domestic scenes, especially those occurring in or beside the kitchen. One of the first of these was *The Jolly Washerwoman*, long thought lost and only recently rediscovered (1851, Hood Museum of Art,

89. Lilly Martin Spencer, *Shake Hands?*, 1854. Oil on canvas with arched top, 30⅛ × 25⅛ in.
Ohio Historical Society, Columbus.

Dartmouth College). It depicts a robust serving maid beaming with amusement while toiling by a washtub. At the American Art-Union auction the painting sold for $161, a relatively high price, and received much favorable comment, encouraging the artist to turn to similar subjects and treatment several more times in the next few years. One effort, *Shake Hands?* (1854, fig. 89), depicts a buxom, broadly grinning, doughy-handed cook pausing to reach out in greeting to a visitor, presumably the viewer of the painting. Another, *Kiss Me and You'll Kiss the 'Lasses* (1856, fig. 90), shows a slender, pert young woman standing before a fruit-laden sideboard while wielding a spoonful of molasses ("'lasses") with which she coyly threatens her visitor, probably a male suitor but also us, given the second-person address of the title as well as her direct gaze out of the painting's space into our own.

Other paintings by Spencer of kitchen scenes include *Peeling Onions* (c. 1852) and *The Young Wife: First Stew* (c. 1856; unlocated). Admired by the public at large and often by critics as well, these images circulated widely in the form of inexpensive prints. *Gossips* (1857; unlocated) was Spencer's most ambitious undertaking of the decade. One art journal deemed it a masterpiece, enthusiastically describing it as "a group of servant-girls out of doors, interchanging domestic news, surrounded with kitchen accessories—pans of clothes, meat, vegetables, babies, furnaces, and tubs of water, into which children have tumbled, laughing at each other's mishaps and at a lean dog running away with a beefsteak in the foreground."[21]

Gossip was unusual for Spencer in that it represented a gathering of household workers instead of a single worker alone. In a sense, though, Spencer's kitchen workers are never alone, even if typi-cally the paintings depicting them are single-figure compositions. The women always address someone just beyond the picture plane. They are never too preoccupied to welcome this implied visitor with a good-natured grin and friendly gag—a doughy hand, a spoonful of molasses.

For a point of comparison, place Spencer's kitchen workers beside Vermeer's scullery maids, who are similarly robust in appearance but so enwrapped in their duties or dreams as well as in a transfiguring light that there is no offstage to their world, no possible intrusion, no sudden visitor, welcome or otherwise (c. 1660, fig. 91).[22] Vermeer's works were not known in the United States until after the Civil War, but even so the transcendent and aestheticized ideal of the silent domestic female that they put forth was already in place in antebellum America, as seen, for example, in Francis Edmonds's *Sparking* (1839) and *The Image Peddlar* (1844). Spencer's kitchen scenes violate the harmony and serenity of Vermeer and the idealization of domestic womanhood that he represents. Her scenes do to him what, a generation later, Mark Twain's Duke and Dauphin were to do to Shakespeare. With a Jacksonian contempt for classical unities and sophisticated European subtleties, these brashly colored, overly detailed, vulgarly forthright kitchen scenes suggest their own version of Catharine Beecher's assertion in her *Treatise on Domestic Economy*, which was reprinted nearly every year from 1841 to 1856, that housework and democratic egalitarianism go hand in hand.[23]

90. Lilly Martin Spencer, *Kiss Me and You'll Kiss the 'Lasses*, 1856. Oil on canvas, 30 1/16 × 25 1/16 in. Brooklyn Museum, New York. A. Augustus Healy Fund.

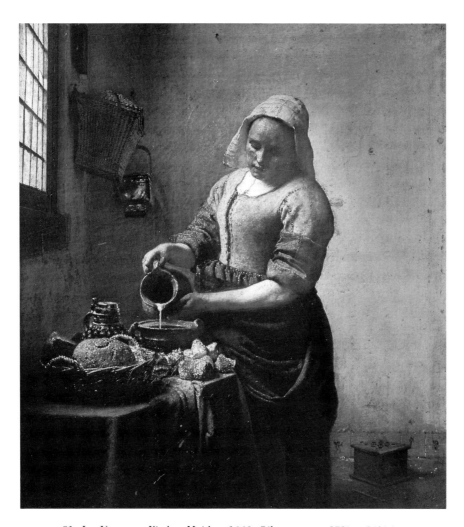

91. Jan Vermeer, *Kitchen Maid*, c. 1660. Oil on canvas, 17⅞ × 16⅛ in.
Rijksmuseum, Amsterdam (Photo: Marburg/Art Resource, New York).

Obviously, not all Jacksonians approved. A high-toned review of *The Young Wife* disdained the artist's "grinning housemaids" and wondered rhetorically, "Is there in her woman's soul no serene grave thought, no quiet happiness, no tearful aspiration, to the expression of which she may give her pencil?" She offended good taste—in this case that of an older type of sentimentalism that looked back to the romantic neoclassicism of, say, Washington Allston's *Ideal*, Samuel Morse's *The Muse*, or Thomas Sully's *Mother and Child* (1840, fig. 92)— by her repeated transgression of the time-honored convention that women depicted in art be demure, that they not grin, giggle, or laugh, that they be still and allow themselves to be admired. "Mrs. Spencer has no power over transitory expression," objects the reviewer, "and the slightest remove from immobility of features ends in grimace." A female artist who chose to be low and comical rather than grave and quiet; female figures within the paintings who grin or grimace rather than maintain radiant or mysterious sangfroid: Spencer and her paintings had become an affront to sexual, political, and aesthetic norms.[24]

92. Thomas Sully, *Mother and Child*, 1840. Oil on canvas, 57 × 45⅜ in.
Metropolitan Museum of Art, New York. Bequest of Francis T. S. Darley.

The Crayon, which carried the "grinning house-maids" review, was a journal devoted to the ideals of John Ruskin, who was as reactionary in his thoughts on "the woman question" as he was progressive on other social issues of the time. Spencer fared better with the *Cosmopolitan Art Journal*, a periodical that courted female middle-class audiences and gave special attention to the productions of women writers and artists, whose works it often promoted for sale. In reference to *Shake Hands?* it claimed that "no picture painted in this country is better fitted for popular appreciation. It reminds us constantly of the incomparable pictures by the Flemish [Netherlandish] artists."[25]

The comparison, not to Vermeer, would have been to seventeenth-century genre painters such

93. Nicolas Maes, *A Sleeping Maid and Her Mistress*, 1655.
Oil on panel, 27½ × 21¼ in. National Gallery, London.

as Gerard Dou, Pieter de Hooch, Gabriel Metsu, and Nicolaes Maes. A student of Rembrandt, Maes painted such cheerfully anecdotal works as *A Sleeping Maid and Her Mistress* (1655, fig. 93) and *The Eavesdropper* (1657). In *A Sleeping Maid and Her Mistress*, the lady of the house wryly smiles out of the composition into the viewer's space while pointing toward her kitchen maid, who dozes in a corner, oblivious to unwashed pots and pans and the cat about to make off with the dinner. In the other work, the mistress turns to us conspiratorially as she eavesdrops with amusement upon a scullery maid embracing her beau beneath the stairs. The differences between Maes and Spencer are significant. For example, his domestic women, wrapped in velvety, Rembrandt-like contrasts of light and

shade, do not jump out at the viewer as do her women, who are pictured head-to-toe in disconcertingly high definition. Also, his housewives are never alone on canvas, unlike her kitchen workers, who are alone but for the implied, off-canvas visitor.

Still, despite the differences, Spencer is like Maes and other baroque artists who sought to incorporate the viewer within the work by means of direct address or, in theatrical terms, dialogue across the footlights. Like many of her antebellum contemporaries, Spencer was greatly taken with Shakespeare, himself a violator of classical unity. In December of 1848, shortly after her move to New York, she drew Hamlet contemplating the skull of Yorick (fig. 94). This may seem the opposite of a direct-address depiction—Hamlet's eyes gaze down at the skull in his hands—until one realizes that it is not Hamlet but the grinning skull itself that peers out at the viewer. "Where be your gibes now? Your gambols, your songs, your flashes of merriment that were wont to set the table on a roar?" Shakespeare's prince asks the dead court jester. It is a query that Spencer may have posed to herself in this time of financial, professional, and domestic hardship. Her comical domestic scenes of the 1850s, with their jocular direct address and reliance on puns, are perhaps her answer.[26]

Let me further situate the challenge to neoclassical unity and decorum that direct address such as Spencer's conveys. In the early twentieth century, the Marxist playwright Bertolt Brecht employed direct address as an "alienation effect" that compelled critical detachment by preventing emotional identification with the spectacle on stage, thus leaving "the spectator's intellect free and highly mobile." Brecht's direct address assaulted theatrical conventions that maintained the ontological separation of characters upon the stage from the audience in front of it. Spencer, working nearly a century earlier, employed direct address to significantly different ends. Instead of undercutting the spectator's emotional involvement, her direct address, which was normal at the time in theater if not in painting, served to solidify it.[27]

Discussing the "engaging narrator" of mid nineteenth-century female novelists such as George Eliot, Elizabeth Gaskell, and Harriet Beecher Stowe, a recent narrative theorist contends that the purpose of interventions of the "Dear Reader" sort was to rouse the reader from passivity and bolster her or his ability to proceed constructively from the world of fiction to that of social reality. "Writing to inspire belief in the situations their novels describe—and admittedly hoping to move actual readers to sympathize with real-life slaves, workers, or ordinary middle-class people—these novelists used engaging narrators to encourage actual readers to identify with the 'you' in the text." Unlike the intruding narrators of earlier novelists such as Fielding, Sterne, and Thackeray who interrupt the narrative to remind the reader in a playful or tongue-in-cheek fashion that this is only a story, the engaging narrators of sentimental fiction do so in order to provoke moral action. Their interventions are attempts to rouse readers from complacency through intimacy rather than alienation.[28]

In Fanny Fern's popular sentimental novel *Ruth Hall* (1854), the working mother named in the title writes a newspaper column for women. One of her readers sends a fan letter. "Every week your printed words come to me, in my sick cham-

94. Lilly Martin Spencer, *Alas, Poor Yorick!*, 1848. Pencil on gray paper, 18½ × 15⅜ in. Private Collection
(Photo: National Museum of American Art, Smithsonian Institution, Washington, D.C.).

ber, like the ministrations of some gentle friend, sometimes stirring to its very depths the fountain of tears, sometimes, by odd and quaint conceits, provoking the mirthful smile." She blesses Ruth for the "soul-strengthening words you have unconsciously sent to my sick chamber, to wing the weary, waiting hours."[29] Perhaps Spencer's kitchen scenes similarly offered "soul-strengthening words" and "mirthful smiles" (Yorick's "flashes of merriment") for antebellum women. The gaze of her kitchen workers out of their own space into the viewer's must have collapsed social distance

and thus helped eradicate the loneliness, the isolation of middle- or lower-middle-class housewives. With their reliance on direct-address grins, comical titles, and other "odd and quaint conceits" such as a dough-covered hand here, a spoonful of molasses there, these kitchen paintings may have seemed not merely anecdotal but antidotal.

Catharine Beecher, the antebellum period's greatest advocate for "domestic economy," acknowledged the stress that managing a household placed upon middle-class women. "There is nothing," she wrote, "which so much demands system and regularity, as the affairs of a housekeeper, made up, as they are, of ten thousand desultory and minute items; and yet, this perpetually fluctuating state of society seems forever to bar any such system and regularity." Beecher recognized this stress to be debilitating. "The anxieties, vexations, perplexities, and even hard labor, which come upon American women, from this state of domestic service, are endless; and many a woman has, in consequence, been disheartened, discouraged, and ruined in health." Or as Elizabeth Cady Stanton, herself a mother and housewife, ruefully declared, "A woman is a nobody. A wife is everything."[30]

To viewers who were in effect kept out of sight in what Stanton called "the isolated household," sequestered by the cult of true womanhood and the economic imperatives that underlay it, how pleasurable it must have been to be looked at, to be seen, to be called upon, even if only by hypothetical women inhabiting a painting or a print in a popular magazine.[31] Although there is indeed

power that derives from being the bearer of a gaze, there may also be power that results from being its recipient. In the words of Mae West, who, admittedly, was neither a feminist nor a sentimentalist, "It is better to be looked over than overlooked."

Antisentimentalists would argue that the power that comes from being looked at (or looked over) is at best only illusory. Being seen can make you *feel* important without actually making you important; hence the workings of hegemony, in which social subjects are seduced into accepting their domination by a class whose interests are ultimately antithetical to their own. Recently, for example, Nancy Armstrong's *Desire and Domestic Fiction* has contended that domestic sentimentalism, far from resisting the segmentations and gender separations of modern life, exacerbated them, teaching readers that women were radically unlike men, more exalted, more sensitive, more subjective. Such discourse privatized experience in a manner that colluded with the ongoing privatization of the economy and the state. "On the domestic front," according to Armstrong, "perhaps even more so than in the courts and the marketplace, the middle-class struggle for dominance was fought and won."[32]

Spencer's paintings may have placated housewives and encouraged them to accept their disfranchised lot, engaging them sentimentally rather than enraging them politically, and yet it seems condescending to write this off as merely bad faith, a manufactured, ersatz solidarity. Recent efforts in the feminist revision of nineteenth-century sentimental culture would urge us not to view sentimentalism as false consciousness imposed from above but instead to investigate how it looked from within. Acknowledging that it would be impossible to read sentimental fiction today with precisely the same sensibility as a mid nineteenth-century

female reader, Jane Tompkins argues nevertheless that "we can and should set aside the modernist prejudices that consign this fiction to oblivion, in order to see how and why it worked for its readers, in its time, with such unexampled effect."[33]

Armstrong's view of domestic fiction derives from Michel Foucault, who argues that social discourses (medical, sexual, architectural, and so forth) produce the subjects that speak them. Sentimental fiction, by these lights, is yet another disciplinary discourse, forming its readers into sentimental and thus weak and submissive objects of social domination (this is the "disciplinary intimacy" described by Richard Brodhead). An opposing view derives from the work of Mikhail Bakhtin, who argues that discourse is "dialogic"— always inevitably a two-way, if not many way, street. (Puns and double entendres, which Spencer and her audiences found so congenial but which today's language police often condemn as offensive, call attention to the dialogical nature of discourse.) For Bakhtin, meaning is invariably plural. Because of this, those who read or hear a discourse produce from it the meanings that they require. The one theory maintains that readers (or viewers) *are shaped* by their language in ways that subject them to social discipline, whereas the other argues that *they shape* that language in a manner that enables them to resist such discipline. In the present context, this means focusing not on the purposes of social control that sentimentalism may have served for statesmen, clergymen, editors, and other leaders of culture who disseminated its doctrines from on high, but rather the uses to which its primary recipients, women, were likely to have put it.[34]

In other words, popular culture artifacts— for example, inexpensive engravings of grinning housewives—can be tools by which socially sub-ordinate classes, such as housewives, try to pry themselves loose from domination by their social superiors. Popular discourse that may have been produced or distributed as a means of reinforcing hegemonic control nevertheless is read by its recipients in a way that is empowering to them. Let us take a late twentieth-century analogy. The popular culture theorist John Fiske argues that the reason adolescent girls were the first to make a star of the pop singer Madonna was that she modeled for them antiauthoritarian behavior and informed them of their own capacity for self-fashioning—as opposed to fashioning by parents, teachers, and boyfriends. "The provocation offered by Madonna to young girls to take control of the meanings of their femininity produces a sense of empowerment in one of the most disempowered of social groups that may well result in political progress in their everyday lives—in their relationships with their boyfriends or parents, in their refusal to give up the street to men as their territory." For Fiske, "improved self-esteem in the subordinate [class member] is a political prerequisite of tactical or even strategic resistances."[35]

With Spencer, the crucial question is whether her kitchen scenes were vehicles of indoctrination into middle-class ideology, assisting women to accept their exclusion from political and economic power, or instead a means by which these women resisted privatization and its concomitant psychological isolation. My own initial response to Spencer led me to favor the former position, but now, after studying the works, I incline toward the latter, though not without continuing reservations

or sense of dialectic—a sense of her work as both/ and rather than either/or.

Part of what I take to be her work's opposition to privatization is its eagerness to undercut romanticism and the solipsistic state of mind that goes with it. During the 1840s Spencer had been a romantic artist, turning often, in the words of a friendly critic, to "poetical and semi-allegorical" themes. Writing at the end of the 1850s, this critic was disappointed by Spencer's abandoning of such subjects and assumed that she had done so out of financial necessity, to cater to a popular art market that preferred cheap anecdotal humor to rarefied meditation on timeless concerns: "She found matter-of-fact pictures more salable than her cherished ideals."[36] Reading the Legend (1852, fig. 95) is the culminating work in Spencer's earlier, romantic style. An aristocratic, ornately gowned young woman rests her head on her hand while gazing pensively upon the ruins of a castle as a young man stationed at her feet reads from the pages of a book. The weathered but erect tower seems to rise from him with what today might be regarded as a hyperbole of phallic dominance. The woman appears passive and secondary, not the main actor. In most of the work that followed Reading the Legend, however, Spencer concentrated on the domestic here-and-now, a milieu in which women were central, active, fully engaged.

In Shake Hands? the sleeves of the grinning, apple-cheeked cook are rolled up, and her skirt is protectively gathered beneath her apron. Spencer's housemaid, a woman named Jane Thompson, modeled for the cook, but various features

of the painting encourage a reading of her as a housewife.[37] The arched shape of the canvas, for example, suggests the sanctified terrain of a similarly arched work, Raphael's The Marriage of the Virgin (1504). But if this is a Madonna of the Kitchen, Spencer plays it for laughs, refusing to honor any ideology that would etherealize housewives and, in so doing, separate them from the real world of work and social relations. On the far right, over a fireplace screen, a depiction of an embracing couple peels away at the edge, as though to insist all the more on the thinness of romantic dreams in contrast to the fullness, the satisfactions, of domestic routine—or perhaps its dissatisfactions; if behind her are clichéd romantic dreams literally peeling off the wall, all that is before her is a plucked chicken. Maybe such dreams are what initially brings a young wife into the kitchen, but clearly they can not take the heat so well as she can, with her earthy, outgoing sense of humor. She is like Fanny Fern's fictional Aunt Hetty, who says, "Now girls . . . do something sensible and stop building air-castles, and talking of lovers and honeymoons. It makes me sick; it is perfectly antimonial [sic]. Love is a farce. . . . The honey-moon is as short-lived as a lucifer-match; after that you may wear your wedding-dress at breakfast, and your night-cap to meeting, and your husband wouldn't know it."[38] One can only imagine what Aunt Hetty, with her disdain for "air-castles," would have thought of Reading the Legend (or of the passage in Atwood's Lady Oracle about not refusing female readers "their castles, their persecutors and their princes").

In other works from this period Spencer similarly eschews romantic sensibility. For example, in the ambiguously titled The Young Wife: First Stew, which is no longer extant but can be roughly known through studies or reproductions in other

95. Lilly Martin Spencer, *Reading the Legend*, 1852. Oil on canvas, 50⅜ × 38 in. Smith College Museum of Art, Northampton, Massachusetts. Gift of Adeline F. Wing and Caroline R. Wing.

media, the housewife was in tears. Was this be-
cause she was chopping onions for a stew or rather
because she was "in a stew" brought on by the
difficulties of adjusting to marital life and respon-
sibility?[39] Another work by Spencer that treats
this subject shows a tear-streaked maiden in the
kitchen wiping her eye. She holds a knife in the
same hand, almost as though contemplating ven-
geance or self-destruction, Rembrandt's Lucretia
in Jacksonian guise. Lest the viewer leap to the
romantic assumption that this young woman weeps
and wields a sharp blade because love has gone
wrong, the reason for the tears and the knife is sup-
plied with a certain taciturn irony by the painting's
title: Peeling Onions (c. 1852, fig. 96).

The implicit or explicit sexuality of these paint-
ings further removes them from a world of totally
sanitized sentimental romanticism. Certainly the
flirtatiousness of Kiss Me and You'll Kiss the 'Lasses,
along with the provocative swivel of the young
woman's hips, addresses itself more toward roving-
eyed men than lonely housewives (I have not meant
to suggest that only the latter group viewed and ad-
mired Spencer's work). The iconography of Shake
Hands? goes back to seventeenth-century Dutch
genre paintings of "sluttish" kitchen maids: there's
something about that plucked (undressed) bird
spread-eagled on the table, the relative untidi-
ness (looseness) of the kitchen, and the earthy
physicality (availability) of the woman herself that
encourages the viewer to understand that query
about shaking hands as a euphemistic invitation
for a shaking of a different kind. Well, maybe that's
overstating things—but by how much? Even Peel-

ing Onions possesses a sexual subtext insofar as
it derives from Dutch paintings such as Gerard
Dou's Girl Chopping Onions (1646, fig. 97), which
trades upon the folkloric identification of onions
with aphrodisiacs.[40]

The irony and/or iconographically implied rib-
aldry of such paintings undermine romantic and
sentimental pieties about female domesticity. In-
stead of adhering to the conventional notion of the
kitchen as the domain of a household angel, these
works portray it as a place not only of sugar but
sauce. Depicting the kitchen in this more com-
plex, dual-edged manner, such paintings would
thus have discursively resisted the ideological en-
closure and marginalization of the kitchen worker
even as that phenomenon was historically occur-
ring. At the same time, however, in juxtaposing the
sentimental (i.e., tears) with the practical (onions),
they enacted the sort of avowal/disavowal typical
of Spencer's letters home, in which every expres-
sion of dire anxiety was quickly renounced by a
joke or a bromide ("Let us hope for the best and it
may come, is my motto").[41]

In other words, rather than imposing an either/
or situation upon Spencer's sentimental kitchen
comedies—either they are instruments of discur-
sive discipline or they are carnivalesque subver-
sions of dominant ideology—we do well to recog-
nize them as instances of discipline and subversion
occurring simultaneously and self-contradictorily.
This is not to make the claim that Spencer's paint-
ings can mean anything or everything we want
them to mean. I am not talking here about the
critic's will to power, to impose or dispose meaning
unchecked by hermeneutic constraints. I am say-
ing instead that Spencer's paintings, like any other
social texts, were likely to have been disciplinary
in some regards to some people some of the time
in some ways, while they may also have been sub-

versive in some regards to some people (or some others) some of the time (or other) in some ways (or other).

Perhaps this formulation is too imprecise to be acceptable, but I don't know that a reified "it was *this* way" or "it was *that* way" formulation is, in the end, any more satisfactory. So I stand my ground (as much as any postmodernist can who questions the notion of a stable epistemological ground) in arguing that the paintings can best be viewed as neither bad nor good, conservative nor progressive, hegemonic nor counterhegemonic, but as entanglements of all these terms, messy, dialectical, and conflicted as to what they offered viewers and what, to diverse groups of viewers, they might have meant.

Although most of Spencer's genre scenes are about domestic women with or without children, some focus on domestic men—that is, husbands. The husbands in Spencer's paintings are never refugees from the home, unlike Washington Irving's henpecked Rip Van Winkle and so many subsequent males in nineteenth-century American art and literature who were all too eager to flee the clutches of domesticity and, in the words of Twain's Huck Finn, "light out for the territory."[42] Instead they are integrated and needed members of the home, taking on an importance much greater than that of mere breadwinner.

We surveyed this terrain earlier in terms of *Domestic Happiness*. In *The Young Husband: First Marketing* (1854, fig. 98), the companion piece to the now-lost *Young Wife: First Stew*, a bearded man carrying an unopened umbrella and an overflowing basket of groceries struggles to prevent the contents from tumbling onto the rain-slicked street. In *Fi! Fo! Fum!* (1858) the husband is an overgrown boy, appearing no less frightened by the spooky

tale he recounts than are his children. In *The Fourth of July Picnic* (c. 1864), a work of the following decade, a portly father in the center of the composition comically collapses a rope-swing under his considerable weight. The humor is good-natured, to be sure, but what counts in all three instances is that Spencer designates husbands as figures as much to be laughed at as revered—even while maintaining that they belong in the domestic world and are not estranged from it.

These paintings rely upon what we nowadays term situation comedy, with its facile arrangement of family life's complexities into formulaic patterns of resolution. The historian John Demos sees this situation-comedy view arising historically as a result of the American father's increased absence from the family circle: "Since such fathers spent so little time at home, they could not acquire savvy and skills in 'domestic employments.' They burbled and bumbled, and occasionally made fools of themselves. They were cajoled, humored, and implicitly patronized by long-suffering wives and clever children. Dagwood Bumstead (of the "Blondie" comic strip), Ozzie Nelson (of the popular radio show "Ozzie and Harriet"), and the faintly ridiculous hero of Clarence Day's memoir (later a Broadway play) *Life with Father* made well-known variants of the general type (*father as incompetent*)."[43]

To the extent that situation comedy enforces regulated norms of response, it seems to restrict the permissible range of human behavior and subsume its viewers into a conservative cultural discourse. In other words, paintings such as *The*

96. Lilly Martin Spencer, *Peeling Onions*, c. 1852. Oil on canvas, 36 × 29 in. Memorial Art Gallery of the
University of Rochester, Rochester, New York. Gift of the Women's Council on
Celebration of the 75th Anniversary of the Memorial Art Gallery.

97. Gerard Dou, *Girl Chopping Onions*, 1646. Oil on panel,
7¼ × 5⅞ in. Royal Collection of Her Majesty
the Queen, St. James's Palace, London.

Young Husband and *Shake Hands?* could be seen as nonprogressive because in the one case husbands are treated as cute little darlings rather than as household tyrants who held virtually complete legal jurisdiction over their wives, and in the other case a woman's confinement to her kitchen is normalized as healthy, happy, and empowering rather than as socially oppressive.

Yet such readings would be ahistorical as well as undialectical. In 1950s America, in the absence of an organized women's movement, the comic depiction on television and in Norman Rockwell-like magazine illustration of husbands rendered helpless by domestic chores may have amounted to an ideological obfuscation of actual power relations. Virtually the same depiction in the 1850s, how-

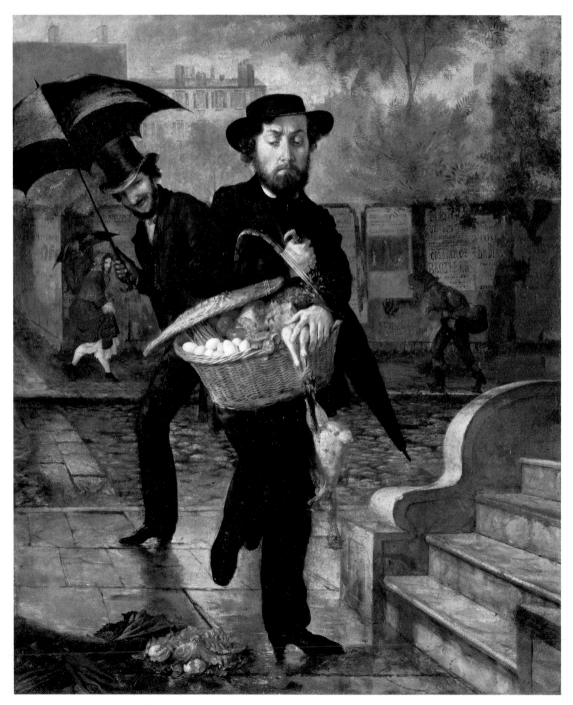

98. Lilly Martin Spencer, *Young Husband: First Marketing*, 1854. Oil on canvas,
29½ × 24¾ in. Masco Collection.

ever, would have participated, if only mutely, in the challenge to masculine authority that was being mounted by feminists and sentimentalists alike in the aftermath of the convention at Seneca Falls.[44] A similar argument applies to the kitchen comedies. The kitchen was or could be an empowering place for antebellum women, at least so Catharine Beecher and her sister Harriet Beecher Stowe maintained, but it was also, as suggested above, an isolated zone, cut off from the hallways of power and thoroughfares of the world.[45] Spencer's kitchen scenes, employing direct address as well as other anticlassical devices, may very well have constituted a form of popular female struggle against, rather than submission to, the privatizing and marginalizing of the domestic sphere.

As industrialization took hold in America, it drew men away from the home, centering their attention elsewhere (as decried in the editorial cited above about the typical husband who "looks upon his 'home' as a very indifferent boarding house"). But even when husbands were staying home, how could they possibly have maintained their traditional authority as paragons of wisdom and stability when sudden swings in the economy, as exemplified by the Panic of 1857, swept thousands of middle-class households to the edge of destitution? A devastating financial collapse that ruined legions of speculators and sent the economy in the industrialized Northeast reeling, the panic inevitably undermined the cherished belief that home was a blessed place, a refuge from the storm, and that fathers, as God's representatives on earth, had the wisdom and power to keep it that way—a plight that is the theme of a little-known work produced during a subsequent crash, Charles Knoll's *The Panic of 1869* (1869, fig. 99). Husbands, who had placed themselves in charge of an economy they considered wives incapable of understanding, had

proven inept. They were no more in control of the economy than they were of the weather.[46]

In a financial climate such as this, *The Young Husband*, Spencer's painting of a man caught in the rain, takes on new meaning. The work was completed in 1854, well before the panic yet in the midst of a period of business stagnation and rising unemployment that led some observers to anticipate the crash yet to come.[47] Viewed in this light it testifies to anxieties about husbanding, being a man, maintaining control. Spencer's model for the husband who comically clutches a plucked chicken in one hand and a useless umbrella in the other was Benjamin Spencer, who in real life appears to have had no better grasp on full-time employment than he did on that slick bird. A hurried pedestrian passing directly behind the young husband chuckles at his predicament. A woman across the street is similarly amused. The scene is funny, but it is also nightmarish, a vision of emasculation and public humiliation. A reviewer complained about "the enormous disproportion" of the husband's head.[48] It is indeed oversized in relation to the body, but given the skill with which Spencer had earlier depicted the male figure in *Domestic Happiness*, this disproportion is probably not, as the reviewer believed, indication of a deficiency of anatomical knowledge on the part of the artist. Instead it may have constituted a device to liken the husband to a child, if not, further, to emphasize his mental inquietude and convey through a stunted bodily form a stunted potency, devices that Edvard Munch was to use decades later in paintings such as *The Scream* (1893). The

99. Charles Knoll, *Panic of 1869*, 1869. Oil on canvas,
34½ × 27¼ in. Colby College
Museum of Art, Waterville, Maine.

husband is coiled like a spring about to pop; his balance is precarious, his posture absurd. The furled umbrella, as black as his clothing, extends from his body like an arm chopped off at the wrist. His right leg, drawn upward in a desperate attempt to prevent his wife's eggs (!) from careening out of the grocery basket, also appears stunted or deformed. Both of these cropped appendages be-

speak a sort of psychic amputation, in Freudian terms, a castration.

The chuckling pedestrian behind the young husband, similarly bearded and clothed in dark tones, seems to emerge from him. Is this the domestically unburdened bachelor that the husband once was or wishes he could be? This fellow virtually launches out of the composition, his shiny um-

brella a black pirate sail or raven's wing already crossing into the infinite open space beyond the confines of the canvas. The husband, by contrast, is stuck in place: edged close to the picture plane, he can not go forward. A wall hems him in from behind and the stairsteps that lead perhaps into his own home are steep and slippery, nothing to be negotiated with ease.[49]

Fi! Fo! Fum! (fig. 100), Spencer's next painting about a husband, is also, by implication, about the dangers that inhere in the marketplace. The fairy-tale that the wide-eyed father recounts to his children, "Jack and the Beanstalk," is the story of a youth who on the way to market trades the family cow for magic beans instead of money, causing his mother (a housewife) to curse his ineptitude. As with *This Little Pig*, painted a year earlier—the year of the panic—the homey setting and family circle motif are belied by the title's indirect allusion to the cruel outside world constituted by the market and its system of inequities, swindlings, imbalances (as rendered in *The Young Husband* by the spilling of groceries), cutthroat competitions, and cannibalistic practices ("Fi! Fo! Fum! I smell the blood of an Englishman!"). In *Domestic Happiness*, from 1848, a husband was a benevolent figure whose enthusiasm needed to be held in check ("Hush, don't wake them"), but in the decade that followed, the middle-class husband typically portrayed by Spencer was a figure associated not only with ineptitude but also with childishness and fear.[50]

Jack's speculation on a handful of beans proved in the end to be a wise investment only because of his willingness to take risks. In fairy tales, mastery of fear is essential. The husband of *Fi! Fo! Fum!* looks to be far from that point: bug-eyed and lock-jawed, bracketed on one side by an ominous shadow and on the other by a surveillant wife, he

clasps his children to him as much for his own security as theirs. Like the young husband trapped in the downpour, he is cute, he is comical, but he is living a nightmare. The child on his lap tugs at his necktie as though choking him with a noose.

In 1862, after the birth of her fifth child, Spencer wrote to her parents, "All the rest of us are well, but Ben is not as hopeful about our affairs as I am. . . . I look upon that as a general failing with the men, not to have so much hope in difficulties as women." To this she adds, "But altogether he is a prety [*sic*] good boy."[51] Spencer's representations of her husband in particular and thus of husbands in general could be regarded as a way of metaphorically describing *their* anxiety over their unsettled roles at home and in the world. I am not claiming that she knew, in a fully self-conscious way, that this was what she was up to; neither do I believe that her viewers understood the paintings in this way. But I think they experienced them in this light, which is to say, viewed them in a historical context in which anxieties over masculinity and masculine authority were profound, if not always publicly acknowledged. As John Demos has explained, the father "was not just the breadwinner for the entire family; he was also its sole representative in the world at large. His 'success' or 'failure' . . . would reflect directly on the other members of the household. And this was a grievously heavy burden to carry."[52]

In *The Artist and Her Family at a Fourth of July Picnic* (fig. 101), the father himself is depicted as a burden too heavy to carry. The prevailing tone, of course, is comical. In an idyllic

100. Lilly Martin Spencer, *Fi! Fo! Fum!*, 1858. Oil on canvas, 35⅞ × 28⅝ in. Private Collection
(Photo: National Museum of American Art, Smithsonian Institution, Washington, D.C.).

country setting, a score of middle-class folk are gathered for an outing on the national holiday. Most of the picnickers reel with laughter as one of the men, a portly, middle-aged Benjamin Spencer, is sprawled in a daze, the rope swing having collapsed under his weight. The implicit allusions to such European works as Watteau's *Embarkation for Cythera* (1717), Fragonard's *The Swing* (1769), and the ancient Roman statue of *The Dying Gaul* are among the devices complicating the apparent single-mindedness of the image, ironically likening these jolly, pleasure-seeking Americans to French aristocrats on the eve of the Revolution and this awkward and overstuffed husband to a lean and muscular vanquished foe. Whether or not such erudite references actually registered, *The Picnic* nonetheless symbolically illustrates an instance of authority deposed as pater familias, in a state of sudden collapse, is publicly laughed at and requires the assistance of a child merely to get back on his feet.

To judge entirely from the textual evidence of *The Young Husband, Fi! Fo! Fum!*, *The Picnic*, and even *Domestic Happiness*, we have reason enough to wonder about Spencer's attitude toward her chronically unemployed husband. Comments about him—and sometimes by him—in letters home further evidence a belittling attitude. In 1852, for example, Benjamin adds this postscript to one of Lilly's letters: "Dear Mother, I have not much to say or to tell you about, only that I am getting too fat, and on that score I no [sic] you can simpathize [sic] with me. if I should complain to Lilly about it she laughs at me and tells me to keep on, and she will soon be able to exhibit me and make a raise of some money to go home and see you all, I hope the money will come before that time." A dozen years later, in *The Picnic*, the artist made

good on her promise to exhibit her fat husband as a means of raising money.[53]

The Picnic can be viewed as more than merely another of Spencer's gently teasing depictions of stumbling, falling, or frightened middle-class husbands. Painted during the upheaval of the Civil War, it can also be understood as an allegorical commentary on the state of the nation.[54] As in a seventeenth-century Dutch genre scene in which household disorder bespeaks spiritual or social disorder, the idyllic world of *The Picnic* unravels, however mildly in comparison to the Dutch scenes, at both the center and the margins.

In the lower right, a grinning black servant distracted by the amusement of the picnickers spills wine into the lap of a lady whose stern expression indicates that she is not amused. A black nanny tending a blond baby notes this incident with a complicit smile. Various other elements of the composition—a boy firing a toy pistol behind a pair of courting lovers, a woman rakishly sporting the cap of the soldier beside her, the waving of the flag by a child too young to comprehend the meaning of patriotism, the Independence Day alluded to in the title, and the general hilarity occasioned by the unexpected fall of the father (who hangs, as it were, from a rope)—all come together in such a way as to provide an ambivalent view of the American family as it relaxes in the American garden during a time of war, violence, rebellion. What happens when white paternal authority takes a spill? A black man squanders the wine, a black woman turns away from the child with whom she has been entrusted: slapstick, yes, but all the same, trouble in paradise.

101. Lilly Martin Spencer, *The Artist and Her Family at a Fourth of July Picnic: A Day to Remember*, c. 1864.

Oil on canvas, 49½ × 63 in. National Museum of Women in the Arts, Washington, D.C.

Given in memory of Muriel Gucker Hahn by her loving husband, William Hahn, Jr.

Beneath the tree, a lone figure rushes to the aid of the fallen father. This is Spencer's representation of herself (easily recognizable from a self-portrait of a few years earlier). Unlike the merrymakers in the group, the Spencer figure is alarmed by what has transpired, as if only she fully grasps the consequences. She reaches out toward her husband with extended arms but seems curiously static, as though unable or maybe even hesitant to come to his rescue. The painting is subtitled *A Day to Remember*. What is not clear is whether this day when the patriarchal social order has symbolically collapsed is to be remembered with rejoicing or with regret.

The Fourth of July, of course, is a national holiday, an officially sanctioned period of recreation during which workers are *given time* to restore their depleted energies before returning to the job. Holidays, as such, were invented during the industrial age as a means of sustaining the work ethic. This is in contrast to fairs of the preindustrial era, during which laborers spontaneously, without official prodding and often without official approval, *took time* from their labor to indulge in sensual release. Bakhtin, in his study of Rabelais, describes the carnival as a time of anarchic laughter, bad taste, and ritual degradation of authority: "Carnival celebrated temporary liberation from the prevailing truth of the established order: it marked the suspension of all hierarchical rank, privileges, norms and prohibitions."[55]

Spencer's *Picnic* can be read as a depiction of a holiday but with remnants, however eviscerated, of authority-mocking carnival. In fact much of Spencer's art seems carnivalesque: punning titles, grinning housemaids, excessively detailed compositions, slapstick and sometimes racist humor, and cheeky disregard for classical and romantic conventions alike. Her artistic transgressions may

have been as "unintentional" as the black servant's spilling of wine into the lap of the stuffy old woman, but intention aside, a transgression is a transgression. Her vulgar comedy—which may strike us today as being in bad taste and certainly struck many of her contemporaries that way—was, like the sentimentalism described earlier, one of the few cultural weapons available to her. Whether or not it was effective as such is another matter.[56]

❦

Once we start to consider the passive-aggressive nature of Spencer's depiction of husbands and fathers we begin to realize that they were not the only potential objects of hostility. So too were African-Americans, female servants, and children.

When African-Americans appear in her work, it is invariably in the guise of comic stereotypes. Like the husbands and children she depicts, black people are humorously innocent folk, the source of avowedly good-natured fun for the wife/adult/white person whose sense of benign superiority is erected upon their lovable and unthreatening inferiority.[57] Her depiction of white female servants is more ambiguous. In such early works as *Shake Hands?* it was not even clear whether the protagonist was a housewife or a hired cook. Reviews such as the one in *The Crayon* that chastised Spencer for the coarseness of her kitchen protagonists encouraged her to make better-dressed, more refined-looking women the subject of her work, as she then did in the case of *Kiss Me and You'll Kiss the 'Lasses*.

102. Lilly Martin Spencer, *Fruit of Temptation*, 1857.
Lithograph by Lafosse, published by Goupil, 24½ × 20⅛ in.
Ohio Historical Society, Columbus.
Transfer from the Campus Martius Museum, Marietta, Ohio.

Tensions between Spencer and her hired help became exacerbated as her financial and career pressures increased. In *Fruit of Temptation* (1857, original unlocated, fig. 102), she shows a young servant, a broom lying at her feet, admiring herself in a mirror while the children she is supposed to be looking after as well as their pets wreak havoc with a feast laid out upon a cloth-covered table.

The middle-class mother, who has just walked in, registers alarm. A letter that Spencer wrote home about the time she painted *Fruit of Temptation* expresses the same dismayed attitude: "I have often heard you dear Mother speak of the pitiful situation of poor servants but I tell you I don't pity them. . . . I do not like a girl that I cannot treat kindly, but it really seems that that cannot be done

now. I cannot be always watching over their shoulders; so I try to rouse their self-respect and to show them that I trust their consciences, but pooh! they laugh in their sleeves at what they consider my stupidity and unsuspiciousness; and thinking that the reason I treat them so kindly is because there is something wonderfully excellent in themselves."[58]

Spencer could poke fun at husbands, construct African-Americans as figures of amusement, and direct barbs at female servants without alienating herself from her primary audience, which I have speculated to be white, adult, female, and middle-class.[59] Expressing hostilities toward children, however, would have been another matter. Nonetheless, it seems to me that such hostility can be discerned beneath the sentimentality of her images. We have seen throughout this chapter that Spencer was an advocate for domesticity but was also threatened and in certain ways suffocated by it. Even when she shows children as darling little angels, there is something outlandish if not demonic-looking about them, as with the imperial infant featured in *This Little Pig*.

To a mother who adores her children but is also prevented by them from fully entering into her work, they may represent more of an obstacle than she is willing to admit. Spencer's frequent remarks to her mother about her continual "mending and patching of the babeys" call to mind the similar frustration of the young housewife Harriet Beecher Stowe, who began her literary career by pleading, "If I am to write, I must have a room to myself, which shall be *my* room. . . . All last winter I felt the need of some place where I could go and be quiet and satisfied. I could not [where] there was all the setting of tables, and clearing up of tables, and dressing and washing of children, and everything else going on."[60] Spencer's *War Spirit at Home* (1866, fig. 103) depicts chaos on the home front similar to that which Stowe describes: a mother attempts to read of a great Union victory while her baby kicks about on her lap, the maid stacks dishes, and the children parade through the dining room banging loudly on pots.

In certain regards *War Spirit* is an updating and feminizing of Richard Caton Woodville's well-known genre scene *War News from Mexico* (1848, fig. 104), in which a community of men gather on the front steps of a public hotel as one of them reads from a newspaper an account of the latest military events. In *War Spirit* there is not the same communal exchange of information. The mother appears to keep to herself as she reads a New York *Times* with the headline "Great Victory [at] Vicksburg, Miss."[61] On the Fourth of July ("A Day to Remember"), 1863, the surrender of the besieged Confederate garrison at Vicksburg, along with the simultaneous defeat of Lee's forces at Gettysburg, marked the turning point of the war. Three young children march about in noisy celebration. In the background, a serving woman dressed in black (and in this instance portrayed sympathetically) looks on with a forlorn expression in her eyes. Possibly her mistress reads aloud to her, so in that sense there is an exchange of information, though not to the degree shown in *War News from Mexico*. The two adults in the painting are no doubt chastened by their knowledge of the human cost of war and perhaps have even lost loved ones during the course of the "great victory." To this the children are oblivious, creating a pandemonium of their own that parodies the chaos of battle. The little girl even sports a Yankee cap, which was a frivolity of

103. Lilly Martin Spencer, *War Spirit at Home (Celebrating the Victory at Vicksburg)*, 1866.
Oil on canvas, 30 × 32¾ in. Newark Museum. Wallace M. Scudder Bequest Fund.

104. Richard Caton Woodville, *War News from Mexico*, 1848. Oil on canvas,
27 × 24¾ in. National Academy of Design, New York.

one of the female pleasure-seekers in *The Picnic*.

The painting's contrast in moods is heightened by its deployment of figures. The merrymakers are left of center, the two women to the right. The women are placed in the foreground and background, the children in the middle. The pairing of the mother and baby is almost a Pietà. The newspaper she holds in front of her is opened in such a way as to suggest the shape of a cross in its creases. Add to this the somberness of the serving woman, and the painting puts forth a Christian philosophy of redemptive agony that the children, with their noisy militarism, inadvertently mock. Children,

this seems to suggest, understand no hurt but their own, being too young to comprehend the suffering of others. They exhibit a "war spirit" at home, while their mother suffers "in spirit."

The moralism purveyed by this contrast goes beyond a mere Sunday school lesson in Christian deportment. It expresses the feelings of a woman whose children could not see or hear, let alone comprehend, her motherly pain (to shift now from scholarly to sentimental language). What sacrifices must Spencer herself have endured to carry children into the world? To mourn the deaths of several of them, who did not live past infancy? To have

compromised her ambitions as an artist on their behalf? To have accepted commissions she did not want because, with a husband who did not earn a living of his own, she could not afford to do otherwise? How must she have resented the fact that her paintings rarely sold for what she asked but then were engraved or lithographed for a widescale distribution from which she earned little if anything? What indignities or slights must she have encountered as one of the few women admitted, and at a lower status, to a virtually all-male club, the National Academy of Design? Could a mother ever explain such things to her children, ever burden them with her problems, ever win their sympathy? The phrase "war spirit at home" bespeaks a war effort on the home front, but, at a time when the ideology of domesticity insisted that mothers served the republic best by bearing and nurturing future republicans, the phrase also suggests that the mother who takes this responsibility seriously must fight daily battles of her own.

An earlier painting entitled *Choose Between* (c. 1857, fig. 105) is not like *War Spirit* in literally depicting a gulf between a mother and her children. It appears instead to be an image of Raphael-esque harmony, as conveyed by the rounding of the canvas on top and the pyramidal grouping within. Still, even here conflict is suggested. The mother, seated next to a table in a Victorian parlor and flanked by her little boy and girl, holds in her lap a litter of four newborn kittens. Below, the mother cat treads on the skirt of the human mother in an effort to see her brood. The little boy points out one of the four. By this he conveys his choice of

which he prefers, but his mother turns instead to the daughter, who, leaning her head on her hand in a gesture of wistfulness or regret, shows that she sees the complexities and injustices of life. The internal drama of the scene is this: one of the litter will be saved, the others drowned. It is necessary to choose between the kittens, but for the girl the choice is awful.

The choosing of a kitten is the explicit referent of the work's title, but at a second level of meaning the choice is that which the mother implicitly makes when she turns away from her son, who has shown cruel decisiveness, to her daughter, who is pained at the thought of favoring one kitten at the expense of the others. Clearly the choice is only emotional, not physical; the mother is not about to drown the child with whom she is less sympathetically bonded. But even when a mother was not responsible for determining which of her children would live and which would die, this was an era when the choice was made for her by society, which would eventually push her son out of the female sphere and keep her daughter behind, and by biology, so to speak, which routinely divided children into those who survived infancy and those who did not. Spencer herself lost nearly half the thirteen children to whom she gave birth.

Yet another sort of choice underlies the painting. As a professional female artist devoted to mothering a large family, Spencer continually had to choose between her work and her children. Or, to look at this another way, this was a choice that, given her circumstances, she was never able to make. *Choose Between* may indeed be a sugar-coated depiction of mother-child intimacy, but its grisly subtext concerning feline infanticide hints at the submerged presence of an unacceptable wish that could never be spoken, never be thought, but also never entirely repressed.

105. Lilly Martin Spencer, *Choose Between*, c. 1857. Oil on composition board with arched top,
10¼ × 8¼ in. Private Collection (Photo: National Museum of American Art,
Smithsonian Institution, Washington, D.C.).

106. Lilly Martin Spencer, *Truth Unveiling Falsehood*, 1869. Oil on canvas, 92 × 69 in.
Unlocated (Photo: National Museum of American Art, Smithsonian Institution, Washington, D.C.).

In 1869 Spencer completed an ambitious allegory entitled *Truth Unveiling Falsehood* (fig. 106). A nightmarish image known today only through a surviving photograph and a printed explanation distributed to contemporary viewers, the painting is schematically divided in half, on one side a good and beautiful mother nursing her babe, on the other a hideous monster about to consume the helpless infant in its grasp. A blond-tressed figure identified as Truth has just pulled off a veil (Falsehood) that had been disguising the mother-as-beast, who is referred to as Selfishness. This painting is normally considered an aberration in Spencer's oeuvre and a wholly misguided effort on her part (despite some acclaim, the work never sold), but it seems to me that its bifurcation of femininity into selflessness and selfishness may in fact have been Spencer's way of summing up an entire adulthood divided painfully between family and career.[62]

By the mid-1870s, American art tastes were very much in transition. Well within the sentimental currents of her time in the 1850s and 1860s, Spencer seemed increasingly old-fashioned in the years thereafter. As Robin Bolton-Smith and

William Truettner have commented, "In an 1879 auction catalog Mrs. Spencer was listed as 'deceased,' perhaps a clerical error [she died in 1902] but also an indication of the disappearance from public view of her work, which had become increasingly inappropriate to the demands of the new patronage."[63]

Let me close, then, not with one of Spencer's late works, but with one of her earliest. The *Self-Portrait* of about 1841 (fig. 107) dates from her first days in Cincinnati. This is a romantic work, to be sure, with the attractive young face that emerges boldly from the darkness framed in ebony curls, one of which falls with fetching disorder in front of eyes that gaze directly, even confrontationally, at the viewer. Lilly Martin was eighteen years old at this point. Her career as an artist had met with triumph, although so far only locally. Cincinnati's nationally esteemed patron of the arts, Nicholas Longworth, who had assisted Hiram Powers financially and later sponsored the career of Duncanson, wanted to do the same for this prodigy from the backwoods. He proposed to send her to Connecticut to meet John Trumbull, to Boston to work with Washington Allston, and to Europe to complete her education. At the time she painted this self-portrait, she had the world before her. It could be that world and not us that she gazes at so intently. Or maybe it is herself and her future that she confronts.

A generation later, the young midwestern artist William Merritt Chase, upon learning that local philanthropists wished to send him to Europe, cried out, "Egads! I'd rather go to Europe than to heaven!" Young Lilly Martin's response was quite different. She turned down Longworth's offer as well as his introductions to Allston and Trumbull. Perhaps she thought she did not need help from easterners. Perhaps as a Jacksonian American,

she considered Europe superfluous. This was, after all, the period of Emerson's "American Scholar" address, which insisted that America forge its own art rather than look to the Old World for assistance.[64] Then again, maybe she was afraid of what such opportunities might require of her. Her art would have evolved very differently had she accepted formal training and European education, but while certainly it would have been refined in style, this probably would have been at the expense of its unrefined vision of contemporary life.

Writing home upon first arriving in Cincinnati, the teenager tells of meeting the illustrious Longworth, who, to her surprise, was "a little bit of an ugly man . . . much shorter than father." Her response to him, she confesses, was that she almost "burst out laughing." It is not clear whether this impulse to laugh was generated by a nervous fear of authority or a desire to cut it down to size ("much shorter than father"). Gilles Martin advised his daughter, "Watch your temper, acquire gentleness and amiability, and I will love you, and your Mother will love you, and everybody will love you—and you and we will do very well." The dimensions of Spencer's art, as we have examined it, can be defined by her mutual—and sometimes mutually opposed—desires to laugh and to please.[65]

Throughout her letters there is a desperate seeking of her mother's blessing and fear of offending her. This may have had something to do with her decision to separate from her mother politically and even geographically. Apparently they never saw each other after Spencer moved to New York. Still, the daughter's paintings may have been a

107. Lilly Martin Spencer, *Self-Portrait*, c. 1841. Oil on canvas, 30⅛ × 25¼ in.
Ohio Historical Society, Columbus.

form of dialogue with her absent mother, embodying some of her sentiments, refuting others, and generally providing a means by which she could "choose between" Angelique Martin's values and her own.

A woman who was often tempted to "burst out laughing" at men despite her need for them, who yearned for her mother's approval yet was determined to set her own course, who could feel solidarity with working women but also animosity toward them, and who was devoted to raising children but was oppressed by the responsibility, Spencer produced a body of work that turns out to be something other than the unadulterated celebration of bourgeois domesticity it is usually considered. When we read Spencer's paintings, as the new connoisseur is likely to read them, as expressions of naive faith in the world-view of the antebellum middle class, the naivete resides not in the works but in the reading. Lilly Martin Spencer confounds the connoisseur not because her work is so good or bad, progressive or reactionary, subversive of the ruling class or collusive with it, but because forms of art history that rely, however implicitly, on such either/or formulations are in the end not supple enough to respond adequately to the contradictory, disunified nature of a cultural production such as hers.

Like most artists of the modern era, Spencer came from, belonged to, and was representative of differing and sometimes competing social groups. In her case, she was a westerner laboring in the eastern metropolis, a female engaged in what was conventionally a male profession, a working woman sometimes commissioned, or patronized (matronized?), by female clients of the leisure class, a low-income, middle-class housewife who fulminated over the performance of her working-class housemaids, a bourgeois daughter of a socialist-feminist mother, and a devoted wife who supported her husband financially while sentimentalizing him but also belittling him in her correspondence and in her art. The work she produced resulted from her never-entirely-stable placement within this variety of overlapping, sometimes antagonistic subject positions. In pondering Spencer's art—not only its iconography but its formal rhetoric, its ways of signifying—we can proceed beyond our current stereotypes (whether positive or negative) regarding middle-class domestic life in antebellum America to encounter work that is not so much a reflection of a particular society as a series of subpolitical interventions within various conflicted areas of that society.

Domesticity was an inescapable part of Spencer's life. How could she not have painted the nursery and kitchen, given how tethered to them she was? What *would* be surprising is if her depictions of the domestic scene were as one-dimensional and blithe as they might at first seem. Under inspection, these paintings appear to be deeply marked by pressures, financial and otherwise, inextricably related to the artist's uncertain embrace of domesticity and its implacable codes of maternal self-sacrifice. It is easy to regard Spencer's paintings as instances of ideological masking, of middle-class hegemony. But to look at the paintings in terms of the material concerns of the artist and of the females in her audience, we see works that are hardly simpleminded propaganda for domesticity. They are instead ambivalent, dual-edged ways of thinking about it, representing it, and maneuvering within its contradictions.

Guys and Dolls:
Framing Femininity in Post–Civil War America

In the spring of 1867, the New York correspondent for San Francisco's *Alta California* filed a report on his visit to the annual exhibition at the National Academy of Design, the nation's most prestigious art establishment. The correspondent, Mark Twain, drolly observed that "more than half of the paintings in the Academy [were] devoted to the usual harmless subjects": "the same old pile of cats asleep in the corner, . . . the same old detachment of cows wading across a branch at sunset, . . . the everlasting farmers, gathering their eternal squashes; and a 'Girl Swinging on a Gate'; and a 'Girl Reading'; and girls performing all sorts of similar prodigies." [1]

The English-born academy member J. G. Brown was a popular purveyor of the sentimental girl paintings that Mark Twain derides. Brown's *Resting in the Woods* (fig. 108) and *Watching the Woodpecker* (fig. 109), both completed in 1866, are good examples of the sort of thing Twain had in mind.[2] They are coy, cleverly painted, and seem as distant as anyone could have wanted from the grim realities of the recently concluded war, the assassination of Lincoln, the controversial Reconstruction of the South, the abruptly massive industrialization and proletarianization of the North, the beginnings of full-scale immigration from southern and eastern Europe, and the greedy materialism, hypocrisy, and cynical corruption that Twain himself would later characterize under the rubric the Gilded Age.

Neither did such blithe pictorial representations of American girlhood serve any notice of the feminist anger and activism that were emerging across America as women who had previously organized on behalf of freeing the slaves and awarding them citizenship now turned to the arduous task of winning their own suffrage and property rights.

As a professional satirist, Mark Twain had reason to be disgruntled with genre painting of the sort turned out by Brown and the other girl painters, for the genre painting that he had grown up with had typically concerned itself if not always with overt political satire, then at least with pointed social commentary.[3] As noted in previous chapters, genre painting is by definition that which is concerned with subjects or scenes from everyday life depicted in a manner thought to be more or less realistic. Unlike history painting, it does not focus on extraordinary individuals or events, and unlike portrait painting it treats the characters it depicts as types or archetypes rather than as specific individuals possessed of a real-world existence. The very term *genre* derives from the Latin *gens*, which means "family" or "clan" and comes from *genus*, meaning "race," "species," or "kind." Traditionally, such paintings depicted common situations of common people—those who were regarded as *generic* members of the so-called family of man. Works of this sort always possessed the potential to satirize, to point out folly or vice or other

108. J. G. Brown, *Resting in the Woods (Girl Under a Tree)*, 1866. Oil on canvas, 18⅜ × 12⅛. Collection of Jo Ann and Julian Ganz, Jr.

inadequacies of the body politic. Hogarth comes to mind and the seventeenth-century Dutchman Jan Steen. The pre–Civil War genre painting that Mark Twain would have known, for example, that of Bingham, his fellow Missourian, or of the Long Islander William Sidney Mount, was never exactly biting in its social commentary but neither was it toothless. For instance, Bingham's *The County Election* (fig. 35) depicts a typical election day at a rural polling place. Note the hard cider ladled out to prospective voters, one of whom is so drunk he can barely keep his feet.

The Pittsburgh artist David Gilmour Blythe was perhaps the one genre painter to persist up to

109. J. G. Brown, *Watching the Woodpecker*, 1866. Oil on canvas,
18 × 12 in. Private Collection.

and through the Civil War as a satirist, as in his Hogarthian *Trial Scene* (1860–63), which depicts a gathering of conspiratorial Molly Maguires who look like thieves out of *The Beggar's Opera*, and in his Daumier-styled *Art Versus Law* (1859–60, fig. 110), in which a tattered artist, probably Blythe himself, returns to his studio to find himself locked out for nonpayment of rent.[4] As the very subject of this painting would seem to indicate, satirical genre painting of the sort practiced by Blythe was no longer a commercially viable enterprise. The work of the political cartoonist Thomas Nast notwithstanding, most Americans during the Civil War and its aftermath apparently did not care to be

reminded of social and human fallibility, for such fallibility was already writ large everywhere they turned. A more easily digestible fare was the order of the day.

By the time the war ended Blythe was dead, Mount old and inactive, and Bingham, engaged in teaching and embroiled in local politics, had run out of steam as a genre painter. Lilly Martin Spencer poured her energies, previously sharp-eyed and socially commentative within a sentimental framework, into nonsatirical allegories such as the neoromantic *We Both Must Fade* (1867) and the grandiose *Truth Unveiling Falsehood* (fig. 106). In 1867, the year Mark Twain reviewed the academy exhibition, Thomas Eakins, as yet unknown, was studying in Paris with the French academician Jean-Leon Gérôme. Eakins's contemporary, the remarkable young illustrator Winslow Homer, had secured his reputation the previous year, 1866, with *Prisoners from the Front*, a vivid depiction of three Confederate types—a hayseed, an old man, and a proud Johnny Reb—who have laid down their arms before a patrician Yankee officer. But in spite of the popular success of this painting, which mythologized and theatricalized the just-ended war rather than satirized the cruelties or pretensions of its participants, Homer, after a brief stay in Europe, turned his attention away from political and topical subjects. He concentrated instead on safer themes of fashionable leisure, as in *Long Branch, New Jersey* (1869) and *The Croquet Match* (1868–69), and then later on country lads and lasses, as in *The Berry Pickers* (1873) and *Feeding Time* (c. 1878, fig. 111).

Henry James, who himself was soon to appropriate the American girl as an artistic subject, was revolted by what he perceived as the inanity of Homer's treatment: "Before Mr. Homer's little barefoot urchins and little girls in calico sun-

110. David Gilmour Blythe, *Art Versus Law*, 1859–60. Oil on canvas, 24 × 20 in. Brooklyn Museum, New York. Dick S. Ramsay Fund.

111. Winslow Homer, *Feeding Time*, c. 1878. Watercolor and gouache over pencil, 8¾ × 11¼ in.
Sterling and Francine Clark Art Institute, Williamstown, Massachusetts.

bonnets, straddling beneath a cloudless sky upon the national rail fence, the whole effort of the critic is instinctively to contract himself, to double himself up, as it were. . . . We frankly confess that we detest his subjects . . . [such as] his flat-breasted maidens, suggestive of a dish of rural doughnuts and pie.[5]

Of the prominent post–Civil War genre painters who commonly featured American girls in their work, none was more highly regarded—at least by those who had a taste for this sort of thing—than the English-born artist Seymour Joseph Guy, a member of the National Academy of Design since 1865.[6] Guy's virtually instantaneous prominence

within this prestigious and powerful organization is indicated by his inclusion in a group photograph taken in 1866 (fig. 112) of a dozen leading New York artists gathered in the Tenth Street studio of Worthington Whittredge, a second-generation Hudson River School landscapist who was soon to serve as president of the academy (Guy is standing second from right).[7] Some of Guy's works from this period are his *Red Riding Hood* (c. 1866, fig. 113), *Story of Golden Locks* (c. 1870, see fig. 135), and *Pick of the Orchard* (c. 1870), each of them featuring an adolescent or preadolescent girl involved in an archetypal, symbolically loaded situation: respectively, meeting a wolf on the road,

112. "Artists Gathered in Worthington Whittredge's Tenth Street Studio," 1866.
Seymour Guy standing second from right. Photographs of Artists
Collection I, Archives of American Art, Smithsonian Institution, Washington, D.C.

reading a scary story to younger children, and reaching for an apple in a garden.

The depiction of American girls typified by such paintings constituted, I will argue, a popular discourse that in reconfirming gender stereotypes helped perpetuate the hierarchy of the sexes and ward off from a white, middle-class, male-dominated social order threats arising from militant feminists and other agents for social change. A newspaper illustration of the period caricaturing woman suffrage activist Susan B. Anthony (1873, fig. 114) as tough, angular, and aggressive indicates by contrast precisely what kind of soft, malleable, unthreatening females Guy's girls were meant to be.

Today, Guy's best-known work is *Making a Train* (fig. 115), a painting of 1867 that was not completed early enough to be in the spring exhibition that Mark Twain reviewed. The title refers to the imaginary skirt that a little girl, probably Guy's nine-year-old daughter, Anna, sweeps be-

hind her. Alone in an attic bedroom, she pretends to be a grown lady, a bride or a queen or simply her mother. Given the theatrical role playing of the girl as well as the stage-set, stage-lit quality of the scene, the painting enjoins its viewers to think of themselves as invisible spectators, positioned in the dark.

Making a Train is a seductive image for any number of reasons, some of which seem to contradict one another. For example, the painting is buoyantly innocent but also teasingly erotic. In one sense the room in which the girl plays is safe, cozy, and warmly lit, but eerie shadows loom, and on the wall a sentimental print of a child in prayer has come ominously undone. Although the girl appears independent and carefree in her play, the architecture presses down as if bending her body beneath its pressure. The items of clothing strewn before her, the toy doll stuffed in a box in the half-open cupboard, the oil lamp set down behind the bars of the banister-back chair, the jutting

113. Seymour Guy, *Red Riding Hood*, c. 1866. Oil on canvas, 8 × 12 in.
St. Johnsbury Athenaeum, St. Johnsbury, Vermont.

114. *"The Woman Who Dared" (Caricature of Susan B. Anthony)*. Cover of *The Daily Graphic*, June 5, 1873. Library of Congress.

dresser drawer, and the rumpled, unmade bed bespeak the spontaneity of the child, but they also convey disorder and an absence of discipline (as in seventeenth-century Dutch paintings in which idle house-servants, surrounded by evidence of neglected duty, symbolized the shortcomings of those Protestants who failed to keep their moral houses in order).[8] Clean-scrubbed, rosy-cheeked, radiant, a middle-class princess, the little girl is also Cinderella, confined to a shabby attic while her haughty stepsisters and wicked stepmother attend the grand ball that she can only dream of attending.

I will examine this particular girl painting along two main lines of inquiry, seeking to understand it first in terms of the cultural implications of childhood as it was conceived at this time and second in regard to the proliferation within the culture of voyeurism, or secretive, surveillant, and objectifying looking. When so examined, paintings such as *Making a Train* are anything but innocent, disinterested, and uninteresting.

❁

Making a Train makes a claim. It claims that children are good and their play a good thing.

Today, we might assume that there was nothing unusual about such a claim. This would be a mistake, for although the claim was rapidly achieving dominance in the era immediately following the Civil War, it ran against the grain of a powerful and much older counterclaim that children are innately depraved and childhood a torturous period during which such depravity must be uprooted by perpetual instruction, correction, and, as necessary, punishment. Thus, while the dominant meaning of *Making a Train* may be that children and their forms of play are good, this meaning was not yet dominant in the culture at large but was still contested, and even where it was accepted, debate

115. Seymour Guy, *Making a Train*, 1867. Oil on canvas, 18⅛ × 24⅜ in.
Philadelphia Museum of Art. George W. Elkins Collection.

arose (as noted in chapter 4) over how best to nurture and protect such innocence.

Rousseau, in the late eighteenth century, was one of the first Western intellectuals to challenge the orthodox teaching that man is born in sin and must be chastised and catechized into submission. For Rousseau and his many followers, not the child but society was depraved: "Man is born free, and yet we see him everywhere in chains," proclaims *The Social Contract* in an utterance that might have shocked Calvinist Americans but that by the middle of the nineteenth century was coming to appear, especially among the middle classes, common sense. Such progressively minded Americans subscribed to the "incontrovertible rule" tendered by *Emile*, Rousseau's popular educational romance, "that the first impulses of nature are always right; there is no original sin in the human heart, and the how and why of the entrance of every vice can be traced."[9]

Rousseau's concepts gained influence in America by way of English romanticism. Blake's *Songs of Innocence* (1789), for example, celebrated this new view of the child, but perhaps even more compelling was the poetry of Blake's contemporary Wordsworth, who, as noted in chapter 3, declared, "The child is father of the man," a sentiment that by midcentury many Americans embraced with almost religious fervor. The Wordsworthian child was not only innately innocent but also innately creative, sensitive, and good—the embodiment of poetic inspiration.[10]

If the romantics were the first to broadcast the view of children as inherently good, the theme was further disseminated by liberal reformers, educators, and philosophers as well as by sentimental authors and artists. As R. Gordon Kelly has observed, "Childhood came to be acknowledged as a separate stage of life valuable in itself, a time during which the child's capacity for wonder and imagination could be freely and safely indulged."[11]

Thus, for example, child-rearing tracts, which previously had insisted upon corporeal correction of disobedient offspring, now told parents that in sparing the rod they would not spoil the child but would instead win the child's affection and trust, necessary ingredients for a truly moral upbringing.[12] The most popular child-rearing manual of the nineteenth century, Jacob Abbott's *Gentle Measures in the Management and Training of the Young* (1871), advised parents to appeal to their children's imaginations, their sense of play. Like Blake and Wordsworth, Abbott regarded play as a blessing, not a trap laid by the devil. Whereas parents of an earlier era misguidedly set limits on a child's play, the modern parent, according to Abbott, understood that free play offered unrivaled opportunities for "gentle . . . management and training."

Abbott tells the story of Della, a young woman charged with looking after two little girls. When Della wishes to teach the girls suitable behavior, she does this not by direct instruction but indirectly by addressing their dolls: "This not only pleased the children very much, but enabled Della . . . to communicate a great deal of useful instruction, and [make] lasting impressions upon their minds."[13]

Focusing upon a child happily engaged in imaginative play, *Making a Train* employed the same conceptual language as *Gentle Measures*. It even, one might say, propagandized for the increasingly dominant belief in the innocence and social utility

of childhood play. To speak of the painting thus is again to emphasize that the attitude conveyed was not natural and universal but rather the result of a long series of ideological battles waged by social groups holding distinctly opposed visions and economic interests. *Making a Train*, this is to say, was a *political* image, even in its apparent eschewal of politics and other worldly considerations.

For example, in idealizing childhood leisure it implicitly idealized leisure per se—a rather self-serving notion for the new leisure class created in America as a result of economic expansion after the war. Guy's patrons, among them the Vanderbilts, Goulds, and Whitneys, were prominent members of the leisure class, but the crowds that enjoyed his works at the annual academy exhibitions were themselves either members in good standing of this class or were subclass outsiders hereby receiving indoctrination into its values and encouragement to aspire to its ranks. The painting's idealization of play took part, moreover, in a massive post–Civil War cultural rejection of all residual Calvinist beliefs that opposed hedonism, aesthetics, and self-gratification, which were the conceptual and behavioral underpinnings of the new "culture of consumption" that was markedly transforming the economy and national life.[14]

In still other ways did *Making a Train*'s picture of childhood amount to a political picture. By portraying a clean, healthy, innocent child playing alone in her room, the painting offered invidious comparison to dirty, unhealthy, and delinquent children, especially those who played in gangs and in the streets. Prior to the Civil War, middle-class reformers had begun spelling out the equation between good child and good citizen, bad child and future criminal. Noting that half the petty offenders in the city's jails were under twenty-one, the founders of the Children's Aid Society of New

York had averred that unless such youths were morally saved "they will influence elections; they may shape the policy of the city; they will assuredly, if unreclaimed, poison society all around them. They will help to form the great multitude of robbers, thieves, and vagrants."[15]

After the Civil War, reformers began arguing that the way to "reclaim" children from immorality was to insulate them from whatever external forces might do them harm. Thus the antebellum effort to *save* children morally from their own antisocial impulses by meting out strict discipline and religious instruction turned into a postbellum effort to *protect* them legislatively from evil originating in the outside world. Children were now thought to be victimized not by inherent wickedness but by the brutish instincts and ignorance of the immigrant and working-class families to which they belonged—or, alternatively, by the excesses of industrial capitalism (which reformers generally believed could be ameliorated while leaving capitalist values intact).

The nation's first child-protection organization, the New York Society for the Prevention of Cruelty to Children, was founded in 1874 in response to the case of Mary Ellen, a young girl who was routinely and savagely beaten by her adoptive mother. The general public, already sensitized by Charles Dickens's enormously popular novels and lectures dramatizing the neglect and abuse of innocent children, must have found in images such as *Making a Train* not only welcome relief but also a positive trope around which to focus their vigorous efforts for reform. Along similar lines, Hora-

116. J. G. Brown, *Bootblack with Rose*, 1878. Oil on canvas,
20 × 14 in. Munson-Williams-Proctor Institute, Utica, New York.

tio Alger's mass-consumed novels about spunky newsboys and J. G. Brown's frolicsome paintings of cherub-faced bootblacks (1878, fig. 116) also served the child-protection cause, picturing each Ragged Dick as a budding capitalist or a middle-class prince in foundling's guise—which made him seem all the more deserving of socially legislated protection. Earlier, David Gilmour Blythe had depicted urchin boys as surly louts, abused or abusive street toughs who picked pockets, as in *Post Office* (1860–63), or looked out at the world with a wary eye (c. 1859, fig. 117), but now works such as these would have been shockingly out of

step with the new insistence on the universality of childhood innocence. To be successful, the reform movement required not only pitiful victims but also fantasy heroes and heroines; representations not only of hell but of heaven, too.

The many protection societies that sprang up in England and America after the formation of the New York society identified a variety of enemies to the child's well-being, not only poor and ignorant parents on the one hand or greedy industrialists on the other, but also abortionists, antiabortionists, and alcohol peddlars. Sometimes the Roman church was to blame. The zealous Dr. Barnardo of

117. David Gilmour Blythe, *A Match Seller*, c. 1859. Oil on canvas,
27 × 22 in. North Carolina Museum of Art, Raleigh.

the East End of London, assisted by a team of burly wrestlers, abducted allegedly mistreated children from their Catholic families and shipped them off to Protestant homes and shelters in Canada.[16] Other times it was pulp literature that was deemed the source of abuse. Anthony Comstock, best known as America's pioneer crusader against pornography, waged a campaign against a subliterary form invented after the Civil War, the dime novel for children. Such fiction, Comstock charged, abused not bodies but minds and was just as much a crime, perhaps an even greater one, for it injured not only the individual child, as did physical abuse,

but society at large. "If at the beginning of life the mind and soul be defiled," Comstock warned, "[Satan] reckons that the youth will become in the community a sure agent to drag others down."[17]

These various protection movements arose from a historically new perception that children were being abused. According to the historian John Demos, it was not merely the perception of abuse that was historically new but the abuse as well. Prior to the modern age children were harshly treated and physically punished within ruling social codes, but they were not, Demos contends, *abused*, as we have come to understand the term.

Instead, abuse of children was a by-product of the nineteenth century's radical shift from agrarianism to industrialism, which led to the typical preconditions for child abuse as these are recognized today: parents are unemployed (unemployment was a negligible factor in agrarian society); children are inessential to the household economy (which was not the case in the preindustrial family unit); and the extended family, in which older members are on hand to keep watch over the younger, has been replaced by the nuclear family, in which parental aggressions can be acted out behind closed doors, unchecked, free from interference.[18]

A more subtle and psychological precondition for abuse is parental disappointment, which occurs when a child fails to live up to the parents' ideal. The more exaggerated the ideal, the sharper the disappointment. Paradoxically, the notion of childhood depravity had protected children from abuse inasmuch as it taught parents to expect them to be bad, whereas the new concept of innocence had the opposite effect, subjecting children to unrealistic expectations.

In this regard, images that fetishize childhood innocence, while providing rallying points for those who wished to protect the child, may nevertheless have exacerbated the very problem the protectors sought to overcome, for what child could live up to the ideal of innocence these paintings portray? Moreover, by picturing the child as an adorable little pet, paintings such as *Making a Train* instructed adults to see children, their own and other people's, as pets to be played with, however benevolently. Should it come as any surprise that the first public organization in America to champion the cause of abused children was the Society for the Prevention of Cruelty to Animals? If the best-selling *Gentle Measures* taught parents to educate their daughters morally by devising scenes with their dolls, paintings such as *Making a Train* went a step further in encouraging parents to think of their daughters *as* dolls.

Child protection societies focused upon abuse that was physical (beatings, privations, excessive labor) or moral (dime novel corruption, for example). Typically the victims of such abuse belonged to the working class. Middle-class children, almost by definition, were thought less likely to be abused in such ways inasmuch as their parents, by virtue of being middle-class, did not require hard labor of them and raised them in accord with the new tenets of "gentle management." As for sexual abuse, it appears not to have been an issue among members of the middle class regarding their own children (whether it actually occurred or not we have little way of knowing), but when it came to the children of the poor, sexual abuse was very much an issue.

The primary manifestation of the sexual abuse of underclass children was child prostitution. The Victorian reformer Henry Mayhew, in his exhaustive study of the London poor, claimed, "It has been proved that 400 individuals procure a livelihood by trepanning [entrapping] females from eleven to fifteen years of age for the purposes of prostitution." According to Mayhew, "Every art is practised, every scheme is devised, to effect this object, and when an innocent child appears in the streets without a protector, she is insidiously watched by one of those merciless wretches and decoyed under some plausible pretext to an abode of infamy and degradation."[19]

The nightmare scene Mayhew depicts is the

118. Oscar Rejlander, "Mother's Clothes," 1861. Photograph.
Graham Ovenden Collection.

lurid counterpart to the scene painted by Guy. Both begin with "an innocent child," but whereas one such child is safeguarded high above the street in her attic room, the other "appears in the streets without a protector." Whereas Guy's little girl is watched over, as it were, by the painting's middle-class art lovers who are encouraged to gaze amusedly at her childish capers, Mayhew's little girl is watched "insidiously" by "merciless wretches" who intend her harm.

Although the child in *Making a Train* may be posed and semiexposed in such a way as to have mildly titillated viewers, and although there is in her make-believe a hint of human nature untamed (that is, still savage), she nonetheless projects an aura of unassailable innocence. An analogous image might be "Mother's Clothes" (1861, fig. 118), Oscar Gustave Rejlander's sentimental but erotic photograph of a girl named Charlotte Baker. Rejlander, a Swede who studied painting in Rome before settling in England, was initially censured for his use of nudity in an allegorical composite photograph entitled *The Two Ways of Life* (1857), but when Queen Victoria herself

119. Oscar Rejlander, "Cupid and Venus," c. 1855–60. Modern print from original glass negative. Royal Photographic Society, Bath.

purchased a copy of it as a gift for the Prince Consort, Rejlander's reputation was secured (later he collaborated with Darwin on *The Expression of Emotions in Man and Animals* and enjoyed a large following). "Mother's Clothes," like *Making a Train*, trades upon the conceit of a prepubescent girl playing in her mother's apparel or apparel that she pretends to be her mother's. With a pensive, perhaps even melancholy, expression on her face, Charlotte Baker pauses amidst a pile of lacy petticoats; most of her lithe young body is naked save for a single white stocking hiked up to the top of one thigh. The photo is printed in the oval format Rejlander's contemporaries equated with sweetness, harmony, and nostalgia. Charlotte shows none of the vivacity or pleasure in play exhibited by her

counterpart in *Making a Train*, and to modern eyes her pose and dishabille may seem more explicitly erotic. Yet here, too, the code of childhood innocence must have been forceful enough to preclude an erotic reading or at least displace it.

That is, the middle-class belief in the innate goodness of the child had grown so powerful that it seems to have put blinders on adults who could look at photographically realistic representations of nude or seminude *middle-class* children—representations that in earlier or later eras would have been deemed lewd—and yet not consider them as such (c. 1860, fig. 119). The photographer Julia Margaret Cameron, a luminary whose circle included such eminent Victorians as Thackeray, Tennyson, Holman Hunt, and Coventry Patmore,

120. Julia Margaret Cameron, "Study of a St. John the Baptist,"
1872. Photograph. George Eastman House, Rochester, New York.

posed naked little boys and girls in positions of quasi-erotic lassitude, as in *Love in Idleness* (1867), depicting tousle-haired, heavily lidded, six-year-old Freddy Gould as the unabashed god Eros, and in her come-hither photo of half-clad Florence Fisher, who clutches at animal skins in imitation of a beardless St. John the Baptist (1872, fig. 120). The Reverend Charles Dodgson, better known by his pen name Lewis Carroll, frequently photographed naked girls from respectable families, always with their mothers' avid consent (1877, fig. 121). As he explained on one occasion, "Naked children are so perfectly pure and lovely" and professed to one little girl, "I am fond of children (except boys)." But even girls lost his attention once they reached puberty: "About 9 out of 10,

I think, of my child-friendships get shipwrecked at the critical point 'where the stream and river meet'. . . and the child-friends . . . become uninteresting acquaintances whom I have no wish to set eyes on again."[20]

Carroll's contemporary the Reverend Francis Kilvert describes in his diary a water fight among a group of "fine good looking spirited girls," one of whom tore open her frock during "the romp" in such a way as to display "vast spaces of white, skin as well as linen." In words appropriate to the sensibility if not the particulars of *Making a Train*, Kilvert (who was twenty-nine at the time) exclaims, "I could not help envying the father his children especially his troop of lithe, lissome, high-spirited, romping girls with their young supple limbs, their

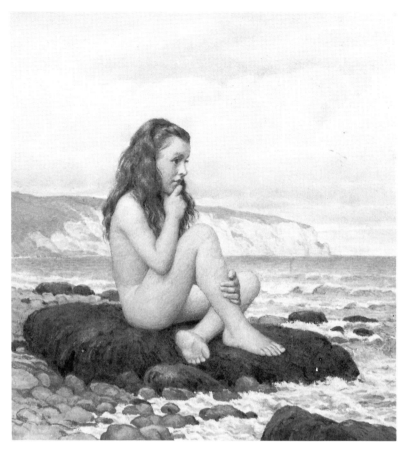

121. Lewis Carroll, "Birdie" [Beatrice Hatch], 1877.
Hand-tinted photograph. Rosenbach Museum & Library, Philadelphia.

white round arms, white shoulders and brows, their rosy flushed cheeks, their dark and fair curls . . . their bright wild saucy eyes, their red sweet full lips and white laughing teeth, their motions as quick, graceful and active as young antelopes or as fawns, and their sweet merry laughing voices, ringing through the woods."[21]

To modern ears, Kilvert's prose drools with pent-up desire; one imagines the writer wearing a raincoat and little else. After all, Humbert Humbert (and Balthus, too) stands by to comment on the Kilverts and Carrolls and their fascination with little girls. "Now I wish to introduce the following idea," says Humbert. "Between the age limits of nine and fourteen there occur maidens who, to certain bewitched travelers, twice or many times older than they, reveal their true nature which is not human, but nymphic (that is, demoniac); and these chosen creatures I propose to designate as 'nymphets.'" He elaborates: "You have to be an artist and a madman, a creature of infinite melancholy, with a bubble of hot poison in your loins and a super-voluptuous flame permanently aglow in your subtle spine . . . in order to discern at once, by ineffable signs—the slightly feline outline of a cheekbone, the slenderness of a downy limb, and other indices . . .—the little deadly demon among the wholesome children; she stands

unrecognized by them and unconscious herself of her fantastic power." [22]

Humbert claims to be able to winnow out "the little deadly demon," the "nymphet," from "wholesome children"—Charlotte Baker, perhaps, from the little girl playing dress-up in *Making a Train*— but, as we have seen, in the Victorian era the opposed notions of childhood innocence and childhood depravity were so thoroughly entwined that every deadly demon was potentially an angel and every angel potentially a demon. This is to say, adults were socially constructed by the clash of the new and old codes in such a way as to conceive of childhood in a dualistic, contradictory manner. One way to reconcile this dualism was to dichotomize the overarching category childhood into subcategories: the innately innocent versus the innately depraved; the socially protected versus the socially abused; children of proper families versus those of miserable wretches.

But another means of reconciliation was the route apparently taken by Carroll and Kilvert and the many admirers of the art of Seymour Guy, and that was to focus fetishistically upon children (in all these instances, female children), extolling their purity, spontaneity, and innocence with such ardor that what Humbert Humbert calls "a bubble of hot poison" and "a super-voluptuous flame" of desire—responses to the demonic sublime—could be safely aroused and safely given vent. If the one means of reconciling contradictory beliefs about children was to divide them into two categories, the good and the bad, here too was a procedure of splitting, but within the psyche of the individual viewer, who, through avowal and disavowal, cathexis and repression, could experience young females as both a paradigm of purity *and* the source of titillating thrills.

Nabokov makes clear in *Lolita* that Humbert

Humbert's spiritual forebear is Edgar Allan Poe, an artist who was dedicated to the bifurcation of females into child brides and suffocating ghouls, whose artistic creed was that there is "nothing more moving than the death of a beautiful woman," and who, at the age of twenty-six, married his thirteen-year-old cousin, Virginia Clemm. A generation later, Lewis Carroll, in his thirties, was deliriously infatuated with the twelve-year-old Alice Liddell and other preteenaged girls, some of whom, as we have noted, he photographed in nude, provocative positions. John Ruskin was twenty-nine when he wed eighteen-year-old Effie Gray, a distant cousin whom he had courted since she was a child. At thirty-nine, a bachelor again, he met ten-year-old Rose La Touche but waited until he was forty-seven to propose to her (she declined). In 1871, the forty-year-old J. G. Brown, the prominent painter of girls and bootblacks mentioned above, married the eighteen-year-old sister of his wife, who had died four years earlier. When seen in this light, some of Brown's paintings from the time, such as *What's Your Name?* (1876) and *Young Girl in a New York Garden* (1871, fig. 122) seem to fix their adolescent or preadolescent female subjects with a gaze not altogether free of desire.

This is not to suggest that Victorian men lusted after little girls as explicitly and self-consciously as the fictional Humbert lusts after Lolita. In those days the idealizing love of Dante for the child Beatrice or of Petrarch for the child Laura was thought the appropriate model and as such was frequently invoked. It is unlikely that Lewis Carroll ever did anything more than kiss (and kiss and

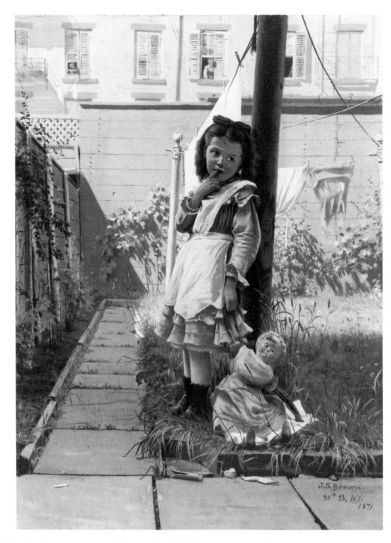

122. J. G. Brown, *Young Girl in a New York Garden*, 1871. Oil on canvas, 23¾ × 18⅛ in.
Collection of Mr. and Mrs. Charles O. Smith, Jr.

kiss) the little girls with whom he was friends, and Ruskin, in fact, was literally unable to consummate his marriage with Effie Gray, which provided the basis for an annulment after six years (the story circulating that the art critic was so dismayed on his wedding night to discover that, unlike children and Greek statues, women possessed pubic hair that he never recovered from the shock). It took a royal commission to propose that the age of marital consent in England be *raised* to fourteen in order to extend the supervision of parents over daughters who from the age of twelve or younger were being courted by adults. The culture that permitted, if not encouraged, grown men to take emotional refuge in the company of pubescent girls is precisely the culture that produced Seymour Guy, his paintings, and his patrons.

Although Guy and his contemporaries would surely have been offended by the suggestion that *Making a Train* elicited any sort of romantic or erotic response, that hardly precludes such from potentially having been the case. I want to suggest

that the response of nineteenth-century viewers, whether male or female, was erotic, if by *erotic* we mean the arousal of sexual love, which in turn is to say love focused on physical, emotional, and political balances and imbalances of power.[23]

It is this complicated series of intersections of the physical and the emotional, innocence and sensuality, power and powerlessness that causes young girls as rendered in such paintings as *Making a Train* to possess ambiguously erotic potential. The proliferation of girl paintings in the decade after the Civil War can be explained in part by the prevalent notion that girls—as opposed to women—were still soft and malleable in nature as well as in physique. Pleasing to the senses, and in that regard sensual objects, but also virgins, and in that regard sensually innocent, the Anglo-American girl as typically represented allowed the adult viewer, male and female, a means by which to experience a sort of purified sensuality, an un-erotic eroticism, if you will.

Whatever she is, the little girl in *Making a Train* is more than simply a little girl. In an era when nothing was taken as merely the thing in itself but was instead always regarded as a sign, a symbol, a type of something else, metaphysical or otherwise, a fetching little girl such as Guy's would virtually have beckoned the viewer to interpret her as something more than, something in addition to, a little girl.

For example, she might have functioned as a middle-class fantasy about the working class. To the extent that the cracked plaster, the rudimentary army cot, and the then-out-of-fashion high-back chair all connote impoverishment, however genteel, the girl appears to be an adolescent servant in her *chambre de bonne* or even, as we have noted, a latter-day Cinderella compelled to dream

of the finery she herself is not able to afford. But if she signifies the working class, what a working class! Not only is she sweet and docile, well scrubbed and beautiful, she even demonstrates the desire to make herself into a fine lady—to be, this is to say to the middle-class viewer, *just like us*. In certain circumstances this might be thought presumptuous, but since Guy's working-class girl is not plausibly working class to begin with except in the most storybook of ways, the upwardly mobile ambition she demonstrates would surely have been considered salutary, not overweening. Insofar as she is designated a poor girl, she is at once an idealized pauper, free of the grime and taint of the streets or any sort of underclass surliness, and a princess in disguise: she is both a princess *and* a pauper, if ever the twain should meet.

The middle-class fantasy that *Making a Train* lends itself to, that which postulates class inferiors as happy, childlike, and well behaved, was part of a larger middle-class effort to scrutinize the great unwashed, fixing that frighteningly unfamiliar aggregation of social groups firmly within its gaze. Such exhaustive works of documentation as Mayhew's *London Labour and the London Poor* as well as the novels of Dickens, Hugo, and Eugène Sue were epic attempts to classify and comprehend the new urban underclass that modern industrial manufacturing had manufactured.[24] Often this proletariat was demonized, but in other instances, as in the work of Marx and Engels, it was viewed sympathetically, even as the hero of history. We have already noted the era's fascination with urchins—the plucky newsboys, cigar-puffing

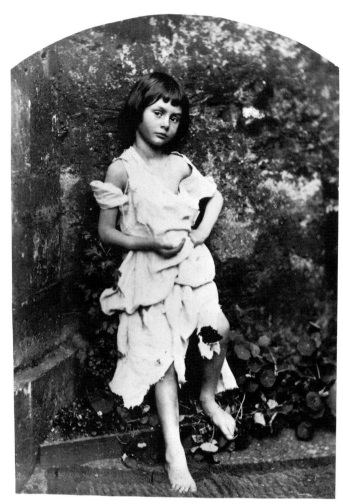

123. Lewis Carroll, "Alice Liddell as a Beggar Girl," c. 1860. Photograph.
Morris L. Parrish Collection, Princeton University Library, Princeton, New Jersey.

bootblacks, and happy-go-lucky waifs depicted by Alger, Brown, and innumerable other sentimental chroniclers of the so-called gypsies of the streets. Whereas Dickens had stressed the pathos of childhood blighted by the exigencies of industrialization, these later authors and artists cosmeticized and sanitized the waifs that they took as their subject, waving a magic wand over disabling poverty to turn it into an exotic disguise.

Lewis Carroll dressed his favorite model, Alice Liddell, as a street beggar (1860, fig. 123). Her cool, saucy demeanor bespeaks a self-assurance that derives both from the class privilege that her costume-trunk rags cannot disguise and from the new convention for representing waifs as jaunty, streetwise rogues. The sexual voyeurism contrived for the viewer is augmented by class voyeurism, which is also a positioning of the viewer as privileged and superior and, moreover, benign. Heartrending photos of destitute children such as Emma Cook, who was admitted to Dr. Barnardo's Home in 1887, also positioned the viewer as elevated (in size, age, and well-being), but the palpable abjection of such waifs called out for a feel-bad rather than feel-good response on the part of the viewer, and a charitable donation as well (fig. 124).[25]

124. "Emma Cook, Admitted to Dr. Barnardo's Home, July 5, 1887."
Photograph. Barnardo Film Library, Ilford, England.

Guy's girl, however, like Carroll's Alice-as-street-beggar, invites the hidden viewer to entertain class-based fantasies that would construct or reconstruct the poor as innocent or childlike, as we have already noted, but also as exotic, strange, happy with their lot, and perhaps even a bit thrilling insofar as they (like the fetching little girl) remain tantalizingly off limits.

Rather than reckon how Guy's girl might have hinted to Victorians of underprivileged classes that could comfortably be imagined as the same as the middle class but also enticingly, provocatively different, let us turn to another symbolic configu-

ration. In a monumental study of representations of young American women from the end of the Civil War to the end of the First World War, Martha Banta claims that a variety of social, economic, technological, and artistic developments came together during this fifty-year period in such a way as to make it "inevitable that the American Girl was singled out as the visual and literary form to represent the values of the nation and codify the fears and desires of its citizens." Popular illustration commonly made use of healthy, robust, Anglo-featured young maidens to symbolize the nation and its interests or needs (1876,

125. *Frank Leslie's Illustrated Historical Register of the Centennial Exposition*,
1876. Cover illustration. Library of Congress.

fig. 125; 1917, fig. 126). Banta argues that the idealized girl served as a blank screen onto which not only private fears, desires, and hopes could be projected, but public, social ones as well. If Uncle Sam stood for Yankee wisdom, authority, and know-how, the all-American Virgin conveyed other qualities equally sought after by Americans in their vision of themselves.[26]

In the stories and novels of Henry James, Daisy Miller and her literary sisters embody a New World innocence that may not be overtly sexual but could nonetheless be considered sexy, that is, having on others an effect of sexiness. After all, the Old World characters in these stories, like high-society vampires, are filled with desire for the girls, wishing to feed upon their abundant and self-generating energy. To the extent that the American Girl could be equated with the nation itself after the Civil War, she and it both were perceived as raw, desirable, and energized, but also as gauche and in need of proper training and moral instruction—not unlike the little girl in *Making a Train*.

126. Howard Chandler Christy, *Fight or Buy Bonds*, 1917.
Poster, 34 × 22 in. Minnesota Historical Society, St. Paul.

Moreover, with the end of the war and the drawing to a close of their first complete century as a nation, Americans thought of themselves as leaving their national childhood behind. As the second century approached, they saw themselves as taking their first steps toward adulthood. *Making a Train*, depicting a little girl on the verge of adolescence, while probably not intended or recognized as a metaphor for America at this stage in its development, seems nevertheless a remarkably apt image, given these public concerns (as apt

as *Ariadne* was in a similar regard half a century earlier). Despite Mark Twain's contemptuous regard for girl paintings as nothing more than social irrelevance, this girl painting is not at all irrelevant. The child within it would seem to embody—literally—many Americans' conception of themselves *as a nation*.[27]

It is even possible to see the little girl as a diminutive Maiden of Liberty garbed in red, white, and blue (note the ribbon atop her head), with a flaglike quilt unfurled behind her. Such a reading

127. Eugène Delacroix, *Liberty Leading the People*, 1830. Oil on canvas, 102 × 128 in.
Musée du Louvre, Paris (Photo: Giraudon/Art Resource, New York).

becomes less farfetched than initially may seem the case when we compare *Making a Train* to another work in which the protagonist is a bare-breasted young female, one who unquestionably symbolizes liberty: Delacroix's *Liberty Leading the People* (1830, fig. 127). Certain similarities are remarkable. In both works a young female's immaculate white shift falls below her bosom, a naked foot emerges from her gown, her face is turned in profile, she wears a fabric atop her dark, drawn-back hair, and a multicolored national flag, in the one painting specifically so, unfurls behind her. Of course Delacroix's maiden is an adult, not a child, outside rather than inside, surrounded by others instead of alone, in the thick of action rather than in the midst of play, and the look on her face is grimly determined rather than sweetly malleable. Yet this amounts to but another way of saying that

post–Civil War Americans such as Guy and his middle-class admirers envisioned social change not as a matter of violent warfare, of which they had had their fill in recent years, but as something else.

What might that something else have been? Guy's Maiden of Liberty, if that is what she is, proffers her benevolence to society not by leading troops *into* the world but, to the contrary, by retiring *from* the world into a cloistered realm of innocent make-believe. She is the animating sprite of the so-called feminine sphere, which in mid to late nineteenth-century social ideology was regarded as the place where morality and virtue were nurtured, safeguarded, and prepared for an eventual march outward into the tainted world. "It is by the promulgation of sound morals in the community, and more especially by the training and instruction of the young, that woman performs her

part towards the preservation of a free government," intoned the statesman Daniel Webster in a typical assessment of women's role in a democracy's gendered division of labor.[28] By these lights, *Onward Christian Soldiers*, not *La Marseillaise*, was the appropriate battle-hymn for that regiment of republican mothers that Guy's little girl could be seen here as training to join.

But what if one prefers to view Guy's girl neither as a personification of America nor as a counter-revolutionary version of Delacroix's Liberty, regressed in age and sent indoors, where she can do no harm? Still, it would be hard to deny that she must have embodied, and perhaps still does embody, many Americans' conception of proper or ideal girlhood as playful, pliable, and pretty; as resourceful, nonthreatening, pleasing, and cute—and hence potentially erotic but also resolutely innocent (a contradiction resulting, as we have seen, from contradictory but concurrent beliefs about childhood innocence and depravity). As such, the post–Civil War girl painting is anything but socially irrelevant, for in effect it constitutes an argument on behalf of certain special-interest ideals of girlhood, statehood, racial purity, and class beauty.

Whether or not Guy's contemporaries considered *Making a Train* a trope for America at its historical turning point, and whether or not the charge it held for them was in any manner erotic, the painting was nevertheless socially relevant precisely because of the underlying ideals to which it gave form. It says, in effect, that children should play, not work; that soft, pliable females are pretty and desirable; that the feminine sphere is a world unto itself, set apart from the hustle and bustle of the man's world outside or down below. It says that children should be seen, not heard; that girls should practice being women and, by extension,

that women, underneath all their fine grown-up airs, are at heart only girls. It says that it is good to be white-skinned and Anglo-featured, clean-scrubbed, free of the stains of physical labor.

"How sweet, isn't that just like a girl!" the painting invites the viewer to exclaim. That it pretends not to be an argument on the side of a dominant social group but instead passes itself off as a candid and disinterested snapshot of the way things really are is a sign not only of its disingenuousness. It is a sign also of the success achieved by artful constructions of socially dominant points of view as being not artful but artless; not class-, race-, or gender-biased but universal, timeless, transcending any single group's narrow special interest.

The painting testifies to the charms not only of being American, but, more specifically, of being a Caucasian, Anglo-European, middle-class American, as given high-art status at the end of the century by academic artists such as George de Forest Brush, Francis Davis Millet, and Abbott Thayer and promulgated by mass-market illustrators such as Charles Dana Gibson and Howard Chandler Christy. But it was not only artists and illustrators who disseminated such views. Many of the era's scientific and medical authorities, not to mention their popularizers, propagated these notions.

Take, for example, Henry T. Finck's *Romantic Love and Personal Beauty* (1887), a quasi-anthropological blend of Ruskin, Darwin, and Herbert Spencer that taxonomically defines physical attractiveness and argues for its social utility. Invidious comparisons abound. According to Finck, "There is reason to believe that the beauti-

fully rounded form of the female bosom is a result of aesthetico-sexual selection; for primitive human tribes resemble in this respect the lower animals." As "the famous anatomist Hyrtl" has noted, "It is only among the white and yellow races that the breasts, in their compact virginal condition, have a hemispherid form, while those of negresses of a corresponding age and physique are more elongated, pointed, turned outwards and downwards; in a word, more like the teats of animals." Finck cites another authority (this one unnamed) who explains that the figure of a preadult female "should be all curves, but slender, promising a fuller beauty when maturity is reached." And why so? For the self-evident reason that "one is not fond of over-ripe pears." [29]

128. John Everett Millais, *Mariana in the Moated Grange*, 1851. Oil on panel, 23½ × 19½ in. Private Collection (Photo: Bridgeman/Art Resource, New York).

Here the discourses of racism and agism intersect with those of childhood development and female sexuality. In this regard, *Making a Train* might be compared with John Everett Millais's *Mariana* (1851, fig. 128), a Pre-Raphaelite painting exhibited in London in the days Guy was an art student there. In both works, a female alone in a cloistered chamber twists her shoulders backward in a contrapposto that draws attention to her breasts. Whereas the bust of the little girl in *Making a Train* is barely formed, that of the woman in *Mariana* is full, even hefty. Millais's painting is based on "Mariana in the South," a Tennyson poem that tells of an aging young woman who lost her one great opportunity for love and now confronts the dire prospect of having "to be all alone, / To live forgotten, and love forlorn." [30]

Making a Train and *Mariana* are kindred paintings in the sense that one depicts a girl on the verge of young womanhood and the other a young woman on the verge of middle age. The works share the same system of values, in which a female's worth (typified synecdochically by her breasts) is cali-

brated by her proximity to or distance from an ideal age, which is to say, the age of being marriageable. The real issue is not how near or far she is from that age but rather whether she is approaching it, like Guy's girl, or, like Mariana, moving inexorably away. Whatever their differences, both paintings are concerned to show a young female as an object of aesthetic beauty and her breasts as a signifier of her sexuality, physiological maturity, and, ultimately, her social utility and desirability.

Aestheticizing the female in such a way makes her seem less a person than an abstraction: a symbol of beauty, innocence, spirituality, narcissism, danger, or whatever, but a symbol nevertheless. And this is a necessary precondition to her social and political subjugation. In the words of the feminist legal scholar Catharine MacKinnon, "Sexual objectification is the primary process of the subjection of women." Or, in the words of the sociologist Edwin Schur, "The entire subordination of women (with all that entails socially, economically, and psychologically) is upheld by the perception and treatment of all females as objects. Women are seen and responded to, first and foremost, not as individual persons, but as women, as instances of their sex-category." Similarly, Guy's little girl becomes an instance not of an individual child but of the category female child, with all the innocence—and vulnerability—that that implies.[31]

Throughout this chapter I have been relatively inexact in distinguishing among girls, young women, and female children, when obviously there is a great difference between, say, a nine-year-old, as in *Making a Train*, an eighteen-year-old, such as Effie Gray when she married Ruskin, and women in their late teens or early twenties, such as James's Daisy Miller. But by now it should be clear that the Anglo-American culture that produced these females, both in fiction and real life,

was itself uncertain how to distinguish or draw the line. Legally, a child was anyone under the age of twenty-one, but inasmuch as grown women were supposed to be like children and they shared children's lack of direct access to political and economic power, is it any surprise that these terms of designation were so readily convertible one to another?

❋

At this point, then, one might ask not merely how *Making a Train* conceptualizes and sentimentalizes its little girl but also eroticizes her, covertly or otherwise. This happens through a variety of formal, art-historical, and iconographic devices, several of which this section will explore.

For example, the painting invokes the Flemish artist Jan van Eyck's fifteenth-century illusionistic masterpiece *The Arnolfini Wedding Portrait* (1434, fig. 129), from which Guy, who probably viewed it at the National Gallery in London, directly or indirectly borrowed a host of elements: stylistically, the "brushless" technique employed for an effect of verisimilitude, and, iconographically, empty slippers, receding floorboards, a bed defining the limits of the room, a centrally positioned representation hung from the wall (in *Arnolfini* it is a mirror), and a beautiful, virginal young female whose apparel forms a train and who is thrust forward at the waist—in the earlier painting to symbolize that she will fulfill her female destiny as the bearer of children. Imagine *The Arnolfini Wedding* without the presence of the bridegroom, and the intertextuality of the two works becomes even more striking, not only providing justification

for seeing Guy's girl typologically as a New Testament virgin or a bride in the making but also for understanding the bedchamber she inhabits to be a sexualized (and sexualizing) environment.

The painting also invokes seventeenth-century Dutch genre painting such as that by Gerrit Dou, Frans van Mieris, Nicolaes Maes, and Adriaen van Ostade, many of whose works were avidly acquired and prominently displayed in the National Gallery and other English collections during Guy's youth as well as widely admired and reproduced in art publications of the period. Guy's American reviewers pointed out similarities between his work and that of the artists known as the Dutch Little Masters—the candlelight subject matter (typical of Dou, Gerrit van Honthorst, and Hendrick Terbrugghen), the ranges of light within shadow (here Maes in particular was cited), and the inviting effect of three-dimensionality ("One could absolutely crawl under the bed [in *Making a Train*]," exclaimed one critic)—but what they left unnoted, whether or not also unnoticed, were the iconographic allusions to female vanity and sexual availability.[32]

Van Mieris's *Young Woman Standing before a Mirror*, (c. 1670, fig. 130), for instance, is similar to *Making a Train* not only in its high-contrast lighting and elements of setting, for example, the chair and floorboards, but also the conspicuous inclusion in the foreground of empty slippers. To seventeenth-century Dutch viewers, empty slippers signified erotic desire or sexual looseness, and so did open dresser drawers, cupboard doors ajar, and rumpled beds—all of which play a prominent part in *Making a Train*. By Guy's time (and, as we saw in the previous chapter, Spencer's) the specifically sexual meaning of such iconography may have been lost from public memory, but still, could this iconography have been appropriated wholly severed from its long-standing

129. Jan van Eyck, *Arnolfini Wedding Portrait*, 1434. Oil on panel, 32¼ × 23½ in. National Gallery, London (Photo: Marburg/Art Resource, New York).

associations? Guy's little girl playfully enacting adult feminine self-presentation inevitably shares with van Mieris's young woman before the mirror a devotion to the project of making herself physically beautiful, which is to say, desirable, and thus the several traditional signifiers of sexuality featured in the Victorian work are entirely appropriate, considerably more so, perhaps, than the artist or his contemporaries might have been aware.

Some of Guy's admirers compared him to Jean-Baptiste Greuze, the eighteenth-century French salon painter whose sentimental and melodramatic genre scenes had been praised by Diderot as "morality in paint."[33] Though Greuze fell out of favor during the revolutionary era, by Guy's day he was back, his didactic family dramas and iconic depictions of innocent but sexually developing girls providing popular fare for Victorian audiences.[34] The iconic pictures, focused entirely on head and semi-exposed bust, were minimal in narrative content, unlike the genre scenes, in which the girl was placed full length in an enclosed setting abundant with significant detail, but in both types of painting sexual titillation was frequently a strong if not central element. *Broken Eggs* (1756) and *The Broken Pitcher* (1785) both allude to the loss of virginity, as does *The Broken Mirror* (c. 1763), in which a disheveled young woman sitting over a cluttered dressing table forlornly ponders her image in a looking glass that lies fractured on the floor, her sexual disgrace obviously the result of her feminine vanity.[35] *The Lament of the Watch* (c. 1775, fig. 131), portraying a young woman whose lover has abandoned her, shares several elements with *Making a Train:* dormer window, cracked plaster, high-backed chair, rumpled bed pushed up against a garret wall, and a girl whose flesh is exposed for the sentimental/erotic pleasure of the viewer.[36] Although the two paint-

130. Frans van Mieris, *Young Woman Standing before a Mirror*, c. 1670. Oil on panel, 16⅞ × 12⅜ in. Alte Pinakothek, Munich.

131. Jean-Baptiste Greuze, *Lament of the Watch*, c. 1755. Oil on canvas, 31⅛ × 24 in. Alte Pinakothek, Munich.

132. Jean-Honoré Fragonard, *Girl with Dog*, c. 1770. Oil on canvas, 35 × 27⅝ in. Alte Pinakothek, Munich.

ings seem widely divergent in the respective stories they tell, even in that regard they are alike, being male-generated narratives of feminine sexuality, its pathos in one instance, future promise in the other, and, in both cases, desirability.

In both paintings, the bed in the background presents an almost irresistible reference to sexuality, especially when a young female alone in her room is shown in such proximity to it. François Boucher's famous *Reclining Girl* (1752) makes explicit the connection between adolescent female and rumpled bed alluded to leeringly by *The Lament of the Watch* and less leeringly by *Making a Train*. Jean-Honoré Fragonard's *Girl with Dog* (c. 1770, fig. 132) is as erotically explicit as the Boucher, laying down a playful, half-naked little girl on an unmade bed, her pet's furry white tail dangling suggestively, caressingly, over her own: she too, this *petite*, is a *pet*—the viewer's. A late work of Guy's, *Dressing for the Rehearsal* (c. 1890, fig. 133), is similar to the Fragonard in strategically placing someone else's hair—in this case, the head of a devoted mother—in front of a naked girl's genitalia. If Guy's audiences were less likely than those of Boucher, Fragonard, and Greuze to assign erotic meaning to depictions of half-naked girls on or beside unmade beds, this hardly guarantees us that they were not titillated by such depictions all the same.

In any case, the eroticism of the image derives from more than its origins in the art of the seventeenth-century Dutch and eighteenth-century French. I am thinking, for example, of the painting's chiaroscuro lighting, the Dutch antecedents of which trace back to the Italy of Caravaggio, who employed tenebrous shadows for specifically erotic purposes, as in *Boy with a Fruit Basket* (1593–94), in which dark shading heightens the sensual aura of the youth's alabaster flesh. But Caravaggio also wrung drama from looming shad-

133. Seymour Guy, *Dressing for the Rehearsal*, c. 1890.
Oil on canvas, 34⅛ × 27⅜ in. National Museum of American Art,
Smithsonian Institution, Washington, D.C. Gift of Jennie Anita Guy.

134. Caravaggio, *Supper at Emmaus*, 1602–03. Oil on canvas, 55½ × 77¼ in.
National Gallery, London (Photo: Art Resource, New York).

ows such as those thrown backward by Christ in the *Supper at Emmaus* (1602–03, fig. 134). Guy makes use of this device, too, casting one grotesque shadow, that of the girl, into the dormer and another, from the bedcovers, onto the wall. In Caravaggio, shadows of this sort usually denote mystery, foreboding, cause for alarm. They have a similar effect in the works of Guy.

For example, in *The Story of Golden Locks* (c. 1870, fig. 135), the adolescent girl who sits at the edge of the bed reading a scary story to her siblings projects a monstrous shape onto the wall behind them, as though it were an expression of their fears—but also, perhaps, of her own. After all, they, the younger children, are tucked in bed and nestled in one another's arms while she, on the other side of puberty, remains outside the bed, her bare feet exposed, her head framed by a dormer window that shows a night riven with tumultuous clouds. Compare this girl to her counterpart in a

Currier and Ives print of the period, *The Four Seasons of Life: Middle Age* (1868, fig. 136), in which a young daughter with doll in arm hurries down a flight of stairs to join her family in greeting the father who has returned home at the end of the day. The domestic interior is open and airy, full of light, free of shadows—quite the opposite of the setting in *Golden Locks*. And yet even here there is a note of alienation, however unintended, for the girl descending the stairs is visually external to the joyous unit gathered below: the picture could be cropped in such a way as to exclude her altogether without a loss in compositional harmony, perhaps even a gain.

Significantly, the growing girl in *Golden Locks* is associated with a doll as well. Here, however, the doll is not tucked in her arms but is stuffed in a cigarbox on the chair, as though to say that this child has outgrown her doll—or to say that, like the doll, which visually echoes her with its two bare

135. Seymour Guy, *Story of Golden Locks*, c. 1870. Oil on canvas, 34 × 28⅛ in.
Collection of Jo Ann and Julian Ganz, Jr.

136. Currier & Ives, *The Four Seasons of Life: Middle Age*, 1868.
Lithograph. Library of Congress.

feet and half-bare forearm, she has awkwardly out-grown her once comfortable confines. The doll's situation, like that of the girl, who has only a nar-row margin of bed on which to sit, contrasts with that of the younger children, who snuggle inside with room to spare. In a sense, Guy's adolescent storyteller is at once too large and too small, too grown-up and not grown-up enough, to occupy the bed, with its connotations not only of the nursery but also the conjugal bedroom (the two children clasped beneath the covers figuring as surrogates for the girl's absent parents coupled beneath *their* blankets). Appropriately, the fairy tale the girl re-counts is that of another young female, one who wanders into someone's home and tries to make it her own only to fail in her attempt to occupy any of the positions available, whether that of father, mother, or child. In the end, when the proper occu-pants of these positions—the three bears—return home, the distraught girl jumps from a window. No wonder Guy's young storyteller casts such a loom-

ing shadow, so ill-defined in shape, so forceful a register of inchoate emotion.[37]

Though the shadow cast by the girl in *Making a Train* has not the apparitional quality of the one in *The Story of Golden Locks*—perhaps be-cause the girl in the earlier painting is younger, less conflicted—it too suggests a doubling of the child, a dark side to her, a gloomy reversal of her glowing innocence. The bright and dark reds of the dress that the girl trails at her feet seem to flood forth from the joining of her legs like a hyperbolically subjective sensation of menstrual flow—a cause for satisfaction, perhaps, as indi-cated by her face, or perhaps for alarm, or at this stage, merely for wonder.[38] Guy's contemporaries, to judge from reviews, did not find these works troubling or ominous, did not notice in them a hint of a young life unsettled or on the edge. The cult of childhood innocence was too much then in its moment of primacy to permit conscious acknowl-edgment of the travails of puberty, female puberty

in particular. This had to wait until a different moment, the end of the century, which produced such works as Munch's *Puberty* (1894–95, fig. 137) and Freud and Breuer's *Studies on Hysteria* (1895), an early psychoanalytic account of young women's self-censored rage and sexuality. Munch's girl, bereft of protective apparel, sits precariously on the edge of a bed, like Guy's storyteller, her naked feet drawn together as a metaphor for the vulnerability, if not also the inconsolability of her condition, her fall into sexuality. An enormous black shadow leaps away from her like an inner beast no longer containable.

The lighting scheme for *Making a Train* thus coincides with, is a part of, the work's sexual thematics. Not only does it heighten the sensuality of the little girl's flesh, as in Caravaggio's rapturous rendering of pearl-skinned boys, but it also hints at a doubling or fracturing of identity, again as in Caravaggio or, later, as in Munch. Moreover, looming shadows have long served in artistic representation to imply a threat of violence or violation. Sometimes the threat is thought of as having come from within: "I am frightened by my own shadow," Munch confided to a diary. "When I have lit the lamp I suddenly see my own enormous shadow covering half the wall and reaching to the ceiling."[39] But also, at least since the Gothic fiction of the eighteenth century and far forward into the era of Hitchcock and film noir, the threat conveyed by looming shadows has also been treated as originating from outside, the lurking projection of a male stalker intent upon victimizing female innocence. This brings us to the voyeurism theme I wish to defer until later. The point for now is that the shadows that are so prominent in *Making a Train* contribute to its eroticization of the child inasmuch as, in keeping with Gothic and melodramatic traditions, these shadows imply, even if only for an

137. Edvard Munch, *Puberty*, 1894–95. Oil on canvas, 59⅝ × 43⅜ in. National Gallery, Oslo.

138. Joshua Reynolds, *Infant Samuel Praying*,
c. 1776. Oil on canvas, 36 × 28⅛ in.
Copy by Reynolds of his original painting,
which was subsequently destroyed by fire.
Tate Gallery, London (Photo:
Art Resource, New York).

instant, that she may be the unsuspecting object of a perverse gaze, a helpless female titillatingly endangered.

This, of course, is to have it both ways: in the Gothic scenario, the shadows configure the girl as an innocent; in the others, as either a sensualist, like a Caravaggio urchin, or, as with Munch, a frail envelope barely capable of containing demonic impulses that may at any moment surge to the surface. Guy's image, we begin to realize, is considerably less stable than first appears to be the case—an instability that registers the instability of childhood itself as it was being worked through in the culture at large.

Perhaps this has something to do with that curious passage in *Making a Train* in which another picture of a child, tacked to a wall, has come undone. Seemingly nothing more than anecdotal detail, a homey, comical touch, there is here nonetheless a suggestion of childhood fallen askew. The print, which was a favorite in nineteenth-century American nurseries, was a copy of Sir Joshua Reynolds's *Infant Samuel Praying* (c. 1776, fig. 138).[40] Detached from its formerly secure position on the wall, the Reynolds print provides *Making a Train* with a moralizing—or sardonic—comment on feminine dressing up as a first fatal step toward innocence gone astray. Itself half-fallen, the print alludes to a fall of a more serious and primal nature.

❁

All of this is yet another way of saying that in *Making a Train* the line between innocence and depravity is not clear-cut. However innocently the child plays, she is, after all, training herself in the arts of Eve. Ever since the biblical condemnation of the woman who paints herself as a whited sepulcher, Western theology has reviled feminine vanity and self-adornment—even as Western artists have been obsessed with it (1515, fig. 139). In the Book

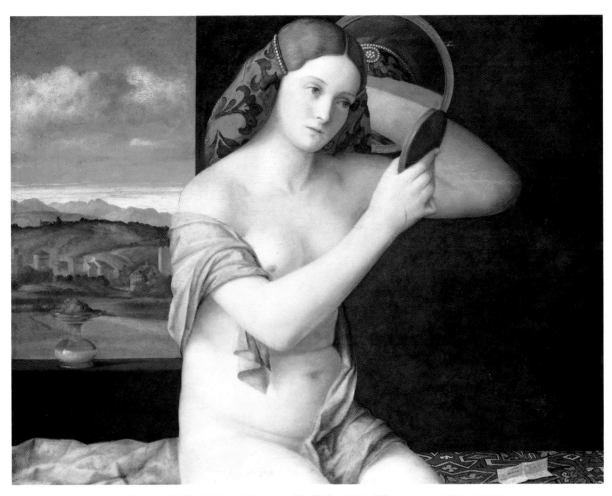

139. Giovanni Bellini, *Young Woman at Her Toilet*, 1515. Oil on canvas, 24⅜ × 31⅛ in.
Kunsthistorisches Museum, Vienna.

of Revelation, a woman "arrayed in purple and scarlet color, and decked with gold and precious stones and pearls" is figured as the type of all evil, "the great whore that sitteth upon many waters."[41]

Guy's little girl is hardly a Whore of Babylon in the making. If anything, she is more akin to one of those foolish New Testament virgins who lit their oil lamps too soon while awaiting the midnight arrival of the bridegroom. In exhibitionistically arraying or decking herself, in paying such heed to her personal adornment, she acts out of consonance with old-line morality. And yet, according to post–Civil War America's newly arisen ethos of consumerism, such actions were neither wicked nor foolish but appropriately modern; in the words of a *Lippincott's Monthly Magazine* advertisement that depicts a corseted young mother approvingly holding up a mirror to an obviously satisfied little girl decked out in corset, garters, and dark stockings, it makes "good sense" for "sensible women" (and their daughters) to "require beauty . . . as well as comfort and durability" (1891, fig. 140).

This clash of new and old moralities in regard to commodity consumption, to be discussed at greater length in chapter 6, paralleled the conflict already described between an orthodox conception of original sin and the liberal, romantic notion of childhood innocence. If Guy's girl, because of the overlay of competing ideologies, may have embodied or elicited both purity and sensuality, so too might she have advertised to some viewers the narcissistic pleasures of consumption while to others she could have served as a reminder that such pleasures were childish and immature.

"Girls learn that 'dressing up' is a lot of fun," Nora Scott Kinzer has recently observed. "A little girl prancing before her mother's dresser in mommy's dress grows up to be an excited young woman who twirls before the department store mirror in her bridal gown."[42] Such appears to be the narcissistic pleasure displayed by the little girl in *Making a Train*, a young consumer in the offing. On the other hand, the out-of-kilter print of the praying child and the lurking shadows warn, however ambiguously, against such self-absorption. Not that these signs constituted in and of themselves a critique of vanity, but they were not "in and of themselves," for they belonged to a much larger antivanity discourse, one that was fully in place, far more so than today.

This influential discourse was circulated by biblical injunctions such as those already mentioned, but also by means of popular culture, from the novels of Dickens and Thackeray to proverbs, quips, and jokes. Even America's leading fashion magazine, *Godey's Lady's Book*, the last place one might expect, spoke out against female vanity, as in an editorial in 1867 titled "Dress and Its Influences": readers are urged to understand "the usefulness of changes in costume and the effect of ornaments in feminine attire." Women must beautifully adorn themselves not for frivolous and selfish reasons but rather, contends the editorial, because, ever since the day the Lord first clothed Eve, "dress has been the sign of hope and comfort to the individual, and the sure mark of progress in the arts of life and in intellectual and social improvement."[43] If a magazine dedicated to selling women on the pleasures of commodity consumption felt the need to provide them with such lofty justification for partaking of these pleasures, this amounted to nothing less than a tacit acknowledgment of the still prevailing point of view: that

FERRIS BROS.'
GOOD SENSE CORSET WAISTS

are sold by all **LEADING RETAILERS** in the United States, England, and Canada. Through their intrinsic merit these waists have gained the favor of **SENSIBLE WOMEN** who require **beauty** in a corse' as well as comfort and durability. These Corset Waists are not made after "French patterns," but are made to conform to the natural beauty of the human form, permitting **FULL EXPANSION OF THE LUNGS** and freedom of motion, are superior to all others as a substitute for the ordinary corset. With buttons front instead of the injurious steel clasp. Buttons are fastened with tape. Button-holes have cord edge—won't wear out. Patent **Ring Buckle** at hip to secure the hose supporter. The shoulder-straps are adjustable, and, being curved and broad, are very comfortable, supporting the skirts and stockings directly from the shoulders. Can be washed without injury. Made in full or slim bust, long or short waist, fit all ages, infants to adults. The excellent material and superior workmanship make the "Good Sense" corset waists worthy of the name.

Every Mother should buy "Good Sense" Corsets for herself and daughters.

140. *Good Sense Corset Waists.* Advertisement from *Lippincott's Magazine*, March 1891. Colby College, Waterville, Maine.

fashion was selfish, vain, and morally debased.

Here again was *Making a Train*'s central ambiguity—the adoration of female innocence but also its eroticization—representative of postwar society at large. Women were urged (by cultural spokesmen such as John Ruskin, by mass media and newly developing consumer industries, and by men in general) to be like children and yet they

were at the same time roundly snickered at, even condemned, for being childish.

Female sentimentalists such as those discussed in the last chapter—Stowe, Fern, Spencer—did not lag behind men in reproaching female vanity, but their reasons for such reproach were different. Men, it seems, chided women for their vanity (even as they constantly offered incentives for it)

141. Lilly Martin Spencer, *Beauty and Barberism*,
c. 1890. Oil on canvas, 25 × 30 in. Unlocated (Photo:
National Museum of American Art, Smithsonian
Institution, Washington, D.C.).

in order to enjoy a feeling of moral superiority—
a sensation not easy to come by at a time when in
most areas of morality women were thought infi-
nitely superior. But when a female sentimentalist
criticized female vanity, it was in order to identify
it as an obstacle to family harmony, social welfare,
and female power.

Spencer's *Fruit of Temptation* (see chap. 4,
fig. 102), a painting made into a popular litho-
graph, shows a mother rushing with alarm into a
dining room in which two small children, a cat,
and a dog have wreaked havoc on a bountifully
set table, all because the pug-nosed servant girl
who had been left in charge is preoccupied with
herself in the mirror. The self-admiration of Guy's
girl, considered charming in one still so young,
is aggravating when displayed by Spencer's girl
(the term that was used not only for an adolescent
female but also for a female servant). As for the
younger girl in the Spencer picture, note the doll
that she has thrown aside in order to reach all
the more greedily, two-handedly, for the forbidden
fruit. This resonates with the cast-aside dolls in
Making a Train and *The Story of Golden Locks:*
the modern Eve, or Eve in the making, is all too
ready to jettison childhood innocence (symbolized
by the doll) in the pursuit of self-fulfillment or
self-gratification.

In a late work of Spencer's, *Beauty and Barber-
ism* (1890s, fig. 141), a little girl decked out in
crinolines sits glumly in front of a dressing table,
refusing to look at herself in the mirror while her
mother curls her hair. What a contrast to *The
First Party* (1867, artist unknown, fig. 142), an
illustration from *Godey's* in which a mother gazes
proudly at her fashionably adorned little daugh-
ter, who stands atop a chair all the better to ad-
mire herself in the mirror (note the similarity of
the situation to the "Good Sense" corset ad of

fig. 140). *Beauty and Barberism* emphasizes, however anecdotally, the emotional pain and psychic destruction involved in turning a little girl into a little lady, whereas *The First Party* treats the same developmental event as a source of narcissistic self-satisfaction and mother-daughter bonding. Moreover, the presence of the parental bed in the background of the *Godey's* illustration hints at the true trajectory of the girl in front of the mirror: *this* matrimonial bed may not be her final destination, but surely some other one will be. *Making a Train* occupies a position somewhere between these two narratives. Although it admits to none of the pain inscribed in *Beauty and Barberism*, it complicates the elements that it shares with *The First Party:* it undresses the little girl, absents her mother, rumples the bed, and knocks *The Infant Samuel Praying*, or a variation thereof, on its side.

The dressing up of the little girl in *Making a Train* needs to be seen in this context, this discourse about female vanity, as much as in the other discursive contexts already indicated, such as that of childhood innocence or the art-historical context in which young women alone in their rooms signify female sexuality, desire, and desirability. Let us look, then, at a short fiction of the era that seems more than others to be a meta-story about female vanity, A. M. Barnard's "Behind a Mask, or A Woman's Power" (1866). Neither a moralistic criticism nor a beauty industry promotion of feminine dedication to personal appearance, "Behind a Mask" calls attention to the economic underpinnings of female vanity.

The story concerns a mysterious young woman who appears one day out of nowhere to serve as the governess for an aristocratic English family. Identifying herself as a nineteen-year-old orphan who, grieved by the untoward events of her life, wishes "to look and seem old," Jean Muir swiftly intrigues

142. *The First Party.* Engraving from *Godey's Lady's Book*, January 1867. Library of Congress.

the two adult brothers in the family, especially when she swoons to the ground in a dead faint after singing a melancholy Scottish air. The younger brother is at once moved by her touching frailty, but the older is initially skeptical: "Scene first, very well done," he whispers. Overhearing him as she awakens, Jean cryptically replies, "Thanks. The last scene shall be still better."[44]

As it so happens, the new governess is an indigent thirty-year-old stage actress adept at controlling audiences, particularly men, by her artful manipulation of the socially encoded signs of true womanhood. During the course of the story she plays a variety of female parts—ingenue, temptress, stoical woman of virtue—whatever is necessary to achieve her goal, which is to marry a wealthy and powerful aristocrat. Barnard suggests that if women are to succeed in a society that withholds from them any personal power other than that deriving from their physical appearance, hiding "behind a mask" is not a matter of choice and certainly not of vanity, but of necessity. In an early scene, the governess, in the privacy of her garret bedroom, sheds the artful disguise that has enabled her to appear to the brothers much younger than she is. Whereas *Making a Train* shows a girl practicing the part of a woman, "Behind a Mask" emphasizes the lengths to which a woman must go to play the part of a girl.

Seen in light of one another, these works suggest that in post–Civil War America women were socialized from childhood not only to be objects of male desire but to *want* to be such objects as well. Three decades later Charlotte Perkins Gilman noted in

Women and Economics (1898) that society had become characterized by a sort of Darwinian natural selection in which females, deprived by both custom and legislation from attaining economic self-sufficiency, were forced to develop exaggerated sex characteristics in order to survive. As Gilman saw it, most modern women were driven to primping, posing, and obsessively adorning themselves for no other reason than financial dependence upon men, an imperative that had been around for so long as to have become internalized as "instinct" or "feminine nature"—that is to say, as their own innate desire. Gilman's turn-of-the-century insight into the relation between female vanity and economic need was complemented by the observations of the economist Thorstein Veblen. In his *Theory of the Leisure Class* (1899), Veblen argued that the more frivolously and uselessly adorned a man's wife, the more he could lay claim to social prestige by means of "conspicuous consumption." If the wife was so tightly bound by corset and yards of sumptuous cloth that she was unfit for performing daily tasks without the aid of servants, it would be clear to everyone that her husband was surely a man of means. Written a full generation before these demystifying accounts, "Behind a Mask" similarly sought to unmask the phenomenon of female vanity with judgments that were economic rather than religious or moral.[45]

Ironically, the author of the story was herself hidden behind a mask, the gender-ambiguous nom de plume A. M. Barnard. Only recently was this thriller, long forgotten, discovered to be the product of Louisa May Alcott, whose best-known protagonist, the independently minded "little woman" Jo March, often retreats to the garret to produce, in secret, sensationalistic stories of exactly this type.[46] With its pervasive air of warmth and unaffected girlhood, *Little Women*, probably the most

popular girls' book ever written, conveys a sensibility similar to that in *Making a Train*. It too is about female theatricality, right from the opening scene during the Civil War, when the four young March sisters act out a play they have devised in honor of their absent father, who is convalescing in a Union hospital.

But if there is good theatricality in *Little Women*, there is also bad theatricality, as embodied by Jo's vain older sister, Meg, who loves dressing up, playing the part of a lady, and, as she grows older, turning men's heads. "You won't stop [performing]," Jo says to Meg, "as long as you can trail around in a white gown with your hair down, and wear gold-paper jewelry."[47] *Making a Train* is thus unlike both these contemporary works by Alcott in that it neither explains nor condemns female theatricality but exalts it instead.

❁

With its dramatic lighting and sightlines inviting us in, its shadows and bars keeping us out, *Making a Train* constructs its viewer not just as any viewer but, more specifically, as a spectator. To the extent that the girl is theatrical, acting out a part, playing a make-believe role as she treads the floorboards, we as viewers are cast in the complementary role of theatergoers watching a play from the other side of the footlights. Various reviews of the painting favorably made note of this (and when Guy painted a version three years later, he entitled it *Making Believe*). Our presence is unacknowledged, however, for the child's gaze disavows our own.[48]

Our offstage viewing of her theatricalization of self casts us in the role of her parents, according to certain educational precepts of the time. Louisa May Alcott's father, Bronson Alcott, a progressive philosopher of education, taught that young people could learn self-restraint and other virtues by acting out moral dramas that the parents were to view,

sometimes in secret. When his own daughters were very young he encouraged them to become "little women" by staging fables, fairy tales, and allegories derived from such works as *Pilgrim's Progress*. He himself created unscripted dramas for them, as when, with loaded symbolism, he would place an apple in the nursery, warn the girls not to touch it, and then leave them to struggle with temptation. Theatrics of this sort were, for Bronson Alcott, worthy means of indoctrination of the young into the religious and moral codes of their elders.[49]

Parents need not be physically present, that is, in order to stage-manage their children. Hence one's sense in looking at *Making a Train* that the girl has an audience, seen or unseen by her, just this side of the painting's footlights and proscenium, even though she appears to be all alone. This also helps to explain why she seems at once oblivious to anyone else and at the same time self-consciously aware of others, playing a part, as it were, for their approval.

Nineteenth-century educational reformers such as Jacob Abbott and Bronson Alcott argued for the effectiveness of domesticating frisky young colts not by breaking their spirits but rather by hobbling them with healthy doses of self-consciousness (what Freud would later call "the superego" and Foucault, later still, "disciplinary discourse"). In the anecdote cited earlier from Abbott's *Gentle Measures in the Management and Training of the Young*, Della disciplines the girls she is looking after by admonishing their dolls (and thus them) that quarreling "spoils your beauty. When chil-

dren are quarrelling they look like little furies."[50] Rather than confronting the girls as her adversaries, she incorporates them into her value system by forming an alliance with them against their supposedly misbehaving playthings. Encouraging them to partake of her "gentle measures" discourse, she makes them self-conscious—conscientious—of adult roles and expectations.

When Della surreptitiously informs the girls that quarreling "spoils your beauty," she is working to induct them into what contemporary semioticians have termed "an enormous complex of cultural practices that can be called the *feminine beauty system*."[51] To the extent that beauty limitedly empowers a female (the thesis of "Behind a Mask") or at least makes her socially acceptable, the notion that misbehavior causes ugliness amounts to a significant threat, however disguised it may be as merely a friendly recognition of the universality of female vanity (little girls, being female, naturally want to be considered beautiful, Abbott's anecdote suggests). *Making a Train* similarly elicits behavioral control by telling viewers, whether children or adult, female or male, that it is both pretty and proper for little girls to act out the conventions of femininity and, moreover, for women themselves to act out those conventions.

Telling girls that anger made them ugly was one way of indoctrinating them into socially acceptable codes of female behavior. The keeping of private diaries was another. Victorian moralists commonly prescribed diary writing as a means by which a girl could keep an eye on herself. To be updated nightly in the privacy of her bedroom,

the diary was an ideal device for self-surveillance and self-policing. In 1878 an article published in the popular children's magazine *St. Nicholas* advocated that daughters confide in their journals every day not only because it was important to take a daily tally of one's behavior but also because regularity in writing would instill habits of consistency and regularity. One of the era's most popular girls' novels, *Stepping Heavenward*, published in 1869, tells of the struggle of a young girl, Kate, to learn to control herself and grow up to be a woman. Her mother, wise and knowing, helps her on her way by purchasing a writing table for Kate's bedroom as encouragement to the child to maintain a journal.[52]

The diary writers, however, could never be assured that their writings would remain private. They fretted considerably over this problem, often covering their journals with warnings and maledictions to intruders ("To read another's secret is a crime. Pause and reflect and dare not do so!").[53] Yet even the most dire of incantations could not guarantee privacy, so no matter how determined the young writer might be to vent her feelings, her awareness that the words she chose might fall before eyes other than her own could not help but mediate her self-expression. Moreover, since whatever language of feeling she possessed was language borrowed from parents, friends, older sisters, advice books, and romantic poetry and prose, it was virtually impossible for her, even in the privacy of her bedroom and the most sacrosanct of diaries, to be truly alone. The diary writers were laid bare to a powerful gaze that originated from the outside even when it appeared to come from within.

Ensconced in the supposed privacy of her bedroom, the little girl in *Making a Train* looks away from herself, probably at the train that trails behind. Whether self-absorbed or self-forgetful, she

143. Pieter Janssens-Elinga, *Woman Reading*, c. 1670. Oil on canvas,
29½ × 24⅜ in. Alte Pinakothek, Munich.

nonetheless, like the diary writers of her gen-
eration, postures for the benefit of the external
gaze, internalized though it may be. Thus, even
if her theatricalized performance is creative and
self-expressive, it still serves to weld her into the
social circuitry of the world beyond her private
theater. Limitedly transgressive behavior (whether
a matter of imaginatively dressing up or of writ-
ing secret complaints) may ultimately serve to
ratify the dominant system more than undermine
it, for what makes the system stable is its tensile
strength, its capacity for absorbing or deflecting
mild shocks.

In this regard as well as in the more readily ap-
parent formal and situational similarities, *Making
a Train* resembles Pieter Janssens-Elinga's *Woman
Reading* (late 1660s or 1670s, fig. 143), a beau-
tifully self-contained seventeenth-century Dutch
painting of a seated young woman bent forward
over the light-struck book in her hand. Whereas
viewers today are likely to take *Woman Reading*
as an affirmation of studious solitude, Janssens-
Elinga's contemporaries would have understood it
as yet another idle servant or indolent daughter
painting, filled with signs of neglected duty and
questionable morals: a seat cushion fallen to the
floor, a fruit dish out of place on a chair, the
rumpled bedcover in the left corner, and, above

all, the empty slippers set askew in the foreground. While the young female indulges herself in imaginative activity, the domestic world for which she is responsible has fallen out of order.[54] As we noted above, *Making a Train*, originating in an era of nascent consumerism that was shrugging off the old Calvinism, celebrates instead of warns against female self-containment and youthful self-absorption. Nonetheless we must wonder if nineteenth-century genre painters such as Guy could borrow so heavily from their old Dutch predecessors without advertently or inadvertently taking on elements of their worldview as well—in this case an underlying conviction that childhood freedom is all well and good but sooner or later a girl must learn to shoulder the domestic responsibilities of a woman.

If play acting and diary keeping were two of the means by which Victorian American girls were taught how to become Victorian American women, yet another was needlework. Samplers, crotchets, and patchworks such as the one depicted in *Making a Train* would serve not only as occasions for girls to practice the "female arts" but also for them to be sewn into—to stitch themselves into—the female sphere. This is the topic of "Patty's Patchwork" (1872), a children's story by Louisa Alcott about a ten-year-old girl named Patty who goes to live with her Aunt Pen when her mother is preparing for a new child.

The story opens with Patty's exclamation, "I perfectly hate it! and something dreadful ought to be done to the woman who invented it." What she hates, we quickly learn, is patchwork. "Well, it *is* tiresome, isn't it, Aunt Pen?" Aunt Pen agrees only long enough to disagree: "Sometimes; but we all have to make patchwork, my dear, and do the best we can with the pieces given us."[55] The story proceeds to detail Patty's transformation from a girl who abhors patchwork, that great signifier of feminine patience, to one who is properly devoted to it and, in that sense, is patched into a feminine system, a female network or quiltwork, that she had initially opposed. Through all of this, Patty, under Aunt Pen's tutelage and encouragement, works diligently at a patchwork that she intends to bestow upon her infant sister. Unfortunately, the baby dies, so Patty's patchwork becomes a comforter for her grieving mother instead. Patty's initial rebellion against learning how to make a quilt has been transformed into her learning how to comfort and be comforted. *Pen* is short for Penelope—the Homeric model of feminine patience and virtue—but it is also an instrument of inscription. By the end of the story Patty is inscribed into the female sphere, or, to give her aunt's name yet another twist, she is penned up in it.

Looking at the patchwork in *Making a Train*, we can see it in a positive light as something comforting, colorful, and warm or negatively as a symbol of that patched-together system of values that covers over or in this instance waits to cover over the little girl, restraining (re-training) her body, repressing her spirit. In the positive light, the quilt alludes to an extended, pieced-together, female-nurturant community, the sort of community that Patty eventually enters—the sort that, in a discussion of the recurring female-centered family in Alcott's fiction, Nina Auerbach claims "finds no greater happiness than its own being and power."[56] In the negative light, the quilt, with its seemingly endless repetition of a closed geometric form, is simply one more instance of the archi-

tecture, decor, and costume restrictively bearing down on the little girl, bending and shaping her into conformance with their rigidity of structure. As the thrusting diagonals around the dormer seem to insist upon a corresponding slant of her upper body, as the sleeves of her half-fallen shift pass around her arms like binding ropes, as the silhouetted back of the chair resembles black iron bars, and as the vectored shadow in the foreground cuts off her range of forward motion, so the quilt covers the striped canvas mattress and simple army-style cot; its myriad diamonds proliferate the diamonds on the wallpaper and the diamond formed by the torn picture of the praying child. Here the quilt, like almost everything else in this microcosmic chamber, constitutes an overarticulated pattern, a pattern to which, metaphorically, the well-trained girl is endlessly subjected.

Thus, although the quilt may qualify as a symbol of female community and of the matriarchal transmission of female values, to the extent that the girl will eventually wrap herself up in it, it also becomes, like the play acting and diary keeping, a device for the internalization of external control. Like the *Infant Samuel* on the wall, the colorful quilt on the bed upstages the little girl in a manner not necessarily in her own interest.

A similar image of disciplinary surveillance may be found in *Johnny's Revenge* (1868, fig. 144), an illustration for one of the popular Dotty Dimple books written by Sophie May (Rebecca Sophia Clarke), who also created the Prudy Parlin and Flaxie Frizzle series of novels for young girls. The child who modeled for *Making a Train* may herself have been a devotee of these books, which were mass-marketed for girls her age. Sophie May's innovation as a popular author was that she replaced the impossibly good children of previous fiction written for girls with protagonists who were anything but perfect.[57]

144. *Johnny's Revenge.* Woodblock illustration from Sophie May [Rebecca Sophia Clarke], *Dotty Dimple at Home*, Boston, 1868. Special Collections, Colby College, Waterville, Maine.

Dotty Dimple's problem is that she has a bad temper, which again and again gets the best of her, despite her mother's efforts to teach her self-control. The scene illustrated in *Johnny's Revenge* occurs after Dotty has insulted a group of little boys at a party and has been sent to her room (which is visually similar to the room in *Making a Train:* apparel hanging from a peg, cracked plaster on the wall, an interplay of light and shadow upon the floor). One of the little boys she insulted, Johnny, gets his revenge by peering into her window with a ghoulish jack-o'-lantern over his head. Dotty responds in hysteria. "She gave one loud, terrified scream, and fell forward upon the floor. She did not rise, she did not speak, she seemed scarcely to breathe."[58] Johnny and the others hasten to revive Dotty, but with little success. Finally she rises but has become so emotionally disturbed by the shock (or more likely by the concerted effort of everyone she knows to root out her bad temper) that her parents decide she should accompany her father on a recuperative trip to the West—the subject of the next novel in the series. Thus ends *Dotty Dimple at Home.*

In 1890, the editor of the nation's most prestigious magazine, the *Atlantic Monthly*, received a story that might be thought of as an adult adventure of Dotty Dimple and the terrors to which she still must be submitted for her failure to comply with the reigning codes of femininity. *Dotty Dimple Goes Insane*, it could have been called, for whereas Dotty's dimpled cuteness always managed to prevent the punishments wreaked upon her from becoming too unsettling, in this story the psychic pain was unremitting. "Dear Madam," responded the editor upon reading it, "I could not forgive myself if I made others as miserable as I have made myself!"[59]

The story thus rejected, "The Yellow Wallpaper" by Charlotte Perkins Gilman, is narrated by a young woman confined to her attic bedroom by her physician-husband who treats her nervous ailment with the "rest cure" treatment then in vogue. As the narrator falls apart mentally, her obsessions focus upon the patterned wallpaper of her room. She begins to see in it a woman imprisoned behind vertical bars. She fears this imagined captive but also sympathizes with her, plotting her escape. At the end of the story, she peels away the wallpaper only to become in her mind the woman who was entrapped within its pattern. She circles the room incessantly, cleaving to the wall, her insanity so apparent now that her husband faints when he sees what has happened to her.[60]

Making a Train is no "Yellow Wallpaper," and yet in the earlier work we can find elements of the latter and see in the latter an angry rejection of the feminine ideal endorsed by the former. Born in 1860, Gilman would have been close in age to the preadolescent girls depicted in *Making a Train*, "Patty's Patchwork," and *Dotty Dimple*. Though written in the closing decade of the century, her tale of entrapment and victimization by a disciplinary gaze originated in the same ideological and discursive world as these products of postwar America. The story she tells, written after her own mental breakdown and divorce, is their story, too, viewed from the position of a female who failed—in the ever-scrutinizing eyes of society and perhaps in her own eyes as well—to be properly quilted or trained.

Like the narrator of "The Yellow Wallpaper," the girl in *Making a Train* is a spectator of herself.

145. Thomas Hovenden, *Bringing Home the Bride*, 1893. Oil on canvas, 56 × 78 in.
Unlocated (Photo: Lee M. Edwards, New York).

We see an alienation from self, in which the little girl spies upon her own body as though it were not hers but someone else's. As Alice in Wonderland exclaims when she has grown so fast that she bumps her head on the ceiling and can no longer see her feet, "Dear, dear! . . . I wonder if I've been changed in the night? . . . I almost think I can remember feeling a little different. But if I'm not the same, the next question is, 'Who in the world am I?' Ah, *that's* the great puzzle!"[61]

"A woman must continually watch herself," claims the art historian John Berger. "Whilst she is walking across a room or whilst she is weeping at the death of her father, she can scarcely avoid envisaging herself walking or weeping. From earliest childhood she has been taught and persuaded to survey herself continually." The reason "she has to survey everything she is and everything she does [is] because how she appears to others,

and ultimately how she appears to men, is of crucial importance for what is normally thought of as the success of her life."

These remarks could be amended to say that men as well as women are taught in modernity to be self-conscious and, in a culture of consumption, narcissistically so. But in the terms provided by *Making a Train*, Berger's gender division seems apt: "Men look at women. Women watch themselves being looked at" and in so doing turn themselves "into an object—and most particularly an object of vision: a sight."[62] Guy's little girl, exhibiting pleasure in watching herself, may be thought of as introjecting a male gaze, whether that of a future suitor or of a proud father admiring his daughter or, a variation on both these themes, a proud father-in-law admiring his new daughter-in-law, as in Thomas Hovenden's *Bringing Home the Bride* (1893, fig. 145). In Hovenden's painting a

young woman displays herself for the admiration of all, most specifically her husband's father, who appraises her from his seat.

And yet note the little girl who gapes at the bride from the margins. Here too, as in *Making a Train*, a doll has been cast aside, as though no longer of primary interest to a child with more important things suddenly on her mind. The little girl's admiring attention suggests that it is not only the so-called male gaze that women introject but also the gazing of their mothers, sisters, and daughters, a veritable network of female gazes that they themselves refashion and return (1954, fig. 146). The self-surveillance of Guy's girl and the pleasure it appears to afford her may be thought of as springing from other, not exclusively male-centered, sources. The childish narcissism she enjoys is in keeping with old beliefs about childhood depravity and female vanity, and yet it also provides a modern twist on the puritanical notion that self-examination must be painfully humbling in order to be spiritually rewarding. This self-scrutinizer likes what she sees—that is, she likes how she sees herself.

Although there is no mirror in *Making a Train*, it is certainly implied, perhaps outside the composition but also, figuratively, within the imagination of the little girl herself. In this regard, *Making a Train* would seem to depict what Jacques Lacan has called "the mirror phase." Looking back over her shoulder to gaze upon the fantasy train at her feet, Guy's girl admires herself in a mental mirror—a Lacanian "imaginary"—in which her own social and corporeal inadequacies are blotted out by that seductive shimmer of illusion that she will pursue, and lack, for the rest of her life.[63]

Titian, Tintoretto, Rubens, Velasquez, many an old master painted Venus admiring herself before a mirror, but it took a modern master, twentieth-

146. "Wedding Ceremony, Washington," 1954. Photograph. UPI/Bettmann Archive, New York.

147. Norman Rockwell, *Girl at the Mirror*. Cover of *Saturday Evening Post*, March 6, 1954.
Norman Rockwell Family Trust (Photo: Curtis Publishing Co., Indianapolis).

century America's answer to Seymour Guy, to make bittersweet comedy from this sort of thing. Norman Rockwell's various depictions of "the mirror phase" stress not the subjective pleasure that comes early on in a girl's life when she sees herself in the mirror but rather the pain that arrives later as she discovers her insufficiency in its pitiless return of her gaze. In Rockwell's *Girl at the Mirror* (1954, fig. 147) a child, alone and disrobed, confronts herself in a looking glass propped up by a piece of furniture similar to the one Guy uses to support a related technology of seeing, an oil lamp. Upon the child's lap is a fan magazine with a full-page photo of a glamorous woman—probably a film star but also a surrogate for her mother—who peers at her with raised eyebrows and pursed lips. The humor/poignancy of the painting resides in the woeful face with which the little girl studies herself, coming to terms with the hard fact that the mirror of glass refuses to give her back the same fantasy image as the mirror of paper—the fan magazine—on her lap.[64]

Painted for the cover of *The Saturday Evening Post*, primarily a women's, rather than children's magazine, Rockwell's *Girl at the Mirror* could be thought of as a reversal of the fairy tale of Snow White, the child, not the wicked stepmother, imploring in frustration at a mirror that refuses to lie. Rockwell's painting shows the moment at which Guy's fantasy train derails.

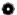

All this talk about the girl's self-surveillance and introjection of parental authority is not meant to obscure the scopophilia that the painting invites. This is what the term voyeurism normally brings to mind: secretive, privileged, male-dominant sexual looking. In today's flourishing literature on the so-called male gaze, it is often taken for granted that men look at women in a sexually objectifying manner in order to assert control over them and allay the anxieties they prompt. Scopophilia, or the sexual instinct-drive related to a love of looking, has been linked by Laura Mulvey and other psychoanalytic feminists to Freud's notion of fetishism as a uniquely male defense mechanism that wards off castration anxiety through visual displacement. In order to divert his attention from the female's disturbing "lack" of a penis (disturbing because it reminds him of the threat he most dreads), the fetishistic voyeur, according to this theory, overinvests his attention in fragments of the female body (hair, breasts, feet) or in metonymic signifiers of those fragments (hat, corset, shoes), thus substituting parts for the whole.[65]

But one need not subscribe to psychoanalytic fetish theory in order to recognize that gazing at women voyeuristically is a means by which men may experience, reexperience, or experience in fantasy their virility and all the potency and social worth that that implies. Voyeurism, by any definition, suggests detachment, estrangement, viewing from a distance. It is the perceptual distance embodied by the voyeur—literally, his standing back from the scene he gazes upon—that allows him to take measure of his sexual difference, his so-called masculinity.

Such seems to be the case with *Interior* (1868–69, fig. 148), a work by Guy's contemporary Edgar Degas. A partially clad woman in a tight, enclosed, wallpapered bedroom is scrutinized by a bearded man who gazes at her from the edge of the painting. Commonly known as *The Rape*, Degas's lurid genre scene makes explicit a side of *Making the Train* that is at most only implied but feasible nevertheless. In both works the body of a young female assumes a posture culturally associated with subordination, thus contributing to the power-dominant position of the male spectator, who in the Degas receives a stand-in, the man with the beard. *Making a Train* offers no such stand-in, and yet it too hails the viewer into being as a voyeur, thanks to the various theatrical devices already described.[66]

Body language is an effective conveyer of one's willingness to be subordinate in any given situation. In a study of gender hierarchies as signified and reproduced by conventions of body language, Erving Goffman offers examples of what he calls "the ritualization of subordination." Several of the body language gestures he identifies, though drawn exclusively from late twentieth-century models, pertain to *Making a Train:* "the bashful knee bend," "the body cant," "the head cant," "smiles," "puckishness," and "body clowning." Each of these, according to Goffman, is a

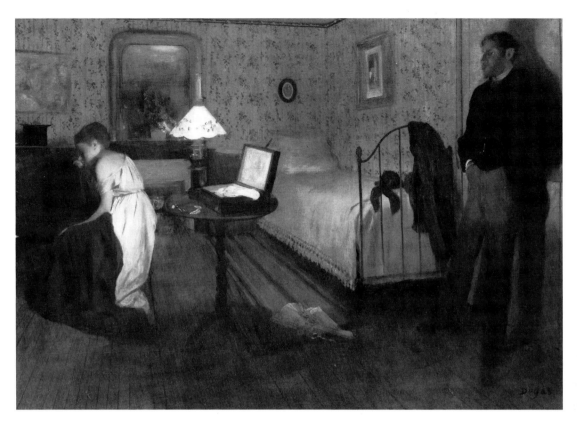

148. Edgar Degas, *Interior (The Rape)*, 1868–69. Oil on canvas, 32 × 45 in. Philadelphia Museum of Art. Henry P. McIlhenny Collection in memory of Frances P. McIlhenny.

means by which one individual signals to others that he or she is not a threat, not intent upon aggression or competition.[67]

Applying Goffman's categories of subordinate body language, let us compare *Making a Train* to Gérôme's *The Slave Market* (c. 1866, fig. 149). Diminutive in size, pale in complexion, and stripped of clothing, the white slave of Gérôme's painting—like Hiram Powers's celebrated *Greek Slave* (figs. 13, 14)—further evidences her subordinate position by means of her knee bend, body cant, and head cant. (Gérôme too provides stand-ins for the heterosexual male viewer, whereas Powers's neoclassical statue leaves the salacious spectatorship of the slave's prospective buyers to the art viewer's imagination.) True, the slave's head cant is not volitional, for the man who examines her

compels the movement with his left hand, even as with the invasive fingers of his right hand (a sexually displaced gesture) he forces what amounts to a smile. Still, the visual effect is similar to the look of subordination and deference that, according to Goffman, is entered upon consciously or unconsciously by one who wishes to signal "nonthreateningness."

Such is the case with the little girl in Guy's painting. Guy has chosen to ascribe to her the body language of deference—and, more particularly, body language that by the mid–nineteenth century was gendered feminine and childlike. Victorians considered body language never accidental or spontaneous, even when spontaneity was the effect desired. Bronson Alcott, according to one of his former pupils, enjoined students "to consider

gestures, and the *rationale* of manners; and . . . that the positions and motions of their bodies were produced by the mind, and that the mind could control them, and therefore they were responsible for the impressions they conveyed in this way."[68] Alcott believed that children who were habituated to moving their bodies in decorous ways would become habituated to leading decorous lives. In the popular etiquette books of the period, however, the goal was not so much moral development as teaching young females to express (and in so doing, reinforce) their childlikeness and femininity.[69] The reviewer of *Making a Train* who praised the "deliciously innocent childish character" of Guy's girl hereby articulated the chief nature of her appeal.[70]

Her body language, this is to say, elicited male heterosexual voyeurism, however repressed and therefore unacknowledged, inasmuch as it signaled to the male viewer that his own body was by contrast strong, powerful, and manly. Moreover, for all her appearance as a nonsexual little girl, various devices hint at a swelling, sexually desirable womanliness: the tight, enameled skin, the cleavage-inducing shadows that fall across it, the corseted waist, bound arms, naked foot (this in a culture famous for covering piano legs so as not to offend morality). Although the painting, in the words of one reviewer, "represents a little girl in an attic 'dressing up' previous to undressing for the night," the emphasis, from the voyeuristic point of view, has more to do with the undressing than the dressing up—or, rather, with the dialectical give-and-take of these two modes.[71] That is, Guy's theatrical, half-naked little girl parading about in costume is, in modern-day terms, a stripper.

Striptease is a twentieth-century phenomenon with nineteenth-century music hall roots. Montmartre's celebrated Moulin Rouge, with its cadre of high-kicking cancan dancers teasingly wagging

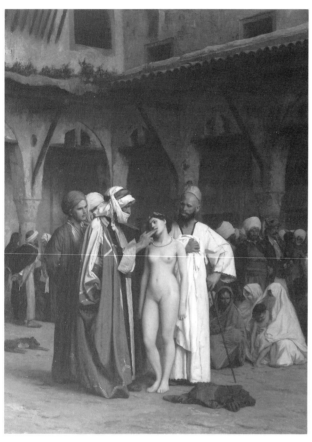

149. Jean-Léon Gérôme, *Slave Market*, c. 1866.
Oil on canvas, 33³⁄₁₆ × 24¹³⁄₁₆ in. Sterling and Francine
Clark Art Institute, Williamstown, Massachusetts.

black-stockinged legs over the heads of bug-eyed male admirers, was an early instance of today's now commonplace commercialization of sexual voyeurism. In the United States the era of commodified sexual display of women may be said to have begun in 1868 with the long-awaited arrival in New York of the British music hall entertainer Lydia Thompson and her British Blondes, who strutted the floorboards of a Broadway theater with daring costumes and taunting, transgressive postures.[72] Guy's girl may have paraded childish innocence rather than sexy insolence, but all the same, Guy's painting, like Lydia Thompson's burlesque and modern striptease, invites a distanced, physically appraising, physically stimulated gaze.

In a brief essay on striptease, Roland Barthes has argued that the purpose of the stripper (at least in the Paris of the 1950s, when he wrote) is not to unleash sexuality but rather to contain it: "It is only the time taken in shedding clothes which makes voyeurs of the public; but here, as in any mystifying spectacle, the decor, the props and the stereotypes intervene to contradict the initially provocative intention and eventually bury it in insignificance: evil is *advertised* the better to impede and exorcize it." Striptease, in Barthes's typically perverse and counterintuitive formulation, functions as "a mystifying device which consists in inoculating the public with a touch of evil, the better to plunge it afterwards into a permanently immune Moral Good: a few particles of eroticism, highlighted by the very situation on which the show is based, are in fact absorbed in a reassuring ritual which negates the flesh as surely as the vaccine or the taboo circumscribe and control the illness or the crime."[73]

Nominally anything but a striptease, *Making a Train* may similarly have functioned as a vaccine for Victorian American audiences, a few crumbs of

titillating eroticism for the greater goal of defusing truly dangerous sexuality: eroticism as administered and channeled sexuality. (As this equation would have it, eroticism is to sexuality what, according to Kenneth Clark, nudity is to nakedness: its abstraction, its idealization.) In the post–Civil War America of *Making a Train*, unmanaged sexuality did indeed loom, like Guy's spooky shadows, as a threat to social order. Working-class prostitution and illegitimacy, middle-class male philandering, and the free love socialism of radical feminists such as Victoria Woodhull all served notice that the ideological war being waged on behalf of bourgeois values, unlike the recently concluded military war, was far from over.

In this context, *Making a Train*, with its "few particles of eroticism," may have functioned, like Barthes's striptease, as a "vaccine . . . [to] control the illness or the crime." Once again, Guy's nearly exact contemporary Lewis Carroll needs to be brought into the discussion. "Questions tease us about the ultimate direction of his verbal and visual celebrations of little girls," notes Nina Auerbach: "are they a violation of childhood, however voyeuristic and oblique, or is Carroll the purest Arnoldian critic of female children, appreciating the object as in itself it really is, adopting the camera's loving detachment in order to define its subject's value to the world?" As she adds, "Feminist viewers might find themselves particularly perplexed by Carroll's obsessive celebration of girlhood, uncertain whether his worship violates his subject or comprehends it."

In Auerbach's view, the power of Carroll's *Alice*

books and nude photographs results from his affection for that theatricality, energy, and even demonic aggression of Victorian girls that he detected at precisely the point in their lives when such vitalism, as a threat to the social order, needed to be effaced. "Carroll's faith in performing little girls was a virtually unique tribute, a denial of the shrouded languor so many Victorians wanted women and children to embody." Might the same be said of *Making a Train?* Here too a little girl's vivacity and transformative energy could be savored as a pleasing alternative to the "shrouded languor" elsewhere required of respectable females, child or adult. This is to say that the sexual voyeurism elicited by Guy's paintings (or Carroll's photographs) may have had less to do with the need to control women, displace castration anxiety, or circumscribe sexuality—the motives adduced above—than with the compulsions of men who were locked in a stultifying, eviscerated environment to experience, as Auerbach puts it, "the inexhaustible gusto and intensity" of playful, theatrical, metamorphic little girls.[74]

Intent upon revealing the anaesthetizing, desexualizing effect of striptease as one more instrument of bourgeois reification, Barthes downplays the possibility that the stripper's feathers and furs, bumps and grinds, and various other outrageous provocations appeal to the voyeur not because they cauterize sensibility but, to the contrary, allow it to be quickened. To speak of it in this way is not to justify modern striptease or the sex-voyeurism industry it services, but to attempt more fully to comprehend its social functions—

and, in so doing, enable a historical leap backward to imagine better what might have been the unstated effects or functions of a painting like *Making a Train*. We can wink at the aforementioned Reverend Kilvert's heart-pounding admiration for "lithe, lissome, high-spirited, romping girls with their young supple limbs," flattering ourselves that we of the twentieth century are more qualified than he to understand that the breathless ardor of his prose masks its lechery. The flip side to this, however, is that what we in our superior wisdom have come to regard as the Victorians' pure sexual desire masquerading as something else may at yet another level symptomize a nonsexual need that those Victorians understood extremely well: the need for irrepressibility in a time of deadening physical and emotional repression.[75]

Barthes claims that the real purpose of a stripper's dance is not to arouse desire but to exorcize "fear of immobility." And yet what, finally, is desire if not a hope of exorcizing both immobility and its fear?

❁

Of course not only men but women viewed girl paintings such as *Making a Train*. In its sentimentalizing of childhood, especially girlhood, it probably served to confirm for the adult female spectator the importance of her socially ascribed role as childhood's primary guardian. At the same time, though, it would have reminded her (that is, reinformed her) of the attractiveness, sexual or otherwise, of girlishness. In so doing it may have positioned the adult female spectator as a jealous voyeur, a female rival of this other woman, this child woman, who potentially threatens to replace her in the eyes, if not literally the arms, of her husband (a possibility both raised and denied by *The First Party*, the *Godey's* illustration that depicts a young mother gazing proudly at her beautiful,

look-alike daughter, a matrimonial bed prominent in the background).

This anxious maternal gaze might be called female envy voyeurism to distinguish it from the male heterosexual voyeurism theorized above. The term *voyeur*, which derives from the French *voir*, originally meant "one who sees" or "one who views," but as noted, it has generally come to stand for one who looks illicitly and usually sexually from a secret or protected place. If *Making a Train* invites the heterosexual male spectator to view the little girl furtively as a sexual object, it similarly invites the heterosexual female spectator to view her as a sexual rival.

Victorians would not have been taken aback at the notion of female voyeurism. A popular depiction of it in the Pre-Raphaelite style was Philip Calderon's *Broken Vows* (1856), in which a young woman, witnessing her fiancé's disloyalty through the crack in a fence, falls into a swoon. Such popular fairy tales as "Snow White" may not have included actual scenes of jealous female voyeurism, but they were activated nonetheless by the envy of an aging (step)mother whose husband's daughter possesses the youth and allure that she herself is losing. In its depiction of a girl in an attic pretending to be a grown lady, perhaps at a dress ball, *Making a Train* alludes almost specifically to "Cinderella," an ancient story of female rivalry that was among the most popular fairy tales of the Victorian era.[76]

A contemporary of Guy's, Clementina, Lady Hawarden, often posed her young daughters in photographs that abound in mystery and suggestiveness.[77] In one of these (c. 1860, fig. 150), a girl stands against the wall of a room with her head bowed before a man who gazes upon her with a solemn expression. Sunlight pours onto the wide wooden floor from an open window, about which

the curtain swirls with theatrical flair, but the man and girl, at the far side of the room, are enshadowed, somber, and still. Spiraling from floor to ceiling like a coiled spring coming unsprung, the curtain externalizes the apparent tension between the two figures. *Making a Train* is in some ways a counterimage to this photograph. Guy's girl, younger than Hawarden's and literally half undressed, is all by herself in a room, frisky and carefree, not, so it seems, the subject of adult supervision and disciplinary gaze. Nonetheless, such structural similarities as the wide apron of floor in the foreground, a diagonal play of light and shadow, and a window tantalizingly edged against the side of the composition hint at other similarities as well, among them that the little girl who prances so playfully is not entirely alone and free from adult observation and oversight. The adult male *inside* Hawarden's photograph ponders the girl with an expression that we lack the information to define: is his gaze parental? disciplinary? longing? Whatever it might be, the adult male *outside* Guy's painting, that is, its male spectator, would have been similarly positioned to gaze with superiority, benign or otherwise (if such a gaze can ever be truly benign).

Hawarden's photograph, however, is the product of an adult *female* spectator who spies—only fictitiously, since the work is posed—on what appears to be a private encounter between adult man and female child. There is nothing here of Lilly Martin Spencer's representations of parent and child; the visual language is of stage melodrama, not hearthside sentimentality. Given the optical

150. Lady Clementina Hawarden, "Man and Girl in a Room," c. 1860.
Photograph. Victoria & Albert Museum, London.

distance of the image, the turned-away disposi-
tion of the figures, and the apparent intimacy of
the encounter, the scene looks as though it were
seen through a keyhole.

If *Making a Train* reassured male spectators
that their bodies were masculine and powerful in
contrast to that of the frolicsome little girl, it may
have inspired in adult female spectators a covert
anxiety that made them less rather than more sure

of their bodies, especially in regard to those of
vigorous young girls who inevitably amounted to
potential competitors for the limited favors avail-
able from men. A trade card for the Adjustable
Duplex Corset (c. 1882, fig. 151) depicts a pair
of women spying enviously into a room where a
third woman, standing before a mirror, admires
the comely shape provided for her by her Adjust-
able Duplex: "The Secret Out at Last," explains

the caption, "—Why Mrs. Brown Has Such a Perfect Figure." Or, in the disapproving words of the beauty authority Henry T. Finck, "The only satisfaction a woman can get from having a wasp-waist is the envy of other silly women." To be made insecure about their abilities to remain physically attractive was for women to be kept on the defensive, encouraged to retain at all costs what Ruskin called their "majestic childishness" and Finck sneered at as "the envy of other silly women," be it the price of a new corset—or the considerably greater price of political passivity.[78]

In order to demonstrate the possibility of a nonvoyeuristic gaze, Griselda Pollock contrasts male-authored Impressionist texts such as Edouard Manet's *Before the Mirror* (1876–77) or Degas's studies of singers, dancers, and prostitutes with Berthe Morisot's *Psyché* (1876, fig. 152), a painting of a teenage female dressing before a mirror. *Psyché*, according to Pollock, "offers the spectator a view into the bedroom of a bourgeois woman and as such is not without voyeuristic potential but at the same time, the pictured woman is not offered for sight so much as caught contemplating herself in a mirror in a way which separates the woman as subject of a contemplative and thoughtful look from woman as object."[79]

The problem here is with the implication that women lack sexual agency; that *in essence* the female gaze is "contemplative and thoughtful" rather than objectifying. A binary opposition between subjective ("contemplative and thoughtful") and objective ("voyeuristic") ways of looking, one tagged female, the other male, serves only to replicate the separate spheres, sexual difference, ideology that Pollock has sought to undermine.[80] As we have seen, certainly with *The First Party* and the "Good Sense" corset advertisement and also perhaps with Hawarden's photograph, a mature

151. *The Secret Out at Last—Why Mrs. Brown Has Such a* Perfect *Figure*, c. 1882–85. Trade card for the Adjustable Duplex Corset. Valerie Steele Collection, New York.

152. Berthe Morisot, *Psyché*, 1876. Oil on canvas, 25⅝ × 21⅜ in.
Thyssen-Bornemisza Collection.

woman's look at a female young enough to be her daughter can plausibly be sexual, not necessarily meaning that the older woman desires the younger one sexually but perhaps envies her sexually or maybe even admires her sexually, envisioning in the girl's youthful body an extension forward in time of her own sexuality—what Morisot's biographer has termed "thinking into the future through her daughter." (Morisot, as it happens, was about thirty-five years old when she painted *Psyché*, recently married, and at a point of being continually disappointed in her efforts to become pregnant).[81]

Certainly Morisot provides an array of sexual signifiers in her depiction of the young female. The bedroom slippers exposing her feet, the falling away of the shift at her shoulder, the thin, black choker, and, above all, her fashionable hand-behind-the-hip stance define her as an object of sexualized gazing, her own (as she looks in the mirror), the artist's, and the viewer's. Even its title sexualizes the image. In classical mythology, Psyche, beloved of Cupid, was a beautiful maiden who aroused the jealous wrath of Cupid's mother, Venus, the goddess of beauty, who would have proceeded to destroy Psyche had Jupiter not intervened. The erotically suggestive pairing of Cupid and Psyche was often depicted in nineteenth-century art (in fact, it was the subject of Seymour Guy's first major painting), but in her unusual choice of showing Psyche without Cupid, Morisot in effect shifts the implied narrative away from the theme of heterosexual desire to one of mirroring. Turned toward her reflection in the mirror, the young model "reflects," to a greater or lesser degree, the woman who in the act of painting her has (figuratively speaking) given her birth, as a daughter reflects, however imperfectly, the mother who bore her or as a painting reflects, no less imperfectly, the artist who painted it.[82]

Psyché, in fact, is a French term for mirror. It also means mind or soul, and as such is the root word for psychiatry and psychoanalysis. Morisot's painting of a young female dressing up alone in her room is like Guy's painting of his own daughter dressing up, gazing at herself in an imaginary mirror, a mirror that resides within her mind, her psyche. And if *Psyché* amounts to an opportunity for a female artist to contemplate herself by way of a female half her age, in effect, a daughter-substitute, so too can *Making a Train* be understood as an artist's self-examination through the medium of a daughter.[83]

❁

In the market world of modern Anglo-America, artists were orphans. Talent, training, connections, all these were important to a painter in search of patrons (fathers, in the original sense of the word), but so too was the ability to flatter and please. Like puppies in the pet store window, those who were cutest or produced the cutest pictures had the best chance of finding a home. Others were more likely to suffer the rejection or eviction allegorized by Blythe in *Art Versus Law* (see fig. 110).

An artist such as Guy, literally orphaned at age nine, may have considered the image of a creative nine-year-old girl alone in a garret a metaphoric way of depicting himself, the artist, alone in his studio (this linkage all the more plausible if the model was his offspring). In this regard the painting "rhymes" with such old master works as Dürer's engraving *St. Jerome in His Study* (1514) and Isaak van Ostade's *The Artist in His Studio* (c. 1640), which also depict a creative individual

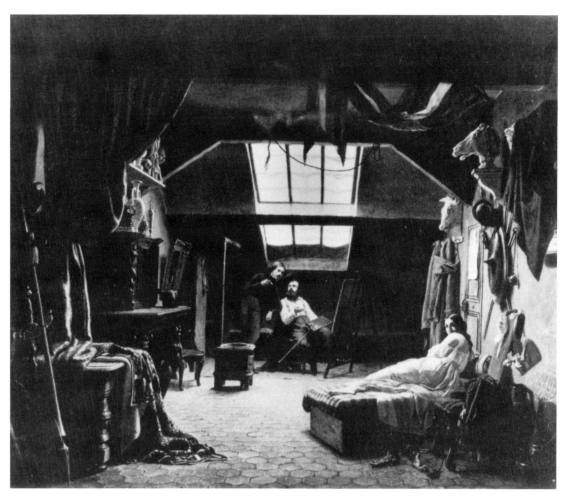

153. *Artist and Model in the Studio*, 1843. Unlocated oil painting,
artist and dimensions unknown (Photo: Roger-Viollet, Paris).

in front of a window in an enclosed, seemingly isolated interior. "Do you know what a painter's studio is, / Bourgeois reader?" taunted the romantic poet Théophile Gautier. "It is a whole world; / A universe apart with nothing to recall / The world we live in."[84]

In this particular metaphorical configuration, Guy's little girl seems to conflate the three archetypal figures depicted in a presently unlocated and unidentified French romantic painting now known as *Artist and Model in the Studio* (1843, fig. 153). She is like the fetchingly bare-shouldered, barefooted model (note the slippers in the foreground),

and, in ways that we have discussed, she is like the gazing spectator. But she also stands in for the artist at his easel. Dormer window, sloping ceiling, narrow cot or makeshift chaise, Bohemian clutter and signs of impoverishment, objects attached to the walls or hanging from them, all these similarities between the two paintings suggest not that *Making a Train* is a direct reference to the earlier work but that it, like the earlier work, makes use of props and setting that belong to a well-established tradition for invoking the cloistered and imaginative world of the artist's studio.

The Joshua Reynolds print on the wall, askew,

might have served, in an even more personal symbol system, to indicate Guy's mixed attitude toward the Royal Academy, of which he was never a member, and its less prestigious American counterpart, the National Academy, to which he had only recently, in 1865, been inducted. Serving as the founding president of the Royal Academy from 1768 to 1790, Reynolds, Georgian England's leading portraitist, was incontestably the definitive academician. His fifteen *Discourses*, a magisterial proclamation of neoclassical aesthetics, standardized within the Anglo-American art world a hierarchy of taste that placed grand-manner history painting and portraiture at the top and its opposites, genre and still-life painting, at the bottom. As a portraitist and an academician, Guy was doubly beholden to Reynolds: both the style of portrait painting he practiced and the academy to which he belonged descended directly or indirectly from the earlier artist. On the other hand, Reynolds's disdain for genre painting must have rankled the English expatriate, who eventually abandoned portraiture for this lower, if more lucrative, branch of art.

Knocking askew the print from Reynolds may have been Guy's moment of resistance against the academy, that orphanage of sorts that fostered his career. Or this was a resistance, if not against the academy per se, against Reynolds, the father of British portraiture and of the elite bias against genre painting. Twice Reynolds painted the infant Samuel praying, first in 1776 and then again in 1789, both of these years of revolution against a symbolic father, a king. Significantly, Reynolds's own father was named Samuel. The biblical Samuel, prototype of obedience, is a child who hears his name called repeatedly by God and answers, "Speak Lord; for thy servant heareth." To paint in 1776 and 1789 a reverent young Samuel *kneeling* in prayer was surely to express disapproval of those who *stood* in rebellion. An admiring former student of Reynolds attributed the exceptional worldly success of this son of a humble clergyman to the fact that he possessed "a mild, bland, amiable character" and manners that "were indeed affable and obliging." That is to say, the motto of this darling of British aristocrats was always, "Speak, Lord, thy servant heareth." *Making a Train*, the work of a middle-class *arriviste*, may constitute a pretty picture of childlike deference, but its ironic device of throwing *Samuel* off kilter makes total submissiveness appear suspect.[85]

But is that all? Is there any greater resistance than that to be found within this image? Does it provide means for its spectators to reject the subject positions constructed for them (as lecherous, jealous, paternalistic, or self-scrutinizing, self-deceiving voyeurs)? Is there room for resistance within this room or is it the inescapable panoptic prison cell conceived by Reynolds's contemporary Jeremy Bentham and theoretically generalized two centuries later by Michel Foucault as the paradigm for modern, surveillant society itself?[86] In actual historical terms there must have been a way out of the hermetically sealed codes of true womanhood, a way to circumvent the totalizing and hobbling gaze of social surveillance (parental or otherwise), for how else to account for the fact that there were women—Anthony, Spencer, Stowe, Alcott, and Gilman are those this chapter has mentioned—who demonstrated the strength to be more than mere children?

Jane Hunter suggests that the self-scrutiny imposed upon the bourgeois girls who kept diaries actually provided them with a device for achieving a measure of autonomy. Diaries permitted these girls "to experiment with (and sometimes even savor) the feeling of challenging parental authority." They afforded a safety bubble for emotional trial and error, a separate sphere within the larger separate sphere of the Victorian home. Inside the protective confines of her diary, outwardly symbolized by the privacy of her bedroom, the girl could "make a train" of dreams and wayward sentiments, even rail at parents, with no harm done, no bridges to the family ever burned. Private diaries, says Hunter, "allowed Victorian girls to assert new selves without rejecting their domestic identities."[87]

The quilt in the back of the room, suggestive as it is of women's culture, might also hint at a way out of the attic. Elaine Showalter warns that "we must . . . deromanticize the art of the quilt, situate it in its historical contexts, and discard many of the sentimental stereotypes of an idealized, sisterly, and nonhierarchic women's culture that cling to it."[88] We have seen in "Patty's Patchwork" how quilt making bonded females of different generations but also provided adults with another means of moral vigilance, like diaries, dolls, and nursery theatrics, to induct girls into the socially and politically restricted sphere of "true womanhood." The quilt that hovers across the center of *Making a Train* exerts force over the image as a whole, not only because of its color and intricate detail, but also because of its predominant diamond pattern-

ing, which is echoed by the diamond shape of the fallen print and the larger diamond suggested by the sloping ceiling and the slicing shadows. This may implicate the quilt as yet another metaphor for the ideological hegemony that has been pointed to throughout this chapter—one that is not only therapeutically comforting for social subjects but also restrictively blanketing of them—but to the extent that quilting, which was considered an exclusively female art, is central to Guy's image and holds it together, female creative power is thereby acknowledged. Patchwork requires joining many small pieces of fabric into an overall design; quilting involves attaching these assembled patches onto a heavy backing. In this regard, Seymour Guy was himself a patchworker and quiltmaker, taking myriad details concerning a girl in a room, arranging these into a composed design, and attaching the result to a frame (not altogether unlike the process of writing this chapter). The girl in the painting is similarly occupied, patching together pieces of apparel and fragments of dreams to construct, for her own pleasure, some grand scheme that unfolds in her imagination and may someday unfold in her life.

Above, we briefly entertained the possibility that the red dress that springs forth from the joining of the little girl's legs could be read as a flow of blood. Such a device was not without artistic precedent. For instance, in Caravaggio's *Beheading of Saint John the Baptist* (1608) a swatch of bright red cloth seems to gush onto the floor from the fallen saint even as a smaller, darker patch of red pours from his severed throat. Edvard Munch, as we saw, treated the onset of female puberty as a signifier of melancholy, even despair, but *Making a Train* encourages a reading of it as a time for experiencing newfound power and capability. The menstrual flow of blood, if that is how for the moment we

agree to read the red dress, seems to provide the girl with pleasure rather than dread. Conventionally, menstruation has been regarded as a sign of female inadequacy and disability, a monthly sickness to be suffered and endured. But this may reflect a patriarchal bias that pubescent females are taught to their detriment. In the words of Emily Martin, a feminist anthropologist who criticizes the traditional medical notion of menstruation as the "failed production" of an embryo: "I can see no reason why the menstrual blood itself could not be seen as the desired 'product' of the female cycle, except when the woman intends to become pregnant." The point here is not that Seymour Guy was intentionally alluding to a girl's first menstrual flow and the psychic pleasure, as opposed to pain, that this might bring, but rather that the painting he produced was capable of allowing for subject positions other than that of voyeur—the position, for example, of a female who could experience her body and its effluents in terms of pride rather than shame, power rather than frailty.[89]

Seen through late twentieth-century eyes, *Making a Train* resonates with both Charlotte Brontë's "madwoman in the attic" and Virginia Woolf's "room of her own"—the one a nightmare of womanhood entrapped, the other a dream of female autonomy. The girl prancing imaginatively through an attic bedroom represents the hopeful side of Gilman's dismal "Yellow Wallpaper," which contends that women are prisoners, not beneficiaries, of the codes of femininity and childhood imposed upon them. But Gilman herself was able to emerge from that wallpapered suffocation. To the extent that *Making a Train* emphasizes the triumph of the performative imagination, it may have allowed its female spectators—middle-class though they were—a device not simply for recirculating those social codes that held them in place

by advising them to remain always beautiful and childlike. It may also, in envisioning satisfaction independent of men, have offered an image that could help women strengthen their resolve not to be dependent and childlike, but instead autonomous and adult.

This of course runs counter to the insistence throughout the chapter that nineteenth-century Anglo-American women were constructed as childish beings and that pictures like *Making a Train* reinforced that construction. Can we have it both ways? Can a painting that served to hold women in place by idealizing their occupancy of the yellow-wallpapered female sphere also have provided, for some women, a symbol of, if not impetus toward, their own performative agency, in other words, toward the peeling away of that constricting and illusionary wallpaper?

Must the painting be one thing or the other, a good object or a bad object but not both? It seems reasonable to believe that however socially as well as artistically conservative *Making a Train* may have been, at times it must have functioned in a liberating or empowering manner for those who "misread" its intentions or were unconstrained by its dominant meanings. After arguing at length that the painting represents a nexus of cultural forces that conspired to infantilize the population at large and women in particular, I am not trying to reverse myself at the last minute. But I do wish to hold open to the end our sense that the work of art, like the society that produced it, like the young female it depicts, like the room she occupies, is inevitably split, contradictory, and inconclusive.

Masculinity, Nostalgia, and the Trompe l'Oeil Still-Life Paintings of William Harnett

This chapter has two stories to tell. One is of how late nineteenth-century American still-life painting made men of its viewers or at least encouraged them to think of themselves as such. The other concerns the nostalgia of these viewers for an era that was disappearing before their eyes, although in their rush to embrace the modern they were largely responsible for the change.

Before telling these stories, I wish to point out that this chapter will be less marked than the others by the deliberately intrusive presence of the story-teller. This is intentional; whether or not it pleases you is another matter. Because I am writing about art that, as we shall see, was predicated upon the suppression of authorial presence—art that seemed to appear on the wall full-blown without any human touch—I have chosen to experiment with suppressing not so much my own touch as the conspicuous signs of that touch: the direct address, the jokes, the puns, the perorations, all the self-reflexive and idiosyncratic stuff that heretofore has been strewn throughout the book.[1] In other words, I have tried (rather inconsistently, I must admit) to write impersonally about impersonal art, coolly about art that is cool, dispassionately about passionlessness. I have tried, this is to say, to write in the bland and neutral style preferred in the academy today.

Why so? Is this a sudden failure of nerve on my part (better clean up my act now before the book is over) or, to the contrary, a sudden flight of straight-faced mimicry? Perhaps I protest too much and what follows is not so different from what precedes it. Decide for yourself, but I do ask that as you read you think about conventions of expository style in art history as well as in art. Consider, if you will, the extent to which "objective" prose is a literary equivalent to the "objective" painting this chapter describes. Is one any more truthful than the other? Any less illusionistic? Both are rhetorical modes of presentation that wear their seeming lack of rhetoric as a badge of honor, integrity, clear-headedness. Writing degree zero, painting degree zero. What some would call a manly style.

There is another matter I wish to mention before we begin. Much of this book has evidenced a sky's-the-limit approach to interpretation. So long as you can point to someone out there in the past who *could have* interpreted the work in question in such and such a way, however contrary that might be to the more predictable, dominant line of interpretation, this, I have claimed, is worth our consideration. Though I will surely be misunderstood as also having claimed that *any* interpretation is valid, this is not what I have meant to say. What has interested me has not been concocting any and every imaginable meaning for a painting but rather trying to imagine how that painting might have elicited a wide, often conflicting range of significations connected to the wide, often conflicting

range of social groups that constituted the society in which both the art and its artist were produced.

But this chapter, like the earlier ones on Duncanson and Spencer, aims for a tighter focus than the omnivorously expansive chapters on Vanderlyn, Bingham, and Guy. I do not see any advantage to repeating once more the procedure of those lengthy chapters, offering the reader yet another quasi labyrinth, mosaic, or patchwork quilt. Instead, in this chapter I will focus attention around a limited set of meanings that can be ascribed to a viewing audience that was white, male, and middle-class. If I do not theorize the counter-meanings trompe l'oeil still-life painting might have had for viewers of color or the working class or homosexuals or Native Americans or whomever (middle-class female viewers are mentioned, but only briefly), this is not because I find such speculation unworthy or uninteresting but, frankly, because this book is already long enough. What follows, therefore, is an attempt to think through rather precisely the modes of reception for a specific artistic style favored by a certain type of viewer that was for the first time ever dominant in American cultural life, the self-made, geographically mobile, urban middle-class bureaucrat, businessman, or career professional.

Along with countless other products manufactured in the latter half of the nineteenth century, "fine art" oil paintings became commodities the production and distribution of which were driven by an impersonal, delocalized market. Whereas in earlier times art was purchased and exhibited by

patrons who at some stage in the proceedings had experienced face-to-face contact with artists, personally commissioning works from them or viewing their latest endeavors in privileged surroundings, now art purchases were more regularly conducted through the intervening agency of art galleries, art auctions, and art lotteries. Previously, patrons and collectors had lived in the same city as the artists they supported, but now they were just as likely to live on the other side of the continent, never laying eyes on the individuals who produced the fine art that embellished their offices and homes.

The personal connection between artist and art consumer was further attenuated by the fact that the art itself increasingly went on public display, such that now a single work was far more likely to be seen by thousands of viewers rather than a select handful. The public's appetite for art had indeed become enormous. Fine-art painting and sculpture were sought by men's clubs catering to wealthy clientele who wished to mix leisure and commerce in culturally refined settings, by magnificent hotel lobbies striving to outdo one another in adornment, and by enormous department stores offering weary shoppers "art salons" in which to rest and partake of aesthetic invigoration before returning to the business at hand. For members of the urban middle classes, the multiple transactions of daily public life frequently took place in the presence of works produced by artists recognized only in name, if even that.

Thus the commodification of art (which, to be sure, had already been commercialized long before) went hand in hand with the democratization of its audience. This delocalizing and depersonalizing of the producer-consumer cycle did much to undermine long-standing academic hierarchies, in which certain types or branches of painting were deemed more worthy than others. Branches that

had previously been disdained for their popular connotations could now flourish precisely because their sanctioning was no longer dependent on the staid, class-biased art academy, but rather on the newly expanded, class-integrated art market.

If economic and class factors altered the way art was consumed (and was thus, in response, produced), so too did considerations of gender. As never before, women entered the marketplace as art makers, art students, art instructors, art critics, art purchasers, and, simply, art viewers. Certain branches and sub-branches of painting that had traditionally been looked down upon by high-minded guardians of culture were now able to thrive: among them, for instance, flower painting and sentimental genre painting. At the same time that these "feminine" branches of painting sprung onto the market, so too did certain reinvigorated "masculine" branches: the hunt scene, for example; the provocative depiction of coy, fair-skinned, rustic maidens; and the trompe l'oeil still life, the subject of this chapter.

I should distinguish right away what I mean by the ungainly term *trompe l'oeil still life*. This entails breaking the phrase in two. Let us begin with the latter half, *still life*, and then come around to the modifier, *trompe l'oeil*, for trompe l'oeil still life is only one type of still-life painting. In general, still-life painting is the depiction of inanimate objects arranged together in a relatively restricted setting—a tabletop, a niche, the corner of a room—in order to achieve one or more of the following effects: (a) a visual and tactile exploration of formal similarities and differences; (b) an allegorical representation of metaphysical verities; (c) a re-creation of commonplace material reality; (d) a re-creation of uncommonly fine and costly material reality. The latter two effects, especially, have tended to require illusionistic efforts

on the part of the artist, since their emphasis is not on inner worlds (the purely formal or the ineffably spiritual) but rather on the external world and its implied social coordinates.

Trompe l'oeil, or "trick the eye," is the term used to describe a particular style of painting, one in which the illusionism is so emphatic as to make certain depicted substances seem identical to their real-world counterparts, especially in terms of their implied texture or feel. Thus in trompe l'oeil, pigment is applied to the two-dimensional canvas in a way that makes a pretended marble surface look amazingly like real marble, causes a picture's "pineboard" background to appear intricately chipped, cracked, and notched as though actually made of wood, and conjures a piece of paper that is so persuasively creased at the corner that it tempts the viewer to swear it projects forward into the third dimension. Trompe l'oeil still life succeeds best—is most convincing—when representing flat objects (too much depth would give the secret away) and objects that are approximate in size to their painted counterparts.[2]

In order to understand why the trompe l'oeil still life flourished in the democratized and commodified art environment of late nineteenth-century America and, furthermore, how it responded to gender issues central to the society of that period, I first should elaborate upon the reasons that this hyperillusionistic form of easel painting had been disdained by the art academies from the time of their foundation in seventeenth- and eighteenth-century Europe. Marrying an obsessive mimesis of style (trompe l'oeil technique) to a lowliness

of subject matter (the mundane household objects typically selected for such illusionistic sleight of hand), the trompe l'oeil still life seemed egregiously lacking in imagination and nobility, artistic signifiers of upper-class taste.

Whereas the trompe l'oeil still life presents itself as a microscopically detailed, point-by-point transcription of the rude material world, history and myth painting—the nineteenth-century academy's most honored branch, as we have noted—asks to be taken as an emotionally or intellectually lofty conception of the illustrious past or otherworldly reality. Given a well-entrenched social hierarchy in which aristocrats, those who had the means and leisure to refine their intellects, commanded substantially greater prestige than did members of the middle and lower classes, who of economic necessity concentrated their energies on the mundane, it is not surprising that the official view of the trompe l'oeil still life ranged from leery to contemptuous. The alleged vulgarity of both the coarse subject matter of these paintings and their literalistic technique represented for the elite the vulgarity of the lower social orders themselves.

Commenting on the penchant of seventeenth-century Dutch merchants for lavish oil paintings of marble tables larded with game, Max Friedländer observes, "A prince, who is accustomed to have delicious food placed before him, does not attach so much importance to these products as the burgher who has got on in the world, or may hope to get on." As president of the Royal Academy, Sir Joshua Reynolds declared, "[Painting] ought to be as far removed from the vulgar idea of imitation,

as the refined civilized state in which we live, is removed from a gross state of nature; and those who have not cultivated their imaginations, which the majority of mankind certainly have not, may be said, in regard to arts, to continue in this state of nature." This dull majority, according to Sir Joshua, rounding out his idea with well-practiced hauteur, "will always prefer imitation to that excellence which is addressed to another faculty that they do not possess."[3]

Such class-derived prejudices against what Reynolds tellingly called "servile imitation" sailed with ease from the European capitals to colonial and early national America and persisted well into the nineteenth century. Hence, for example, the low artistic status of the Philadelphia trompe l'oeil specialist Raphaelle Peale, who excelled in illusionistic depictions of tabletop baskets filled with fresh-picked fruit, its ripe, round surfaces harmoniously neoclassical but also individualized by painstakingly recreated dimples and blemishes (1814, fig. 154). Peale's father, Charles Willson Peale, one of the nation's leading lights, questioned Raphaelle's choice of style (trompe l'oeil) and subject matter (still life), which to the father may have been as lamentable as his son's marriage to a sharp-tongued Irish-American.[4] Nonetheless, with the development by midcentury of a democratized art market that could stand independent of academic accreditation, painting that strived to please the eye by tricking it finally found its audience.

Still, it was only after the Civil War that trompe l'oeil still-life painting in America began to flourish. The increased interest in highly detailed, precisionistically rendered, ultrarealistic depictions of everyday objects corresponded to public fascination with scientific inquiry, photographic realism, and intricate machinery, all of which were

154. Raphaelle Peale, *A Dessert*, 1814. Oil on panel, 13⅜ × 19 in.
Collection of Jo Ann and Julian Ganz, Jr.

continually praised in the popular press and extolled at such forums as the Centennial Exhibition. No doubt there were connections between these new reproductive technologies and trompe l'oeil's methods and objectives, connections to be explored below. But surely there were more intimate, psychological reasons as well for the proliferation of this type of easel painting. Here is where the matter of gender takes its place. Trompe l'oeil paintings, I want to suggest, were "manufactured" not only in keeping with expanded technologies of mechanical reproduction and increased patterns of consumption but also in response to what many American men may have perceived as *diminished* opportunities for masculine self-expression and enrichment.

One hardly need mention the various causes to which this feminization or emasculinization of late nineteenth-century American culture has been attributed: feminism, sentimentalism, the closing of the frontier, economic crises and collapses, the rise of consumer capitalism—themes all encountered earlier in this book. Warren Susman, to cite only one recent commentator, has argued that when the economy veered away from localized, individualized, small-scale production to urban mass consumption, the concept of self that was prevalent in the nation also shifted so that Americans began to think of themselves as possessing infinitely malleable *personality,* which was continually redefined and re-expressed by their purchases, rather than granite-solid *character*, something formed over a prolonged period by their productive labor.[5] Endlessly subject to flux, personality was volatile and thus bred insecurity and perpetual distrust, whereas character, by definition immune to such rapid fluctuations, had made individuals feel more secure, more sure of where they stood. Whatever the explanation, old-fashioned masculinity had come to seem imperiled, forever in need of support or reinforcement from external sources. Dude ranches, dime novels,

hunting expeditions, and expansionist wars were some of the means by which American men were able to reassert their manhood in fantasy or in the flesh. It is my thesis that the viewing of trompe l'oeil still-life painting similarly served a psychologically affirmative function.[6]

That is to say, late nineteenth-century trompe l'oeil painting constructed its viewer as masculine both by means of the objects depicted (iconography) and the mode in which they were depicted (style). I mean to claim neither that only men viewed these works nor that the men who did view them did so deliberately and self-consciously for purposes of shoring up their masculinity. And I should add that not only men painted them.[7] What I do mean to suggest is that whatever pleasure this art afforded, a significant part of that pleasure, whether for men or for women, had to do with the way that the paintings aesthetically demarcated gender and encouraged its stabilization.[8]

Even in the best of times (which this period was not), gender difference can be problematic, causing men and women alike to appreciate guidelines or rules pertaining to sexual self-identification. Any cultural product that can successfully mark itself off as clearly masculine or clearly feminine is reassuring to members of either sex insofar as it permits them to place themselves solidly on one side of the gender fence or the other. For example, professional football games cause some men to feel all the more like men because they enjoy these rugged contests and some women to feel all the more like women precisely because they do not.

In general, the objects portrayed in American trompe l'oeil still-life painting are those that in the last century, if not this as well, were culturally typified as masculine. These are objects that men, often across class lines, traditionally used in their everyday lives. There are three types: work objects, pleasure objects, and objects that blur the boundaries between work and pleasure or were once associated with the one but at some point came instead to be associated with the other. Let me give some examples, turning mostly to the work of William Michael Harnett, the first of the trompe l'oeil painters to make his mark and the one who remained most influential on all the others.[9] I should point out, by the way, that in many instances Harnett knew his patrons on a firsthand basis and even occasionally used objects belonging to them as props in his paintings. Still, given the widespread public display of his art in men's bars, hotel lobbies, and business offices, his true audience consisted of thousands of individuals who never met him but who nevertheless, I contend, took ample cues from his work in regard to their own gendered self-definition.

Consider the early Harnett oil known as *Still Life—Writing Table* (1877, fig. 155). It makes use of trompe l'oeil elements but is not fully a trompe l'oeil painting, for one of the most important ingredients of the style is the reliance on a flat background, usually a wall or door, pressing close to the picture plane, thus restricting the viewer's sense of looking into space. The eye, as mentioned above, is more easily deceived by the two-dimensional representation of objects that are two-dimensional or nearly so than by those with a prominent third dimension. But more on technique later; now let us concentrate on the objects that the technique is used to render. In *The Writing Table*, eight meticulously described items are

155. William Harnett, *Still Life—Writing Table*, 1877. Oil on canvas, 8 × 12 in. Philadelphia Museum of Art.
Alex Simpson, Jr., Collection.

arranged on a cool green trompe-l'oeiled marble slab: a hefty leather-bound tome; a small shiny gold or copper coin; a sparkling silver coin; a roll of well-worn five-dollar bills; a folded, handwritten letter; a quill pen; a postmarked envelope; and a smudged ink pot. What is readable of the letter suggests business correspondence, which can be pieced together thus: "received you[r] . . . early part of last mo[nth] and was extremely glad to hear that [yo]u had succe[ss] reflecting. . . ." [10] The book, a geographical index, is entitled *U.S. Gazetteer, Vol. II.* Artfully balanced and monumentally scaled, all the objects in this small painting—cash, correspondence, writing tools, geographic directory—come together to suggest a world of business. Moreover, a world of business that is carefully ordered, solid, experienced, and useful.

Less connected to work or business and more associated with leisure and pleasure were, in other paintings, such objects as books for reading, rare editions for collecting, decorative vases, musical instruments, smoking and drinking utensils, and sometimes even pictures of women or children. Harnett, especially after he developed a well-to-do following, occasionally painted arrangements of fancy antiques and other rare collector items—bric-a-brac—laid out on a heavy, dark rug spread over a table, as in the still life he painted for the textile manufacturer William H. Folwell, which displayed in oil his patron's most prized possessions (1878, fig. 156). [11] Bric-a-brac was generally considered to be the realm of the worldly male connoisseur, for to collect it successfully (that is, in such a way as to elicit admiration, indeed, envy)

required a trained eye and, more often than not, both sufficient leisure and the independent means to go with it, hallmarks of a gentleman. Other times, particularly early in his career, Harnett was content to paint so-called mug and pipe pictures, with perhaps some tobacco spilled out of a pouch, a smouldering match, and a rolled-up daily newspaper. John Peto, Harnett's friend and emulator, remained throughout his own career fond of paintings of this sort. [12] Both these artists and various other trompe l'oeil painters often depicted fiddles and horns and sheet music illusionistically attached to a wall or hung in an alcove (1886, fig. 157).

Stringed instruments had long been associated in American painting with a world of masculine leisure divorced from the female realm, as in Mount's *Dance of the Haymakers* (1846) and Bingham's *The Jolly Flatboatmen* (1846, fig. 158). In a late nineteenth-century genre painting known as *The Pathetic Song* (1881) Thomas Eakins depicts domestic leisure of a mixed-gender nature—a parlor musicale—but even here the stringed instrument, a cello, is associated with the man, while it is the woman who sings to his accompaniment.

As I suggested above, some of the objects displayed in the trompe l'oeil still lifes, particularly weapons and implements of the hunt, may have once possessed a utilitarian significance, but now, in an urban milieu, they functioned as pleasurably nostalgic reminders—that is, fictionalizations—of a time when men went stalking game to feed their families (c. 1886, fig. 159). Like modern game hunting itself, trompe l'oeil depictions of manly items hanging on a wall after the hunt were at best theatricalizations of an idealized past as well as metaphors for current breadwinning or bringing home the bacon (in this regard, look again at Thomas Hovenden's *Bringing Home the Bride,*

fig. 145). The trompe l'oeil artists also painted rack pictures. Here the illusionistic rendering was of two-dimensional mementos from some fellow's recent past: postmarked envelopes, the invitation to a party, business cards, a theater stub, a newspaper clipping, most of these being fastened together tightly against a backboard by deceptively real looking strips of ribbon or tape.

Only two rack pictures by Harnett are known to exist, but Peto excelled in painting them, as did John Haberle, the New Haven artist whose variation on a rack picture, *A Bachelor's Drawer* (1890–94, fig. 160), is especially explicit about the masculine nature of the objects depicted, whether they are associated with work, pleasure, or a combination of the two.[13] Bank notes, horse race tickets, a comb, penknife, corncob pipe, and wooden matches are, in the late nineteenth-century context, particularly masculine signifiers, as are the King of Spades playing card, the assorted tintypes of women, and the girlie picture of a robust nude teasingly censored at the hips by a paper binder. A booklet entitled *How to Name the Baby*, while ostensibly gender-neutral, functions here as a joke about the ineptness and unpreparedness of bachelors-turned-husbands when it comes to the most basic of familial activities, such as naming baby. This gender joking is made even more pronounced by the placement of the baby booklet directly above the caricature of a Victorian dandy, as though the fellow were gazing up at the infant with a certain degree of alarm. At his feet, wedged between pictures of lovely smiling lasses, is baby in the high chair kicking and wailing with abandon.

Few twentieth-century commentators on American trompe l'oeil still-life painting have failed to remark upon the masculine nature of the objects generally represented. All I have done so far is

point to some specific instances. But now I want to suggest a more subtle, less immediately apparent way of perceiving the iconography as masculine. This entails a brief digression returning us to the subject of commodity production and the culture of consumption that emerged in late nineteenth-century America.[14]

What virtually all of the objects represented in the trompe l'oeil paintings had in common besides their association with what was commonly thought of as the male sphere is that they seemed distinctly different from modern, urban, factory-made consumer goods. By and large, the objects pictured in these paintings stood heroically separate from the world of mass production and consumption, the so-called commodity realm. Whereas commodities, as Marx defined them in the opening chapter of *Capital*, were products esteemed as much or more for their exchange value as for their use value, artifacts such as those featured in the trompe l'oeil still lifes were ones in which use value reigned, whether the use was for work or pleasure or both. Commodities, that is, were identified by what they could command in price, whereas the typical objects depicted in trompe l'oeil still-life painting were typically negligible in economic value but not at all so in usefulness or sentimental meaning.[15] Even if the objects portrayed had initially been produced and sold as commodities, over time they had proven their usefulness, thus acquiring a venerable, uncommodity-like aura.

Commodities, of course, are not just consumer products; the term might also refer to food staples

156. William Harnett, *Still Life with Bric-a-Brac*, 1878. Oil on canvas, 30 × 41⅜ in.
Harvard University Art Museums, Cambridge, Massachusetts. Gift of Grenville L. Winthrop.

157. John Peto [spurious signature "W. M. Harnett"],
Old Cremona, 1886. Oil on canvas, 16 × 12 in. Metropolitan
Museum of Art, New York. Harris Brisbane Dick Fund.

158. George Caleb Bingham, *Jolly Flatboatmen*, 1846. Oil on canvas, 38½ × 48½ in. Manoogian Collection.

159. Richard La Barre Goodwin, *Cabin Door Still Life*, c. 1886. Oil on canvas, 56¼ × 34⅛ in.
National Museum of American Art, Smithsonian Institution, Washington, D.C.
Museum purchase in memory of the Rev. F. Ward Denys.

160. John Haberle, *A Bachelor's Drawer*, 1890–94. Oil on canvas, 20 × 36 in. Metropolitan Museum
of Art, New York. Museum purchase by Henry R. Luce Gift.

traded at the bourse or to land or, as Marx points out, to human labor. Money itself is a commodity—although when Harnett and his confreres represented it, which was often, it usually seemed decidedly uncommodified; the greenbacks were as well worn as a friendly old pair of work boots, and the newly minted coins gleamed as merrily as a stack of copper buttons.[16] For our purposes, though, *commodities* will refer to consumer products that are mass produced and mass distributed. An essential component for the mass distribution of the commodity, as used in this sense, is its being made visible to vast numbers of potential consumers. And, indeed, beginning more or less after the Civil War, various aspects of the American economic landscape literally did become more visible as entrepreneurs brought commodities into sight as pervasively and *noticeably* as possible.

Modern advertising illustration originated during this period. Mail-order catalogues broadcast detailed line drawings of homey products for sale, the newly born department stores, aided by the recent creation of the plate-glass window and the electric light, aggressively displayed their wares, and manufacturers, seeking national distribution for their products, began to rely on attractive, standardized packaging that was visually "branded" in such a way as to distinguish their goods from, and give them the edge over, similar goods by competitors.[17] Most objects depicted in trompe l'oeil paintings, however, looked considerably different from these ubiquitously exhibited and advertised commodities. For one thing, mass-produced commodities then, as now, were often promoted for their newness. With the notable exception of shiny coins, the objects in trompe l'oeil paintings, as we shall see later in some detail, were almost never new in nature or appearance: they tended to be well-worn, well-handled, familiar remnants of the

past, even if that past was as recent as yesterday's newspaper or last night's trip to the theater. And unlike the commodities suddenly everywhere in sight, the trompe l'oeil objects were usually non-branded or no longer branded; the labels or signs that can be seen in the paintings are often torn or peeled away, as for instance in Peto's *The Poor Man's Store* (1885, fig. 161).

Advertisers, retailers, and the manufacturers of domestic goods frequently considered middle-class women to be their primary target, and it was to them, therefore, that much of the commodity display was aimed (1897, fig. 162). Commenting on the astounding number of American Victorian women who were nabbed shoplifting in department stores, Elaine Abelson observes that for such women as well as thousands more who never shoplifted but were equally subject to culturally manufactured commodity desire, "shopping dwarfed all other activities. Women shopped constantly. There is no statistically accurate way to determine how often women shopped in the stores, but diaries indicate it was an ongoing process." Shoplifting was an unfortunate side effect of that stereotypical female impulsiveness that was in fact socially sanctioned—and constructed—despite continual snickering. As a lighthearted poem in the back pages of *Harper's Monthly* alleged in 1877, "With folly and with pride / Their husbands' pockets trimming, / The ladies are so full of *whims*, / That people call them *whim-men*."[18]

Whether this baldly stated or otherwise, a common assumption of the period was that man's job was to earn money and woman's job was to spend

161. John Peto, *Poor Man's Store*, 1885. Oil on canvas on wood, 35½ × 25½ in.
Museum of Fine Arts, Boston. Karolik Collection of American Painting.

it. Shoppers as a social category were construed as feminine—that is, impulsive, not entirely governed by reason, often unable to defer gratification (hence all that middle-class shoplifting). An editorial in *The Show Window*, a retailers' trade journal, advised merchants to note that "the average woman . . . buys, if it may be so expressed, emotionally. If she sees something that pleases her and [she] wants it, she will have that particular thing if her pocketbook permits." To seal his point, the author archly adds, "and the matter of the intrinsic value compared with the price mark never strikes her." [19]

Less prosaically, Theodore Dreiser offered a similar observation about female consumer desire in his novel *Sister Carrie* (1900):

Carrie [in a Chicago department store] passed along the busy aisles, much affected by the remarkable displays of trinkets, dress goods,

162. Alice Barber Stephens, *Woman in Business*, 1897.
Oil on canvas, 25 × 18 in. Brandywine River
Museum, Chadds Ford, Pennsylvania.

shoes, stationery, jewelry. Each separate counter was a show place of dazzling interest and attraction. She could not help feeling the claim of each trinket and valuable upon her personality. . . . The dainty slippers and stockings, the delicately frilled shirts and petticoats, the laces, ribbons, hair-combs, purses, all touched her with individual desire.

Or, as Émile Zola had noted in *Au Bonheur des dames* (1883), a naturalistic novel concerned with what today we might call the brainwashing of shoppers: "It was woman the department stores fought over for their business, woman they continually entrapped by their bargains, after having made [her] dizzy by their displays. They had awakened in her flesh new desires . . . working up women to the madness of fashion which was ever dearer and dearer." [20]

Here, then, is another way in which the iconography of the trompe l'oeil still life constructed the viewer as masculine. The implied dissimilarity of the objects featured in the paintings to commodities sold in catalogues and stores must have made the viewers who admired these paintings feel, by contrast, more manly—or, this is to say, less like a woman.

Yet, as suggested at the start, it was not merely the iconography of the paintings that traded upon the gender identifications of viewers, but also the trompe l'oeil style itself. Let us explore two ways in which this style might have served to construct or enunciate the viewer as masculine (as *Making a Train* enunciated or "hailed" its viewer as voyeur). The first of these has to do with the rarely acknowledged fact that the trick-the-eye illusionism of trompe l'oeil never really tricks but only pretends to do so, for as the art historian H. W. Janson has categorically insisted, "Nobody, animal or human, is ever actually deceived by any painting, no matter how illusionistic."[21]

In a manner of speaking, then, trompe l'oeil raises the issue of fraudulence. This was a subject dear to the heart of the renowned American trickster Phineas T. Barnum, who in his autobiography, *Struggles and Triumphs*, spelled out the difference between legitimate and illegitimate fraud. Barnum claimed he was doing his audiences a service by deceiving them; in fact they came to his American Museum with a desire to be deceived. As he boasted, "I have yet to learn of a single instance where a visitor went away from the Museum

complaining that he had been defrauded of his money. Surely this is an offset to any eccentricities to which I may have resorted to make my establishment widely known." These "eccentricities"— exaggerations, prevarications, clever illusions— were all part of the game. A swindler, according to Barnum, is someone who does not play by the rules, someone who lies and cheats without the other party finding out until it is too late and damage has been done. But a humbug, which is what Barnum proudly called himself, is someone who fools people that are looking for the pleasure, the entertainment, of being fooled. They enter into the relation knowingly, and the humbug, if he has got the stuff, responsibly fulfills his part of the bargain by making good on the deceit he was commissioned to provide.[22]

Barnum's singing mermaids and bearded women could deceive the paying customers only for a moment before allowing them to see through the disguise, unmask the deception, and experience the gratification that comes from solving a mystery in a burst of insight. Customers, that is, paid to be fooled in order to achieve the *frisson* of abrupt recognition—the sudden head-rush of knowledge and the sense of power and superiority that come with it. As Daniel Boorstin has written, "Contrary to popular belief, Barnum's great discovery was not how easy it was to deceive the public, but rather, how much the public enjoyed being deceived." Horkheimer and Adorno treat this idea as a general cynical principle: "The triumph of advertising in the culture industry," they argue, "is that consumers feel compelled to buy and use its products even though they see through them."[23]

Surely most consumers of trompe l'oeil painting enjoyed it precisely to the extent that they could see through its brassy illusionism, especially in light of all the folklore about various experts who

were not so adept at discernment (this despite Janson's assertion that it is simply not possible for an easel painting to be entirely convincing). Harnett, legend has it, was arrested by U.S. Treasury agents because the greenbacks in his paintings were convincing enough to be thought counterfeit. Haberle, too, was chided for counterfeiting, but in a different way. When *U.S.A.*, his provocatively entitled painting of two superimposed bank notes, was exhibited at the Art Institute of Chicago in 1889, a local art critic wrote the following indignant review:

> There is a fraud hanging on the Institute walls concerning which it is not pleasant to speak. It is that alleged still life by Haberle, supposed by some to be a painting of money. A $1 bill and the fragments of a $10 note have been pasted on canvas, covered by a thin scrumble of paint, and further manipulated to give it a painty appearance. A glass has been put over the "painting" since the writer of this picked loose the edge of the bill. That the management of the Art Institute should hang this kind of "art" even though it were genuine, is to be regretted, but to lend itself to such a fraud, whether unwittingly or not, is shameful.

According to Alfred Frankenstein, a rival Chicago newspaper subsequently reported with glee that a group of experts, examining the work in the presence of Haberle and his accuser, proved without doubt that the painting was not a fraud (not a pasting of real bills onto canvas) but a brilliantly executed artistic deception or, this is to say, a legitimate rather than illegitimate fraud.[24]

Haberle's detractor in Chicago was embarrassed about having been fooled. He apologized in print, saying of himself, "Just how the writer of the notice came to be deceived in the matter is of no particular moment . . . and he has nothing to plead in justification." The man had been unmanned, as it were, made foolish, duped. Thus another gender component to trompe l'oeil: it sets up for the viewer a test of such putative male traits as clarity of eye and shrewdness of reason. Unlike the embarrassed Chicago newspaperman, Harnett's typical viewer was almost invariably sure to pass this test, if not in the first instance, then in the last.

The testing of manhood goes back ages; certainly there is nothing uniquely late nineteenth century about it. Perhaps men have always had to concern themselves with being tricked: by the weather, their business associates, their wives. But I would argue that in the last quarter of the nineteenth century men's fear of trickery was raised to new heights. Prior to Grant's administration, the U.S. government, whatever corruptions it manifested, had never seemed so scandalously infested with public deceivers. Time and again in the 1870s attention was called to the way that strikers were betrayed by strikebreakers, shareholders by corporations, and sharecroppers by banks. Thousands of men had been disastrously caught short by the Panic of 1873. The old reliable verities were coming to seem less than reliable.

How appropriate, then: a style of painting that thematizes deception. More important, it ritually enacts deception in such a way that the viewer always emerges triumphant in the end. It is like the roller coaster ride or the ghost story that frightens you only long enough to provide you the opportunity to master your fear in a controlled environment—akin, for example, to "Fire and Flames," the four-story building at Coney Island's Luna Park

163. William Harnett, *Attention, Company!*, 1878. Oil on canvas,
36 × 28 in. Amon Carter Museum, Fort Worth.

that was repeatedly set ablaze only to be repeatedly "saved" by a fire brigade.[25] In this one isolated corner of his daily life, the trompe l'oeil viewer was able to demonstrate to himself that he was smart, in control, not easily tricked, a man's man. A man's man because women, along with children, workers, immigrants, blacks, Indians, and country yokels, were popularly regarded as those who are easily duped, seduced, or patronized (an attitude perhaps conveyed by *Attention, Company!* [1878, fig. 163], one of Harnett's rare human de-

pictions, in this case of a stereotypically cute little "pickaninny" [black child], whose shabby clothes, woolly hair, bright wide eyes, and broad shiny lips allowed the artist textured surfaces and layers with which to demonstrate his control and the viewer opportunity to indulge in the pleasure of his own superiority). The visual structure of trompe l'oeil, I am arguing, dramatized a narrative of mystification and demystification that offered the viewer an imaginary sense of mastery and triumphant masculinity. To the extent that female viewers shared this

pleasure of mastery when regarding trompe l'oeil, they too were experiencing a sensation culturally encoded as masculine, indication, of course, that masculinity is not purely the domain of males.

Another way in which the trompe l'oeil form masculinized the subject who viewed it also has to do ultimately with matters of mastery and control. It may at first appear, though, that I doubly contradict my earlier remarks about the anticommodity aspect of trompe l'oeil iconography, for now I want to claim (a) that the visual style of the trompe l'oeil—as opposed to its iconography—bore significant resemblances to the visual style of the mass-produced commodity and (b) that masculine identity was already more wrapped up in commodity consumption than men of the period were willing to admit (hence their projection of consumer irrationality onto women).

A noteworthy feature of mass-produced commodities is the absence of markings that indicate the hand of the maker. There are exceptions, to be sure—mass-manufactured items that imitate the look of handcrafting or hand assembling. But in most consumer commodities, labor is repressed, the laborer effaced. The objects typically represented in trompe l'oeil painting seem distinct from those that are comprised in the commodity realm precisely because they highlight, rather than obscure, the human touch. That is, these objects have the look of being handmade as well as muchhandled. Harnett, who in the mid-1870s lost his job as a silver engraver thanks to a newly invented engraving machine, may have had something of a personal stake involved in idealizing a craft tradition that was rapidly losing ground to mechanization. Indeed, all the scrupulous care that he put into the making of his paintings might have signified to him and his admirers a perpetuation

of fine craftsmanship and a refusal to tolerate the mediocre standards of mass production.

But curiously enough, Harnett's paintings depicting handmade, well-handled objects are just the opposite of the objects depicted: they look as though they have never been touched, either by painter or owner. They look instead as though they were made by an intricate, inordinately sophisticated, superphotographic machine. If it took great craftsmanship on the artist's part to achieve these results, it was a craftsmanship that seemingly erased the craftsman—although paradoxically it was precisely that self-erasure that left viewers most impressed with the artist's skills. As one contemporary observer of Harnett's work exclaimed, "The extreme care which reason convinces the beholder must have been constantly exercised in finishing all the exquisite details of such a painting is entirely concealed. We see not the artist nor his method of working. The things themselves only are seen."[26]

Rarely in late nineteenth-century American trompe l'oeil painting (with the major exception of Peto) is brushstroke visible. Edges are hard and sharp, and the surface of the canvas is highly finished, submerging roughnesses of pigment beneath the unifying and glossy smoothness of an applied varnish. Even the artist's signature is altogether absent or appears to have been carved into the painting's overall illusion. Such is the case in *The Faithful Colt* (1890, fig. 164), a work that trades upon the mass-produced, mechanically reproductive style in order to represent a mass-produced, mechanically operating item that

164. William Harnett, *Faithful Colt*, 1890. Oil on canvas, 22½ × 18½ in. Wadsworth Atheneum,
Hartford, Connecticut. Ella Gallup Sumner and Mary Catlin Sumner Collection.

it treats nevertheless with a veneration more normally reserved for the most individualized and personalized of craft objects.[27]

These formal characteristics, by the way, explain why it was easy for forgers to deceive the experts in the early stages of the Harnett revival in the 1930s and 1940s.[28] The trompe l'oeil style was so determinedly impersonal or apersonal that it took a while before twentieth-century collectors and art historians could begin sorting out Harnett from Peto or a trompe l'oeil painter named Pope from his exact contemporary named Cope. These are also reasons the trompe l'oeil artists were forgotten in the first place: unlike the observer quoted above who praised Harnett for his astonishing mimetic skills, nineteenth-century art critics usually reproached the trompe l'oeil style for being too mindlessly imitative and impersonal, devoid of what was considered an artist's touch or soul.[29] In effect, this was a reemergence of the old aristocratic prejudice against mimetic vulgarity and the class vulgarity with which it was associated. By contrast, in the paint-loaded, free-slashing still lifes and cluttered studio scenes of the critically acclaimed William Merritt Chase, for example, canvases were saturated with soul of the proper artistic sort (1880, fig. 165). Trompe l'oeil still lifes, by contrast, were too much like those commercial artifacts, or commodities, from which fine art, by its highly personal and handmade nature, was supposed to differ. Never mind that fine art itself had become commodified; its admirers continued to cling to the notion that it somehow eluded commodification—a notion that did in fact bestow upon fine-art painting a privileged, otherworldly aura not granted to more mundane artifacts.[30]

By denying the presence of the artist's hand or brush, trompe l'oeil paintings thus advertently or inadvertently partook of the machine aesthetic characterizing modern mass-produced commodities.[31] In this way the paintings offered to their viewers membership in modernity. Granted, certain seventeenth-century Dutch and Flemish trompe l'oeil paintings had also expunged traces of the artist and in doing so had appeared to present an entirely transparent medium. But those works, particularly *vanitas* still lifes, which featured objects with strictly prescribed allegorical meaning, suggested to viewers a transcendence that the Americans' doggedly secular mimicking of the visible world seems to have lacked.[32] Besides, whatever their allegorical and traditionalist aspirations, the Netherlandish still lifes nonetheless conveyed connotations of modernity, their precise visual detail an implicit allusion to the innovative optical technologies just then being developed.[33]

Regardless of what the smooth-licked, brushless visual style meant in the seventeenth century, at the end of the nineteenth century it bespoke the new, modern look of commodities. It was impersonal, clean, devoid of the marks of labor, all of which must have helped the male consumer feel sophisticated and worldly—a man of the world, as the saying goes. Female consumers were hailed by products somewhat differently, at least according to male commentators such as Dreiser: "Fine clothes were to [Carrie] a vast persuasion; they spoke tenderly and Jesuitically for themselves. When she came within earshot of their pleading, desire in her bent a willing ear: . . . 'My dear,' said the lace collar she secured from Partridge's, 'I fit you beautifully; don't give me up.'" If the commodities that beckoned women sought to play

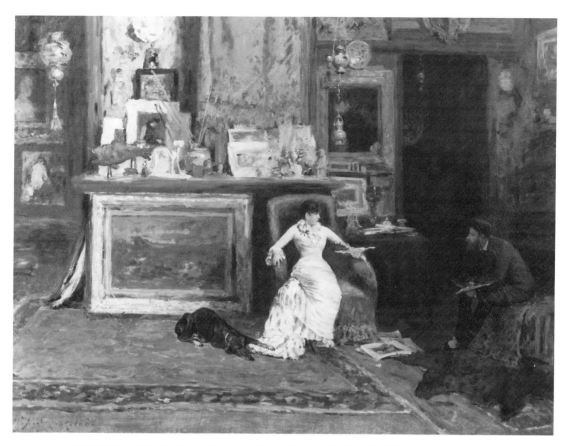

165. William Merritt Chase, *Interior of the Artist's Studio (The Tenth Street Studio)*, 1880.
Oil on canvas, 36 × 48 in. Saint Louis Art Museum. Bequest of Albert Blair.

upon some putative combination of female desires to nurture ("they spoke tenderly") and be guided by authority (". . . and Jesuitically"), the commodities summoning men worked the other side of the street, playing up stereotypes of tough-minded, no-nonsense, up-to-date masculinity, with part of the pride therein perhaps deriving from a sense of being the first man to possess the virgin object in question.[34]

This fetishization of the new and the untouched might in fact have had something to do with the lack of commercial success secured by Peto, Harnett's friend and disciple who frequently veered away from the hard-edged, anonymous, impersonal look preferred by Harnett and his patrons. Today it seems odd that fifty years ago collectors could not immediately spot formal differences between the two painters. Despite his often-expressed admiration for his colleague's work, Peto seems to have been uninterested in the smooth-surface, clean-licked style. His work instead is characterized by an almost poignant sense of the medium. With Peto the feel for paint is prominent, the attention to surface rich and involved.

In Harnett's *Job Lot Cheap* (1878, fig. 166) the mountainous pile of books and the multilabeled wooden crate beneath it are cheerily lit, sharply focused front to back, and everywhere microscopically detailed from the grains of wood on the shelf to speckles and highlights on the leather bindings.

Peto's variations on this, for example, *Take Your Choice* (1885) or *Discarded Treasures* (c. 1904, fig. 167), are by contrast dark, turbulent, chaotically jumbled. Whereas the Harnett begs to be liked for its sunny disposition and genial one-upsmanship of photographic realism, the Petos are gloomy laments, addressing the viewer in a register of feeling obtained by plangent brushstrokes, suffused tones, and an oppressive overwhelming of forms. In 1939, at the start of the Harnett revival, *Discarded Treasures* was sold as a Harnett thanks to a spurious signature; it is not known who owned the painting originally. We do know, however, that *Job Lot Cheap* was purchased from Harnett by a certain Byron Nugent, a prominent dry goods merchant from St. Louis.[35] One might imagine how the spiffy, polished style of Harnett's painting must have pleased the eye of Mr. Nugent, whose livelihood entailed the artful display of saleable items, albeit ones that were brand new rather than old and used. One cannot so easily picture Mr. Nugent taking to Peto's moody evocations of physical objects in dusty decay. Old and worn objects provided appealing subject matter, but just so long as the portrayal of them, the painting itself, had the look of an object good as new.

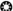

Thus trompe l'oeil painting constructed masculine subjectivity in seemingly opposite or contrary ways vis-à-vis the commodity. At the level of iconography it eschewed the impersonal commodity and the feminized commodity realm for what appeared to be a world of objects that were personal and manly. At the level of form, however, these paintings mimicked aspects of the mechanically produced and reproduced look of commodities, thus optically providing the viewer with the sense of worldly sophistication and manly ownership that so many of these commodities made it their busi-

ness to offer. Like Barnum's customers who got to be tricked and at the same time see through the trickery, trompe l'oeil viewers got to feel masculinely superior to the female commodity realm and yet at the same time enjoy acts of gazing and visually possessing. This was having your cake and eating it too.

In contemporary theory, discussions of the so-called male gaze usually concern representations of women rather than of objects—albeit the point of the discussion is that women are treated *as* objects of fetishistic fantasy.[36] Along these lines a striking comparison might be made between Harnett's photographic still life of sheet music, trumpet, and a medieval helmet (1883, fig. 168) and the still-life-like photograph of a nude stretched out before a suit of armor (c. 1860, fig. 169) by the French art photographer B. Braquehais. Similar props, similar composition; in one a curvaceous musical instrument is laid across a table, in the other a naked woman. William Gerdts has perceptively remarked that "the frequency of unclothed women communing with deceptively 'real' still lifes in [late nineteenth-century] American saloons and grill rooms is a subject worthy of further study." As Gerdts points out, the era's best-known barroom trompe l'oeil was *After the Hunt* (1885, fig. 170); its most famous barroom nude was William Bouguereau's *Nymphs and Satyr* (1873, fig. 171). The transformation of the latter from a French Salon painting to an American saloon painting is not hard to track. In 1887 the entrepreneur Edward Stokes installed it—next to a stag's head, no less—over the bar of his Hoffman House, a popu-

166. William Harnett, *Job Lot Cheap*, 1878. Oil on canvas, 18 × 36 in. Reynolda House,
Museum of American Art, Winston-Salem, North Carolina.

167. John Peto [spurious signature "W. M. Harnett"], *Discarded Treasures*, c. 1904. Oil on canvas, 22 × 40 in. Smith College Museum of Art, Northampton, Massachusetts.

lar New York gathering place for male celebrities (c. 1890, fig. 172). While working-class saloons had for years provided customers with paintings of voluptuous female nudes, now a respectable middle-class establishment took the bold step of doing the same and was rewarded with such notoriety that one morning a week had to be set aside at the male-only bar to allow curious women visitors an opportunity to see what all the fuss was about. At the same time across town, viewers were lining up at Theodore Stewart's Warren Street saloon to marvel at the equally large and provocative *After the Hunt*, and here too visiting hours had to be reserved for women eager to see for themselves this much-lauded marvel.[37]

In both cases, not only was the subject matter decidedly masculine (frolicking nudes, remnants of a hunt), but also both works thematically played up the stereotypical notion of the male as hunter. In the Bouguereau as in the Harnett, the hunt is over: the satyr is not pursuing nymphs but enjoying them. In both works the viewer is encouraged to admire, if not also desire, what has been caught. In both, the figure or object that metaphorically

or metonymically stands in for the viewer is compositionally centered or otherwise featured: in the Bouguereau, the satyr is surrounded by delighted nymphs; in the Harnett, the hunter's hat occupies pretty much the same position it would hold if this were a full-length portrait of the hunter himself. Both works, moreover, are predicated upon giving the viewer generous access to sights normally not accessible: a bevy of voluptuous naked maidens in the one instance, inanimate objects magically detailed and alive in the other, the one being mythical, the other super real. Vision equates with understanding, and with understanding one gains control or at least its semblance. Total vision simulates total mastery. Within the realm of fantasy, the viewer becomes the hunter/conqueror, in the one instance of the nymphs, in the other of the game, but in both of an optically visible world served up for sheer delectation. Thus, in a society in which hunting is culturally encoded as masculine, both of these paintings define their viewers, be they men *or women*, as male. Of course, as I have argued throughout this book, viewers may have resisted such external acts of definition and "misread" the

168. William Harnett, *Still Life with Helmet, Books, Trumpet, and Sheet Music*, 1883. Oil on panel, 10¼ × 13¾ in. High Museum of Art, Atlanta. Gift of Mr. and Mrs. James M. Dyer and Mr. and Mrs. Truman Bragg in Memory of Mrs. Mary Newcomb Bull and Robert Scott Newcomb, 1964.

art in front of them in a manner more congenial to their own self-interest. Viewers do not always allow themselves to be constructed in the way that texts would construct them. This is not because these viewers are in the last analysis stronger than the texts that implore them (as objects implored Sister Carrie) but only because viewers already embody multitudinous social texts in varying combination, making them in any given instance either more available or less available to the inducements of yet another.

What we have begun to see, therefore, is that late nineteenth-century American trompe l'oeil paintings were not simply masculine works that men, more than women, found appealing. Rather, these paintings were a highly articulated cultural product that encouraged some viewers more than others to think of themselves as men. This entailed their defining themselves as separate from and not

like women or whatever it was that social norms portrayed as womanly. These paintings were thus public enunciators of gender difference, treating gender as an essentially static and reified thing rather than as a forever tentative state of mind constantly requiring renegotiation and reinforcement.

The notion of gender as a stable, predetermined essence is itself, we might say, a trompe l'oeil. It looks real, it is persuasive, but ultimately it lacks depth. The same might be said about the precommodity objects and, by extension, the precommodity way of life that the American trompe l'oeil paintings varnished—which is the subject of the remainder of this chapter. Despite their mimicry of a bygone visual order, despite their egalitarian disdain for academic pretense and their warm and glowing allusions to republican simplicity, despite their nostalgic reference to a time in which virile makers and users of

169. B. Braquehais, "Nude beside a Suit of Armor," c. 1860. Photograph. Bibliothèque Nationale, Paris.

utilitarian and pleasure-providing objects encountered one another in familiar locales, despite their fabrication of masculine ambiance in an all-too-feminized environment—despite, that is, their implicit eschewal of the department store world overrun by consuming women, the paintings of William Michael Harnett and his colleagues remain in the end commodified artifacts of a spectacular new visual age.

Harnett was a portraitist, not of people but of things—old things. He preferred them that way. As he once explained, "The chief difficulty I have found has not been the grouping of my models, but their choice. To find a subject that paints well is not an easy task. As a rule, new things do not paint well. . . . I want my models to have the mellowing effect of age . . . the rich effect that age and usage gives."[38]

In the so-called Gilded Age following the Civil War, when excesses of wealth and ostentation astounded observers across the land, the representation of objects that bespoke a less materialistic and greedy past must have seemed comforting indeed. Hence, it was in this sense, too, and not simply that of their golden patina, that the old models Harnett chose to portray conveyed the mellowing—the meliorating—effects of age. In most scholarly assessments, however, Harnett's exuberant mimesis of cherished physical objects, whether commonplace or rare, is thought to be of a piece with Gilded Age proclivities toward material accumulation and conspicuous consumption. Generally, his work has been regarded as a painterly ancillary to the era's outsized appetite for collecting and displaying objects old or new (this amounts to a reapplication of Friedländer's account of seventeenth-century

170. William Harnett, *After the Hunt*, 1885. Oil on canvas, 71½ × 48½ in. Fine Arts Museums of
San Francisco. Mildred Anna Williams Collection.

171. William Bouguereau, *Nymphs & Satyr*, 1873, 102⅜ × 70⅞ in.
Sterling and Francine Clark Art Institute, Williamstown, Massachusetts.

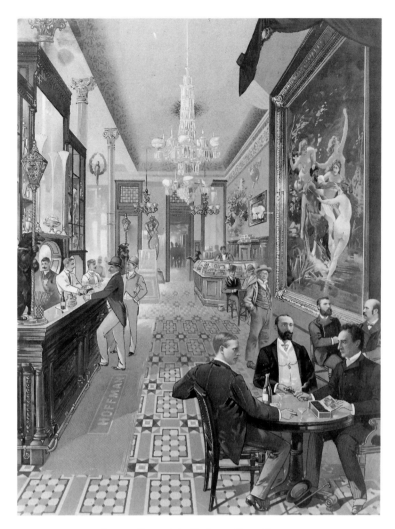

172. *Interior View of the Hoffman House Bar*, c. 1890.
Lithograph published by Thomas & Wylie. Library of Congress.

Dutch still-life painting as the by-product of rapid capital expansion, with a commercial bourgeoisie eager to celebrate its own remarkable good fortune). Such an interpretation makes sense, but to abandon analysis on that level is to do an injustice to the complexities of the art and era in question.

Certainly Harnett's paintings participated in the materialism of their time, but they also subtly resisted it or at least attempted to mediate it by means of their ennobling, quietly inspiring, or even down-home humorous treatment of familiar artifacts that exuded "the mellowing effect of age."

This is not to suggest that his art was antimodern in the sense described by Jackson Lears or that it failed to take part and pleasure in the era's adoration of accumulation and display, but only that its way of doing so—of reconciling potentially guilty consciences and abundant material success—involved dusting off old objects and bathing them in a reverential light.[39]

Take, for example, Harnett's last work, *Old Models* (1892, fig. 173). This atypically large painting (nearly five-and-a-half feet high) serves as a virtual summation of the artist's career. Almost

173. William Harnett, *Old Models*, 1892. Oil on canvas, 54 × 28 in.
Museum of Fine Arts, Boston. Charles Henry Hayden Fund.

everything about it, not only the title, conveys age. The brass bugle at the top has been knocked about countless times; the ornate cover of the sheet music is tattered from too many rehearsals; the rusty hinge at the upper right barely bridges the yawning gap between two splintered, weathered, nail-holed planks; the thick brown volume on the shelf is torn along the spine; and the Dutch jar appears to have survived this long only by some sort of miracle. The chiaroscuro lighting, with its deep shadows, bright highlights, and golden glow, signifies the faraway days of the old masters. While Americans certainly read books, played music, and drank from quaint drinking vessels during the 1890s, nothing about these activities points to the 1890s themselves, as would, for instance, a bicycle wheel or tennis racket. Reading, drinking, and music making are time-honored activities of leisure that, even at the close of the last century, conveyed a premodern aura because of their continuity with earlier eras.

Harnett painted *Old Models* with the intention of exhibiting it at the World's Columbian Exposition of 1893 in Chicago. This 650-acre celebration of American progress showcased the latest in industrial technology and commercial production and devoted numerous respectful exhibits to the nation's colonial past. *Old Models* never reached Chicago, however, for Harnett died prior to the opening of the fair. The painting was auctioned as part of his estate.

It is significant, nonetheless, that Harnett devised this work for the exposition, which he must have realized would be the largest forum he would ever attain for his art and the point of view it expressed. Hence the majestic size of the canvas: the scale of the painting was proportionate to the scale of the event. The title, too, is appropriate, for with it Harnett suggests not simply that the objects portrayed are old studio models but that they are also venerable exemplars—that is, models for behavior. The painting enjoins the viewer to admire and follow the old-fashioned way of life, the premodern sensibility, that these long-enduring remnants of the past seem to typify.

How intriguing to imagine this tribute to yesteryear occupying a place in the art pavilion of the fair's White City, a trompe l'oeil dreamworld of faux-marble Beaux-Arts edifices erected in lofty homage to genteel good taste (fig. 174). But whereas the academic architecture of the fair recalled Roman and Renaissance ideals, in effect suggesting bureaucratic rationalization and social control as antidotes to what many perceived as the spreading barbarism of the day, *Old Models* prescribes instead a vernacular, plain-speaking, unassuming approach. Its compositional geometry, simply balanced, sturdily poised, is to the rigidly fixed, deterministic geometry of the White City what, in political terms, republicanism was to imperialism. Historians today debate whether or not republicanism, the notion of civic virtue based on classical and agrarian ideals of balanced, selfless living, persisted in America beyond the Civil War. Some scholars argue that the farm movements of the late nineteenth century were republican in that regard. Perhaps works such as *Old Models* could be considered republican as well. The simple and good way of life, not the magnificent and majestic, is what Harnett's painting, despite its scale and complexity, models for its viewers.[40]

However didactic the White City was intended to be, surely Harnett's paintings were neither meant

174. "Court of Honor, Looking West, World's Columbian Exposition, Chicago," 1893.
Photograph. Chicago Historical Society.

nor regarded as heavy-handed sermons. Their invocations of the past—whether of last night's smoking party (as in *The Social Club* of 1879) or of old folkways (1888, fig. 175)—were too redolent with feeling to be merely didactic but were nostalgic instead. By devoting such a finely tuned, dramatically lit focus to objects and implied activities associated with a benign past, Harnett invested his paintings—and through them the past—with a powerful, resonant emotion. In recent years the term *nostalgia* has become discredited, referring to a culturally and politically reactionary frame of mind or to an ersatz emotion artificially stimulated by advertising and the mass media. Previously, however, the word was used to indicate genuine, not manufactured, feelings. In some instances it referred to a terrible, destructive homesickness; coined in the seventeenth century, *nostalgia* was

a medical term, a combination of the Greek for "home" and "suffering." More commonly, though, it came to mean warm pleasure derived from thinking about the past mixed with sadness at one's distance from it.[41]

Nostalgia was a hallmark of late nineteenth-century America. The popular songs of the period (including such earlier favorites as "The Old Folks at Home" and "Home, Sweet Home") frequently alluded to and played upon sentimental longings for the past, as did popular theater, the prints of Currier and Ives, lyric poetry, historical fiction, historical painting, and even multivolumed historical treatises. David Lowenthal has observed that prior to the nineteenth century, most people "scarcely differentiated past from present, referring even to remote events, if at all, as though they were then occurring."[42] With all the stupen-

175. William Harnett, *Music and Good Luck (Still Life—Violin and Music)*, 1888. Oil on canvas, 40 × 30 in. Metropolitan Museum of Art, New York. Catharine Lorillard Wolfe Collection.

dous changes wreaked upon age-old traditions, a new sensibility arose, one that made the present seem palpably different from the past—for better or for worse. The often-cited formulation of the twentieth-century novelist L. P. Hartley, "The past is a foreign country," tells only half the story, for the reverse holds true as well: newcomers to modernity find that it is the present, not the past, that seems distressingly foreign.[43]

"Peter," a tale published in 1892 (the year Harnett painted *Old Models*), concerns the homesick immigrant Sadelack, who cherishes his violin from the old country as though it were his life. Written by Willa Cather, then a Nebraska college student, and based on the experiences of the father of a childhood friend, Peter Sadelack's story reappeared years later, even more poignantly, in Cather's well-known novel *My Ántonia*. In both instances, the immigrant farmer, called Shimerda in the novel, is unable to cope with his gnawing loneliness and homesickness. A violin—Harnett's old object par excellence—is the symbol around which this homesickness revolves. Poor refugees to the new land could afford to bring along

only necessities, so any additional belongings had to be of considerable personal significance. Yet when Shimerda's sadness for days gone by grows unbearable, even his beloved violin, with all its happy associations, cannot rouse him. His daughter Ántonia confides in broken English, "My papa sad for the old country. He not look good. He never make music any more. At home he play violin all the time; for weddings and for dance. Here never. . . . Some days he take his violin out of his box and make with his fingers on the strings, like this, but never he makes the music. He don't like this kawn-tree."[44]

Cather's story of a man for whom the true foreign country is not the past but the present has moved readers because it embodies not simply one man's nostalgia but that of an entire generation. Shimerda regards his violin and the memories of community it evokes as necessities for survival in an uncongenial environment. He invests this remnant of the past with magical powers, as if it were a talisman to keep the wolves of despair from his door. If he could no longer bring himself to play his violin, at least he could take it from its box and caress it. But that, finally, is not enough. Shimerda's suicide suggests that emotion-laden objects connected to the past can go only so far in offsetting the pain of irrevocable separation from that which beckons in memory so vividly, so cruelly. Everyday objects are not capable of restoring the past, but they can radiate its aura. And it is precisely such objects with precisely this aura that Harnett was adept at portraying.

This ability was probably the reason the wealthy Minnesota lumberman Thomas Barlow Walker asked Harnett to produce a still life in commemoration of his recently deceased son (the artist appears to have refused the offer, probably because he was ill at the time). Walker's son, who had met

Harnett and admired his work, was a craftsman himself; he had once commissioned "a beautiful Winchester Rifle" and, as a present for his father, made "a very nice tomahawk hunting hatchet."[45] Walker wanted these nostalgic objects recreated as a means of keeping alive the memory of his son and their hunting excursions together (game hunting was commonly seen as a way for fathers and sons to enjoy a fastening of emotional bonds). To the extent that one can recapture through mere personal effects a longed-for past or beloved person who remains transfixed in that past, trompe l'oeil painting is an especially potent force: if we can trick the eye, maybe we can also trick time and space and reclaim that prior sense of well-being that evocative objects so powerfully represent.

❖

Shimerda's fiddle, Walker's hunting hatchet—such were the tokens of the past that Harnett portrayed again and again, along with pipes, mugs, sheet music, and horseshoes. Did he himself experience such longings and bittersweet attachments to the objects he repeatedly represented? Probably, though no documents exist to support such a claim. Certainly in his career as an artist he frequently returned to familiar old things. In *Old Models*, the pun in the title refers to the age of the objects depicted as well as to the moral sensibility embodied. But there is a more personal pun here as well, for the specific items shown in the painting are props that had appeared previously in other works by Harnett: the Dutch jar, for example, can be seen in *The Cincinnati Enquirer* of 1888 and in *Still Life* of the same year; the violin is

featured in *The Old Violin* and reappears in *Music and Good Luck* and *The Old Cupboard Door* (1889) before taking its final bow (in both senses of the word) in *Old Models*. Even if the artist initially repeated subjects for economic reasons ("I could not afford to hire models as the other students did") and later for more distinctly formal purposes ("As a rule, new things do not paint well"), it seems likely that they grew to have strong personal associations for him—or perhaps had such associations from the start.[46]

When Harnett sold his first paintings of his studio props, he knew he had found his métier. His viewers were drawn to the work not merely because of the skill with which it recalled familiar, everyday objects but also because of its ability to summon the past—and not just any past, but the right one.

In this context, the right past was not necessarily the same as the "real" past, but instead the past as it was preferred. And that past need not be ancient and far away; it could be as recent and close at hand as a meerschaum pipe still smoldering, a German beer mug still cold to the touch. The close-at-hand items Harnett portrayed were in a sense nostalgic even if they were wholly contemporary, for in a fragmented and stressful world, the pipes, mugs, books, and fiddles bespoke calmer, less hurried times; times that might indeed have been experienced long ago but could just as well have been savored yesterday or today. Objects need not actually have been old to have conveyed a comforting sense of age and permanence; they need only to have appeared enduring and stable in

contrast to the unsettling flux of the present.

As already noted, the desire to grab hold of a vanished or vanishing past appears to have been widespread in Harnett's day. Consider the tens of thousands of Americans, whether native-born or immigrant, who, in the decades after the Civil War, abandoned the country for the city. Undertaking forms of labor different from those they had known before and struggling to learn new, unfamiliar urban folkways while unlearning the rural ones by which they had been raised, countless Americans experienced an enormous disruption of custom and dislocation from familiar ground. There was every reason, then, for these multitudes of refugees to modernity, that foreign country, to look yearningly upon the past from which they had become separated. Surely this accounts for the popularity of Thomas Hovenden's *Breaking Home Ties* (1890, fig. 176), a theatrical depiction of a stalwart but hesitant youth forsaking his loved ones in order to make his way in the world. When the painting was shown at the Chicago fair, the extraordinarily sympathetic public response it elicited (including poetry and sermons) attested to the frequency with which such wrenching scenes took place or had taken place across the land.[47]

The need to maintain or revivify memory was thus not merely a private affair dependent upon careful devotion to a personally significant violin, rifle, or beer mug, but was instead a collective problem requiring solutions of a more public nature. What has recently been called "the invention of tradition" dates from this period: national holidays were instituted, public memorials dedicated, family trees traced, and "traditional" ethnic costumes newly conceived (for example, Scottish tartans were endowed with a made-up clan significance they had never had before). History museums were founded to provide supposedly sci-

176. Thomas Hovenden, *Breaking Home Ties*, 1890. Oil on canvas, 52⅛ × 72¼ in. Philadelphia Museum of Art. Given by Ellen Harrison McMichael in Memory of C. Emory McMichael.

entific knowledge of the social and political past of various nations, while art museums, for example, the Metropolitan Museum of Art, established in 1870, served up the past in displays that aimed to be more aesthetic than scientific. Modern methods of ethnography were developed with the intention not only of transcribing aboriginal customs before the aboriginal peoples became extinct, but also of recording ethnic folkways—music, language, legends, dress—before they too were irretrievably forgotten.[48]

This, as we have already noted, was a time of many marvels connected with mechanical—or, in the case of trompe l'oeil painting, seemingly mechanical—reproduction. Alexander Graham

Bell's telephone, able to reproduce the human voice with amazing fidelity, was introduced to the public at the Philadelphia Centennial Exposition in 1876. Thomas Edison's phonograph, patented in 1877, not only reproduced the voice but also recorded it. George Eastman's dry-plate process, perfected in 1880, soon led to the invention of his popular amateur camera, the Kodak. In each of these instances, as in Harnett's technique, what seemed so wonderful was that physical reality could be reproduced in a manner that appeared immediate, free from interference and distortion, for in the words of Harnett's admirer quoted above, "We see not the artist nor his method of working. The things themselves only are seen."[49]

Almost from the start a transcriptive tool for historians and ethnographers, photography later came to be viewed as an easy, inexpensive way for tourists to preserve the past, be it that of some exotic social group or of their friends, families, and homes.[50] One reason photographs seemed so unimpeachable as witnesses to the past was that a mechanical apparatus, a machine, had produced them. Having no mind or emotions, no soul, this machine thereby appeared free of subjectivity: hence the presumed objectivity of its transcriptions. We have already considered how Harnett's trompe l'oeil technique implied a similar degree of objectivity, how it too seemed less the product of the human hand than of a reproductive machine. Its glossy, highly finished surfaces, its undetectable brushwork, its offhanded and apparently haphazard method of composition, and its various other suppressions of expressive (artistic) style all contributed to what Roland Barthes, referring to nineteenth-century French literature, has termed "the reality effect."[51]

That trompe l'oeil paintings such as *Old Models* reverently invoked the premodern past through representational techniques associated with the wonders of modernity was in keeping with the impulse governing the great world exhibitions, which sentimentally venerated the old while fetishizing the new.[52] To millions of citizens across the land, a symbolic watershed in American history occurred in 1876, the year Philadelphia's Centennial Exposition glorified both the nation's past and its future. Visitors marveled at the fair's spectacular exhibits of newly developed technological prowess but also at its quieter, museumlike displays of local and regional history.

William Dean Howells, reporting on the fair for *Atlantic Monthly*, was typical in his response in that he extolled both the magnificent, twenty-thousand-horsepower Corliss steam engine (fig. 177) that generated electricity for the fair ("an athlete of steel and iron with not a superfluous ounce of metal on it") and Ye Olden Time New England Kitchen (fig. 178), an intimate, small-scale, living-history recreation of domestic labor during the colonial period. When Howells noticed an elderly Quaker woman emerge from a crowd to demonstrate the way colonial spinning wheels were actually meant to work, he found the sight "altogether the prettiest thing . . . at the Centennial."[53] Thomas Eakins's painting known as *In Grandmother's Time* (1876, fig. 179) may have been inspired by a similar sight and certainly by a similar admiration. However fascinating the complex new technology embodied by the Corliss engine, the older, simpler way of life symbolized by the old-fashioned spinning wheel conveyed a higher order of good. The new machines were miraculous, but without the human touch and amply revered authority of the past, what lasting benefit could they truly provide?

Harnett's self-effacing, "touchless" paintings provided that touch; they were the product of a cool-eyed, steel-handed machine possessed of warmhearted soul and memory. Harnett, as it were, reversed Richard Strauss's famous dictum about the composer of *Tristan:* "Such sustained fire of passion could only have been written by a man of ice." This is not to say that Harnett or, more specifically, his art was all passion inside, but that this art must have struck viewers as human beneath its inhuman shell. It was like the Tin Man created by L. Frank Baum at the end of the decade: the exterior was robotic, the interior romantic. And

177. Theodore Russell Davis, *Our Centennial: President Grant
and Dom Pedro Starting the Corliss Engine.*
From *Harper's Weekly,* May 27, 1876.

178. "Ye Olden Time New England Kitchen," 1876. Photograph published by the Centennial
Photographic Co., Philadelphia. Free Library of Philadelphia.

yet for all the salutary longing conveyed by Harnett's obsessive focus on well-worn remnants of the premodern past, the thrill for viewers came from seeing that focus achieved with the exceptionally high degree of calibration and impersonality associated with the latest in contemporary devices of mechanical transcription and reproduction. As one astonished admirer gasped, "There is not a tiny splinter, not a nailhead, nothing that is not depicted to perfection."[54]

Take *The Golden Horseshoe* (1886, fig. 180), for instance. Horseshoes were by no means obsolete or even old-fashioned in this era preceding the introduction of the horseless carriage. Nonetheless, the horseshoe Harnett depicted is old, worn out, and rusted, retired from duty and hung like a trophy or an amulet against the cracked and splintered planks of a country barn. Even if horseshoes were still common in modern 1880s urban society, *this* horseshoe was a reminder of rural traditions (horseshoes are folk symbols of good luck) and of a more leisurely pace of life (the shoe, if not the horse that wore it, has been put to pasture). Although the objects within the painting signify the old and premodern, Harnett's incredibly precise rendering of them—his virtually microscopic attention to texture, his simulation in oil pigment of oxidized iron, curled paper, a pearl-headed pin, and weatherstreaked house paint—is phenomenal, belonging more to the realm of machine than man.

True, the artist signed the picture, thus laying claim to his accomplishment, but by making his name appear to be carved into wood rather than painted upon canvas, he perpetuated the illusion of this being a taken rather than a made picture (in a sense similar to what we mean when we say that cameras take or transcribe views of a preexisting reality rather than make or construct them). The

179. Thomas Eakins, *In Grandmother's Time*, 1876.
Oil on canvas, 16 × 12 in.
Smith College Museum of Art, Northampton, Massachusetts.

180. William Harnett, *Golden Horseshoe*, 1886. Oil on canvas,
16 × 14 in. Berry-Hill Galleries, New York.

appeal of Harnett's work, as we have seen, was its ability to strike viewers as being at once reality and illusion, hardheaded fact and poetic recollection; as the skilled product of an emotive human being who possessed the consistency and precision of an inhuman machine.

Harnett's veneration of long-lived, man-made objects—books, violins, mugs, and horseshoes—suggested a former way of life that could usefully endure into the present, just as these objects themselves endured (unlike, for example, the perishable fruit and foodstuffs depicted by Raphaelle Peale). This concern for enfolding a reliable past into a less reliable present extended beyond the world of art, crossing even into the realm of the economy. In order for Americans to be induced to accelerate patterns of consumption as necessary to justify mass production and mass distribution, they needed to be convinced not only that buying as a way of life was desirable but that it was also in line with earlier notions of proper conduct. At this time, age-old injunctions against "throwing away money" were strong indeed. Each act of spending was a morally weighted affair demanding caution and thoughtfulness, a clearheaded sense of responsibility. In the words of Benjamin Franklin, "A penny saved is a penny earned." All the more so did this seem the case during the closing decades of the century as the nation suffered a series of economic depressions that made the earlier panics pale by comparison.

Given these circumstances, merchants with vision, for example, John Wanamaker of Phila-

delphia and Richard Sears of Chicago, realized that encouraging people to spend was more than a matter of making them want what they saw. They needed to be assured that in consuming they were still adhering to the traditional Franklinesque virtues of perspicacity, wisdom, and restraint. Wanamaker endlessly proclaimed to his customers the importance of caution and thrift—which, of course, was why they should frequent his establishment, which held such values dear. Just as the Centennial Exposition, of which Wanamaker was an organizer, portrayed industrialism as the compatible outgrowth of old agrarian ways rather than their annulment, the new consumer economy he helped spawn also appealed to tradition for its legitimacy.[55]

All of Wanamaker's sales innovations were thus aimed at assuaging consciences made uneasy by the insistence with which an ethos of spending replaced that of saving. Inspired by the fair's enormous exhibition halls, which encouraged crowds to ogle items and artifacts gathered from the four corners of the earth, Wanamaker opened his "new kind of store," as he called it, in an old train depot that had been cleared to make way for two acres of retail space containing hundreds of display counters organized in concentric circles radiating from a central core (1877, fig. 181). Such large-scale open display served the dual function of impressing shoppers with the dazzling abundance of goods and of making them feel safe from fraud by allowing them to inspect items closely and at their leisure. Wanamaker's advertising copy, departing from the hard-sell approach associated with bamboozling the public, was written in plainspoken, everyday language. "No 'catchy headings,' no catches . . . no 'fine writing,'" was how his chief copywriter later described it. In short, shopping at Wanamaker's was not threatening: everything appeared visible,

straightforward, truthful. This new style of retailing offered modern, big-city enticements with all the safeguards—and then some—of shopping in traditional, small-town communities.[56]

Harnett's paintings had something in common with the new methods of retailing. In their apparent eschewal of high style, they looked as plain and honest as the new advertising sounded. Not all of his paintings possessed this tone, for some aimed self-consciously at European sophistication, but the "no fine writing" approach is characteristic of popular works like *The Golden Horseshoe, The Faithful Colt*, and *For Sunday's Dinner* (1888, fig. 182)—which depicts a plucked chicken hanging upside down. These paintings, like the new retailing, sought to transport old-style agrarian values into a new urban milieu. (*For Sunday's Dinner* was actually displayed at Wanamaker's, providing a concrete instance of barnyard meets big city.) Moreover, by definition, still-life paintings

arranged objects in a manner calculated to please or entice. Their job, in other words, was to put items on display. By doing so in an aesthetically compelling manner, they breathed life into lifeless objects, investing them with magic and wonder—the very goal of the modern retailer.

Even so, Harnett's still-life arrangements do not resemble late nineteenth-century merchandise counters and shop windows as seen in photographs. Inside the emporia, counters are piled high with products stacked in pyramids and towers, the fastidious symmetry indicating the management's laudable attention to organization and detail (fig. 183). The windows are packed with goods from top to bottom and side to side as if empty space

181. *John Wanamaker's Grand Depot*, 1877. From *Golden Book of the Wanamaker Stores*, Philadelphia, 1911.

might connote to shoppers an ill-stocked estab-
lishment (fig. 184). As Frank Baum, the inventor
of Oz but also a specialist in shop window deco-
ration, advised retailers in his *Art of Decorating
Dry Goods Windows and Interiors*, "Many things
are to be considered. There are the technicalities
to be learned, judgment and good taste to be exer-
cised, color harmony to be secured: and, above all,
there must be positive knowledge as to what con-
stitutes an attractive exhibit, and what will arouse
in the observer cupidity and a longing to possess
the goods you offer for sale."[57]

What a contrast to the wholesaler's world de-
picted in Harnett's *Job Lot Cheap*, in which the
arrangement of goods seems so casual, even care-
less. Worn leather volumes, their forms and tex-
tures carefully delineated, jostle one another in
precarious stacks on a rude wooden bookseller's
table adorned by faded and torn advertising labels
—the two that are readable, "Job Lot Cheap"
and "Just Publishe[d]," functioning ironically, for
clearly these are not new but old books containing
old wisdom that goes, alas, for cheap in a modern
era unable to assess wisdom's true worth.[58]

As mentioned above, the painting was pur-
chased by Byron Nugent, a dry goods merchant
from St. Louis. Despite the role Nugent and his fel-
low merchandisers played in modernizing Ameri-
can habits of consumption, they themselves may
have been nostalgic for the traditional system of
values that their collective enterprise was uproot-
ing. Perhaps Nugent enjoyed the painting as a sort
of common man's alternative to the ornate, com-
pulsively symmetrical new methods of retail dis-
play. Or maybe he comprehended it as a parable.
Fettered by the formalist hegemony of twentieth-
century aesthetics, we today are not as adept as
he would have been in reading supposedly non-
narrative works narratively, but this was an era in

182. William Harnett, *For Sunday's Dinner*, 1888.
Oil on canvas, 37⅛ × 21⅛ in. Art Institute
of Chicago. Wilson L. Mead Fund.

which it was common for a still-life painter such as Harnett to explain, "I endeavor to make the composition tell a story" or for a business writer such as Baum to counsel window dressers, "Let your goods tell some clear, legible story."[59] The tale told by Nugent's painting is one of mistaken identity and unfair neglect: old volumes, like old people, embody priceless wisdom and do not deserve our underestimation. This particular tale, however, is far from tragic, for the painting's cheerful blond tonality signals that the situation will not remain this way, or at least that an admirer of books such as these and of a painting such as this knows better than to discount the past and reject what is old.

And yet Harnett's paintings themselves were not old. They did not originate in some agrarian, republican, good old days but were instead products of the urban industrial scene. Painted in Philadelphia, Munich, and New York, exhibited at trade fairs, sold at auctions, and hung in hotel lobbies, offices, department stores, and drinking establishments, they were modern-day commodities, regardless of the precommodity artifacts and eras they so appealingly invoked. The old objects they depict may have movingly implied to viewers a personal history of makers and users who were linked by communal ties or across generations (as Shimerda's violin linked him to Bohemia or Walker's hatchet connected him to his son). But regardless of the superlative craftsmanship with which Harnett produced his paintings and regardless of the craftsmanship that is their implied subject, these works originated in and circulated through the impersonal marketplace instead of being anchored to the communal systems they celebrate and to which the artist may or may not have belonged.

The paintings are like commodities in still another manner. Commodities promise to deliver social benefits and improved social relations for a monetary price. They offer the consumer happiness and well-being for an over-the-counter cost. They purport to provide instant, or relatively instant, satisfactions that in earlier eras most people assumed could be achieved only by years of long, hard work, if even then. To the extent that Harnett's paintings seemed able—for the price of purchase or admission—to put viewers back in touch with a vanishing past that they were loathe to see disappear, they functioned as commodities. Retrieving the past is never simply a matter of a purchase, even when the item purchased is intended, in all sincerity, as a tribute to that past. The notion that a commodity can make up for lost values and communal relations may be the greatest illusion of all.

Still, it would be wrong to conclude that Harnett's paintings were meant in bad faith or that, even if well intended, their ultimate effect was solely to promote commodification rather than resist or at least soften its depredations. Here again we might look to Harnett's contemporary John Wanamaker, who in old age recalled aspects of his own past with immense nostalgia: "Sitting in my mother's old armchair . . . I seem to lose myself in the flood of memories, and to feel that the arms of the chair have loosed themselves to become my very own mother's arms around me again."[60] Privileged, esteemed, remarkably successful, Wanamaker—unlike Shimerda or Walker—had no obvious reason to invest an ordinary old object with extraordinary powers for recuperating the past.

That he did so, that perhaps all of us are inclined to do so, suggests that in modernity the cultural need to retain old value systems is so pressing that no one, regardless of rank, is immune. A century after they were painted, Harnett's trompe l'oeil still lifes continue to address this need. Whether their meticulous illusions of old objects serve to distance us further from the past or instead genuinely bring us closer to a world that has been lost, there is more to these paintings than meets the eye.

And thus the two separate stories of this chapter merge. Living in the age of what the physician George Beard called American Nervousness, the men who admired the art of Harnett and his fellow trompe l'oeil artists, who drank, dined, and conducted business in its presence, were therapeutically assisted by it in their need to repair injured masculinity *and* soothe their profound sense of disjunction from the past. Yeats complained of modernity, "Things fall apart; the centre cannot hold; / Mere anarchy is loosed upon the world." Trompe l'oeil still-life painting says this is not so. With its meticulous symmetry, its utopian perfection of

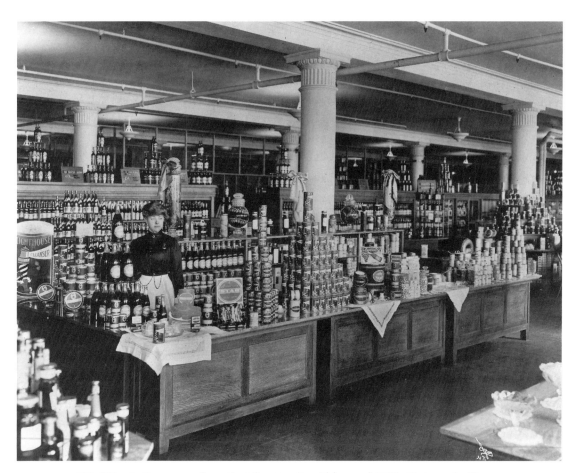

183. "Macy's Department Store Food Counter, Herald Square," 1902. Photograph. Museum of the City of New York. Byron Collection.

balance in which even items hanging precariously over the edge of a crowded tabletop refuse to fall, it embodies what another poet, Wallace Stevens, designated a "blessed rage for order."[61]

In the quarter century preceding the First World War, more than one hundred utopian novels were published in America. The best known of these, Edward Bellamy's *Looking Backward* (1888), set the tone for all that followed by imagining a future in which things did not fall apart, the center would hold, the rage for order would be satisfied. Bradford Peck's *The World a Department Store* (1900) was more explicit than most utopian fiction in conceiving of a society organized on the model of the latest achievements in modern commercial enterprise. In this novel consuming women are the embodiment of disorder, the force of anarchy to be regulated rather than loosed upon the world:

"Crowds of women, becoming as they did frantic and almost wild, pushed and crowded one another to gain an opportunity of purchasing something, because some other woman wanted it."[62]

The wholesalers, retailers, drummers, and businessmen who supported Harnett and so heartily enjoyed his efforts would surely have smiled in knowing agreement. The absence of women, even the merest iconographic or stylistic sign of them, gave the work of the trompe l'oeil artist they most preferred its exclusively masculine aroma and permitted them a vision of the past that sat well with their dreams of the future.

184. "Cotton Goods Display," 1900. Photograph from L. Frank Baum, *The Art of Decorating Dry Goods Windows and Interiors*, Chicago, 1900. Butler Library, Columbia University, New York.

Notes

Chapter 1
Labyrinths of Meaning in Vanderlyn's *Ariadne*

1. Samuel Y. Edgerton, Jr., "The Murder of Jane McCrea: The Tragedy of An American '*Tableau d'Histoire*,'" *Art Bulletin* 47:4 (December 1965): 481–89, and Kathleen H. Pritchard, "John Vanderlyn and the Massacre of Jane McCrea," *Art Quarterly* 12 (1949): 361–66. Written at the close of the eighteenth century, Barlow's *Columbiad* was not published until 1807.

2. Kenneth C. Lindsay, in *The Works of John Vanderlyn: From Tammany to the Capitol* (Binghamton, N.Y.: University Art Gallery, 1970), 71–73, convincingly sees *Marius* as Vanderlyn's tribute to his close friend and former patron Aaron Burr, who had recently and notoriously suffered a series of political reversals. This Burr interpretation, of course, does not obviate a Napoleonic one so much as run parallel to it.

3. William Townsend Oedel, "John Vanderlyn: French Neoclassicism and the Search for an American Art" (Ph.D. diss., University of Delaware, 1981), 13, 396.

4. Annette Kolodny, *The Lay of the Land: Metaphor as Experience and History in American Life and Letters* (Chapel Hill: University of North Carolina Press, 1975), traces this trope of woman to land and vice versa in American literature of the eighteenth and nineteenth centuries.

5. Many books in recent years have emphasized the idea that nature, so far as we can ever know it, is a social construction; an important early explication was Roland Barthes, *Mythologies*, trans. Annette Lavers (1957; reprint, New York: Hill and Wang, 1970). For an essay that historically examines the nature/culture opposition in terms of woman/man, the gender opposition that fell specifically and influentially into place during the early industrial period, see L. J. Jordanova, "Natural Facts: A Historical Perspective on Science and Sexuality," in *Nature, Culture and Gender*, ed. Carol D. MacCormack and Marilyn Strathern (Cambridge: Cambridge University Press, 1980), 42–69.

6. The Ariadne story, told by various classical authors such as Hesiod, Ovid, and Plutarch, predates Greek civilization at least as far back as the time of the Minoans, for whom Ariadne was a goddess of vegetation. See Martin P. Nilsson, *The Minoan-Mycenaean Religion and Its Survival in Greek Religion* (Oxford: Oxford University Press, 1927), 451–56.

7. Lindsay, *Works of John Vanderlyn*,

8. The nineteenth-century sources of information on Vanderlyn's life are William Dunlap, *A History of the Arts of Design in the United States* (New York, 1834), Robert Gosman, "Biographical Sketch of John Vanderlyn, Artist" (manuscript in Senate House Museum, Kingston), Anon. [William Kip], "Recollections of John Vanderlyn, the Artist," *Atlantic Monthly* 19:112 (February 1867): 228–35, Henry T. Tuckerman, *Book of the Artist* (New York, 1867), and Marius Schoonmaker, *John Vanderlyn, Artist, 1775–1852* (undated manuscript written prior to 1894; Kingston, N.Y.: Senate House Association, 1950). See also Louise Hunt Averill, "John Vanderlyn, American Painter" (Ph.D. diss., Yale University, 1949), which in addition to its account of Vanderlyn's careeer includes a transcription of the Gosman manuscript, some of Vanderlyn's papers, and eighty-six letters from his correspondence. Salvatore Mondello, "John Vanderlyn," *New-York Historical Society Quarterly* 52:2 (April 1968): 161–83, and Oedel, "John Vanderlyn: French Neoclassicism," are other valuable resources.

8. Aaron Burr to Peter van Gaasbeek, June 21, 1795, Edward Coykendall Collection, Senate House Museum, Kingston. Quoted in Mondello, "John Vanderlyn," 163.

9. Elizabeth McKinsey, *Niagara Falls: Icon of the American Sublime* (New York: Cambridge University Press, 1985), examines visual and verbal representations of the falls by a variety of eighteenth- and nineteenth-century artists.

10. Lindsay, *Works of John Vanderlyn*, 56–57.

11. Aaron Burr, *The Private Journal of Aaron Burr during His Residence of Four Years in Europe*, ed. Matthew L. Davis (New York: Harper and Brothers, 1838), 2:431–32.

12. Although in the lower left the painting appears to be dated 1814, Kenneth Lindsay argues that the work, begun in Paris in 1809, was completed there by 1812. Lindsay, *Works of John Vanderlyn*, 138.

13. Schoonmaker, *John Vanderlyn, Artist*, 25. Also see Dunlap, *History of the Arts*, 36, who mentions "two or three figures of reduced size from a picture representing Leda and the swan, by Correggio."

14. See Jane C. Nash, *Veiled Images: Titian's Mythological Paintings for Philip II* (London: Associated University Presses, 1985), 24–28. "[Danäe] presents an overtly erotic image; even her hand, falling in the normal chaste *Venus pudica* gesture, is exaggerated into a position that blatantly contradicts its original sense" (25).

15. On the lost painting by Ingres, see Robert Rosenblum, *Jean-Auguste-Dominique Ingres* (New York: Abrams, 1967), 104. In her entry for *Ariadne* (cat. no. 19) in Theodore E. Stebbins, Jr., et al., *A New World: Masterpieces of American Painting 1760–1910*, exhib. cat. (Boston: Museum of Fine Arts, 1983), Diana Strazdes observes, "For the pose of Ariadne, the artist looked to the highly acclaimed Roman copy of a Hellenistic sculpture then known as 'the abandoned Ariadne.' Long at the Vatican, it had been taken to Paris where it was displayed at the Musée Central des Arts

between 1800 and 1815" (216–17). On the topic of *Ariadne*'s sources, Oliver Larkin asks, "Had the artist seen, at the Park Theater in 1797, the melodrama of *Ariadne Abandoned by Theseus?*" [Vanderlyn was in Paris in 1797, and so would not have seen this play unless it had also been in Philadelphia the previous year.] Larkin continues, "The attitude of his nude figure suggests that he knew the Hellenistic marble of that title in the Vatican . . . and perhaps the *Cymon and Iphigenia* of Sir Joshua Reynolds in a print by Francis Hayward." Oliver W. Larkin, *Art and Life in America* (New York: Holt, Rinehart and Winston, 1960), 131. In a Sunday review of the San Francisco exhibition "Man: Glory, Jest, and Riddle," in 1964, Alfred Frankenstein illustrated the connection between Vanderlyn's *Ariadne* and van Neck's *Diana*. Alfred Frankenstein, *San Francisco Chronicle* (October 11, 1964), 30. Wayne Craven, in his authoritative essay "The Grand Manner in Early Nineteenth-Century American Painting: Borrowings from Antiquity, the Renaissance, and the Baroque," posits van Dyck's *Jupiter and Antiope* (c. 1618) as "the specific prototype" for *Ariadne*. See *American Art Journal* 11 (April 1979): 4–43, esp. 19–20. The depiction of a sensuous male nude slumbering in dark woods, *The Sleep of Endymion* (1792) by David's pupil Anne-Louis Girodet-Trioson, builds upon many of the same art-historical sources as *Ariadne* and may also have contributed to Vanderlyn's eroticizing treatment of his subject. Lois Marie Fink, *American Art at the Nineteenth-Century Paris Salons* (Washington, D.C., and Cambridge: Smithsonian Institution and Cambridge University Press, 1990), points out that the Salon of 1812 included two other Ariadne paintings besides Vanderlyn's; intriguingly, she suggests that the American selected this particular subject as a means of "placing himself in direct rivalry" with his French confreres (see 26–27).

16. For this and the following quotation, see Schoonmaker, *John Vanderlyn, Artist*, 36–37.

17. Vanderlyn to John R. Murray, July 3, 1809. Murray, who had commissioned Vanderlyn to paint the *Antiope* copy, once complained to William Dunlap, "What can I do with it? It is altogether indecent. I cannot hang it up in my house, and my family reprobate it." See Dunlap, *History of the Arts*, 36.

18. See Lillian B. Miller, "John Vanderlyn and the Business of Art," *New York History* 32:1 (January 1951): 33–44.

19. Zola, *La Situation* (July 1, 1867), quoted in H. Barbara Weinberg, *The Lure of Paris: Nineteenth-Century American Painters and Their French Teachers* (New York: Abbeville Press, 1991), 136, which details the influence of French academic nude painting on nineteenth-century American artists.

20. See Peter Brooks, "Storied Bodies. or Nana at Last Unveil'd," *Critical Inquiry* 16 (Autumn 1989): 1–32; and T. J. Clark, "Olympia's Choice," in *The Painting of Modern Life: Paris in the Art of Manet and His Followers* (New York: Knopf, 1985), 79–146.

21. Yvon Bizardel, *American Painters in Paris*, trans. Richard Howard (New York: Macmillan, 1960), 101–02. On Burr's sexual predation, including that occurring during his sojourn in Paris, see Charles J. Nolan, Jr., *Aaron Burr and the American Literary Imagination* (Westport, Conn.: Greenwood Press, 1980), 39–42.

22. This and the following quotation are from Schoonmaker, *John Vanderlyn, Artist*, 36–37.

23. John Durand, *The Life and Times of A. B. Durand* (1894; reprint, New York: Da Capo, 1970), 76.

24. Item in the *Ariadne* file, Archives of the Pennsylvania Academy of the Fine Arts [February 1891]. According to the handbill, one unidentified woman "whose relatives and friends have contributed a number of beautiful pictures" went so far as to remark, "I hate these pictures with a bitter hatred."

25. The Philadelphia collector Henry C. Gibson commissioned Cabanel to paint a copy (1870) of *The Birth of Venus*, which subsequently entered the collection of the Philadelphia

Museum; a second copy (1875), commissioned by the New York banker John C. Wolfe, is now in the Metropolitan Museum. See Weinberg, *The Lure of Paris*, 272, n. 29.

26. On the status of *The Gross Clinic* and *William Rush* in post–Civil War Philadelphia, see Elizabeth Johns, *Thomas Eakins: The Heroism of Modern Life* (Princeton: Princeton University Press, 1983). On the vexed tradition of the academic nude in nineteenth-century Philadelphia, see David Sellin, *The First Pose* (New York: Norton, 1976), 21–72.

27. See Strazdes in Stebbins, *A New World*, 217, and Joy Kasson, *Marble Queens and Captives* (New Haven: Yale University Press, 1990), chap. 3. See also Vivien M. Green, "Hiram Powers's *Greek Slave*: Emblem of Freedom," *American Art Journal* 14 (Autumn 1982): 31–39.

28. The conceptual pairing of *Marius* and *Ariadne* has been noted by Lois Fink, who believes that the latter painting was "conceived as a pendant" to the former, thus producing a traditional gender pairing of hard, upright masculinity as represented by the muscle-bound general and soft, supine femininity as embodied by the curvaceous maiden. "Whereas the Marius painting suggests a cycle of human ambition culminating in the force of destruction, Ariadne asleep represents the rhythm of nature and implies [through sexually suggestive devices such as the prominent hollow of the tree and the breastlike volcanic mountain] human participation in nature's inherent power to create" (*American Art at the Paris Salons*, 25).

29. Benjamin Constant, *Adolphe*, trans. Leonard Tancock (Harmondsworth: Penguin, 1964), 75.

30. Mary Shelley, *Frankenstein, or, The Modern Prometheus*, ed. M. K. Joseph (London: Oxford University Press, 1969), 57. My thinking about *Frankenstein* has been influenced by Barbara Johnson's discussion of the novel in "My Monster / My Self," *Diacritics* 12 (Summer 1982): 2–10, and by various essays in George Levine and U. C. Knoepflmacher, eds., *The Endurance of Frankenstein: Essays on Mary Shelley's Novel* (Berkeley and Los Angeles: University of California Press, 1979), especially, in the

present context, Ellen Moers, "Female Gothic" (77–87), Kate Ellis, "Monsters in the Garden: Mary Shelley and the Bourgeois Family" (123–42), and Lee Sterrenburg, "Mary Shelley's Monster: Politics and Psyche in *Frankenstein*" (143–71).

31. Richard Slotkin, *Regeneration through Violence: The Mythology of the American Frontier, 1600–1860* (Middletown, Conn.: Wesleyan University Press, 1973), 317–19.

32. Moers, "Female Gothic," 83–84.

33. This and the quotation in the following paragraph are from Christine Stansell, *City of Women: Sex and Class in New York, 1789–1860* (New York: Knopf, 1986), 23–24.

34. Aaron Burr to Theodosia Prevost Burr, February 16, 1793, from Aaron Burr, *Memoirs of Aaron Burr with Miscellaneous Selections from His Correspondance*, ed. Matthew L. Davis (New York: Harper and Brothers, 1836–37), 1:363. Quoted in Linda Kerber, *Women of the Republic: Intellect and Ideology in Revolutionary America* (Chapel Hill: University of North Carolina Press, 1980), 224.

35. See Stansell, *City of Women*, 34–35, 63–68, on reformers' increasingly moralistic attitude toward the poor.

36. Nancy Cott, *The Bonds of Womanhood: 'Woman's Sphere' in New England, 1780–1835* (New Haven: Yale University Press, 1977), 153.

37. Dorothy Weil, *In Defense of Women: Susanna Rowson (1762–1824)* (University Park, Penn.: Pennsylvania State University Press, 1976), 5.

38. Patricia L. Parker, *Susanna Rowson* (Boston: Twayne, 1986), 86–87.

39. Jay Fliegelman, *Prodigals and Pilgrims: The American Revolution against Patriarchal Authority, 1750–1800* (Cambridge: Cambridge University Press, 1982), 83.

40. "'Bless my heart,' cries my young, volatile reader, 'I shall never have patience to get through these volumes, there are so many ahs! and ohs! so much fainting, tears, and distress, I am sick to death of the subject.' My dear, cheerful, innocent girl . . . my lively, innocent girl, I must request your patience: I am writing a tale of truth: I mean to write it to the heart. . . .

I pray you throw it not aside till you have perused the whole; mayhap you may find something therein to repay you for the trouble." Susanna Rowson, *Charlotte Temple: A Tale of Truth*, ed. Clara M. and Rudolf Kirk (New Haven: College and University Press, 1964), 139.

41. Anna Clark, "The Politics of Seduction," in *The Progress of Romance: The Politics of Popular Fiction*, ed. Jean Radford (London: Routledge and Kegan Paul, 1986), 46–70, quotes from 47–48. Clark is looking at British history, but her observations apply, with modification, to the American context, which remained at this time culturally, politically, and economically derivative. For a reading of early American seduction fiction in terms of middle-class identity formations, see Carroll Smith-Rosenberg, "Domesticating 'Virtue': Coquettes and Revolutionaries in Young America," in *Literature and the Body*, ed. Elaine Scarry (Baltimore: Johns Hopkins University Press, 1988), 160–84.

42. A recent compilation of essays on Enlightenment-era views of seduction are contained in Jonathan Miller, ed., *Don Giovanni: Myths of Seduction and Betrayal* (Baltimore: Johns Hopkins University Press, 1991). See, for example, Roy Porter, "Libertinism and Promiscuity" (1–19), and Robert Darnton, "Don Juanism from Below" (20–35).

43. Frank Rahill, *The World of Melodrama* (University Park, Penn.: Pennsylvania State University Press, 1967), 121–22.

44. See Peter Brooks, *The Melodramatic Imagination: Balzac, Henry James, Melodrama, and the Mode of Excess* (New Haven: Yale University Press, 1976), and Thomas Elsaesser, "Tales of Sound and Fury: Observations on the Family Melodrama," *Monogram* 4 (1972), which has been reprinted in numerous recent collections, including Christine Gledhill, ed., *Home Is Where the Heart Is: Studies in Melodrama and the Woman's Film* (London: British Film Institute, 1987), and Marcia Landy, ed., *Imitations of Life: A Reader on Film and Television Melodrama* (Detroit: Wayne State University Press, 1991). For a historical study of melodrama in America, see David Grimsted, *Melodrama Unveiled:*

American Theater and Culture, 1800–1850 (Chicago: University of Chicago Press, 1968).

45. See, for example, Leslie A. Fiedler, *Love and Death in the American Novel* (New York: Stein and Day, 1960; rev. 1966), and Terry Eagleton, *The Rape of Clarissa: Writing, Sexuality, and Class Struggle in Samuel Richardson* (Minneapolis: University of Minnesota Press, 1982). Also, Fliegelman, *Prodigals and Pilgrims*.

46. Philip Young, "Pocahontas, Mother of Us All," *Kenyon Review* 24:3 (Summer 1962): 392.

47. John Rolfe to Sir Thomas Dale (1614), in Lyon Gardiner Tyler, ed., *Narratives of Early Virginia, 1606–1625*, Original Narratives of Early American History series (New York: Charles Scribner's Sons, 1907), 239–44. Reprinted in Wilcomb E. Washburn, ed., *The Indian and the White Man* (Garden City, N.Y.: Anchor Books, 1964), 20–25 (quotation on 22).

48. *Amerigo Vespucci: Letter to Piero Soderini, Gonfaloniere* (1497), trans. and ed. George Tyler Northup (Princeton: Princeton University Press, 1916), 7–10. Reprinted in Washburn, *The Indian and the White Man*, 7–8.

49. John Smith, *Generall Historie of Virginia* (London, 1624), quoted in Young, "Pocahontas," 395.

50. John Davis, *The First Settlers of Virginia, An Historical Novel*, 2d ed. (New York: Riley, 1806), 39.

51. On the distinction between the wild man and the noble savage, see Hayden White, "The Forms of Wildness: Archeology of an Idea," and "The Noble Savage Theme as Fetish," in his *Tropics of Discourse* (Baltimore: Johns Hopkins University Press, 1978). See also Antonello Gerbi, *The Dispute of the New World: The History of a Polemic, 1750–1900*, rev. ed., trans. Jeremy Moyle (Pittsburgh: University of Pittsburgh Press, 1973), and Lewis Hanke, *Aristotle and the American Indians: A Study in Race Prejudice in the Modern World* (Chicago: University of Chicago Press, 1958).

52. William Tudor, "An Address delivered to the Phi Beta Kappa Society, at their anniversary meeting at Cambridge," *North-American Review* 2 (1815): 19. For on-site depictions of native life made by John White and Jacques le Moyne, two artists who, separately, accompanied early expeditions to the New World, and for samples of the classicizing engravings made from these depictions by unknown engravers employed by de Bry, see Stefan Lorant, ed., *The New World: The First Pictures of America* (New York: Duell, Sloan and Pearce, 1946). Hugh Honour, *The European Vision of America* (Cleveland: Cleveland Museum of Art, 1984), contains a large and varied selection of European images of the New World. For more on the neoclassical and romantic comparisons of Indians to ancient Romans and Greeks, see Robert F. Berkhofer, Jr., *The White Man's Indian: Images of the American Indian from Columbus to the Present* (New York: Knopf, 1978), 45–47, 72, Michael Kraus, *The Atlantic Civilization: Eighteenth-Century Origins* (Ithaca: Cornell University Press, 1949), 217–19, and Ellwood C. Parry, *The Image of the Indian and the Black Man in American Art: 1590–1900* (New York: Braziller, 1974). Thomas Jefferson, by the way, was the proud owner of a three-volume folio edition of de Bry, which he boasted about to John Adams *(The Adams-Jefferson Letters: The Complete Correspondence between Thomas Jefferson and Abigail and John Adams*, ed. Lester J. Cappon [Chapel Hill: University of North Carolina Press for the Institute of Early American History and Culture at Williamsburg, Virginia, 1959], 2:306).

53. E. McClung Fleming, "The American Image as Indian Princess, 1765–1783," *Winterthur Portfolio* 2 (1965): 73; see also, id., "From Indian Princess to Greek Goddess: The American Image, 1783–1815," *Winterthur Portfolio* 3 (1967): 37–66.

54. On Vanderlyn and his relatively frequent depiction of Indians, see Lindsay, *Works of John Vanderlyn*, 74, 142. Provocative material on the relation between official Indian policies and such "official" American art of the period as that originally planned for the Capitol is detailed in Vivien Green Fryd, *Art and Empire: The Politics of Ethnicity in the United States Capitol, 1815–1860* (New Haven: Yale University Press, 1992). Essential contributions to any discussion concerning the conscious and unconscious attitudes of white Americans toward Native Americans during (as well as before and after) the period of *Ariadne* are Berkhofer, Jr., *The White Man's Indian*, Roy Harvey Pearce, *The Savages of America: A Study of the Indian and the Idea of Civilization* (1953; reprint, Baltimore: Johns Hopkins University Press, 1965), and two books by Richard Slotkin, *Regeneration through Violence* and *The Fatal Environment: The Myth of the Frontier in the Age of Industrialization* (New York: Atheneum, 1985).

55. Gustavus Myers, *The History of Tammany Hall* (1917; reprint, New York: Dover Publications, 1971), 4–6.

56. Young, "Pocahontas," 412–13.

57. James Nelson Barker, *The Indian Princess; or, La Belle Sauvage: An Operatic Melo-Drame in Three Acts*, music by John Bray (1808; reprint, New York: Da Capo Press, 1972), 52. On the fictional and dramatic representation of Indians for the legitimation of white republicanism, see Werner Sollors, *Beyond Ethnicity: Consent and Descent in American Culture* (New York: Oxford University Press, 1986), chap. 4.

58. Davis, *First Settlers of Virginia*, vii.

59. Ronald Satz, *American Indian Policy in the Jacksonian Era* (Lincoln: University of Nebraska Press, 1975), 2; and Richard Drinnon, *Facing West: The Metaphysics of Indian-Hating and Empire Building* (Minneapolis: University of Minnesota Press, 1980), 102.

60. This and the following quotation are from Peter Nabokov, ed., *Native American Testimony: An Anthology of Indian and White Relations* (New York: Harper and Row, 1978), 119–20.

61. This and the preceding quotation are from Michael Paul Rogin, *Fathers and Children: Andrew Jackson and the Subjugation of the American Indian* (New York: Knopf, 1975), 124–25. The Melanie Klein that Rogin cites is her *Contributions to Psychoanalysis* (London: Hogarth Press, 1948), and Melanie Klein et al., eds., *New Directions in Psychoanalysis* (New York: Basic Books, 1955). Important essays by Klein are collected in *Love, Guilt and Reparation and Other Works, 1921–1945* (New York: Dell, 1977).

62. Walter Benjamin, *Illuminations*, ed. and intro. Hannah Arendt, trans. Harry Zohn (New York: Harcourt, Brace, and World, 1968), 256.

63. Washington Irving, "Traits of Indian Character," in *The Sketch Book* (New York: New American Library, 1981), 282. Even among the sympathetic, the conviction that Indians were destined to die out has racist implications—and has proven wrong. See Brian Dippie, *The Vanishing American: White Attitudes and U.S. Indian Policy* (Middletown, Conn.: Wesleyan University Press, 1982).

64. Catharine Maria Sedgwick, *Hope Leslie; or, Early Times in the Massachusetts*, ed. and intro. Mary Kelley (New Brunswick, N.J.: Rutgers University Press, 1987).

65. Tudor, "An Address delivered," 19.

66. Sydney J. Krause, Introduction, in Charles Brockden Brown, *Edgar Huntly, or, Memoirs of a Sleep-Walker*, ed. Krause and S. W. Reid (1799; reprint, Kent, Ohio: Kent State University Press), xlix.

67. J. G. A. Pocock, *The Machiavellian Moment: Florentine Political Thought and the Atlantic Republican Tradition* (Princeton: Princeton University Press, 1975), e.g., 545–46.

68. This and the following quotation are from Gordon S. Wood, ed., *The Rising Glory of America: 1760–1820* (New York: Braziller, 1971), 13, 175. A detailed narrative account of the politics of the 1790s is contained in John C. Miller, *The Federalist Era: 1789–1801* (New York: Harper and Row, 1960). For a revisionist view of early national culture and politics, see Steven Watts, *The Republic Reborn: War and the Making of Liberal America,*

1790–1820 (Baltimore: Johns Hopkins University Press, 1987). Wary of overly simple political and cultural dichotomies, historians in the past two decades have produced a nuanced literature on republicanism in the founding years of the United States. In addition to the books by Kerber, Miller, Pocock (esp. chaps. 14, 15), Watts, and Wood cited above, see Joyce Appleby, *Capitalism and a New Social Order: The Republican Vision of the 1790s* (New York: New York University Press, 1984), Bernard Bailyn, *Ideological Origins of the American Revolution* (Cambridge: Harvard University Press, 1967), Gordon S. Wood, *The Creation of the American Republic, 1776–1787* (Chapel Hill: University of North Carolina Press, 1969), and Robert E. Shalhope's bibliographic essays, "Toward a Republican Synthesis: The Emergence of an Understanding of Republicanism in American Historiography," *William and Mary Quarterly*, 3d ser., vol. 29 (1972): 49–80, and "Republicanism and Early American Historiography," ibid., vol. 39 (1982): 334–56. The several essays contained in *American Quarterly* 37:3 (1985) are devoted to republicanism and the recent debates concerning what it was, to whom, and under what circumstances.

69. Pocock, *Machiavellian Moment*, 546.

70. Schoonmaker, *John Vanderlyn, Artist*, 7–8 (Schoonmaker's emphases); and [Robert Gosman], "Review of Biographical Sketch of John Vanderlyn published by William Dunlap . . . By a Friend of the Artist" (New York, 1838), 5–6. Archives of American Art, microfilm roll 44.

71. Lindsay, *Works of John Vanderlyn*, 142. See Appleby, *Capitalism and a New Social Order*, 61–66, 77–78, 81. For a delineation of the class makeup of Tammany in the period during which Vanderlyn was a member, see Peter Paulson, "The Tammany Society and the Jeffersonian Movement in New York City, 1795–1800," *New York History* 34:1 (January 1953): 72–84. On the political affiliations of New York mechanics (middle- to lower-class working males, including skilled artisans and craftsmen such as Vanderlyn was initially trained to þe), see Alfred Young, "The Mechanics and the Jeffersonians: New York, 1789–1801," *Labor History* 5 (1964): 247–76. Even as Vanderlyn

departed from the mechanics category by leaving a New York paint shop for the Parisian academy, that class category itself was fragmenting into economically antagonistic subcategories such as journeymen, master mechanics, casual laborers, and factory workers. See David Montgomery, "The Working Classes of the Pre-Industrial American City, 1780–1830," *Labor History* 9 (1968): 3–22, and Sean Wilentz, *Chants Democratic: New York City and the Rise of the American Working Class, 1788–1850* (New York: Oxford University Press, 1984), chaps. 1, 2.

72. Vanderlyn to Roger Strong, July 6, 1806; Vanderlyn to Fulwar Skipwith, June 11, 1806, Darrow Collection, Senate House Museum. Quoted in Mondello, "John Vanderlyn," 169. Concerning Murray and Hone, see Dunlap, *History of the Arts*, 36, and Allan Nevins, "Introduction: Philip Hone, The Man and Diarist," vii–xx, in *The Diary of Philip Hone: 1828–1851*, ed. Nevins (New York: Dodd, Mead, 1936

73. Adams to Mercy Otis Warren, August 8, 1807. Quoted in Linda K. Kerber, "The Republican Ideology of the Revolutionary Generation," *American Quarterly* 37:3 (1985): 474.

74. Thomas Jefferson, "First Inaugural Address" (March 4, 1801), in Richard Hofstadter, ed., *Great Issues in American History: From the Revolution to the Civil War, 1765–1865* (New York: Vintage, 1958), 188.

75. Leonard W. Levy and Carl Siracusa, eds., *Essays on the Early Republic: 1789–1815* (Hinsdale, Ill.: Dryden Press, 1974), 53. The David Montgomery and Alfred Young articles cited above are both included.

76. "Whether Federalist or Republican, [writers] shared the traditional vocabulary of images in which the Indian functioned as a symbol for the internal and external forces threatening social order. However, in composing their national epics, they tended to emphasize the second and more hopeful association of the Indian with the natural potential for goodness in man." Slotkin, *Regeneration through Violence*, 347. See also chapter 4, "Regeneration through Violence: History as an Indian War, 1675–1820," in Slotkin, *Fatal Environment*, 52–53, for Slotkin's recent

restatement in summary form of his thesis concerning the Indian as bivalent symbol for white expansionist rhetoric.

77. The papers of the Barnard conference are collected in Carole S. Vance, ed., *Pleasure and Danger: Exploring Female Sexuality* (Boston: Routledge and Kegan Paul, 1984).

78. Janice Radway, *Reading the Romance: Women, Patriarchy, and Popular Literature* (Chapel Hill: University of North Carolina Press, 1984). See also Tania Modleski, *Loving with a Vengeance: Mass-Produced Fantasies for Women* (New York: Methuen, 1984). Two recent collections of essays considering how women view popular culture differently from men are Lorraine Gamman and Margaret Marshment, eds., *The Female Gaze: Women as Viewers of Popular Culture* (Seattle: Real Comet Press, 1989), and E. Deidre Pribram, *Female Spectators: Looking at Film and Television* (New York: Verso, 1988).

79. Eliza Southgate to Moses Porter, undated (autumn 1800), in *A Girl's Life Eighty Years Ago: Selections from the Letters of Eliza Southgate Bowne*, ed. Clarence Cook (New York: Scribner's Sons, 1888), 39. Quoted in Nancy F. Cott, ed., *Root of Bitterness: Documents of the Social History of American Women* (New York: E. P. Dutton, 1972), 104.

80. Southgate, *A Girl's Life*, 38, 41. As an emblem of female self-sufficiency, Ariadne becomes not only an heir to the romantic young women who abandon male civilization for a pocket of (colonial) nature in the popular French novel of the late eighteenth century *Paul et Virginie*, but also an Amazonian foremother to the inhabitants of feminist utopias from Charlotte Perkins Gilman's *Herland* (1915) to Monique Wittig's *Les Guérillères* (1969). Or, with her legs pressed together, she might seem an experiencer of that female *jouissance* that the contemporary French feminist Luce Irigaray describes: "A woman 'touches herself' constantly without anyone being able to forbid her to do so, for her sex is composed of two lips

which embrace continually. Thus, within herself she is already two—but not divisible into ones—who stimulate each other." For in Irigaray's vision, "woman's autoeroticism is very different from man's. He needs an instrument in order to touch himself: his hand, woman's genitals, language—And this self-stimulation requires a minimum of activity. But a woman touches herself by and within herself directly, without mediation, and before any distinction between activity and passivity is possible." Luce Irigaray, "This Sex Which Is Not One," trans. Claudia Reeder, in Elaine Marks and Isabella de Courtivron, eds., *New French Feminisms* (New York: Schocken, 1981), 100. Other essays by Irigaray exploring the conceptual possibilities of female-centered discourse and subjectivity are collected in *This Sex Which Is Not One*, trans. Catherine Porter and Carolyn Burke (Ithaca: Cornell University Press, 1985).

81. Roland Barthes, *The Pleasure of the Text*, trans. Richard Howard (New York: Hill and Wang, 1975), and Julia Kristeva, *Revolution in Poetic Language*, trans. Margaret Waller (New York: Columbia University Press, 1984), elaborate upon the connection between sexual pleasure and unfixed, endlessly deferred meaning.

82. Simone de Beauvoir, *Must We Burn De Sade?* trans. Annette Michelson (London: Nevill, 1953), 48; Ronald Hayman, *De Sade: A Critical Biography* (New York: Crowell, 1978), 130. On Sade, see also Georges Bataille, *Literature and Evil*, trans. Alastair Hamilton (New York: Boyars, 1985); Roland Barthes, *Sade/Fourier/Loyala*, trans. Richard Miller (New York: Hill and Wang, 1976); and Angela Carter, *The Sadeian Woman* (New York: Pantheon, 1978).

83. Gayatri Spivak proposes that Victor Frankenstein's refusal to create a propagating helpmate for his wretched creature is a symbolic condensation of English middle-class anxieties about colonial native hordes and working-class masses whose proliferation was considered beneficial for industrialism but deeply threatening in every other way. See Gayatri Chakravorty Spivak, "Three Women's Texts and a Critique of Imperialism," in *"Race," Writing, and Difference*, ed. Henry Lewis Gates, Jr. (Chicago: University of Chicago Press, 1985–86), 273–78.

84. Quoted in Zillah R. Eisenstein, *The Radical Future of Liberal Feminism* (New York: Longman, 1981), 60. Rousseau's call for a hierarchical, asymmetric structure of authority within the family might remind some readers of the outcry heard in recent years on behalf of a dignified and morally decent, monological textual analysis that would redress the interpretive promiscuities of poststructuralism and multiculturalism.

85. Claire Goldberg Moses, *French Feminism in the Nineteenth Century* (Albany: State University of New York Press, 1984), 6 ff.; Southgate, *A Girl's Life*, 38.

86. On the sexual place of women in the ancient world, see Eva Cantarella, *Pandora's Daughters: The Role and Status of Women in Greek and Roman Antiquity*, trans. Maureen B. Fant (Baltimore: Johns Hopkins University Press, 1987), and Amy Richlin, ed., *Pornography and Representation in Greece and Rome* (New York: Oxford University Press, 1992).

87. John D'Emilio and Estelle Freedman, *Intimate Matters: A History of Sexuality in America* (New York: Harper and Row, 1988), 86–87.

88. Rayna Green, "The Pocahontas Perplex: The Image of Indian Women in American Culture," *Massachusetts Review* 16:4 (Autumn 1975): 711. The song lyric in the following paragraph is also from p. 711.

89. J. Hillis Miller, "Ariadne's Thread: Repetition and the Narrative Line," *Critical Inquiry* 3 (Autumn 1976): 57–77.

Chapter 2
Bingham's *Boone*

1. The best biographical studies of Boone are John Mack Faragher, *Daniel Boone: The Life and Legend of an American Pioneer* (New York: Henry Holt, 1992), and, of earlier vintage, John Bakeless, *Daniel Boone: Master of the Wilderness* (New York: William Morrow, 1939). The most influential literary study of the Boone legend is Henry Nash Smith's chapter "Daniel Boone: Empire Builder or Philosopher of Primitivism?" in *The Virgin Land: The American West as Symbol and Myth* (1950; reprint, Cambridge: Harvard University Press, 1970). See William Carlos Williams, *In the American Grain* (1925; reprint, New York: New Directions, 1956), 130–39, for an early twentieth-century reconsideration of Boone and his legacy from the point of view of a leading modernist poet. Faragher, *Daniel Boone*, 338, discusses Bingham's painting and suggests that the artist may have conflated the earlier and later expeditions and that the heavily enshadowed young scout who stops to adjust his mocassin may represent Boone's son James, who died in the ambush. Dawn Glanz, *How the West Was Drawn: American Art and the Settling of the Frontier* (Ann Arbor: UMI Research Press, 1982), offers a similar observation and proposes that "the dark and threatening sky and the grimly alert expressions of the leading figures allude to the dangers of emigration which had been so vividly demonstrated in the tragic ending of Boone's first attempt." Bingham's painting, she concludes, "is not so much the record of a specific event as a tribute to the courage and achievements of Daniel Boone and those other early pioneers who persevered in the face of danger and discouragement" (21).

2. Boone's often-quoted boast that his wife and daughter were the first white women to stand on the banks of the Kentucky River would suggest that the young woman shown here must be Susannah, his eldest daughter, who was not yet fifteen at the time of the wilderness crossing. Several years later Jemima Boone, who was twelve at the time of the crossing, married Flanders Callaway, a younger man than Boone and thus not likely to have served as the historical basis for the grizzled older pioneer at Boone's side. Of course his-

torical accuracy, as we shall see, was not the name of Bingham's game.

3. On *Boone* as a Flight out of Egypt, see Patricia Hills, *The American Frontier: Images and Myths* (New York: Whitney Museum of American Art, 1973), 8, and "Picturing Progress in the Era of Westward Expansion," in *The West as America: Reinterpreting Images of the Frontier, 1820–1920*, exhib. cat., ed. William H. Truettner (Washington: National Museum of American Art and Smithsonian Institution Press, 1991), 113–15. On *Boone* and the Twenty-third Psalm, see J. Gray Sweeney's study of nineteenth-century depictions of Boone, *The Columbus of the Woods: Daniel Boone and the Typology of Manifest Destiny*, exhib. cat. (St. Louis: Washington University Gallery of Art, 1992), 47. Chapter 6 in Sweeney is richly suggestive in its interpretation of Bingham's painting and raises some of the same issues treated here.

4. John Francis McDermott, *George Caleb Bingham: River Portraitist* (Norman: University of Oklahoma Press, 1959), 193. Other book-length studies of Bingham are E. Maurice Bloch, *George Caleb Bingham: The Evolution of an Artist* and *George Caleb Bingham: A Catalogue Raisonné* (both Berkeley: University of California Press, 1967), id., *The Paintings of George Caleb Bingham* (Columbia: University of Missouri Press, 1986), Albert Christ-Janer, *George Caleb Bingham of Missouri: The Story of an Artist* (New York: Dodd, Mead, 1940) and *George Caleb Bingham: Frontier Painter of Missouri* (New York: Abrams, 1975), Lew Larkin, *Bingham: Fighting Artist* (Kansas City, Mo.: Burton Publishing, 1954), Nancy Rash, *The Painting and Politics of George Caleb Bingham* (New Haven: Yale University Press, 1991), Fern Helen Rusk, *George Caleb Bingham: The Missouri Artist* (Jefferson City, Mo.: Hugh Stephens, 1917), and the exhibition catalogue of the Bingham retrospective at the Saint Louis Art Museum and the National Gallery of Art (1990), *George Caleb Bingham*, with essays by Michael Edward Shapiro et al. (New York: Harry N. Abrams for the Saint Louis Art Museum, 1990). This volume is critically assessed by Alan Wallach in "Regionalism Redux," *American Quarterly* 43:2 (June 1991): 259–63, 269–78. For a specifically

political interpretation of Bingham's river paintings, see Rash, "George Caleb Bingham's *Lighter Relieving a Steamboat Aground*," *Smithsonian Studies in American Art* 2 (Spring 1988): 17–31, and *Painting and Politics*, chap. 3.

5. In the words of a contemporary Anglican sermon, "Life bears us on like the stream of a mighty river." Reginald Heber, *Sermons* (London, 1838), 2:471, quoted in the Reverend Gorham D. Abbot, *Cole's Voyage of Life: A Series of Allegorical Pictures* (New York, 1860), 14. See Alan Wallach, "The Voyage of Life as Popular Art," *Art Bulletin* 59:2 (June 1977): 234–41.

6. In the eighth canto of *Don Juan* (1822) Byron wrote of Boone, who was already an international legend, "'Tis true he shrank from men even of his nation, / When they built up into his darling trees,—/ He moved some hundred miles off, for a station / Where there were fewer houses and more ease; / The inconvenience of civilization / Is, that you neither can be pleased nor please."

7. A provocative psychoanalytic interpretation of Cole's work is in Bryan Jay Wolf, *Romantic Re-Vision: Culture and Consciousness in Nineteenth-Century American Painting and Literature* (Chicago: University of Chicago Press, 1982). The most detailed and suggestive sociopolitical readings of Cole are Angela Miller, "Thomas Cole and Jacksonian America: The Course of Empire as Political Allegory," *Prospects* 14 (1989) 65–92, and a series of writings by Alan Wallach, including "The Ideal American Artist and the Dissenting Tradition: A Study of Thomas Cole's Popular Reputation" (Ph.D. diss., Columbia University, 1973), and "Thomas Cole and the Aristocracy," *Arts Magazine* 56:3 (November 1981): 94–106. Presently Wallach and William H. Truettner are preparing a full-scale retrospective of Cole's work to be held in 1994 at the Smithsonian Institution's National Museum of American Art.

8. William Cullen Bryant, "Thomas Cole. A Funeral Oration, Delivered before the National Academy of Design, New York, May 4, 1848," in *Orations and Addresses* (New York: G. P. Putnam's Sons, 1873), 1–41. See J. Gray Sweeney, "Embued with

Rare Genius: Frederic Edwin Church's *To the Memory of Cole*," *Smithsonian Studies in American Art* 2:1 (Winter 1988): 45–71. For another reading of *Kindred Spirits*, see Bryan Wolf, "All the World's a Code: Art and Ideology in Nineteenth-Century American Painting," *Art Journal* 44:4 (Winter 1984): 328–30. On Durand, see the biography by his son, John Durand, *The Life and Times of A. B. Durand* (1894; reprint, New York: Da Capo Press, 1970), and David B. Lawall, *Asher Brown Durand*, and id., *Asher Brown Durand: His Art and Art Theory in Relation to His Times* (New York: Garland, 1977).

9. Letter of March 30, 1851, reprinted in "Letters of George Caleb Bingham to James Sidney Rollins," ed. C. B. Rollins, *Missouri Historical Quarterly* 32 (October 1937): 20–21, and letter to A. Warner, March 1, 1852, Letters Received, vol. 64, American Art-Union Papers, New-York Historical Society (citation given in Rash, *The Painting and Politics*, 242).

10. On American history painting, see William H. Truettner's two important essays "The Art of History: American Exploration and Discovery Scenes, 1840–1860," *American Art Journal* 14 (Winter 1982): 4–31, and "Prelude to Expansion: Repainting the Past," in *The West as America*, 55–95. Also see William H. Gerdts and Mark Thistlethwaite, *Grand Illusions: History Painting in America* (Fort Worth: Amon Carter Museum, 1988). On Emanuel Leutze, the leading history painter of the era, see Barbara S. Groseclose, *Emanuel Leutze, 1816–1868: Freedom Is the Only King*, exhib. cat. (Washington: National Collection of Fine Arts, Smithsonian Institution, 1975).

11. Bingham to Rollins, March 30, 1851, in "Letters," 20. See John Francis McDermott, "George Caleb Bingham and the American Art-Union," *New-York Historical Society Quarterly* 42:1 (January 1958): 66–67. See also James T. Callow, *Kindred*

Spirits: Knickerbocker Writers and American Artists, 1807–1855 (Chapel Hill: University of North Carolina Press, 1967), 32–36.

12. McDermott, "George Caleb Bingham and the American Art-Union," 68–69; Callow, *Kindred Spirits*, 35–36; James Thomas Flexner, *History of American Painting*, vol. 3: *That Wilder Image* (1962; reprint, New York: Dover, 1970), 98–99.

13. Paul C. Nagel, "The Man and His Times," in *George Caleb Bingham*, Shapiro et al., 40–41, discusses the slaveholding of Bingham and his friends.

14. On antebellum Whig politics in general, see Thomas Brown, *Politics·and Statesmanship: Essays on the American Whig Party* (New York: Columbia University Press, 1985), and Daniel Walker Howe, *The Political Culture of the American Whigs* (Chicago: University of Chicago Press, 1979). On Whig politics in Missouri, see Perry McCandless, *A History of Missouri*, vol. 2, *1820–1860* (Columbia: University of Missouri Press, 1972), and John Vollmer Mering, *The Whig Party in Missouri*, University of Missouri Studies, 41 (Columbia: University of Missouri Press, 1967). Essays focused on the Whig politics of Bingham's paintings include Scott Casper, "Politics, Art, and the Contradictions of a Market Culture," *American Art* 5:3 (Summer 1991): 27–47, John Demos, "George Caleb Bingham: The Artist as Social Historian," *American Quarterly* 17:2 (1965): 218–28, Barbara S. Groseclose, "Painting, Politics and George Caleb Bingham," *American Art Journal* 10 (1978): 5–19, Gail E. Husch, "George Caleb Bingham's *The County Election:* Whig Tribute to the Will of the People," *American Art Journal* 19:4 (1987): 5–22, and Robert F. Westervelt, "The Whig Painter of Missouri," *American Art Journal* 2 (1970): 46–53. Rash, *The Painting and Politics*, provides considerable detail on these twin aspects of Bingham's life.

15. Bingham to Rollins, November 2, 1846, "Letters," 15.

16. Rash, *The Painting and Politics*, chap. 3.

17. The artist's son, James Rollins Bingham, claimed that the artist's grandfather was "exceedingly kind and indulgent [to slaves], never using the lash nor allowing it to be used on his place." Appendix, "The Bingham Family," in Bloch, *George Caleb Bingham: The Evolution of an Artist*, 309–11.

18. On this point see Sweeney, *The Columbus of the Woods*, 49–50.

19. Bingham to Rollins, March 30, 1851.

20. John G. Cawelti, "The Frontier and the Native American," in Joshua C. Taylor, ed., *America as Art* (Washington: National Collection of Fine Arts, Smithsonian Institution Press, 1976), 144.

21. Bingham to Rollins, September 23, 1844, in "Letters," 13–14.

22. See Henry Adams, "A New Interpretation of Bingham's *Fur Traders Descending the Missouri*," *Art Bulletin* 65 (December 1983): 675–80; and Rash, *The Painting and Politics*, chap. 3. As a young Lexington lawyer, Henry Clay flourished in the legal system that had earlier invalidated Boone's claims on land that he had explored. In the words of Boone's biographer John Bakeless, "Indians with knives, rifles, war clubs, and tomahawks held no terror for Daniel Boone. Lawyers with calf-bound books, writs, summonses, and suits conquered him easily enough" (340). See Stephen Anthony Aron, "How the West Was Lost: The Transformation of Kentucky from Daniel Boone to Henry Clay" (Ph.D. diss., University of California at Berkeley, 1990).

23. Bingham to Rollins, February 21, 1841, in "Letters," 12.

24. Cawelti, "The Frontier and the Native American," 144; and Glanz, *How the West Was Drawn*, 22.

25. See, for example, Kathryn Kish Sklar, *Catharine Beecher* (New Haven: Yale University Press, 1973), Ian Gough, "Marx's Theory of Productive and Unproductive Labor," *New Left Review* 76 (November–December 1972): 42–72, and Lise Vogel, "The Earthly Family," *Radical America* 7 (July–October 1973): 9–50.

26. See Linda Kerber, *Women of the Republic: Intellect and Ideology in Revolutionary America* (1980; reprint, New York: Norton, 1986).

27. Johnny Faragher and Christine Stansell, "Women and Their Families on the Overland Trail to California and Oregon, 1842–1867," *Feminist Studies* 2:2/3 (1975): 150–66. See John Mack Faragher, *Women and Men on the Overland Trail* (New Haven: Yale University Press, 1979). My figures are from Merrill J. Mattes, *The Great Platte River Road* (Lincoln: Publications of Nebraska State Historical Society, 1969), 23, and the demographic table reproduced in Lillian Schlissel, *Women's Diaries of the Westward Journey* (New York: Schocken Books, 1982), 24.

28. Helen M. Carpenter, Overland Journey, July 3, 1846 (Newberry microfilm 4–7, compiled by M. J. Mattes in 1945), 9. Quoted in Robert L. Munkres, "Wives, Mothers, Daughters: Women's Life on the Road West," *Annals of Wyoming* 42 (October 1970): 218.

29. "Mr. Burnett hauled a box out on the sidewalk, took his stand upon it, and began to tell us about the land flowing with milk and honey on the shores of the Pacific. . . . With a little twinkle in his eye he said 'and they do say, gentlemen, they do say, that out in Oregon the pigs are running about under the great acorn trees, round and fat, and already cooked, with knives and forks sticking in them so that you can cut off a slice whenever you are hungry.' . . . Father was so moved by what he heard . . . that he decided to join the company that was going west to Oregon." Verne Bright, "The Folklore and History of the Oregon Fever," *Oregon Historical Quarterly* (1951): 251–52. Quoted in Schlissel, *Women's Diaries*, 20–21.

30. Lavinia Honeyman Porter, *By Ox Team to California: A Narrative of Crossing the Plains in 1860* (Oakland: author, 1910), 41. Cited in Faragher and Stansell, "Women and Their Families," 153.

31. "Journal of Myra Eells. Kept while passing through the United States and over the rocky mountains in the spring and summer of 1838," in *Transactions of the Oregon Pioneer Association*,

Seventeenth Annual Reunion (Portland, June 18, 1889), 9 (entry for April 30, 1838). Quoted in Munkres, "Wives, Mothers, Daughters," 191. The quotation about Rebecca Boone is from Timothy Flint, *Biographical Memoir of Daniel Boone*, ed. James K. Folsom (1833; reprint, Schenectady, N.Y.: New College and University Press, 1967), 129. The passage actually describes not the Boones' errand into the wilderness but rather their emigration away from it a few years later when Rebecca, believing herself a widow (Daniel had been captured by Indians and was presumed dead), returned east with the remainder of her family. Surely if Bingham had wished to strike a happier note, he could have taken his cues instead from this earlier passage in Flint (36): "On a fine April morning [Boone] set forth for the land of promise—wife, children, servants [slaves], flocks, and herds, forming a patriarchal caravan through the wilderness. No procession bound to the holy cities of Mecca or Jerusalem, was ever more joyful, for to them the forest was an asylum. Overhung by the bright blue sky, enveloped in verdant forests full of game, nought cared they for the absence of houses with their locks and latches." Bloch, *The Paintings of George Caleb Bingham*, 19, note 68, proposes that Humphrey Marshall's *History of Kentucky* (1824) supplied Bingham with his imagery, whereas Glanz, *How the West was Drawn*, 164, note 73, claims instead that it came from a passage in John M. Peck's *Life of Daniel Boone* (1847), but of course the point of this chapter (and book) is to demonstrate that artistic imagery derives from countless discursive sources in a culture and can never exclusively, or usefully, be pinned down to any single one.

32. On mourning rituals in Victorian America, see Karen Halttunen, *Confidence Men and Painted Women: A Study of Middle-Class Culture in America, 1830–1870* (New Haven: Yale University Press, 1982), chap. 5, John Morley, *Death, Heaven and the Victorians* (Pittsburgh: University of Pittsburgh Press, 1971), and Lawrence Taylor, "Symbolic Death: An Anthropological View of Mourning Ritual in the Nineteenth Century," in *A Time to Mourn: Expressions of Grief in Nineteenth Century America*, ed. Martha V.

Pike and Janice Gray Armstrong (Stony Brook, N.Y.: The Museums at Stony Brook, 1980). The ultimate send-up of Victorian mourning art, of course, is Huck Finn's description of the woman-leaning-on-a-tombstone drawings of young Emmeline Grangerford, which are captioned with such expressions as "Shall I Never See Thee More Alas" and "I Shall Never Hear Thy Sweet Chirrup More Alas." Such sad pictures, according to Huck, "always give me the fan-tods." Mark Twain, *The Adventures of Huckleberry Finn* (1885), chap. 17.

33. Joseph C. and Owen Lovejoy, *Memoir of Elijah P. Lovejoy* (New York: John S. Taylor, 1838), 149 ("To My Fellow Citizens," November 5, 1835) and 156 (letter of November 2, 1835). Thomas Ford, *A History of Illinois from Its Commencement as a State in 1818 to 1847* (Chicago: S. C. Griggs, 1854), 234–45, offers a view of Lovejoy as a fanatical, mob-provoking abolitionist who "goaded [citizens] on to madness" (242) and was largely responsible for starting the riot that lead to his death. The Lovejoy Papers are held in Special Collections, Colby College, Waterville, Maine.

34. As Sweeney, *The Columbus of the Woods*, 49, astutely notes, "At [Boone's] feet and to his side are rude cruciforms, reminding the spectator that unlike the Hebrew prophet Moses, Daniel Boone and his party are the new American chosen people emigrating West to a Promised Land that is specifically Christian."

35. Brutus [Samuel F. B. Morse], *Foreign Conspiracy against the Liberties of the United States* (New York: Leavitt, Lord, 1835). See the Reverend Francis John Connors, "Samuel Finley Breese Morse and the Anti-Catholic Political Movements in the United States (1791–1872)," *Illinois Catholic Historical Review* 10:2 (October 1927): 119. On antebellum nativism and prejudice, see David Brion Davis, "Some Themes of Counter-Subversion: An Analysis of Anti-Masonic, Anti-Catholic, and Anti-Mormon Literature" (1960) and "Some Ideological Functions of Prejudice in Ante-Bellum America" (1963), in his *From Homicide to Slavery: Studies in American Culture* (New York: Oxford University Press, 1986), 137–54, 155–65, respectively, and David H. Bennett, *The Party of Fear: From Nativist Movements to the New Right in*

American History (Chapel Hill: University of North Carolina Press, 1988), part 1.

36. Thomas Jefferson to John Adams, June 11, 1812, in *The Adams-Jefferson Letters: The Complete Correspondence between Thomas Jefferson and Abigail and John Adams*, ed. Lester J. Cappon (Chapel Hill: University of North Carolina Press for the Institute of Early American History and Culture at Williamsburg, Virginia, 1959), 2:308.

37. This and the quotes in the following two paragraphs are from Andrew Jackson, "First Annual Message" (December 8, 1829), in J. D. Richardson, ed., *A Compilation of the Messages and Papers of the Presidents: 1789–1897* (Washington: Bureau of National Literature, 1913), 2:1021–22, id., "Second Annual Message" (December 6, 1830), 2:1084–85, and, in regard to the ruling by the chief justice, Jackson as quoted in Horace Greeley, *The American Conflict: A History of the Great Rebellion in the United States of America* (Hartford, Conn.: O. D. Case, 1864–66), 1:106. See Robert V. Remini, *The Life of Andrew Jackson* (New York: Harper and Row, 1988), 216.

38. Jane A. Gould Tourtillott, "Diary. 1862." Photocopy in Bancroft Library, University of California, Berkeley. Quoted in Schlissel, *Women's Diaries*, 225.

39. Herman Melville, *The Confidence Man: His Masquerade*, afterword by R. W. B. Lewis (New York: New American Library, 1964), 154, 156.

40. Bingham, September 23, 1844, in "Letters," 13–14; and Flint, *Biographical Memoir*, 49, 46.

41. Vivien Green Fryd, *Art and Empire: The Politics of Ethnicity in the United States Capitol, 1815–1860* (New Haven: Yale University Press, 1992), 89–105, details the commission of *Rescue* for the Capitol and discusses its subsequent history. According to a contemporary review, the statue group "communicated to every spectator . . .

the natural and necessary superiority of the Anglo-Saxon to the Indian" (101) (Fryd cites her source as J.A., "Greenough the Sculptor, and His Last Production," *Bulletin of the American Art-Union* [September 1851]: 96–98).

42. Flint, *Biographical Memoir*, 149.

43. Melville, *The Confidence Man*, 151, 157.

44. Cole's concealment of the braves tests the eyes of his viewers, as if to demand of them the keen perceptual skills that were commonly attributed to Indians or their white counterparts, for example, Cooper's Leatherstocking, who was also known as Hawkeye. The fact that most reproductions of *Schroon Mountain* fail to discriminate these details further accounts for why they have gone unnoticed.

45. Drinnon, *Facing West: The Metaphysics of Indian-Hating and Empire Building* (Minneapolis: University of Minnesota Press, 1980), 134–39. Drinnon invokes Bingham's *Boone* on 131–32, 147.

46. Concerning the commonly held view that American Indians were in fact Jews (direct descendants of one of the so-called lost tribes of Israel), see Thomas Jefferson's letter to John Adams, June 11, 1812, in *The Adams-Jefferson Letters*, 306–07. Jefferson scoffs at the idea but then advances his own imagined parallel between Indians and "the antient Patriarchs, the Noahs, the Abrahams, Isaacs and Jacobs."

47. W. Harrison Ainsworth, editor's preface to first English edition of *Nick of the Woods* (London: Richard Bentley, 1837), vi. See Robert M. Bird, *Nick of the Woods or the Jibbenainosay: A Tale of Kentucky*, ed. Curtis Dahl (1837; reprint, New Haven: New College and University Press, 1967).

48. One might recall here Durand's habit of inscribing the trees he painted with names such as Cole and Bryant or with his own signature: the writing of civilization onto or into that which most signifies nature.

49. Scholars of Henry James have noted his predilection for incorporating popular fiction and theater into his own fiction. Could he have been ironically alluding to Ralph Stackpole when he devised the names Ralph Touchett and Henrietta Stackpole for *The Portrait of a Lady?* On James and popular theater and fiction, see William Veeder, *Henry James—The Lessons of the Master: Popular Fiction and Personal Style in the Nineteenth-Century* (Chicago: University of Chicago Press, 1975).

50. Melville, *The Confidence Man*, 153, 152.

51. Ralph Waldo Emerson, "Self-Reliance" (1840), in *Selections from Ralph Waldo Emerson: An Organic Anthology*, ed. Stephen E. Whicher (Boston: Houghton Mifflin, 1957), 147–68.

52. Junius [Calvin Colton], *Democracy. Number VI of The "Junius" Tracts* (January 1844), 87, and in Daniel Walker Howe, *The American Whigs: An Anthology* (New York: John Wiley and Sons, 1973), 98. For a detailed study of *George Washington*, see Fryd, *Art and Empire*, chap. 3.

53. Boone moved from North Carolina to Kentucky in the mid-1770s, Jackson from the Carolinas to Tennessee in 1788, and Clay from Virginia to Kentucky in 1797.

54. See Carol Clark, "Charles Deas," in Amon Carter Museum, *American Frontier Life: Early Western Painting and Prints*, exhib. cat. (New York: Abbeville Press, 1987), 51–77. Also, Elizabeth Johns, *American Genre Painting* (New Haven: Yale University Press, 1991), chap. 2, "From the Outer Verge of Our Civilization," esp. 73–75.

55. David Crockett, *A Narrative of the Life of David Crockett by Himself* (Philadelphia: E. L. Carey and A. Hart, 1834), 171.

56. *Davy Crockett's Almanac 1837* (Nashville, 1837), 19, quoted in Carroll Smith-Rosenberg, "Davy Crockett as Trickster: Pornography, Liminality, and Symbolic Inversion in Victorian America," in her *Disorderly Conduct: Visions of Gender in Victorian America* (New York: Knopf, 1985), 97. Excerpts from the Nashville almanacs are collected in Franklin J. Meine, ed., *The Crockett Almanacs: Nashville Series, 1835–1838* (Chicago: The Caxton Club, 1955). See Michael A. Lofaro, "The Hidden 'Hero' of the Nashville Crockett Almanacs," in *Davy Crockett: The Man, The Legend, The Legacy, 1786–1986*, ed. Lofaro (Knoxville: University of Tennessee Press, 1985), 46–79.

57. Smith-Rosenberg, "Davy Crockett as Trickster," 103.

58. Quoted in Walter Blair, "Six Davy Crocketts," *Southwest Review* 25 (July 1940): 451. On Crocket as an embodiment of raw, untamed power, see Catherine L. Albanese, "Davy Crockett and the Wild Man; Or, The Metaphysics of the Longue Durée," in Lofaro, *Davy Crockett*, 80–101.

59. Mary Douglas, *Natural Symbols: Explorations in Cosmology* (New York: Pantheon Books, 1970) and *Purity and Danger: An Analysis of Concepts of Pollution and Taboo* (New York: Routledge and Kegan Paul, 1966).

60. Bingham to Rollins, November 2, 1846; March 10, 1847; and March 30, 1851 (in "Letters," 15, 17, and 20). The Crockett line is from *Davy Crockett's Almanac 1836* (Nashville, 1836), 39, quoted in Smith-Rosenberg, "Davy Crockett as Trickster," 97.

61. For more on this work, see Demos, "George Caleb Bingham: The Artist as Social Historian," 222, John McDermott, "Another Bingham Found: 'The Squatters,'" *Art Quarterly* 19 (Spring 1956): 68–71, and Ron Tyler, "George Caleb Bingham, The Native Talent," in *American Frontier Life*, 35–36. Barbara Groseclose considers Bingham's portrayal of the squatters relatively sympathetic in "The 'Missouri Artist' as Historian," in *George Caleb Bingham*, Shapiro et al., 62, as does Elizabeth Johns in "The 'Missouri Artist' as Artist," ibid., 112–18. Glanz, *How the West Was Drawn*, 21–22, argues the case for interpreting *The Squatters* negatively and, furthermore, sees in the switch-wielding mule driver etched against the sky in *Boone* a "disconcerting image of cruelty" that she links to the artist's profound distrust of "a less desirable element in the pioneer population . . . this restless and landless class so often found on the fringes of a frontier society" (21).

62. Bingham wrote to the board of the Art-Union, "The Squatters as a class, are not fond of the toil of agriculture, but erect their rude Cabins upon those remote portions of the National domain, where the abundant game supplies their phisical [sic] wants. When this source of subsistence be-

comes diminished, in consequence of increasing settlements around, they usually sell out their slight improvement, with their 'presentation title' to the land, and again follow the receding footsteps of the Savage" (George C. Bingham to the American Art-Union, November 19, 1850, Letters from Artists, vol. 6, American Art-Union Papers, New-York Historical Society). The artist worried about the legitimacy of suffrage for squatters inasmuch as they made no long-term commitment to the localities in which they voted. "These illegitimate Loco focos [Democrats], whose votes we wish to brush out of our way, have so scattered since the election, over our big praries [sic], that it takes a long time, with a good deal of pulling and hauling to get them up to mark. Some of them have gone clear off to parts unknown" (Bingham to Rollins, November 2, 1846, "Letters," 15). See Rash, The Painting and Politics, 58–61, for a contrast of The Squatters and The Wood Boat, which she sees as pendants, the one painting depicting a selfish despoilment of the land, the other its judiciously industrious husbandry. On the artistic representation of deforestation, see Nicolai Cikovsky, Jr., " 'The Ravages of the Ax': The Meaning of the Tree Stump in Nineteenth-Century American Art," Art Bulletin 61 (December 1979): 611–26. The painting that best exemplifies a genteel mid nineteenth-century distaste for deforestation is Sanford Gifford's Hunter Mountain, Twilight (1866, Terra Musuem of American Art, Chicago). See also Barbara Novak, Nature and Culture: American Landscape Painting, 1825–1875 (New York: Oxford University Press, 1980), 157–65, and J. Gray Sweeney, Themes in American Painting, exhib. cat. (Grand Rapids, Mich.: Grand Rapids Art Museum, 1977), 83.

63. Drinnon, Facing West, 147–49; and Niles Register 24 (May 17, 1823): 166, quoted in Smith, The Virgin Land, 54.

64. The Crockett Almanac 1846, n.p., quoted in Smith-Rosenberg, "Davy Crockett as Trickster," 106. In "A Snake Story," Davy Crockett's Almanac 1847 (Philadelphia, 1847, collection of the St. Louis Mercantile Library Association), n.p., Davy recounts, "When I war courting Ann Hunky, up in Dog's Paradise, it war a hot summer's evening, and we sot in doors without anything around one another's necks, an I war feeding Ann with the eend of a sassenger [sausage] and a pig's tale. She held open her mouth while I poked it in. All of a sudden we looked around, an the room behind us war full of snakes as it could hold; I took up Ann and sot her on the shelf out of the way, but I war in sich a hurry that I sot her behind into a plaitern o' hot soap, an she jumpt down pesky fast, an squirmed most beautiful, for it burnt her sum, I think. Then the snakes cum at me an twisted around my legs, an arms an body, like a Yankee peddlar when he wants to cheat you out of a dollar." Surely the sexuality alluded to in this passage is neither strictly heterosexual nor homosexual but polymorphously perverse.

65. Annette Kolodny, The Lay of the Land: Metaphor as Experience and History in American Life and Letters (Chapel Hill: University of North Carolina Press, 1975), 112. D. H. Lawrence, in his acerbic essay on Cooper, argues that "one is forced to admire the stark, enduring figure of Deerslayer. . . . He says: 'Hurt nothing unless you're forced to.' Yet he gets his deepest thrill of gratification, perhaps, when he puts a bullet through the heart of a beautiful buck, as it stoops to drink at the lake." Studies in Classic American Literature (1923; reprint, New York: Penguin, 1981), 68.

66. Flint, Biographical Memoir, 38–40.

67. Not only Boone but all of Bingham's work may be seen as an effort on his part to sanitize the westerner for eastern audiences. On this point, see Angela Miller, "The Mechanisms of the Market and the Invention of Western Regionalism: The Example of George Caleb Bingham," in American Iconology: New Approaches to Nineteenth-Century Art and Literature, ed. David Miller (New Haven: Yale University Press, 1993), 112–34. Elizabeth Johns, "Settlement and Development: Claiming the West," in Truettner, The West as America, 191–235, surveys a number of images by Bingham and others that advertise western settlement and the progressive, democratic spirit of western settlers: "The story these pictures tell is that of the winners in the West. . . . There the disciplined settler flourished, gentility went hand-in-hand with technical expertise, and, above all, energy and hard work were rewarded" (233). Or as Timothy W. Luke in Shows of Force: Power, Politics, and Ideology in Art Exhibitions (Durham: Duke University Press, 1992), 20, observes, "Bingham's paintings clearly were invitations in homespun composition and color to Easterners to 'Go West' in the 1840s and 1850s. Depicting a mode of direct, face-to-face democracy from the then distant golden age of Jefferson and Jackson, Bingham illustrated a mythological way of American life innocent of abolitionism, sectionalism, and industrialism even as these destructive forces gripped Bingham's audience east of the Mississippi."

68. [John L. O'Sullivan], "The True Title," New York Morning News, December 27, 1845: "[It is] our manifest destiny to overspread and to possess the whole of the continent which Providence has given us for the development of the great experiment of liberty and federated self-government entrusted to us." The two most influential studies of Manifest Destiny are Frederick Merk, Manifest Destiny and Mission in American History: A Reinterpretation (New York: Knopf, 1963), and Albert K. Weinberg, Manifest Destiny: A Study of Nationalist Expansionism in American History (Baltimore: Johns Hopkins University Press, 1935).

69. Thomas Hart Benton, speech delivered before Congress (May 1847), in William M. Meigs, The Life of Thomas Hart Benton (Philadelphia: J. B. Lippincott, 1904), 308–10.

70. Not that warlike ambition and peaceful settlement were necessarily thought incompatible. As John L. O'Sullivan rhapsodized in 1845 (in terms similar to those of Benton's "Caucasian vanguard" speech), "Already the advanced guard of the irresistible army of Anglo-Saxon emigration has begun to pour down upon [California], armed with the plough and the rifle, and marking its trail with schools and colleges, courts and representative halls, mills and meeting-houses."

[O'Sullivan], "Annexation," *Democratic Review* 17:85 (July–August 1845): 9. This almost sounds like a program for Bingham's major canvases from *Boone* to *The County Election* and *The Verdict of the People* (1854–55).

71. Bloch, *Evolution of the Artist*, 128; Garry Wills, *Cincinnatus: George Washington and the Enlightenment* (New York: Doubleday, 1984).

72. Henry Vest Bingham, "The Diary of Henry Vest Bingham: The Road West in 1818," ed. Marie Windell, *Missouri Historical Review* 40 (1945–46), 21–54, 174–204; Nagel, "The Man and His Times," 18–19.

73. Boone was cheated out of his property in the mid-1780s by none other than Gilbert Imlay, the adventurer who later took up with Mary Wollstonecraft in Paris and abandoned her after she bore their child. In his *Topographical Description of the Western Territory of North America* (1792), Imlay celebrated (or perhaps slyly mocked) Boone as the epitome of backwoods innocence. Reprinting the book the following year, Imlay appended Boone's "autobiography" as recorded by John Filson in his *Discovery, Settlement and Present State of Kentucke* (1784). These works, along with Daniel Bryan's epic poem *The Mountain Muse: Comprising the Adventures of Daniel Boone* (1813), provided the hunter with his initial fame. On Boone and Imlay, see Faragher, *Daniel Boone*, 246–47; on the mythography of Boone, see ibid., chap. 10, and Slotkin, *Regeneration through Violence*.

74. Chester Harding, *My Egotistography* (Cambridge, Mass.: John Wilson and Son, 1866), 35–36, reprinted as *A Sketch of Chester Harding, Artist, Drawn By His Own Hand*, ed. Margaret E. White (Boston: Houghton, Mifflin, 1890), 47–48. See Clifford Amyx, "The Authentic Image of Dani⸍¹ Boone," *Missouri Historical Review* 82:2 (1988): 153–64, Faragher, *Daniel Boone*, 317, 334, Leah Lipton, "Chester Harding and the Life Portrait of Daniel Boone," *American Art Journal*

16:3 (Summer 1984): 4–19, and id., *A Truthful Likeness: Chester Harding and His Portraits* (Washington, D.C.: National Portrait Gallery, 1985), and Sweeney, *The Columbus of the West*, chap. 2.

75. According to a recently discovered letter by Bingham to J. Colvin Randall of Philadelphia (December 25, 1872), the artist as a child avidly watched Harding complete the Boone portrait in a rented studio in Franklin, Missouri. See Leah Lipton, "George Caleb Bingham in the Studio of Chester Harding, Franklin, Missouri, 1820," in *American Art Journal* 16:3 (Summer 1984): 90–91, and, for a survey of Boone portraits derived from Harding's, Roy T. King, "Portraits of Daniel Boone," *Missouri Historical Society Review* 33 (January 1939): 171–83. For discussion of various nineteenth-century paintings of Boone in addition to Bingham's, see Glanz, *How the West Was Drawn*, chap. 1, and Sweeney, *The Columbus of the Woods*.

76. Matthew Arnold, "Stanzas from the Grande Chartreuse" (1852), in his *Poems: Dramatic and Lyric* (London: Macmillan, 1869), 2:219.

77. Herman Melville, *White Jacket* (1850; London: Oxford University Press, 1966), 157 (chap. 36, "Flogging not necessary"); Nathanial Hawthorne, *The House of the Seven Gables* (1851; Columbus: Ohio State University Press, 1965), 182 (chap. 12, "The Daguerreotypist"); Karl Marx, *The Eighteenth Brumaire of Louis Bonaparte* (1852; New York: International Publishers, 1963), 15; Thomas Jefferson to Samuel Kercheval, July 12, 1816, in *The Writings of Thomas Jefferson*, Memorial Edition, vol. 15, ed. Andrew A. Lipscomb and Albert Ellery Bergh (Washington: Thomas Jefferson Memorial Association, 1903–04), 43. The remainder of the passage from Marx seems appropriate to Bingham's *Boone* and the era in which he painted it: "And just when [the living] seem engaged in revolutionizing themselves and things, in creating something that has never yet existed, precisely in such periods of revolutionary crisis they anxiously conjure up the spirits of the past to their service and borrow from them names, battle cries and costumes in order to present the new scene of world history in this time-honoured disguise and this borrowed language."

Chapter 3
Reconstructing Duncanson

1. For discussion of Duncanson and his art, see David C. Driskell, *Two Centuries of Black American Art* (New York: Alfred A. Knopf, 1967), Lynda Roscoe Hartigan, *Sharing Traditions: Five Black Artists in Nineteenth-Century America* (Washington: Smithsonian Institution Press, 1985), 51–68, Joseph D. Ketner II, "Robert S. Duncanson (1821–1872): The Late Literary Landscape Paintings," *American Art Journal* 15:1 (Winter 1983): 35–47, id., "Robert Duncanson (1821–1872)," in *Artists of Michigan from the Nineteenth Century*, ed. J. Gray Sweeney (Muskegon, Mich.: Muskegon Museum of Art, 1987), 62–67, Guy McElroy, *Robert S. Duncanson: A Centennial Exhibition* (Cincinnati: Cincinnati Art Museum, 1972), James Dallas Parks, *Robert S. Duncanson: 19th Century Black Romantic Painter* (Washington, D.C.: Associated Publishers, 1980), and James A. Porter, "Robert S. Duncanson: Midwestern Romantic-Realist," *Art in America* 39:3 (October 1951): 99–154. A detailed bibiliography to 1972 is in *Afro-American Artists: A Bio-bibliographical Directory*, comp. and ed. Theresa Dickason Cederholm (Boston: Boston Public Library, 1973), 83–85, and a more selective one in McElroy, *Robert S. Duncanson*, 15–17. On the 1987 Hudson River School exhibition, see *American Paradise: The World of the Hudson River School*, exhib. cat., intro. John K. Howat (New York: Metropolitan Museum of Art, 1987).

Two recent books that deal extensively with nineteenth-century paintings of, and in some cases by, black Americans—although neither concerns itself with Duncanson—are Albert Boime, *The Art of Exclusion: Representing Blacks in the Nineteenth Century* (Washington, D.C.: Smithsonian Institution Press, 1990), and Guy C. McElroy, *Facing History: The Black Image in American Art 1710–1940*, exhib. cat. (Washington, D.C.: Bedford Arts and the Corcoran Gallery of Art, 1990). The introductory essay to *Facing History* by Henry Louis Gates, Jr., "The Face and Voice of Blackness" (xxix–xlvi), observes that most black Americans in the nineteenth century steered clear of the fine

arts because the visual field was so surfeited with grossly stereotypical representations that virtually any attempt to depict blacks nonstereotypically would have failed to achieve credibility. Hence, according to Gates, black artists and intellectuals of the time relied on literature instead of the visual arts to tell their story or, as was the case with Duncanson, they "achieved success not by developing a repertoire of African-American imagery but by emulating developing American artistic conventions, which were in turn based on European models" (xxx). Gates concludes, "Until the 1920s there was virtually no black counterpoint to the hegemony of racist visual images that dominated the popular arts and more subtly infiltrated the fine arts" (xliv). The present chapter ponders ways in which the landscape paintings of Duncanson could in fact be taken as a black counterpoint to racist hegemony, albeit a counterpoint that to this day remains muffled and hard to hear.

2. bell hooks, *Talking Back: Thinking Feminist, Thinking Black* (Boston: South End Press, 1989), 43. Diana Fuss, *Essentially Speaking: Feminism, Nature and Difference* (New York: Routledge, 1989), discusses the difficult issues involved in reconciling identity politics (i.e., group solidarity through a perception of shared essence) with a postmodernist rejection of essentialism. In an antagonistic review of *Essentially Speaking*, hooks contends that Fuss unfairly criticizes as divisive the identity politics of such marginalized groups as African-Americans and fails to see that in the classroom as well as in society at large the white majority maintains an exclusionary, if unacknowledged, identity politics. See hooks, "Essentialism and Experience," *American Literary History* 3:1 (Spring 1991): 172–83.

3. hooks, *Talking Back*, 48. A less hopeful view of the possibilities for racial transcendence on the part of white critics is presented by Michael Awkward in "Negotiations of Power: White Critics, Black Texts, and the Self-Referential Impulse," *American Literary History* 2:4 (Winter 1990): 581–606. Toni Morrison, *Playing in the Dark: Whiteness and the Literary Imagination* (Cambridge: Harvard University Press, 1992), 9–10, points out that many white critics today are

so afraid of offending anyone by calling attention to race in their critical discussions that they avoid the topic altogether, and blackness thus encounters yet another form of invisibility: "The habit of ignoring race is understood to be a graceful, even generous liberal gesture," she explains, but unfortunately this "well-bred instinct . . . *against noticing* [the racial dimensions of the text] . . . forecloses adult discourse."

4. See, for example, Albert Boime, *The Magisterial Gaze: Manifest Destiny and American Landscape Painting* (Washington: Smithsonian Institution Press, 1991), Angela Miller, *The Empire of the Eye: The Cultural Politics of Landscape Representation in the United States, 1825–1875* (Ithaca: Cornell University Press, 1993), David C. Miller, *Dark Eden: The Swamp in Nineteenth-Century American Culture* (New York: Cambridge University Press, 1989), and William H. Truettner and Alan Wallach's exhibition catalogue for the forthcoming Cole retrospective at the National Museum of American Art in Washington.

5. William Stafford, " 'This Once Happy Country': Nostalgia for Pre-Modern Society," in Christopher Shaw and Malcolm Chase, eds., *The Imagined Past: History and Nostalgia* (Manchester: University of Manchester Press, 1989), 44–45. The Nietzsche quotation is in Paul de Man, "Literary History and Literary Modernity," in de Man's *Blindness and Insight: Essays in the Rhetoric of Contemporary Criticism*, 2d ed., rev. (Minneapolis: University of Minnesota Press, 1983), 149–50. For a different translation, see Friedrich Nietzsche, "On the Uses and Disadvantages of History for Life" (1874), in Nietzsche, *Untimely Meditations*, trans. R. J. Hollingdale, intro. J. P. Stern (Cambridge: Cambridge University Press, 1983), 76 (the passage in question is in the final paragraph of section 3). Paul de Man achieved posthumous notoriety when it was discovered that he had invented his own past in order to pass in academic circles in America after the Second World War, having gone to great lengths to obscure the collaborationist and anti-Semitic activities of his youth in Nazi-occupied Belgium. See David Lehman, *Signs of the Times:*

Deconstruction and the Fall of Paul de Man (New York: Poseidon Press, 1991).

As a black artist working in a predominantly white artistic environment, James Baldwin often described high-pressure situations in his own life that may bear comparison to those encountered by Duncanson in somewhat similar (if in other ways very different) circumstances a century earlier. In *Nobody Knows My Name: More Notes of a Native Son* (New York: Dial Press, 1961), 232, Baldwin offers the Nietzschean reflection that "to become a Negro man, let alone a Negro artist, one had to make oneself up as one went along," but in a subsequent work, *The Fire Next Time* (New York: Dial Press, 1963), 95, he also echoes Nietzsche's caution about inventing a new past for ourselves by trying to eradicate the old: "To accept one's past—one's history—is not the same thing as drowning in it; it is learning how to use it. An invented past can never be used; it cracks and crumbles under the pressures of life like clay in a season of drought."

6. Asher B. Durand, "Letters on Landscape Painting, Letter VIII," *The Crayon* 1:23 (June 6, 1855): 355.

7. See Inman's *Trout Fishing in Sullivan County, New York* (c. 1841, Munson-Williams-Proctor Institute, Utica, New York) and Sonntag's *Landscape* with two boys fishing (1854, Cincinnati Art Museum) as well as a possible compositional source from an earlier generation, Cole's *In the Catskills* (1827, Arnot Art Museum, Elmira, N.Y.), in which the staffage figure is not a boy fishing but a solitary Leatherstocking leaning on his rifle.

8. Joseph D. Ketner II, author of the forthcoming *The Emergence of the African-American Artist: Robert S. Duncanson, 1821–72* (Columbia: University of Missouri Press, 1993), has recently informed me that his exhaustive research has uncovered no evidence that Duncanson's paternity was Scots or Scots-Canadian. Having studied the relevant census records,

Ketner has concluded that the artist's father, John Dean Duncanson, was the freeborn mulatto son of Charles Duncanson, himself a mulatto who came from Virginia and was possibly a former slave set free after the Revolution for military services rendered or may have been emancipated by a white slave owner who perhaps fathered him (a relatively common scenario during that period). The Duncansons moved to Fayette, New York, where Robert was born to John Dean and his wife, Lucy, who according to census indications was also a mulatto. Ketner believes that the Scots background attributed to Duncanson by twentieth-century scholars is a modern fabrication, a sort of art-historical folklore without any discernible roots in the nineteenth-century (no nineteenth-century sources on Duncanson identify him as being of Scots or Canadian descent). Even the middle name now commonly attributed to him, Scott, appears to be of twentieth-century coinage, inasmuch as during his lifetime the artist's middle name was represented only by the letter *S*. Still, one wonders where the name Duncanson originated, if not from a Scottish forebear somewhere along the line (typically mulatto slaves were fathered by their owners or owners' near relations, although it is true that slaves were identified by the master's family name whether or not there was actually a biological connection).

Ketner also disputes the notion that as a child Duncanson lived with his father in Canada (maybe in Wilberforce, Ontario, a town formed in 1830 as a refuge for freed and escaped slaves), and that he later moved to Mount Healthy, Ohio, to be with his mother. Judging from tax and census records, Ketner claims that Duncanson's parents were never separated and that in the late 1830s they moved as a unit from Fayette to Monroe, Michigan, a flourishing river town where Robert acquired the handyman and housepainter skills that he carried to Cincinnati with him in his pursuit of employment opportunities.

My interpretations in this chapter are based upon what I learned of Duncanson from the generally accepted secondary literature that Ketner argues is more folkloric than factual. His research is intriguing and will surely be controversial, cutting as it does against the grain of the Duncanson scholarship. At this point I think it best to let my chapter stand as I have written it, with its acceptance of the standard presumption that the father was white or, if not white, the son or grandson of a white and that he may have taken his boy to live with him in Canada.

What will become clear as the chapter proceeds is that life in the antebellum and postbellum North was full of heinous indignities for African-Americans, regardless of how dark or light they may have been. Under such circumstances, the Scottish ancestry assigned to Duncanson by twentieth-century commentators may very well have been invented by the artist himself (although I must emphasize that, given his lightness of skin and his surname, the possibility of actual Scottish paternity from one or two generations back is hardly out of the question, regardless of what census records may indicate). To borrow once more from Nietzsche, Duncanson may have endowed himself with the past from which he preferred to descend. Whatever the exact details of his parental background, Duncanson was conspicuously the product of racial if not also cultural mixing. We may never be able to find out with certainty whether or not this was a persistent and troubling issue in his personal life, but what we do know with certainty is that race and racial mixing were matters of obsessive concern to his contemporaries. This is the one essential fact around which my reading of the artist and his art revolves.

9. Quotations from Donald Ralph MacKenzie, "Painters in Ohio, 1788–1860" (Ph.D. diss., Ohio State University, 1960), 28, and Charles Cist, *Cincinnati in 1841, Its Early Annals and Future Prospects* (Cincinnati: Charles Cist, 1841), 138. For a modern overview of mid nineteenth-century Cincinnati, see Denny Carter, "Cincinnati as an Art Center, 1830–1865," in *The Golden Age: Cincinnati Painters of the Nineteenth-Century*, exhib. cat. (Cincinnati: Cincinnati Art Museum, 1979),

13–21, and Steven J. Ross, *Workers on the Edge: Work, Leisure, and Politics in Industrializing Cincinnati, 1788–1890* (New York: Columbia University Press, 1985).

10. *Philanthropist*, November 10, 1841, quoted in Richard W. Pih, "Negro Self-Improvement Efforts in Ante-Bellum Cincinnati, 1836–1850," *Ohio History* 78:3 (Summer 1969): 181. For a detailed study of black labor and life in Ohio during the nineteenth century, see David A. Gerber, *Black Ohio and the Color Line, 1860–1915* (Urbana: University of Illinois Press, 1976), esp. chap. 1 on the antebellum period, and the pioneering essay by Carter G. Woodson, "The Negroes of Cincinnati Prior to the Civil War," *Journal of Negro History* 1:1 (January 1916): 1–22.

11. Leon F. Litwack, *North of Slavery: The Negro in the Free States, 1790–1860* (New York: University of Chicago Press, 1961), 97.

12. Leonard P. Curry, *The Free Black in Urban America 1800–1850: The Shadow of the Dream* (Chicago: University of Chicago Press, 1981), 107–08.

13. Roscoe Hartigan, *Sharing Traditions*, 51. In his study of mulattoes in the United States, Joel Williamson defines his terms thus: "For Caucasians 'white' will be used. For people of African heritage unmixed with Caucasians on this side of the Atlantic I shall use the term 'black.' 'Mulatto' in the United States has generally been understood to refer to people in whom the mixture of black and white is visible. Such, for instance, was the use made of the word in the United States Census from 1850 to 1920. I shall use the term, however, to refer to people with any mixture at all of black and white ancestry. For groups of people that include both mulattoes and blacks I shall use the term 'Negro.' " By this principle of definition, Duncanson was a Negro and certainly was considered as such, despite the very light shading of his skin. Joel Williamson, *New People: Miscegenation and Mulattoes in the United States* (New York: Free Press, 1980), xii.

14. The Ohio abolitionist James G. Birney was willing to admit that the laws of his state discriminated against "colored" persons but he claimed that "in Ohio the laws regard all who are mulattoes, or above the grade of mulattoes, as *white*" (emphasis his).

Such was the case in theory, not in practice. The legislators left it to the state supreme court to define what the laws meant. The court ruled that persons who could prove *more than* 50 percent white ancestry counted legally as white in their civil and political relations with society—although the same court later ruled against admitting children with a preponderance of white ancestry into the regular public schools and did not prevent mulattoes from being barred at the polling place. See Birney, "American Slavery" (1839), in Louis Ruchames, *The Abolitionists: A Collection of Their Writings* (New York: Capricorn Books, 1964), 176, and, as a refutation, Gerber, *Black Ohio*, 7–9.

15. James Oliver Horton, "Shades of Color: The Mulatto in Three Antebellum Northern Communities," *Afro-Americans in New York Life and History* 8:2 (July 1984): 47, and E. Franklin Frazier, *Black Bourgeoisie* (Glencoe, Ill.: Free Press, 1957), 137. See Ira Berlin, *Slaves without Masters: The Free Negro in the Antebellum South* (New York: Pantheon, 1974), 257–58. Also, Henry Taylor, "The Commercial City and the Formation of Black Neighborhoods in Cincinnati: 1800–1850," working papers, Cincinnati Urban Studies Project, 1982.

16. John G. Mencke, *Mulattoes and Race Mixture: American Attitudes and Images, 1865–1918* (Ann Arbor: UMI Research Press, 1979, n.p. ["Introduction"]).

17. Malcolm X quoted in Alex Haley, "Epilogue" to *The Autobiography of Malcolm X* (New York: Grove Press, 1965), 417.

18. Frederick Douglass, *Narrative of the Life of Frederick Douglass, An American Slave*, ed. Houston A. Baker, Jr. (1845; reprint, New York: Penguin, 1982), 106–07; William Wells Brown, *Narrative of the Life of William W. Brown, An American Slave* (1845; reprint, London: Charles Gilpin, rev. ed. 1850), 83 (chap. 11); and Harriet Beecher Stowe, *Uncle Tom's Cabin, or Life among the Lowly*, intro. Ann Douglas (1852; reprint, New York: Penguin, 1981), 117 (chap. 7).

19. See Howard Thurman, *Deep River* (Dublin, Ind.: Friends United Press, 1975), 70.

20. Frazier, *Black Bourgeoisie*, 112–13.

21. Douglass, *Narrative of the Life*, 58.

22. Du Bois describes Negro spirituals as the means by which "the slave spoke to the world" through a hidden code, "naturally veiled and half articulate," that sought to elude the master's suspicions. For Lovell, hymns about the other world implicitly served to rebuke this world: to praise paradise was to condemn the plantation. Spirituals are "the key to [the slave's] revolutionary sentiments and his desire to fly to free territory." These are two extraordinary essays. See W. E. B. Du Bois, "Of the Sorrow Songs" (chap. 14), in *The Souls of Black Folk* (1903), and John Lovell, Jr., "The Social Implications of the Negro Spiritual," *Journal of Negro Education* (October 1939): 638–39. For other authoritative claims about the covert resistance contained in slave spirituals, see Sarah Bradford, *Harriet Tubman: The Moses of Her People* (New York: George Lockwood, 1886), 27, and Booker T. Washington, *Up from Slavery* (New York: Doubleday, Page, 1901), 19–20. A good collection of nineteenth- and early twentieth-century essays on this topic is Bernard Katz, ed., *The Social Implications of Early Negro Music in the United States* (New York: Arno Press and New York Times, 1969). Two other influential studies are James H. Cone, *The Spirituals and the Blues: An Interpretation* (New York: Seabury Press, 1972), and Lawrence J. Levine, *Black Culture and Black Consciousness: Afro-American Folk Thought from Slavery to Freedom* (New York: Oxford University Press, 1977).

23. See Du Bois, "The Forethought," in *Souls of Black Folk*.

24. "The whites left the camp meeting and went out to conquer the wilderness. The Negroes left spiritual singing and plotted to upset the system of slavery. In each case, the song was just a stimulation for the march." Lovell, "The Negro Spiritual," 133. Probably the earliest *theoretical* articulation of the point I am trying to make is by the Soviet literary theorist V. N. Vološinov [possibly a front for Mikhail M. Bakhtin, who was politically censored], in *Marxism and the Philosophy of Language*, trans. Ladislav Matejka and I. R. Titunik (1929; reprint, Cambridge: Harvard University Press, 1986), 21–23. Vološinov/Bakhtin asserts that "every

sign . . . is a construct between socially organized persons in the process of their interaction. . . . Every ideological sign—the verbal sign included—in coming about through the process of social intercourse, is defined by the *social purview* of the given time period and the given social group." Social signs, in this case the Hudson River School formulae for landscape painting, are "multiaccentual" even though they are normally treated as being "uniaccentual": "The ruling class strives to impart a supraclass, eternal character to the ideological sign, to extinguish or drive inward the struggle between social value judgments which occurs in it, to make the sign uniaccentual." To the contrary, though, "every living ideological sign has two faces, like Janus. Any current curse word can become a word of praise, any current truth must inevitably sound to many other people as the greatest lie." Hemingway's Lieutenant Henry demonstrates Vološinov's point: "I was always embarrassed by the words sacred, glorious, and sacrifice and the expression in vain. . . . [To me] abstract words such as glory, honor, courage, or hallow were obscene." See Ernest Hemingway, *A Farewell to Arms* (New York: Charles Scribner's Sons, 1929), 184–85 (chap. 27).

25. My understanding of signifyin' is based on Henry Louis Gates, Jr., "The 'Blackness of Blackness': A Critique of the Sign and the Signifying Monkey," in *Figures in Black: Words, Signs, and the "Racial" Self* (New York: Oxford University Press, 1987), 235–50, and id., *The Signifying Monkey: A Theory of Afro-American Literary Criticism* (New York: Oxford University Press, 1988). As Gates explains in his essay "Criticism in the Jungle," in *Black Literature and Literary Theory*, ed. Gates (New York: Methuen, 1984), 6, "Black people have always been masters of the figurative: saying one thing to mean something quite other has been basic to black survival in oppressive Western cultures." For anthropological background, see Roger D. Abrahams, *Deep*

Down in the Jungle: Negro Narrative Folklore from the Streets of Philadelphia (rev. ed., Chicago: Aldine Publishing, 1970), and Claudia Mitchell-Kernan, "Signifying," in *Language Behavior in a Black Urban Community*, Monographs of the Language-Behavior Laboratory, University of California, Berkeley, no. 2 (February 1971), 87–129, as well as Zora Neale Hurston's pioneering account of the practice in her folklore study *Mules and Men* (1935; reprint, New York: Negro Universities Press, 1969). The white man, Hurston's anonymous voice of the black folk proclaims, "can read my writing but he sho' can't read my mind" (19). Gates spells the term *signifyin(g)*, but I have preferred to write *signifyin'* instead as a means of emphasizing the black vernacular quality of the word and the casual, antiformalistic behavior associated with it. Seeing it written this way is a good reminder of how, to use the lingo, it "signifies on" the word that it replaces, sounding almost like it but not quite the same.

26. R. W. B. Lewis, *The American Adam* (Chicago: University of Chicago Press, 1955).

27. Genesis 9:13–15.

28. Psalm 137:1.

29. Harriet E. Wilson, *Our Nig*, intro. Henry Louis Gates, Jr. (New York: Vintage, 1983). The book's subtitle is "Sketches from the Life of a Free Black, In a Two-Story White House, North. Showing That Slavery's Shadows Fall Even There."

30. William Wordsworth, "The Rainbow" (1802), *The Poetical Works* (Edinburgh: William Paterson, 1882), 2:260. See Jonathan Wordsworth, Michael C. Jaye, and Robert Woof, "The Child is Father of the Man" (chap. 3), in *William Wordsworth and the Age of English Romanticism*, exhib. cat. (New Brunswick, N.J.: Rutgers University Press, 1987), 60–85.

31. The fullest, and most fulsome, review of the painting ("The sight of it cannot fail to be a source of intense enjoyment") is "The Land of the Lotus-Eaters. Painted by R. S. Duncanson," *Art Journal* (London), n.s. 5 (1866): 95. The reviewer, by the way, identifies Duncanson as "a native of the States" but makes no mention of race.

32. Joseph D. Ketner II, "Robert S. Duncanson (1821–1872): The Late Literary Landscape Paintings," 39.

33. Alfred Lord Tennyson, "The Lotos-Eaters" (1832, rev. 1842), *Tennyson's Poetry: Norton Critical Edition*, ed. Robert W. Hill, Jr. (New York: Norton, 1971), 47–52.

34. Alan Sinfield, *Alfred Tennyson* (New York: Basil Blackwell, 1986), 39.

35. See Katherine Manthorne, *Tropical Renaissance: North American Artists Exploring Latin America, 1839–79* (Washington: Smithsonian Institution Press, 1989).

36. John Blassingame, *The Slave Community: Plantation Life in the Ante-Bellum South* (New York: Oxford University Press, 1972), 2–6.

37. [David Goodman Croly], *Miscegenation: The Theory of the Blending of the Races, applied to the American White Man and Negro* (New York: H. Dexter, Hamilton, 1864).

38. Thomas Jefferson, February 4, 1824, letter to Jared Sparks, in *Writings* (Washington: Thomas Jefferson Memorial Association, 1904), 16:8.

39. Samuel Sullivan Cox, "Emancipation and Its Results—Is Ohio to Be Africanized?" *Speech of Hon. S. S. Cox, of Ohio, Delivered in the House of Representatives, June 6, 1862* (Washington, 1862), 1–16, reprinted in Stanley Feldstein, ed., *The Poisoned Tongue: A Documentary History of American Racism and Prejudice* (New York: William Morrow, 1972), 139–47. Leon Litwack, *North of Slavery*, 279, is eloquent on the irony of the situation faced by northern blacks and mulattoes after 1860: "Having excluded the Negro from profitable employments, the whites scorned his idleness and poverty; having taxed him in some states for the support of public education, they excluded his children from the schools or placed them in separate and inferior institutions and then deplored the ignorance of his race; having excluded him from various lecture halls and libraries, they pointed to his lack of culture and refinement; and, finally, having stripped him of his claims to citizenship and having deprived him of opportunities for political and economic advancement, the whites concluded that the Negro had demonstrated an incapacity for improvement in this country and should be colonized in Africa."

40. For purposes of cross-cultural comparison, see Syed Hussein Alatas, *The Myth of the Lazy Native* (London: Frank Cass, 1977), which examines the colonialist functions of the nineteenth-century laziness myth in regard to islanders of the South Seas. In his classic study *The Colonizer and the Colonized* (1957; reprint, Boston: Beacon Press, 1967), 79, the Tunisian writer Albert Memmi identifies "the often-cited trait of laziness" as occupying "an important place in the dialectics exalting the colonizer and humbling the colonized," for "nothing could better justify the colonizer's privileged position than his industry, and nothing could better justify the colonized's destitution than his indolence."

41. W. Alfred Jones, "A Sketch of the Life and Character of William S. Mount," *American Whig Review* 14 (1851): 124 ff., quoted in [Mary] Bartlett Cowdrey and Hermann Warner Williams, Jr., *William Sidney Mount, 1807–1868: An American Painter* (New York: Columbia University Press for the Metropolitan Museum of Art, 1944), 17. On the racial politics of *Farmers Nooning*, see Boime, *The Art of Exclusion*, 93–95, and Elizabeth Johns, *American Genre Painting: The Politics of Everyday Life* (New Haven: Yale University Press, 1991), 33–38. Also on Mount's depiction of African-Americans, see Bruce Robertson, "*The Power of Music*: A Painting by William Sidney Mount," *Bulletin of the Cleveland Museum of Art* 79:2 (February 1992): 38–62. On the black male body as a designated locus for mid nineteenth-century white dread of and desire for laziness and sensuality, see Michael Hatt, " 'Making a Man of Him': Masculinity and the Black Body in Mid-Nineteenth-Century American Sculpture," *Oxford Art Journal* 15:1 (1992): 21–35. Elizabeth V. Spelman, *Inessential Woman: Problems of Exclusion in Feminist Thought* (Boston: Beacon Press, 1988), 126–28,

points out that the traditional sexist reification of the female body as being more earthy, natural, and bound to the senses—more embodied—than that of men parallels the white racist description of the black body in those same terms, and she warns feminists that any effort to eschew female physicality (as a means of fighting the socially restrictive equation of anatomy with destiny) tends to buy into sexist and racist assumptions alike about embodiedness as the marker of mental and spiritual inferiority.

42. Constance McLaughlin Green, *The Secret City: A History of Race Relations in the Nation's Capital* (Princeton: Princeton University Press, 1967), 65. See also Mencke, *Mulattoes and Race Mixture*, 25.

43. David Brion Davis, *The Problem of Slavery in Western Culture* (Ithaca: Cornell University Press, 1966), 59; Blassingame, *The Slave Community*, 136. Quotation from Dr. Samuel A. Cartwright, "On the Caucasians and the Africans," *DeBow's Review* 25 (July 1858): 45–56.

44. My thanks to Joseph Ketner for calling this important but easily missed detail to my attention. We know of the daguerreotype (unlocated) from an engraving in *Graham's Magazine* 32:6 (June 1848): between pp. 300 and 301. Albert Boime compares the painting to the engraving in *Magisterial Gaze*, 120–23. Duncanson's *Uncle Tom and Little Eva* (1853), discussed below, also features a black figure, but that work is at least as much a genre scene or literary illustration as a landscape painting. So far as we know, these are the only two Duncanson paintings to include black subjects.

45. This was recognized by even such a figure of probity as Asher Durand, who wrote, "To the rich merchant and capitalist, and to those whom even a competency has released from the great world-struggle, so far as to allow a little time to rest and reflect in, Landscape Art especially appeals—nor does it appeal in vain." Durand, "Letter IV," *The Crayon* 1:7 (February 14, 1855): 98.

46. See, for example, Karl Marx, "Private Property and Communism," in *The Economic and Philosophic Manuscripts of 1844*, ed. and intro. Dirk J. Struik (New York: International Publishers,

1964), 135; Paul Lafargue, *The Right to Be Lazy* (1883), trans. Charles H. Kerr and intro. Joseph Jablonski, with bio-bibliographical essay ("Paul Lafargue, Work & Leisure") by Fred Thompson (Chicago: Charles H. Kerr, 1989). See Vincent Geoghegan. *Utopianism and Marxism* (New York: Methuen, 1987), 60–61. Thompson, "Paul Lafargue," 88, notes that Lafargue was born in Cuba and was the grandson of a Haitian mulatta and her French planter husband.

47. Antonio Gramsci, "The Intellectuals" (c. 1930), in *Selections from the Prison Notebooks*, ed. and trans. Quintin Hoare and Geoffrey Nowell Smith (New York: International Publishers, 1971), 9; W. E. B. Du Bois, "The Talented Tenth" (1903), in *Writings by W. E. B. Du Bois in Non-Periodical Literature Edited by Others*, comp. and ed. Herbert Aptheker (Millwood, N.Y.: Kraus-Thomson Organization, 1982), 17. This essay originally appeared in [editor unknown] *The Negro Problem: A Series of Articles by Representative American Negroes of Today* (New York: James Pott, 1903), 33–75.

48. James O. Horton, "Black Urbanites: An Interpretation of Afro-American Life in the Antebellum City," *Afro-Americans in New York Life and History* (January 1983): 67–68. William Stafford makes a related point in warning historians about assuming that earlier cultures or subcultures were as individualistic as our own—and therefore about writing off as mere nostalgia or wishful thinking views such as Horton's, which propose that there were indeed organic and nonindividualistic social communities. Stafford, " 'This Once Happy Country,' " 45.

49. R. S. Duncanson to Reuben Graham, June 29, 1871, reprinted in Parks, *Robert S. Duncanson: Black Romantic Painter*, 30.

50. See Milton Meltzer, ed., *In Their Own Words: A History of the American Negro, 1619–1865* (New York: Thomas Y. Crowell, 1964), 150–51; and Moncure D. Conway, "A Cincinnati Colored Artist in England," Cincinnati *Gazette*, November 24, 1865. On Duncanson in Canada, see Allan Pringle, "Robert S. Duncanson in Montreal, 1863–65," *American Art Journal* 17 (Autumn 1985): 28–50.

and Dennis Reid, *"Our Own Country Canada" Being an Account of the National Aspirations of the Principal Landscape Artists in Montreal and Toronto, 1860–1890* (Ottawa: National Gallery of Canada, 1979), 40–44.

51. The work also bears comparison to earlier views of Loch Katrine by Turner (c. 1831–33), John Ruskin (1838), and the leading Scottish landscapist of the period, Horatio McCulloch (1866). See James Holloway and Lindsay Errington, *The Discovery of Scotland: The Appreciation of Scottish Scenery through Two Centuries of Painting*, exhib. cat. (Edinburgh: National Gallery of Scotland, 1978), chap. 9. The French artist Gustave Doré traveled through the Highlands a few years after Duncanson (in 1873). The mountain and lake views that resulted—for instance, his *Loch Lomond* (1875)—are considerably more dramatic, less serene or melancholy, than what Duncanson produced. See Robert B. Simon, "Doré in the Highlands," *Journal of the Walters Art Gallery* 47 (1989): 53–60.

52. Douglass, *Narrative of the Life*, 147; W. E. B. Du Bois, "Criteria of Negro Art" (1926), in *The Seventh Son: The Thought and Writings of W. E. B. Du Bois*, ed. Julius Lester (New York: Random House, 1971), 2:313–14. See Ketner, "The Late Literary Landscapes," 45–46, which compares the painting and Scott's poem.

53. This and the two passages from the poem that follow are from Sir Walter Scott, *The Lady of the Lake* (1810; reprint, Edinburgh: Adam and Charles Black, 1869), 29, 45, 43 (Canto First, stanzas 3, 15, 14).

54. Elias Nason, *The Life and Times of Charles Sumner* (Boston: B. B. Russell, 1874), 335; Porter, "Robert S. Duncanson," 151. Sumner's Civil Rights Bill, introduced in 1870, boldly guaranteed all citizens equal access to public accommodations, common carriers, jury service, public schools, churches, and cemeteries, but by the spring of 1872 it floundered in Congress and washed up dead. See Eric Foner, *Reconstruction:*

America's Unfinished Revolution, 1863–1877 (New York: Harper and Row, 1988), 504–05.

55. Holloway and Errington, *The Discovery of Scotland*, 109.

56. Trevor R. Pringle, "The Privation of History: Landseer, Victoria and the Highland Myth," in *The Iconography of Landscape: Essays on the Symbolic Representation, Design and Use of Past Environments*, ed. Denis Cosgrove and Stephen Daniels (New York: Cambridge University Press, 1988), 153. See also Hugh Trevor-Roper, "The Invention of Tradition: The Highland Tradition of Scotland," in *The Invention of Tradition*, ed. Eric Hobsbawm and Terence Ranger (New York: Cambridge University Press, 1983), 15–41. On the industrialization of the Highlands, see John B. S. Gilfillan and H. A. Moisley, "Industrial and Commercial Developments to 1914," in *The Glasgow Region: A General Survey*, ed. Ronald Miller and Joy Tivy (Glasgow: British Association, 1958), 178–80. Bernard Aspinwall, *Portable Utopia: Glasgow and the United States, 1820–1920* (Aberdeen: Aberdeen University Press, 1984), is a rich and relevant source of information about Scotland in the minds of nineteenth-century Americans. Glasgow, which was the second city of the British empire, was described by Horace Greeley as "more American than any city I have seen in Europe. Half of Pittsburgh spliced on to half of Philadelphia would make a city like Glasgow" (xi). Americans who visited the Highlands were typically stunned by the raw physical beauty of the region and appalled by its poverty. An agent for the American Colonization Society, convinced that the world-famous Scottish abolitionism was hypocritical, exclaimed, "Would that half the sympathy and eloquence now expended in Scotland in behalf of American slaves were directed to her wretched and perishing poor" (8).

On the subject of Scottish abolitionism (a reason, of course, that Duncanson might have favored Scotland even without benefit of an ancestral connection), see C. Duncan Rice, *The Scots Abolitionists, 1833–1861* (Baton Rouge: Louisiana State University Press, 1981). On Duncanson's abolitionist patronage, see Hal S. Chase, "Abolitionist Patronage in Afro-American Art, 1833–72," in *Duncanson: A British-American Connection*, exhib. cat. (Durham: North Carolina Central University Museum of Art, 1984), 5–7. Alan Thomas, *Time in a Frame: Photography and the Nineteenth-Century Mind* (New York: Schocken Books, 1980), 136–40, discusses the work of Thomas Annân.

57. Freud claims that when the patient says of the person who appeared in his dream, " 'It's *not* my mother' . . . We emend this to: 'So it *is* his mother.' " Sigmund Freud, "Negation" (1925), in *The Standard Edition* (London: The Hogarth Press and the Institute of Psycho-Analysis, 1961), 19:235. See Ernst Bloch, *The Utopian Function of Art and Literature: Selected Essays*, trans. Jack Zipes and Frank Mecklenburg (Cambridge: MIT Press, 1988); and Bertolt Brecht, "Against Georg Lukács" (notes orig. publ. posthumously 1967), in Theodor Adorno et al., *Aesthetics and Politics*, trans. Stuart Hood, afterword Fredric Jameson (London: Verso, 1980), 83. "Whether a work is realistic or not cannot be determined merely by checking whether or not it is like existing works which are said to be realistic, or were realistic in their time" (85). Herbert Marcuse's is another voice to add to the discussion about the ability of art to negate the status quo by envisioning a world that presently does not exist. See, for example, his *One-Dimensional Man: Studies in the Ideology of Advanced Industrial Society* (Boston: Beacon Press, 1964), 56–77, although I suspect Marcuse would find Duncanson's nineteenth-century fantasy landscapes to be more a harbinger of the formulaic, one-dimensional mass consciousness to reach fruition in the twentieth century than a protest against it. Nietzsche yet again can be used to comment on the false or invented consciousness that would appear to pertain both to Duncanson himself and to his imaginary (that is, false or erroneous)

landscapes of peace and plenty: "The erroneousness of a concept does not for me constitute an objection to it; the question is—to what extent is it advantageous to life?" Quoted in Allon White, *The Uses of Obscurity: The Fiction of Early Modernism* (London: Routledge and Kegan Paul, 1981), 62.

58. New York *Tribune*, April 24, 1849.

59. Detroit *Free Press*, September 16, 1871; and Duncanson to Ruben Graham, June 29, 1871, in Parks, *Robert S. Duncanson: Black Romantic Painter*, 30.

60. hooks, *Talking Back*, 67.

61. Henry Mosler, quoted in McElroy, *Robert S. Duncanson*, 15; and Detroit *Tribune*, December 26, 1872, quoted in Parks, *Robert S. Duncanson: Black Romantic Painter*, 24.

62. Since Duncanson's era, the tragic mulatto has been a stock figure of literature, film, and drama. I do not mean to portray Duncanson as the embodiment of this stereotype or explain away his fatal breakdown as the result of an inability to accept mixed-race status (both Ruskin and Nietzsche, for example, were also committed to mental institutions for the remainder of their lives, and neither was a mulatto). I am, however, joining what little information there is about Duncanson's collapse to considerable sociological evidence about the mental damage brought on by life in a society of extreme racial divisiveness to infer that such life was psychologically debilitating for him— more so, perhaps, than it was for other African-Americans who, in the racist catchphrase, knew their place. On the phenomenology of racial oppression, see the essays of Frantz Fanon, particularly those collected in his *Black Skin, White Masks*, trans. Charles Lam Markham (New York: Grove Press, 1967), and on the literary tradition of the tragic mulatto, see Judith R. Berzon, *Neither White nor Black: The Mulatto Character in American Fiction* (New York: New York University Press, 1978).

63. Alexis de Tocqueville, *Democracy in America*, ed. Phillips Bradley (New York: Vintage Books, 1955), 2:270; William W. Stephenson, Jr., "Integration of the Detroit Public School System during the Period 1839–1869," *Negro History Bulletin* 26:1 (October 1962): 23–28; *Walton's Weekly Art Journal* (April 1865), cited in Walter Hopps,

"Foreword," in Peter Wood and Karen C. C. Dalton, eds., *Winslow Homer's Images of Blacks: The Civil War and Reconstruction Years* (Austin: University of Texas Press, 1988), 7; Hartigan, *Sharing Traditions*, 69–70.

64. William Chambers, *Things as They Are in America* (London: William and Robert Chambers, 1854), 357.

65. Du Bois, *The Souls of Black Folk* (1903; reprint, New York: New American Library, 1969), chap. 1 ("Of Our Spiritual Strivings"), 45.

66. Matthew 6:24.

67. See Brown, *Narrative of the Life*, 96–98.

68. For a contemporary version of this matter of black intellectual filiation (to use Edward Said's apt term), see Harold Fromm, "Real Life, Literary Criticism, and the Perils of Bourgeoisification," *New Literary History* 20:1 (Autumn 1988): 49–64, Norman Harris, "'Who's Zoomin' Who': The New Black Formalism," *Journal of the Midwest Modern Language Association* 20 (1987): 37–45, and Joyce A. Joyce, "The Black Canon: Reconstructing Black American Literary Criticism," *New Literary History* 18 (1986): 335–44. These essays charge certain well-known black male literary theorists with misguidedly—or opportunistically—becoming epigones of the currently dominant white theoretical establishment. Houston A. Baker, Jr. ("In Dubious Battle") and Henry Louis Gates, Jr. ("'What's Love Got to Do with It?': Critical Theory, Integrity, and the Black Idiom"), also in *New Literary History* 18 (1986): 363–69 and 345–62, put forth rebuttals to Joyce, who initiated the exchange. Michael Awkward comments on the debate in "Race, Gender, and the Politics of Reading," *Black American Literature Forum* 22 (1988): 5–27, and "Negotiations of Power," cited above, 595–99. Signifyin' on Tina Turner's sexual query, "What's love got to do with it?" Gates, in effect, seems to rephrase Duncanson's "What have the colored people done for me?"

In the opinion of the maverick art historian and anthropologist Cedric Dover, *American Negro Art* (Greenwich, Conn.: New York Graphic Society, 1960), 25, Duncanson was a discredit to his race, an opportunistic and self-absorbed formalist with a "feeling of superiority which caused him to reject the Negro people and identify himself with Scotland. . . . [Duncanson was] a character afflicted beyond recognition of the momentous struggle around him, or appreciation of the progressive attitudes of the patrons who sustained him." Similarly, Eldridge Cleaver, in *Soul on Ice* (New York: McGraw-Hill, 1968), 102–03, roundly dismisses contemporary black artists and intellectuals (specifically James Baldwin) who "act white," which is to say, write, paint, or think white: "The gulf between an audacious, bootlicking Uncle Tom and an intellectual buckdancer is filled only with sophistication and style. On second thought, Uncle Tom comes off much cleaner here because usually he is just trying to survive, choosing to pretend to be something other than his true self in order to please the white man and thus receive favors. Whereas the intellectual sycophant does not pretend to be other than he actually is, but hates what he is and seeks to redefine himself in the image of his white idols. He becomes a white man in a black body. A self-willed, automated slave, he becomes the white man's most valuable tool in oppressing other blacks."

69. Frances E. W. Harper, *Iola Leroy or Shadows Uplifted*, intro. Hazel V. Carby (1892; reprint, Boston: Beacon Press, 1987), 263, 235; and Charles W. Chesnutt, *The Wife of His Youth and Other Stories of the Color Line* (1899; reprint, Ann Arbor: University of Michigan Press, 1968).

70. Stowe, *Uncle Tom's Cabin*, 381.

71. Douglass, *Narrative of the Life*, 106.

72. Stowe, *Uncle Tom's Cabin*, 381.

73. The dark-brown curve of Tom's back recapitulated in the arch of the trunks overhead, Eva's twisted yellow locks falling to her shoulders in the same manner that the Spanish moss drips from the trees, the ghostly pallor of her face and negative space of his, her paper doll flatness, the preternatural flowers in the left foreground, the ominously discarded straw bonnet, the humid atmosphere—in short, the *weirdnesses* of this undulating work—may make it more compelling to modern eyes than anything to be found in Duncanson's more rational, conventional, well-wrought celebrations of nature.

74. Detroit *Free Press*, April 21, 1853, 2, quoting the Cincinnati *Commercial Gazette*. See Porter, "Robert S. Duncanson," 129.

75. Stephen C. Foster to E. P. Christy, May 25, 1852, in John Tasker Howard, *Stephen Foster, America's Troubadour* (New York: Tudor, 1939), 196. See Robert C. Toll, *Blacking Up: The Minstrel Show in Nineteenth-Century America* (New York: Oxford University Press, 1974), and for a provocative recent study of minstrelsy, Eric Lott, "'The Seeming Counterfeit': Racial Politics and Early Blackface Minstrelsy," *American Quarterly* 43:2 (June 1991): 223–54. "De Camptown Races" (1850) and "Old Folks at Home" (1851) can be found in *The Music of Stephen C. Foster: A Critical Edition*, vol. 1 *(1844–1855)*, ed. Steven Saunders and Deane L. Root (Washington: Smithsonian Institution Press, 1990), 82–85, 191–94.

76. The term *denigrate* derives from the Latin *nigrare*, "to blacken." To denigrate something is to characterize it as black: to blacken its value or reputation. In the present context, the racial dimensions of the term are striking.

77. John Ruskin, *Modern Painters* (1860), in *Works*, ed. E. T. Cook and Alexander Wedderburn (London: George Allen, 1903–12), 5:326; and Ishmael Reed, *Yellow Back Radio Broke-Down* (Garden City, N.Y.: Doubleday, 1969), 36.

Chapter 4
Lilly Martin Spencer's Domestic Genre Painting

1. Virgil Barker, *American Painting: History and Interpretation* (New York: Macmillan, 1950), 513.

2. Ann Byrd Schumer, "Lilly Martin Spencer," *Notable American Women, 1607–1950*, vol. 3 (Cambridge: The Belknap Press of Harvard University Press, 1971); Robin Bolton-Smith and William H. Truettner, *Lilly Martin Spencer (1822–1902): The Joys of Sentiment* (Washington: National Collection of Fine Arts, 1973).

3. See, for example, Whitney Chadwick, *Women, Art, and Society* (New York: Thames and Hudson, 1990), Wendy Slatkin, *Women Artists in History: From Antiquity to the 20th Century* (Englewood Cliffs: Prentice-Hall, 1990), and Eleanor Tufts, ed., *American Women Artists, 1830–1930* (Washington: National Museum of Women, 1987).

4. Two recent responses to Spencer that insightfully examine the diverse ways her art functioned during a period of fledgling woman's rights activism and the sentimental cult of true womanhood are Elizabeth Johns, *American Genre Painting: The Politics of Everyday Life* (New Haven: Yale University Press, 1991), 160–75, and Helen S. Langa, "Lilly Martin Spencer: Genre, Aesthetics, and Gender in the Work of a Mid-Nineteenth Century Woman Artist," *Athanor* 9 (1990): 37–41. Also, at this point I would like to acknowledge three pathbreaking essays that, without saying a word about Spencer, are integral to the sensibility that informs this chapter: Linda Nochlin's "Why Have There Been No Great Women Artists?" (1971), in *Art and Sexual Politics: Women's Liberation, Women Artists, and Art History*, ed. Thomas B. Hess and Elizabeth C. Baker (New York: Collier Books, 1973), 1–44, and Tillie Olsen's "Silences: When Writers Don't Write" (1962) and "One Out of Twelve: Women Who Are Writers in Our Century" (1971), in *Silences* (New York: Delacorte Press / Seymour Lawrence, 1978), 6–21, 22–46.

5. Michael Denning, "The End of Mass Culture," *International Labor and Working-Class History* 37 (Spring 1990): 4. As Gareth Stedman Jones has shown, the term *social control* is massively problematic for cultural studies, Marxist or otherwise, in that it implies a one-way sort of domination, a monolithic, totalistic operation in which one class ideologically overwhelms another. Conceptual corsetting of this kind proves to be intellectually restrictive in various ways, not the least of which, according to Jones, is that it is idealist, shunting off the various classes of any given period into preassigned roles and responses (e.g., the bourgeois are those who brainwash, the proletariat those who sit there and take it). In this chapter, then, I resort to the term *social control* only as a means of putting into shorthand the argument I am ascribing to certain critics of sentimentalism, perhaps fairly to them but perhaps not. Jones, "Class Expression versus Social Control? A Critique of Recent Trends in the Social History of 'Leisure,'" in his *Languages of Class: Studies in English Working Class History, 1832–1982* (Cambridge: Cambridge University Press, 1983), 76–89. Brian Rigby, *Popular Culture in Modern France: A Study of Cultural Discourse* (New York: Routledge, 1991), a detailed study of popular-culture debates taking place in France during the past half century, is particularly good at tracing the political implications of the various opposing positions, and as such it is pertinent here.

6. Henriette A. Hadry, "Mrs. Lilly M. Spencer," *Sartain's Union Magazine* 9:2 (August 1851): 152–53, quoted in Bolton-Smith and Truettner, *Lilly Martin Spencer*, 133; and Elizabeth Ellet, *Women Artists: In All Ages and Countries* (New York: Harper and Brothers, 1859), 324.

7. Heman Humphrey, *Domestic Education* (Amherst, Mass.: J. S. and C. Adams, 1840), 16, reprinted in David Brion Davis, ed., *Antebellum American Culture: An Interpretive Anthology* (Lexington, Mass.: D. C. Heath, 1979), 10. See Philip Greven, *The Protestant Temperament: Patterns of Child-Rearing, Religious Experience, and the Self in Early America* (New York: Knopf, 1977), on the historically evolving religious controversy over child-rearing.

8. Humphrey, *Domestic Education*, 21.

9. Lydia Maria Child, *The Mother's Book* (1831; reprint, New York: C. S. Francis, 1844), 22.

10. Richard Brodhead, "Spare the Rod: Discipline and Fiction in Antebellum America," *Representations* 21 (Winter 1988): 74. For a dispute with Brodhead's reliance on Foucault, see Steven Watts, "The Idiocy of American Studies: Poststructuralism, Language, and Politics in the Age of Self-Fulfillment," *American Quarterly* 43:4 (December 1991): 633–37.

11. *The Phalanx* 1:21 (February 8, 1844): 318, in Nancy Cott, ed., *Root of Bitterness* (New York: E. P. Dutton, 1972), 246–47. In *The Anti-Social Family* (London: Verso, 1982), Michèle Barrett and Mary McIntosh make a similar point about the social consequences of the "isolated household" of the nuclear family, although as late twentieth-century Marxist feminists their language as well as their analysis is decidedly (though not entirely) less sentimental than that of the Fourierists. The most complete source on the mid-century woman's movement is Elizabeth Cady Stanton, Susan B. Anthony, and Matilda Joslyn Gage, *History of Woman Suffrage*, vol. 1 (1848–61) (2d ed.; Rochester, N.Y.: Susan B. Anthony, 1889). See also *Elizabeth Cady Stanton / Susan B. Anthony: Correspondence, Writings, Speeches*, ed. with critical commentary by Ellen Carol DuBois (New York: Schocken Books, 1981), and id., *Feminism and Suffrage: The Emergence of an Independent Women's Movement in America, 1848–1869* (Ithaca: Cornell University Press, 1978). A fascinating glimpse into the rich feminist dialogues of the period is provided by Ann Russo and Cheris Kramarae, eds., *The Radical Women's Press of the 1850s* (New York: Routledge, 1991).

12. [Jane Sophia Appleton] "Sequel to the 'Vision of Bangor in the Twentieth Century,'" in *Voices from the Kenduskeag* (Bangor, Me.: David Bugbee, 1848), 256, which is reprinted in Arthur O. Lewis, Jr., ed., *American*

Utopias: Selected Short Fiction (New York: Arno Press and The New York Times, 1971). For an antebellum-era discussion of Fourier's principles, see Parke Godwin, *A Popular View of the Doctrines of Charles Fourier* (1844; reprint, New York: AMS Press, 1974). See also Charles Fourier, *Design for Utopia: Selected Writings of Charles Fourier*, trans. Julia Franklin (New York: Schocken Books, 1971), and Dolores Hayden, *Seven American Utopias: The Architecture of Communitarian Socialism, 1790–1975* (Cambridge: MIT Press, 1976). Phoebe Pyncheon's snuffing out of the Fourierist impulses of the young bachelor Holgrave in Hawthorne's *House of the Seven Gables* is tellingly and wittily discussed by Joel Pfister in *The Production of Personal Life: Class, Gender, and the Psychological in Hawthorne's Fiction* (Stanford: Stanford University Press, 1991), 156–61.

13. Lilly Martin Spencer to Angelique Martin, October 11, 1850, and December 29, 1859, Archives of American Art microfilm roll 131. All subsequent quotations from letters are from this source. See Elsie Freivogel, "Lilly Martin Spencer: Feminist without Politics," *Archives of American Art Journal* 12:4 (1972): 9–14. Spencer's feminist contemporary Elizabeth Cady Stanton recalled of this period, "Fourier's phalansterie community life and co-operative households had a new significance for me. . . . The general discontent I felt with woman's portion as wife, mother, housekeeper, physician, and spiritual guide, the chaotic conditions into which everything fell without her constant supervision, and the wearied, anxious look of the majority of women impressed me with a strong feeling that some active measures should be taken to remedy the wrongs of society in general and of women in particular." Stanton, *Eighty Years and More: Reminiscences, 1815–1897*, intro. Gail Parker (1898; reprint, New York: Schocken, 1971), 147–48.

14. Letter, July 9, 1848.

15. Margaret Atwood, *Lady Oracle* (New York: Ballantine Books, 1976), 35 [and 20]. Elizabeth Cady Stanton's response to this passage might be imagined from the heading of one of her short pieces for a feminist newspaper known as *The Lily:* "Don't

Give Us Romance, We'll Take Self-Dependence." *The Lily* 4:5 (May 1852): 40, reprinted in Russo and Kramarae, *Radical Women's Press*, 282–83.

16. Stephanie Coontz, *The Social Origins of Private Life: A History of American Families, 1600–1900* (London: Verso, 1988), 193; and "Home Sweet Home," from the Lynn *Pioneer*, reprinted in *The Lily* 1:2 (February 1, 1849): 10, and in Russo and Kramarae, *Radical Women's Press*, 74.

17. The Fourier-influenced American anarchist Stephen Pearl Andrews, in a manuscript written in the early 1850s, attacked the centrifugal energy of the privatized nuclear family in words that might almost have been written to apply not only to the theme of *Domestic Happiness* but to its formal properties: "The intense concentration of all the affections upon the little circles of immediate family relations and connections, instead of being a positive virtue, as has been assumed, is in fact only a virtue relatively to the existing falseness and antagonism of all the relations outside of the family. It is a secret and contraband hoarding of the affections." Stephen Pearl Andrews, *Love, Marriage, and Divorce, and the Sovereignty of the Individual; and a Hitherto Unpublished Manuscript: Love, Marriage, and the Condition of Women*, ed. Charles Shively (Weston, Mass.: M & S Press, 1975), 49–50, as quoted in Pfister, *The Production of Personal Life*, 160.

18. Susan Warner, *The Wide, Wide World*, afterword by Jane Tompkins (1850; reprint, New York: Feminist Press, 1987). Pertinent to several of the issues raised in this chapter is Nancy Schnog, "Inside the Sentimental: The Psychological Work of *The Wide, Wide World*," in *Genders* 4 (Spring 1989): 11–25.

19. A concise summary of these developments is contained in Carroll Smith-Rosenberg, *Disorderly Conduct: Visions of Gender in Victorian America* (New York: Alfred A. Knopf, 1985), 79–89.

20. From Marietta *Intelligence*, September 12, 1839, quoted in Ann Byrd Schumer, "Lilly Martin Spencer: American Painter of the Nineteenth Century" (M.A. thesis, Ohio State University, 1959), 12.

21. *The Crayon* 5:6 (June 1858): 177. "There is a vigor of the brush, and a successful rendering of expression in this picture that astonishes as much as one is repelled by the intense vulgarity of the scene." For details on all of Spencer's work, extant and otherwise, see Bolton-Smith and Truettner, *Lilly Martin Spencer*.

22. In the words of Sir Lawrence Gowing, "It is simple, immaculate: the perfection of Vermeer no longer needs expounding. His pictures contain themselves, utterly self-sufficient. . . . The scene is a familiar room, nearly always the same, its unseen door is closed to the restless movement of the household, the window opens to the light. Here a domestic world is refined to purity. . . . [Its female inhabitant] has no thought in particular, no remarkable occupation. Her mooning is caught in a mathematic net, made definite at last, part of a timeless order." Lawrence Gowing, *Vermeer* (New York: Harper and Row, 1970), 17–18.

23. Catharine Beecher, *A Treatise on Domestic Economy* (1841), intro. Kathryn Kish Sklar (New York: Schocken Books, 1977).

24. *The Crayon* 3:5 (May 1856): 146. In effect, Spencer's kitchen paintings eschew the code of modernism that Michael Fried, in *Absorption and Theatricality: Painting and Beholder in the Age of Diderot* (Berkeley: University of California Press, 1980), has described as the triumph of "absorption" over "theatricality" or, in other words, of the art object's internal self-sufficiency over evidence of concern with a world and an audience beyond itself. In this regard, Spencer is strictly premodern. Or is she instead what many today would describe as postmodern? The way her jaunty females insist upon eyeballing us is a brazen transgression of one of Western art's most adhered to codes, that of the invisibility of the viewer. With portraits one expects the direct gaze and thinks nothing of it, but these are genre scenes, not portraits.

They aggressively disrupt the "separate spheres" convention that neatly divides the world of the narrative from the world outside it.

25. *Cosmopolitan Art Journal* 1:5 (September 1857): 165. On the widespread influence of seventeenth-century Dutch genre painting on antebellum artists and their patrons, see H. Nichols B. Clark, *Francis W. Edmonds: American Master in the Dutch Tradition* (Washington: Smithsonian Institution Press, 1988). The most explicit account of Ruskin's ideal of true womanhood is contained in his lecture "Lilies—Of Queens' Gardens," which he published in *Sesame and Lilies* (1865). For a careful study of *The Crayon* and other American manifestations of Ruskin's aesthetics, see Roger B. Stein, *John Ruskin and Aesthetic Thought in America, 1840–1900* (Cambridge: Harvard University Press, 1967). See also *The New Path: Ruskin and the American Pre-Raphaelites* (New York: The Brooklyn Museum and Schocken Books, 1985), catalog of an exhibition curated by Linda S. Ferber and William H. Gerdts.

26. See *Hamlet* V.i.185–97, and Bolton-Smith and Truettner, *Lilly Martin Spencer*, 30. On Shakespeare in nineteenth-century America, see Lawrence W. Levine, *Highbrow/Lowbrow: The Emergence of Cultural Hierarchy in America* (Cambridge: Harvard University Press, 1988), 13–81.

27. Bertolt Brecht, "A Short Organum for the Theatre," in *Brecht on Theatre: The Development of an Aesthetic*, ed. and trans. John Willett (New York: Hill and Wang, 1964), 191. For discussions of the political or counterideological effects of Brecht's alienation device, see Walter Benjamin, "What is Epic Theater?" (1939), in *Illuminations*, ed. and intro. Hannah Arendt, trans. Harry Zohn (New York: Schocken Books, 1969), 147–54, Ernst Bloch, "*Entfremdung, Verfremdung:* Alienation, Estrangement" (1965), trans. Anne Halley and Darko Suvin, in *Brecht*, ed. Erika Munk (New York:

Bantam, 1972), 3–11, and Colin MacCabe, "Realism and the Cinema: Notes on Some Brechtian Theses," in *Screen* 15:2 (Summer 1974). In *The Messingkauf Dialogues*, trans. John Willett (1948; reprint, London: Methuen, 1965), a series of didactic dramatic exchanges, Brecht clearly and entertainingly sets forth his ideas about pulling down "the fourth wall" (the naturalistic convention by which actors on stage are compelled to seem oblivious of their audience). Levine, *Highbrow/Lowbrow*, discusses the interaction of actors and audiences in nineteenth-century American theater.

28. ʼRobyn R. Warhol, "Toward a Theory of the Engaging Narrator: Earnest Interventions in Gaskell, Stowe, and Eliot," *PMLA* 101:5 (October 1986): 811–18.

29. Fanny Fern [Sara Willis Parton], *Ruth Hall* (New York: Mason Brothers, 1855), 260–61. Lauren Berlant, "The Female Woman: Fanny Fern and the Form of Sentiment," *American Literary History* 3:3 (Fall 1991): 429–54, situates Fern's consolation literature and first-person journalism in an antebellum context that simultaneously isolated bourgeois women within their homes and reinscribed them in the public sphere by way of self-commodification.

30. Beecher, *Treatise on Domestic Economy*, 18. For a full account of Beecher's views, see Kathryn Kish Sklar, *Catharine Beecher: A Study in American Domesticity* (New Haven: Yale University Press, 1973). The Stanton quotation is in Howard Zinn, *A People's History of the United States* (New York: HarperPerennial, 1980), 121. Not that Stanton wholly meant it when she said a wife is everything; her voluminous letters, speechs, and publications are filled with criticisms of prevailing marital inequality. "There can be no true dignity or independence where there is subordination to the absolute will of another, no happiness without freedom," she cautioned in her first public address. "Let us then have no fears that the [woman's rights] movement will disturb what is seldom found, a truly united and happy family." "Address Delivered at Seneca Falls," July 19, 1848, in DuBois, *Stanton / Anthony*, 34.

31. Stanton, *Eighty Years and More*, 147. Noting the historical origins of the relation between housewife isolation and capitalist production, Eli Zaretsky observes that "in contrast to the proletarian who worked in large socialized units and received a wage, the housewife worked alone and was unpaid. . . . Housework and child-rearing came to be seen as natural or personal functions performed in some private space outside society." Zaretsky, *Capitalism, the Family, and Personal Life* (New York: Harper Colophon, 1976), 81. See also pp. 85–90 on the strengths and limits of Fourier's critique of the nuclear family.

32. Nancy Armstrong, *Desire and Domestic Fiction: A Political History of the Novel* (New York: Oxford University Press, 1987), 24.

33. Jane Tompkins, *Sensational Designs: The Cultural Work of American Fiction, 1790–1860* (New York: Oxford University Press, 1985), 127. Some of the other key texts to have argued for treating women's sentimental or romantic literary production with respect rather than disdain are Nina Baym, "Melodramas of Beset Manhood: How Theories of American Fiction Exclude Women Authors," *American Quarterly* 33:2 (Summer 1981): 123–39, Nancy Cott, *The Bonds of Womanhood: "Woman's Sphere" in New England, 1780–1835* (New Haven: Yale University Press, 1977), Mary Kelley, *Private Woman, Public Stage: Literary Domesticity in Nineteenth-Century America* (New York: Oxford University Press, 1984), Tania Modleski, *Loving with a Vengeance: Mass-Produced Fantasies for Women* (New York: Methuen, 1984), and Janice Radway, *Reading the Romance: Women, Patriarchy, and Popular Literature* (Chapel Hill: University of North Carolina Press, 1984). Two recent books making analogous claims for the critical recuperation of working-class texts are Michael Denning, *Mechanic Accents: Dime Novels and Working-Class Culture in America* (London: Verso, 1987), and George Lipsitz, *Time Passages: Collective Memory and Popular Culture* (Minneapolis: University of Minnesota Press, 1990). Influential arguments that sentimental fiction contributed to the cultural domination of American women and of Americans in general include Ann

Douglas, *The Feminization of American Culture* (New York: Knopf, 1977), George Forgie, "Sentimental Regression from Politics to Domesticity," in his *Patricide in the House Divided: A Psychological Interpretation of Lincoln and His Age* (New York: Norton, 1979), and Barbara Welter, "The Cult of True Womanhood, 1820–1860" *American Quarterly* 18 (Summer 1966): 151–74. See also Armstrong, *Desire and Domestic Fiction*, Brodhead, "Spare the Rod," Nina Baym, *Woman's Fiction: A Guide to Novels By and About Women in America, 1820–1870* (Ithaca: Cornell University Press, 1978), and Karen Halttunen, *Confidence Men and Painted Women: A Study of Middle-Class Culture in America, 1830–1870* (New Haven: Yale University Press, 1982).

34. See Michel Foucault, *History of Sexuality*, vol. 1, *An Introduction*, trans. Robert Hurley (New York: Pantheon, 1978), and Mikhail Bakhtin, *The Dialogic Imagination: Four Essays*, trans. Michael Holquist (Austin: University of Texas Press, 1981). On punning as a form of class struggle, see John Fiske, *Understanding Popular Culture* (Boston: Unwin Hyman, 1989), 106–14.

35. John Fiske, *Reading the Popular* (Boston: Unwin Hyman, 1989), 10–11; and id., *Understanding Popular Culture*, 68. See chap. 5 of *Reading the Popular* on Madonna as a vehicle for popular resistance to patriarchy. For a collection of essays focusing on Madonna as the site of cultural and feminist debate, see Cathy Schwichtenberg, ed., *The Madonna Connection: Representational Politics, Subcultural Identities, and Cultural Theory* (Boulder: Westview Press, 1993). Tania Modleski argues against Fiske, Janice Radway, and other "ethnographers" of popular culture, calling into question their empirical methods of gaining—or assuming they have gained—reliable knowledge of their informants' various responses to popular-culture texts (Madonna, romance novels, soap operas, etc.). See Modleski, "Some Functions of Feminist Criticism; Or, the Scandal of the Mute Body," in *Feminism without Women: Culture and Criticism in a "Postfeminist Age"* (New York: Routledge, 1991), 35–58. For a more explicitly neo-Marxian criticism of the appropriation of radical cultural studies by Fiske and other recent champions of mass culture,

see Mike Budd, Robert M. Entman, and Clay Steinman, "The Affirmative Character of U.S. Cultural Studies," *Critical Studies in Mass Communication* 7 (1990): 169–84.

36. Ellet, *Women Artists*, 323. "This [low, comic] manner the artist has been obliged to adhere to on account of the ready sale of such pictures, while the subjects that better pleased her own taste have been neglected" (324).

37. For valuable information and insights regarding this and other works by Spencer, I am indebted to Elizabeth O'Leary. See her chap. 3, "Lilly Martin Spencer: Women's Work and Working Women, 1840–1870," in "At Beck and Call: The Representation of Domestic Servants in Nineteenth-Century America" (Ph.D. diss., University of Virginia, 1993).

38. Fanny Fern, *Fern Leaves from Fanny's Port-Folio* (Auburn and Buffalo, N.Y.: Derby and Miller, 1853), 377.

39. One contemporary reviewer, not convinced of the youth of the "young" wife, complains that she "looks like an old maid who might have been in a great many stews before." *Knickerbocker* 47 (May 1856): 547.

40. Philadelphia Museum of Art, *Masters of Seventeenth-Century Dutch Genre Painting*, exhib. cat., organized by Peter C. Sutton, cat. entry by Otto Naumann (Philadelphia: Museum of Art, 1984), 184–85.

41. Letter, September 10, 1856. Gillian Brown shows that even among middle-class domestic women the political nature of housework was contested, with Catharine Beecher, for example, proclaiming its integral alliance with democracy while her sister, Harriet Beecher Stowe, worried that it needed to be purged of its complicity with slavery and capitalism alike. Contrary to our present-day stereotypes, sentimental culture had no single, monolithic understanding of what it meant for a woman to work in her kitchen. See Brown, "Getting in the Kitchen with Dinah: Domestic Politics in *Uncle Tom's Cabin*," *American Quarterly* 36:4 (Fall 1984): 503–23, and, on the link between nineteenth-century domestic ideology and possessive individualism, id., *Domestic Individualism: Imagining Self in Nineteenth-Century America* (Berkeley: University of California Press, 1990). For a historical

view of the cult of domesticity in America, see Glenna Matthews, *"Just a Housewife": The Rise and Fall of Domesticity in America* (New York: Oxford University Press, 1987), and more specifically on housework in the early industrial period, Jeanne Boydston, *Home and Work: Housework, Wages, and the Ideology of Labor in the Early Republic* (New York: Oxford University Press, 1990).

42. In Leslie Fiedler's infamous formulation, "The figure of Rip Van Winkle presides over the birth of the American imagination, and it is fitting that our first successful homegrown legend memorialize, however playfully, the flight of the dreamer from the shrew." *Love and Death in the American Novel* (New York: Criterion, 1960), xx–xxi.

43. John Demos, *Past, Present, and Personal: The Family and the Life Course in American History* (New York: Oxford University Press, 1986), 61. Benjamin Spencer, of course, was not an absent father, but what he made up for in presence he seems to have lacked in moral authority.

44. According to some commentators, the traditional authority of the father has *always* been undermined in America. Geoffrey Gorer, in "Europe and the Rejected Father," chap. 1 of his *The American People: A Study in National Character* (1948; rev. ed., New York: Norton, 1964), 23–49, contends that the formative experience for European immigrants to America has forever been the rejection of the traditional male figure of authority, whether priest, king, rabbi, or father. Spencer's French contemporary Alexis de Tocqueville noted of American families, "As mores and laws become more democratic the relations between father and sons become more intimate and gentle; there is less of rule and authority, often more of confidence and affection. . . . Among democratic nations every word a son addresses to his father has a tang of freedom, familiarity, and tenderness all at once,

which gives an immediate impression of the new relationship prevailing in the family." *Democracy in America* (1835), vol. 2, part 3, chap. 8 ("Influence of Democracy on the Family"), trans. George Lawrence, ed. J. P. Mayer (Garden City, N.Y.: Doubleday, 1969), 587–88.

45. Stowe believed that the American kitchen had once been and still could be a crossroads and political gathering place rather than a cloistered retreat from the problems facing society. If the home was to serve as society's heart, the kitchen would have to function as that heart's chief artery. See chap. 6, "Fire-Light Talks In My Grandmother's Kitchen," in *Oldtown Folks* (1869), intro. Dorothy Berkson (New Brunswick, N.J.: Rutgers University Press, 1987).

46. Ann Fabian, "Speculation on Distress: The Popular Discourse of the Panics of 1837 and 1857," *Yale Journal of Criticism* 3:1 (1989): 127–42. See James L. Huston, *The Panic of 1857 and the Coming of the Civil War* (Baton Rouge: Louisiana State University Press, 1987), 1–34. *The Panic of 1869* looks like a mad blend of William Holman Hunt's *The Awakening Conscience* (1854) and the German Expressionist silent film *The Cabinet of Dr. Caligari* (Robert Wiene, 1919). For a more stolid rendering of mid nineteenth-century middle-class men faced with financial ruin, see the detailed street scene collaboratively painted by James H. Cafferty and Charles G. Rosenberg, *Wall Street, Half Past 2 O'Clock, Oct. 13, 1857* (1858, Museum of the City of New York; a scaled-down version is in the Metropolitan Museum).

47. Samuel Reznek, *Business Depressions and Financial Panics: Essays in American Business and Economic History* (New York: Greenwood, 1968), 103.

48. *The Crayon* 3:5 (May 1856): 146.

49. David Leverenz, *Manhood and the American Renaissance* (Ithaca: Cornell University Press, 1989), rereads the male-authored American classics of this period not, in the way Leslie Fiedler did, as flights from threatening womanhood but as expressions of and mystifications of their respective authors' fears of humiliation in the marketplace or, for that matter, any other place where men can be seen to fail. He regards the formal inventiveness of Hawthorne, Melville, etc., as a sort of fear-driven swagger, a confidence game to outwit the reader and in so doing fashion the author as a figure of risk and intrepidness—of "intrepidtude," we might say, rather than of ineptitude. By these lights, Hawthorne jibed against "that d—d mob of scribbling women" not so much because he resented their professional success per se as because it magnified his own failure in the world compared to other men.

50. Carroll Smith-Rosenberg, *Disorderly Conduct*, 90, describes a world of marginal or "liminal" men set adrift in the vast and hostile sea of modernity by social and economic forces beyond their control, causing them to respond with regressive fantasies often violent and cannibalistic in nature—as is the story the father recounts in *Fi! Fo! Fum!* "When the social fabric is rent in fundamental ways," she generalizes with this period specifically in mind, "bodily and familial imagery will assume ascendancy. . . . [These], at least, one can control and manipulate. Thus sexuality and the family . . . serve as reservoirs of physical imagery through which individuals seek to express and rationalize their experience of social change." Spencer's genre depictions of her awkward, boyish, ill-proportioned husband can be viewed as *her* attempt to stop the chaos (what Smith-Rosenberg calls "massive and unremitting social transformation") by representing *his* signal inability to do so himself.

51. Letter, May 12, 1862.

52. Demos, *Past, Present, and Personal*, 33.

53. Letter, August 11, 1852. I thank Elizabeth O'Leary for calling this to my attention.

54. Angela L. Miller discusses the prevalence and allegorical significance of picnic pastorals in America art between 1830 and 1880. Noting that "the primary generic element of the picnic theme is the congruence—eventually the conflation—of landscape stage and human actor, of nature and society," she argues that "because the very fluidity of nineteenth-century American society created a pressing need for class definition, rituals and other forms of socially symbolic action such as picnics increasingly assumed the task of identifying social values and loyalties" (114). Miller, "Nature's Transformations: The Meaning of the Picnic Theme in Nineteenth-Century American Art," *Winterthur Portfolio* 24:2/3 (Summer/ Autumn 1989): 113–38.

55. Mikhail Bakhtin, *Rabelais and His World*, trans. Helene Iswolsky (Cambridge: MIT Press, 1965), 10. See also Peter Stallybrass and Allon White, *The Politics and Poetics of Transgression* (Ithaca: Cornell University Press, 1986). On the invention of holidays, see Colin Mercer, "A Poverty of Desire: Pleasure and Popular Politics," in *Formations of Pleasure* (London: Routledge and Kegan Paul, 1983), 84–100.

56. As B. Ruby Rich points out in "Feminism and Sexuality in the 1980s," *Feminist Studies* 12:3 (Fall 1986): 558, "In the era of postmodernism, it is easy to forget that humor is the oldest form of deconstruction: it breaks down barriers, shatters polarities, and conducts subversive, or even liberatory, attacks upon the reigning order."

57. In "Everybody's Protest Novel" (1949), reprinted in *Notes of a Native Son* (Boston: Beacon Press, 1955), 13–23, James Baldwin claims that racism is an essential ingredient of sentimental art in general and *Uncle Tom's Cabin* in particular. Spencer's depiction of African-Americans as happily insouciant, wide-eyed children and clowns lends support to this insight. For examples in addition to *The Fourth of July Picnic*, see *Power of Fashion* (c. 1851), *Height of Fashion* (c. 1854), and *Blind Faith* (1896), which are illustrated in Bolton-Smith and Truettner, *Lilly Martin Spencer*, 40–41, 71, and *Dixie Land* (1862), which was one of Spencer's best-known works and is illustrated in Guy C. McElroy, *Facing History: The Black Image in American*

Art 1710–1940, exhib. cat. (Washington, D.C.: Bedford Arts and the Corcoran Gallery of Art, 1990), 52.

58. Letter, March 7, 1857. O'Leary, "Spencer: Women's Work," discusses at length Spencer's changing attitude toward the serving women who worked for her and whom she sometimes portrayed.

59. Laura Wexler examines the class and race superiorism of middle-class sentimentalists in "Tender Violence: Literary Eavesdropping, Domestic Fiction, and Educational Reform," in *The Culture of Sentiment: Race, Gender, and Sentimentality in 19th Century America*, ed. Shirley Samuels (New York: Oxford University Press, 1992). Several other essays in this volume concentrate on the intersection of sentimentalism with racism and also tend to regard the former as a discourse that, despite intentions otherwise, not merely reflects but actually reproduces the latter; see, for example, Karen Sánchez-Eppler, "Bodily Bonds: The Intersecting Rhetorics of Feminism and Abolition" (92–114). For a competing view that emphasizes the politically contestatory and antiracist potential of sentimental culture, see Tompkins, *Sensational Designs*, and Jean Fagan Yellin, *Women and Sisters: The Antislavery Feminists in American Culture* (New Haven: Yale University Press, 1989). Hazel V. Carby, *Reconstructing Womanhood: The Emergence of the Afro-American Novelist* (New York: Oxford University Press, 1987), shifts the focus from the nineteenth-century sentimental discourse of white women to that produced by black women writers and argues that such discourse served these authors as a powerful means of articulating and contending against their own racial oppression.

60. Harriet Beecher Stowe, *Life and Letters of Harriet Beecher Stowe*, ed. Annie Fields (Boston: Houghton Mifflin, 1897), 104–05. A contemporary of Spencer and Stowe, Elizabeth Stuart Phelps (1815–52), tells a similar tale of domestic frustration in her short story "The Angel over the Right Shoulder" (1852), reprinted in Judith Fetterley, ed., *Provisions: A Reader from 19th-Century American Women* (Bloomington: Indiana University Press, 1985), 203–15. I suspect that many a reader today, regardless of gender, who is struggling to balance the pressing demands of family with equally pressing needs of the self would find Phelps's story harrowing, as frightening as anything by, say, Poe—and its mystical happy ending no more nor less fantastical.

61. Compare to a similar familial situation in chapter 1 of Louisa May Alcott's *Little Women* (1868).

62. See Bolton-Smith and Truettner, *Lilly Martin Spencer*, 61–63, 204–07.

63. Ibid., 67–68.

64. "We have listened too long to the courtly muses of Europe. . . . We will walk on our own feet; we will work with our own hands; we will speak our own minds. . . . A nation of men will for the first time exist, because each believes himself inspired by the Divine Soul which also inspires all men." Ralph Waldo Emerson, "The American Scholar" (1837), in *Selections from Ralph Waldo Emerson: An Organic Anthology*, ed. Stephen Wicher (Boston: Houghton Mifflin, 1957), 79–80. See also William Cullen Bryant's "To Cole, the Painter, Departing for Europe" (1829), in which the poet pleads to his friend not to forsake America permanently for "the light of distant skies" and, while gazing upon the scenes of Europe, to remember "that earlier, wilder image bright" that he left behind. Bryant's poem is available in John W. McCoubrey, *American Art, 1700–1960: Sources and Documents* (Englewood Cliffs: Prentice-Hall, 1965), 96, as is Thomas Cole's "Essay on American Scenery" (1835), 98–110, which is similarly nationalist in spirit.

65. Letter, November 3, 1841; Gilles Martin to Lilly Martin, March 23, 1842.

Chapter 5
Guys and Dolls: *Making a Train*

1. Mark Twain, "Academy of Design" (May 28, 1867), in *Mark Twain's Travels with Mr. Brown, Being Heretofore Uncollected Sketches Written by Mark Twain for the San Francisco Alta California in 1866 and 1867*, collected and edited with intro. by Franklin Walker and G. Ezra Dane (New York: Knopf, 1940), 240.

2. On Brown, see Martha J. Hoppin, *Country Paths and City Sidewalks: The Art of J. G. Brown*, exhib. cat. (Springfield, Mass.: George Walter Vincent Smith Art Museum, 1981).

3. See Elizabeth Johns, *American Genre Painting: The Politics of Everyday Life* (New Haven: Yale University Press, 1991), for the most recent and fully formulated discussion of the political agendas of antebellum genre painting. For surveys of nineteenth-century American genre painting, see Patricia Hills, *The Painter's America: Rural and Urban Life, 1810–1910* (New York: Whitney Museum of Art, 1974), and Hermann Warner Williams, Jr., *Mirror to the American Past: A Survey of American Genre Painting, 1750–1900* (Greenwich, Conn.: New York Graphic Society, 1973). Sarah Burns, *Pastoral Inventions: Rural Life in Nineteenth-Century American Art and Culture* (Philadelphia: Temple University Press, 1989), specifically attends to rural (and at times antiurban) genre painting and printmaking; see in particular chap. 13, "Barefoot Boys and Other Country Children."

4. Bruce Chambers, *The World of David Gilmour Blythe (1815–1865)*, exhib. cat. (Washington, D.C.: Smithsonian Institution Press, 1980).

5. Henry James, "On Some Pictures Lately Exhibited," *Galaxy* (July 1875), reprinted in *The Painter's Eye: Notes and Essays on the Pictorial Arts by Henry James*, selected and edited with intro. by John L. Sweeney (London: Rupert Hart-Davis, 1956), 96–97.

6. On Guy, see Lesley Wright, "The Taste for Genre: American Genre Painting and Its Public, 1850–1880" (Ph.D. diss., Stanford University, 1993). For recent notes on Guy, see Linda Ayres, "The American Figure: Genre Painting and Sculpture," in *An American Perspective: Nineteenth-Century Art from the Collection of Jo Ann and Julian Ganz, Jr.*, exhib. cat., ed. John Wilmerding et al. (Washington: National Gallery of Art, 1981), 56–61, with catalogue entries and biography by Deborah Chotner, Stephen Edidin, and John Lamb, 135–36, and Nathalie Spassky et al., *American Paintings in the Metropolitan Museum of Art*, vol. 2: *A Catalogue of Works by Artists Born between 1816 and 1845* (New York: Metropolitan Museum of Art, 1985), 239–42. Older sources of information include *Dictionary of American Biography*, ed. Dumas Malone (New York: Charles Scribner's Sons, 1932), 8:62–63, *National Cyclopedia of American Biography*, (New York: James T. White, 1901), 2:301, Samuel G. W. Benjamin, *Art in America: A Critical and Historical Sketch* (1880; reprint, New York: Garland, 1976), 115, Sylvester R. Koehler, *American Art* (1886; reprint, New York: Garland, 1978), 54, Walter Montgomery, ed., *American Art and American Art Collections*, (1889; reprint, New York: Garland, 1978), 2:589–91, G. W. Sheldon, *American Painters* (1878; rev. 1881; reprint, New York: Benjamin Blau, 1972), 65–70, and Lemuel E. Wilmarth, "American Painters: Seymour Joseph Guy, N.A.," *Art Journal* (New York) 1 (September 1875): 276–78. On nineteenth-century domestic genre painting in general, including several works by Guy, see Lee M. Edwards et al., *Domestic Bliss: Family Life in American Painting, 1840–1910*, exhib. cat. (Yonkers, N.Y.: Hudson River Museum, 1986).

7. See Annette Blaugrund, "The Tenth Street Studio Building: A Roster, 1857–1895," *American Art Journal* 14 (Spring 1982): 64–71, and Mary Sayre Haver-stock, "The Tenth Street Studio," *Art in America* 54 (September–October 1966): 48–57.

8. Two very useful studies of the material culture of nineteenth-century middle-class northeastern females, with a special emphasis on children, were published under the auspices of the Margaret Woodbury Strong Museum in Rochester, New York: see Harvey Green, *The Light of the Home: An Intimate View of the Lives of Women in Victorian America* (New York: Pantheon Books, 1983), and Mary Lyn Stevens Heininger et al., *A Century of Childhood* (Rochester, N.Y.: Margaret Woodbury Strong Museum, 1984).

9. Jean-Jacques Rousseau, *The Social Contract*, rev. ed. of 1791, trans. with intro. by Charles Frankel (New York: Hafner, 1947), 5; and id., *Emile*, trans. Barbara Foxley (1762; reprint, London: J. M. Dent, 1911), 56. The romantic view of the child's innate goodness ran afoul not only of Calvinism but also Lockean empiricism, which held that the mind of the infant is a tabula rasa, neither bad nor good but merely blank.

10. See L. Terry Oggel, "The Background of the Images of Childhood in American Literature," *Western Humanities Review* 33:4 (1979): 287–89. The seventh stanza of Wordsworth's "Ode: Intimations of Immortality from Recollections of Early Childhood" (1807) seems almost to provide a text for *Making a Train:* "The little Actor cons another part;/ Filling from time to time his 'humorous stage'/ . . . As if his whole vocation/ Were endless imitation." William Wordsworth, *Poetry and Prose*, intro. David Nichol Smith (Oxford: Oxford University Press, 1969), 115.

11. R. Gordon Kelly, "Children's Literature," in *Concise Histories of American Popular Culture*, ed. Thomas M. Inge (Westport, Conn.: Greenwood Press, 1982), 59. See Bernard Wishy, *The Child and the Republic: The Dawn of Modern American Child Culture* (Philadelphia: University of Pennsylvania Press, 1968).

12. On shifting notions regarding the corporeal discipline of children, see Richard H. Brodhead, "Spare the Rod: Discipline and Fiction in Antebellum America," *Representations* 21 (Winter 1988): 67–96. See also chap. 4 above.

13. Jacob Abbott, *Gentle Measures in the Management and Training of the Young* (New York: Harper & Brothers, 1871), 114–16.

14. See Richard Wightman Fox and T. J. Jackson Lears, eds., *The Culture of Consumption* (New York: Pantheon, 1983), for a recent and influential account of this transformation.

15. Circular of the Children's Aid Society (1853), quoted in Charles Loring Brace, "The Children's Aid Society of New York: Its History, Plans, and Results," in *A History of Child-Saving in the United States: Report of the Committee on the History of Child-Saving Work to the Twentieth National Conference of Charities and Correction, Chicago, June, 1893*, ed. C. D. Randall et al. (1893; reprint, Monclair, N.J.: Patterson Smith, 1971), 3.

16. See George K. Behlmer, *Child Abuse and Moral Reform in England, 1870–1908* (Stanford: Stanford University Press, 1982) and Joy Parr, *Labouring Children: British Immigrant Apprentices to Canada, 1869–1924* (London: Croom Helm, 1980). See also John Herridge Batt, *Dr. Barnardo: The Foster-Father of "Nobody's Children": A Record and an Interpretation* (London: Partridge, 1903), and, for a more recent evaluation, Gillian Wagner, *Barnardo* (London: Weidenfeld and Nicholson, 1979).

17. New York Society for the Suppression of Vice, *Sixth Annual Report*, 6; Anthony Comstock, *Traps for the Young* (New York: Funk and Wagnalls, 1883), 241. Quoted in Mark I. West, *Children, Culture, and Controversy* (Hamden, Conn.: Archon Books, 1988), 12, 18.

18. See John Demos, *Past, Present, and Personal: The Family and the Life Course in American History* (New York: Oxford University Press, 1986), 68–91. For the opposing view that child abuse is transhistorical, see Lloyd deMause, "The Evolution of Childhood," in *The History of Childhood*, ed. deMause (New York: Psychohistory Press, 1974), 1–73. "The history of childhood is a nightmare from which we have only recently begun to awaken," proclaims deMause. "The further back in history one goes, the lower the level of child care, and the more likely children are to be killed, abandoned, beaten, terrorized, and sexually abused" (1).

On the history of the concept of child abuse, see Ian Hacking, "The Making and Molding of Child Abuse," *Critical Inquiry* 17 (Winter 1991): 253–88.

19. Henry Mayhew, *London Labour and the London Poor: A Cyclopaedia of the Condition and Earnings of Those That Will Work, Those That Cannot Work, and Those That Will Not Work* (1861–62; reprint, London: Frank Cass, 1967), 4:211. Not that Mayhew believed in the innate innocence of urchins: "Perhaps the most remarkable characteristic of these wretched children is their extraordinary licentiousness. Nothing can well exceed the extreme animal fondness for the opposite sex which prevails among them [and] it would appear that the age of puberty, or something closely resembling it, may be attained at a much less numerical account of years than that at which most writers upon the human species have hitherto fixed it" (1:477; see also 1:412–14). William Thomas Stead, in *The Maiden Tribute of the Modern Babylon* (Philadelphia, 1885; orig. pub. in the *Pall Mall Gazette*, London), shocked Victorians with his detailed report on the sexual traffic of female children and included interviews with the alleged victims. The prominent physician and reformer William Acton analyzed childhood sexuality in his often-reprinted *The Functions and Disorders of the Reproductive Organs in Youth, in Adult Age, and in Advanced Life: Considered in Their Physiological, Social, and Psychological Relations* (1857; 2d American ed., Philadelphia: Lindsay & Blakiston, 1867) and *Prostitution, Considered in Its Moral, Social, and Sanitary Aspects, in London and Other Large Cities: With Proposals for the Mitigation and Prevention of Its Attendant Evils* (1857; 2d ed., 1870; abridged 2d ed., London: MacGibbon and Kee, 1968). The anonymous author of *My Secret Life* (c. 1890; reprint, New York: Grove Press, 1966) goes into explicit detail concerning his sexual encounters with child prostitutes; see Steven Marcus's discussion in *The Other Victorians: A Study of Sexuality and Pornography in Mid-Nineteenth-Century England* (1966; reprint, New York: New American Library, 1974). Various matters of Victorian urban life are treated in H. J. Dyos and Michael Wolff, eds., *The Victorian City: Images and Realities*, 2 vols. (London: Routledge and Kegan Paul,

1973). Victorian-American prescriptive theories about female sexuality are detailed in G. J. Barker-Benfield, *The Horrors of the Half-Known Life: Male Attitudes toward Women and Sexuality in Nineteenth-Century America* (New York: Harper and Row, 1976). On Victorian pedophilia, see James R. Kincaid, *Child-Loving: The Erotic Child and Victorian Culture* (New York: Routledge, 1992), which provides a Foucauldian reading of its subject.

20. See Carroll's letter to Beatrice Hatch's mother, Evelyn Hatch, March 14, 1877, in Morton N. Cohen, ed., *The Letters of Lewis Carroll* (New York: Oxford University Press, 1979), 1:272–73. Or his letter to another mother, Mrs. P. A. W. Henderson, in 1879 (Cohen, *Letters*, 1:346): "With children who know me well, and who regard dress as a matter of indifference, I am very glad (when mothers permit) to take them in any amount of undress which is presentable, or even in none (which is more presentable than many forms of undress)." In the same year he wrote to Mrs. A. L. Mayhew (Cohen, *Letters*, 1:338): "Here am I, an amateur-photographer, with a deep sense of admiration for *form*, especially the human form, and one who believes it to be the most beautiful thing God has made on this earth— and who hardly ever gets a chance of photographing it! . . . Now your [eleven-year-old daughter] Ethel is beautiful, both in face and form; and is also a perfectly simple-minded child of Nature, who would have no sort of objection to serving as model for a friend she knows as well as she does me. So my humble petition is . . . that you will allow me to try some groupings of Ethel and [her younger sister] Janet . . . without any drapery or suggestion of it." Carroll's remark about the purity of naked children is from a letter he wrote to the illustrator Harry Furniss, who quotes it in his *Confessions of a Caricaturist* (New York: Harper and Brothers, 1901), 1:106; his quip about boys is in a letter to Kathleen Eschwege, October 24, 1879 (Cohen, *Letters*, 1:351); and his observation about the transience of his friendships with children is from a letter to Isabel Standen, August 4, 1885 (Cohen, *Letters*, 1:595). Ruskin's adoration for little girls, according to his biographer Joan Evans, was similarly predicated: "So soon as they began to be women they

belonged to another world than his, into which his emotions could not follow." Evans, *John Ruskin* (London: Jonathan Cape, 1954), quoted in Peter Webb, *The Erotic Arts*, rev. ed. (New York: Farrar Straus Giroux, 1983), 207. For examples and discussion of Carroll's photography, see Helmut Gernsheim, *Lewis Carroll, Photographer*, rev. ed. (New York: Dover Publications, 1969).

21. Robert Francis Kilvert, entry for April 19, 1870, in *Kilvert's Diary, 1870–1879: Selections from the Diary of the Reverend Francis Kilvert*, ed. and intro. William Plomer (New York: Macmillan, 1947), 28–29.

22. Vladimir Nabokov, *Lolita* (New York: G. P. Putnam's Sons, 1955), 18–19.

23. The greatest art critic of the Victorian era and rapidly becoming one of its most powerful social critics, the forty-two-year-old Ruskin crowed about his preadolescent beloved, "Her affection takes much more the form of a desire to please me and make me happy in any way she can, than of any want for herself." Evans, *John Ruskin*, 267. Lyn Hunt, ed., *Eroticism and the Body Politic* (Baltimore: Johns Hopkins University Press, 1991), containing a collection of essays on eroticism, politics, and art in France from the Revolution to the Fin de Siècle, conveys the wider meaning of *erotic* that I am trying to get at here.

24. See Louis Chevalier, *Laboring Classes and Dangerous Classes in Paris during the First Half of the Nineteenth Century*, trans. Frank Jellinek (1958; reprint, New York: Howard Fertig, 1973). (For Mayhew, see note 19.) Alan Sekula, "The Body and the Archive," *October* 39 (Winter 1986): 3–64, provides a detailed study of photographic and ideological surveillance of the criminal poor in the nineteenth-century metropolis, Paris in particular. See also Walter Benjamin's unfinished study, "The Paris of the Second Empire in Baudelaire," in *Charles Baudelaire: A Lyric Poet in the Era of High Capitalism*, trans. Harry Zohn (London: New Left Books, 1973), 35–66. The

Scotsman John Thomson carried a large, tripod-mounted camera into city slums to capture images he published as *Street Life in London* (1877) just as he had recorded Chinese scenes in a previous book, *China and Its People* (1873). The quirky Victorian poet A. J. Munby was ecstatic at the sight of poor working women dressed in heavy boots, kerchiefs, and trousers, and he would hire them to pose in such apparel during private photographic sessions. He then went so far as to marry one of them. See Derek Hudson, *Munby, Man of Two Worlds: The Life and Diaries of Arthur J. Munby, 1828–1910* (London: John Murray, 1972), and two feminist analyses, Leonore Davidoff, "Class and Gender in Victorian England: The Diaries of Arthur J. Munby and Hannah Cullwick," *Feminist Studies* 5 (1979): 86–141, and Judith Mayne, "The Limits of Spectacle," *Wide Angle* 6:3 (1984): 4–15.

25. See Sheila M. Smith, " 'Savages and Martyrs': Images of the Urban Poor in Victorian Literature and Art," in *Victorian Artists and the City: A Collection of Critical Essays*, ed. Ira Bruce Nadel and F. S. Schwarzbach (New York: Pergamon Press, 1980), 14–29. Wagner, *Barnardo*, 144 ff., discusses Barnardo's justification of himself before charges that in order to augment fund-raising for his orphan homes he invented or exaggerated the destitution of the children he photographed. On the representation of the urban and agrarian poor in Victorian painting and graphics, see Julian Treuherz et al., *Hard Times: Social Realism in Victorian Art*, exhib. cat. (London: Lund Humphries in association with Manchester City Art Galleries, 1987).

26. Martha Banta, *Imaging American Women: Ideas and Ideals in Cultural History* (New York: Columbia University Press, 1987), 2. Howard Chandler Christy (1873–1952), born in the era of *Making a Train*, explicates ad nauseam his view of the so-called Christy girl

in *The American Girl: As Seen and Portrayed by Howard Chandler Christy* (1906; reprint, New York: Da Capo Press, 1976).

27. George L. Mosse, *Nationalism and Sexuality: Middle-Class Morality and Sexual Norms in Modern Europe* (Madison: University of Wisconsin Press, 1985), explores conjunctions between nineteenth-century German ideals of youthful sexuality and the subsequent rise of the fascist state, as the youthful physical ideal helped crystallize incipient nationalism into a coherent and powerfully attractive form. Beginning in the years immediately after the Civil War, the image of the all-American girl similarly served to pull together diverse national ideals (for example, virginal innocence and democratic self-confidence) that when amalgamated would be far-reaching in their effect on global events over the course of the twentieth century.

28. Daniel Webster, "Influence of Woman," reprinted in *Godey's Lady's Book* 74 (January 1867): 95.

29. Henry T. Finck, *Romantic Love and Personal Beauty* (London: Macmillan, 1887), 2:208–09, 211.

30. Alfred Tennyson, "Mariana in the South" (1833; rev. 1842), *The Complete Poetical Works* (Boston: Houghton Mifflin, 1898), 29–30. Recent feminist studies of Pre-Raphaelite sexual ideology have tended to focus on the work of Millais's fellow painter Dante Gabriel Rossetti. See Virginia Allen, " 'One strangling golden hair': Dante Gabriel Rossetti's *Lady Lilith*," *Art Bulletin* 64:2 (June 1984), and Griselda Pollock, "Woman as Sign: Psychoanalytic Readings," *Vision and Difference: Femininity, Feminism and Histories of Art* (London: Routledge, 1988).

31. Catharine A. MacKinnon, "Feminism, Marxism, Method, and the State," *Signs* 7 (Spring 1982): 541; Edwin M. Schur, *The Americanization of Sex* (Philadelphia: Temple University Press, 1988), 71.

32. See, for example, the section on Guy in Sheldon, *American Painters*, 65–70, and various newspaper clippings reviewing the exhibition of the late George Whitney's art collection at the American Art Galleries, New York, in December 1885 (Archives of American Art, George Whitney Collection, reel 2029, frames 83–85).

33. See "The First Needlework: S. J. Guy, N.A." (unidentified clipping, Art Division, Boston Public Library, from about 1884; might be from Charles M. Kurtz, ed., *National Academy Notes* [1884]). On the admiration for Greuze held by his contemporary Denis Diderot, see Michael Fried, *Absorption and Theatricality: Painting and Beholder in the Age of Diderot* (Berkeley: University of California Press, 1980). See also Anita Brookner, *Greuze: The Rise and Fall of an Eighteenth-Century Phenomenon* (New York: Graphic Society, 1972).

34. See, for example, Clarence Cook, *Art and Artists of Our Time* (New York: Selmar Hess, 1888), 1:xxiv–xxxii. Even as formidable a figure as Émile Zola, creator of the courtesan Nana (and, as noted in chap. 1, ridiculer of Cabanel's *Venus*), was not immune to the appeal of Greuze's girls, as he noted at age twenty in a letter to his friend Paul Cézanne. See Peter Brooks, "Storied Bodies, or Nana at Last Unveil'd," *Critical Inquiry* 16 (Autumn 1989): 30–32.

35. William K. Vanderbilt, the son of Guy's patron William H. Vanderbilt, railroad and shipping multimillionaire, was fond of Greuze and purchased *Broken Eggs* in the 1870s, around the time that Guy depicted William H.'s family in the large group portrait known as *Going to the Opera* (1873, Vanderbilt House, Ashfield, N.C.). See Jerry E. Patterson, *The Vanderbilts* (New York: Abrams, 1989), 108, 126. Another of Guy's patrons was the California railroad magnate Collis P. Huntington, whose Central Pacific connected with the Union Pacific in 1869 to form the nation's first transcontinental railway. A third patron was the financier Jay Gould, who wrested control of the Erie Railroad from the Vanderbilts during a vicious stock battle in 1867–68. With so many ruthless railroad barons hankering for sentimental pictures of poor little boys and girls, it seems inevitable that Guy would have worked up a painting that came to be known as *Making a Train*. The work was first owned by George Whitney of Philadelphia, a collector who, according to a newspaper account after his death in 1885, was "an admirer of the miniature in art. He loved to look at a picture with a magnifying glass." Unidentified newspaper

clipping ("Fine Arts: The Whitney Collection at the American Art Galleries"), George Whitney Collection, Archives of American Art, reel 2029, frame 83. Earl Shinn, who in 1872 penned an unsigned ten-part series entitled the "Private Art-Collections of Philadelphia," devotes only a paragraph to Whitney's art gallery, which was undergoing renovation, but singles out for admiration Guy's "ten-year-old rustic belle who trails an imaginary ball-dress about the garret in which she sleeps." Given that Shinn disdains "the popular scramble for works by Greuze and Watteau, the flimsy idols of the hour," it appears that to his way of thinking Guy fit more comfortably in the tradition of the bourgeois Dutch than the decadent French. In closing the series, he lavishes praise on Philadelphia's "regal capitalists" whose taste in art displays an "always advancing" aesthetic intelligence. *Lippincott's Magazine* 10 (December 1872): 709–10.

36. The painting, also known as *La vertu chancelante* or *Inconstant Virtue*, is discussed in Johann Georg Prinz von Hohenzollern's catalogue entry for *Alte Pinakothek Munich*, ed. Peter Eikemeier and Kevin Perryman, trans. Perryman (Munich: Edition Lipp, 1986), 234.

37. See Bruno Bettelheim, *The Uses of Enchantment: The Meaning and Importance of Fairy Tales* (New York: Knopf, 1976), 215–24, for a Freudian analysis of this story, which, by the way, appears to have been invented in the nineteenth century—its first recorded instance is as a tale written in 1831 by a Scottish "spinster" aunt (of thirty-two) for her nephew. For brief discussions of the painting, see Nancy Wall Moure's catalogue entry in *American Narrative Painting*, exhib. cat. (Los Angeles: Los Angeles County Museum of Art, 1974), 125, and Ayres et al., *An American Perspective*, 57–58, 136. For a brief history of the tale, see Iona and Peter Opie, *The Classic Fairy Tales* (London: Oxford University Press, 1974), 199–200. Initially the intruder in the home of the three bears was an "angry old woman," but over the course of the nineteenth century she metamorphosed into a girl initially called Silver Hair and then, by 1868, Golden Hair and, finally, by 1904, Goldilocks.

38. Lesley Wright, in a Stanford graduate seminar presentation on Guy (1986), alerted me to this interpretive possibility. More recently (December 1991) I showed *Making a Train* as an "unknown" on a final examination in my art history class at Colby College and found that several female students, with no prompting or prior discussion, regarded the red dress as a sign of menstrual flow and saw the painting in general as an allegory of female passage. "Her mother's red dress is brash and sophisticated," one student wrote. "Red is the color of the lipstick she will someday wear. Red is the color of the menstrual blood that will mark her true entry into womanhood. . . . The top drawer on the bureau has been opened. Although the drawer is out of the girl's reach, she was determined to open it, her mother's secrets, and peak inside. By doing so she has begun the journey toward maturity and womanhood."

39. Quoted in Ulrich Bischoff, *Edvard Munch, 1863–1944*, trans. Michael Hulse (Cologne: Benedikt Taschen, 1988), 34.

40. Anita Schorsch, *Images of Childhood: An Illustrated Social History* (Pittstown, N.J.: Main Street Press, 1985), 111, 154. The original *Infant Samuel* was destroyed in a fire in 1816. In 1838 a replica was bequeathed to the National Gallery of London by Lord Farnborough, one of several lords to own a copy by Reynolds of this work. Thenceforth, many other people copied it as well. A Victorian account observes, " 'The Infant Samuel' has always enjoyed the greatest popularity, and is one of those [paintings] in the National Collection most frequently copied." W. J. Loftie, *Reynolds and Children's Portraiture in England* (London: Blackie and Son, n.d.), 17.

41. Revelation 17:1–6. "The mirror was often used as a symbol of the vanity of woman," notes John Berger. "The moralizing, however, was mostly hypocritical. You painted a naked woman because you enjoyed looking at her, you put a mirror in her hand and you called the painting *Vanity*, thus morally condemning the woman whose nakedness you had depicted for your own pleasure. The real function of the mirror . . . was to make the woman connive in treating herself as, first and foremost, a sight." John Berger et al., *Ways of Seeing* (Harmondsworth: British Broadcasting Corporation and Penguin Books, 1972), 51.

42. Nora Scott Kinzer, *Put Down and Ripped Off: The American Woman and the Beauty Cult* (New York: Thomas Y. Crowell, 1977), 22.

43. See "Dress and Its Influences," *Godey's Lady's Book* 74 (June 1867): 556–57.

44. A. M. Barnard, "Behind a Mask: or, A Woman's Power," serialized in the weekly newspaper *The Flag of Our Union* 21:41 (October 13, 1866).

45. Charlotte Perkins Gilman, *Women and Economics: A Study of the Economic Relation between Men and Women as a Factor in Social Evolution*, ed. Carl N. Degler (1898; reprint, New York: Harper and Row, 1966); Thorstein Veblen, *The Theory of the Leisure Class: An Economic Study of Institutions*, intro. C. Wright Mills (1899; reprint, New York: New American Library, 1953), and id., "Economic Theory of Women's Dress," *Popular Science Monthly* 55 (1894): 198–203.

46. The story is reprinted in Louisa May Alcott, *Behind a Mask: The Unknown Thrillers of Louisa May Alcott*, ed. Madeleine Stern (New York: William Morrow, 1975), 1–104, and id., *Alternative Alcott*, ed. Elaine Showalter (New Brunswick, N.J.: Rutgers University Press, 1988), 95–202. (The passage quoted earlier is from *Behind a Mask*, 7.) In addition to the introductory essays by Showalter and Stern, see Judith Fetterley, "Impersonating 'Little Women': The Radicalism of Alcott's *Behind A Mask*," *Women's Studies* 10 (1983): 1–14. " 'Behind a Mask,' " Fetterley contends, "articulates a radical critique of the cultural constructs of 'femininity' and 'little womanhood,' exposing them as roles women must play, masks they must put on, in order to survive."

47. Louisa May Alcott, *Little Women*, intro. Ann Douglas (1868; reprint, New York: New American Library, 1983), 7.

48. "'Making a Toilet' [*Making a Train*] . . . represents a little girl in an attic 'dressing up' previous to undressing for the night. The heroine of the little comedy is illuminated by a lamp which stands on a chair, while through the window streams the pale moonlight, which softly touches her on the shoulder." New York *Evening Post*, December 9, 1885, Archives of American Art, George Whitney Collection, reel 2029, frame 85. *Making Believe* is in the Ganz collection; see Ayres et al., *An American Perspective*, 57–58, 61, 135–36.

49. See Karen Halttunen, "The Domestic Drama of Louisa May Alcott," *Feminist Studies* 10:2 (Summer 1984): 233–54. See also Eugenia Kaledin, "Louisa May Alcott: Success and the Sorrow of Self-Denial," *Women's Studies* 5 (1978): 251–63, and Judith Fetterley, "*Little Women:* Alcott's Civil War," *Feminist Studies* 5:2 (Summer 1979): 369–83. For more on the senior Alcott's principles of education, see Dorothy McCuskey, *Bronson Alcott, Teacher* (New York: Macmillan, 1940).

50. Abbott, *Gentle Measures*, 210.

51. Dean MacCannell and Juliet Flower MacCannell, "The Beauty System," in *The Ideology of Conduct: Essays in Literature and the History of Sexuality*, ed. Nancy Armstrong and Leonard Tennenhouse (New York: Methuen, 1987), 208.

52. W. S. Jerome, "How to Keep a Journal," *St. Nicholas* 5 (October 1878): 799; Elizabeth Payson Prentiss, *Stepping Heavenward* (New York: A. D. F. Randolph, 1869), 7. See Jane H. Hunter, "Inscribing the Self in the Heart of the Family: Diaries and Girlhood in Late-Victorian America," *American Quarterly* 44:1 (March 1992): 51–81.

53. Ella Lyman, c. 1880, in Ella Lyman Cabot Papers (A 139), Arthur and Elizabeth Schlesinger Library on the History of Women in America, Radcliffe College, Cambridge, Mass. Quoted in Hunter, "Inscribing the Self," 60.

54. See Peter Eikemeier's catalogue entry for *Woman Reading* in *Alte Pinakothek*, 268–69 (see n. 36 above).

55. Louisa May Alcott, "Patty's Patchwork," in *Aunt Jo's Scrapbag* (Boston: Roberts, 1872), 1:193. See Elaine Showalter, "Piecing and Writing," in *The Poetics of Gender*, ed. Nancy K. Miller (New York: Columbia University Press, 1986), 232–33. A cultural and historical study of nineteenth-century quilting is Pat Ferrero, Elaine Hedges, and Julie Silber, *Hearts and Hands: The Influence of Women and Quilts on American Society* (San Francisco: Quilt Digest Press, 1987).

56. Nina Auerbach, *Communities of Women: An Idea in Fiction* (Cambridge: Harvard University Press, 1978), 73.

57. See Alice M. Jordan, *From Rollo to Tom Sawyer and Other Papers* (Boston: Horn Book, 1948), 35–37.

58. Sophie May [Rebecca Sophia Clarke], *Dotty Dimple at Home* (Boston: Lee and Shepard, 1868), 164. "Johnny's Revenge" amounts to a nineteenth-century prototype for Alfred Hitchcock's *Psycho* (1960), in which a "guilty" female is voyeuristically watched by a grotesquely costumed male (Norman Bates disguised as his dead mother) who acts out his anger (in Norman's case, toward his mother) with dire, punishing results. "Johnny's Revenge" is no shower sequence, but its sadomasochistic overtones are certainly the stuff of many a slasher film of today.

59. See Charlotte Perkins Gilman, *The Living of Charlotte Perkins Gilman: An Autobiography* (New York: D. Appleton-Century, 1935), 119.

60. Charlotte Perkins Gilman, *The Yellow Wallpaper*, afterword by Elaine R. Hedges (1892; reprint, New York: Feminist Press, 1973).

61. Lewis Carroll, *Alice's Adventures in Wonderland* (chap. 2), in *The Annotated Alice*, ed. Martin Gardner (New York: Penguin Books, 1970), 37.

62. Berger, *Ways of Seeing*, 46–47.

63. Jacques Lacan, "The Mirror Stage as Formative of the I" (1936), in his *Écrits: A Selection*, trans. Alan Sheridan (New York: Norton, 1977), 1–7. Although Lacan introduced his concept of the mirror phase in a professional psychoanalytic context, it has been employed by feminists, film theorists, and popular culture analysts as a means of accounting for the difficult-to-resist lure of mass market images of the self. See, for example, Judith Williamson, *Decoding Advertisements* (London: Marion Boyers, 1979).

64. "She's growing up. Or down—for yesterday she *was* a grownup, mothering her doll, and today she is a subdeb, having her first go at painting the lily. That she now wants to look fifteen years more grown-up, like Glorianna Lovely in the movie magazine, is confusing, isn't it? Perhaps it is better to be a boy, and just sprout chronologically. Well, Little Lady, forget Glorianna. Rejoice that you're a charmer, a knockout, a manslayer—otherwise, how did you hypnotize Norman Rockwell into picking you for his cover girl? As for the next fifteen years, savor slowly the sweet pleasure of causing suitors the sweet pain of romance. Then life's best years will still lie ahead, when you become the daughter of the father of the bride." Editorial caption, *Saturday Evening Post* 226:36 (March 6, 1954): 3. See also Rockwell's *Saturday Evening Post* cover for March 19, 1949, in which an older girl, characterized by various signifiers as a tomboy, holds up a prom gown while warily scrutinizing herself in the mirror.

65. Laura Mulvey, "Visual Pleasure and Narrative Cinema," *Screen* 16:3 (Autumn 1975): 6–18; E. Ann Kaplan, "Is the Gaze Male?" in *Powers of Desire: The Politics of Sexuality*, ed. Ann Snitow, Christine Stansell, and Sharon Thompson (New York: Monthly Review Press, 1983), 309–27. For classical psychoanalytic statements on fetishism, see Sigmund Freud, "Fetishism" (1927), *The Standard Edition of the Complete Psychological Works of Sigmund Freud*, trans. and ed. James Strachey (London: Hogarth Press and the Institute of Psycho-analysis, 1961), 21:152–57, and Otto Fenichel, *The Psychoanalytic Theory of Neurosis* (New York: Norton, 1945), 341–45. Two lucid discussions of vision and fetishism (Marxist as well as Freudian) are to be found in W. J. T. Mitchell, *Iconology: Image, Text, Ideology* (Chicago: University of Chicago Press, 1986), and Linda Williams, *Hardcore: Power, Pleasure, and the "Frenzy of the Visible,"* (Berkeley: University of California Press, 1989).

Freud argues in *Three Essays on the Theory of Sexuality* (1905; *Standard Edition* 7:156–57) that scopophilia, the love of looking, originates in a desire to touch and know that which is forbidden, namely, the sexual body of the prohibited other, and he conjectures that the production and consumption of visual art is the normal result of this culturally mandated prohibition: "The progressive concealment of the body which goes along with civilization keeps sexual curiosity awake. This curiosity seeks to complete the sexual object by revealing its hidden parts. It can, however, be diverted ('sublimated') in the direction of art, if its interest can be shifted away from the genitals on to the shape of the body as a whole. It is usual for most normal people to linger to some extent over the intermediate sexual aim of a looking that has a sexual tinge to it; indeed, this offers them a possibility of directing some proportion of their libido on to higher artistic aims [which is not, Freud goes on to say, the case with the fetishist, who is unable to shift interest away from the genitals]." I take this scenario to be one way of characterizing the sexually tinged and sublimated nature of *Making a Train*.

66. On the notion of ideological "hailing," or "interpellation," see Louis Althusser, "Ideology and Ideological State Apparatuses (Notes towards an Investigation)," *Lenin and Philosophy and Other Essays*, trans. Ben Brewster (New York: Monthly Review Press, 1971), 127–86. On Degas's *Interior*, see Theodore Reff, *Degas: The Artist's Mind* (New York: The Metropolitan Museum of Art and Harper and Row, 1976), 200–38.

67. Erving Goffman, *Gender Advertisements* (New York: Harper and Row, 1976).

68. [Elizabeth Palmer Peabody], *Record of a School: Exemplifying the General Principles of Spiritual Culture* (Boston: James Munroe, 1835), 8. Cited in Halttunen, "The Domestic Drama," 237.

69. Elizabeth Cady Stanton entered a powerful protest against precisely this type of training. "Let the girl be thoroughly developed in body and soul, not modeled, like a piece of clay, after some artificial specimen of humanity, with a body like some plate in Godey's book of fashion, and a mind after the type of Father Gregory's

pattern daughters, loaded down with the traditions, proprieties, and sentimentalities of generations of silly mothers and grandmothers, but left free to be, to grow, to feel, to think, to act. Development is one thing, that system of cramping, restraining, torturing, perverting, and mystifying, called education, is quite another." Stanton, "To the Woman's Convention, held at Akron, Ohio, May 25, 1851," in Elizabeth Cady Stanton, Susan B. Anthony, and Matilda Joslyn Gage, *History of Woman Suffrage* (1881; reprint, Rochester, N.Y.: Susan B. Anthony, 1889), 1:816, and in Gerda Lerner, *The Female Experience: An American Documentary* (Indianapolis: Bobbs-Merrill, 1977), 416.

70. "It is the naivete of the little girl that charms us—her deliciously innocent childish character." "The Whitney Collection: Impressions Gained from a Private View of the Pictures," New York *Press*, December 8, 1885, in Archives of American Art, George Whitney Collection, reel 2029, frame 83.

71. New York *Evening Post*, December 9, 1885, in ibid., frame 85.

72. Robert C. Allen, *Horrible Prettiness: Burlesque and American Culture* (Chapel Hill: University of North Carolina Press, 1991).

73. Roland Barthes, "Striptease," *Mythologies*, trans. Annette Michaelson (1957; reprint, New York: Hill and Wang, 1970), 84. For another 1950s French analysis of the social function of sexuality as spectacle, see André Bazin, "Entomology of the Pin-Up Girl," in *What Is Cinema?* trans. Hugh Gray (Berkeley: University of California Press, 1971), 2:158–62, and for an Italian view, see Umberto Eco, "The Socratic Strip" (1960), in *Misreadings*, trans. William Weaver (San Diego: Harcourt Brace, 1993), 27–32.

74. Nina Auerbach, "Falling Alice, Fallen Women, and Victorian Dream Children" (chap. 9), in *Romantic Imprisonment: Women and Other Glorified Outcasts* (New York: Columbia University Press, 1985), 165, 157–58. See also chap. 8, "Alice and Wonderland: A Curious Child."

75. Foucault challenges the conventional "repression hypothesis" about the Victorians, claiming that, far from repressing sexuality, they *produced* it by proliferating discourses about it. See Michel Foucault, *The History of Sexuality*, vol. 1, *An Introduction*, trans.

Robert Hurley (New York: Pantheon, 1976). Certainly the era was saturated in discourses of sexuality, as Foucault has convincingly shown, but to the extent that individual subjects were normalized by such discourses and administered into socially prescribed channels of behavior, this was still a form of repression, although in a new key—what Herbert Marcuse refers to as "repressive desublimation."

76. Karen E. Rowe, "Feminism and Fairy Tales," *Women's Studies* 6 (1979): 237–57, examines the mother-daughter rivalry motif of these and other popular fairy tales. See also Bettelheim, *The Uses of Enchantment*, for a Freudian analysis of these stories. Jack Zipes provides a radical-left perspective on fairy tales and the fairy-tale "industry" in various of his books; see, for example, *Breaking the Magic Spell: Radical Theories of Folk and Fairy Tales* (Austin: University of Texas Press, 1979), esp. chap. 6, "On the Use and Abuse of Folk and Fairy Tales with Children: Bruno Bettelheim's Moralistic Magic Wand." Zipes contends that Bettelheim's reading of "Cinderella" and other fairy tales is socially conservative, as are these fairy tales themselves (and so, it might be claimed, are Guy's paintings based upon them). See also Roger Sale, *Fairy Tales and After: Snow White to E. B. White* (Cambridge: Harvard University Press, 1978), 23–47.

For a Victorian assessment of the Cinderella story, see Marian Roalfe Cox, *Cinderella*, Publications of the Folk-Lore Society, vol. 31 (London: D. Nutt, 1893). See also Anna Birgitta Rooth, *The Cinderella Cycle* (Lund: C. W. K. Gleerup, 1951). A more recent folkloric survey is Alan Dundes, *Cinderella: A Folklore Casebook* (New York: Garland, 1982). A concise history of the tale followed by Robert Samber's translation from Perrault (1729) is in Iona and Peter Opie, *Classic Fairy Tales*, 117–27.

77. Clementina, Viscountess Hawarden (1822–65) remains a sketchy figure in the history of photography, although a

manuscript on her life and work (some 775 photographs were donated to the Victoria and Albert Museum in 1939) is currently being prepared by Virginia Dodier, who in 1985 wrote a master's report on the subject under the direction of John House of the Courtauld Institute of Art at the University of London. See Dodier, "Clementina, Viscountess Hawarden: 'Studies from Life,'" in *British Photography in the Nineteenth Century: The Fine Art Tradition*, ed. Mike Weaver (Cambridge: Cambridge University Press, 1989), 141–50, and Roy Aspin, "Oh Weary Neutral Days: The Photography of Lady Hawarden," *British Journal of Photography* 129 (May 28, 1982): 564–66. Lewis Carroll admired Lady Hawarden's photographs and even arranged to bring some of his favorite little girls to sit for her.

78. Finck, *Romantic Love and Personal Beauty*, 186; John Ruskin, "Of Queen's Gardens," Lecture II ("Lilies") in *Sesame and Lilies* (1865; reprint, London: Oxford University Press, 1951), 102. In recent years there has been an ever-expanding literature on the Victorian corset. To pour yourself into it, take a deep breath and begin with Valerie Steele, "Clothing and Sexuality," in *Men and Women: Dressing the Part*, exhib. cat., ed. Claudia Brush Kidwell and Valerie Steele (Washington: Smithsonian Institution Press, 1989), 52–55, and Steele's *Fashion and Eroticism: Ideals of Feminine Beauty from the Victorian Era to the Jazz Age* (New York: Oxford University Press, 1985). See also David Kunzle, "The Corset as Erotic Alchemy: From Rococo Galanterie to Montaut's Physiologies," in *Woman as Sex Object: Erotic Art, 1730–1970*, ed. Thomas Hess and Linda Nochlin (New York: *Art News Annual* 38 [1972]: 91–165), and id., *Fashion and Fetishism: A Social History of the Corset, Tight-Lacing and Other Forms of Body Sculpture in the West* (Totowa, N.J.: Rowman and Littlefield, 1980). Beatrice Faust, *Women,*

Sex, and Pornography: A Controversial and Unique Study (New York: Macmillan, 1980), 53, surmises that for some Victorian women the corset may have been sexually exhilarating and in that regard an instrument of freedom and expression rather than captivity or repression: "Most analyses of corsets and high heels—including analyses by feminists—concentrate on the visual impact on the male [yet] neglect the experience of the female wearer or assume that it is uncomfortable. But there may be method in the madness of women who resist rational dress and defend bizarre fashions. High heels and corsets provide intense kinesthetic stimulation for women, appealing to the sense of touch but extending more than skin deep. . . . The Victorian corset was probably as much a tactile fetish among women as it was a visual fetish among men."

79. Pollock, "Modernity and the Spaces of Femininity," in *Vision and Difference*, 81.

80. Karen-edis Barzman, reviewing *Vision and Difference* in *Woman's Art Journal* 12:1 (Spring/Summer 1991): 36–41, argues that Pollock straitjackets her interpretations of Morisot and others, disallowing for "multiple and often contradictory readings contingent upon viewers' race, gender, sexual orientation, and age as well as other terms of difference; upon the time and place within which viewers are situated; and, last but not least, upon their relative familiarity with competing systems of knowledge" (38).

81. Anne Higonnet, *Berthe Morisot* (New York: Harper and Row, 1990), 3. In 1875 Morisot wrote, "I'm horribly sad this evening, tired, nervous, in poor spirits and having had proof once again that the joys of maternity are not for me. . . . There are days when I'm disposed to complain bitterly of fate's injustice." Quoted in Higonnet, *Berthe Morisot*, 134. When three years later Morisot did bear a child, she was "mesmerized by [her daughter's] every feature, identifying with her every need, endlessly and happily occupied by her development" (150). Painted in 1876, *Psyché* could be seen as a sort of visual anticipation by Morisot of the daughter she yearned for: an artistic conception predating the biological one. See also Higonnet, "The Other Side of the Mirror," in *Perspectives on*

Morisot, ed. with intro. T. J. Edelstein (New York: Hudson Hills Press in association with Mount Holyoke College Museum, 1990), 67–78.

82. Kathleen Adler and Tamar Garb, *Berthe Morisot* (Ithaca: Cornell University Press, 1987), 93, 97, point out that Morisot's contemporaries viewed the activity of a woman at the toilette as the equivalent of art-making for men—i.e., women painted their faces instead of canvases. "Paradoxically, what Morisot, the committed painter, presents in these paintings is an image of femininity which is entirely in keeping with the prescriptions for women of her time" (97). True, *Psyché* lends itself to this stereotype of female narcissicism and displaced creativity but could it not also be seen as a play on that stereotype, with the young female who stands before the looking glass *standing in for* the more mature female, Morisot, who herself stands before representations of her own making, ones that exist on a surface not of glass but canvas?

83. A related analysis might be applied to *The Artist's Daughter* (c. 1787), Elizabeth Vigée-Lebrun's depiction of a female child gazing raptly into a handheld mirror that is positioned in such a way as to provide us with a full frontal view of the girl's face—tilted askew. The painting is reproduced in Linda Nochlin, "Why Have There Been No Great Women Artists?" (1971), in *Art and Sexual Politics: Women's Liberation, Women Artists, and Art History*, ed. Thomas B. Hess and Elizabeth C. Baker (New York: Collier Books, 1973), 21.

84. Quoted in Michael Peppiatt and Alice Bellony-Rewald, *Imagination's Chamber: Artists and Their Studios* (Boston: Little, Brown, 1982), 57.

85. I Samuel 3:9; and James Northcote, as quoted in William Hazlitt, *Conversations of James Northcote, Esq., R.A.* (London: Henry Colburn and Richard Bentley, 1830), 163, 289. On the "innocence" and "sexuality" of Reynolds's depictions of children compared to similar works by his French contemporary Greuze, particularly Greuze's *Morning Prayer* (c. 1775–80, Musée Fabre, Montpelier), see Robert Rosenblum, "Reynolds in an International Milieu," in *Reynolds*, ed. Nicholas Penny (London: Royal Academy of Arts, 1986), 47–48. The child who posed for *The Infant Samuel* was one

of Reynolds's preferred models, an orphan "beggar boy" who made and hawked cabbage nets, although, according to the artist's friend Hannah More, Sir Joshua was much annoyed by visitors who wished to learn the urchin's identity. See Penny, id., 273, 277; Loftie, *Reynolds and Children's Portraiture*, 14.

86. Michel Foucault, *Discipline and Punish: The Birth of the Prison*, trans. Alan Sheridan (New York: Pantheon, 1977).

87. Hunter, "Inscribing the Self," 74.

88. Showalter, "Piecing and Writing," 227.

89. Emily Martin, *The Woman in the Body: A Cultural Analysis of Reproduction* (Boston: Beacon Press, 1987), 52–53. See also Joyce Delaney, Mary Jane Lupton, and Emily Toth, *The Curse: A Cultural History of Menstruation*, rev. ed. (Urbana: University of Illinois Press, 1988). Mary Douglas analyzes cross-cultural significations of menstruation in *Purity and Danger: An Analysis of Concepts of Pollution and Taboo* (London: Routledge and Kegan Paul, 1979). Elaine and English Showalter assemble Victorian claims and counterclaims about the menstrual "handicap" in "Victorian Women and Menstruation," in *Suffer and Be Still: Women in the Victorian Age*, ed. Martha Vicinus (Bloomington: Indiana University Press, 1972), 38–44. Barbara Ehrenreich and Deirdre English discuss the nineteenth-century medical view of menstruation as pathology in *Complaints and Disorders: The Sexual Politics of Sickness* (Old Westbury, N.Y.: Feminist Press, 1973), 20–21, and *For Her Own Good: 150 Years of the Experts' Advice to Women* (Garden City, N.Y.: Anchor Press/Doubleday, 1978), 110–11. They quote W. C. Taylor, M.D., *A Physician's Counsels to Woman in Health and Disease* (Springfield, Mass.: W. J. Holland, 1871), 284–85, who writes, "We cannot too emphatically urge the importance of regarding these monthly returns as periods of ill health, as days when the ordinary occupations are to be suspended or modified. . . . Long walks, dancing, shopping, riding, and parties should be avoided at this time of month invariably and under all circumstances. . . . Every woman should look upon herself as an invalid once a month."

Chapter 6
The Trompe l'Oeil Paintings of William Michael Harnett

1. For an example of self-reflexive scholarly writing, see David M. Lubin, *Picturing a Nation: Art and Social Change in Nineteenth-Century America* (New Haven: Yale University Press, 1994), esp. chap. 6, n. 1.

2. For historical and philosophical views on trompe l'oeil painting, see Martin Battersby, *Trompe L'Oeil: The Eye Deceived* (New York: St. Martin's Press, 1974), Norman Bryson, *Looking at the Overlooked: Four Essays on Still Life Painting* (Cambridge: Harvard University Press, 1990), and Miriam Milman, *Trompe L'Oeil Painting: The Illusion of Reality* (New York: Rizzoli, 1983). An especially provocative essay is Jean Baudrillard, "The Trompe-L'Oeil," in *Calligram: Essays in New Art History from France*, ed. Norman Bryson (Cambridge: Cambridge University Press, 1988), 53–62. Charles Sterling, *Still Life Painting: From Antiquity to the Twentieth-Century*, 2d rev. ed., trans. James Emmons (1959; New York: Harper and Row, 1981), is the most complete and authoritative study of still-life painting in general, and Meyer Schapiro, "The Apples of Cézanne: An Essay on the Meaning of Still-life" (1968), in his *Modern Art: Nineteenth and Twentieth Centuries* (New York: George Braziller, 1982), 1–38, has set contemporary standards for reading still-life painting interpretively.

3. Max J. Friedländer, *On Art and Connoisseurship*, 3d ed. (London: Bruno Cassirer, 1944), 131; Sir Joshua Reynolds, *Discourses on Art*, ed. Robert R. Wark (New Haven: Yale University Press, 1975), 232–33 (from the thirteenth discourse, 1786). John Barrell examines the ideological underpinnings of British academic theory in *The Political Theory of Painting from Reynolds to Hazlitt: 'The Body of the Public'* (New Haven: Yale University Press, 1986).

4. See Nicolai Cikovsky, Jr., "Democratic Illusions," in Cikovsky et al., *Raphaelle Peale Still Lifes* (Washington: National Gallery of Art, 1988), 69, n. 19, on Charles Willson Peale's view of still-life painting and, in the same volume, Linda Bantel, "Raphaelle Peale in Philadelphia," 21, on the father's disapproval of his son's marriage to Patty McGlathery.

5. Warren I. Susman, *Culture as History: The Transformation of American Society in the Twentieth Century* (New York: Pantheon Books, 1984), 271–85.

6. "This is the real miracle of affirmative culture. Men can feel themselves happy even without being so at all. . . . In its idea of personality affirmative culture reproduces and glorifies individuals' social isolation and impoverishment." Herbert Marcuse, "The Affirmative Character of Culture" (1937), in his *Negations: Essays in Critical Theory*, trans. Jeremy J. Shapiro (Boston: Beacon Press, 1968), 122.

7. A woman with the gender-ambiguous name Claude Raguet Hirst (1855–1942; she was named after a French great aunt) mastered the trompe l'oeil style in watercolors that typically depicted such supposedly masculine objects as books, pipes, matches, and shavings of tobacco. See Charlotte Streifer Rubinstein, *American Women Artists* (New York: Avon, 1982), 144–45, and Eleanor Tufts, *American Women Artists, 1830–1930* (Washington: National Museum of Women in the Arts, 1987), cat. nos. 94–96.

8. For recent work on "the cultural construction of sexuality," see Arthur Brittan, *Masculinity and Power* (New York: Basil Blackwell, 1989), Pat Caplan, ed., *The Cultural Construction of Sexuality* (New York: Tavistock Publications, 1987), and Harry Brod, ed., *The Making of Masculinities: The New Men's Studies* (Boston: Allen and Unwin, 1987), esp. Michael S. Kimmel's essay, "The Contemporary 'Crisis' of Masculinity in Historical Perspective."

9. The primary source of information on Harnett and his art has long been Alfred Frankenstein, *After the Hunt: William Harnett and Other American Still Life Painters, 1870–1900*, rev. ed. (Berkeley: University of California Press, 1969). A major retrospective on the centennial of Harnett's death resulted in an exhibition catalogue containing twenty-two new essays on his

art and life. See Doreen Bolger, Marc Simpson, and John Wilmerding, eds., *William M. Harnett* (New York: Amon Carter Museum, Metropolitan Museum of Art, and Harry N. Abrams, 1992).

10. Frankenstein, *After the Hunt,* 167.

11. Ibid., 45–47. See also William H. Gerdts, "The Bric-a-Brac Still Life," *Antiques* 81 (November 1971): 744–48. Rémy G. Saisselin, *Bricabracomania: The Bourgeois and the Bibelot* (London: Thames and Hudson, 1985), offers an insightful study of bric-a-brac collecting and other turn-of-the-century aesthetic consumerisms.

12. See John Wilmerding's monograph on Peto, *Important Information Inside: The Art of John F. Peto and the Idea of Still-Life Painting in Nineteenth-Century America* (Washington: National Gallery of Art, 1983). Frankenstein devotes an essay to Peto in *After the Hunt.*

13. On Haberle, see Frankenstein's essay in *After the Hunt* and Gertrude Grace Sill, *John Haberle: Master of Illusion* (Springfield, Mass.: Museum of Fine Arts, 1985). See also Doreen Bolger-Burke et al., *American Paintings in the Metropolitan Museum* (New York: Metropolitan Museum, 1980), 3:277–81.

14. In addition to Susman's *Culture as History,* important discussions of late nineteenth-century American concerns with commodity consumption are contained in Simon J. Bronner, ed., *Consuming Visions: Accumulation and Display of Goods in America, 1880–1920* (New York: Norton, 1989), Stuart and Elizabeth Ewen, *Channels of Desire: Mass Images and the Shaping of American Consciousness* (New York: McGraw-Hill, 1982), Richard Wightman Fox and T. J. Jackson Lears, *The Culture of Consumption: Critical Essays in American History, 1880–1980* (New York: Pantheon Books, 1983), Daniel Horowitz, *The Morality of Spending: Attitudes toward the Consumer Society in America, 1875–1940* (Baltimore: Johns Hopkins University Press,

1985), Saisselin, *Bricabracomania,* Alan Trachtenberg, *The Incorporation of America: Culture and Society in the Gilded Age* (New York: Hill and Wang, 1982), and, of course, Thorstein Veblen, *The Theory of the Leisure Class* (1899; reprint, New York: Penguin Books, 1979).

15. Bric-a-brac still lifes like that of William H. Folwell (see fig. 156) that did tend to emphasize the rareness, and hence costliness, of the items portrayed were usually not executed entirely in the trompe l'oeil style, perhaps because the emphasis here was on the uniqueness of the objects rather than on their marvelous recreation in paint: the conspicuous consumption demonstrated by the patron's ownership of valued artifacts was more important to him than the artist's hyperrealistic skills. As one critic of the time wrote concerning a certain much-admired French bric-a-brac specialist, "Desgoffe's pictures are precious copies of precious things," the key word, of course, being "precious." Philip Gilbert Hamerton, *Painting in France after the Decline of Classicism* (1869), quoted in Gerdts, "The Bric-a-Brac Still Life," 746.

16. On the subject of American trompe l'oeil painting and money, see Bruce W. Chambers, *Old Money: American Trompe L'Oeil Images of Currency* (New York: Berry-Hill Galleries, 1988), and Edward J. Nygren, "The Almighty Dollar: Money as a Theme in American Painting," *Winterthur Portfolio* 23:2–3 (Summer-Autumn, 1988): 129–50. These essays challenge Frankenstein's formalist claim (for example, p. 51) that the trompe l'oeil artists liked to represent currency primarily because of its flatness, which was conducive to their illusionistic goals ("The representation of flat or very shallow objects is of the very essence. . . . [Hence] the fascination of Harnett and his school with paper money"). At a time when extremely acrimonious debates on currency raged across the nation, surely the depiction of greenbacks, coppers, and silver meant more than simply a handy device for achieving representational flatness! For still another view, see Walter Benn Michaels, *The Gold Standard and the Logic of Naturalism: American Literature at the Turn of the Century* (Berkeley: University of California Press, 1987), 137–80, esp. 161–67.

17. See Neil Harris, Introduction, *Land of Contrasts, 1880–1901,* ed. Harris (New York: George Braziller, 1970), 1–28. In the 1950s through the early 1970s in France, neo-Veblenite observers such as Roland Barthes (*Mythologies*), Jean Baudrillard (*Le système des objets* and *La société de consommation*), and Guy Debord (*Society of the Spectacle*) stressed the "spectacular" nature of commodities, which not only are themselves highly visible but also purport to enable consumers to be better seen, that is, more significant in society, less invisible.

18. Elaine S. Abelson, *When Ladies Go A-Thieving: Middle-Class Shoplifters in the Victorian Department Store* (New York: Oxford University Press, 1989), 21; and "Editor's Drawer," *Harper's New Monthly Magazine* 55 (November 1877): 949. Concerning women and late nineteenth-century urban shopping, see Abelson, *When Ladies Go A-Thieving,* Susan Porter Benson, *Counter Cultures: Saleswomen, Managers, and Customers in American Department Stores, 1890–1940* (Urbana: University of Illinois Press, 1986), Rachel Bowlby, *Just Looking: Consumer Culture in Dreiser, Gissing and Zola* (New York: Methuen, 1985), William R. Leach, "Transformations in a Culture of Consumption: Women and Department Stores, 1890–1925," *Journal of American History* 71 (1984): 317–42, and "Female Representation and Consumer Culture," special issue of *Quarterly Review of Film and Video* 11:1 (1989), ed. Jane Gaines and Michael Renov. The consumerist 1980s produced a veritable showroom of academic scholarship on the subject of consumerism, including the history of department stores. Some of the initial and influential work, in addition to that mentioned above and in notes 14 and 17, appeared in Gunther Barth, *City People: The Rise of Modern City Culture in Nineteenth-Century America* (New York: Oxford University Press, 1980), 110–47, Stuart Ewen, *Captains of Consciousness: Advertising and the Social Roots of the Consumer Culture* (New York: McGraw-Hill, 1976), Richard Sennett, *The Fall of Public Man* (New York: Vintage Books, 1978), 141–49. An excellent review of the new scholarship on consumerism is Jean-

Christophe Agnew, "Coming Up for Air: Consumer Culture in Historical Perspective," *Intellectual History Newsletter* 12 (1990): 3–21. For a sampling of twentieth-century hints to merchants and advertisers on how to appeal to consumers according to gender, see Donald A. Laird, "The Customer's Unconscious Desire for Masculinity" and "Woman's Peculiarities as a Purchaser," in his *What Makes People Buy* (New York: McGraw-Hill, 1935), 65–74, 133–146, respectively, and Janet L. Wolff, *What Makes Women Buy: A Guide to Understanding and Influencing the New Woman of Today* (New York: McGraw-Hill, 1958).

19. H. Walter Scott, "The Difference in Customers," *The Show Window* 11:1 (July 1902): 1.

20. Theodore Dreiser, *Sister Carrie* (New York: Norton, 1970), 17; Zola quoted in Saisselin, *Bricabracomania*, 39.

21. H. W. Janson, "Realism in Sculpture: Limits and Limitations," in *The European Realist Tradition*, ed. Gabriel P. Weisberg (Bloomington: Indiana University Press, 1982), 291.

22. P. T. Barnum, *Struggles and Triumphs; or, Forty Years' Recollections* (Buffalo: Courier, 1883), 59. See Richard Herskowitz, "P. T. Barnum's Double Bind," *Social Text* 2 (Summer 1979): 133–41. A twentieth-century defender of advertising's falsifications practically rewords Barnum in contending that "embellishment and distortion are among advertising's legitimate and socially desirable purposes; and that illegitimacy in advertising consists only of falsification with larcenous intent." Theodore Levitt, "The Morality of Advertising," in *Advertising's Role in Society*, eds. John S. Wright and John E. Mertes (St. Paul, Minn.: West Publishing, 1974), 279.

23. Daniel Boorstin, *The Image: A Guide to the Pseudo-Event in America*, rev. ed. (New York: Atheneum, 1971), 210; Max Horkheimer and Theodor W. Adorno, "The Culture Industry: Enlightenment as Mass Deception," *Dialectic of Enlightenment* (1947), trans. John Cumming (New York: Continuum Press, 1987), 167.

24. Frankenstein, *After the Hunt*, 38; 117. Does it come as a surprise that a professional art viewer could have been so resoundingly defeated by the image before his eyes? Like everyone else, professionals see what they *think* they see—or what they think they are going to see. Despite the folk wisdom that seeing is believing, the reverse may more often be the case: believing precedes seeing, it determines what will (and will not) be seen. Paul J. Staiti, "Illusionism, Trompe l'Oeil, and the Perils of Viewership," in Bolger et al., *William M. Harnett*, 31–48, provides a thoughtful study of the late nineteenth-century reception of Harnett's trompe l'oeil illusions in terms of the phenomenology of William James and the hucksterism of P. T. Barnum.

25. John F. Kasson, *Amusing the Million: Coney Island at the Turn of the Century* (New York: Hill and Wang, 1978), 71–72.

26. Unsigned, undated Harnett clipping ("Queer Art Illusions: Some of the Many Methods Employed to Produce Them") quoted in Frankenstein, *After the Hunt*, 81, and reproduced in the Blemly scrapbook, Alfred Frankenstein Papers, Archives of American Art, Smithsonian Institution, Washington, D.C., reel 1374, frame 327.

27. See Carol Troyen's entry for *The Faithful Colt* (cat. no. 71) in Theodore E. Stebbins, Jr., et al., *A New World: Masterpieces of American Painting 1760–1910*, exhib. cat. (Boston: Museum of Fine Arts, 1983), 285–86.

28. See Frankenstein, *After the Hunt*, 3–24. In "Harnett Enters Art History" (Bolger et al., *William M. Harnett*, 101–12), Elizabeth Johns details the circumstances surrounding the twentieth-century discovery of Harnett.

29. "Mr. Harnett's popular success in cheating the untrained eye, following the earlier example of other mechanic painters, has had a bad influence of late; and the greater the handi-craft skill displayed by [his] disciples . . . the greater the regret we must feel that it could not be directed by better taste. Only children and half taught people take pleasure in such tricks of the brush as Mr. Harnett has lately made the fashion." Unsigned, "The Society of American Artists, Ninth Exhibition," *The Studio* 2 (June 12, 1887): 217, quoted in Nancy Troy, "From the Peanut Gallery: The Rediscovery of De Scott Evans," *Yale University Art Gallery Bulletin* (Spring 1977): 42.

30. Sarah Burns shows how even the artifact-laden studios of such fashionable painters as Chase not only served to attest to the artists' refined yet exotic taste and to present them to their admirers as priests of beauty, but also functioned as showroom environments that put visitors in a buying frame of mind. She aptly draws a connection between display in the art studio and in the department store, which would suggest that even though Chase's piling up of objects looked more artistic than Harnett's, both were facets of the new commodity realm and its spectacular visual regime. Burns, "The Price of Beauty: Art, Commerce, and the Late Nineteenth-Century American Studio Interior," in *American Iconology: New Approaches to Nineteenth-Century Art and Literature*, ed. David C. Miller (New Haven: Yale University Press, 1993), 209–38.

31. John Kasson argues that the late nineteenth-century American "machine aesthetic" was not entirely the "form-follows-function," "lean-and-efficient" absence of styling that such twentieth-century critics as John Kouwenhoven and Lewis Mumford praised in their attacks on Victorian decorative excess. Kasson notes that even the most ungainly of heavy machines were usually dressed up with neoclassical or neo-Gothic ornament, and he contends that this was not for hypocritical reasons of disguise but rather because the Victorians perceived their machines as protagonists and antagonists in symbolic melodramas about strength, weakness, endurance, and so forth. One should be careful, therefore, to distinguish between the anthropomorphized machines that manufactured consumer goods and the comparatively impersonal, unanthropomorphized items that they produced. See Kasson, *Civilizing the Machine: Technology and Republican Values in America, 1776–1900* (New York: Grossman Publishers, 1976), chap. 4, "The Aesthetics of Machinery."

32. Harnett, a devout Catholic, was fond of the *vanitas* still life. His highly literary arrangement of such studio props as skulls, musical instruments, and melting candles may have derived from both his personal religious sensibilities and from a keen business sense that knew how to play upon the Victorian infatuation with the old master look and the mystery-laden morality with which it was associated. See Barbara S. Groseclose, "Vanity and the Artist: Some Still-Life Paintings by William Michael Harnett," *American Art Journal* 19:1 (1987): 51–59, and Chad Mandeles, "Grave Counsel: Harnett and Vanitas," in Bolger et al., *Willaim M. Harnett*, 253–63.

33. The classic text on the iconography of Dutch still lifes is Ingvar Bergström, *Dutch Still-Life Painting in the Seventeenth Century* (1947), trans. Christina Hedström and Gerald Taylor (London: Faber and Faber, 1956). Bergström specifically links "progress in the natural sciences" and the accompanying invention of devices such as the microscope and magnifying glass to the "scientific naturalism" evidenced by Netherlandish still-life painting (40–41).

34. Dreiser, *Sister Carrie*, 75. A generation later, in her book about modern "working girls," the satirist Bett Hoopes made fun of this notion in explicit terms: "Every man likes to think his Prize Package is a Virgin in cellophane—direct from maker to consumer, untouched by human hand." Hoopes, *Virgins in Cellophane: From Maker to Consumer Untouched by Human Hand*, with illustrations by James Montgomery Flagg (New York: Long and Smith, 1932), n.p. See Martha Banta, *Imaging American Women: Ideas and Ideals in Cultural History* (New York: Columbia University Press, 1987), 244–50.

35. Frankenstein, *After the Hunt*, 45–47. See also, "Trade in Philadelphia," *Dry Goods Economist* 47, no. 2521 (November 12, 1892): 38. For an investigation into Harnett's patronage,

see Doreen Bolger, "The Patrons of the Artist: Emblems of Commerce and Culture," in Bolger et al., *William M. Harnett*, 73–85.

36. The single most influential discussion of the male gaze is Laura Mulvey, "Visual Pleasure and Narrative Cinema," which first appeared in *Screen* 16:3 (Autumn 1975): 6–18 (see discussions of the gendered gaze in chaps. 1, 4, and 5 above).

37. William H. Gerdts, *Painters of the Humble Truth: Masterpieces of American Still Life, 1801–1937* (Columbia: Philbrook Art Center and University of Missouri Press, 1981), 29; Lois W. Banner, *American Beauty* (Chicago: University of Chicago Press, 1983), 111; and Frankenstein, *After the Hunt*, 78–82. On turn-of-the-century working-class saloon culture, see Roy Rosenzweig, *Eight Hours for What We Will* (Cambridge: Cambridge University Press, 1983). For a study of working-class female culture of the same period, see Kathy Peiss, *Cheap Amusements: Working Women and Leisure in New York City, 1880 to 1920* (Philadelphia: Temple University Press, 1985).

38. "Painted Like Real Things: The Man Whose Pictures Are a Wonder and a Puzzle," interview in New York *News*, probably 1889 or 1890, quoted in Frankenstein, *After the Hunt*, 55.

39. See T. J. Jackson Lears, *No Place of Grace: Antimodernism and the Transformation of American Culture, 1880–1920* (New York: Pantheon Books, 1981).

40. Harnett often employed aesthetic devices associated with European art of the baroque era, which in itself was surely no period of republican simplicity. His work repeatedly strives to reconcile these two seemingly antithetical sensibilities, one sophisticated and ornate, the other unpretentious and plain. On the continuation of republicanism beyond the early national period, see Steven Hahn and Jonathan Prude, eds., *The Countryside in the Age of Capitalist Transformation: Essays in the Social History of Rural America* (Chapel Hill: University of North Carolina Press, 1985), and David E. Shi, *The Simple Life: Plain Living and High Thinking in American Culture* (New York: Oxford University Press, 1985), chaps. 5–7. Concerning the White City

as an expression of dominant ideology, see Trachtenberg, *Incorporation of America*, chap. 7.

41. Fred Davis, *Yearning for Yesterday: A Sociology of Nostalgia* (New York: Free Press, 1979), chap. 1. Nostalgia is an activity much practiced but little analyzed. For a variety of different approaches to the topic, see Ralph Harper, *Nostalgia: An Existential Exploration of Longing and Fulfilment in the Modern Age* (Cleveland: Western Reserve University Press, 1966), Fredric Jameson, "Versions of a Marxist Hermeneutic: Walter Benjamin; or, Nostalgia," *Marxism and Form: Twentieth-Century Dialectical Theories of Literature* (Princeton: Princeton University Press, 1971), 60–83, Renato Rosaldo, "Imperialist Nostalgia," *Culture and Truth: The Remaking of Social Analysis* (Boston: Beacon Press, 1989), 68–87, Jean Starobinski, "The Idea of Nostalgia," trans. William S. Kemp, in *Diogenes* 54 (1966): 81–103, and Richard Terdiman, "Deconstructing Memory: On Representing the Past and Theorizing Culture in France since the Revolution," *Diacritics* (Winter 1985): 13–36.

42. David Lowenthal, *The Past Is a Foreign Country* (New York: Cambridge University Press, 1985), xvi.

43. L. P. Hartley, *The Go-Between* (New York: Stein and Day, 1953), 3.

44. Willa Cather, *My Antonia* (1918; reprint, Boston: Houghton Mifflin, 1954), 89. See id., "Peter," *Early Stories of Willa Cather*, selected and with commentary by Mildred R. Bennett (New York: Dodd, Mead, 1957), 1–8. "Peter" first appeared in *The Mahogany Tree* (Boston), May 21, 1892, and again in the University of Nebraska *Hesperian*, November 24, 1892.

45. Walker to Harnett, September 16, 1887, quoted in Frankenstein, *After the Hunt*, 86.

46. "Painted Like Real Things," quoted in ibid., 55. Although Harnett had been only an infant when his family migrated from Ireland to Philadelphia, he was raised in an Irish-American community keen in its sentimental longings for the old country, the old days. And although we have no record of his feelings about parting from his family, which he did when he moved to New York before he was twenty, one can imagine that a youth such as Harnett

living far from home, as New York in those days would have seemed, might have lovingly recreated friendly old objects as a means of tempering within himself the pangs of homesickness—all the more so, perhaps, because of his Catholicism, with its tradition of venerating holy relics imbued with the power to heal and redeem. Doreen Bolger ("The Patrons of the Artist," 74) notes that "Harnett, who had faced the economic difficulties so often encountered by his fellow countrymen in America, joined the Hibernian Society, which assisted destitute Irish immigrants" and that at the time of his death he had plans to donate to St. Patrick's Cathedral in New York a trompe l'oeil painting of an ivory crucifix he had purchased in Paris. See Kerby A. Miller, *Emigrants and Exiles: Ireland and the Irish Exodus to North America* (New York: Oxford University Press, 1985), on Irish-American immigrants thinking of themselves as exiles from the old country, uneasily displaced on these shores until they could manage a proper return to the homeland that ceaselessly beckoned them. The classic account of American immigrant nostalgia, anomie, and assimilation is a five-volume sociological study and compendium of letters, papers, and diaries, *The Polish Peasant in Europe and America* by William I. Thomas and Florian Znaniecki (1918–20).

47. Sarah Burns, "The Country Boy Goes to the City: Thomas Hovenden's *Breaking Home Ties* in American Popular Culture," *American Art Journal* 20:4 (1988): 59–73. See also Burns's *Pastoral Inventions: Rural Life in Nineteenth-Century American Art and Culture* (Philadelphia: Temple University Press, 1989), part 3, "The Anxieties of Nostalgia," for a variety of late nineteenth-century popular images of "Home, Sweet Home," "childhood," and other sites of urban nostalgia.

48. See Eric Hobsbawm and Terence Ranger, eds., *The Invention of Tradition* (New York: Cambridge University Press, 1983), especially Hobsbawm, "Inventing Traditions," 1–14, and Hugh Trevor-Roper, "The Invention of Tradition: The Highland Tradition of Scotland," 15–41. Another valuable collection is Christopher Shaw and Malcolm Chase, eds., *The Imagined Past: History and Nostalgia* (Manchester: Manchester University Press,

1989). On the formation of the Metropolitan Museum, see Lawrence W. Levine, *Highbrow/Lowbrow: The Emergence of Cultural Hierarchy in America* (Cambridge: Harvard University Press, 1988), 146–55. George Lipsitz, *Time Passages: Collective Memory and American Popular Culture* (Minneapolis: University of Minnesota Press, 1990), eloquently conceives of much American popular culture since the end of the nineteenth century as an attempt by readers, listeners, and viewers to retain or reinitiate connection to their own or their ancestors' class and ethnic origins.

49. "Queer Art Illusions," quoted in Frankenstein, *After the Hunt*, 81. In his celebrated essay "The Work of Art in the Age of Mechanical Reproduction" (1936), Walter Benjamin argues that the advent of mechanical reproducibility diminished the "aura" of works of art that had in previous eras been treated reverentially precisely because of their uniqueness. It is important to note, however, that mechanical reproducibility, in its "miraculousness," was itself a source of awe (and continues to be so), especially at the start of each new phase of its historical manifestation. See Benjamin, *Illuminations*, 217–51.

50. Umberto Eco, noting the devotion of Americans to mimetic recreations of the past, wonders if "there is a constant in the average American imagination and taste, for which the past must be preserved and celebrated in full-scale authentic copy; a philosophy of immortality as duplication." Umberto Eco, *Travels in Hyperreality*, trans. William Weaver (New York: Harcourt Brace Jovanovich, 1986), 6.

51. "The reality effect," particularly as it arose in the mid nineteenth century under the aegis of novelists such as Balzac, historians such as Michelet, and photographers such as Daguerre, was typically achieved by the accumulation of myriad details that seemed random, haphazard, unplanned: "natural," that is to say, rather than premeditated and artfully constructed. See Roland Barthes, "The Effect of the Real," in his *The Rustle of Language*, trans. Richard Howard (New York: Hill and Wang, 1986), 141–48.

52. World exhibitions, Walter Benjamin acidly observed, "are the sites of pilgrimages to the commodity fetish." *Reflections, Essays, Aphorisms, Autobiographical Writings*, ed. Peter Demetz and trans. Edmund Jephcott (New York: Harper and Row, 1978), 151. On Benjamin and nineteenth-century modernity, see Susan Buck-Morss, *The Dialectics of Seeing: Walter Benjamin and the Arcades Project* (Cambridge: MIT Press, 1989). See also Neil Harris, "Museums, Merchandising, and Popular Taste: The Struggle for Influence," in *Material Culture and the Study of American Life*, ed. Ian M. G. Quimby (New York: Norton, 1978), 140–74.

53. William Dean Howells, "A Sennight of the Centennial," *Atlantic Monthly* 38 (July 1876): 92–107, quotes on 96, 101.

54. Quoted in Frankenstein, *After the Hunt*, 69.

55. See Joseph H. Appel, *The Business Biography of John Wanamaker, Founder and Builder: America's Merchant Pioneer from 1861 to 1922* (New York: Macmillan, 1930), and Herbert Adams Gibbons, *John Wanamaker* (New York: Harper and Brothers, 1926). See also [author not given], *The Golden Book of Wanamaker's* (Philadelphia: John Wanamaker, 1911).

56. John E. Powers in *Printers' Ink* (October 23, 1895), quoted in Stephen Fox, *The Mirror Makers: A History of American Advertising and Its Creators* (New York: William Morrow, 1984), 26. A seminal essay on the cultural study of nineteenth-century advertising is Raymond Williams, "Advertising: The Magic System" (1960), in his *Problems in Materialism and Culture: Selected Essays* (London: Verso, 1980), 170–95. See also T. J. Jackson Lears, "From Salvation to Self-Realization: Advertising and the Therapeutic Roots of the Consumer Culture, 1880–1930," in *The Culture of Consumption*, ed. Fox and Lears, 3–38. On the amiable,

direct address, plainspoken style of advertising at the turn of the century, see Richard Ohmann, "History and Literary History: The Case of Mass Culture," in *Modernity and Mass Culture*, ed. James Naremore and Patrick Brantlinger (Bloomington: Indiana University Press, 1991), 24–41, and id., "Advertising and the New Discourse of Mass Culture," in Ohmann's *Politics of Letters* (Middletown, Conn.: Wesleyan University Press, 1987), 152–70.

57. L. Frank Baum, *The Art of Decorating Dry Goods Windows and Interiors* (Chicago: Show Window Publishing, 1900), 8. See Stuart Culver, "What Manikins Want: *The Wonderful Wizard of Oz* and *The Art of Decorating Dry Goods Windows*," *Representations* 21 (Winter 1988): 97–116.

58. For more on this painting, see Andrew Walker, " 'Job Lot Cheap': Books, Bindings, and the Old Bookseller," in Bolger et al., *William M. Harnett*, 233–42.

59. Quoted in Frankenstein, *After the Hunt*, 55; Baum, *Decorating Dry Goods Windows*, 225.

60. Appel, *Biography of John Wanamaker*, 10.

61. George M. Beard, *American Nervousness: Its Causes and Consequences* (New York: G. P. Putnam's Sons, 1881). Tom Lutz has borrowed Beard's evocative title for his recent survey of this period, *American Nervousness, 1903: An Anecdotal History* (Ithaca: Cornell University Press, 1991). See William Butler Yeats, "The Second Coming" (1921), in *W. B. Yeats, The Collected Poems*, ed. Richard J. Finneran (New York: Collier Books, 1983), 187, and Wallace Stevens, "The Idea of Order at Key West" (1934), in *The Palm at the End of the Mind: Selected Poems and a Play*, ed. Holly Steve.. (New York: Vintage Books, 1972), 98.

62. Bradford Peck, *The World a Department Store: A Story of Life under a Cooperative System* (Lewiston, Me.: 1900), 78. Earle Shettleworth, Jr.,

director of the Maine Historic Preservation Commission, has undertaken research on Peck, a department store owner and utopian architect based in Lewiston, Maine, at the turn of the century. On American utopian fiction of this period, see Neil Harris, "Utopian Fiction and Its Discontents," in *Cultural Excursions: Marketing Appetites and Cultural Tastes in Modern America* (Chicago: University of Chicago Press, 1990), 150–73. A twentieth-century conception of the department store as a model for urban planning was proposed by Percival and Paul Goodman in *Communitas: Means of Livelihood and Ways of Life* (Chicago: University of Chicago Press, 1947).

Index

The details that appear at the beginning of each chapter are from the following works: chapter 1, John Vanderlyn, *Ariadne Asleep on the Isle of Naxos* (fig. 3); chapter 2, George Caleb Bingham, *Boone Escorting Settlers through the Cumberland Gap* (fig. 34); chapter 3, Robert S. Duncanson, *Blue Hole, Little Miami River* (fig. 61); chapter 4, Lilly Martin Spencer, *Self-Portrait* (fig. 107); chapter 5, Seymour Guy, *Making a Train* (fig. 115); chapter 6, William Harnett, *After the Hunt* (fig. 170).